#$4⁰⁰

RD

ART IN
OCEANIA
A NEW HISTORY

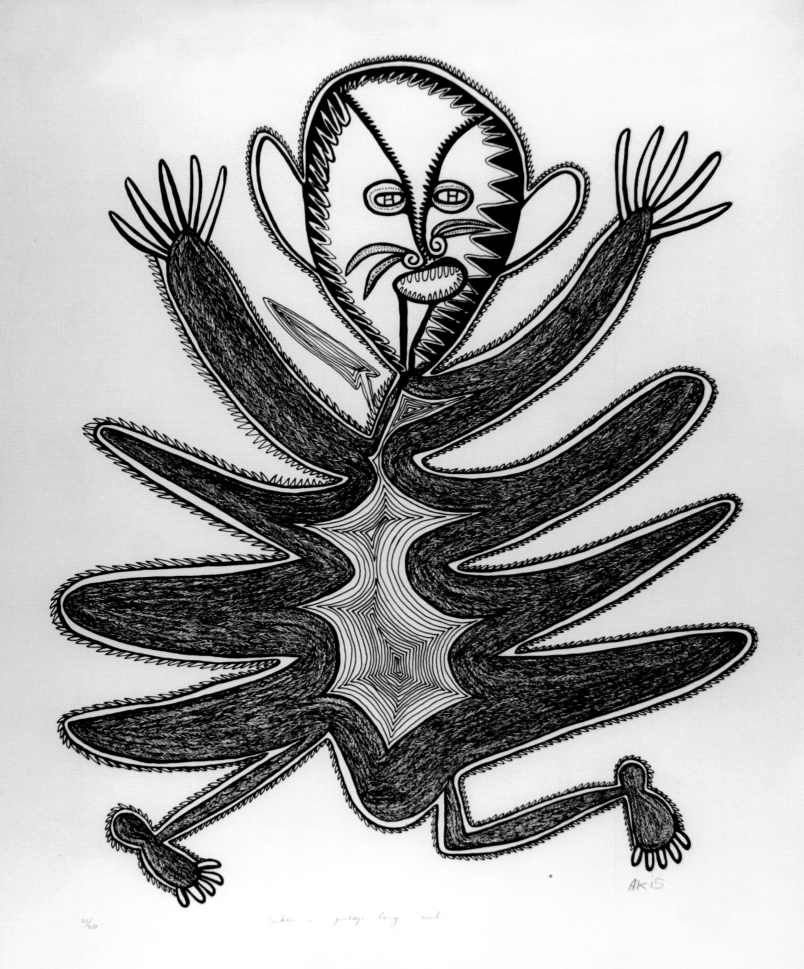

21/30 AKIS

ART IN

OCEANIA

A NEW HISTORY

PETER BRUNT, NICHOLAS THOMAS, SEAN MALLON,
LISSANT BOLTON, DEIDRE BROWN, DAMIAN SKINNER,
AND SUSANNE KÜCHLER

EDITED BY PETER BRUNT AND NICHOLAS THOMAS
ASSISTED BY STELLA RAMAGE

YALE UNIVERSITY PRESS

NEW HAVEN AND LONDON

The publisher and authors are grateful to the following institutions and organizations for their generous support of this project:

Published in North America by Yale University Press

P.O. Box 209040

302 Temple Street

New Haven, CT 06520-9040

www.yalebooks.com/art

Published by arrangement with Thames & Hudson Ltd., London

frontispiece

Timothy Akis, *Sikin i Pulap Long Nil (Skin Full of Thorns)*, 1977. Screenprint. Image height approx. 57 cm (22½ in.). Museum of Archaeology and Anthropology, Cambridge.

Library of Congress Cataloging-in-Publication Data

Art in Oceania : a new history / Peter Brunt [and six others]; edited by Peter Brunt and Nicholas Thomas, assisted by Stella Ramage.

 pages cm

Includes bibliographical references and index.

ISBN 978-0-300-19028-1 (cloth : alk. paper) 1. Art—Oceania. I. Brunt, Peter William, 1955–

N7410.A735 2012

709.95—dc23

 2012026213

Designed by Maggi Smith

Printed and bound in China by Hing Yip Printing Co. Ltd.

CONTENTS

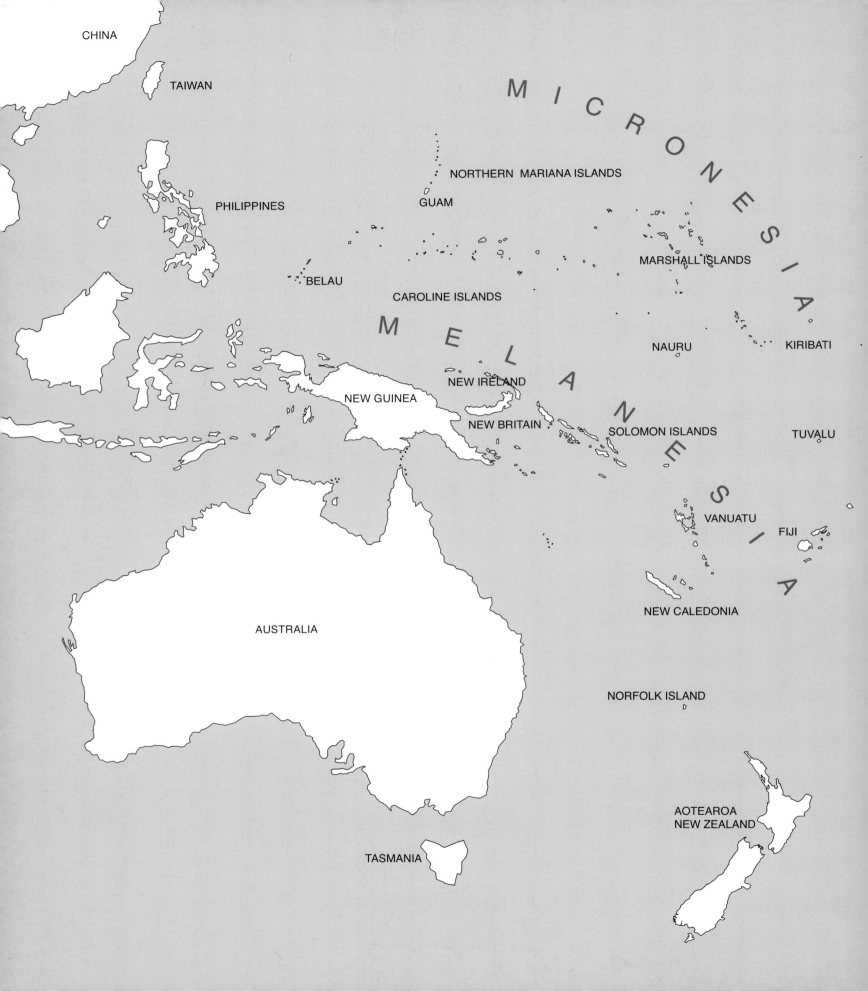

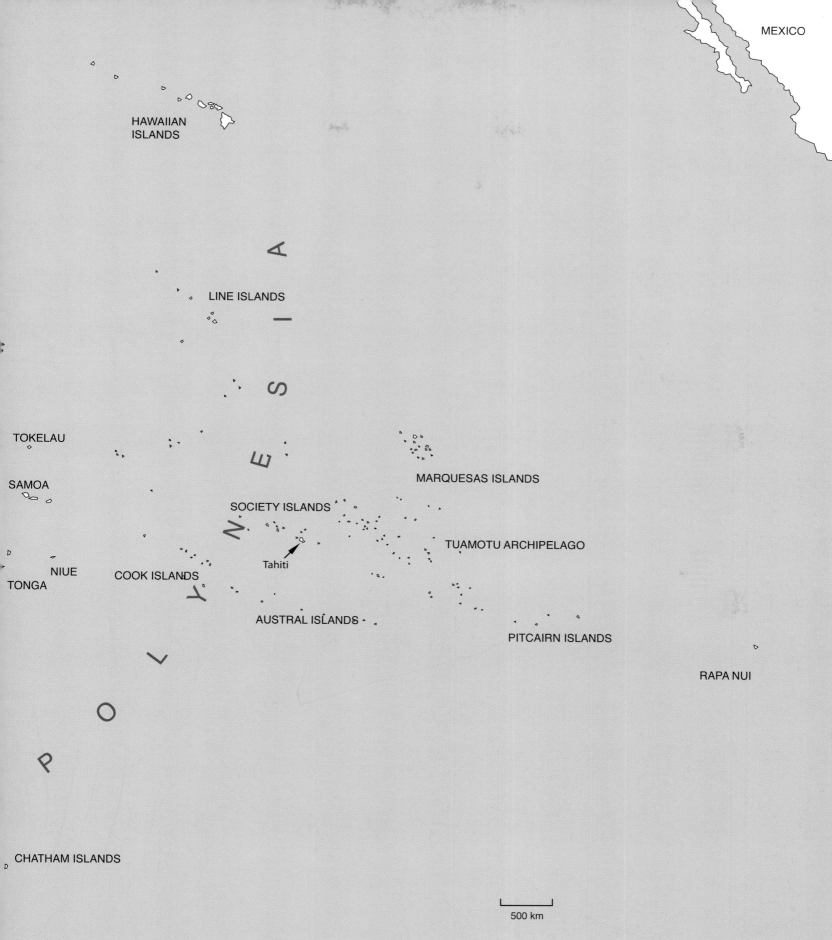

MEXICO

HAWAIIAN
ISLANDS

P O L Y N E S I A

LINE ISLANDS

TOKELAU

SAMOA

NIUE

TONGA

COOK ISLANDS

SOCIETY ISLANDS

Tahiti

AUSTRAL ISLANDS

MARQUESAS ISLANDS

TUAMOTU ARCHIPELAGO

PITCAIRN ISLANDS

RAPA NUI

CHATHAM ISLANDS

500 km

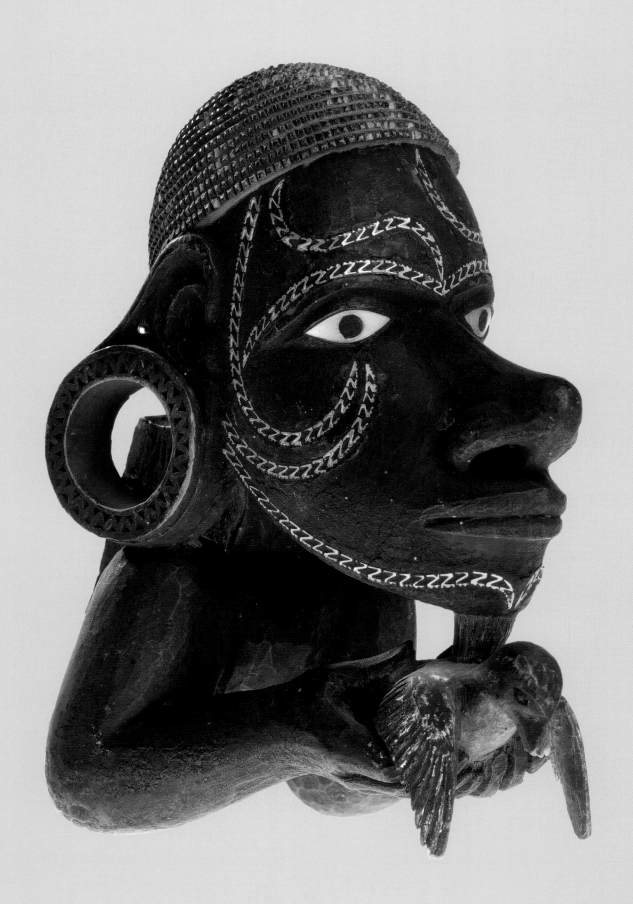

INTRODUCTION

opposite
Nguzunguzu, canoe prow figure, Marovo, Solomon Islands, collected by E. Paravicini in 1929. Wood, shell inlay. Height 17 cm (6¾ in.). Museum der Kulturen, Basel.

right
Turtle sand drawing, Vanuatu, by Jacques Gédéon.

The art is not in the completed design but in the fluency of the act of drawing, which must be effected in a single continuous movement. As well as their performative and aesthetic appeal, sand drawings hold deeper meanings, recording and conveying local cultural knowledge through the symbolic representation of myths, dances, histories and songs. In 2008 the practice of sand drawing was added to UNESCO's Representative List of the Intangible Cultural Heritage of Humanity.

Oceanic art: the rubric brings to mind bold masks and figures that hark from an obscure and remote world of myth and ceremony. They include figures such as, for example, the *nguzunguzu*, the canoe-prow ornament from Marovo in the western Solomon Islands, a sculpture that might strike one as impressively enigmatic. Its features are powerfully exaggerated, yet also perfectly proportioned. In one sense it is all form, in another it is arresting, above all, because of its decoration: almost mobile lines of shell inlay delineate its features, point out its eyes, as if to underline a determination of expression. The bird has the vulnerability of an offering, and its softer, reddish-brown colour matches that of the head-covering, dramatizing the intense black of the figure proper, which in turn is highlighted by the brilliance of the iridescent shell inlay. Small wonder that the carving has been published in at least half a dozen books on Oceanic art; it is justly considered a masterpiece.

This book seeks to draw attention to the power of the art of Oceania. There are many, many great works that, like this, are captivating, that command and reward our attention. Some, like the *nguzunguzu*, are well known to connoisseurs, have frequently been published, and have long been displayed to museumgoers in New York, Paris and Auckland. But many others have remained obscure. There are not only remarkable objects but also whole genres of remarkable objects that are known only to curators and specialists. This book aims, among other things, to reveal works of Oceanic art that have languished in museum storage for generations.

But – we hasten to add – we are motivated not only by admiration for an extraordinary range of work. This book is provoked also by our dissatisfaction with the ways of thinking about art in Oceania that have

prevailed for many years. We challenge the assumption that Oceanic art consists essentially of masks and sculptures, and the associated expectation that these works are to be appreciated essentially in aesthetic terms. We do not in any sense wish to diminish the importance of figure sculpture, but to draw attention to other creative forms that have been significant to Pacific cultures past and present – rock engravings, tattooed and painted bodies, beaten and stained fabrics, woven cloaks and containers, and drawings on sand and paper, to name a few.

Similarly, we do not suggest that an aesthetic interest is irrelevant to the understanding of Oceanic art. But we do insist that we consider the fuller range of significances and uses that artworks have had, in both

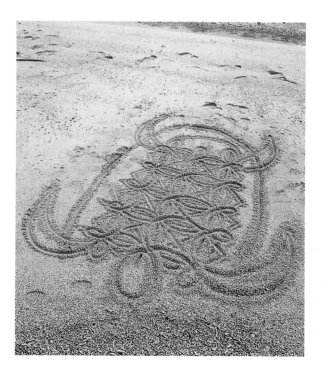

the past and present. And we do reject the kind of talk that foregrounds not the milieux which produced these artworks, but the milieux, far from the Pacific, in which they are and have been appreciated. We cannot censor our own aesthetic responses – on the contrary we should enjoy and explore them – but we need to consider how the aesthetic has been and can be understood, and what connoisseurship has masked. Insofar as it has obscured the perceptions of art forms in the Pacific, and the interests of Islanders today in both the great art forms of the past and their various modern and contemporary successors, our agenda is, emphatically, to turn the tables.

Debate about such issues is, of course, not new. With respect to cross-cultural art, it has long been argued that categories such as art and aesthetics are simply inapplicable to non-Western traditions.[1] Ostensibly a gesture that acknowledges the profound cultural differences between Western conceptions and those of indigenous peoples, such questioning risks enshrining a gulf of mutual incomprehension, acknowledging that these great non-Western art forms come from another world, consigning them to mystery. There are indeed cases where the significance of early works can only be guessed at. But exoticism may also be exaggerated, and the art of modern and contemporary Oceania – which must, alongside historical material, loom large in any genuinely representative account – embraces Western media, techniques, styles and ideas to varying degrees. Certainly, contemporary Pacific art speaks from cultural grounds that remain distinctive, but it is not 'exotic' in any absolute sense.

Arguments about art in Oceania have acquired new energy in part because Pacific Islanders – scholars, curators, cultural activists and artists, as well as community members concerned to document their own traditions – are no longer excluded from the debate. Not only European categories but also alienating analytical languages and what have been seen as acts of academic appropriation have all been challenged. At the same time, it has been recognized that historic collections, photographic archives and scholarly research may be of tremendous importance to Islander communities. Museum curators are turning increasingly toward collaborative work that draws local knowledge and historic collections together.[2]

There is thus a new conversation about art in Oceania, which inspires this book. We have tried to acknowledge this veritable feast: our book aims to open up a space in which many different voices may be heard. Yet we also sense a need for a new paradigm that takes us beyond the diversity of local responses, and more decisively beyond the classical 'appreciation' of Oceanic art. We suggest that the most crucial shortcoming of understandings to date has been not the making of a canon out of some genres at the expense of others, and not the imposition of any particular aesthetic theory, but a failure to place the arts of Oceania within their historical context. Anthropologists were once notorious for evoking indigenous cultures out of time, as coherent orders that existed somehow prior to contacts with colonial systems, even though it was only those contacts that enabled such cultures to become known to anthropology. Similarly, works of Oceanic art have been treated as expressions of untouched traditions, though needless to say it is only as a result of colonial contact that these objects and art traditions have become visible to a wider world. At one time or another explorers, traders, colonial officials, tourists, ethnologists and art collectors have all avidly sought what were at first called 'curiosities' from Islanders. Many works, in fact, took the form they did precisely because of such contacts. Things were made with tools introduced by traders, were made for sale, or in effect on commission. Their making was in other cases stimulated, in less direct ways, by colonial interaction.

Over the last thirty or so years, researchers have begun to historicize indigenous art, in Africa and native America as well as Oceania.[3] Individual artists have been identified, changing styles documented and contextualized within colonial contact. The preoccupation with notionally 'traditional' material has been qualified by the inclusion of innovative genres and contemporary practice. But overviews of Oceanic art have consistently reverted to an area-by-area presentation, dedicating sections to regions such as the Sepik, the Papuan Gulf and New Ireland, each with its characteristic genres and styles.[4]

Of course, any survey must deal with geographic and cultural diversity. But the identification of things by place has been more than just a tool of exposition. In conjunction with the long-standing assumption that native cultures lacked history, it has sustained an

understanding that at best lacks chronological specificity, and at worst amounts to primitivist fantasy. The notion that these arts emerged from a timeless but archaic world has remained alive, especially with respect to New Guinea. If primitivism has long been a canonical topic in histories of modernist art, and Oceanic material consistently cited among the stimuli of modernists, studies of Pacific art have been pursued, somehow, in isolation. History has not been acknowledged as the formative process that we contend it has been.

It is important to add that if this history's most conspicuous chapters are those of contact, colonialism and decolonization, we know that great changes also took place before Europeans arrived. Pre-contact history cannot be documented in quite the same way that post-contact history can be – though the archaeological evidence has begun to accumulate rapidly, and archaeologists have become more attuned to matters of social change, generating interpretations relevant to questions of culture and art. Though oral traditions are selective, only sometimes available, and sometimes hard to interpret, they have enabled rich reconstructions of the century or so prior to European contact in some regions.

Earlier developments, over the longer duration of human settlement in the Pacific, can only be reconstructed more speculatively. Most art forms have not endured – of the media employed, only stone, shell and pottery were not prone to rapid natural decay, though carved timbers have survived under certain environmental conditions. Hence, of the objects extant in museum collections and elsewhere, the overwhelming proportion was either made not long before or at various times after European contact. So a history of art in Oceania will inevitably be doubly imbalanced, toward the most recent centuries, and within that epoch, toward the two hundred and forty or so years since Islanders' works began to be avidly collected by Europeans, and their cultures and histories documented. But it remains vital to understand the cultures of the nineteenth century as the outcomes of longer-term histories, of Islanders' voyages, in literal and metaphoric senses.

Nguzunguzu in History

By way of illustration, consider the object with which we began. The canoes from which *nguzunguzu* were detached were associated primarily with headhunting.

This activity was part of a singular and dynamic prestige economy in the New Georgia region. Powerful men, *bangara*, or chiefs, staged ceremonies and used shell money to buy fishing and headhunting magic (itself traded within the archipelago), and finance the construction of great canoes and canoe houses (*previous page*). Raids secured heads, spiritual power and so-called slaves, some of whom were sacrificed, some effectively adopted, and some (women) prostituted, their services offered in exchange for shell money; that in turn enabled leaders to sustain canoe-building, raiding, and feasting activities.[5]

The earliest example of a *nguzunguzu* appears to have reached a European museum by 1805. This is remarkable, given that only very few ships had passed through the New Georgia group by this date. This piece, now in Te Papa, Wellington, and others collected during subsequent decades, have features that differ from the example in Basel (*page 10*) and that could inform a discussion of changing styles. In this book, we do address shifts in style and the development of genres, but by history we mean more than this.

Over the last decade, archaeological research has dramatically enhanced our understanding of New Georgia societies.[6] The region's rich legacy of shrines, fortifications and other sites has enabled the emergence of the dynamic pattern of trade and warfare described

by Europeans in the late nineteenth century to be dated. In all likelihood, this was a relatively late development in the Solomons' human history. While the islands have been occupied for many thousands of years, a regionally extensive but centralized exchange system emerged, it appears, only around the sixteenth century. If this had elements in common with many Melanesian ceremonial exchange networks – the 'kula ring' made famous by the anthropologist Bronislaw Malinowski being one instance – a distinctive economic principle was crucial to what emerged in New Georgia. Valuables – notably shell valuables – were not produced solely for ceremonies or ceremonial exchanges of particular sorts; instead they could be exchanged for a whole range of services or things. *Nguzunguzu*, like canoes and canoe houses, were products of this system. They must have had antecedents – canoes across Oceania bore elaborate prows, among other 'decorations'. But it is likely that their nineteenth-century form was no older, say, than the tradition of British landscape painting associated with Richard Wilson (1714–1782). Theirs was a genre engendered by an epoch, a society and an economy of a particular kind, not a culture out of time.

Prior to British annexation in 1898, New Georgia was considered a dangerous, conflict-ridden region; British punitive raids had responded to 'outrages'

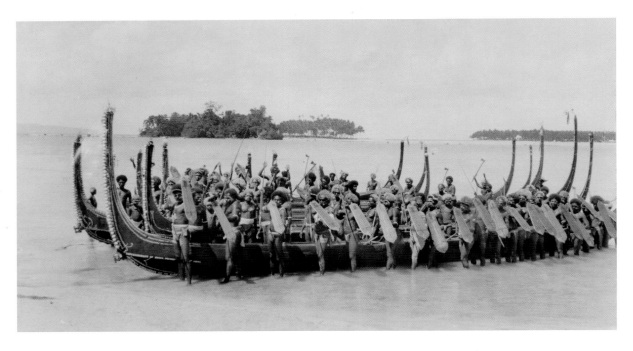

14

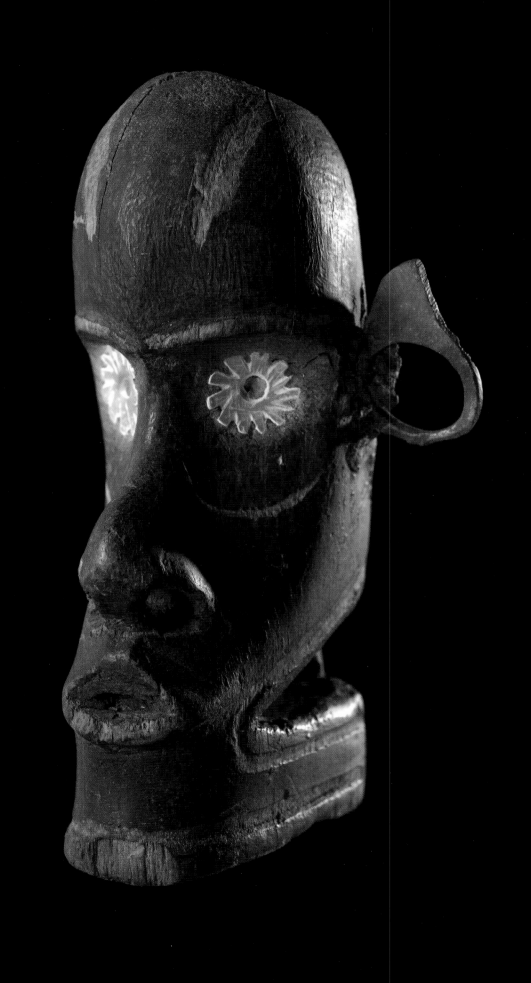

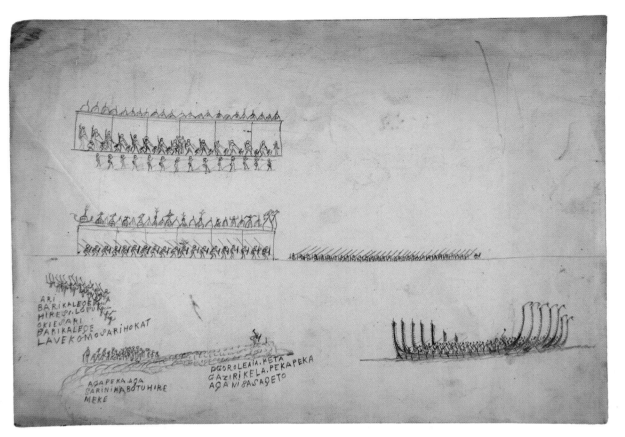

committed against traders or settlers; and very shortly after the Protectorate was declared, a campaign of pacification was undertaken across the archipelago, and war canoes were destroyed in considerable numbers. The raiding that had been a feature of life until the late nineteenth century came to an end, undermining much of the cult life and ceremony that was linked with it. Soon afterwards the Methodist and subsequently the Seventh-Day Adventist missions arrived. Within a decade, it seems, the Methodists had encouraged the revival of canoe-building. What were described in magazines for supporters at home as 'mission war canoes' were raced on mission days and, on at least one occasion, used in a filmed re-enactment of a headhunting raid (*page 14*).

Around the same time, anthropologists Arthur Hocart and William Rivers were on Simbo for a stay vividly and poignantly evoked by the novelist Pat Barker in *The Ghost Road*. They gathered data on kinship, rites, medicine, trade and war. They collected myths, and commissioned wonderfully intricate drawings in which, rather strikingly, canoes are massed as if to evoke the awe-inspiring sight of an approaching raiding fleet. Hocart's notes on canoes are frustratingly incomplete, though he did dismiss the traveller H. B. Guppy's report that the prow figure represented a 'little tutelary deity that sees the hidden rock'. 'The natives', Hocart insisted, 'always declared that it is merely an ornament.'

In 1998 I showed a photograph of the Basel *nguzunguzu* (*page 10*) to John Wayne, a carver from the western Solomon Islands who was then in Noumea for the opening of the Jean-Marie Tjibaou Cultural Centre. He drew attention to the bird held by the figure, and said, 'This is a dove – this is from a peace canoe, not a war canoe.' He went on to explain that when canoes were revived by the missions, the prow carvings were modified; they no longer showed figures holding heads, but instead birds were substituted to signal that Islanders now lived in peace. It seemed a revelation to gather that the Basel carving was not, as it were, a work of traditional art but a novel form associated with conversion to Christianity. Yet this was not in fact correct. Anthropologist Edvard Hviding subsequently drew attention to the fact that, before pacification, *nguzunguzu* might hold either heads or birds. The birds

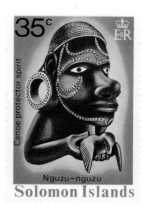

**Solomon Islands
35 cent stamp, 1976.**
'Native Artefacts' series.

were in fact pigeons, known for their propensity to fly dead straight over great distances towards remote islands, hence they exemplified navigational virtuosity. Though the Basel example was not collected until 1929 – by the ethnologist Eugen Paravicini – it was, in Hviding's view, probably made prior to pacification.[7]

Photographs of 'mission war canoes' do not capture the details of prows, so it is unclear what kinds of carvings they featured. However, it is reasonable to assume that there were carvings of some sort, and that missionaries would have discouraged the representation of heads. Hence, even if the bird motif was not originally in any sense a sign of peace, it is not surprising that it should have become one, given the propensity of evangelical culture in the Pacific to engender understandings of rupture. The passage from past to present was one from heathenism to Christianity, darkness to light, war to peace. Yet the explicit idea that the different types of figureheads were symbols of war and peace respectively is reported, it appears, only as recently as the 1980s.

If New Georgia had generated a host of distinctive and spectacular art forms – great food dishes and troughs associated with ceremonial feasts, as well as canoes, canoe houses and weapons – many of these things were, by the turn of the twentieth century, no longer being made, and no longer meaning what they once had meant. In 1908 Rivers's and Hocart's interlocutors were recalling raids and rites they had participated in or witnessed, yet from which they were already decisively separated. Those who, a few years later, would feature in the Methodist film, *The Transformed Isle*, were engaging in a re-enactment, but one that expressed the remoteness of the performers from the practices that they performed.[8]

If, at the very beginning of the nineteenth century, it had already been possible to separate a prow carving from a canoe, and consider it an object for barter and export, by the mid-twentieth century, when US soldiers among others sought souvenirs, prow carvings that were never near canoes were being carved in considerable numbers. They were soon to become emblems of the Western Province, and, as decolonization approached, of the emerging nation of the Solomon Islands. Subsequently, they were widely reproduced – on money, stamps, T-shirts and so forth. Much more could be said about these fascinating objects. But here our point is only that they emphatically do have a history – one marked by discontinuities and innovations, in the social worlds around these works of art, in the uses of the canoes they were attached to and detached from, and in the meanings they were and are seen to bear.

Art and Aesthetics

It is, as we have already noted, commonly pointed out that the term 'art' does not have a precise equivalent in most indigenous languages, hence it could be seen as inappropriate to the discussion of indigenous cultures. This observation is usually accompanied by the suggestion that any sort of aesthetic attitude toward the objects in question is alien to their contexts of origin: it is 'our' business (supposing 'us' to be Western museumgoers), not 'theirs'. These stances may have been well-intentioned but were arguably overstated and misguided. It is indeed true that there are rarely precise equivalents in local languages for the word 'art', but this does not mean that there were and are not other relevant categories, such as Māori *taonga* (heirlooms); indeed, almost every culture had some category of 'valuables', and 'valuables' were typically carefully and elaborately produced artefacts.

These artefacts, moreover, had qualities that were certainly intended to elicit sensory and intellectual reactions – awe, admiration, curiosity and pleasure among them. These are aesthetic responses in a broader sense, if not in the particular sense of the appreciation of beauty, which the idea of the aesthetic commonly implies. Yet there has always been much more to art, even within Western traditions, than this, and pegging a definition of art, or any judgment as to the usefulness of categories such as art, to appreciation of this particular sort, was always an unproductive exercise.

We are concerned to work, not with a restrictive concept of art, but with a looser and more open approach that embraces diverse cultural creations, ranging from food presentation and body decoration to architecture. We do not attempt to cover every expressive cultural medium – were we to do so we would produce an encyclopaedia rather than a history, and range well beyond our collective expertise. Hence we foreground the material and the visual, and we address, for the most part, art objects, representations

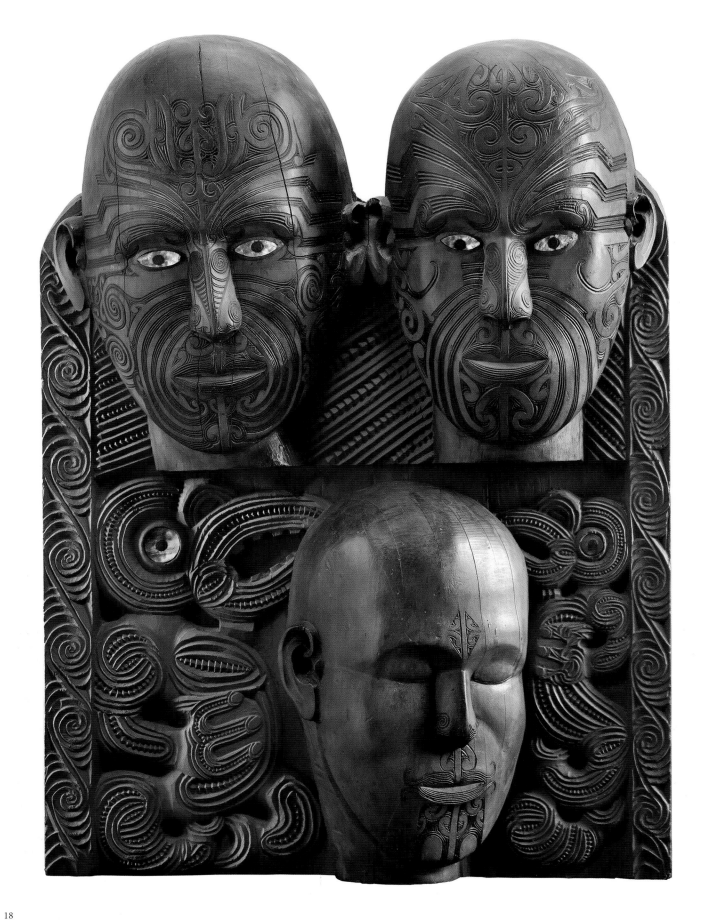

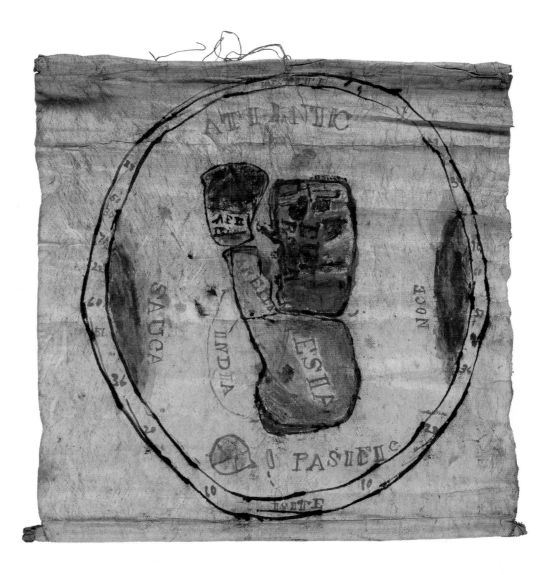

and images, but we stress that in many instances these are inseparable from practices and performances.

It should be added that the long-standing idea that indigenous works encountered in museum settings today are profoundly 'decontextualized' is also misleading. We indeed encounter works of Oceanic art in museums at a radical remove from their places of origin. But the assumption that artefacts were removed from traditional use in customary milieux is often wrong. Many important objects were made by indigenous artists specifically for sale to outsiders. There were no doubt often discrepancies between the interests and understandings of collectors and artists, but their exchanges led to the creation of unprecedented sorts of things – objects that were never in local use, that in some cases took unique forms. An example is the magnificent

relief panel carved by Tene Waitere around 1896 for the ethnologist and curator Augustus Hamilton, essentially an illustration of Māori male and female tattoos.[9] These sorts of things were not extracted from the flow of ordinary life, from community or ceremonial use; they were arguably 'out of context' – works of 'art', dare we say it – in the first place.

If we must enlarge our sense of 'context' and consider the histories that created 'contexts' of new kinds, we cannot neglect art forms integral to the lives of communities, to the ceremonies and exchanges that dramatized local life for centuries. From New Guinea to Hawai'i, from Palau to Rapa Nui, a bewildering range of art forms was created, used, celebrated and gifted. If, as we observed at the outset, carvings and masks come to mind, that is understandable.

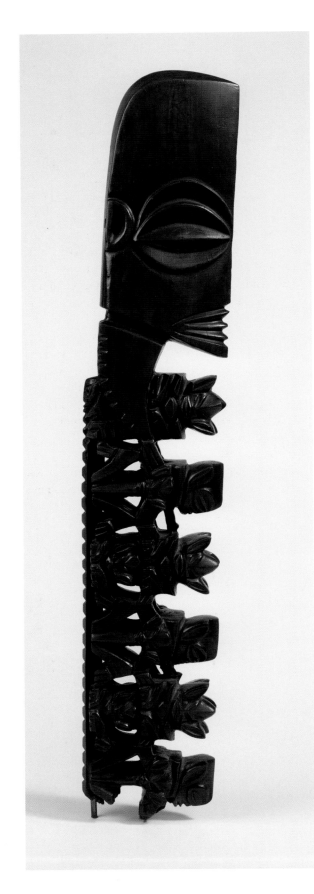

Sculptures of men, women, hermaphroditic and hybrid beings proliferate, not just in wood and paint but also in stone, shell and many other media. And masks of wood, fabric and fibre that may incorporate shell, bone, tusks, hair, feathers, paint, clay, seeds and just about every other imaginable material similarly take diverse and remarkable forms. But, as we have already emphasized, many other sorts of art were produced too: intricately carved personal ornaments, stained and woven fabrics, great lengths of painted barkcloth, engraved bamboo pipes and flutes, and drawings on sand or rock.

How is this astonishing variety of art to be interpreted? In this book we avoid a tendency in modern scholarship to be theory-driven. We are far from hostile to theory but draw on available ideas strategically and eclectically. In the early twenty-first century we are privileged in that decades of discursive approaches have generated a host of rich analyses of symbolism, metaphor and meaningful innovation in artworks. The questions of how artworks communicate, how their significance is articulated, have been much discussed. Yet the last twenty or so years have witnessed a retreat from the commitments of the linguist Ferdinand de Saussure, the anthropologist and ethnologist Claude Lévi-Strauss and others to meaning as the holy grail, as the end of interpretation. In its

place, experience, embodiment, materiality and the senses have variously been advocated, as fundamental dimensions of humanity, society and culture that a preoccupation with language had led theorists and scholars to diminish. In the context of art, Alfred Gell has provocatively attempted to set issues of meaning aside, instead mapping out a theory of art 'as agency', as the mediation of social and political projects.[10]

History and Histories

We have emphasized the need to situate the arts of Oceania in history. For many readers this may beg the question of what we mean by 'history'. It may indeed invite a criticism – that despite the revisionist nature of our project, we are susceptible to Eurocentrism. Are we assuming that 'history' is merely a matter of objective process? Can it not be argued, in contrast, that histories are themselves culturally constituted, and that local understandings of events, epochs and temporality may be very different from those postulated in the histories conventionally generated by Western scholarship?[11]

Here we want to have our cake and eat it too. 'History' has been one of the most contested categories in Pacific studies over the last thirty years. Some of the most influential writings from the region have used the disciplines of anthropology and history to subvert each other. Such seemingly self-evident categories as that of the 'event' have been pulled apart and put back together in stimulating ways. Compelling but often controversial arguments for the local distinctiveness of forms of historical understanding have been put forward at one time and another for Māori, Fijians, Hawaiians and the peoples of various parts of Papua New Guinea. In this book we introduce local concepts of time and history, as we bring in other concepts – of space, environment, power and sanctity – where they enable the understanding of Islanders' art forms in their varied contexts.

This is to acknowledge the need for an open and nuanced approach to how happenings, continuities and changes have been construed locally, an approach that neither assumes the global salience of Western chronology nor insists that Islanders have been conceptual prisoners of exotic categories. But, because this book ranges across Oceania, we never had the option of structuring it as a whole on the basis of local ideas – of genealogy, for instance – since these are of

course varied, as different from each other as from a 'Western' history.

The temporal and historical framing of this book is therefore a scholarly construct, which does not aspire to capture or mimic an indigenous history; but it is one that avoids reproducing divisions long employed in colonial histories, such as pre- and post-contact. It instead responds to what we know of the Pacific and what has happened here over the timeframe we consider. The comparatively recent period that we foreground is understood against the longer human history of Oceania. With respect to what has taken place over the last few centuries, we are mindful that in various local and colonial understandings the passage of time has not been like a single river, but that of an array of distinct, connected or partially connected flows. Time, continuity and change in no sense provide self-evident contexts for the arts we explore; rather, both arts and their 'times' may take forms that surprise us, that require new kinds of description and analysis, remote from both established art histories and anthropologies.

Boundary Issues

Something too must be said about the regional framing of this volume. 'Oceania', like 'Asia' or 'Europe', is not a

right
Hei tiki, acquired 1912.
Greenstone pendant.
Height 16 cm (6¼ in.).
Auckland Museum.

The canonical Māori pendant and valuable heirloom came to be extensively produced as a souvenir and, most controversially, cheaply reproduced in plastic.

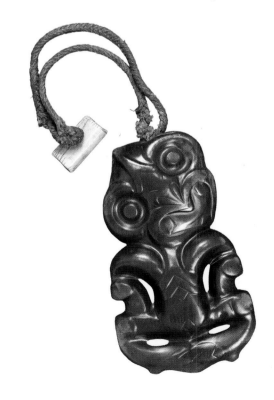

naturally distinct part of the world but a geographic rubric with a long history. Clearly, this term, like the 'South Sea', the 'South Seas' and the 'Pacific Islands', is not an indigenous one, though labels of this kind, like Melanesia, Polynesia and Micronesia, which became current over the eighteenth and nineteenth centuries, have been and are used today by many Islanders in many contexts. Ideas of place and region are the products of entangled histories.

Though 'Oceania' is of course a construct, it is not a wholly arbitrary one. The region does have a degree of cultural coherence, a far greater one than Asia or Europe ever possessed, simply because the bulk of the islands of the Pacific were settled by branches of a single population, speakers of Austronesian languages, that moved through the archipelagoes of the south-western part of the ocean from around four thousand years ago, and subsequently settled the islands of the central Pacific, and eventually remoter islands to the north, east and south – those of Hawai'i, Rapa Nui and New Zealand (or Aotearoa New Zealand, to use the bicultural combination of Māori and settler name preferred by many within the country today). Hence the extraordinary diversity of island Melanesian, Polynesian and some Micronesian cultures is underpinned by ancestral affinities. Peoples more closely related, if geographically separated, such as Hawaiians and Māori, had much more in common, in ritual categories such as taboo (*kapu* or *tapu* in their respective languages) and in tattooing – both in the art itself and in what it was understood to accomplish, not only as an ornament for but as a kind of armament of the body.

Needless to say, the human history of the Pacific is more complex than this. The island of New Guinea and the area to the immediate east was settled long before the Austronesian migration eastwards; indeed the distinctiveness of coastal New Guinea and archipelagoes such as those of the Bismarck Islands derived from long periods of interaction between older Papuan cultures and Austronesian immigrants. Similarly, the Micronesian islands were settled both from Polynesia and from the Philippines, hence this too was an area of interaction.

Oceania has fairly clear boundaries to the east, north and south – it embraces the more remote Polynesian islands of Rapa Nui, Hawai'i and New Zealand but not the unrelated cultures of northeast

Asia or the Americas. To the west, a more arbitrary line needs to be drawn. The cultures of what is now eastern Indonesia were historically related to those of the island of New Guinea, and those of Austronesian speakers in island Melanesia. Those disposed to compare woodcarvings and figurative sculptures will easily track stylistic similarities from Flores and Timor to the Admiralty Islands and beyond. But we have to stop somewhere. And, more importantly, this book is not an antiquarian pursuit of cultural traits but a historical project, and there is a major historical distinction between insular southeast Asia and the region the book is dedicated to: the former area was profoundly affected by world religions – Buddhism, Islam and Hinduism – while the islands of the Pacific were not, before the incursions of evangelical Christian missionaries at the end of the eighteenth century.

The term 'art in Oceania' should in principle include art made by Europeans in the Pacific. Therefore, we do illustrate voyage artists such as William Hodges and John Webber, we address Paul Gauguin's work in French Polynesia, and we look at a few colonial photographers – not least because these image-makers have all interested, impressed or influenced Islanders, both at the time they worked and more recently. But we do not have the space to explore 'European vision' in the Pacific in anything like the sustained fashion that Bernard Smith did in his pioneering survey of 1960, nor can we enter into histories of white settler art in New Zealand, Hawai'i or elsewhere. Insofar as settler artists were inspired by local motifs and styles, their stories belong to the cultural exchanges that we track in this book, and are touched upon here. But any fuller discussion would amount to a distraction from our core project, to offer a fuller understanding of the arts of indigenous Oceania and the histories that have shaped them over the last few centuries.[12]

Oceania

Until the mid-1990s, the term 'Oceania' had a slightly antiquarian flavour. It was employed in the departments of European museums and by American connoisseurs of tribal arts, but was seldom used in the region itself. Historians, anthropologists and those concerned with the politics of the islands always referred to 'the Pacific'. But then, in a brief essay, one of the region's most imaginative and radical intellectuals,

Epeli Hauʻofa, called for a new imagining. The 'Pacific Islands', he argued, was a term that had come to imply the sort of understanding of the region to which development economists subscribed. Islands were dots in a vast emptiness, tiny and essentially unsustainable, politically and economically. In contrast:

> 'Oceania' connotes a sea of islands with their inhabitants. The world of our ancestors was a large sea full of places to explore, to make their homes in, to breed generations of seafarers like themselves. People raised in this environment were at home with the sea. They played in it as soon as they could walk steadily, they worked in it, they fought on it. They developed great skills for navigating their waters, and the spirit to traverse even the few large gaps that separated their island groups. Theirs was a large world in which peoples and cultures moved and mingled, unhindered by boundaries of the kind erected much later by imperial powers.[13]

This vision of a 'sea of islands' is, Hauʻofa acknowledges, a romantic one, intended to value and empower a future for Islanders defined by and for Islanders. It does not describe all Pacific livelihoods from all times: more or less all larger islands had inland populations whose lives were not at all sea-based. If, in this respect, Hauʻofa's vision suppresses the true diversity of the region, there is another sense in which his evocation foregrounds a feature of Oceanic life that was of genuine and paramount importance, namely, exchange. Throughout the islands, various forms of gift giving and trade were the substance of sociality, the foci of people's energies, and typically the most prestigious and celebrated practices. It is no coincidence that one of the most influential theoretical texts of twentieth-century anthropology, Marcel Mauss's *The Gift*, took the exegesis of a Māori elder as its departure point, nor that the most famous of all ethnographic monographs – Malinowski's *Argonauts of the Western Pacific* – was dedicated to a description of Melanesian ceremonial exchange.

Hauʻofa was absolutely right to insist that the peoples of Oceania did not form discrete and isolated populations; on the contrary, they had always been mutually engaged through exchange. Throughout this volume we will encounter a remarkable range of evidence for the fertility of trade in the past and present. The art forms we consider were never products of isolated local aesthetics, but of histories that were entangled in many ways before, during and after the colonial periods. Hence, for just the reasons Hauʻofa describes, it makes sense for us to embrace the 'grand and somewhat romantic' term that he has reintroduced. Let us look, then, at art in Oceania.

'A *lakatoi*, large canoe/raft with sails', Port Moresby, Papua New Guinea, 1885.
Photograph J. W. Lindt.
© The Trustees of the British Museum, London.

Lindt was one of the most professionally accomplished of the early photographers of Melanesia. His *Picturesque New Guinea* (1887) was one of the earliest published photographic albums from the Pacific.

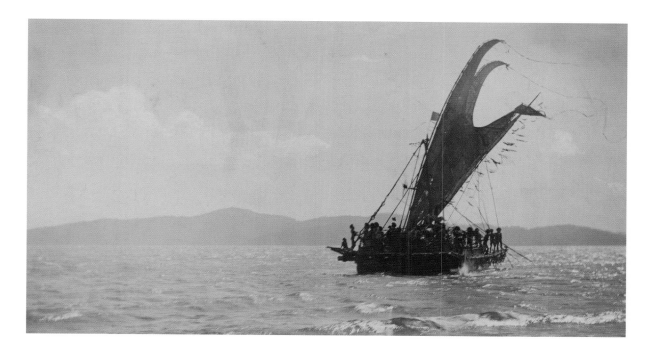

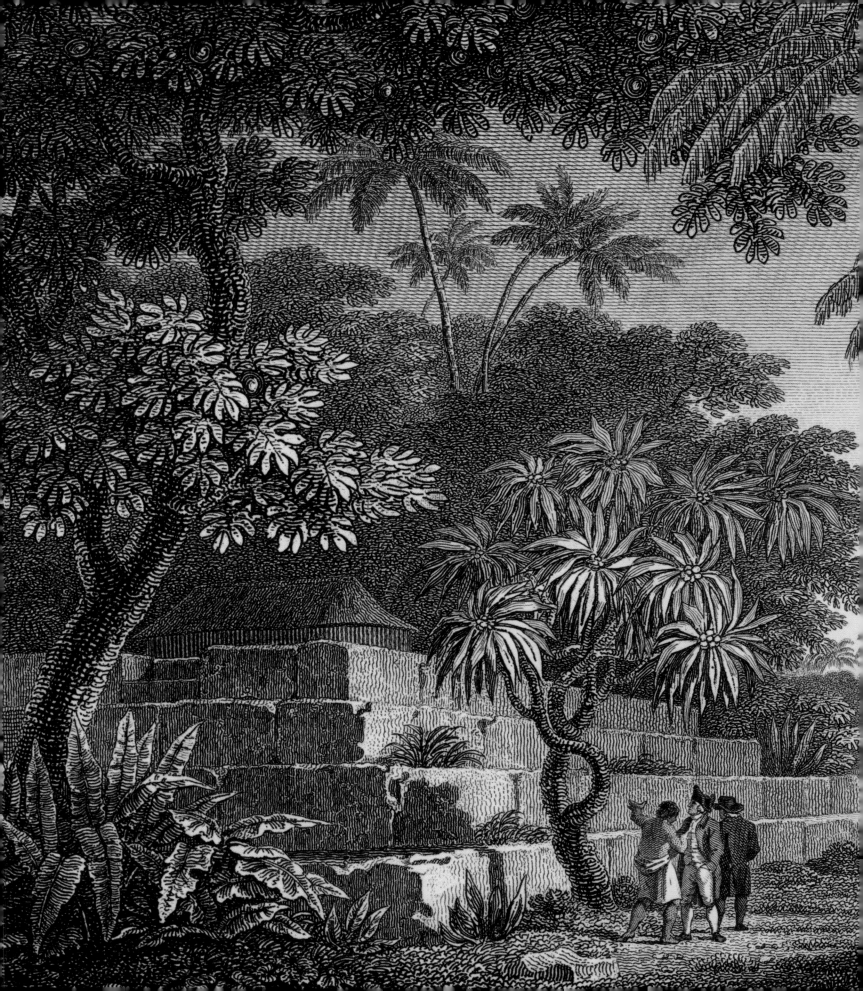

PART ONE ART IN EARLY OCEANIA

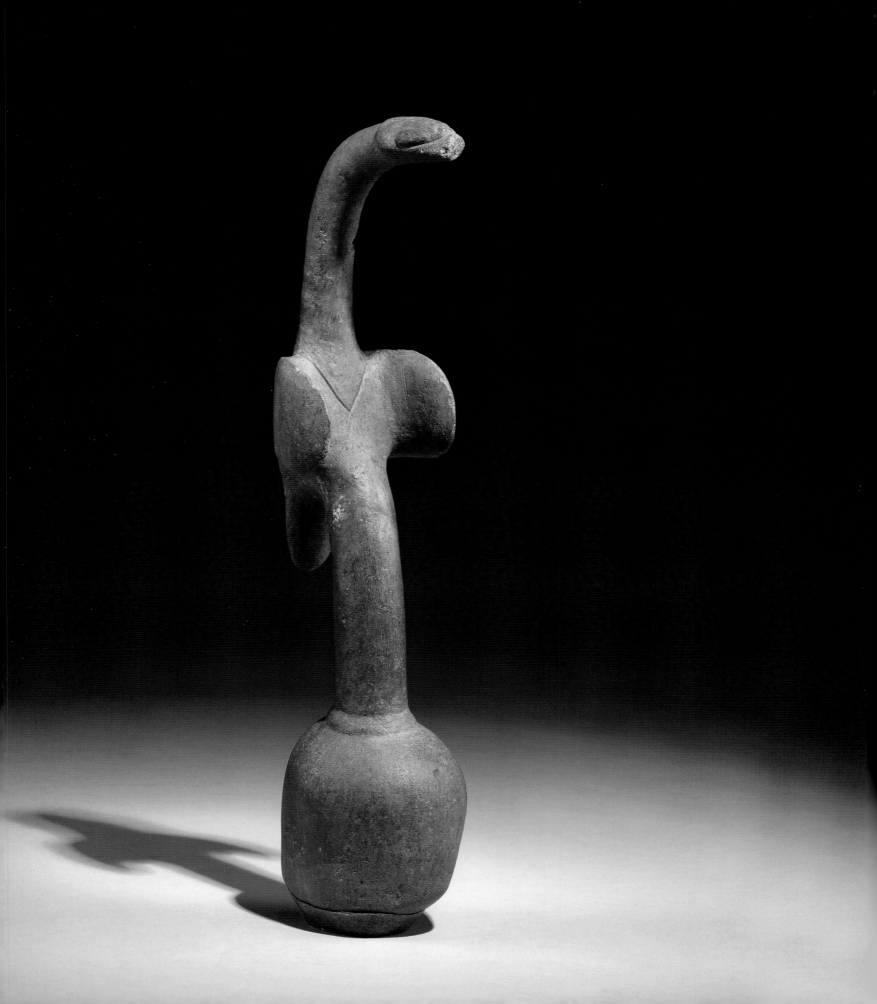

Lissant Bolton

AESTHETIC TRACES: THE SETTLEMENT OF WESTERN OCEANIA

The first settlement of the Pacific was on the island of New Guinea, at a time when, with Australia, it was part of a larger continent now known as Sahul. Evidence suggests that Sahul was settled by successive voyagers who reached it over sixty thousand years ago from islands to the west, making sea journeys between islands visible to each other, over distances of ten to one hundred kilometres; Patrick Kirch argues that this is possibly the earliest purposive voyaging in the history of humankind.[1] There is a tendency to imagine that life in this era was 'nasty, brutish and short', as Thomas Hobbes described the natural condition of mankind. But in fact there is no reason not to allow these early settlers the aesthetic sensibilities of our species. Why should they not have felt delight and disappointment, excitement and tedium as much as any other people? Why should they not have made objects that they found powerful and meaningful, even if we no longer know what those objects were?

Most of this long history of human endeavour is unknown, and with it the art history of the prehistoric epoch in the region. Some of the more recent events in the region's history are recounted in oral traditions, but much knowledge about it is accessible only through research in archaeology, genetics, biology, linguistics, geology and allied disciplines. Archaeology in particular is constantly extending and revising contemporary understanding of this history. The discovery, excavation and analysis of new sites have sometimes radically transformed previous understandings of the history of this region. Many kinds of objects do not survive in the archaeological record – no textiles have yet been recovered – but even so, a picture is gradually being developed of an increasingly complex sequence of population movements, technological and agricultural innovations, warfare, ritual practices, and the expansion and contraction of trading systems. All this took place in a region itself constantly changing as sea-level fluctuations, earthquakes, volcanic eruptions and cyclones modified the landscape again and again. Far more archaeological research has taken place in Papua New Guinea than in the western part of New Guinea,

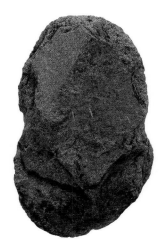

Rock painting representing a female crocodile ancestor with three string bags hanging off her head and neck. Gimbat Creek, Northern Territory, Australia.
Photograph George Chaloupka.

inevitably emphasizing what happened in the eastern part of New Guinea. This chapter surveys what is presently known about the early history of the western Pacific – an area archaeologists refer to as 'Near Oceania' – starting at the beginning of human occupation.

Early Human Settlement in Near Oceania

Once the first voyagers reached the continent of Sahul, presumably making landfall on the north-west coast, they spread very quickly over the whole landmass. Early evidence of the settlement of the north of Sahul, now New Guinea, has been found on the Huon Peninsula in northern New Guinea, where the archaeologist Les Groube found stone implements known as 'waisted blades' dated between 61,000 and 52,000 years ago (*page 27*). Groube has suggested that these tools would have been suitable for activities such as producing sago, splitting cycad trunks, or thinning pandanus stands to promote the ripening of the fruit. In other words, these tools may have been used to manage and access food resources in a way that represents an early form of forest management and food production.[2]

The stone tools found in New Guinea from the Pleistocene epoch resemble those found in Australia at the same period, and it must be assumed that the population of Sahul shared other characteristics. In both New Guinea and Australia people use plant-fibre string to loop netbags. String bags appear in rock art images in western Arnhem Land in art identified as being made at the last Glacial Maxima, around 20,000 years ago.[3] If they were making looped bags in the extreme north of Australia at that time, it seems likely that this technology had been known for an equally long period elsewhere in Sahul, specifically, nearby in New Guinea.

There has always been a water crossing between what is now the New Guinea mainland and the offshore islands of the Bismarck Archipelago, and initially, the inhabitants of Sahul did not cross it. It is presently believed that people first made that journey about 35,000 years ago: sites for the manufacture of stone tools from chert have been found in the interior of New Britain at Yombon, dated between 35,000 and 33,000 years ago.[4] For Pacific history, this water crossing is a very important one. The first people who sailed from Sahul across the strait to New Britain might have been making a relatively short journey, but they

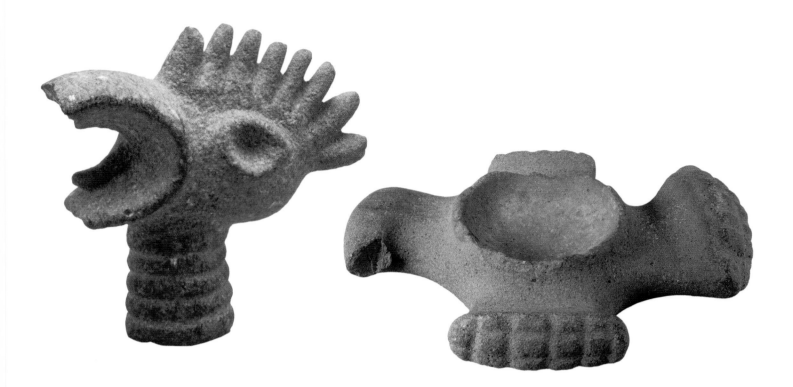

were taking a very significant step for Pacific history: the Bismarcks were the first true Pacific Islands to be colonized, beyond the shifting continental margins of Sahul.[5] From the Bismarcks, people gradually moved into what is now the Solomon Islands to the east, and into the Admiralties to the west. Evidence of this settlement includes a date of 29,000 years ago from Buka, Solomon Islands, and 13,000 years ago from Manus Island. As Matthew Spriggs has observed, the settlement of Manus is significant because it was never in sight of either Sahul or the nearest Bismarck island of New Hanover. Getting there involved a voyage in which for at least 60–90 kilometres (40–55 miles) no land was visible.[6] New Guinea, the Bismarck Archipelago and main Solomon Islands (often described by archaeologists as Near Oceania) were thus settled in the Pleistocene. Islands beyond the end of the main Solomon chain – beyond Makira – were not settled until much more recently: people did not reach Santa Cruz and the Reef Islands, Vanuatu and New Caledonia until about 3,500 years ago.

It seems that until about 20,000 years ago populations in Near Oceania remained low. There is no evidence to explain why this was so: it is sometimes suggested that the low population was caused by diseases such as malaria, but there is no

direct evidence to support any explanation.[7] No evidence of villages from this period has yet been discovered. At present it seems that these people lived in small, perhaps partly nomadic, groups, hunting and fishing a wide range of species, including various birds, lizards, snakes, rats and fruit bats, and both fish and shellfish. Microscopic analysis of residues on stone tools suggests that the people were also gathering tubers such as wild taro. On the whole, they seem to have lived inland, rather than on the coast. In the Highlands of New Guinea people may have hunted a range of now extinct marsupials. By 21,000 years ago people in the Highlands were burning the vegetation of their valleys, presumably both to aid in hunting and to promote the growth of food plants, gradually creating the extensive grasslands that European observers saw when they arrived there in the mid-twentieth century.[8]

Significant changes in the archaeological record occur from about 12,000 years ago throughout Near Oceania, including evidence of plant domestication. This led to the independent development of agriculture in New Guinea. In the Highlands of New Guinea, the existence of horticulture from about 9,000 years ago is now well established, demonstrated by archaeological evidence of drainage channels and other kinds of land

far left
Bird-head pestle, Morobe Province, Papua New Guinea, c. 3,000–8,000 years old.
Stone. Height 30 cm (11¾ in.). Australian Museum, Sydney.

above
Bird-shaped mortar, Western Highlands Province, Papua New Guinea.
Stone. Length 49.5 cm (19½ in.). Australian Museum, Sydney.

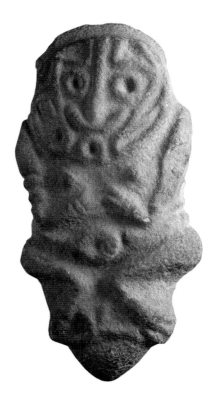

canarium nuts and anvil stones used to crack the nuts' hard shells. Shell-working technology has also been recorded for this era, with shell adzes and fishhooks, and shell beads and armbands appearing in the archaeological record.

Stone pestles and mortars have been found widely in New Guinea and the Bismarck Archipelago. It has been established that these artefacts were made and used between about 8,000 and 3,000 years ago, and that they are always found in areas where taro can be grown. It seems that they were used to pound cooked

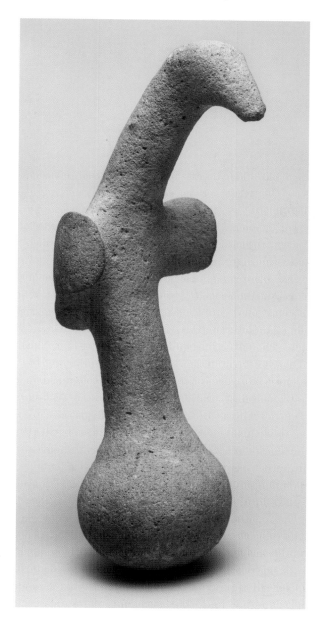

above
Anthropomorphic pestle, Madang Province, Papua New Guinea, *c.* 3,000–8,000 years old.
Stone. Height 44 cm (17⅜ in.). Australian Museum, Sydney.

right
Bird-shaped pestle, Western Province, Papua New Guinea, *c.* 3,000–8,000 years old.
Stone. Height 30 cm (11¾ in.). Australian Museum, Sydney.

use. The most famous archaeological site is that of Kuk swamp in the Western Highlands, where successive phases of drainage for agriculture have been documented. This represents one of seven independent developments of agriculture in the world after the last Ice Age. The oldest dated agricultural implement from New Guinea so far recorded is a wooden digging stick with a paddle-like blade from Tambul, Western Highlands, dated to 4,000 years ago. Such tools were used by Highlanders the length of New Guinea, from Paniai Lakes to Kainantu, for trenching and earth moving in both dryland and wetland agriculture.[9]

Plant geographers and ethnobotanists recognize New Guinea, with the Bismarck Archipelago, as the probable place of origin for many crops, because the wild ancestors of these plants are restricted in their natural distributions to this region. Among these plants are taro and the canarium almond, both subsequently very important to Melanesians. In the early Holocene, arboriculture – the cultivation of fruit and nut trees – was an important development in Near Oceania. Excavations dated to 4,250–4,050 years ago at Apalo, Kumbun island, New Britain, provided evidence of canarium almond, coconut and other tree species, while on Guadalcanal in the Solomon Islands, the archaeologist David Roe found charcoal from

View from Dilava Mission Station, Central Province, Papua New Guinea.
Photograph Frank Hurley, 1921. National Library of Australia, Canberra.

taro and local nut products into a rich edible paste or 'pudding'. This kind of dish is still prepared for feasts in a few predominantly coastal areas of Papua New Guinea, as well as in the Solomon Islands and Vanuatu. Most pestles and mortars are undecorated, but some, coming mainly from Papua New Guinea, are carved in the form of birds (*previous pages*). The largest cluster of finds comes from the shores of a brackish inland sea, which existed in the area of northern Papua New Guinea now known as the Sepik-Ramu basin, and many have been found on major pathways from the coast to highland valleys. Pamela Swadling, who has made an extensive study of these objects, suggests that they may be related to trading between the Highlands and the coast of plumes from birds of paradise.[10]

The significance of the focus on birds in the design of these pestles and mortars is of course unknown. Most of the birds sculpted on the handle tops of the pestles found on the shores of the inland sea have their wings folded rather than raised. Some pestles, like one from the Aikora river in the north-eastern part of the island, now in the British Museum, have long and delicate necks, suggesting that they may have been used only on special occasions, rather than for everyday food preparation. The Aikora River pestle is also unusual in that the bird carved on the neck has its wings opened.

The inland sea brought the coast close to the Highlands region, and, as Swadling points out, the proximity of this shoreline to the Highlands would have allowed 'an almost direct exchange of ideas and products' between the two regions.[11] As well as plumes from birds of paradise that may have been traded from the Highlands to the coast, there is good evidence of shell making its way to the Highlands, where it became a highly prized valuable. There is also evidence of trade from this region to regions further west, in Asia. In the far west of New Guinea, people had long been trading with islands further west, and items from this trade made their way along the northern shore of the island as far as the inland sea.

In the Bismarck Archipelago and the Solomons, the changes in the archaeological record at about 20,000 years ago are marked by the development of inter-island trade. Obsidian, a volcanic glass, is an

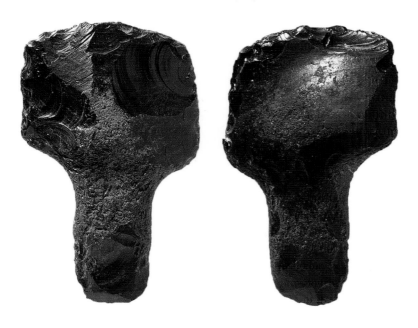

Obsidian stemmed tool found on Biak Island, North Papua, 10,000–3,300 years ago.
Height approx. 15 cm (6 in.).

did not affect the whole Bismark Archipelago, it occurred at the same time as a major shift in the settlement of the region. From about 3,500 years ago a series of new and distinctive archaeological sites appear across Near Oceania. These sites have a number of characteristics, but the one that has come to define them is the presence of earthenware pottery, with 'dentate-stamped' designs – that is, with designs impressed in the outer surface using some kind of comb or other stamping tool. This pottery, and the people who used it, are today both known as Lapita.

Lapita

Archaeologists are divided about the appearance of Lapita in Near Oceania, some suggesting that it was a local development in the Bismarcks, others that the Lapita people were immigrants from areas to the west who brought a whole cultural complex with them. Another view is that immigrants from further west integrated with the existing populations in Near Oceania and made innovations there, developing the suite of characteristics that belong to Lapita. These theories are constantly being modified as new evidence is uncovered. Recently, dentate-stamped pottery has been found in Luzon, securely dated to a pre-Lapita period, and it has been pointed out that in the earliest phase of Lapita ceramics so far identified, 'the pottery is at its most spectacular, with needlepoint dentate, a specific range of vessel forms and often very complex design motifs'.[13] This would suggest that, however much they changed and developed once they reached Near Oceania, the first Lapita people arrived there with many of the distinctive characteristics by which they are now identified.

If Lapita people were first recognized by their distinctive open-fired pottery marked with fine incised or dentate-stamped designs, that was not all that distinguished them. They are now known to have made both plain and decorated ceramics, and 'adzes in stone as well as in shell, flake tools of obsidian and chert, shell scrapers and peeling knives, anvil stones, polishers, slingstones, shell rings of a variety of sizes and shapes, bracelet units, arm-rings, beads, discs, needles, awls, tattooing chisels, fishhooks, sinkers and other items'.[14] They also had domesticated animals: pigs, dogs and chickens.

excellent marker of this trade, since it occurs only in a limited number of locations in island Melanesia. When worked into tools, obsidian can have blade edges of almost molecular thinness, making it very sharp, and a highly valuable resource. Obsidian can be analysed and identified to the specific place where it was formed, so that when archaeologists find obsidian they can determine how far it has been traded. The first obsidian to appear archaeologically in the Bismarcks comes from two places in New Britain, Talsea and Mopir, and was transferred over distances of up to 350 kilometres (220 miles) within the archipelago.

About 3,600 years ago Mount Witori, New Britain, erupted with devastating force, blanketing much of that island in ash lying sometimes metres deep. In archaeological deposits, this ash marks a clear break. The evidence that lies below the ash is quite different to the evidence that appears above it. In West New Britain, from between about 5,990 and 3,600 years ago there are 'distinctive, well-worked obsidian tools with stemmed bases, presumably for hafting'.[12] These tools do not appear above the ash. Although the eruption

Feathers

MOST OF THE OBJECTS made in the long prehistory of the island of New Guinea are now invisible to us: it is possible only to speculate about those that have not survived in the archaeological record. Pamela Swadling suggests that the stone mortars and pestles depicting birds, found in New Guinea and dated to the period between 8,000 and 3,000 years ago, may be related to the trading of bird of paradise plumes between the Highlands and the coast, but any such traded plumes no longer exist. More recently, records show that birds of paradise, which occur only in the New Guinea mainland and offshore western and south-western islands, were traded to China and the Near East from at least the seventh century AD.[i] People in the past must have paid attention to and used birds of paradise, even if we no longer know exactly how.

Today, bird plumes are constantly traded, exchanged and borrowed in the New Guinea Highlands as people acquire certain combinations of feathers to construct headdresses for particular occasions. When not in use, these feathers are carefully stored in hollow bamboos, or pandanus leaf packages. Feathers, especially from birds of paradise, are used as components of the elaborate headdresses worn at ceremonies and festivals in different parts of the Highlands. Commonly, a clan will all wear identical headdresses, demonstrating their unity in their combined appearance. In making these headdresses, the whole bird will sometimes be mounted on a stick; in other cases plucked feathers are combined together in headbands and other arrangements. Anthropologist Ralph Bulmer comments that the best time to see headdresses incorporating Lesser Birds of Paradise is when the dancers perform by firelight at night. At such times the stick mount to which the bird of paradise skin is attached is barely visible, so that the apparently unattached waving white and yellow plumes reflect the firelight high above the circlets of cockatoo or eagle feathers the dancers are also wearing, producing a stunning effect.[ii] It is likely that in the past whole birds of paradise were prepared in much the same way.

Today there are a great many birds in the Highlands area of Papua New Guinea – over 350 different species – including parrots, honeyeaters, flower-peckers, pigeons, rails, cuckoos, owls, nightjars, hawks, kingfishers, quails, swifts, warblers, thrushes and birds of paradise. Many of these birds have brilliant and decorative plumage: many also produce beautiful songs. In forest regions especially, people pay attention to birdsong – it is the principal way in which the birds can be perceived in the forest. Indeed people in New Guinea often consider birdsong to be deeply evocative, associated with all kinds of human emotions such as grief. Much has changed in this region over the last 8,000 years – the significance of the mortars and pestles is long forgotten – but the importance of birds seems to have been continuous over that long period. Their songs, their territories, their comings and goings, their plumage, are all things that people who live in the forest with them notice about birds, and this noticing is evocative and meaningful.[iii] LB

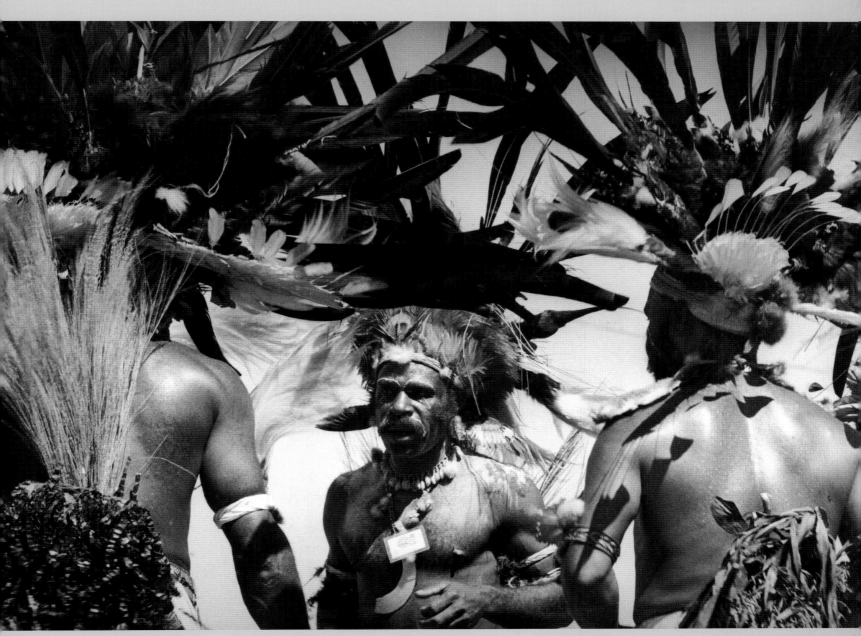

Chimbu performers at the South Pacific Festival of Arts. Port Moresby, Papua New Guinea, 1980.
Photograph Gil Hanly.

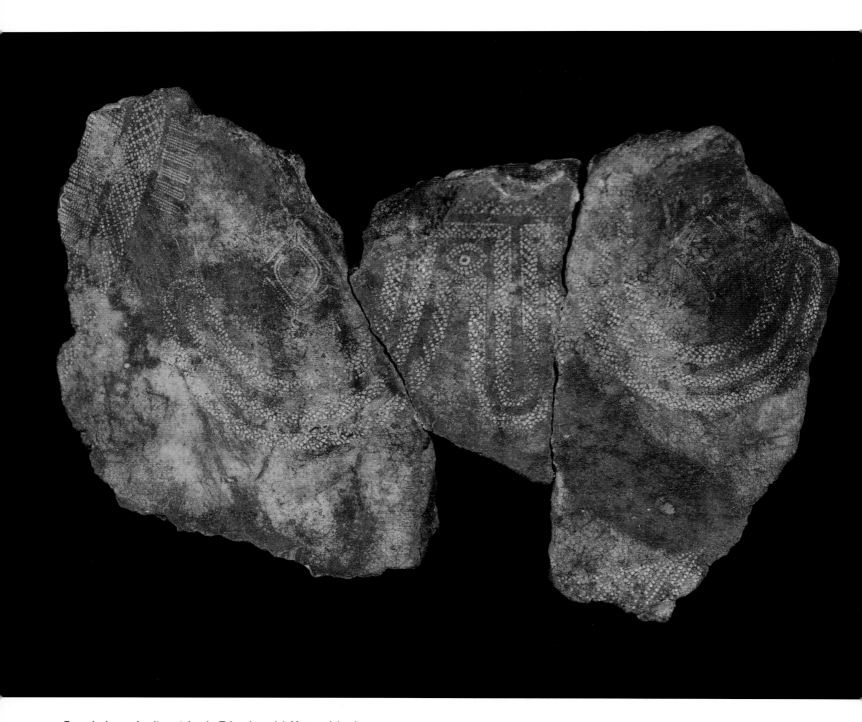

Face design on Lapita potsherds. Talepakemalai, Mussau Islands, _c._ 3,500 years ago.

These fragments from Talepakemalai exemplify the frequent occurrence of stylized face motifs on early Lapita pottery, here applied in bands filled with impressed geometric patterns. Interestingly, this design is combined with naturalistic imagery. Notice the animal figures on either side of the face, and the 'claws' protruding from the end of its u-shaped arms. These elements have recently been interpreted as inspired by sea turtles.

One evident characteristic of the Lapita peoples is that, whereas earlier populations of Near Oceania tended to live inland, the first Lapita people were coastal-dwelling and sea-oriented. Indeed, all the earliest Lapita sites so far discovered are on offshore locations, commonly lying across from or near a major pass in the adjacent reef, permitting ready canoe access to the open sea. They are usually sited close to fresh water and good gardening land. A group of major early sites has been found on Mussau, a small island group lying on the northern arc of the Bismarck Archipelago. Of these, a site known as Talepakemalai is the earliest and largest Lapita site yet on record. The site was inhabited between 3,550 and 2,700 years ago, and consists of a village on a beach. Some houses were built as stilt houses over water while others were built on the ridge behind the beach above the high waterline. Over time detritus falling from the houses built up under them – a dense accumulation of shell midden, ceramics, oven stones, and other cultural materials – so much so that the beach gradually migrated out to cover these remains, and the stilt houses were built further out, so that around 2,800 years ago there was a new zone of stilt houses, and a new midden accumulating underneath them. When the site was excavated, waterlogged anaerobic sands had preserved much of the deposit, including the remains of the house stilts, still standing where they had supported the houses. Ceramic fragments found in the deposit include both plain-ware jars and incised and dentate-stamped vessels.

Lapita decorated pottery is generally embellished with repeating designs that are both incised and stamped using a variety of stamping tools, some possibly made of turtleshell. Analysis of the designs on specific pots has shown how the same tool was impressed into the pot in carefully arranged repeating patterns. No tools have yet been found but it is possible to identify them from the repeating forms they created. Faces appear frequently in these designs, sometimes so stylized that they are barely visible in the overall geometric design, evident as rows of eye motifs, or noses. There are many face designs on the pottery found in the beach sands at Talepakemalai. Patrick Kirch, who excavated the site, reports that these face designs ranged from 'finely executed motifs with eyes, nose, arms, digits, and a kind of "headdress" all clearly

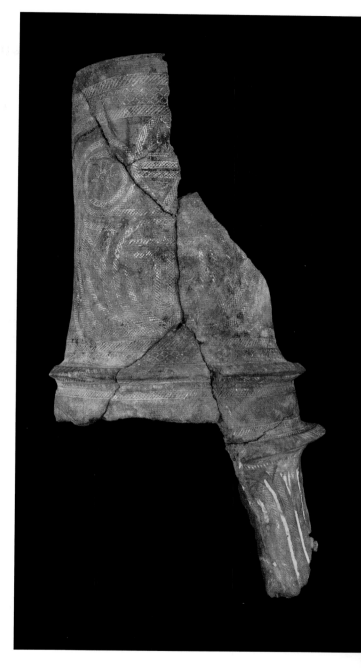

depicted, to more simplified versions'.[15] Indeed, as more and more Lapita pottery is found, it seems that the Lapita design system is essentially focused on the representation of human faces: they peopled their pottery. It has been suggested that the various Lapita face types might represent social group affiliation – that the designs represent a specific kin group.

As well as pottery, Talepakemalai produced a unique small human sculpture carved from bone – probably porpoise bone. The figure has an exaggeratedly large face, with eyebrows (or slit eyes) and a well-delineated nose, and a hint at a mouth. The carving tapers to two short legs with cross-grooves that Kirch hypothesizes may have been used to attach it to some kind of haft. We have no sense of the meaning of this work, nor indeed of whether it is in some way related to the face motifs that are so conspicuous on Lapita pottery.

Analysis of the clay and the sands used to temper the clay demonstrates that a large number of the vessels found in excavations on Mussau were no made there. Some have been provisionally identified to the Manus group in the Admiralty Islands, just west of Mussau. The Mussau sites also contain obsidian from Manus and from the Willaumez Peninsula in New Britain, and other objects such as stone brought from elsewhere. The Mussau community was connected to a wider community of Lapita people, spread along the coasts of the Bismarck Archipelago and further afield.

Lapita Colonization of the Western Pacific

Several hundred radiocarbon dates from archaeological sites across island Melanesia demonstrate the Lapita expansion into the Pacific. Having once arrived in the Bismarck Archipelago, and spread along its coasts, the Lapita people sailed further east along the main Solomon chain, and then crossed the water barrier between Makira and Santa Cruz. The move from Near Oceania happened around 3,200 years ago, when they established small settlements in the Santa Cruz group, and then sailed south to Vanuatu, eastward to the Fijian archipelago and south again to New Caledonia. Lapita is named after a beach on New Caledonia's Kone peninsula where excavations in 1952 recovered decorated pottery that was dated to around 2,800 years ago. The archaeologist E. W. Gifford linked these finds to earlier random finds of pottery in New Britain and Tonga, and recognized that they represented a common pottery style.

The expansion from Near Oceania as far south as New Caledonia and as far east as Tonga and Samoa occurred over only two to three centuries, a remarkable achievement in seamanship and navigation, involving

Carved anthropomorphic figure. Talepakemalai, Mussau Islands, c. 3,500 years ago.
Porpoise bone. Height approx. 10 cm (3¼ in.).

This small figurine, easily held in the palm of a human hand, is unique in the archaeological record of the Lapita era.

above

**Teouma site, Efate,
Central Vanuatu.**

Photograph Mark Adams, 2008.

An extensive Lapita cemetery was discovered at Teouma on an upraised beach terrace about 800 metres (2,600 ft) from the sea on the southeast coast of Efate in 2004. Burial sites contained decorated Lapita pots used for mortuary practices.

as it did the crossing of great distances without sight of land. Although people did, and still do, get lost at sea and drift in their boats for many hundreds of kilometres, the seamanship and intentional voyaging of the Lapita people is not in question. No remains of their canoes have yet been found, but linguists studying the family of Pacific languages suggest that the earliest Austronesian languages had words for outrigger canoes, masts, sails and so forth. These voyagers carried domestic animals and planting stocks of tuber, fruit and tree crops, and they sustained contact with other Lapita communities for many centuries, trading obsidian and other resources over huge distances.

If Lapita people had sailing canoes, they must also have had textiles. Most ethnographically documented sails in the Pacific are made of plaited pandanus fibre, and it is very likely the Lapita people also made such sails, and almost certainly other kinds of plaited textiles, such as floor mats and garments. Tattooing equipment has been found in Lapita sites. Given the decoration of Lapita pottery, and the existence of tattooing, it seems probable that any textiles might also have been decorated.

Until 2003 very few human remains had been found of Lapita people themselves. In that year quarrying operations on Efate island, at a place called Teouma, exposed a piece of Lapita dentate-stamped pottery. As Stuart Bedford *et al.* report, by 2006 excavations at Teouma had revealed a largely intact Lapita cemetery with almost fifty burials.[16] There is considerable variation in the burial positions of these individuals, but decorated Lapita pots were intimately connected to burial practice at the site. One consistent characteristic of these burials is that some time after burial the grave was opened and the skull removed. One burial contained an individual with three skulls laid across his chest, while in another a carinated (ridged) pot contained a complete skull sitting on top of a broken shell ring; a flat-bottomed dish was turned upside down and placed over this burial, as a lid. This dish is decorated with a double-face motif (*overleaf*). A repeating pattern of 'long nose' or 'elongated face' motifs (known from many other Lapita pots) is alternated with a triangular face, also known from other pots, which, uniquely in this instance, has been flipped or inverted so that it sits against the 'long nose' faces.[17]

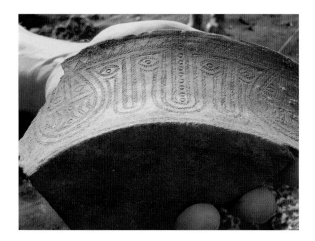

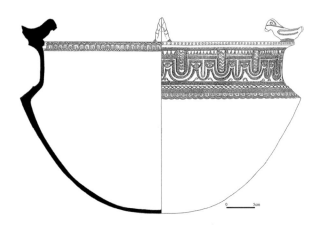

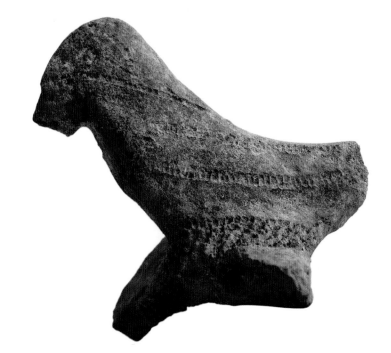

Another distinctive pot found at Teouma is a carinated pot with a dentate-stamped face motif on the rim.[18] Inside the rim are perched modelled clay birds. Although the pot is not complete, it would appear that there were four birds on the rim with their heads oriented towards the centre of the vessel. The lower part of the pot, which was still more or less together in the archaeological deposit, contained a collection of assorted human bone. The upper part of the pot had been broken and scattered in antiquity as a result of later burials in the same area of the site. One bird's head from the pot has dentate stamping on it suggesting the features of the bird – appearing, for example, to define a wing. This kind of modelled figure occurs only very rarely in Lapita deposits, although one other bird figure with dentate stamping on it was found in the Reef-Santa Cruz group. Human figures and human faces have also been found occasionally. For example, Robin Torrence and J. P. White report three sculpted faces that were found on the seabed in shallow water just off Boduna Island, New Britain. Modelled in three dimensions, these pieces were either incorporated within the body of a larger pot or detached from a larger clay body. They are undated, but were found with Lapita stamped potsherds.[19]

As the centuries passed the dominance of Lapita was overturned. Ceramic styles began to diversify so that in New Caledonia, for example, a distinctive Southern Lapita style developed, which in turn led to the development, alongside classic Lapita, of paddle-impressed utilitarian ceramics known as Podtanéan ware.[20] Equally, the location of Lapita sites across the whole region changed, with a greater preference for defensive locations for villages. Lapita people seem to have begun to develop more conservative gardening techniques. Gradually the extensive trade networks of the early years began to contract, and the styles of pottery to simplify.

left above
Sherd of flat-bottomed dish used as a mortuary lid, showing double face motifs. Teouma, Vanuatu, c. 3,000 years ago.
Reconstructed diameter 36 cm (14⅛ in.).

left below
Carinated vessel with birds on the rim. Teouma, Vanuatu, c. 3,000 years ago.
Drawing Fidel Yoringmal.

above
Bird from rim of carinated pot. Teouma, Vanuatu, c. 3,000 years ago.
Length approx. 6 cm (2½ in.).

above

**Lapita face found on the
seabed off Boduna Island,
Papua New Guinea.**

Length approx. 7.5 cm (3 in.).
Private collection.

below

**Lapita carinated vessel from the Teouma site
on display at the Vanuatu Cultural Centre.**

Height approx. 32 cm (12½ in.). Photograph Mark Adams, 2007.

This is one of a small number of near-complete Lapita
pots found at the Teouma burial site on the coast
of Efate in Vanuatu. In fact the discovery of a single
decorated sherd from this pot, unwittingly further broken
and scattered during earthmoving activities, led to
the discovery of the site in 2004. After its parts were
gradually assembled, the pot was reconstructed at the
Australian Museum and is now in the collection of the
Vanuatu Cultural Centre.

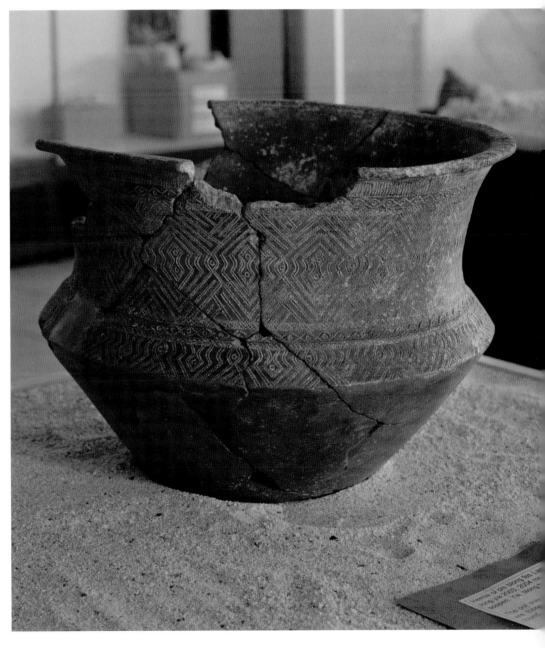

'EVERY DESIGN IS DIFFERENT'

My job is to join together in drawings the motifs on Lapita pots.

I come from Wala, Malakula, and I work as an Artist in the Archaeological Section at the Vanuatu Kaljoral Senta. I trained as an artist when I was young. In 2005 I was working as a sign-painter in Lakatoro, Malakula, when the archaeologist Stuart Bedford came and found me, took me to Vao, and tested me on a small design. When he found I could draw it he said 'Great! Come and work for us.'

My job is to join together in drawings the motifs on Lapita pots, to look attentively at the motifs, noting the tools which made them. If you look at the design on the broken pieces, then you can see the specific marks left by each tool used to make them. The tools were made from turtle bone or coconut leaf ribs. They are all different, so that the marks made by an individual tool can be recognised: on some the points are square, on some they are round, it all depends on the tool. The Lapita artists wiggled the tool as they made the designs – it is possible to see how they did that. By attending carefully to the tool marks, it is possible to join together the different fragments to see the whole motif. The artists had a signature, made with a tool, which appears on each pot, although we don't know if that was an individual artist's signature, or a family signature.

Fidel Yoringmal's desk at the Vanuatu Cultural Centre, 2008.
Photograph Mark Adams.

The designs, by contrast, are never the same, every design is different. It might look the same, but the motif is always different. When you look at the designs you can see that the men who made them really concentrated on what they were doing. When I first drew them I missed lots of small details but Stuart Bedford helped me. I like their designs. Every single one of them is interesting, and it is clear that every part of the design has meaning. When I draw them I try to put myself in the time when they made the designs, but it is too far away. They had something really special, a milieu in which they worked, where spirits were present. The spirits must have helped them.

Fidel Yoringmal (d. 2010),
artist and archaeological illustrator,
Vanuatu, 2010.[i]

Initially, Lapita people seem to have sailed into the Pacific as energetic traders without extensive territorial ambitions, perched on the margins of islands (like the birds on the rim of the Teouma pot) and sailed further and further in search of new resources and new materials. Over time they settled the islands, moving back from the beaches, and developed more independent identities, marked by their increasingly divergent and distinctive material remains. The term 'Lapita' is not used for sites or assemblages that continue beyond about 2,000 years ago, but this is not a matter of an abrupt change so much as a gradual transformation. Their descendants continued to be traders, but the networks of their trade changed, rarely reaching as far afield as their forebears did. Ceramic production ceased altogether in many parts of the region from about 2,000 years ago.

Developments in Western Oceania after Lapita
The archaeological history of the period after about 2,000 years ago is much more difficult to summarize, as it took different trajectories in each region. In various places people began to produce locally distinctive styles of pottery that archaeologists identify with a range of names. Through this period people developed increasingly sophisticated agricultural techniques. The intense cultural and linguistic complexity that now characterizes the region developed through this era. The landscape of the region was also changing. By 2,000 years ago the Sepik-Ramu inland sea had substantially reduced in size as the rivers discharged sediments into it. Oral traditions and linguistic research suggest that there was a large migration of people from a location south of the Middle Sepik towards the coast. At the same time the Highlands–coastal trade declined.[21]

Extensive excavations carried out in New Caledonia have provided a detailed account of the transformations that occurred there after the end of the Lapita era.[22] There was an early diversification between the Lapita motifs used on the main island of New Caledonia (Grande Terre) and those used on the Loyalty Islands immediately to the east, but by around 2,700 years ago Lapita pottery and a series of distinctive shell ornaments dropped out of the archaeological record altogether. As those objects disappeared, people started to move inland on the Grande Terre. Forest clearance more than 10 kilometres (6.2 miles) from the coast seems to have commenced at the very end of the Lapita period, and to have developed on a large scale between 2,500 and 2,000 years ago. The local landscape was profoundly changed.

In the Loyalty Islands, around 1,500 years ago, stone fortifications were constructed. On Mare, Loyalty Islands, there were monumental enclosures with walls 4 metres (13 ft) high: one of these, at Hnakudotit, had walls with a volume of about 20,000 cubic metres (over 700,000 cubic ft) of stone. Oral tradition associates these structures with the golden age of the Eletok, a group who were almost exterminated at the beginning of the nineteenth century. On the Grande Terre, in the same era, there was an explosion of petroglyph production, in which engravings were concentrated on natural frontiers such as riverbanks, hilltops and watershed divides between valleys. This is interpreted as resulting from the need to identify boundaries between different groups as the population grew (*overleaf*).[23]

On the Grande Terre about 1,000 years ago, two major techniques developed to intensify agricultural production. These were irrigated terraces, mainly for wet taro, and long, high mounds for dry yams. Over the next thousand years hundreds of hills were transformed by the construction of thousands of taro terraces, flushed with fresh water by numerous artificial water channels, sometimes several kilometres long. The hills of Grande Terre today are still ringed and ridged with abandoned taro terraces (*page 45*). At the same time, more permanent settlements appeared, characterized by elevated round house-mounds, often organized in precise patterns around a central alley. New pottery types, new adze types, and particular forms of traditional shell money also appear in this period. It was from this point that the cultural and political specificities that are characteristic of New Caledonian indigenous societies during the historic era began to appear.

The sequence of events in New Caledonia is better documented than the history of other parts of island Melanesia, but similar patterns can be traced.[24] For instance, agricultural intensification has been documented both for Guadalcanal in the Solomon Islands and for Aneityum in southern Vanuatu. On Aneityum, valley flats created by increased sedimentation and valley infilling began to be used for settlement and agriculture around 950 years ago.

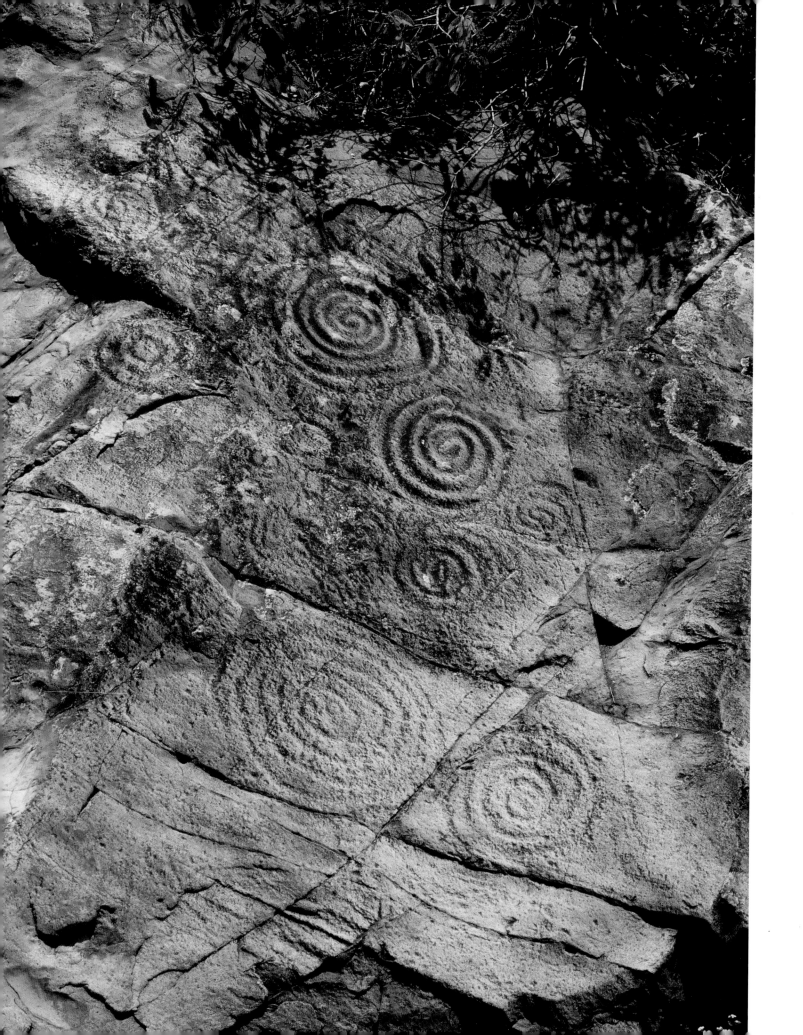

Petroglyphs, Grande Terre, New Caledonia.

These petroglyphs on the Grande Terre of New Caledonia are thought to mark group boundaries. Their proliferation across the island suggests an expanding and increasingly differentiated population moving inland beyond initial coastal settlements.

right
Abandoned taro pondfield terraces, New Caledonia.

The most complex taro pondfield terraces in the Pacific are found on the Grande Terre of New Caledonia, where they cover hundreds of hectares in some areas. The command of labour needed to build and maintain such fields indicates the existence of complex chiefdoms in early island Melanesia.

About 700 years ago distinctive adzes made from *Terebra* shell appear in sites from the Bismarck Archipelago to Vanuatu. These adzes also appear very commonly in sites in the Micronesian islands to the north, suggesting that there was trade and communication not just through the Melanesian islands, but also into Micronesia. In the last 700 years also, there is substantial evidence of contact with the islands of Polynesia, and of Polynesians moving back to and settling in islands within Melanesia. Several islands in Melanesia today, such as Tikopia and Anuta in the Solomons group, are recognized as Polynesian 'outliers' – as being occupied by a population deriving from further east. In other cases Polynesian settlers were absorbed into the existing population.

One of the most famous stories of probable Polynesian influence is that of Roi Mata, a leader who arrived in central Vanuatu from the 'south' and is credited with bringing the coastal populations of Efate and the Shepherd Group immediately north of Efate under his control, and of bringing peace to the region.

There are many oral traditions about Roi Mata in this region, notably about his death and burial. Roi Mata was said to have been buried with bodies of his kinsfolk and with representatives of the various clans, some against their will. The archaeologist José Garanger took these stories seriously, and excavated the place where Roi Mata was said to be buried, Retoka Island, off north Efate. There Garanger uncovered a burial ground with a single central male skeleton, an old man, surrounded by the burials of eleven embracing couples, who appear to have been buried alive. Oral traditions suggest that the men were heavily drugged with kava (which is a tranquillizer) before burial: they lie on their backs as if sleeping. The women were all in different positions, clutching at their partners at the moment of death. Other skeletons lie between and around this main group, over fifty individuals in all (*overleaf*).[25]

Most of the skeletons are richly decorated in shell and pig-tusk ornaments. No couple wore the same set of ornaments: Garanger proposes that the body decorations were kin group insignia. The central figure

José Garanger's 1967 excavation of 'Roi Mata's' burial site, Artok Island (Retoka), Vanuatu, *c*. AD 1265.

This burial site contains some fifty human skeletons and confirms oral accounts of the death of a powerful chief named 'Roi Mata'. The site also gives evidence for the cultural influence of Polynesian back-migration westward into parts of island Melanesia. The burial centres on the remains of 'Roi Mata' whose elaborate body adornments include whale-tooth beads and pig teeth.

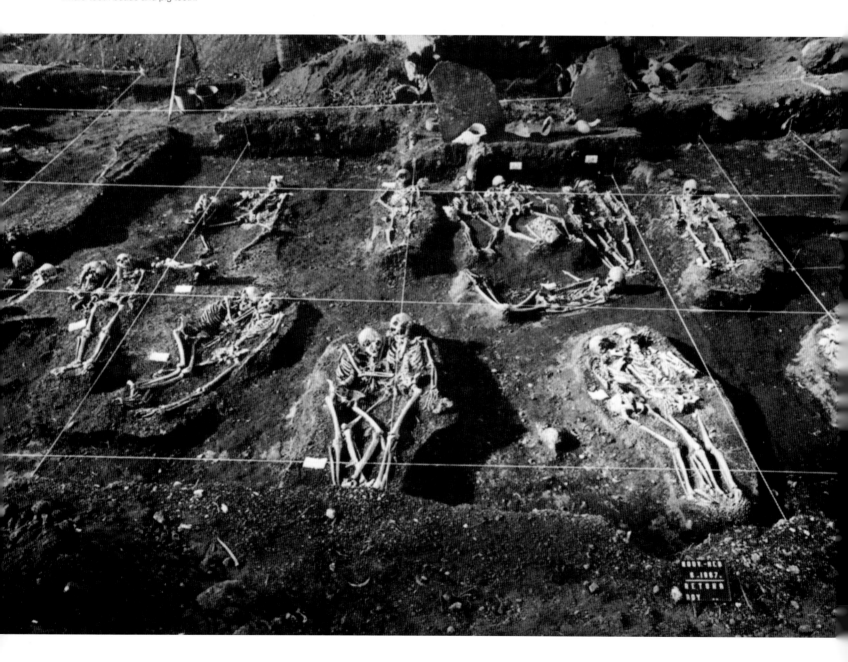

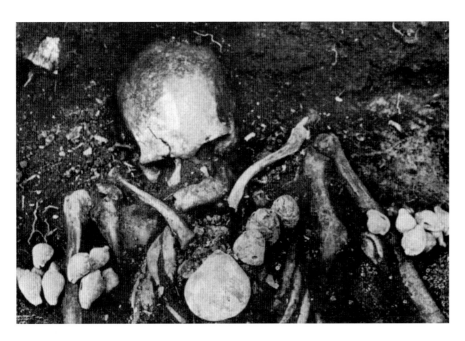

Detail of a skeleton identified as 'Roi Mata's'.

is heavily decorated. On each arm he wore an armband decorated with small shell beads; he wore two bracelets made of twelve *Ovula* shells, and a necklace of several rows of disc beads, nine mammal-bone beads (probably pig tooth), a perforated *Spondylus* shell, and three large whale-tooth beads. Around his waist he had a band of numerous rows of shell beads, and on his wrists were circular pig-tusk bracelets, two on the right, and one on the left. This last kind of bracelet is still produced and worn as rank insignia in Vanuatu today. Many of the ornament types in this burial, such as whale-tooth beads, do not occur in earlier sites in the region. Matthew Spriggs comments that the burial is very reminiscent of chiefly burials found on East 'Uvea in western Polynesia.[26]

Local traditions credit Roi Mata with bringing peace to central Vanuatu at a time of considerable conflict. Oral traditions report that the peace he left was disrupted by a volcanic disaster on an island called Kuwae. Again, the stories have been validated. As Matthew Spriggs discusses, geologists have established that a major eruption took place, probably in AD 1452, between what are now the islands of Epi and Tongoa.[27] The eruption was one of the ten biggest volcanic events in the world in the last 10,000 years, releasing huge amounts of dust and acid gases into the stratosphere. The dating of the eruption is based on ash found in Antarctic ice cores. Tree-ring data from the

west of the United States and elsewhere show a particularly severe winter in 1453, while in China extraordinarily cold weather in that year led to crop failure and thousands of deaths. In central Vanuatu, where preceding earthquakes had warned people of the impending disaster, giving them time to escape to nearby islands, the eruption created lasting social complications as refugees settled on other islands, complications that are still echoing in central Vanuatu today.

Matthew Spriggs has also traced the interconnections between the archaeology of island Melanesia and the first reports by Europeans visiting these shores. A series of Spanish explorers sailed through or past island Melanesia, starting with Álvaro de Saavedra in 1528. In several cases people from these islands joined the expedition ships and gave some accounts of their homelands. Álvaro de Mendaña discovered the Solomon Islands in 1568. The account from his voyages includes a description of a leader from Estrella Bay on Isabel who wore different body decorations to his companions. He wore 'on his head a turban, formed of numerous black and white feathers, and on his wrists armlets made of very white bone which looked to us like alabaster' (but which Spriggs suggests would have been *Tridacna* shell), and a 'small shield, which they called *taco-taco* hung from his neck' (which Spriggs suggests may have been a *Tridacna kapkap* ornament).[28]

Archaeological research at Graciosa Bay, Nendo, Santa Cruz, has uncovered the site of a brief attempted Spanish settlement there in 1595. It has also revealed a coastal village with a tightly clustered set of houses on generally rectangular terraces, located around a central dance circle, and contained within a pig wall. Excavation revealed multiple periods of use for various structures extending back about 500 years. The archaeological evidence fits the Spanish description of village size and layout in 1595.

Those early European visitors had no way to grasp the length of history in Melanesia, nor the degree of historical interconnection between its various islands. Europeans have often been slow to recognize the historical detail expressed in Melanesian oral traditions, unable to interpret the metaphorical codes used in them. The excitement, the complexity and the achievement of Melanesian history could not but pass them by.

Shrines and Stories

N 1994, RISLEY AMOS OF CHEA village found a stone figure in an uphill garden area on Marovo Island in the Western Solomon Islands. The figure had emerged when Amos was clearing the undergrowth near where large cylinder-shaped slabs of basalt lie in the bush. Local people regard these slabs as having been made by unknown people who lived on the island a long, long time ago. The figure is a fairly naturalistic image of a woman sitting on something, and appears to be made of a porous rocklike pumice. People recognized it as dating back to a much earlier period. Its emergence in just this location was considered to be extremely important: this spot is associated with an iconic story about the creation of Marovo – the story of Vekuveku – and the figure was identified as representing the woman who is the focus of that story.

The story of Vekuveku, which is a long one, tells how a chiefly woman was forced to leave her home: her two sons paddled her in a canoe until they got to an area in the middle of the deep sea between Gatokae and Vechala (later called the Russell Islands).[i] The woman asked to be thrown into the sea, and there she sat on her basket, floating. Then a shark came and took her on its back, and the shark instructed a ray to go down to the bottom and fan with its wings to bring up sand so that the woman could sit down on land. A turtle was instructed to bring soil to pile on the sand, and together they made an island that is still there today. The old woman lived on the island, and her pet flying fox, called Vekuveku, found her there and brought her many of the things she needed, including fire. Some of the things he brought were waylaid and ended up on other adjacent islands, including Marovo itself. This figure seems to represent the old woman sitting on the basket, or perhaps on the ray that helped to form the island.

Other stone figures from this region are associated with burial sites and shrines. Sometimes a male relative of the deceased would carve a stone image of the deceased to place at a grave site where it would act to deter people from going near the grave. An image of a seated figure with a mortar and pestle from Gatokae, probably used in this way, was published in a survey of Solomon Islands art in 1978.[ii]

It isn't possible to study the figure of the woman that Amos found. It was photographed at the time by Edvard Hviding, who was then working in the area, but people were very unwilling to send it to Honiara to be kept in the museum there. They wanted it to remain in Marovo. Some time later on, some young men sold it to people in a passing yacht, and no one knows now where it is. As the story of Vekuveku, told by the late James Vora and translated by Edvard Hviding, concludes: 'So the story goes, and it is finished.' LB

Stone figure, found in 1994 on Marovo Island, Western Solomon Islands.
Height approx. 60 cm (23½ in.).
Photographed by Edvard Hviding
on Marovo Island, 1994.

Deidre Brown and Peter Brunt

AFTER LAPITA: VOYAGING AND MONUMENTAL ARCHITECTURE
c. 900 BC–*c.* AD 1700

The prehistory of eastern and northern Oceania provides a fascinating glimpse into the aesthetic, formal and architectural worlds of the people who explored, settled and lived in this vast region of the Pacific Ocean – but only a glimpse. For this period is known to us only through fragmentary remains and the reconstructions of archaeological, linguistic and ethnobotanical science, which have only recently been able to assemble a coherent picture of it, flickering in and out of focus. The early art of this region is particularly elusive. Most of it has disappeared forever and what remains is permanently enigmatic. There are no ancient texts to allow us to decode how prehistoric Islanders named, imagined and storied their worlds. And yet we can still experience something of the aesthetic power of ancient Oceania in ceramic works in museums and at numerous monumental sites scattered throughout the region. Some of these, like the *ahu*

moai (ancestor statue) of Akapu on Rapa Nui have been expertly restored and still evoke an echo of the awe they must have first inspired. But other sites lie undisturbed under tropical bush at the back of villages – mute witnesses to a past that is simply lived with.

Lapita Foundations

The first settlers of eastern and northern Oceania, in other words of Polynesia and Micronesia, trace back to the same Austronesian language-speaking peoples discussed in the previous chapter who had ventured from coastal China into the region of southeast Asia some 5,000 to 6,000 years ago. Around 3,500 years ago, or 1500 BC, some of these people sailed north-eastward to the islands of Palau and the Marianas in western Micronesia, probably from the Philippines and Sulawesi, while others sailed southward into the coastal areas of New Guinea, the Bismarcks and the northern Solomons – an area that archaeologists now refer to as 'Near Oceania'. As discussed in the previous chapter, there they interacted with pre-existing populations from much earlier migrations and developed the complex maritime culture named for its distinctive pottery tradition, Lapita, after a site in New Caledonia where samples were first found. Around 1200 BC the 'Lapita people' continued these remarkable feats of voyaging, venturing northward from the Bismarck Archipelago and the Solomons into Yap and the Caroline Islands in eastern and central Micronesia, and south-eastward into the regions of Vanuatu and New Caledonia, and by about 1100 BC into the islands of Fiji, Tonga, Samoa and their outlying neighbours: Niue, Futuna, 'Uvea, Niuatoputapu and others. This last region – here identified as western Polynesia – would prove crucial for the development of a distinctively *Polynesian* culture, ancestral to the numerous variations of

Polynesian societies that would eventually dot the breadth of the Pacific Ocean to the east, north, south and west.[1]

The Lapita culture with its maritime technology, agricultural practices and distinctive ceramic tradition was in some form brought to western Polynesia by its first settlers. But it was transformed over time into new cultural formations adapted to the unique ecologies and societal circumstances of these dispersed but related island archipelagos. One of the indicators of that transformation was the rapid demise of complex Lapita designs of the kind found to the west in preference for plain ware, and eventually (with the exception of Fiji where a plain-ware tradition continued), the abandonment of ceramic production altogether. Lapita fragments have been discovered throughout western Polynesia, attesting to the geographical breadth of the 'Lapita cultural complex' that extends from the Admiralty Islands and Bismarcks in the west to the Samoan archipelago in the east. This is not to say that the 'Lapita cultural complex' was homogeneous or unchanging. The term is used in the same way one might speak of the 'Judeo-Christian cultural complex' and its artistic expression in Western pictorial naturalism with all their variations over two thousand years of history. Within the 'Lapita cultural complex' too there were many localized adaptations of the culture over time, and its permutation in western Polynesia would prove yet another – perhaps the most radical.

Lapita ceramics in western Polynesia consist of varieties of plain ware and decorated pots. Though the latter are not as elaborate or prevalent as decorated ceramics to the west, they bear variations of the same 'vocabulary' of curvilinear and rectilinear designs, typically applied in horizontal bands and made by dentate stamping, incising, notching, raised modelling, shell impressions and other methods. The designs are frequently infilled with lime paste and burnished with reddish slip coatings. And they share a comparable range of types (jars, bowls, dishes) and globular shapes as their counterparts in the west. Relatively quickly, however, within the space of about two centuries, there is a change from highly decorated ceramics to a more formally restricted plain ware. The rapidity of change is illustrated in the case of the Ha'apai Islands in the Tongan group, where the transition has been dated to

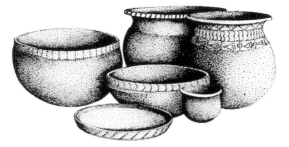

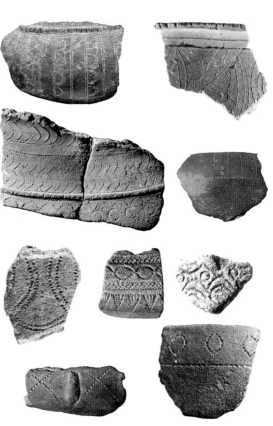

about 700 BC, a date corresponding to the demise of Lapita designs in other parts of western Polynesia as well.[2]

The reasons for this demise are much debated among archaeologists. Even the term 'demise' is problematic insofar as it implies some inevitable cultural 'decline'. Such a view obscures other transformations that might have been occurring or the transference of Lapita designs to other material surfaces such as human skin (tattooing), barkcloth and wood, which have simply not survived in the archaeological record (and certainly Polynesian art from historical times bears the stylistic echo of Lapita).

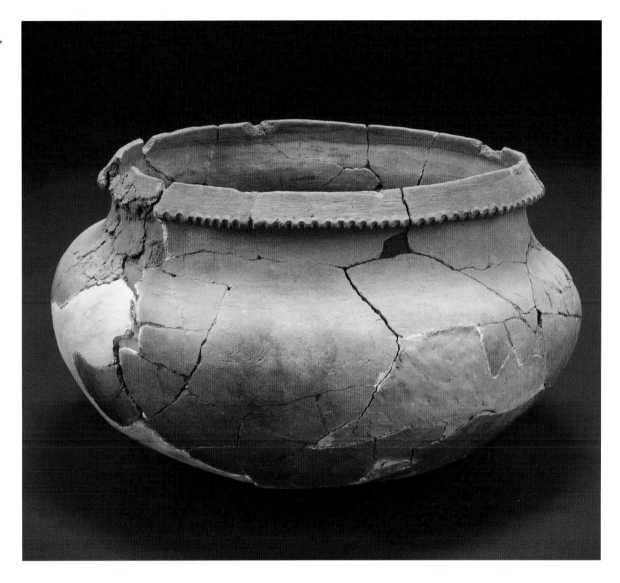

Reconstructed plain-ware pot from Lapita era, Viti Levu, Fiji, *c.* 700–500 BC.
Diameter approx. 50 cm (19¾ in.). Museum of New Zealand Te Papa Tongarewa, Wellington; on loan from Fiji Museum.

Alternately, the reduction of complex designs may have been a conscious rejection by breakaway settlers of the social hierarchies and ritual functions that highly decorated Lapita evidently served in island Melanesia, or perhaps just the gradual irrelevance of those norms and rituals in the situation presented by their new island environments. David Burley describes early Lapita sites in Tonga as coastal sites comprising 'hamlets of no than three or four family groups'. These people were 'opportunistic foragers' exploiting a 'previously unexploited' environment, rich in 'bird, sea turtle, fish, and other natural resources'.[3] At the same time, as Patrick Kirch suggests: 'These were not merely voyages of discovery by itinerant sailors who came for

a brief period and then returned to a homeland in the western Pacific. Quite the contrary, these were purposeful voyages of discovery and colonization.'[4]

At what point and in what terms – and for what reasons – does a new culture or society emerge, and how is it to be defined? Such questions dominate interpretations of the entire prehistory of Oceania, and explaining the fate of Lapita pottery is a case in point. Complicating the question is the fact that it was not only in western Polynesia that Lapita designs were waning. By the beginning of the first millennium BC, they were waning in island Melanesia as well.[5] Although it is not possible to explain conclusively why this occurred, it corresponds temporally and

geographically with the expansion of Lapita peoples beyond the region of 'Near Oceania' into the ever more distant and dispersed archipelagoes of 'Remote Oceania'. In 900 BC the islands of western Polynesia constituted the farthest edge of the Lapita cultural dispersal. It is possible that this stretched zone of migrant peoples remained in trading contact with each other. Scholars debate this possibility with respect to western Polynesia and the islands to its west, with some arguing that the logistics of meaningful contact would have been impossible over this distance and others disagreeing.[6] Whatever the case, the question should not obscure the extent to which the archipelagoes of western Polynesia presented for their first settlers rich and more easily accessible sites to exploit, inhabit and cultivate.

After the demise of Lapita designs around 700 BC, plain ware continued to be produced in western Polynesia for over a thousand years when it too, except in Fiji, was eventually abandoned. Burley cites AD 450 for its disappearance in the Tongan islands, and comparable or somewhat later dates elsewhere.[7] Archaeologists have uncovered scarce evidence of pottery in the Polynesian islands east of Samoa: a few plain-ware sherds in the Marquesas, some apparently imported from Fiji, and a few in the Cook Islands, apparently originating from Tonga.[8]

Exploratory Voyaging and the Settlement of Oceania

The period following the abandonment of pottery in western Polynesia is enigmatic, as the archaeological record falls virtually silent until the emergence of monumental architecture about a thousand years later. Yet it was by no means, as was once said, the 'dark age' of Polynesian prehistory.[9] To the contrary, the period was one of its most dynamic and creative. Basing their conclusions primarily on ethnohistory and linguistic inferences from later Polynesian languages, scholars now argue that within the time of plain ware, a distinctive *Polynesian* culture began to emerge within this region, with a common set of cosmological concepts and deities, cultural heroes, social roles, ritual practices and spaces, and an identifiable subvariant of the Austronesian language family that linguists call 'proto-Polynesian', from which all Polynesian languages spoken today derive. Overturning

nineteenth- and early twentieth-century theories that puzzled over where Polynesians came *from*, scholars now argue that Polynesian culture developed as such *within* the environs and conditions, and from among the populations, of western Polynesia itself.[10]

The post-Lapita period is also associated with the most dramatic expansion of Polynesians into the rest of the Pacific. Exactly when these colonizing voyages began is uncertain, and there is debate over the question of whether there was a significant 'pause' within western Polynesia until late in the first millennium BC, or later still into the first millennium AD, or whether there was no significant interruption to exploratory sailing at all.[11] Whatever the case, at some point in the centuries following the settlement of western Polynesia, Polynesians fanned out to explore and colonize the rest of the habitable Pacific. They sailed northward to settle in the islands of Tuvalu and Tokelau and north-west across the equator into central and eastern Micronesia (already partially populated by earlier Austronesian migrants who were simultaneously making explorations eastward within the Micronesian chain). Polynesians also sailed westward into the so-called 'Polynesian outliers' north of Vanuatu and New Caledonia (also already partially populated). And they sailed eastward into the vast scatter of islands comprising central Polynesia (the Cooks, Marquesas, Society Islands, Austral Islands and the Tuamotus). And from central Polynesia – though from where exactly is another matter of continuing debate – they sailed into the outer points of the 'Polynesian triangle': Hawai'i in the north, Rapa Nui to the south-east, both settled around AD 400 (although some scholars propose the much later date of AD 1200), and Aotearoa New Zealand in the south-west, settled about AD 1300. Indeed, it is now known that Polynesians reached all the way across the eastern Pacific Ocean to South America and made landfall as far south as the sub-Antarctic islands, although there is no evidence to suggest that they remained at these extreme edges of the Pacific. Their occupation of these new islands completed the human settlement of the world, excluding the polar ice caps.[12]

However, paradoxically, little remains of this epic period of Oceanic voyaging. All of our knowledge about it is based on recent scientific and experimental reconstructions, including such proto-voyaging experiments as those of the *Hōkūle'a* in the 1970s.

'I STAND ON THE BOW OF *HŌKŪLEʻA*'

I stand on the bow of *Hōkūleʻa* watching the sun dropping toward that
cloud bank and I question how much control, if any, I have in finding
the land. This is the way things are supposed to be. Closer and closer it
comes to the cloud, and I have a different, almost strange feeling. The sun
is right in the compass direction of 'Aina-land'. It is pointing out the land.
I walk to the bow of the canoe for I know the island is there. I don't know
how I know. Steve Somsen also knows. Not that he really knows, but he's
picked up on my knowing it's there. Suddenly a particular cloud begins
separating. It has the same quality as other clouds in terms of whiteness.
But this one is not traveling. It's stationary, and it opens up to reveal
a long, gentle slope with a slight bump – a cinder cone on the side of
Mauna Kea! The navigation at this moment seems to be out of my hands
and beyond my control. I'm the one given the opportunity of feeling the
emotion of the navigator not yet ready to have a complete understanding
of what is happening. It is a moment of self-perspective, of one person
in a vast ocean given an opportunity of looking through a window into
my heritage. I hear the crew cheering as the edge of the sun begins
disappearing behind Mauna Kea. I feel their happiness, but a silence
in me sets in. Venus follows the sun and touches the mountain an hour
later. It is now time to sleep, for there is nothing else to do. The sun has
led us to the land. Ahead of us is our *kūʻula*, and I'm filled with a feeling
of emptiness and gratitude. (I remember a story I was told one time [how
accurate I do not know] of the people of ancient Polynesia. They had their
family guardians, *kūʻula*, that gave them prosperity. They were symbolized
as figures shaped of carved stone. Fishing families had their *kūʻula* that
attracted fish and gave them protection. The navigator of old, as the story
goes, was not like other men. He was separated from them – a man of the
sea, not of the land. So his *kūʻula* was not bound to the land but was the
land itself – the highest mountain, a mountain of power.)

Nainoa Thompson, navigator on the *Hōkūleʻa*, 1980[1]

Remembering the Ocean

FOR THOUSANDS OF YEARS Pacific people have guided their canoes across the vast Pacific Ocean, drawing upon a deep knowledge of their environment. The settlement of the Pacific was not an act of chance or accidental landfall. To navigate successfully between atolls and islands, navigators looked for signs in the atmosphere and the ocean to help them find their way. They studied the behaviour of land-based fishing birds, the movement and colours of clouds over land, the currents and the patterns of swells. They observed the night sky and the rising and setting points of stars on the horizon, using them as bearings to keep their canoes on course. The Oceanic world was challenging and difficult to contain, but it was crucial for navigators to understand its many dimensions.

Despite modern shipping and air travel, for the people of the Marshall Islands in Micronesia, navigation is a specialist task undertaken by a few dedicated individuals. Seafarers have long used a type of 'stick chart' to help them voyage safely and navigate accurately between islands and archipelagoes. Unlike Western navigational maps, stick charts don't indicate precise distances between locations. They are tools that show swell patterns and their disruptions around islands; they are used by navigators as memory aids, and as devices to pass on knowledge to students.

There are three types of stick chart. The *mattang* is like an abstract instructional model that shows ocean swell patterns and highlights a simple set of conditions.[i] This stick chart is often symmetrical in appearance. The *meddo* is different in form and shows swell patterns in relation to a few islands represented by small cowrie shells (*Cypraea* sp.), which are usually a section of one of the two island chains that make up the Marshalls.[ii] The *rebbilib* is different again and shows the positions of many more islands within the Marshallese group.

This example of a *mattang* from the British Museum in London gives us an insight, a tangible representation of how Marshall Islands navigators conceptualize their world and the oceanic terrain and pathways between its atolls. It is like a map, but *mattang* are not taken on voyages and consulted at sea. Memory is an important attribute of navigators. The patterns of the *mattang*, *meddo* and *rebbilib* travel in the mind of the expert navigators and help them visualize swell patterns, make decisions and anticipate the hazards of their journeys. The thin sticks cut from

coconut midrib and the simple ties that bind them create an ocean they can grasp within the comfort of the canoe house and recall when required on the ocean.

Although stick charts are a crucial mnemonic device for indigenous seafarers, they have also been a curiosity for Western collectors of artefacts. They are the bearers of symbolic and artistic dimensions that mark them today as attractive souvenirs for modern tourist markets. Anthropologist William Davenport has remarked on the design of *mattang*, noting that 'a certain amount of aesthetic licence is to be found on some charts…[as] wave patterns rarely, if ever, occur in such perfectly symmetrical relationships…'. However, he suggests that '[t]hese creative liberties hardly can be attributed to the scientific naïveté of a tribal people; the trained technicians who construct the coloured ball and wire models of the atom in order to illustrate principles of nuclear physics also seem to sacrifice some scientific accuracy for visual appeal.'[iii]

Today, on many maps of the Pacific, the hundreds of atolls sprinkled across the ocean barely register on the page or among the pixels of a computer screen. They are tiny in size, lie low on the horizon, and are almost invisible from the sea until you are upon them. Most computer desktop technology struggles to capture or map them. Satellites and Google Earth™ reveal but a few of their many dimensions. However, to generations of indigenous navigators, finding, travelling and living among these islands was not a matter of chance – it was a necessity of life, an act of imagining, knowing and remembering the ocean. SM

'Stick chart', Marshall Islands, acquired 1941.
Wood, shell. Length 63 cm (24¾ in.). © The Trustees of the British Museum, London.

The *Hōkūle'a* was a simulated ancient voyaging canoe that re-enacted epic journeys between distant Polynesian islands. These efforts, in conjunction with corroborating evidence from archaeology and ethnobotany, have yielded detailed and highly credible accounts of early Oceanic voyaging and navigation. Challenging earlier theories about drift voyaging and accidental discovery, these accounts, although not excluding chance as a factor, have shown the extent to which Oceanic voyaging in its exploratory and colonizing phases was a skilled and *deliberate* endeavour. Polynesians and Micronesians, extending ancient sailing technologies developed in the western Pacific such as outrigger canoes and lateen sails, created large double-hulled voyaging craft, and undertook ever more ambitious voyages into unexplored seas. In making exploratory forays, they used strategies such as sailing into the prevailing easterly winds to ensure the capacity to return to their point of origin, and drew on an experienced knowledge of wind patterns, sea currents, stars, seasons, cloud forms and other signs to navigate their way, take their bearings and predict the chances of landfall.[13]

Scientific reconstructions have explained in detail the likely techniques and methods of Oceanic voyaging; what ought to be added here is acknowledgment of its profoundly aesthetic and creative dimensions. The relationship of islands, skies and seas across vast regions of space constituted the sensory and conceptual world of early Islanders, which they no doubt envisioned in

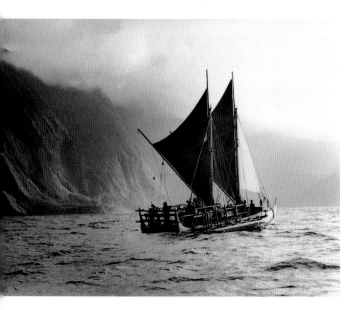

imaginative and meaningful ways, and in a dynamic relationship between the known and unknown. Most prehistoric art and architecture (the Parthenon, the Pyramids) is exemplified by structures, sites and places that were conceptually invested in ideas of place and permanence. By contrast, voyaging was a kinetic, performative and temporal art invested in the wind, the horizon and the exploration of the unknown. It presupposed no fixed place except the guiding orientation of the stars.

Centres of Power and Monumental Architecture in Micronesia

In his book *Real Spaces* David Summers observes the tendency of supreme rulers to identify with divinities or grand cosmological forces (the sun, the Pole Star), and to build elaborate ceremonial centres, commandeering vast labour forces, that make visually and physically manifest their power. Thus they create within their own architectural order the very order of the world.[14] A striking aspect of the prehistory of Micronesia and Polynesia is the emergence within the last thousand years, in contrast to the previous era, of precisely such centres of power: monumental earthworks and stoneworks constituting centres of various descriptions, associated with powerful chiefs or chiefly dynasties exercising sovereignty over an entire island or island group. As the power of chiefly lineages increased, typically through their identification with divine ancestors, so too did the scale of monumental structures. In these societies, height, size and number were associated with *mana* (power), and ceremonial complexes expanded by replicating or scaling up their component units, while stepped structures or terraced mounds were built that reached skyward.

Nan Madol, for example, is an extraordinary ceremonial and administrative complex spread across ninety-two artificial islets in a shallow lagoon surrounding Temwen, a small island rising from the reef of Pohnpei (formerly Ponape) in the Caroline Islands. The islets served as foundations for a variety of rectangular stone enclosures, their walls built from 'logs' of stacked prismatic basalt. These rocks were quarried from the mainland, brought to the site by raft, and put into place with levers and ropes. The entire complex was connected by waterways or canals that filled at high tide. It extended 1.4 kilometres (1 mile)

The *Hōkūle'a* sailing off Moloka'i, 1980.
Photograph Monte Costa.

In 1976 the simulated ancient voyaging canoe *Hōkūle'a* first sailed from Hawai'i to Tahiti and back again, giving credibility to the thesis of intentional voyaging between distant island archipelagoes. The *Hōkūle'a* has since become a symbol of a renaissance of ancient skills and knowledge.

Aerial view of the royal mortuary compound Nan Dauwas, looking south, Nan Madol, Pohnpei, c. AD 1400–1700.

Chiefly dynasties projected their power and mediated between the realms of the living and the dead through the construction of elaborate ritual and administrative complexes such as Nan Madol. The extraordinary scale of Nan Madol, built on ninety-two artificial islets, is visible in this aerial photograph of Nan Dauwas, a mortuary enclosure situated in the southeast corner of the complex.

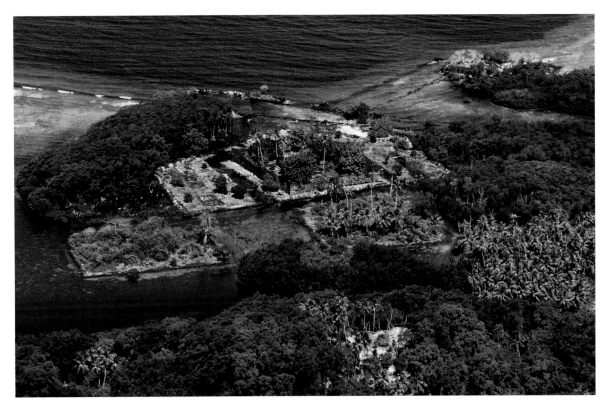

Site plan of Nan Madol.

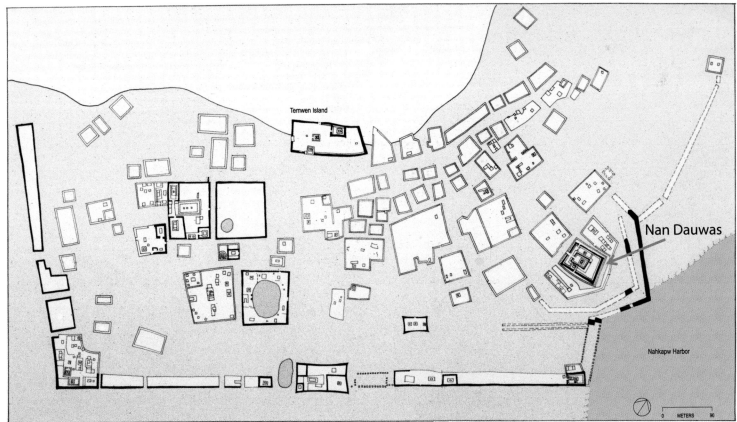

across its longest axis and comprised a total area of 200 acres (81 hectares) (*previous page*).[15] Although the site was occupied from AD 100 to 200, islet construction began around 700 or 800, with stone architecture and monuments appearing around 1200 to 1300 when the entire island of Pohnpei came under the leadership of one paramount chief, remembered by the name of Sau Deleur. The Sau Deleur dynasty ruled Pohnpei for about three centuries until it was replaced by the Nahmwarki dynasty in the early seventeenth century, which divided power into three chieftainships. Western contact had already occurred by this stage, with the arrival of the Spanish explorer Álvaro de Saavedra Cerón in 1528, but it is not clear whether this had any significant effect on Pohnpeian society. (However, a gold crucifix and

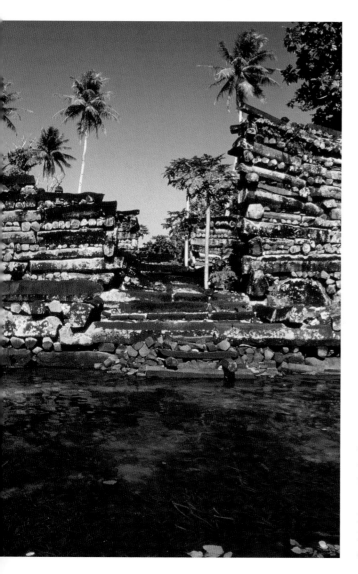

silver-handled dagger were found by visiting ships' captains in the early nineteenth century, suggesting that interactions with the Spanish were not without effects.[16]) One hundred years after his dynasty's rise to power the incumbent Nahnmwarki re-established his residence away from Nan Madol and the centre began to lose its prestige and population. By the 1820s Nan Madol was unoccupied, although it still functioned as a religious centre until the mid-nineteenth century when its final abandonment appears to have coincided with the arrival of American missionaries.

The architectural structure of Nan Madol attests to the stratified and centralized character of political authority on Pohnpei under the reign of the Sau Deleur. During the time of its construction, the site was dramatically expanded in several ways. The number of artificial islets increased; large breakwaters and seawalls were constructed to protect the complex from the impact of wave action; and scores of rectangular stone enclosures were built, some with walls rising to a height of 9.1 metres (30 ft). There were pathways, tunnels, wells; residential houses for royalty, priests and nobility; and special locations for food cultivation, canoe building and the performance of sacred rituals. Turtles, for example, were kept in an artificial basin on the islet of Paset and brought at appropriate times to Idehd – 'place of the sacred eel' – where they were killed, cooked and their entrails fed to a sacred eel kept in that enclosure. The names of other islets – Sapenlan ('place of the sky'), Kohnderek ('place for dancing and anointing the dead'), Peinering ('place of coconut-oil preparation') – suggest something of the fusion of religious belief and political authority at Nan Madol. Most structures in fact were royal mortuary compounds, the largest – known as Nan Dauwas – occupying the south-east corner of the complex and housing the sacred remains of the Sau Deleur. The site was also spatially divided into two main areas separated by a central waterway: Madol Pah in the south-west, a largely administrative sector with royal dwellings and ceremonial areas; and Madol Powe in the north-east, a mortuary sector with major tombs, burial sites and priestly dwellings.

A similar complex developed on the reef island of Lelu, off Kosrae, about 560 kilometres (350 miles) east of Pohnpei.[17] Like Nan Madol (though there is no evidence of any connection between the two complexes), Lelu

Entrance to mortuary enclosure of Nan Dauwas, Nan Madol, Pohnpei, *c.* AD 1400–1700.

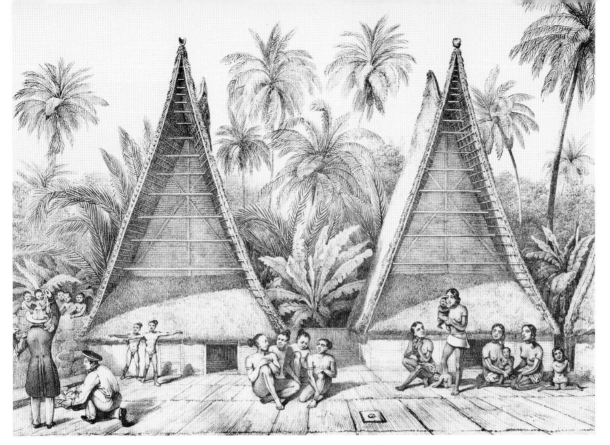

Feast houses and courtyard, Lelu, Kosrae, 1827–28.
Engraving from Frédéric Lütke, *Voyage autour du monde...dans les années 1826, 1827, 1828 et 1829*, Paris: Didot, 1836.

Early European voyagers to the Pacific often encountered highly developed island polities with remarkably sophisticated architectural structures. These feast houses sat within large stone-walled enclosures on the 'island city' of Lelu, built over a reef.

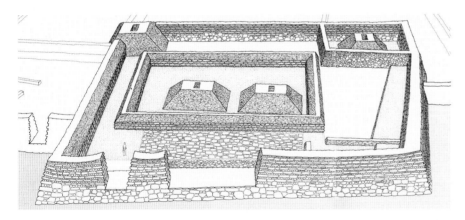

above
Royal tombs in the mortuary compound of Insru, Lelu, Kosrae.
Drawing William Morgan.

was the built expression of a consolidation of chiefly power into a single dynastic paramountcy or 'kingship' in about the seventeenth century. Originally a much smaller chief's compound with probably only local authority, it expanded into the reef on reclaimed land in various phases after AD 1400 as the chiefdom's authority grew. By the middle of the seventeenth century, Lelu had become a veritable 'island city' with royal residential and mortuary compounds, feasting houses, dwelling houses, ritual places, pathways, harbours, and a canal running through its centre. This complex sustained a feudal-like hierarchy of 'kings', high chiefs, lower chiefs and commoners. The scale of Lelu was again enormous: two mortuary enclosures

housing royal tombs called Insru and Inol together measured 5,467 square metres (53,819 sq ft), 'an area larger than a football field'.[18] Like Nan Madol, Lelu gave spatial and ceremonial order to the world over which its rulers reigned. Tributary offerings were brought to the complex on a regular basis and particular compounds are known to have shared the same names as parts of Kosrae, suggesting they may have housed subordinate chiefs with responsibility for the management of those areas.

But not all cases of monumentality in Micronesia reflected tiered societies and encompassing chiefly hierarchies. In the Marianas, clan houses were attached to the tops of parallel rows of stone piles cut from coral limestone called *latte*: squarish columns of varying heights capped with inverted hemispheres that served as house foundations.[19] These structures date from about AD 1000 and continued to be made and used until the mid-eighteenth century, well after European contact by Spanish explorers in the early sixteenth century. Sets of *latte* stones can be found at various sites on the main islands of the Marianas chain: Guam, Tinian, Rota and Saipan. They typically consist of six to fourteen columns arranged in parallel rows on a rectangular plan and were sited close to the sea or river ways with their long axis running parallel to the shore.

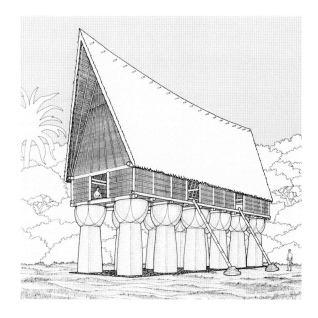

The houses themselves have not survived, though a reconstruction is tendered in a drawing by William Morgan. They are thought to have been mainly clan houses associated with a household or larger kin group falling under the authority of a local chief. Some houses were associated with more high-ranking chiefs or chiefly alliances, but at no point during their usage by the ancient Chamorros (the native people of the Marianas) did they represent a single over-arching chiefdom or supreme ruler. However, they do indicate, in their size and number of columns, rivalries among

chiefdoms for dominance. On Tinian, for example, the 'house of Taga' once sat on twelve columns almost 5 metres (16 ft 5 in.) tall, twice the height of the next highest stone foundations in the Marianas, while on Rota even bigger columns that would have measured 5.5 metres (18 ft) tall lie half-excavated in their quarry.

Centres of Power in Western Polynesia

Monumental architecture of a different type appears to have evolved independently in Polynesia, where it too was associated with increasingly complex and populous societies and the rise of powerful chiefdoms.[20] In terms of scale and labour, the most significant stone excavations and stone monuments in western Polynesia are located at the village of Lapaha on the island of Tongatapu.[21] Lapaha was appropriated as the home of the Tu'i Tonga ('lord of Tonga') in the late thirteenth century by the twelfth Tu'i Tonga, a lineage of thirty-nine chiefs who reigned from about AD 950 to 1865. The adoption of Lapaha at this point in time, and its spatial reconfiguration by land-modification projects and the construction of monumental stoneworks, corresponded to the Tu'i Tonga's achievement of political hegemony over the Tongan archipelago. The business of renovating Lapaha began with the creation of a large ditch cut out of limestone bedrock that removed around 28,000 tons of stone. Once thought by archaeologists to have been a defensive boundary, recent excavations have prompted the reinterpretation

left
Reconstructed perspective drawing of the House of Taga on Tinian showing 5-metre- (16-foot-) high stone columns and capstones supporting a traditional wood frame house.
Drawing William Morgan.

below
Columns and capstones of the House of Taga, Tinian, Marianas, *c.* 1925.
Photograph Hans G. Hornsbostel. Bernice P. Bishop Museum, Honolulu.

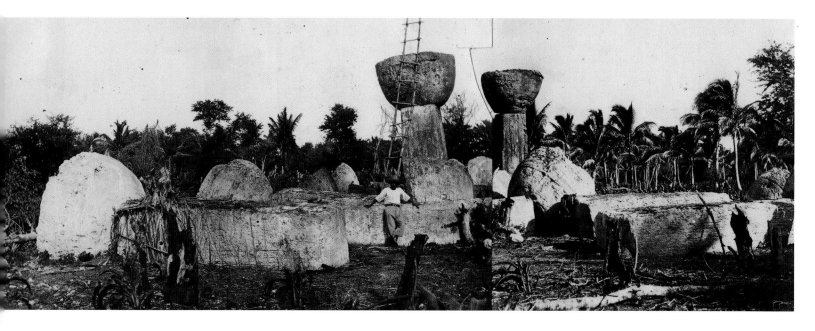

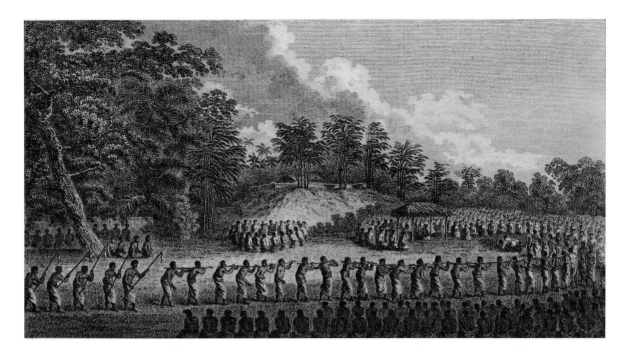

above right

Tribute presentation of 'first fruits' ('*inasi*) on the *malae* (ceremonial plaza) at Muʻa (Lapaha), Tongatapu, Tonga, 1777.
Engraving by Hall and Middiman after John Webber.

Lapaha was a ceremonial and mortuary centre associated with the Tuʻi Tonga (lords of Tonga), a dynasty whose influence at the peak of its power extended through most of western Polynesia. The slab-faced mound in the background of this engraving and the stepped tomb of Fatafehi on page 64 are two of numerous burial sites found at Lapaha.

below right

Plan of the major built features at Lapaha, Tongatapu, Tonga.
Reprinted with permission from Geoffrey Clark.

of this ditch as a unique waterway that enabled access to fresh drinking water and demarcated a ceremonial space – a *malae* – for the '*inasi*, an annual 'first fruits' presentation ritual. During the '*inasi*, people from around Tongatapu and other islands brought tribute goods to Lapaha to show their respect for the Tuʻi Tonga's leadership and the social order it supported. Attesting to the longevity of the dynasty and its ritual traditions, an '*inasi* presentation on the *malae* at Lapaha was witnessed by Captain Cook in 1774 and recorded in a drawing by John Webber.

Further changes altered Lapaha again some time between 1300 and 1450, suggesting changes in both the extent of the Tuʻi Tonga's ruling influence and the very nature of its avatars. During this time, a massive land-reclamation project was undertaken extending the area of Lapaha westward into the lagoon and creating a small harbour with a protective 'narrow entrance for mooring large double-hulled canoes'.[22] The mooring would have been socially, politically and spiritually important because it facilitated the arrival of visitors for the '*inasi* and presumably also the inward and outward flow of goods and people. Then, around 1450, the site was transformed again. In a project initiated, it is thought, by the twenty-fourth Tuʻi Tonga, Kauʻulufonua I, and continued by subsequent title holders, large, tiered burial structures for the Tuʻi

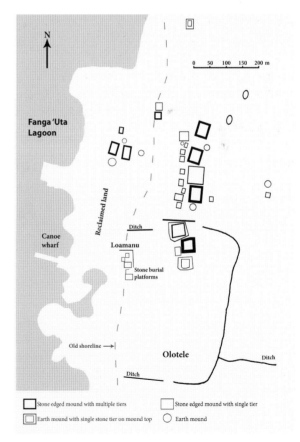

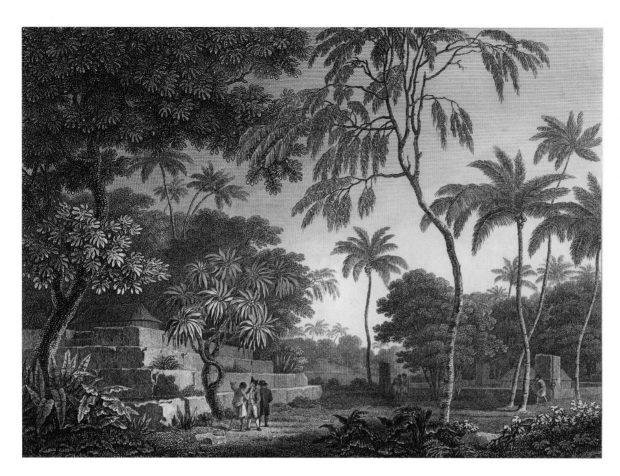

The *langi* tomb of Fatafehi, Lapaha, Tonga.
Engraving by M. A. Rooker after a sketch by William Wilson. *A Missionary Voyage to the Southern Pacific Ocean,* London: Chapman, 1799. J. C. Beaglehole Room, Victoria University of Wellington Library.

Tonga, known as *langi*, were built over the ceremonial area. Thirty-four *langi* and earth mounds have been identified at Lapaha, with ten featuring terracing. The largest slab identified in the construction of these tombs is a beach rock about 10 metres (33 ft) long, sitting 2.4 metres (8 ft) above ground and weighing approximately 50 tons, which is equivalent to some of the largest stones in Stonehenge.

Archaeologists who excavated the site in 2006–7 argue that these architectural transformations corresponded with the transformation of the status of the Tuʻi Tonga from a divinely sanctioned chief of the people to a semi-divine being in his own right. Kauʻulufonua I separated the secular and divine roles of the Tuʻi Tonga title into the junior Tuʻi Haʻatakalaua title of secular status, while retaining the Tuʻi Tonga title as separate and semi-divine – a duality reflected in new spatial divisions of the site, with the secular title located on the area of reclaimed land and the Tuʻi Tonga located on the original land, dominated by its mortuaries.[23]

From this time, the tombs themselves became the focus of ceremonial activity as the Tuʻi Tonga expanded its sphere of influence into the wider region. At the height of its power, that influence extended beyond Tonga to Fiji, Samoa, Futuna and ʻUvea (referred to by Jean Guiart as the 'Tongan empire'),[24] and a Tongan presence has been archaeologically identified or otherwise remembered in most of western Polynesia and indeed in parts of island Melanesia. Tonga's elite rulers also figured large in a regional network of trade and tribute in prestige items and specialist services. Red feathers, barkcloth, fine mats, whale teeth, Fijian ceramics, basketry, weapons and ornaments were traded between the archipelagoes of Tonga, Fiji and Samoa; timber for the construction of voyaging canoes, if not the canoes themselves, were imported into Tonga from Fiji; tattooing services were imported from Samoa; and high-ranking spouses from these islands married their elite counterparts.[25] However, the physical, social and spiritual separation of the Tuʻi Tonga from the rest of society also initiated instability, rivalry and warfare. The arrival of Europeans, particularly the missions, led to the eventual collapse of the Tuʻi Tonga dynasty with the death of Tuʻi Tonga Laufilitonga in 1865.[26]

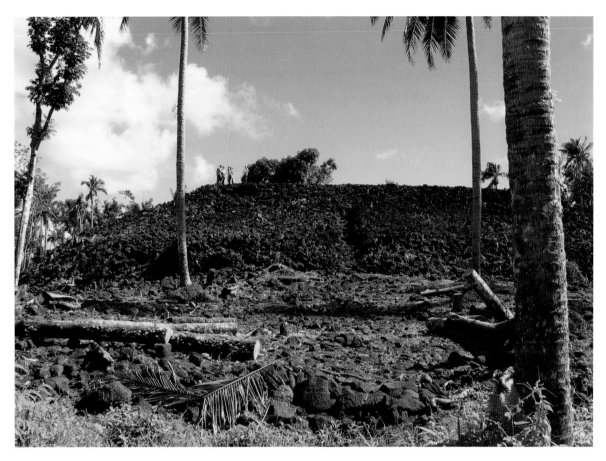

right
Pulemelei mound, Letolo plantation, Savai'i, Samoa, *c.* AD **1100–1500.**

below
***Pu foafoa*, shell trumpet, found 1960s at Pulemelei archaeological site, Savai'i, Samoa.**
Cassis cornuta shell. Auckland Museum.

The existence of elite alliances and the regional influence of the Tuʻi Tonga casts an intriguing shadow over the significance of other monumental sites in the region, some of which are known to have been created through some relationship with the Tongan chiefdom.[27] Chiefs in Tonga, Samoa and ʻUvea, for example, participated in the chiefly sport of pigeon-snaring, associated with the construction of 'star mounds' and 'cog mounds' found in these islands: flat-topped mounds of earth and stone that in plan featured radiating arms or bite-like niches around a circular perimeter.[28] But perhaps the most intriguing monumental site in western Polynesia is the great mound of Pulemelei on Savaiʻi in Samoa, built with 30,000 cubic metres (1 million cu ft) of stone and situated on a hillside rising above Savaiʻi's southern coast. There is little traditional or historical information about Pulemelei beyond its association with an ancient chief by the name of Lilomaiava Nailevaiʻiliʻili. But the site itself is revealing. Excavated by archaeologists in the 1960s and examined again in

2002, it suggests that Pulemelei was once the dominant structure within a larger complex of platforms, pathways, earth ovens and walls, which sat in turn on a hillside filled with the evidence of former occupation. The visible mound is a two-tiered structure oriented to the cardinal points of the compass, with sunken entranceways on its eastern and western sides leading to the top. Radiocarbon dating indicates the site had previously had a long occupation history, beginning in 150 BC, before a stone-faced platform was built between AD 1100 and 1300. In the following two centuries, a period coinciding with the expansion of the Tuʻi Tonga, another two platforms were built on top of the first (although only the base and top platforms remain visually prominent), raising the top level to over 12 metres (39 ft) above ground level. The height of Pulemelei, together with its footprint measuring 60 by 65 metres (197 by 213 ft), would have most likely made it the largest free-standing stone structure in Polynesia at the time. Pulemelei was abandoned sometime around 1700 to 1800, which coincides with changes to the Samoan political system.[29]

'FROM THE TOP OF THE MOUND'

The Pulemelei site [*previous page*] is made up of several mounds. The principal mound was excavated during 2002–4. When the excavation reached foundation level and the near approaches were cleared, the spectacle of what was exposed was awesome. It invited re-assessment.

In terms of the Samoan landscape, the Pulemelei mound seemed to me to be overwhelmingly large and high. One of the smaller mounds on elevated ground to the North gave a commanding view of the top level of the principal mound. Another platform on the Southern slope and the other stone platforms nearby each incited wonder and curiosity. Even more curious was the pathway from the East.

The pathway or *auala* in Samoan, is significant in Polynesian culture. Our funeral rituals are called *auala* or the pathway, meaning the pathway to *lagi* (heaven) or Pulotu (the underworld). From the top of the mound one has a good view to the South and it is possible to trace a 'pathway' linking Manono, Apolima and Upolu islands. In early 2003 bush and trees hid this 'pathway'. However today the 'pathway' is clearly visible, thanks to the clearings made by the hurricane in January 2004. Whilst at the top of the principal mound one can not help but reflect on the strategic and navigational value of such a view for our ancestors.

In early 2003 I invited two Maori friends, an anthropologist Dr Pita Sharples, and Reverend Morris Gray, former Head of the Maori Department at the University of Canterbury, to visit Pulemelei. We climbed the path to the Pulemelei complex and to the top of the large Pulemelei mound, where we seated ourselves on flat slabs of stone.

Shortly after, Morris stood up, walked inwards, stopped when he reached the middle, threw his arm out and pointed to the ground: 'Down in the bottom in the ground level is buried an *ariki*' he said. He seemed like someone who was, as we say in Samoan, *ua ulu i ai le agaga*, meaning 'possessed'. 'I know this place' he continued, 'this is where our people came from. My family emblem is the *wheke* (octopus) and this mound is a legacy of the *wheke*. And, there are in this environment definitive markings which underline the sacred figure of eight'.

Morris's reference to the *wheke* and the figure of eight impacted on me because the river that flows through the plantation on which Pulemelei is sited has eight waterfalls. He did not know this at the time. 'There are links between this mound and the skies, the sun, the moon and the stars', he proclaimed. 'There is a link between this mound and the pathway'. The astronomy of this, he suggested, was what enabled the Polynesia Diaspora.

Hon. Tui Atua Tupua Tamasese Ta'isi Tupuola Tufuga Efi, a paramount chief of Samoa and Samoa's Head of State, 2007

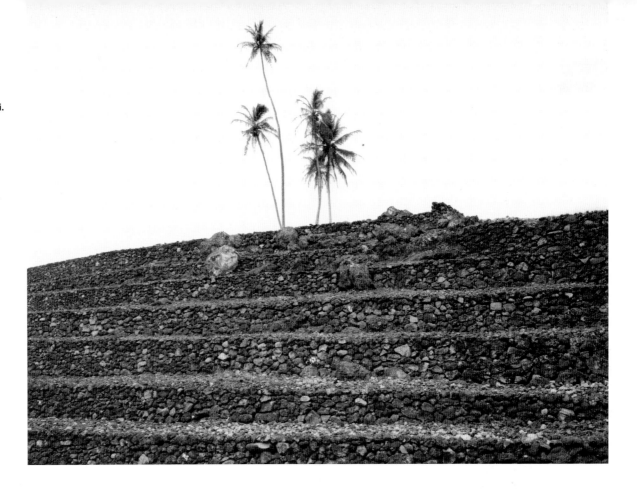

Hale o Pi'ilani, Maui, Hawai'i.
Photograph Anne Kapulani
Landgraf, 1996.

Hale o Pi'ilani is the largest
existing *heiau* (temple) in the
Hawaiian Islands and dates
back to the thirteenth century.
The photograph captures
a segment of its stepped
stone retaining wall leading
to a massive three-acre
platform above.

Transformations in Polynesian *Marae*

The early settlers of central Polynesia, as well as those
who subsequently settled Hawai'i, Rapa Nui and
Aotearoa New Zealand, no doubt brought with them
the concept of *marae* and its associated practices. The
word *marae* and its cognates in different Polynesian
languages (*malae, me'ae, tohua, heiau, ahu*, etcetera)
refers to a form of communal or ritual space that must
have existed in earlier times, although there is 'no firm
evidence' in either western or eastern Polynesia of
marae structures from their early settlement periods.[30]
Most structures across the Pacific date to within the
last thousand years. However, in eastern Polynesia we
see the development of monumental *marae* that were
far more complex and diverse in structure and use
than both those that had preceded them and their
western Polynesian counterparts. The open space,
characteristic of all *marae*, was formalized into raised,
walled or otherwise demarcated rectangular stone
courts, sometimes several courts in one complex;
the most important spiritual part of eastern *marae*
came to feature elevated platform altars or stone
ziggurats; there was greater artistic elaboration of
anthropomorphic stone statues or wood sculptures
used to represent or embody ancestral deities; and
the overall scale of *marae* complexes increased.

In Hawai'i, before the fourteenth century when
chiefly religious authority was largely distinct from
political authority, *heiau* (the Hawaiian term for
marae) were relatively simple structures used for
worship or communal meetings. They varied in size
and complexity depending on whether they served a
family or community or were required for divination
related to harvest, communal meetings or other social
purposes. However, probably during the fourteenth
century, the political leadership of chiefs became
increasingly merged with religious authority. To
support and demonstrate their supremacy, chiefs
commissioned the construction of large open courts,
stone platforms, buildings, uprights and altars. They
often resided or lived near these structures. By the
fourteenth century the status of chiefs had been
transformed to such an extent that it warranted their
removal from common life, a separation architecturally
expressed by elevated court platforms and the
enclosure of *heiau* by stone walls.

In the Society Islands, the great *marae* known
as Taputapuātea at Opoa on the island of Ra'iātea –

Rock Art

PREHISTORIC PETROGLYPHS and pictograms are found in many parts of Oceania, although their distribution is uneven. There are only a few in the Fijian and Tongan islands and none, it appears, in the Samoan islands. They are also scarce on Micronesian atolls, which obviously do not lend themselves to making 'rock art'. On the other hand, there are copious examples in western Oceania as well as in central Polynesia, particularly the Marquesas, and in the Hawaiian islands, Rapa Nui and parts of Aotearoa New Zealand.[i]

To some extent, cultural information acquired from historical ethnographies or early informants can illuminate their significance. The image of a foot carved on a *langi* tomb in Tongatapu, for example, has been interpreted as a symbol of the sanctity of the chief buried therein, based on nineteenth-century reports that touching the soles of the feet of Tongan chiefs featured among the acts of showing respect towards them.[ii] But in most cases their meaning eludes us. As J. Halley Cox and Edward Stasack put it, speaking of Hawaiian petroglyphs: 'They mean what they were meant to mean by their creator and are no more apprehensible to an outsider than is the alphabet to an illiterate.'[iii]

And yet, no genre prompts as much effort to decipher the enigmatic, or as much reflection about the methodological limits of the task, as does the humble petroglyph. Moreover, it is possible that the enigma was not entirely unintentional. The decision to scrape, gouge or engrave a picture or symbol into rock, as opposed to more perishable material, suggests that among the intentions of its maker may, in some cases, have been that of addressing future beholders.

One of the richest petroglyph sites in the Hawaiian Islands is a place called Puʻuloa, in the district of Puna on the island of Hawaiʻi.

The site comprises a hillside of smooth lava called *pahoehoe*, cracked into numerous sections, each roughly equivalent in size to the crouch or stretch of a human body. It is not hard to imagine the invitation these surfaces would have presented to mark them. Scraping or pecking them with a hard stone or stone hatchet would have easily exposed the contrasting texture and tone of the rock beneath, creating a line or mark. And the cast of light across their surface at different times of the day (and night) would have further enlivened those marks, bringing out different contrasts and tonalities. Far from being the fixed marks usually associated with 'rock art', petroglyphs are light drawings, in constant interplay with light and atmosphere.

Puʻuloa is covered with over 21,000 discrete graphic units, making it the largest petroglyph site in Hawaiʻi. It is also one of the few sites about which there is some information. In 1915 the anthropologist Martha Beckwith was informed by her guide Konanui that the thousands of small holes, or cupules, that predominate at Puʻuloa were made by parents as places to deposit the *piko* (the umbilical stump or cord) of a newborn child in order to invoke long life. Rings encircling a cupule denoted a firstborn, whereas a row of holes or a ring encircling several cupules denoted a family group. The name 'Puʻuloa' literally means 'long hill', but Hawaiians local to the area interpret the name as 'Hill of Long Life'.[iv]

This account does not explain every symbol or picture at Puʻuloa but it does make clear that the main purpose of the site, the custom it engendered, was to register the origin of a life – and inevitably a death. Indeed, the spiritual power of Puʻuloa, and the real nature of its aesthetic impact, comes not from these marks as individual signs (or as signs of individuals) but from the cumulative record they represent of many generations over time, assembled together in one sacred place. PB

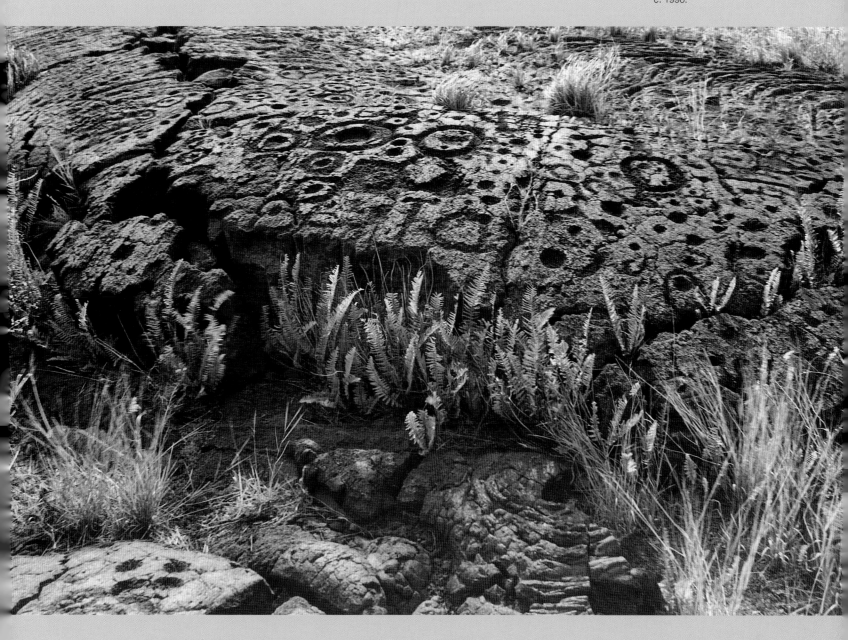

Section of petroglyphs at Pu'uloa, Hawai'i.
Photograph Thérèse I. Babineau, c. 1996.

remembered in Hawaiian and New Zealand Māori oral histories as the embarkation point for migrations beyond central Polynesia – was the ritual centre for a heterogeneous cult known as the 'arioi. This 'society of orators, priests, navigators, travelling performers, warriors and famed lovers' dominated Ra'iātea in the seventeenth century and extended its influence into Tahiti in the following century through the ascendancy of one of its local deities, 'Oro, the "supreme god of earth and air"'.[31] Drawn by Sydney Parkinson in 1769, the *marae* then consisted of an *ahu* (an elevated stone platform) of coral slab facings of around 2.5 metres (8 ft) in height, with a number of carved panels rising from its surface. Beside it was a raised platform for offerings, and nearby (though these elements are not visible in Parkinson's drawing), a storehouse for the *marae* drums and a number of deity houses. Like other *marae* sites, Taputapuātea reveals a prior history of occupation, with its form in the eighteenth century constituting a much larger superimposition over an earlier structure. Kenneth Emory suggests this was an attempt to make it bigger than at least two other monumental *marae* on the neighbouring Leeward Islands.[32]

But not all *marae* were the undertakings of paramount chiefs or societies seeking to extend their religio-political dominance. On Tahiti and Hawai'i, besides *marae* and *heiau* of public importance that operated at island and district levels, there were a number of classes of domestic *marae*, associated with clan-groups, extended families and certain occupations, such as fishing, healing and watercraft construction. On Tahiti these *marae* generally consisted of a sacred space that was delineated as a parallelogram in plan by either a low fence of stones or an elevated platform encircled and paved with stone. Where a *marae* was rectangular in plan, the long side generally ran parallel to the shoreline or track and the space between was kept bare. New *marae* were established when others were superseded through the installment of new leaders, or when a clan or extended family migrated to a new area. Stones from earlier *marae* were integrated into the new *marae* to activate it and, where necessary, to ensure that the status of the old *marae* and its leadership were translocated. In the Hawaiian Islands, fishing *heiau*, or *ko'a*, were often small shrines marked by an upright stone called *kū'ula*, where offerings were placed to

top
The grand *ahu* (altar) of Taputapuātea *marae*, Ra'iātea, Society Islands.

above
Taputapuātea *marae*, Ra'iātea, Society Islands, 1769.
Sydney Parkinson, 'A morai with an offering to the dead', 1769. Pen and wash, 24 x 37 cm (9½ x 14⅝ in.). © All Rights Reserved. The British Library Board.

left
An upright *kū'ula* stone within a small *ko'a* or fishing shrine, Keone'o'io Archaeological District, Maui, Hawai'i.
Photograph Thérèse I. Babineau, 1993.

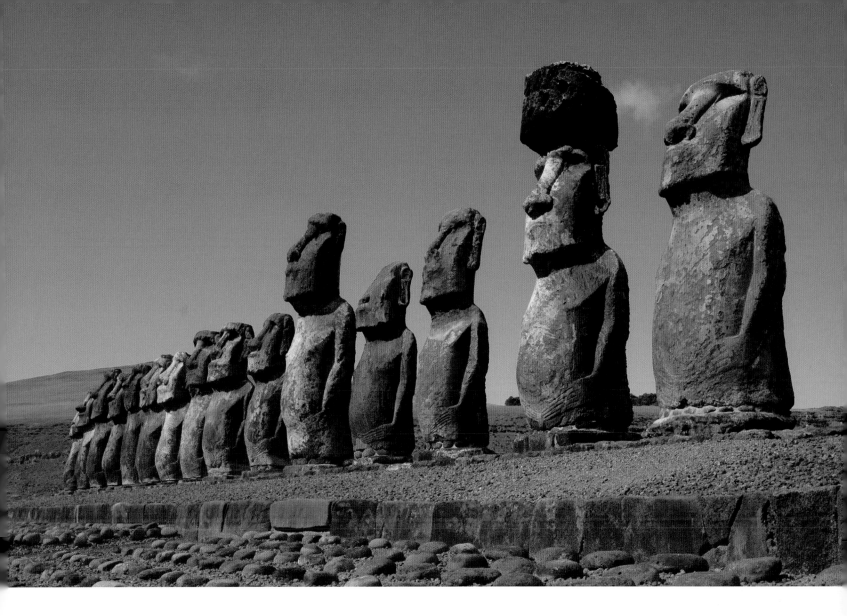

Ahu Tongariki, Rapa Nui, AD **1300–1500.**

Restored in the 1990s, Ahu Tongariki is an awe-inspiring complex with fifteen *moai*, their backs to the sea, aligned on a raised platform overlooking what would have once been clan settlements. Tongariki was the principal *ahu* of the Hotu Iti alliance, a confederation of clans that dominated Rapa Nui's eastern coast.

invoke the favour of particular deities. These shrines and stones, like other *heiau*, sit within specific sites: sea coasts, cliff tops, hillsides and so forth. They are open structures that commune with the specific character of their surroundings in ways that can still be felt (even if their religious or ideological force has gone). They structured and gave meaning to ordinary lives and daily practices as much as they did to the grand undertakings of paramount chiefs.

But perhaps the most remarkable *marae* in eastern Polynesia are those of Rapa Nui. The *marae* of Rapa Nui are known as *ahu*, which in the Society Islands was a name only associated with the raised platform element. Most *ahu* are situated near the coast and typically consist of a raised stone terrace running parallel with the sea on which was erected stone ancestral deity figures, known as *moai*, that faced

inland. The long seaward-facing side of the terrace consisted of a robust retaining wall with a declining stone ramp on the other side leading down to a flattened rectangular court; beyond that were communal dwellings. *Moai* were carved *in situ* in a quarry of soft volcanic rock on a hill called Rano Raraku and then transported (using a system of rolling logs) to particular *ahu* to be raised on platforms, capped with red scoria 'topknots' called *pukao*, and transfigured by the insertion of shell eyes. The platforms alone reached heights of up to 7 metres (23 ft), over which the *moai* themselves towered.[33]

The prevalence of *ahu* sites on Rapa Nui (there are 245), some of which show evidence of multiple cycles of statue-raising, attest to the centrality of the entire ritual of creating these ancestral temples, built continuously between AD 1000 and 1500.

The 'Kaitaia Carving'

N O OTHER NEW ZEALAND Māori carving has elicited as much speculation about the origins of the art as the so-called 'Kaitaia carving'. It was found near the northern town of Kaitaia during drain construction in a swamp, such locations often being used as safe repositories for *tapu* (sacred) objects during times of conflict. In 1921 it was acquired by the Auckland War Memorial Museum.

The simple humanoid figure at its centre, quadruped figures at its end, chevron infilling, and notched edges distinguish it from most other pre-contact Māori carving, where *tiki* and zoomorphic figures are highly abstracted and adornment is often a complex system of surface patterns. However, the same characteristics locate the carving within a wider Polynesian style of art, as is apparent in a carving attributed to the Austral Islands and now held in the Museum of Archaeology and Anthropology, Cambridge. Many scholars have cited this similarity as a reason to regard the Kaitaia carving as an early example of the art, and evidence that Māori carving may have begun in the north of New Zealand. Some have even speculated that the carving was brought to New Zealand by early Polynesian travellers, but this is unlikely since it is made from totara, a native timber, and its figures are like those seen on four other northern carvings recovered at Doubtless Bay.

The year after it was acquired by the museum, the ethnologist H. D. Skinner observed that its composition followed the same alternating 'profile-frontal-profile' figurative form of carved Māori door lintels.[i] Although he also noted that door lintels were never carved on both sides like the Kaitaia carving, the name 'Kaitaia lintel' has persisted up until recent times. Today the carving is generally regarded to be part of a gateway. Despite its renown, the Kaitaia carving does not appear to have influenced the formalism that the School of Māori Arts and Crafts developed in the 1930s as part of its recovery of the northern carving style. Nevertheless, for northern Māori, the Kaitaia carving is a revered treasure due to its apparent antiquity that provides it with *tapu* (sacredness) and *mana* (prestige). It has inspired contemporary artists, such as the painter Kura Te Waru Rewiri who employs an image of the carving in her 1994 painting *In Te Po there are many Beginnings* as a device to symbolize the origins of Māori culture. The Kaitaia carving has also been used as an organizational logo by Te Rūnanga-o-Te-Rarawa, the tribal council associated with its place of discovery. The carving's most enduring influence, it could be argued, is on a new generation of carvers who have copied its form for the *pare* (lintel) of at least three recent meeting houses built within the Te Rarawa tribal district. DB

above

**'Kaitaia carving',
New Zealand.**
Wood, acquired 1921 (thought
to date from about AD 1300–
1400 but may be more recent).
Length 225 cm (88⁵⁄₈ in.).
Auckland Museum.

right

**Carving with two Janus
figures and a dog, attributed
to the Austral Islands
but likely to have been
collected in Tahiti, mid-
eighteenth century.**
Wood, collected during
Cook's first voyage. Length
53 cm (20⁷⁄₈ in.). Museum
of Archaeology and
Anthropology, Cambridge.

Like other Polynesian *marae*, *ahu moai* were associated with particular communities or clans with common descent lines. The increasing size, number and aesthetic refinement of *moai* over this period of time, culminating in the majestic spectacle of *ahu* Tongariki on Rapa Nui's eastern coast with fourteen *moai*, suggests the competitive nature of *ahu moai* construction among these clans (*page 71*). However, by the end of the sixteenth century, the cult of *ahu moai* construction and the order of chiefs and ancestors it supported began to implode in the face of the compounded effects of over-population, food scarcity and environmental disaster (caused in large part by over-exploitation of the island's natural resources). One consequence of this breakdown was the rise of a militant warrior class called the *matato'a*, who asserted their new dominance over traditional chiefs by carrying out destructive raids on *ahu moai*, and toppling them.

In Aotearoa New Zealand, *marae* were open spaces associated with a chiefly house and *pātaka* (a raised storehouse of *tapu* objects), both of which were distinguished from other buildings by their display of small decorated wood-carved architectural elements. Although there are echoes of central Polynesian *marae* in Māori *marae* (both, for example, share a religious function centred on an open courtyard and include a house of sacred objects), the latter do not display many of the former's 'classic' architectural traits, such as its stone construction, walled or elevated platform courts and monumental scale. Monumentality might not have been so easy to achieve, or desirable, in a new environment that was heavily forested and colder than the rest of the Pacific. It is also possible that migrants to New Zealand may have been of a restricted range of social classes that did not perpetuate the custom of *marae* monumentality, even as their society grew more complex over time. Certainly, it might be expected that

Māori *pā* site, Maungakiekie, Auckland.

Photograph Kevin L. Jones, 2010.

Māori *pā* were terraced, fortified villages built on prominent hilltops between AD 1500 and 1800. Used for defence and food storage, they were also a form of land sculpture, projecting *mana* through their height and the impressive scale of their earthworks.

social hierarchies would initially become flattened in a challenging physical environment that required significant labour from all members of a social group in order to survive.

However, between 1500 and 1800 competition for land and the need to express *mana* within an ancestral landscape did give rise to monumental earthworks in the form of *pā*, or terraced fortified villages, built mostly in the North Island. Although the use of individual *pā* varied across time, each with its own occupational history, most were not occupied continuously. Some were used as defensive positions in battles, although many had important peacetime functions as places for the storage of food.[34] The lack of evidence of permanent habitations at most *pā* sites has led to the suggestion that their general role was to indicate the *mana* and wealth of a user group through the accumulation and storage of food, demonstration of defence capabilities, and the command of the natural landscape that surrounded them and represented them.[35] Like the earthworks of Lapaha, the *pā* of Aotearoa New Zealand indicated the ability of a chief to command sufficient *mana* and labour to culturally modify a natural landscape that had been originally made by the deities.

The Contingency of History

The prehistoric cultures of northern and eastern Oceania over the *longue durée* surveyed in this chapter reveal a developing sense of social and metaphysical order that was unique to these parts of the Pacific, as compared to western Oceania. Two dynamic artistic expressions of that metaphysical order were open-sea voyaging in quest of new islands from the first millennium BC to about AD 1300 and the construction of large architectural monuments and land-modification projects. The era of exploratory voyaging for Pacific Islanders must have corresponded with an almost limitless sense of the world, which existed always in relation to the lateral extent of the horizon and the ever-present possibility of other islands to discover and colonize. By the fourteenth century these Islanders had reached as far as the western edge of the American continent and discovered every habitable island in the Pacific Ocean. Long-distance voyaging waned in the second millennium AD and eventually ceased around 1500. From that point, voyaging was mainly confined to coasts or specific archipelagoes, and pursued for the purposes of trade, conquest or regional empire building.[36]

The era of monumental architecture and *marae* building largely follows this exploratory epoch. These structures were associated with the rise of powerful chiefdoms in societies that had rapidly become more populous and complex. At their most elaborate, these ceremonial complexes manifested the divine or near-divine status of powerful chiefs, marking their separation from other classes, and giving rise to stratified societies or competitive or warring chiefdoms. In many instances, however, domination was unsustainable, and chiefdoms and empires collapsed or fragmented, their architectural complexes attacked or abandoned, to be replaced by others, or covered over by the tenacious tropical bush. Earlier scholars, looking at these societies and their art through the lens of antiquarianism, have sometimes associated instances of decline of chiefdomships and monumentality with a corresponding decline in 'civilization', but it is important to recognize that the contingency of Polynesian and Micronesian societies was a continual and inevitable part of their existence in history.

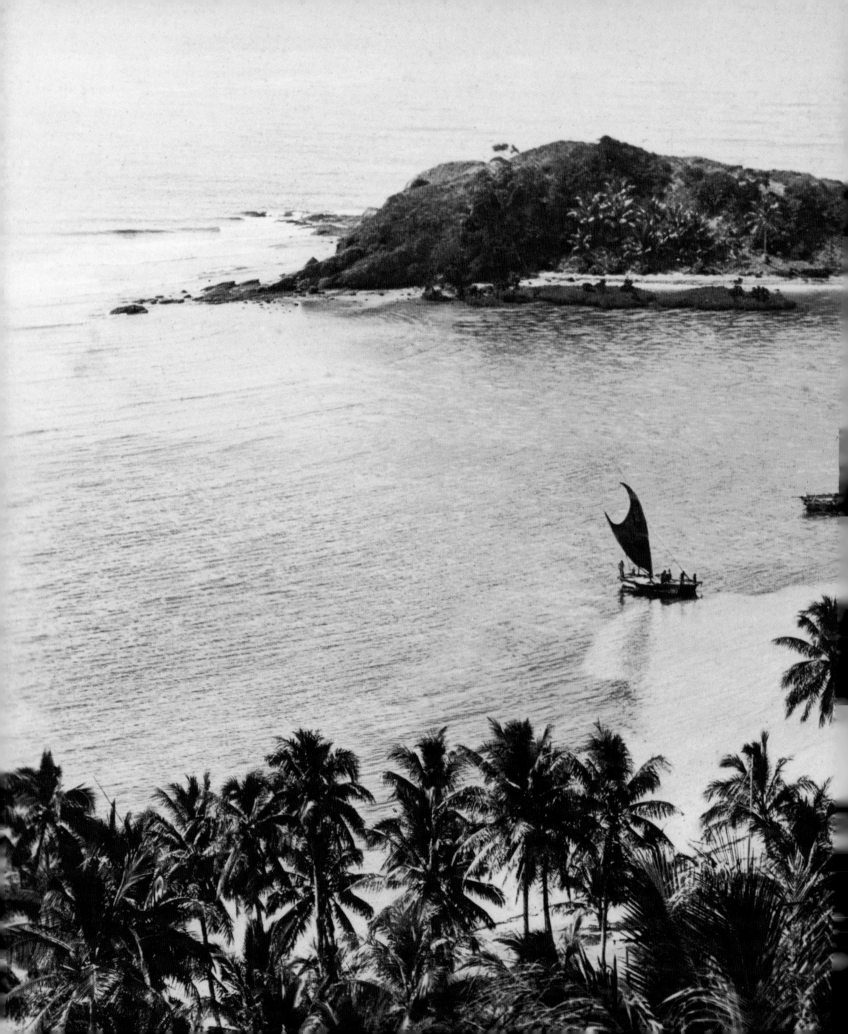

PART TWO NEW GUINEA 1700–1940

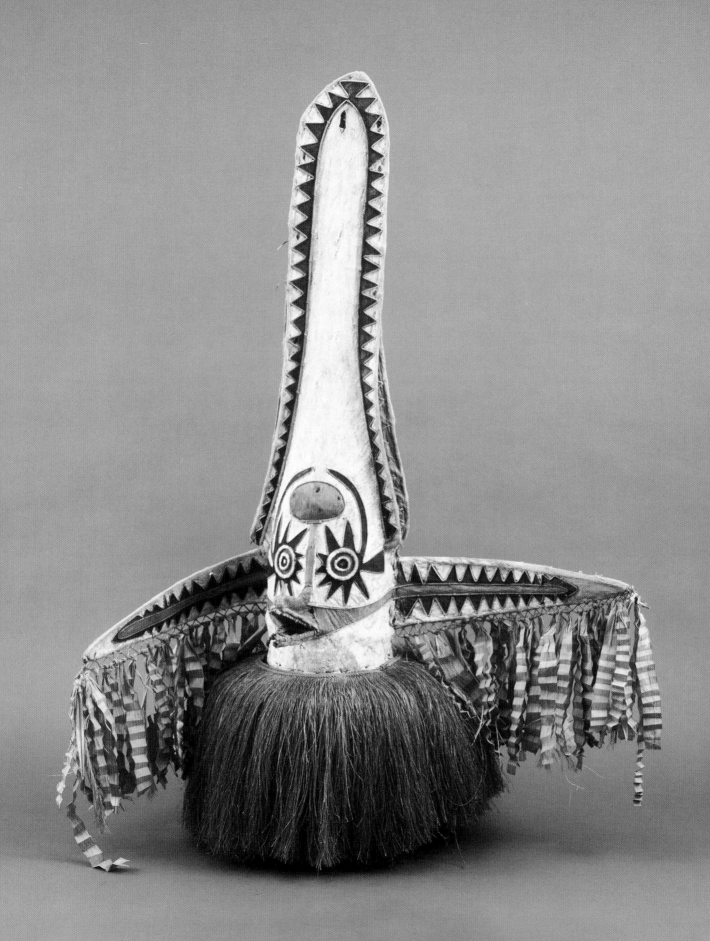

Nicholas Thomas, Susanne Küchler and Lissant Bolton

ART, TRADE AND EXCHANGE: NEW GUINEA 1700–1900

New Guinea might be seen as Oceania's 'continent'. Though categorized by geographers as an island, it was and is, relative to the rest of the islands of the Pacific, a land on a massive scale, the bulk of it at a considerable remove from the seas, reefs and coasts that the idea of an island brings to mind. It occupies some 900,000 square kilometres (347,500 square miles). Its topography and ecology embrace great mountain ranges, rising to over 5,000 metres (16,400 ft), extensive river systems, inland lakes, coastal and high rainforests, grasslands and a bewildering diversity of other environments. Its pre-European population may have amounted to two million.

Diversity and History

Diversity has been the motif of much writing on New Guinea's societies, languages and cultures. It has become a somewhat hackneyed theme, but it remains an unavoidable one. True, the peoples of the landmass – today divided between Papua New Guinea, an independent nation since 1975, and the Indonesian territory of West Papua – shared certain broad affinities. They were largely horticulturalists, rather than hunter-gatherers like indigenous Australians or grain cultivators like most of the people of insular southeast Asia, though fishing, hunting and the gathering of wild plants were more or less important to the subsistence base for many communities.[1] They all inhabited what might loosely be described as small-scale societies. It would be misleading to describe these as 'egalitarian' – lives were shaped by many forms of rank and status, based on gender, age, accomplishment and sacredness, among other considerations – but their hierarchies were localized. In a few regions there were hereditary chiefs, but there were no kingdoms or political confederations of the sort found in parts of northern and eastern Oceania.[2]

Other generalizations could be made. Rituals of exchange and passages in the life cycle were everywhere important; they were often highly dramatic, and the artefacts that we recognize as works of Oceanic art, of New Guinea art – masks, costumes and spirit images – were in many cases produced in the context of such rites and ceremonies. Local-level fighting also loomed large in the lives of most societies, and decorated shields – which, within Oceania, were made only in New Guinea and the Solomons – among other weapons are conspicuous in museum collections (*overleaf*). They have likewise been much studied and admired; in outsiders' eyes they are one of the genres constitutive of New Guinea art. Trade and exchange were also of great importance to many New Guinea societies. People trafficked in food and raw materials, but also produced goods for trade, including highly valued and highly decorated objects, such as pots, barkcloth, baskets, and body ornaments, which

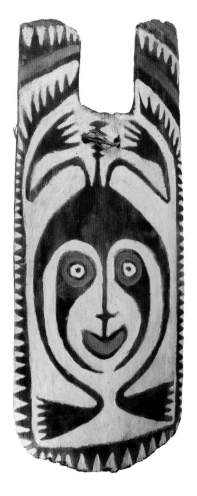

moved both locally and greater distances. The sea and the island's major rivers constituted great highways, in many cases ones travelled during particular seasons.[3]

But broad-brush statements about social scale, ritual, warfare and exchange can capture little of life or art in any part of New Guinea. The basic affinities are overwhelmed by striking contrasts. For example, the peoples of the swampy south coast occupied great mangrove-lined estuaries, subsisted in many cases on sago and fish, held 'fervent mythic-cosmological beliefs in the need for fertility regeneration', and conducted massive ritual enactments involving spirits and ancestral beings in masked or effigy form, also represented or embodied in the architecture of great houses.[4]

In the Highlands, on the other hand, 'extensive and orderly food plantations' dominated by the sweet potato supported 'the biggest and densest populations in the entire island'.[5] Yet these populations did not form large villages; instead they were dispersed in scattered small settlements in the mid-altitudes. Fertility-oriented rituals of the south-coast type were less extensively performed here (though some practices and beliefs were imported, it appears, from the south coast). Localized and larger groups came together to fight, but also to challenge each other with great gifts.

opposite
Frank Hurley, two basketry figures in front of a *daima* (men's longhouse), Tovei, Uraima Island, Gulf Province, 26 June 1921.
Courtesy of the Australian Museum, Sydney, Frank Hurley Photograph Collection.

The Australian Frank Hurley (1885–1962) produced some of the most remarkable images made by any colonial photographer in Melanesia, as well as a film and book, both entitled *Pearls and Savages* (1921 and 1923 respectively). Though he exploited racist stereotypes while energetically promoting his work, his visual documentation of Papuan peoples, architecture, arts and environments remains of great importance.

above left
Shield, Orokolo area, Papua New Guinea, acquired 1883.
Wood, pigment. Height 86 cm (33⅞ in.). Australian Museum, Sydney.

below left
'Sing-sing, Mount Hagen', 1934.
Photograph George Heydon. National Library of Australia.

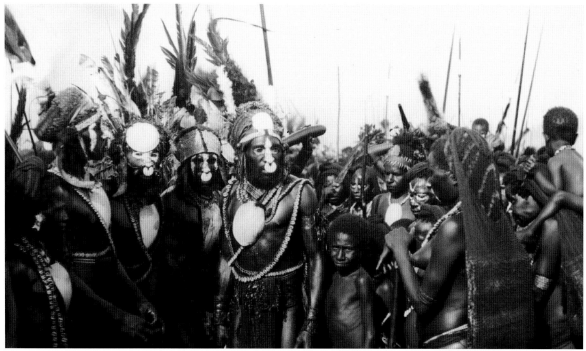

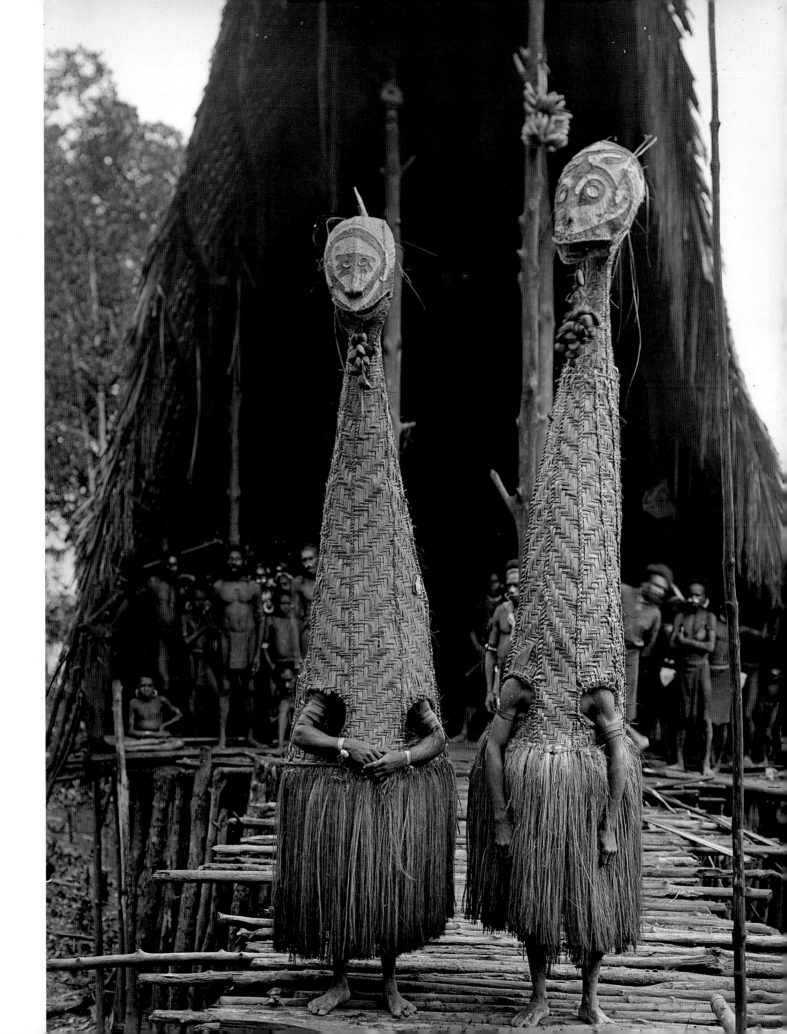

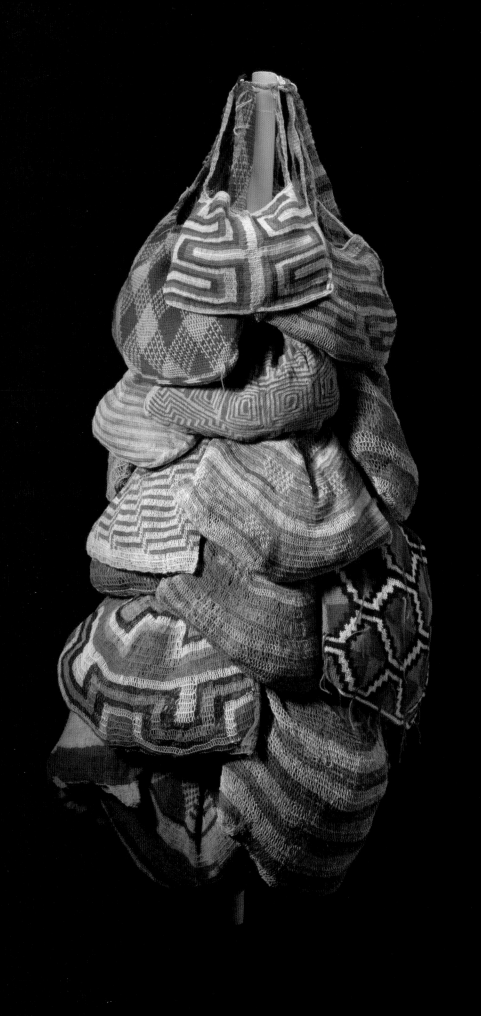

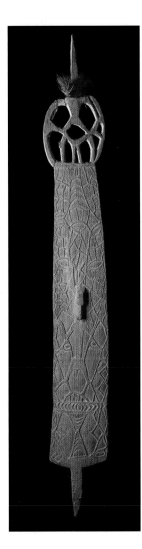

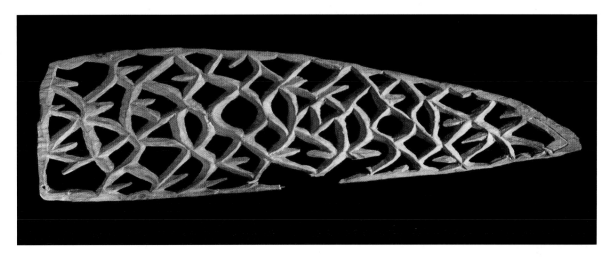

Shell ornaments (traded ultimately up from the coast), axes, pigs and other valuables were brought together and presented on spectacular occasions.

In the Highlands, there were few counterparts to the sculpted or assembled ritual art forms for which regions such as the south coast and the Sepik are renowned. Art's most obvious expressions were in body art, elaborated flamboyantly for performances linked with great competitive exchanges. Yet this is not to say that Highlands art was essentially non-artefactual: ornaments of various kinds were vital elements of body decorations (*page 80, below left*); bride wealth was presented in the form of elaborate shell and feather assemblages; fighting shields were boldly decorated; and the looped string bag, or *bilum*, assumed a bewildering range of aesthetically refined forms, even before it began to bear innovations stimulated by contact and modernity.[6]

Nor, needless to say, did diversity stop with these gross regional differences. The Asmat of the south coast, among other peoples, were renowned for their predatory headhunting, which was closely linked with male prestige and ritual efficacy. Though their neighbours the Kamoro did fight, they invested more in ceremony, hence vigorously carved and painted shields loom large in Asmat art but were not made by Kamoro. And one can go on and on, making more and more localized distinctions in modes of life and art styles within New Guinea's various regions.[7]

But diversity of style is not only, incontrovertibly, a fact of New Guinea art. It has also been its hallmark, *the fact* that has dominated the ways the art forms of the region have been recognized, analysed and appreciated over the last century. A visitor's encounter – say in one of the great European ethnographic museums – with a bewilderingly strange and various

display of masks from Papua, the Sepik and New Britain creates an overwhelming impression of a plurality of separate cultures. This sense is fostered too by flipping through compendia of New Guinea art: every area appears to possess an equally distinctive style. This is (more or less) true: but is conducive to an understanding of the art of a region, dominated by variation across space, or among a plurality of ethnic and tribal groups that occupied each their own space, rather than across time. We identify New Guinea art ethnically or tribally, not temporally or historically. What has been identified as the 'one tribe one style' paradigm has been extensively criticized and lamented, primarily in African rather than Oceanic art studies.[8] Yet it has also proved tenacious; it underpins what seems the obvious, the unavoidable approach to the art of this region.

The central concern of this book is to sketch out a different and genuinely historicized understanding of art in Oceania. At first sight, this would seem formidably difficult for New Guinea. We are confronted, on the one hand, by what seems an excess of exuberant cultural and artistic diversity, and on the other a paucity of historical depth. Whereas a good deal is known about late eighteenth-century Hawaiian art – and an important range of examples collected by voyagers are available for study – for many parts of New Guinea few pieces were collected, illustrated or described prior to the 1880s. For parts of the Highlands no contact took place, and hence no collecting, until shortly before or after the Second World War. Hence, no sooner were traditions identified than they began to suffer decay, or so it has long been presumed. The traditions themselves seem to have no histories, they simply exist in an archaic state, out of time, and then begin to degenerate, with the irruption of modernity. And if the various inhabitants of New Guinea did, obviously, make art for generations prior to colonial contact, there would seem no way of knowing that art – some important archaeological stone and shell pieces excepted[9] – and so no way of historicizing our understanding either of the cultures in general or the art forms specifically.

The problem would seem to be compounded by the kind of knowledge that scholars have generated of many New Guinea cultures. The relevant discipline is anthropology, and when the Highlands of Papua New Guinea became open to investigation in the postwar decades there was something of an ethnographic scramble to investigate systems of kinship, marriage and exchange. In the 1960s and 1970s, 'Melanesia' (meaning primarily the Highlands, rather than the region as a whole) was a privileged site of anthropological study and theory, as West Africa had been for an earlier generation. The significant point in this context is that these ethnographers produced knowledge in a monographic form, that is, studies of 'the Enga', 'the Melpa', 'the Baruya', or others, that in many cases were outstandingly rich, in their accounts of local social relationships and cosmologies, but which typically focused on the contemporary life of the specific group, thus reinforcing a sense of New Guinea as a plethora of distinct cultures, incidentally possessing unknowable histories.

But the picture is far more positive than it might at first appear, even though it is indeed the case that New Guinea's conventionally documented history is relatively short. In giving the issue fresh consideration, we might start by asking what counts as history? And what therefore counts as historical evidence? If our aim were to arrive at a counterpart to a conventional Western history, or conventional Western art history –

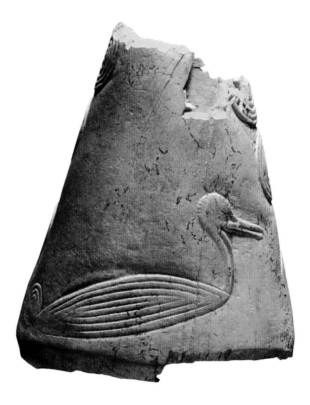

Engraved cone shell found in an ancient village midden, Wanigela area, Collingwood Bay, Oro Province.
Australian Museum, Sydney.

a precisely dated narrative of events, or periodization of styles – it is difficult to envisage sufficiently precise information ever emerging from oral history or archaeology, the disciplines that provide such evidence as we have, for culture and change in this region prior to colonial contact.

However, if certain questions cannot be answered, others certainly can be. New Guinea's past is not, in fact, unknowable. There are various kinds of understandings of the region's history that we can not only work toward but in some cases we already possess. For there is no doubt that all New Guinea cultures were shaped in powerful and profound ways by historic change over the past few thousand years, and in more recent centuries, both prior to, and after, first contacts with Europeans. Their environments changed, their subsistence bases changed, and their wider affiliations, their connections through trade, changed.

**Environment, Production
and Precolonial 'Colonialism'**

Over the last few centuries Highlands societies have been transformed by the introduction of the sweet potato. Agriculture has a very long history in the region – indeed, the Highlands is one of the few parts of the world where it was independently invented, rather than diffused from early centres of plant and animal domestication in south-west Asia – but the earlier staple, taro, was difficult to grow above 1,500 metres (3,280 ft), and notably required more labour relative to yield. The sweet potato, which originated in South America and very likely reached New Guinea following its European introduction to insular south-east Asia during the sixteenth and seventeenth centuries, was decisively important, not only as a food source for people themselves but as a considerably better food for their pigs. Pigs were of paramount importance. They were the single most important item of wealth, their nurturing, accumulation and deployment the preoccupation of the male leaders known as 'big men' in the anthropological literature. The density of Highlands populations, the elaborate systems of ceremonial exchange that centred upon competitive presentations of pork, and the big men who vied for prestige by orchestrating these gifts and performances, were empowered by a sweet-potato economy. It followed from this agricultural revolution

that the life observed by the ethnographers who entered the Highlands in the wake of colonial pacification was distinctively 'modern'.[10]

Yet what existed beforehand must have had a close relationship with the cultural forms that were documented, as they were again rapidly changing, in the mid-twentieth century. Given how widespread a broad mode of group affiliation and inter-group ceremonial exchange was across the Highlands, together with a division of labour and accompanying ideas of gender, it is likely that this broad mode existed in some form, in say the sixteenth century, on the eve of the introduction of the new crop. Indeed, it cannot have been the availability of the tuber in itself that propelled change, but propensities within these societies that motivated the apparently swift adoption and adaptation of a new form of horticulture, and an effort to capitalize upon its potential. Pigs can only have already been 'highly valued as the means of access into exchange systems of every kind'.[11] Hence, for the Highlanders of four to five hundred years ago, a key arena of artistic expression may well have been self-decoration for performance in the context of inter-group exchange and competition, as it was at the time of European contact – but the numbers of people involved, the scale of the ceremonies, may only have been upon a more limited scale. Fewer pigs perhaps were offered, yet the shared preoccupations that engendered competition, the understanding of the mediation of competition through performance, and the interest in creating an arresting, dazzling, collective 'image' in the context of performance, were very likely already present.

For the last few hundred years, there is also a complex range of evidence that suggests movements of people – migrations, invasions, displacements. Some groups appear to have expanded, others were marginalized. Certain languages, ritual systems and the art styles associated with them seem to have grown to embrace peoples that at an earlier time they did not. In this context it should be acknowledged that if much anthropology was indeed unhistorical, 'out of time', continental European research sustained older interests in cultural history, in migrations, and in the relationships between groups over wider areas and regions. Though these questions were at one time dismissed by sociologically inclined anthropologists

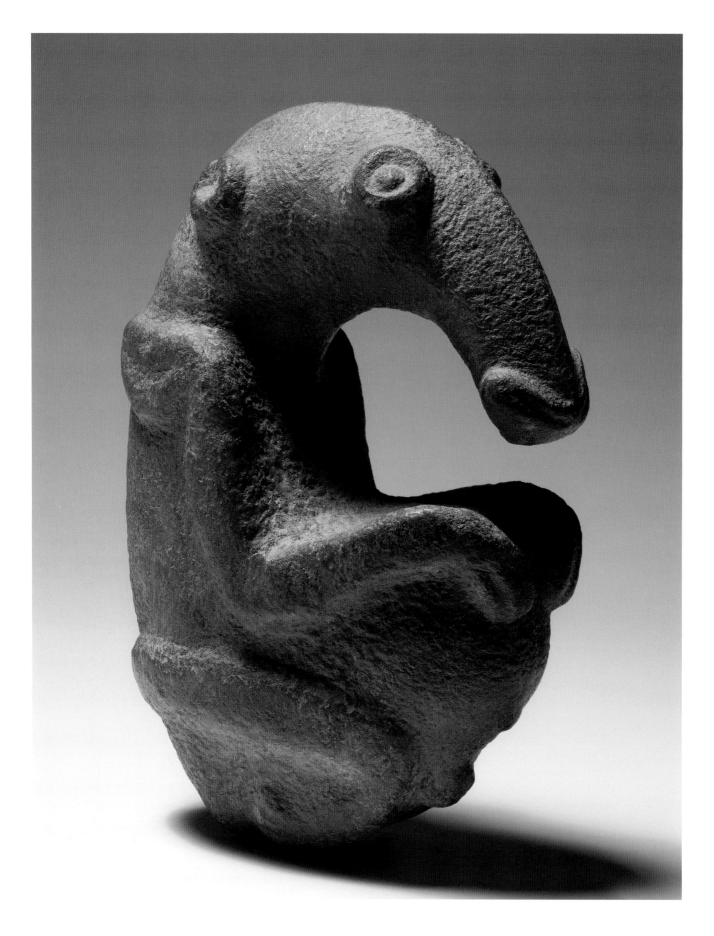

as those of a merely 'conjectural history', the growth of linguistic and archaeological research, and the new sophistication in studies in oral history, particularly from the 1960s onward, made it possible to revisit them. Although an interest in early migrations may still carry the taint of antiquarianism, it has become increasingly clear that the peoples of New Guinea were never discrete 'tribes' that each exhibited a variation on some social or cultural principle. Rather, all were caught up in complex and unstable regional systems, the dynamics of which resulted in a particular state of play at the time of colonial contact. The histories of those regional systems – of how groups engaged with each other, adapted to changing circumstances, and took on new cultural forms from the milieux around them – will never be understood completely, but this does not mean that the effort should not be made to understand them partially.

This is certainly the case in the Sepik, where several generations of Basel researchers, among others, have addressed ethnography and history across a host of interlinked communities. In all of these communities stories are told of people's movements, and any accumulation of these narratives makes the mind boggle. This may be especially so for those of us unfamiliar with the lakes, swamps, hills and villages that anchor the accounts and give them salience. But even the Australian administrator, Lawrence Bragge, who spent some years in the area, assembling oral histories in the course of his efforts to understand and resolve local disputes about land and other matters, wrote that he sometimes 'wondered if there was ever to be an end to the stories of ancient wandering clans travelling giant distances and doing amazing things'.[12] Traditions of this kind also raise methodological issues, obviously. Which are constructions of some cultural salience that bear no relationship to any actual movement, and which reflect more recent events, 'history' in a conventional sense? The awkward, if necessary, assumptions behind questions of this kind have been much debated, and that debate is tangential here, but it is worth pointing out that the distinction between myth and history is not merely a Western imposition, but one sometimes made locally, by Sepik peoples themselves, through analogy in recent years to the 'old and new testaments', for example. In some cases seemingly fantastic tales incorporate secret or

sensitive information in disguised forms. An arresting feature of art forms, stories and rites from this region is that they typically both reveal and conceal; they display powers, spirits and events, yet in a fashion that only ever communicates the full picture to certain insiders such as initiated men of status. Others might observe a spectacle or listen to a narrative, and be daunted without fully grasping the inner workings of what was being disclosed.

Migration histories were and are taken extremely seriously by groups such as the Nyaura (an Iatmul people of the middle Sepik). The places where, for example, women have rights to fish, are situated on the migration routes of the groups to which they belong; those migration routes are represented in knotted cords, and also in songs, which link migration events, totems, names and rights.[13] Though histories and rights, obviously, are negotiable and disputable, history underpins contemporary practice in a powerful sense.

The nexus between past population movements and rights to resources mean that the former will inevitably be controversial, and their precise history irrecoverable. But the broader outlines of middle Sepik history over the last few centuries are clear. Several groups of the Ndu language family, notably the Abelam but also including the Boiken and Kwanga, have expanded over the last few hundred years, from the middle Sepik across the plains and into the foothills, displacing pre-existing groups and establishing new, dense populations, based around bigger-than-average villages for the region. Anthony Forge's influential arguments with respect to Abelam make a strong case that puts art at the centre of this dynamic. The power of these people was not the upshot of superior technology, greater political centralization, or a distinctive military strategy. It lay rather in the domains of ritual and magic, and in the often spectacular art forms that expressed magical efficacy and spiritual power.[14]

The prestige of the Abelam, Arapesh, Iatmul and certain other groups was expressed monumentally in the great structures referred to generically as *haus tambaran*, men's houses associated with initiation rites (*overleaf*), that bore elaborate painted facades, rising in some cases to 30 metres (100 ft), but also in a bewildering variety of sculpted, painted, woven and assembled art forms. The prestige of Abelam ritual was

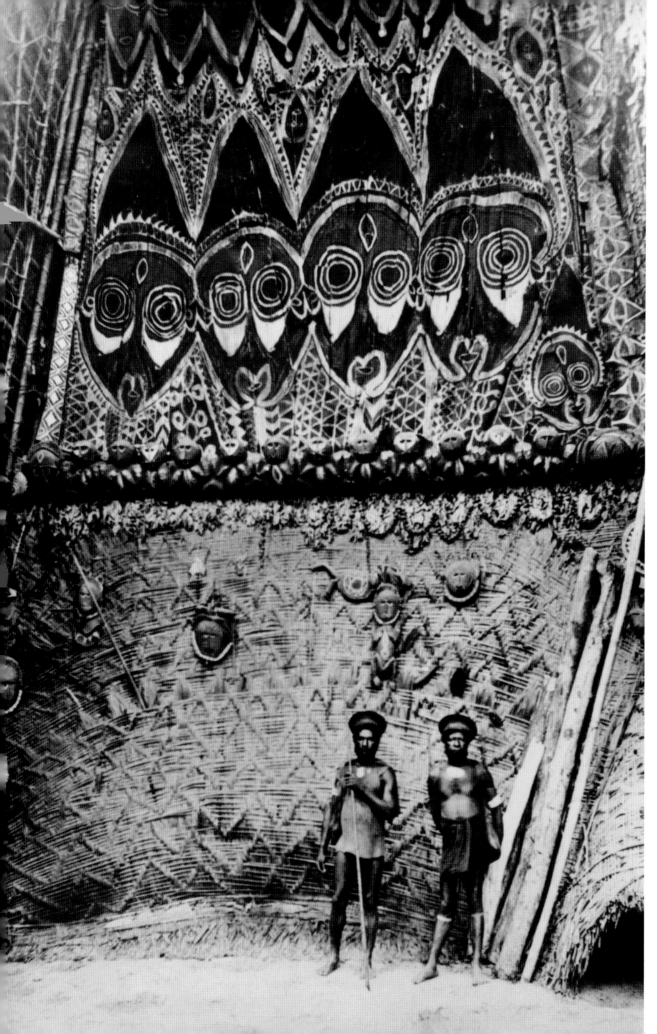

Haus tambaran,
Sepik region,
Papua New Guinea, *c.* **1930.**
National Library of Australia,
Canberra.

such that they were regularly engaging in selling rights to practise certain ceremonies, objects for use in secret ceremonies, ritual artefacts and spells. 'The sales were sometimes outright, but more usually attempts were made to "lease" ritual complexes and claim payment each time they were staged.' Most intriguingly, Forge emphasizes that the Abelam felt that nothing they were making available was 'of real supernatural value' because parts of rites and secret formulae were never disclosed. They considered they were selling the actual objects (which were made beforehand, not in the presence of purchasers), 'not the rights to reproduce them or the techniques and ritual of their manufacture'.[15] The activities around these exchanges, moreover, reaffirmed the superiority of the Abelam – the selling party would often devastate, or go through the form of devastating, property as they entered the buyers' village; they might subsequently be feasted, seduce local women, and so forth. In other words, all this could be seen as a pronounced, if localized, cultural imperialism, a dependent group paying dearly for goods provided by a dominant power, the former suffering some humiliation in the process. Yet of course these transactions, like any others, could be seen in different ways by the opposed parties, and the Arapesh for example might take the view that they in fact gained understanding, and spiritual strength, at the expense of the Abelam.

This dominance, whether contested or uncontested, carried over into other exchange relationships. Groups that produced specialized products which the Abelam needed – Forge cites Arapesh makers of finely cut and polished shell rings – were nevertheless treated as inferior, and themselves behaved deferentially toward the Abelam, making no effort to raise their prices, as they theoretically ought to have been able to do.

There is some controversy as to whether the expansion of Abelam postulated by Forge actually entailed the movement or the increase of the Abelam population itself, or rather the incorporation and as it were the 'Abelam-ization' of peripheral populations. There is certainly historic evidence that various Sepik groups have given up speaking one language and taken on another, over recent generations. It may be that the 'colonizing' that Abelam (and other strong populations such as the Iatmul) engaged in entailed absorption of

this kind, rather than the more obvious forms of conquest.[16]

Trade and its Ramifications

That trade has been of fundamental importance in New Guinea's history and art history – as well as in the wider history of art in Oceania – has already been signalled. Yet the topic has a somewhat uncertain status. In anthropological and wider scholarly understandings, the Pacific and Melanesian regions generally, and New Guinea in particular, are strongly identified not with the traffic in commodities, but with the alternative economy of the gift. Bronislaw Malinowski's *Argonauts of the Western Pacific* (1922) was the seminal anthropological study: it described the 'Kula ring' of the Trobriand Islands, an inter-island exchange system made up of non-utilitarian transactions with ceremonial and more generally social ends. Soon afterward Marcel Mauss's *The Gift* placed the *kula* alongside Māori, Samoan, New Caledonian and Native American examples of transactions that were motivated not by the interest in acquiring the

specific object, but by the creation of networks of reciprocity, by spiritual links, by social relationships.[17] While his text, like Malinowski's, was influential across the humanities and social sciences, both also cast long shadows over research and writing in the region: the dos and don'ts of gifting, and the theory of the gift, have loomed large in Melanesian scholarship ever since.

But there had long been (at least) three forms of exchange in New Guinea societies. Long-distance trade, often between hereditary trading partners, barter for resources and specialist products between neighbouring communities, and competitive ceremonial exchange were all widely reported. Almost everywhere, in fact, the three forms coexisted, with varying degrees of relative importance, and of course innumerable permutations. Only the third was directly represented by the gift paradigm, which thus not only lent itself to an imbalanced understanding of Melanesian economies, but also tended to make the societies of the region look more local than they actually ever were.

Kula **armlet and neck-ornament, 1886.**
Shell, fibre, cowrie shell.
© The Trustees of the British Museum, London

Bronislaw Malinowski's *Argonauts of the Western Pacific* (1922) made the 'Kula Ring' famous for generations of anthropology students, but it was in fact just one of many networks that linked insular, coastal and inland New Guinea, and that entailed both ceremonial gift exchange and barter in various localized resources and products.

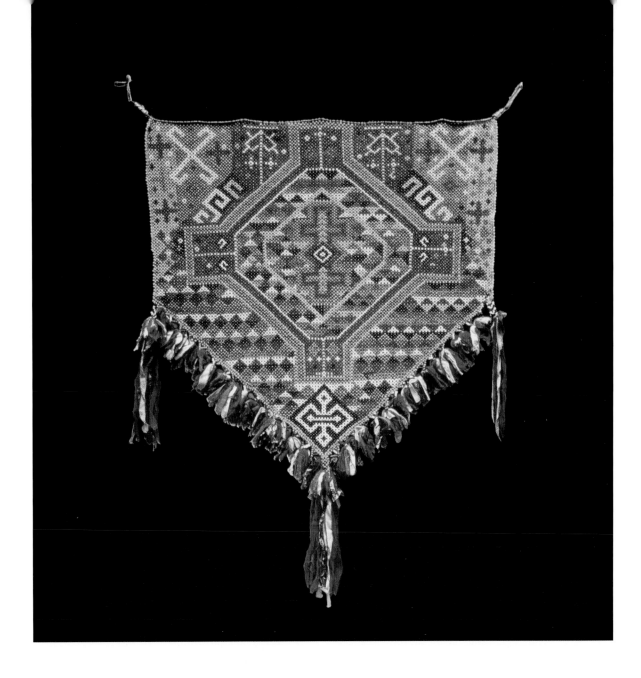

Dance apron, Geelvink Bay, West Papua, late nineteenth century.
Glass trade beads on fibre. Height 50 cm (19⅝ in.). Wereldmuseum, Rotterdam.

The history of north-western New Guinea – and particularly of the great peninsula known as the Bird's Head – draws attention not only to the destabilizing vitality of long-distance trade but also the interplay between external and internal exchange. Just as the Torres Strait was a domain of interaction between New Guinea and Aboriginal Australia, the Bird's Head was marked by engagement between New Guinea and insular south-east Asia, particularly to the eastern islands of what is now Indonesia, such as Maluku. In both cases, trade shaped art's contexts – the relationships expressed in artefacts, the rites in which they were deployed – but was also itself reflected in works of art that incorporated traded

material, that exhibited the 'international' networks of the makers.

For centuries, if not millennia, there have been manifold connections – cosmological, mythological and economic – between Maluku, the archipelago formerly known as the Moluccas, particular island groups to its east, and the coastal Bird's Head communities.[18] Though in some form these links are very ancient, archaeological and historical sources indicate that they assumed new momentum and importance in different ways at several times: first when trade contacts began to link China and island southeast Asia (from 3,000 to 4,000 years ago); secondly, with the spread of Islam and the emergence

of new political forms in insular southeast Asia (1,000 years ago); and again with the ascendancy of the Majapahit dynasty of Java, which sought to extend influence as far east as Papua during the thirteenth and fourteenth centuries. During the sixteenth century, feathers from birds of paradise began to be traded from Papua, ultimately for connoisseurs of rarities in Europe. Europeans such as the emissaries of the Dutch East India Company and the British merchant Thomas Forrest did not independently 'discover' western New Guinea, but followed the sultans and their agents along well-established routes into the region.

From the perspective of the global economy, the trade was extractive – as well as birds' plumes and hides, slaves and bêche-de-mer were destined for wider markets – but textiles and beads among many other commodities moved in the reverse direction, into New Guinea communities. Some Papuans, such as the Islanders of Biak and Numfor, were notably active as voyaging entrepreneurs and out-migrants. Not the local partners of traders who intruded upon them as representatives of a wider commercial world, they were great innovators themselves, and at some point in recent centuries took up metalwork, producing and trafficking in spear-points, knives and arm ornaments.[19]

The introduction of *kain timur*, exotic woven cloths (which differed notably in their qualities and aesthetics from the beaten barkcloths produced widely in New Guinea), is thought to have triggered a shift in internal organization, and in local political economy, in the Ayamaru Lakes region in the centre of the Bird's Head. Oral histories from this region suggest that in an earlier epoch people practised restricted exchange (that is, local groups intermarried, in theory men giving their sisters to the same group from whom they took wives themselves). But some 400 years ago, these communities became increasingly involved in importing woven cloths, and woven cloths became essential elements of marriage payments. Groups were drawn into a wider network of marriage exchanges (rather than A and B giving to, and taking women from, each other, A took from B, B took from C, and so forth). 'Asymmetrical' marriage is not inevitably associated with political hierarchy, but where valuables are involved it creates scope for men to manipulate exchange and accumulate wealth, and for some villages or chiefdoms to assume precedence over others. In this particular region, 'big men' appear also to have consolidated their power by deploying accusations of witchcraft against non-compliant women.

The reconstruction of this history is speculative and incomplete. Local narratives that recount the transformation of one order into another may often be considered charter-myths, as pseudo-historical

Kain timur fabric, ikat weave, late nineteenth–early twentieth century.
Wereldmuseum, Rotterdam.

justifications of a social order, rather than as accurate histories in the usual Western sense. But whether that would be right in this instance is unclear. Some New Guinea populations have surely transformed their modes of marriage and exchange from more localized and egalitarian systems to more regional and hierarchical ones, and the tradition is not inherently implausible.[20] Whatever may emerge from future research in this case, the point of greatest importance is that a novel art form, a distinctive type of textile, may have been central to the transformation. The role attributed to *kain timur* here would be entirely consistent with the highly valued nature of woven and beaten fabrics right across the Pacific, their associations with divinity and sanctity, and their frequent deployment as gifts and as forms of wealth.

Yet fabrics were not the only art forms that entered New Guinea in the context of this trade. A prominent figure style of Teluk Cernderawasih, the great bay to

the east of the Bird's Head, formerly known as Geelvink Bay, was the *korwar*, an ancestral sculpture used in divination. It sometimes incorporated the actual skull of the ancestor, otherwise a carved representation or incarnation, and typically featured an openwork symmetrical or partially symmetrical curvilinear board in the front, somewhat like a shield. The ramifications of trade are underscored by the use of blue beads as eyes on numerous *korwar*, and by the emergence of elaborate patterned aprons, made entirely out of imported beads, on Yapen and Ambai islands. These material links, as well as the stylistic affinities between *korwar* and Maluku (and particularly Tanimbar) woodcarvings, and also Timorese pieces (among others) at a slightly greater remove, reveal cultural continuities that extend across the distinction between Melanesian and insular southeast Asian domains. Some of these continuities no doubt reflect ancient affinities, others more recent contacts. In either

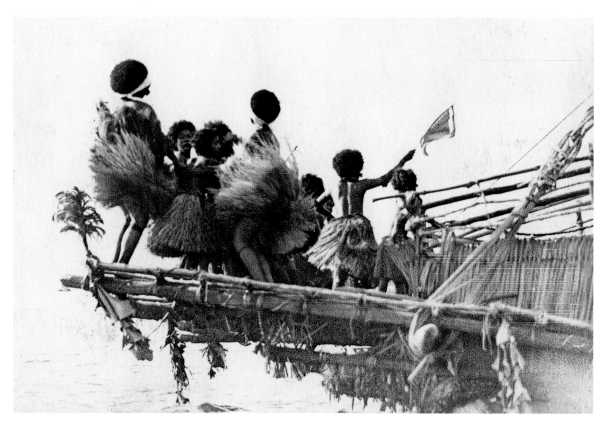

Young women dancing on a *lakatoi*. Papua New Guinea, early twentieth century.
Goodyear collection © The Trustees of the British Museum, London.

During the festivities associated with the launching of the new season's *lakatoi* fleet, groups of young women would gather on the projecting prows and dance vigorously on the springy platform.

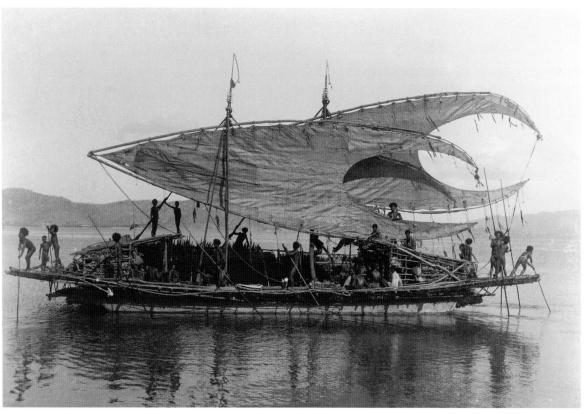

***Lakatoi,* near Port Moresby, Papua New Guinea, 1904.**
Cooke-Daniels Expedition collection, © The Trustees of the British Museum, London.

Pottery being prepared for a trading voyage, near Port Moresby, Papua New Guinea, 1881–91.
Tyrell collection, Powerhouse Museum, NSW.

case they are hardly unexpected, though contacts with the trading sultanates appear to have made an impact, not just in north-west New Guinea but right along the island's north coast. Such contacts are manifest in the Sepik both immaterially, in a related design system featuring interlinked curvilinear motifs, and materially – this was the likely route of sweet potato, ultimately towards the Highlands, and no doubt other objects travelled in the same way, passing through many, many hands en route.[21]

Traders of the South Coast

If the dynamic engagement between north-west New Guinea and the region to the west is not surprising, there also existed complex long-distance trading systems along New Guinea's southern and south-eastern coasts, which were unconnected with Maluku.[22] In the latter part of the nineteenth century, two groups dominated the trade networks along the south Papuan coast: the Mailu and the Motu, both of which, the archaeological evidence suggests, had sustained their dominance over the last thousand years. The Mailu, who lived on an island off the east coast, were merchant traders, acting as middlemen in a series of annual, seasonal exchanges. The Motu, on the other hand, lived near what is now Port Moresby, the capital city of independent Papua New Guinea, and from there made an annual trading voyage – a round trip of about 800 kilometres (500 miles) – exchanging pots and valuables made from shells for sago and canoe hulls. In 1910 F. R. Barton evocatively described the annual Motu voyage:

> Every year, at the end of September, or the beginning of October, the season of the south-east trade wind being then near its close, a fleet of large sailing canoes leaves Port Moresby and the neighbouring villages of the Motu tribe on a voyage to the deltas of the Papuan Gulf. The canoes are laden with earthenware pots of various shapes and sizes which are carefully packed for the voyage in dry banana leaves. In addition to these, certain other articles highly valued as ornaments (and latterly foreign made articles of utility) are also taken for barter. The canoes return during the

FEATURE

Balancing Men and Women

OUTSIDERS OFTEN INTERPRET Melanesian gender relations – the roles assigned to men and women and the ways in which they relate to each other – as involving the oppression of women by men. In fact, it is impossible to generalize about anything, let alone about gender, in a region as complex as Melanesia. There are many different roles and relationships for men and women in various Melanesian societies, while hierarchy and oppression by no means always occurred along gender lines. Among the people of the Murik Lakes at the mouth of the Sepik River, for example, birth order was the basis of rank, and firstborn siblings – men and women – achieved and administered authority together over other members of their groups. The roles of Murik men and women were complementary, and there were both men's and women's secret societies which paralleled each other and involved interdependent ritual cycles that initiated members into successive grades.[i] This little figure of a woman is a female initiation figure from the Murik women's cult.

The Murik Lakes are the last remnants of the inland sea that once filled the entire Sepik basin but which gradually silted up, until about one thousand years ago when the Murik Lakes were established. The Murik inhabited (and indeed still inhabit) a world of water, living on the narrow frontier between the lakes and the sea, their houses on stilts on the beach or above tidal flats. Without land to cultivate, they harvested fish and shellfish from the mangroves, and acquired other food and resources by trade. They exchanged fish for sago with people inland, and in their outrigger sailing canoes they traded with people living on the offshore islands and along the coast. Murik women made baskets which were important goods in that overseas trade, much sought after by their trade partners who gave in return garden produce, tobacco, canarium almonds, clay pots and sometimes pigs. Men made the outrigger canoes in which they sailed to visit their trading partners. If men mostly made the trading voyages, they also recognized (and still recognize today) that 'the canoe travels on the strength of the women'.[ii] Men and women both contributed to, and were both equally capable of disrupting, the means by which the Murik pursued their sometimes precarious livelihood. Men and women together made society work, and both men and women made the objects that, practically and powerfully, made life both possible and meaningful.

Female initiation figures like this were displayed to young female novices in the women's cult, and they represented spirits that gave power, prophecies and love magic: young women learnt, in the cult, that their sexuality should be used in the service of prestige, access to resources and spiritual power.[iii] At the same time this figure also depicts a Murik woman. For example, the concentric oval designs over her shoulder blades are initiatory scarifications associated with the moon, which were cut on women's bodies. The little figures squatting between her legs perhaps represent children: certainly, maternal nurture is a key characteristic of Murik women. The figure represents an ideal and physically strong image of Murik womanhood.[iv] LB

**Girls' initiation figure, Murik Lakes,
East Sepik Province, Papua New
Guinea, acquired 1947.**
Wood. Height 24 cm (9½ in.).
Australian Museum, Sydney.

north-west monsoon after an absence of about three months, laden with sago which the voyagers have obtained in exchange for their pots and other articles.[23]

The trading canoes, called *lakatoi* (*page 94*), were reconstructed each year for the voyage. In April or May individual men decided to make the voyage and recruited their crew, and in August they began overhauling the large dugout hulls, then lashed them together and built a deck above them. The masts were stepped, and the sails manufactured, of plaited mats sewn together to form the 'crab-claw' shape that made the *lakatoi* so arresting. Once the *lakatoi* were ready, they held races across the harbour. Groups of young women collected on the projecting platform at the prow of each canoe, and as Barton described it 'danced

there with great vigour, the springy nature of the platform adding largely to their lively movements'.[24] Up to thirty people travelled on each *lakatoi*, and according to Barton twenty of these great canoes made the voyage in the 1903 season, taking in total nearly 26,000 pots to their trading partners.

By contrast, the islanders of Mailu, further east along the south Papuan coast, were middlemen. Like the Motu, they built large double-hulled canoes, called *oro'u*, which also used crab-claw sails woven from pandanus. The Mailu, however, did not make just one major voyage a year, but a whole series, in each case trading different goods to different peoples in an annual cycle that began in July or August and continued until late January. Malinowski, who conducted fieldwork in the area before he made his great 'discovery' of the *kula*, described the sequence:

Frank Hurley, View of Mailu village, Mailu Island, Papua New Guinea, 1921.
National Library of Australia.

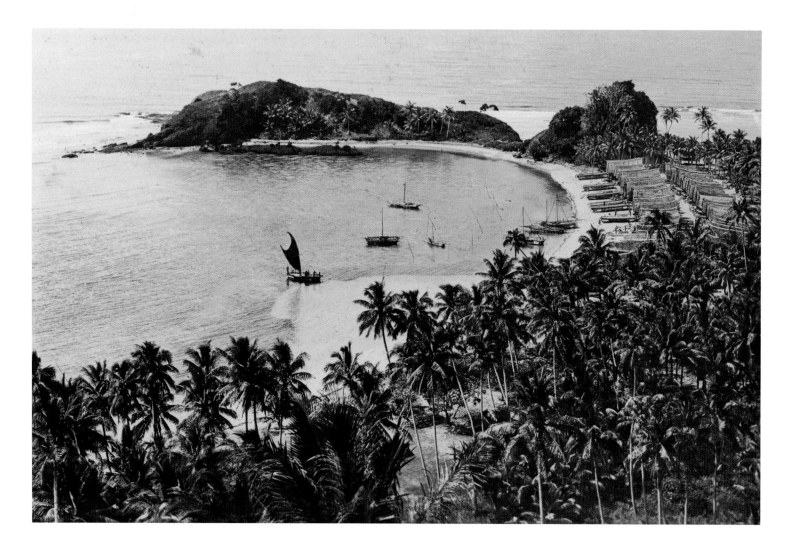

Murik mask, acquired 1910.
Wood. Height 42 cm (16½ in.).
Australian Museum, Sydney.

This was collected 200
kilometres (125 miles) up the
Sepik River from Murik Lakes,
having presumably been
passed from one group
to another in trade.

The trading was essentially seasonal and regular,
each expedition forming a step in a consecutive
series of ceremonial transactions and industrial
activities (making of armshells, sago, pottery...)
and everything leading up to the final expedition
which brought back the all important pig supply.[25]

The trading season was followed by a feasting season,
which was of great importance in the life of the
community. By this regular pattern of trading, the
Mailu linked a number of different groups along the
south Papuan coastline, and this network engaged
with others that took objects inland and brought
inland products back.

Traders never just traded in goods. They also
traded in information, in stories and gossip. They
learned about the whole region that they visited, and
became familiar with the knowledge and practice of
its peoples. As Frank Teisler observes of the Murik of
the north coast, the paradox of these outrigger-canoe
peoples was that they were the ones who acquired great
prestige, not the groups upon whom they were in fact
materially dependent.[26] The Mailu lacked sufficient
land to sustain themselves, but over time had assumed
great prominence, in part no doubt because they knew
so much about the culture and politics of the whole
area that they visited.

Trade shaped art in the sense that materials, whole
objects, motifs and styles travelled. Trade shaped art,
too, in the sense that it sometimes transformed local
sociality, for example by engendering a new bride-price
economy (in the Bird's Head case cited above), that
demanded valuables, aesthetically elaborate things of
one sort or another. But if trade had manifold impacts
on art, art was also vital to trade. Most obviously, the
canoes that materially enabled the trade were works
of art, arguably often the greatest works their
communities produced.

Like their counterparts across the Pacific, the
seagoing canoes of the south coast were nothing if not
impressive. Here, as in many other contexts, technical
perfection and beauty were closely identified. European
navigators – predisposed to be interested in and
knowledgeable about boats – were frequently
astonished by the speed, handling and size of
indigenous trading canoes, and we can be pretty sure
that Papuans similarly admired their own creations,

in terms that conflated aesthetics and efficacy. The vessels were both vehicles and expressions of a group's accomplishments, the effect of their approach under full sail was spectacular, but they were also elaborately and intricately decorated, as striking from nearby as from a distance. Unfortunately, few really big seagoing canoes from New Guinea survive with their full array of embellishments and accoutrements, but detached components such as prows and splashboards were collected extensively, while travellers' sketches and photographs convey some sense of the effect of the whole.

Prows were typically carved or painted, sometimes with faces or figures of birds, more often with complex curvilinear forms. In the case of the canoes of Trobriand *kula*-traders, Alfred Gell has argued influentially that the involuted and beguiling splashboards constituted a 'technology of enchantment', part of a system designed not simply to impress but to dazzle and overawe the hapless exchange-partners, who would be diminished by the spectacle of their visitors' canoe-borne arrival, and so play a weak hand, in the ensuing competition of gift-exchange. If Gell's theorization of 'art as agency' has been controversial as well as influential, there can be little doubt about its broad appropriateness in this case.[27] For the seagoing traders as well as other canoe-builders of New Guinea's coasts, estuaries and rivers, the canoe was not simply a means of getting about and moving things, nor was it even simply an aesthetically daunting and finely decorated artefact; it also functioned as a theatrical stage for a whole array of subordinate art forms and appendages – shell ornaments, tassels, streamers and so forth – that were renewed when appearance, with all finery, was called for. The canoe was also a stage in the sense that it bore performers, who themselves were elaborately decorated, who might dance to instruments, some associated only with the canoe and the trade, and not otherwise played.[28] Gell emphasized the work of this artefactual and performative technology, to disarm opponents, but what it did for the people themselves was surely equally important. Those who created these great canoes, those who belonged to their community, were not daunted but impressed: the canoes and their associated appearances and performances made their own power and vigour real and present in spectacular form.

Figurehead of a canoe, Louisiade archipelago.
Owen Stanley, watercolour, 1849. Mitchell Library, State Library of NSW

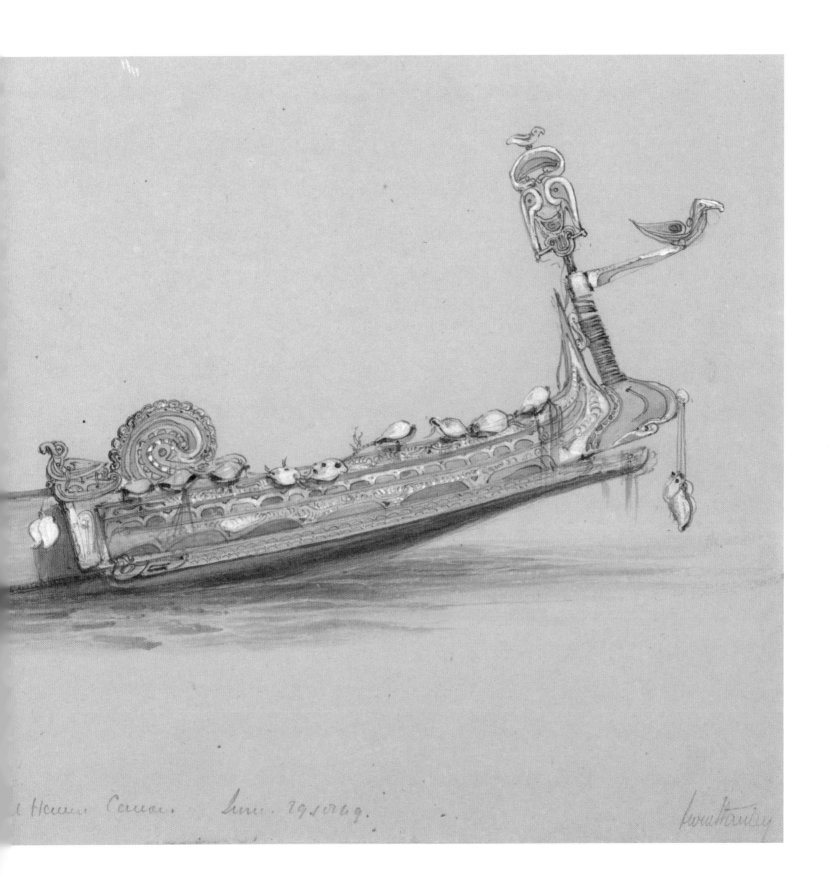

Henen Canoe June 29.1869. ~~signature~~

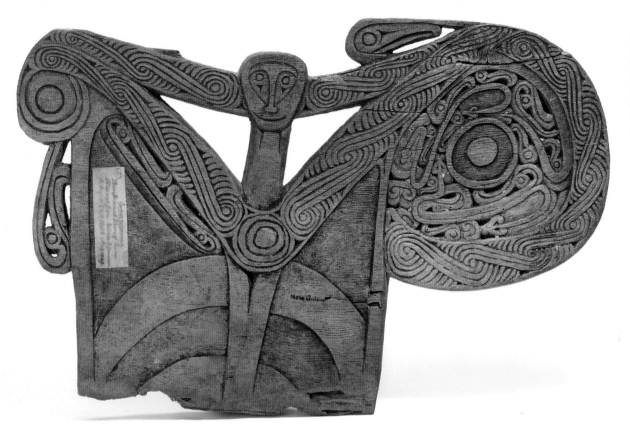

The New Guinea societies that existed on the eve of contact – and which we know indirectly, through early post-contact observations, as well as more partially via archaeological and oral historical evidence – were all, in their own way, remarkable. This may sound a naive or meaningless observation. It is intended to draw attention to a sense in which lives among virtually all the diverse peoples were marked by some great, intense and spectacular pursuit, that did not necessarily permeate everyday life all of the time but that periodically took over, absorbing all energy and attention in extraordinary endeavours. The great ceremonial exchanges of the Highlands, the creation of *haus tambaran*, indeed the massive production of art in the Sepik, and the voyages of the south-coast traders, were all-consuming, dramatic, risky and ambitious undertakings. While the social adventures and cultural accomplishments of New Guineans have interested outsiders – anthropologists and art collectors alike – for more than a century, the point here is different. It is that in each of these examples, the adventure was a comparatively modern one in a chronological sense.

In the Highlands and in the Sepik, as well as along the south coast, the systems of production and the engagements between people within which these ventures took place, emerged during the last thousand years in the case of the trading networks, and over only the last few centuries in the other regions.

To recognize the introductions, innovations and invasions that enabled unprecedented ceremonies, voyages and (we could even say, in the case of the Sepik) art worlds as belonging to the modern epoch is not to say that they belong to modernity. The economies, institutions and ideologies that we associate with the modern in the West had no presence or relevance for the people, the art makers, we have been concerned with here. But this is precisely the point. These histories of interaction and invention were situated beyond the West, indeed largely beyond the emergent world systems that linked both Europe and Asia. Yet – just as in eighteenth-century England, or India – they resulted in things that were new, that made history.

VOICE

'A RISK WORTH TAKING'

The two canoe logs for the *lakatoi* were the biggest that had ever been rolled up near the village. 'Look at how that man has almost disappeared into the canoe,' Hoiri remarked. 'Only his head and shoulders are visible. Oh yes, I think I know who the man is; it is Haiveta Malala, the man who is heading the *lakatoi* building with my father.'

'You need those big hulls to accommodate the sago and betel nuts for the Motu people who live in Hanuabada,' Sevese explained. 'On the return journey, that is where we will store the pots we will get in exchange for the sago and betel nuts. Besides, the *lakatoi* has to ride huge waves, the likes of which you have never seen. Some of them are as high as the tall coconut palms.'

Hoiri knew that his father wasn't telling what wasn't true. He spoke from actual experience. Few men in the village would talk as he did, men who have actually been on the trip. Sevese had two journeys on the rough seas to his credit. 'The journey,' he said, 'is a risk, but it is a risk worth taking in the eyes of those who know what beautiful things one can get: beautiful calico from white men's shops and pots of all sizes and shapes and armshells from the Motu people. But of course the first thing is to have that very necessary trading partnership built up. Just as important are the friends one makes in the coastal villages where *lakatois* usually stop. Deny them and you deny yourself fresh water, coconuts and fresh green vegetables like bananas and pawpaws.'

'How true is your father's word,' added Haiveta. 'This won't be the first time your father and I have been to Hanuabada. Few houses in this village would boast of having as many pots as we have on our pot racks. The last trip your father and I made was when you and your friend Malala were not old enough to remember. The hulls of that *lakatoi* were used in the flooring of the clan *elavo* at Operoro. In fact your mother's coffin was made from part of one of the hulls.'

From Vincent Eri, *The Crocodile*, 1972

Crocodile into Man

THE PEOPLES OF THE TORRES STRAIT Islands had links with both New Guinea and Cape York, but were predominantly Melanesian, and there are many affinities between their art styles and those of neighbouring groups along the south coast of New Guinea. South coast masks and other objects appear in late nineteenth-century photographs from Torres Strait, making it evident that there was much travel and traffic between the islands and the mainland to the north.[i]

The islands are renowned especially for a genre not produced on the mainland, elaborate masks stitched together from pieces of turtle-shell, which typically also incorporated diverse other materials. They were mentioned by the Portuguese explorer Luis Baés de Torres in 1606 – among the first documented European observations of any genre of Melanesian art – and sketched by various nineteenth-century voyage artists as well as by Tom Roberts, the Australian impressionist, during his 1892 visit to the Strait.

This elaborate composite mask (*krar*) is known to have been made by a man named Gizu; it was collected by Alfred Cort Haddon on Nagir in August 1888. Its hybrid form – a crocodile head surmounted by a human face – was ingeniously designed to surprise and captivate audiences. When the dancer was fully upright, the mask was on top of the head and only the crocodile was visible, but during the performance, the bearer would abruptly bend down to reveal the human face. Neither the particular significance of the transformation, nor any specific identities that either the crocodile or the man possessed, are known, but it is likely that significances changed from place to place: these art forms were traded and used by communities other than those that produced them, in ceremonies including harvest and funerary feasts, and initiation and war rites. Plates from the carapace of the hawksbill turtle were steamed to render them supple, then moulded, incised, stained and stitched together. The assemblage was a kind of anthology in artefact form of the bewildering range of Islanders' trading links: *krar* incorporated cowries and goa nuts, cassowary feathers (and, in other examples, bark belts) from New Guinea, and ochre traded from Cape York. European materials obtained through trade – the iron used for the outstretched hands and strands of calico – are also conspicuous.

By the beginning of the twentieth century the turtle-shell assemblages were seldom made, seeming to confirm the notorious Western assumption that indigenous arts 'died out' with colonization. In fact, dance and performance continued to thrive and develop right through the last century and remain vital today, both among Torres Strait Islanders at home and those who have migrated to the Australian mainland, where they are concentrated particularly in north Queensland towns such as Cairns. Ken Thaiday is renowned for 'dance machines' that he began making in the late 1980s for the Darnley Island (Erub) Dance Troupe (see page 495). His accomplishment was quickly recognized and his works began to be acquired by institutions such as the National Gallery in Canberra and the Museum of Archaeology and Anthropology in Cambridge, but they did not thereby become static art objects: he and his sons and kin continue to wear them and dance in them. His art has, however, taken new forms: it works as installation, and it is equally at home in the cool white cubes of contemporary art museums and the heat and dust of a Cairns park, turned for an afternoon into a community dance ground.　　　　NT

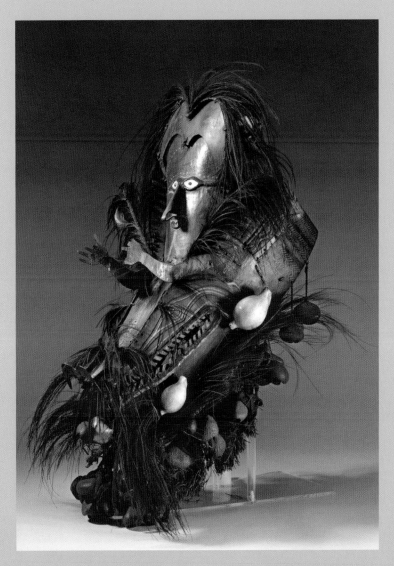

**Tortoise shell mask,
Torres Strait Islands,
collected by A.C. Haddon in
the late nineteenth century.**
Museum of Archaeology and
Anthropology, Cambridge.

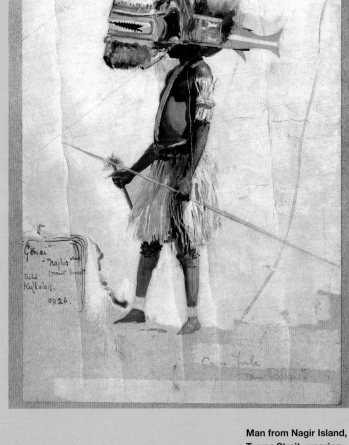

**Man from Nagir Island,
Torres Strait, wearing
a ceremonial costume.**
Tom Roberts, watercolour
and graphite, 1892.
© The Trustees of the
British Museum, London.

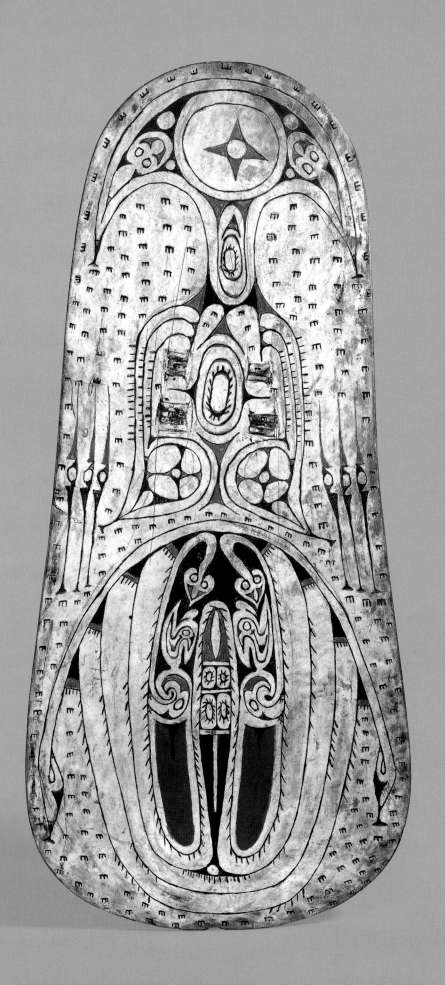

Nicholas Thomas and Susanne Küchler

ART, WAR AND PACIFICATION: NEW GUINEA 1840–1940

opposite
Painted shield, Trobriand Islands, acquired 1893.
Acacia wood, ochre, cane.
Height 70.5 cm (28 in.).
© The Trustees of the
British Museum, London.

Shields of this kind have been central to a long-running debate in the anthropology of art. In the 1950s the distinguished Cambridge anthropologist, Edmund Leach, drew attention to the female sexual form of the most prominent, lower central motifs, interpreting the effect of the shield in broadly Freudian terms. This approach has been challenged from various perspectives, notably by Harry Beran, who draws attention to indigenous explanations that define the motifs differently.

It is well known that the colonial age engendered stereotypes of savagery. The Islanders of Melanesia, and of New Guinea in particular, were often represented via such stereotypes during the nineteenth and twentieth centuries. Through popular exhibitions and illustrations, graphic physical proofs of primitive savagery were presented. The horrors of headhunting and cannibalism were not just rumoured, but demonstrated by objects that would, at another time, and incongruously, be considered works of Oceanic art. Of decorated human heads that he appropriated from a Lake Murray longhouse, the Australian photographer and traveller Frank Hurley wrote that he had 'never seen objects more ghastly and horrible than these grim trophies'. Hurley, a notoriously self-aggrandizing showman, was probably not so much reporting his actual responses as playing up the extremity of what he had encountered. He went on to say that one could only assume that the people who made and preserved the artefacts were 'infinitely barbarous, ferocious, and cruel, with no feeling nor thought for human agony and suffering'.[1] With varying emphasis, hundreds of Western publications aired imputations of this sort, which dehumanized the inhabitants of New Guinea.

During the twentieth century a different understanding emerged of the forms of violence that provoked these characterizations. The colonial administration under Sir Hubert Murray was marked by liberal protectionism and the promotion of anthropology. Missionaries had campaigned against

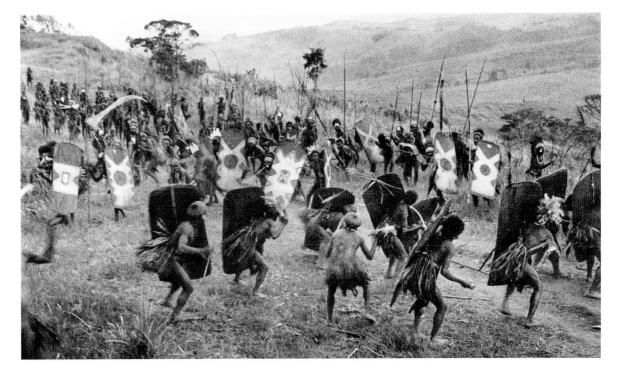

right
Mock battle prior to burning of weapons after pacification. Mount Hagen, c. 1936.
Photograph Michael Leahy.

While most Highlands groups were formally 'pacified' in the decades before or after the Second World War, the relations between groups that engendered feuding remained alive, and fighting re-emerged periodically after decolonization.

TO THE COMMODORE OF
THE AUSTRALIAN NAVAL STATION

Melbourne, April 8, 1881

Sir,

The constant recurrence in the daily papers of paragraphs relative
to murders and massacres in the South Sea Islands and the review
of my own experience of several years of life spent amongst the
aboriginals of different islands in the Pacific, impel me to express my
opinion on this matter, and to direct attention to some special points
connected therewith.

That the exportation of slaves (for it is only right to give the transaction
its proper name) to New Caledonia, Fiji, Samoa, Queensland and other
countries by kidnapping and carrying away the natives, under cover of
false statements and lying promises, still goes on to a very large extent,
I am prepared to aver and support by facts.

The conduct of many whites towards the aboriginals of the South
Sea Islands is in no way justifiable, and of the truth of this, I have many
instances at my command, so that I am not surprised that reprisals
on the part of the natives take place.

Impartial observations of the South Sea Islanders teaches that
they are assuredly not more cruel and more revengeful than the whites
(skippers and traders) who visit them, and that they know how to value
and understand just and equitable treatment. Cases occur in which the
natives kill the whites, simply for the sake of killing, but such deplorable
abnormalities are not confined to the blacks alone; besides, the apparent
wanton character of the massacres depends, not unfrequently, simply on
the difficulty in ascertaining the causes and details of the transactions.
Ignorance of the customs and language of the blacks makes it difficult
for the whites to find out the rights of the matter in most cases.

It is certain that, so long as such institutions as kidnapping, slave
trade, and slavery are suffered, or even sanctioned by the Government
(under the name of 'free labor trade') and that shameless spoliation which
goes by the name of 'trading' continues in the islands, the results – the
massacres – will constantly recur.

Nikolai Miklouho-Maclay, traveller, scientist and humanist. An open letter to the Commander of
the Royal Navy in the south-eastern Pacific published in the Melbourne *Argus*, 18 April 1881.[i]

Skull rack, men's cult house, Urama village, Purari delta, c. 1921.
Photograph Frank Hurley. National Library of Australia, Canberra.

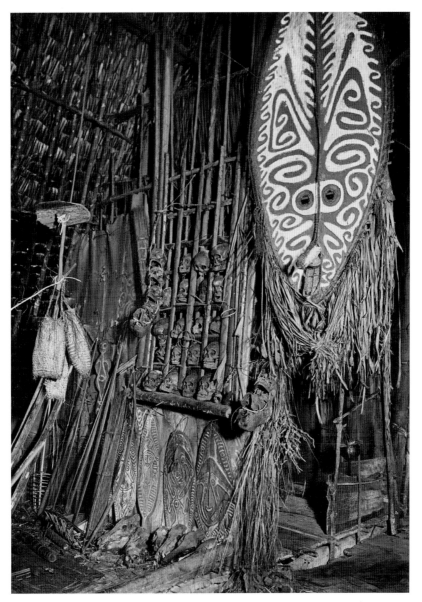

Fighting was indeed performance, and there was much art to it. However, the liberal evocation of Melanesian warfare as functionally necessary and relatively benign became, if not exactly a stereotype, a mystification of its own. It represented an understandable, even a desirable reaction against a demonization of native people, but it profoundly distorted the indigenous past. Warfare loomed large in many parts of New Guinea. Though it was sporadic – it was prosecuted during particular seasons or provoked by particular incidents – war was commonplace. Nor was it just a theatrical game that might result in injuries and the odd fatality on either side. It was conducted in many modes and some were indeed relatively restrained. Yet all-out campaigns that resulted in the killing of hundreds, the dispossession of peoples, and often the ravaging of resources, were not uncommon. Though anthropologists were generally able to study fighting only through reconstruction rather

indentured labour – seen with some justification as a new form of slavery – and against settler violence. Their sympathetic if paternalistic attitudes toward Islanders were taken up by ethnographers, who did not merely produce scientific descriptions of native cultures but affirmed their value. Societies were structured, marked by their own orders and rhythms, distinguished by elaborate systems of kinship, taboo and ceremony; they were wholes within which violence might have its place and function. Fighting constituted a safety valve; and importantly often also had a formal, ritual, or staged character.[2]

than direct observation, hence a precise sense of its incidence and effects in particular regions was and remains hard to arrive at, there is evidence from a number of regions that as many as a third of all male deaths resulted from war – a staggeringly high proportion.[3] To draw attention to shocking levels of violence is not to revive the colonialist condemnation of Melanesian society. It is rather to insist that we step beyond primitivism's Manichean binaries and acknowledge that New Guinea societies, like any in Europe or elsewhere, were distinguished by great cultural accomplishments, and had many other

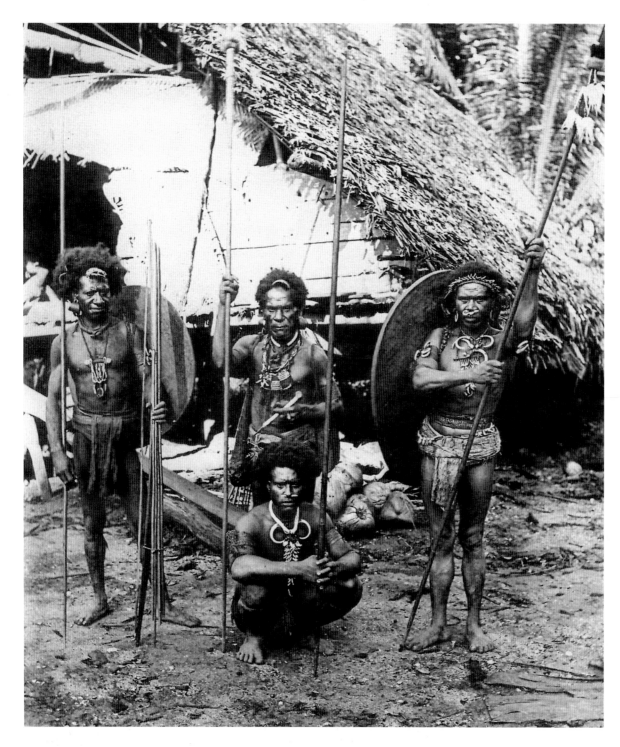

Armed men of Astrolabe Bay, 1894.
From Meyer and Parkinson, *Album von Papua Typen*, Dresden 1894, plate 34.

dimensions we might celebrate, as well as violent and arguably irrational propensities.

Warfare was a psychologically and socially enveloping business, not just an injurious and potentially lethal physical contest. So, though it had its techniques and its implements, what might be called the 'art of war' embraced many more artefacts and activities than weapons. Warriors' houses, rites and decorations were all essential to it, and its legacies included not only the decorated heads of enemies, which aroused Hurley's anathema, but ornaments indicative of a killer's accomplishments, songs of triumph that might form part of a group's repertoire decades after the events they referred to, and personal names appropriated from victims, to be bequeathed to children or relatives.[4]

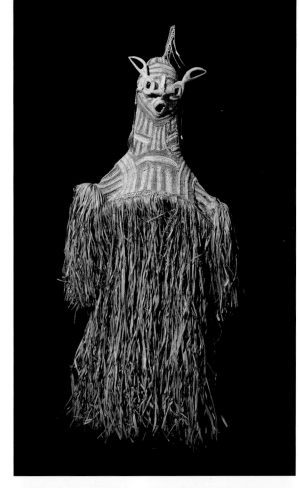

***Jipae* costume mask, north-west Asmat, 1953**

Rope, wood, lime, red ochre, sago leaf fibre, Coix seeds, cassowary quills and feathers. Length 175 cm (68⅞ in.). Rijksmuseum voor Volkenkunde, Leiden.

These masks represented the spirits of the recently deceased and were worn in ceremonies intended to encourage them to move on, rather than linger among, and trouble, the living. Such ceremonies were held periodically up until the 1970s, when government and mission authorities began to work more actively to suppress them.

Men's cult house interior, Kaimari Village, Purari delta, *c*. 1921.

Photograph Frank Hurley. National Library of Australia, Canberra.

The Art of the Shield

Yet weapons were diverse, often elaborately decorated, and highly valued by their owners. The most arresting were shields, made in many parts of the island.[5] They were typically carved out of single pieces of wood, boldly incised and painted, though sometimes also woven out of rattan; they might incorporate feathers, cord, tassles or barkcloth. A purist might classify a shield as an artefact of personal defence rather than a weapon, but such hair-splitting would miss the point in the New Guinea context. Shields might indeed prevent stones, spears or arrows from striking a warrior's body, but they were emphatically aggressive instruments. Their designs were meant to dazzle, disorient, intimidate and frighten. They frequently exhibit visual complexity, disrupted symmetry and figure–ground ambiguity, all of which render the object at once powerful and unsettling – in the hands of a killer advancing upon one, simply terrifying.

What the motifs imaged, from the perspective of the intended victim, was probably often obscure, yet he or she might associate anthropomorphic elements with

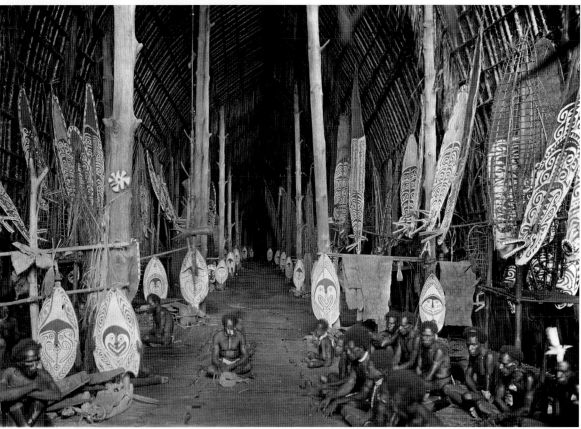

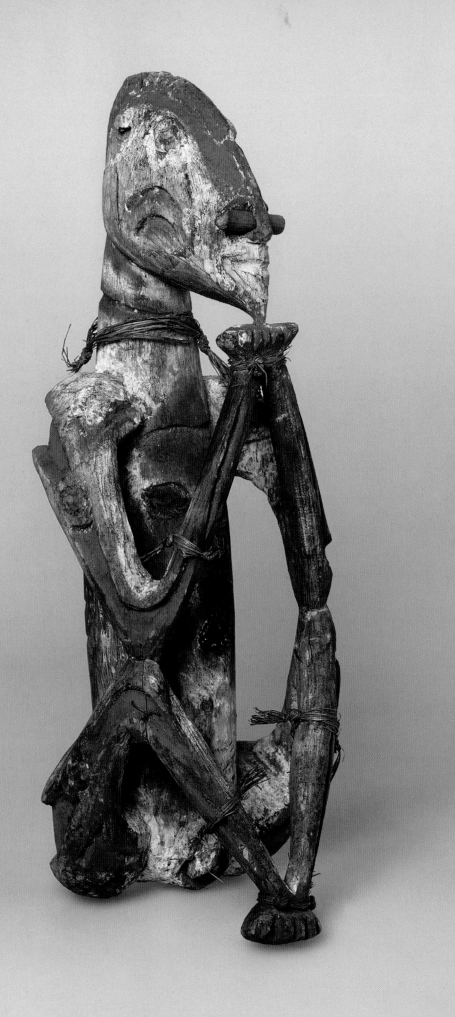

**Sculpture of a woman,
north-west Asmat,
collected 1908 or 1913.**
Wood, lime, red ochre,
charcoal, sago leaf fibre,
bamboo. Height
40.5 cm (16 in.). Rijksmuseum
voor Volkenkunde, Leiden.

Slender, angular figures with
finely proportioned ovoid heads,
typically painted with white and
red ochres, and strong hook-like
motifs make Asmat art highly
distinctive. Such figures connote
the praying mantis, associated
in Asmat art with headhunting
because the female mantis bites
off the head of the male after
mating. This is one of the earliest
figures collected from the Asmat
and refers to a creation story
in which the first people were
carved from wood with their
elbows and knees attached,
to separate as they came alive.

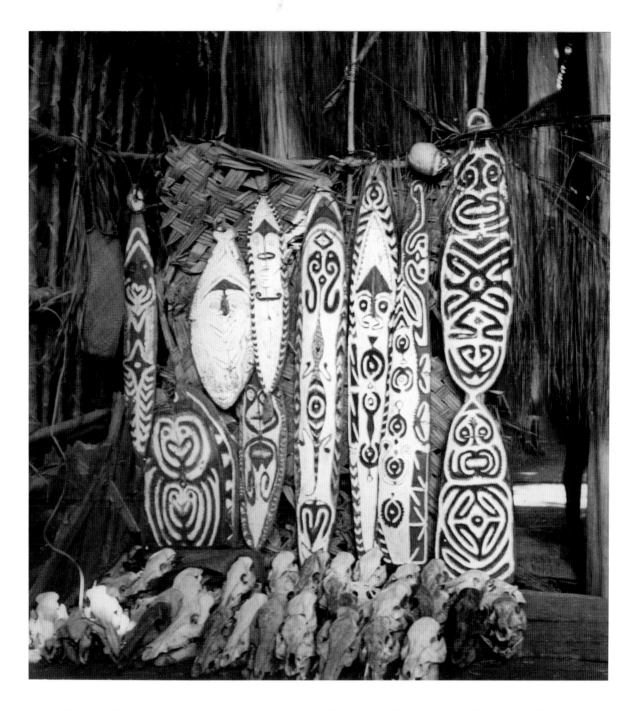

malevolent and threatening spirits. Among Asmat certain designs alluded to crocodiles, birds of prey, biting and acts of decapitation or dismemberment.[6] Shields of the north-eastern Asmat, Brazza River style, feature a face across the triangular top; the central Asmat variant bears a sculpted ancestor at the centre of a flatter top, at once an element of a daunting, confronting display, and an empowering figure for the warrior himself and his community. When they were not in use, shields were often placed in front of houses to protect the occupants, and displayed in groups or lines during feasts, to image the power of the group.[7] Outside the context of combat, they were works of art that had continuous use; as expressions of power they were like the wall-post ancestor carvings, the *poupou*, in Māori meeting houses, only those incarnations were not detachable. Instead they remained within the clan or tribal house.

While, among some populations, it is suggested that warfare was conceived in largely secular terms, a profoundly spiritual understanding was more typical. Among Wahgi, those who fought successfully were

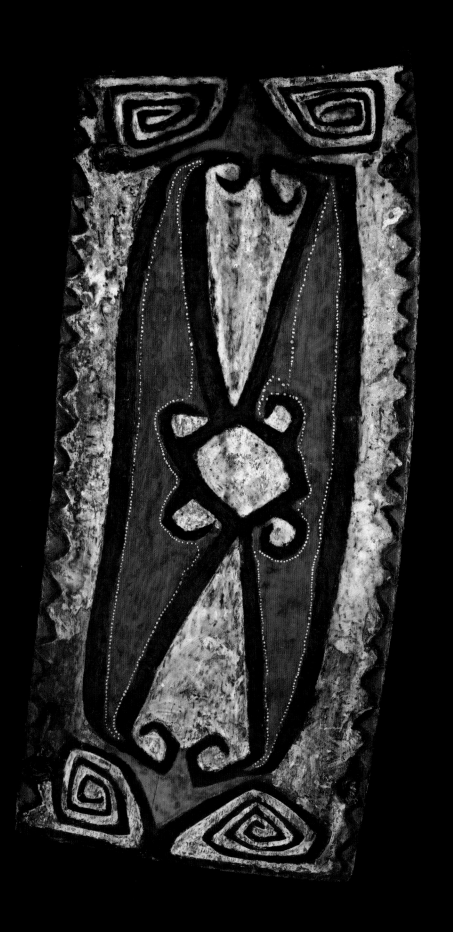

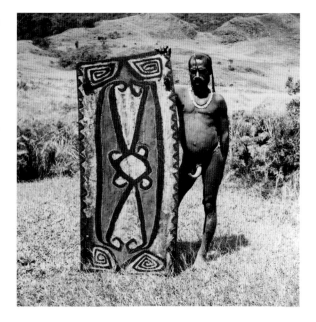

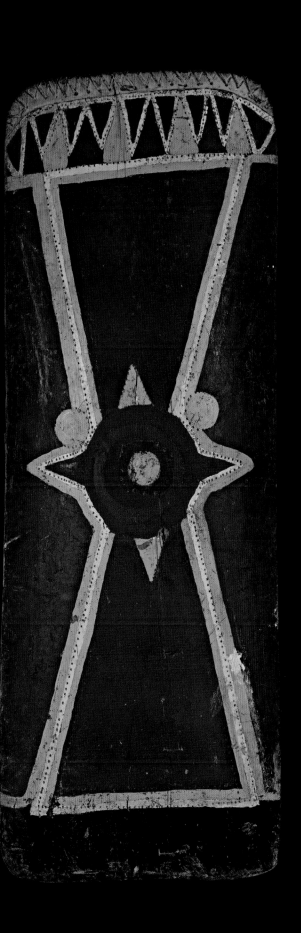

presumed to have secured the support of ghosts; and indeed the assistance of ghosts was considered necessary, to enable a warrior to carry and deploy a heavy battle shield – typically weighing some 9 kilograms (20 lbs) – over the course of a day's fighting.[8]

It is consistent with all this that shields did not hide the bearer by providing camouflage. Rather they were vibrant and mobile – colours such as red and orange stood out against the greens and browns of the natural environment, and feathers or tassles shook or swung as the fighter moved, as he advanced upon his opponent, feinting and taunting. In the Highlands, men typically repainted their shields just before venturing into battle, ensuring they would appear as fresh, bright and vigorous as the warriors themselves. Motifs featured such potent and valued objects as cassowary feathers, paths and streams indicative of territory, and women's genitals – feared for their capacity to trap and drain the strength of men.[9]

Many of the larger and heavier mainland New Guinea shields were designed to be slung over the shoulder, leaving the bearer's arms free to use a bow and arrow. In the Trobriand Islands, shields were smaller, made of thick curved slabs of acacia wood, and were used to parry in hand-to-hand fighting. Most were unpainted, but those of the bravest warriors featured fairly standardized, intricate black-and-red-on-white designs, said to represent swift and agile insects, and the red snake, the bearer of war magic. In an essay from 1954 the distinguished British anthropologist Edmund Leach, drew attention to the seemingly vaginal form of the most prominent, lower central motif, in an implicitly Freudian argument that the shield's threat lay in the association with feared flying witches who loomed large in local belief.[10] Though controversial, and at odds with indigenous exegesis obtained more recently, his analysis is consistent with ideas present in many New Guinea cultures, that posit life-giving but dangerous female powers within or beneath male artefacts and identities (*page 106*).[11]

While it has generally been presumed that unpainted Trobriand shields were simply undecorated, some in fact bear the same designs, more subtly incised in the surface, which has often become dark, a result of a shield having long been kept in the rafters of a house, and exposed to smoke and soot. Today, some Islanders take this darkening to mark value, though this

understanding may reflect the migration of the shield from the category of weapon to that of heirloom, rather than criteria that would have been relevant to those who actually used the late nineteenth- and early twentieth-century shields that have ended up in museum collections.[12]

Ongoing argument around Leach's interpretation of the Trobriand shield reflects a wider debate concerning what meanings were communicated by forms such as shields and by the designs they featured. Anthropologists and other outside commentators had long been bewildered by what appeared to be an absence of local interest in commenting upon or explaining the meanings of designs, not only those upon shields, but including designs on elaborate works of art such as the painted facades of great Sepik ceremonial houses. In some instances, elements of designs had names, but different local men understood these differently, and there was no consensus as to their significance. Or, there might be agreement that a motif indeed represented a particular feather – and feathers have wider uses in the decoration of men, and wider associations with male power and identity – but it was nevertheless unclear that the motif's name was its meaning. (Knowing that a motif on a flag is a star does not help one understand the meaning of the flag.) It seemed peculiar that artefacts and representations associated with ritual activities that were central to the life of a society, or with activities such as fighting that were bound up with spiritual beliefs, should not possess meanings. It was speculated that meanings did exist, which were subliminal, or non-verbal, associated with cultural values such as the paradoxical interplay of male and female power, that were not susceptible to articulation.[13]

There is unlikely to be a single answer to the question of how an artwork ought to be interpreted, in the absence of indigenous exegesis. What a house facade does is evidently different from what a shield or a mask does, and if all of these forms do have power or meaningful effectiveness – not the same as symbolism or significance, understood narrowly – the character of that meaning may well be accordingly different, from context to context. In the Wahgi case (*previous page*) Michael O'Hanlon, however, came up with a fresh and revealing approach:

Only later during my original fieldwork [after fruitless efforts to elicit the meanings of shield

designs] did I come to understand that there was one quite different way in which shield surfaces *were* locally thought of as meaningful.... Essentially, the overall appearance of shields – whether they looked bright, vivid and glowing or seemed unimpressively dull, ashy and pale – was read as a reflection of the inner moral condition of the warriors with respect to...issues of concealed treachery, unconfessed anger and unhonoured debts.... As warriors emerged from their pre-fight rituals, spectators were said to evaluate the appearance both of shields and of the shield-bearers more generally. If the men of a clan did not impress, they would be advised to go back into seclusion...there was no point in fighting as the clan would inevitably lose. On the other hand, I was repeatedly told that the appearance of clansmen whose internal relations were harmonious...would be so overwhelming that I would be unable even to bear looking at such warriors.[14]

This does not imply that the connotations of motifs are entirely incidental or arbitrary. But the force of a work of art, its importance and effect, arises not from these connotations but from the local assessment of the work's quality, and what that quality is taken to reflect or index. The fundamental social or political preoccupation, among Wahgi, was with the solidarity of the group: the fear was that individual interest or anger, often secret or undisclosed anger, subverted such solidarity. Hence the appearance of a form such as a shield – or for that matter a decorated man – was expressive. Lustre or dazzle suggested that all was well, that the group was united and potent, likely to overwhelm enemies; dullness or pallor indexed disorder and weakness. The identification, in this case between brilliance and social harmony, is specific to the values of Wahgi and to some extent Highlanders more generally. But an interest in visual effect, and especially in an effect that may be captured in English by the idea of brilliance, of dazzle, is widespread in New Guinea (and indeed elsewhere in Oceania and Australia).[15]

Brilliance is elsewhere considered an expression of spiritual strength, the command of effective magic, or as in Wahgi of social unity, but the underlying logic is the same. A work of art is created above all for public exposure, often for dramatic revelation in the context of some show of strength or actual contest. The work's

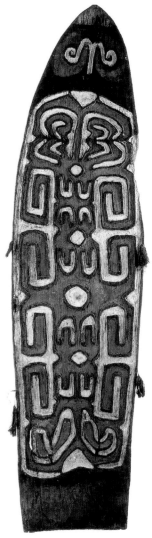

Shield, Brazza people, north-east Asmat, collected 1971.
Wood, lime, red ochre, charcoal. Height 203 cm (79⅞ in.). Konrad Collection, Völkerkundemuseum, Heidelberg.

significance lies not in what it represents or may be presumed to represent, but in its state and virtuosity. Local observers are attuned to particular measures of colour, brightness, lustre or pattern, which they take to index a desirable state, or the absence of that state. All this is apt for many objects that are not weapons – dynamically painted canoes, long strips of patterned barkcloth, and dazzling dyed woven fabrics – genres often characterized by what looks to a Western eye like an op-art effect. For all their local particularity, the aesthetics of the New Guinea shields had affinities that ranged across diverse genres, and across Oceania.[16]

The Art of Headhunting

The dominant form of warfare along much of New Guinea's south coast was headhunting. While, in the Highlands, peace could be made subsequent to a killing through payments of compensation in valuables and pigs, the south coast cultures took human life to be equivalent only to human life. Hence groups exchanged women, they did not pay brideprice, and death engendered cycles of feuding.[17] Yet headhunting was not necessarily marked by reciprocity. Certain groups raided others persistently, and were so feared that they were seldom attacked themselves.

The Marind-Anim, just to the west of the border separating the territories colonized by the Dutch and the British, cultivated a passion for fighting among young boys, who frequently decorated themselves and battled it out with juvenile versions of adults' weapons. Just as trading voyages were considered great and glamorous undertakings by Mailu, among others, in British New Guinea, so the Marind-Anim regarded the headhunting expedition as an inspiring and splendid affair. Some of the coastal warriors, who made extended canoe voyages accompanied by women, children and supplies of food, to strike at a considerable distance from their home villages, indeed routinely mounted an annual expedition like that of the traders, and engaged in some trading along the way.[18]

Once a decision had been made to launch a raid, prospective participants, who might come from one or more settlements, worked together to construct a *kui-aha*, a feast-house featuring carved and decorated posts, which would later be converted into an ordinary men's house (*overleaf*). Gardens were planted in advance of feasts, provisions were prepared, canoes were stocked, all younger people were anxious to participate, 'the forthcoming headhunt became the one and only topic of conversation'.[19] A group of canoes would in due course depart, making their way eastward along the

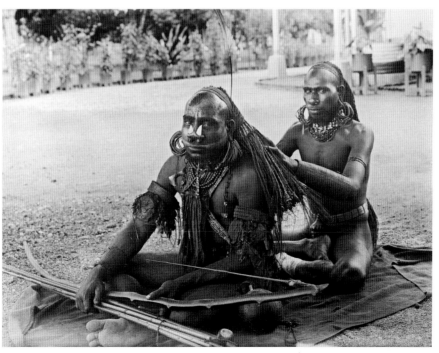

far left
Stylized representation of the *ahat dema*, an underworld god associated with death and destruction, Marind-Anim people, West Papua, early twentieth century.
Wood, paint. Total height 398 cm (156¾ in.). Rijksmuseum voor Volkenkunde, Leiden.

left
Hair-braiding, Marind-Anim people, South Papua, early twentieth century.
Tropenmuseum, Amsterdam.

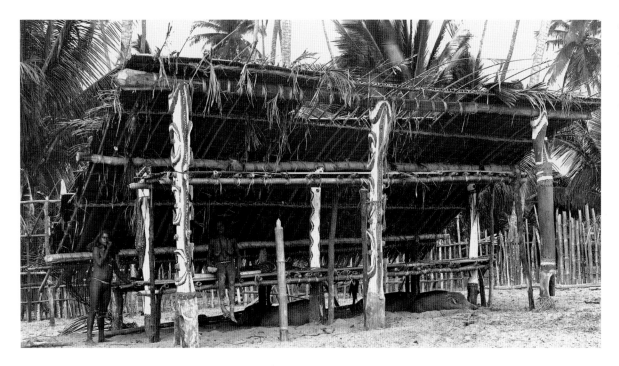

Kui-aha, feast-house,
**Marind-Anim people,
South Papua,
early twentieth century.**
KITLV (Royal Netherlands
Institute of Southeast Asian and
Caribbean Studies), Leiden.

coast, visiting known friends en route into the territory of alien peoples not themselves considered human. In the vicinity of intended victims, a camp would be established, and those who arrived first would wait for any stragglers. Reconnaissance parties would be despatched, and when the time was considered right, the warriors would approach a settlement with great stealth in darkness. At first light they would attack, suddenly and lethally. As many would be killed as was feasible in a short time, their heads taken, and the fighters would withdraw, before traumatized locals had any opportunity to regroup and launch a retaliatory action.

Among the Keraki, studied with considerable empathy and imagination by the government anthropologist F. E. Williams in the late 1920s and early 1930s, raids conducted by parties travelling across land had broad affinities with those undertaken by Marind-Anim, in that the strategy was to approach a village during the night and mount a swift surprise attack. Victims were identified with the wallabies that Keraki routinely hunted; the legs of dead wallabies were broken as incantations were recited in the course of preparations. But here raiding appears to have been less a preoccupation than it was among Marind-Anim; it was undertaken less frequently, and within the

region rather than more remotely. These people indeed were victims of the long-distance assaults of the Marind-Anim, known to them as the Tugeri, and were awed if not actually routinely attacked by the Wiram to their immediate north. However, here as elsewhere, the headhunting raid was an assault upon outsiders. Within a group, a brawl arising from an insult might take place, and might lead to injury, but typically conclude with reconciliation, marked by a feast and a smoke.[20]

Not only among Marind-Anim but also along much of the south coast, it was considered essential that a victim was struck, prior to being beheaded, with a beautifully painted open-work club, known variously as a *pahui*, *parasi*, or *baratu*. If this was not always practical, there was at any rate an idea that the leader of a particular party should bear the *parasi*, and strike a first blow with it. In some cases the artefact had a stone disc with a hole through which the shaft of the weapon was inserted, apparently just prior to an assault, with conscious sexual symbolism, according to the Dutch ethnographers.[21]

In this form the club was a lethal weapon itself, but among the Keraki and other groups to the west of the Fly River, 'it is a highly ornamented object resembling a wand rather than a club...carved into a sometimes

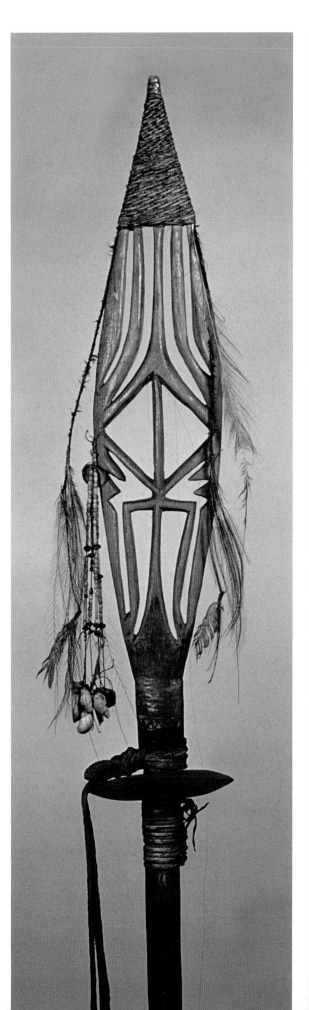

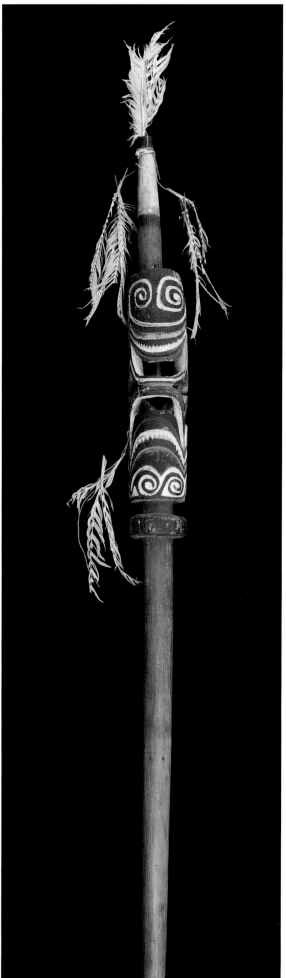

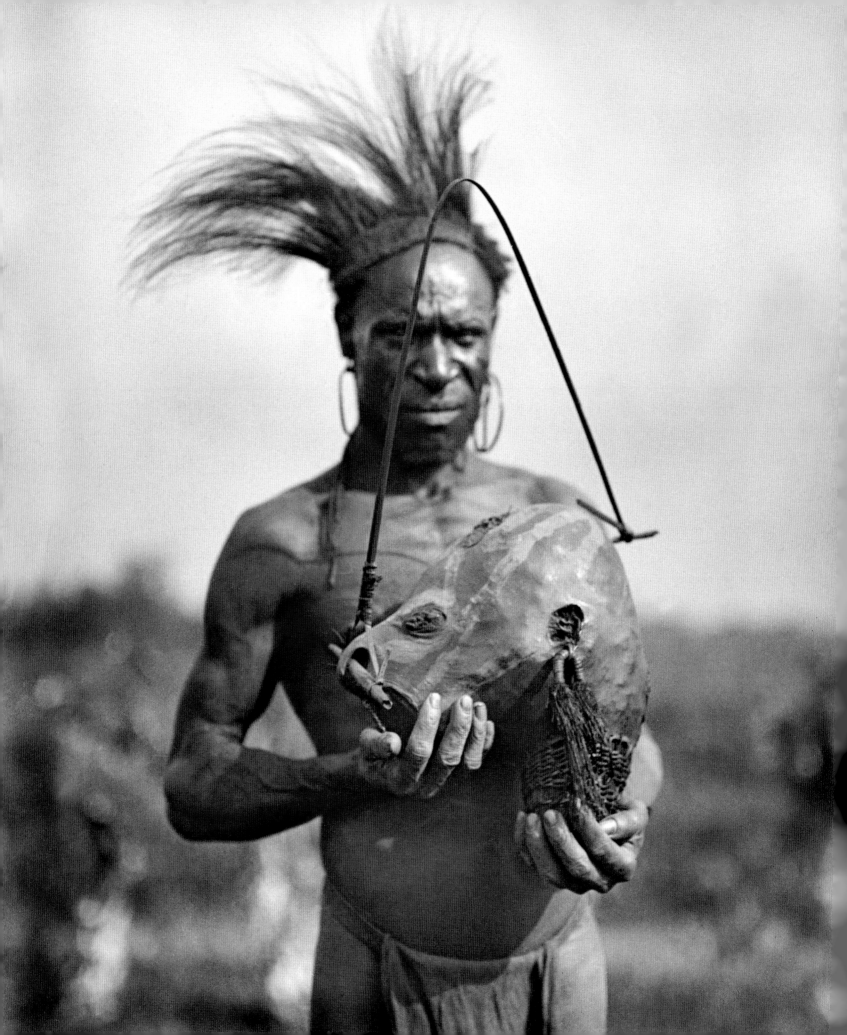

delicate fretwork', painted 'and a number of feathers and streamers of Job's tears and red seeds are attached at various points'.[22] This instrument was a sort of ceremonial precursor to the actual club or spear employed in killing; in either case it was intended to shatter, the fragments of the decorated part to be left scattered in the vicinity of victims' bodies, albeit with totemic, or in any case locally distinctive markings sufficiently intact, brazenly to identify the perpetrators of the raid. While 'No man [Williams was assured] would have the face to return from an expedition bearing a *parasi* intact', the handle might be retained by the warrior, a potent relic of deadly accomplishment.[23]

Though actual killing was performed only by men, women were notably involved. Among some groups they incited men to kill, injecting sexual lust into what was already an affair marked by heightened anticipation and excitement. Themselves often the infertile victims of ritually sanctioned serial rape, women sought young children or babies for abduction – about 10 per cent of the Marind-Anim population was believed to be made up of captives, in this way incorporated into the group. 'Such children were raised as their own children and enjoyed all the rights of native-born Marind.' And women too had head-names, names appropriated from victims, that were adopted and bestowed, a supreme expression of the prestige of a successful warrior.[24]

On the return of a war party, heads were displayed in the *kui-aha*, the house constructed previously. They were suspended from decorated bamboos split into the form of forks, and later removed to a larger decorated post, made from a forked tree, set up in front of the house, the focal point for a final feast and celebration. Among some populations the taking of heads constituted a distinct ritual cycle; among others the practice was closely linked to male initiations. In some cases heads were cooked and token morsels consumed, or drops of blood were drunk off a leaf, these practices reflecting an incorporation of the victim's individuality, substance or life force.

Conspicuous among the art forms of this genre of war were, of course, preserved trophy heads, of the kind that had at once delighted and appalled Frank Hurley, with whom this chapter began. As F. E. Williams observed wryly, 'these truly atrocious objects represent one of the highest achievements of native craftsmanship in the Trans-fly region'.[25] There called *piforo*, they involved the removal and careful cleaning of the skin, and the stuffing of the head with bark and vegetable matter. The lower jaw would be removed and replaced with an arc of rattan cane, resulting in an uncannily distorted, dehumanized facial form. This negation of individuality reflected the appropriation of life force and the identity of the name, which could then be bestowed upon another.[26] The eye sockets were filled with clay, scarlet seeds might stand for eyes, the entire form painted with white, red and yellow stripes, to be suspended normally within the warrior's house; though it was said, or at least rumoured, that *piforo* might be carried in dance, when large seeds within a hollowed head would rattle.

Among the Namau of the Purari delta, heads were also said to be fed to the extraordinary large wicker figures known as *kaiamunu* or *kopiravi* (*overleaf*). These monstrous beings, loosely resembling boars, were normally kept in a screened-off area at the back of the great longhouse. They were used to threaten initiates, and in the context of ceremony their calls and cries would terrify those who were not in on the secret that the sounds were actually produced by bullroarers.[27]

The Art of Peacemaking

The last fifteen years of the nineteenth century were marked by the assertion of colonial control over the coast of New Guinea. The Dutch had nominally been masters of west New Guinea since 1828, but had taken only limited steps to govern or settle the territory. But after Papua and New Guinea (the southern and northern parts of what became the independent nation) were claimed by Britain and Germany respectively in 1884, the pace of intervention accelerated. Planters and prospectors began to enter the territories, and government stations that quickly assumed the character of colonial towns were established – Port Moresby in 1885, Finschhafen in the same year, Friedrich Wilhelmshafen, later Madang, in 1891, and Hollandia, later Jayapura, in 1910.[28]

Missionaries had, as in many other parts of the Pacific, established stations prior to the declaration of colonial rule. Though Italians had begun evangelizing islands near New Britain in the 1840s and Germans had made a start at Dorey Bay in West Papua in the 1850s, it would be another twenty years before mission work

left
Kaiamunu or kopiravi cane figure, Ukiravi village, Purari delta, 1914.
Photograph Kathleen Haddon. Museum of Archaeology and Anthropology, Cambridge.

below
Kaiamunu cane figure, Purari Delta. Collected by Paul Wirz, 1931.
Length 330 cm (10 ft). Museum der Kulturen, Basel.

Paul Wirz (1892–1955) was one of the most important twentieth-century ethnographers of New Guinea, though his work, primarily published in German, has suffered undeserved neglect among Anglophone scholars. In addition to numerous anthropological monographs, he photographed extensively, creating a vitally important visual record of the Marind-Anim, and the peoples of Lake Sentani, parts of the Papuan Gulf and various parts of the Highlands.

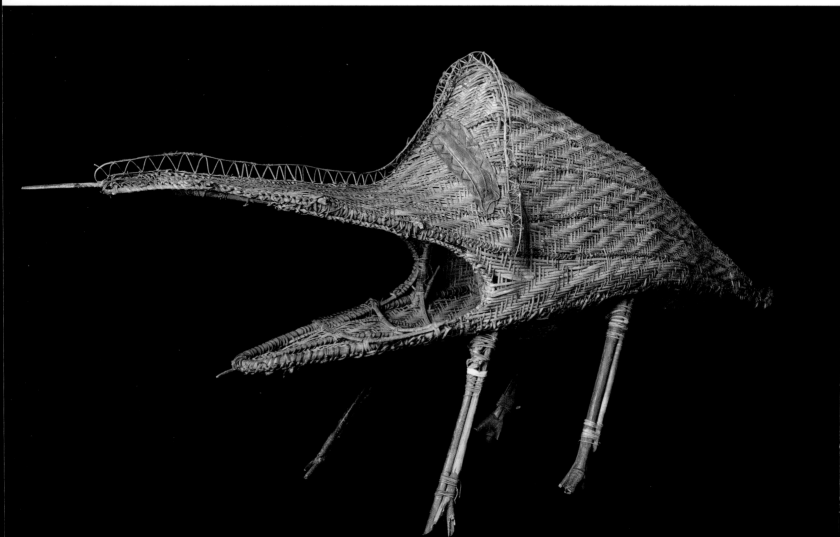

acquired real momentum in the territories of Papua and New Guinea. The London Missionary Society had been active in the Torres Strait from 1871, and began work around Port Moresby in 1874. As in Polynesia and island Melanesia, Islander 'teachers' and their wives served as evangelical foot soldiers, working in considerable numbers among many communities, occasionally visited and only loosely supervised by the white missionaries. From 1885 Catholic Orders began work both on the south coast, at Yule Island, and some ten years later on the north coast. German New Guinea was soon entered by various Lutheran societies. In most areas Christian teaching in the strict sense was slow to gain influence, but the missions became busy trading stations and were soon important to locals as sources of useful or prestigious novelties, manufactured goods and tobacco. They functioned as de facto government outposts, as sources of intelligence, for colonial administrations that wished to assert the rule of law and make the country safe for labour recruiters, planters and other agents of development.[29]

Once established, the British worked to pacify the population. They established a native constabulary, sent officials on tours of inspection, put individuals on trial or took punitive actions when they were considered necessary. Though certain areas such as Goilala, in the hills inland from Port Moresby, sustained armed resistance to colonial control for decades, it is striking that in many areas warfare was easily suppressed. Admittedly the colonial administration was not seeking at the same time to appropriate land, impose taxes or take other steps that local peoples might have been provoked to resist. Hence the relative lack of opposition to this aspect of the assertion of colonial governance is hard to compare to, for example, the subordination of the people of the interior of the main Fijian island of Viti Levu, who were not only being pacified, but forced, essentially, to convert to Christianity and acknowledge the pre-eminence of the high chiefs of coastal confederations allied with the British, but who had long been their customary enemies.[30] In New Guinea the British, German and Dutch administrations were initially concerned simply to put an end to fighting, though this was conceived, albeit somewhat differently by the various colonial agents, as a means to other civilizing and colonizing ends.

It needs to be acknowledged that in many areas there were post-pacification outbreaks of fighting – some of which were brutally repressed. Yet such incidents were often minor in nature, and tended not to occur repeatedly within a particular area. A typical incident, sparked off apparently by conflict between Christian and pagan Islanders, involved a reaction considered disproportionate at the time, according to the official record of 1899:

From Kiwai Island [Lieutenant Governor William MacGregor and party] went to the village of Baramura, on the mainland, where there had been a slight collision between the villagers and some of the boat's crew from the Mission Station at Saguane, who had apparently provoked the resentment of the villagers by trying to get one of their idols. One boy had been slightly wounded by an arrow, and they had decamped leaving their boat behind. A native constable, who happened to be on leave near there, and a village policeman from one of the Kiwai villages, settled the matter, got back the boat, and nothing was probably needed but a cautionary visit from the Magistrate when an opportunity should occur. Instead of this the [presumably white] officer then at Daru (since left the service) proceeded with an armed force to Baramura, the villagers fled; he burned the long 'dubu' or communal dwelling, a building over 600 feet in length, capable of accommodating probably 300 inhabitants, three other detached houses, killed the pigs, and made an address to those present on the example he had

Rabu Banaky

N NOVEMBER 1889 one G. H. Woodelton, of Brisbane, Queensland, was fined £100 'for keeping a common gambling house'. He kept a photographic studio and a 'fancy goods' shop, but 'carried on wholesale gambling, his victims being coloured men'. These 'coloured men' were probably, though not certainly, Melanesian migrant labourers, and were 'victims' in the sense that Woodelton cheated them: the packs of cards found in his establishment were 'cleverly marked'.[i]

Does this stray piece of information tell us anything about a cabinet-card photograph, stamped with the imprint of Woodelton's studio, of a Papuan, an Aroma man named Rabu Banaky? The period was marked by considerable enthusiasm about photography, which claimed the status of an 'art'. But was it also something of a front, something of a racket?

From the 1860s onwards, photographic studios were established in New Zealand, Australia, and various parts of the Pacific. W. A. Dufty ran a studio in the Fijian colonial capital of Levuka; Allan Hughan produced many images in New Caledonia; J. W. Lindt toured New Guinea in the 1880s and published a famous album of views; and Thomas Andrew worked in Samoa, Niue and elsewhere from the 1880s on. Virtually all these photographers produced images of scenery, colonial towns and buildings, the great and the good of settler society, and images of indigenous peoples and aspects of their ways of life. This was to contribute to a public visual culture – prints were made for sale, not merely for individual clients – at a time when Australians and New Zealanders were beginning to think in nationalistic terms and to consider the south-west Pacific as a region that it was their destiny to colonize, on Britain's behalf.

In this context, photographs of local women and men, variously identified as native 'belles', 'chiefs', 'warriors', or simply 'types' began to proliferate. Often photographed in studio settings, these picturesque images belonged in a loose sense to a project of imaginative appropriation. If there was much inconsistency in the ways Pacific peoples were represented in the late nineteenth century, a carefully posed photograph of a warrior could have it both ways: the fearsome savage was evoked, but only in an obviously domesticated manifestation.

Yet images of this kind were always, and are always, able to be seen in different ways. 'Rabu Banaky' was the son of a powerful chief, Koapena, who was considered responsible for assaults and raids in defiance of colonial pacification. Rabu's identification as an individual is at odds with the convention of the study of the native 'type', even if the subject is too encumbered by local paraphernalia for the image to be considered a portrait. Woodelton was not a successful, entrepreneurial photographer like Andrew or Dufty, and this cabinet card may have been a one-off, or one of just a few prints; it was not produced as a commercial multiple. We know nothing of the circumstances of its making. If it is unlikely that Rabu Banaky himself commissioned it, he may well have been happy to be photographed. He certainly had greater status in his own society than the shyster Woodelton had in that of colonial Australasia. NT

Rabu Banaky, a young Aroma man, son of Chief Koapena, posing in front of a painted backdrop, late nineteenth century.
Cabinet card (inscribed rear)
G. H. Woodelton.

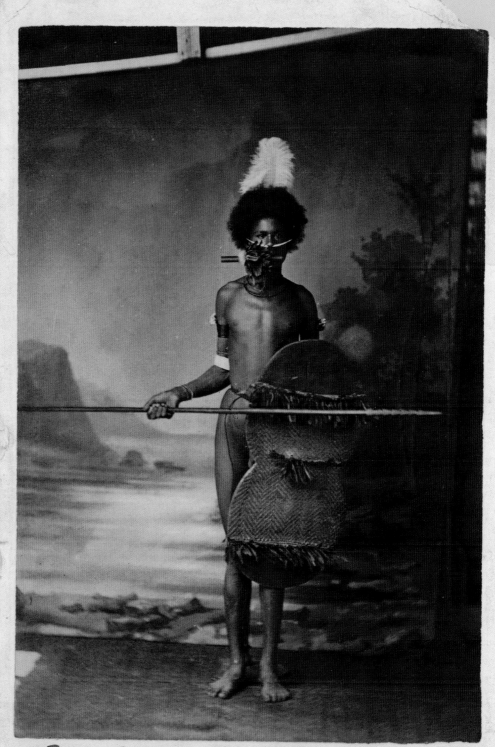

Rabu Banaky, Son of Koapena, a powerful Aroma chief – New Guinea.

made in the name of the Government. After a little while, very friendly relations were established with the chief and his people [i.e. by MacGregor during his own visit], and some tools were given them to assist them in rebuilding their village.[31]

It might be anticipated that repression of this kind, in the wake of a minor fracas, would engender considerable resentment, and it is hard to judge whether the injured people were really so swiftly reconciled to the administration. In any event, the government does appear to have found it easier to suppress warfare than one might expect, given the apparent centrality of fighting for male Melanesian identity, ritual and society. This does not mean that fighting did not loom large and was not vital to the masculine sense of self and to a range of ritual activities. But it was vital to different degrees in different societies. And it is also clear that the commitment of warriors to war was powerfully motivated by fear. It has been argued for the Highlands that men participated in assaults upon enemies, not because they had any great appetite for the prestige gained by successful killers, but because they hoped to pre-empt lethal attacks on themselves and their kin. Men are moreover reported to have denounced war, considered a wild, bad or unhappy activity, even as the courage of individuals may have been celebrated.[32] If this mix of ideas is contradictory or irrational, it is so in much the way war is upheld as noble and lamented as tragic among many peoples. The 'small scale' of New Guinea societies should not be equated with an incapacity to entertain diverse or ambivalent ideas of the sort we expect to encounter among any larger population.

The Marind-Anim were difficult to pacify, perhaps because their commitment to fighting was more trenchant, and because they lived on the Dutch side of the border but had long raided peoples within British New Guinea. The Dutch were slower to intervene along the south coast than the British, and the 'Tugeri', as Marind-Anim were known by their victims, were a thorn in the side of the British pacification campaign for the first decade or so of colonization. But MacGregor went in active search of raiders, during the season in which they were known to be active, and in May 1895 was fortunate to intercept a substantial Marind-Anim party:

The island of Boigu was reached on a journey undertaken with the express object of meeting the so-called Tugeri tribes that raid this colony from Dutch territory. From Boigu the smoke of the hunting-parties of the invaders was seen in the district of the Wassi Kussa. Next day a detachment of some dozen Tugeri canoes was encountered in the channel between New Guinea and the Talbot Islands. Those that remained in the channel were immediately attacked; several casualties were inflicted on them; their canoes with the whole of their food and camp gear were all captured, and their owners fled for refuge into the mangrove islands of the Talbot Group, without having been able to use their bows and arrows with any effect. No prisoners were carried away, though they were much desired. The possibility of securing prisoners could not be taken advantage of because the fugitives were already outside the jurisdiction of this colony...it was therefore necessary to remain satisfied with the complete rout inflicted in this division.[33]

A subsequent attack on another group led to the capture of some fifty canoes and the killing of several further Marind-Anim warriors, including one believed to be the leader of the expedition.[34] Again, how the operation was perceived by those attacked is hard to reconstruct.

Asmat men with shields ready for sale to collectors, 1971.
Photograph Ursula Konrad.

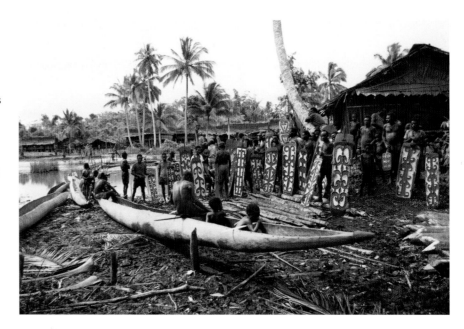

'I THINK OF OLD MEN, AND I SORRY. ALL FINISH NOW.'

Amongst the relics Maino showed me the navel shrine (*kupai* or *kupor*) of Sigai, a great warrior and traveller of long ago. Before going to fight the men would stand around the shrine of large shells and dig their bows and arrows into the ground there, so that virtue might pass into them. ...

I believe I was the first European to whom these revered relics of the past had been shown, and I felt quite sorry for my friend when, looking at one of the memorable stones with tears in his eyes, he said, 'I think of old men, and I sorry. All finish now.'

Later Maino gave me the head-dress his father, 'king' Kebiso, wore when on the war-path, and a boar's tusk ornament which he stuck in his mouth to render his appearance yet more terrible.

Like a true gentleman, Maino did not let me know at the time of his reluctance to part with these relics of his famous father. I did not ask him for them, seeing how highly he valued them, but he offered them freely to me. I then asked what he wanted in return, and gave him what he asked for – a small oval looking-glass, a pocket-knife, a blue bead necklace, and seven sticks of tobacco for the head-dress; and for the tusk ornament a pocket-knife, two clay pipes, and four sticks of tobacco. He wanted me to have these mementoes of his father, partly because of our real friendship for each other, but also partly because he wanted them exhibited in a big museum in England, where plenty of people would see them and would know to whom they once belonged. They are now in the British Museum.

Maino, Tutu Island, Torres Strait, 1888, as reported by A. C. Haddon, 1901[i]

The Consequences of Peace

With pacification, the groups that gained most from war were the losers, and those who suffered most gained most. If the grim prestige possessed by Marind-Anim was forever lost, the Keraki among others, who had been more raided than raiders, were not only relieved of fear, but could drop the defensive and evasive effort that they had needed to sustain for so long. In some areas this gave new energy to ceremonial life and to art. In the Highlands the consequence was not that more objects were created – works of art had never primarily been artefacts in the sense of objects, but accomplishments and performances. Those performances depended upon sustained work in gardens, effective mobilization of the labour of women, and the support of one's followers or potential followers. These efforts were realized in great presentations of pork, and the dances that accompanied these gifts, gifts on the grandest scale that people knew. Just as this competitive economy – which fused the aesthetics of body art, dance, exchange and local politics – had been energized and transformed by the introduction of the sweet potato three hundred years earlier, it was energized again by pacification, by the opportunity for concerted production, for interaction and exchange without the diversion of war, that British and postwar Australian administrations created. Photographs such as those taken by Michael Leahy in the 1930s suggest that Highlanders had acquired extraordinary quantities of shell valuables (much of it flown in by himself), and travel writers would remark, in the immediate postwar years, on the greater elaboration in body decoration.[36]

The exotic rites and performances witnessed in great Highlands shows by journalists and film-makers in the 1950s and 1960s were indeed exotic and remarkable, but their sheer elaboration was the upshot of a succession of interactions with a wider world. These interactions involved neither the direct imposition of any particular practice by colonizers nor the direct local appropriation of anything colonizers had to offer. Adopting the sweet potato, harnessing new sources of shell valuables, capitalizing upon a colonial peace, were all cases of locals making the most of new opportunities and circumstances, in ways no outsider could have predicted.

The action did not have the lasting result that MacGregor hoped for, though in due course a combination of more effective policing within the Dutch territory, and further British attacks upon raiders on their side of the border, saw Marind-Anim headhunting largely suppressed. Some populations that had been feared and renowned raiders, such as Asmat, in due course reconstituted their sociality around other institutions – indeed around making art (*page 126*). But Marind-Anim suffered to an unusual degree during the global influenza pandemic of 1918. It is possible that the deep-seated nature of commitments to violence, and to a particular institutionalized form of ritual homosexuality, both intolerable to the colonial administration, made for a more acute confrontation than other peoples had to negotiate.[35] In any event the combination of imposed change and disease seems to have been more profoundly adverse, more permanently damaging, than it was among many other Melanesian peoples.

left
Men of the Nondugl on a spirit shrine, Goroka, Eastern Highlands, during ceremonies in which reputedly 2,000 pigs were killed, *c.* **1952–56.**

above
Sacred spears, Murik Lakes, East Sepik, acquired 1915.
Wood, feathers, pigment.
Length 217 cm (85⅜ in.).
Australian Museum, Sydney.

Male and female figures, Purari delta, collected by Paul Wirz, 1931.
Wood, pigment, fibre, seeds. Man's height 187 cm (73⅝ in.); woman's 156 cm (61⅜ in.). Museum der Kulturen, Basel.

Though generation and reproduction are vital themes in Melanesian cosmologies, representations of pregnancy are rare. This pair of figures is the only one of its kind in collections from the Papuan Gulf. It reminds us that many works of indigenous art are not examples of 'types', but unique creations.

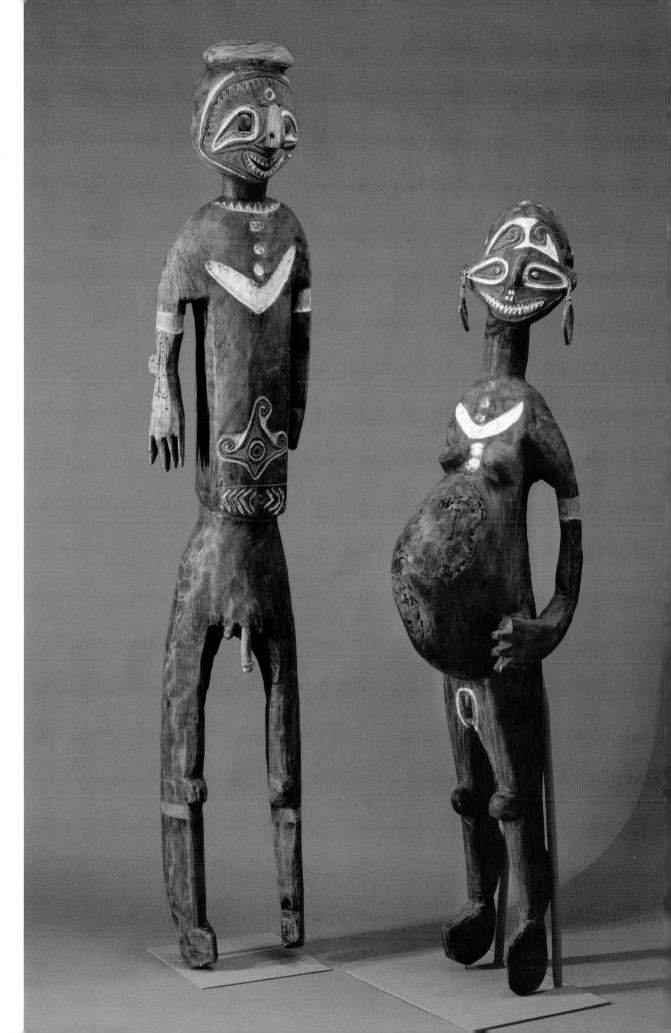

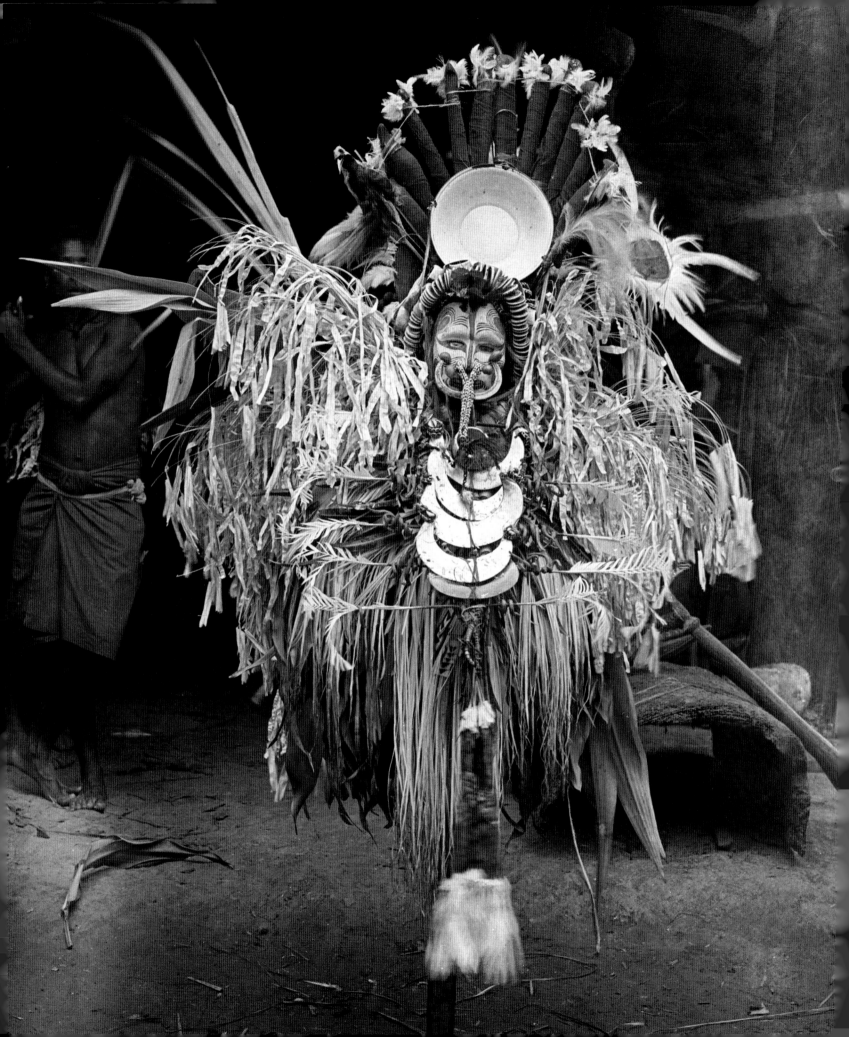

Nicholas Thomas

COSMOLOGIES AND COLLECTIONS: NEW GUINEA 1840–1940

Many New Guinea art objects were in everyday use. *Bilums*, the string bags woven by women that have become an emblem of the modern nation of Papua New Guinea, were and are seen and handled every day. Pots for storage and cooking, in some cases elaborately decorated and traded with neighbouring peoples, were similarly a visible part of ordinary, domestic life.[1] But the most elaborate art forms were associated with cults and rites, such as male initiations. Some of these spiritually charged artefacts and assemblages were publicly visible. Elaborate men's houses dominated their villages, for example. Other artefacts were hidden away, to be revealed only on rare and dramatic occasions to initiates who had undergone ordeals, who had been secluded and scarified and were now to be transformed, and considered for the first time as fully adult males. Many of the most spectacular works of art were embedded in spiritual beliefs, in cosmologies that constructed the order of the world, its balance of male and female power and its tensions and contradictions.[2]

Among the finest early studies of local beliefs was Gregory Bateson's *Naven* (1936).[3] Based on fieldwork among the Iatmul of the Sepik in the late 1920s and early 1930s, his theoretically ambitious study described ritualized behaviours involving mothers' brothers and sisters' children, and conversely fathers' sisters and brothers' children. The accomplishments of the young were celebrated by their relatives in an arresting and comical way, involving exaggerated role reversal and cross-dressing. The women would pantomime the behaviour of men, men would dress in ragged old rain capes and dirty skirts, hobbling like elderly women, and opening their legs in sexually suggestive ways. These acts and behaviours would prompt embarrassment among the brothers' or sisters' children, who would produce gifts, prompting the uncles and aunts to revert to their normal selves, and lead to further reciprocal presentations. More or less elaborate versions of these performances responded to particular achievements, such as a first

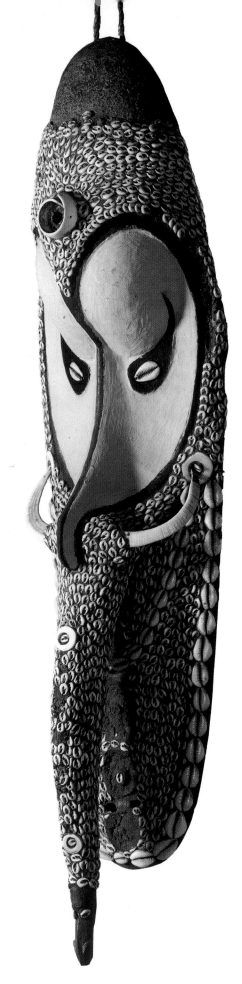

success in fishing or hunting, or a productive act of any kind, such as securing shell valuables through exchange with some outsider, killing a pig, or mounting a feast.

The paramount such achievement at the time of Bateson's research was recognized to be homicide: 'the first time a boy kills an enemy or a foreigner or some bought victim is made the occasion for the most complete *naven*, involving the greatest number of relatives and the greatest number of ritual incidents'.[4] Warfare was already largely suppressed, hence this dimension of the rites' context had already changed, yet in other respects the understandings of kinship and relatedness that underpinned them remained alive, and indeed remain relevant to Iatmul today.

Though indigenous cosmologies came under sustained assault over the first half of the twentieth century, some peoples retained profound understandings of historic beliefs and of the art forms associated with them. Bateson collected a number of *mwai*, long-nosed masks covered in the shells of *nassa* (small mud snails), featuring tusks, other shells, hair, and delicate, more or less symmetrically decorated faces. Of these, there were two main types, a wider female and a narrower male version. All were named, and names were specific to clans; the masks were not secret, but had esoteric meanings that were known only among a few individuals. Their production has waxed and waned but they are still made today.[5]

Christianity, Iconoclasm and Culture

In many regions, Christian missionaries worked long and hard to suppress practices they associated with heathenism. The Gogodala, who occupied the wetlands between the Aramia and Fly Rivers on the coast, staged elaborate ceremonial rites known as *aida*. They centred on male initiations, in which a whole range of sacred objects and elements of costume such as feather decorations were revealed and used. A huge drum, the *diwaka*, was sounded, and a rattle was used exclusively during the ritual and identified with one that belonged to the culture hero Aida himself. Most of these objects, and the great estuary canoes that were used in ceremonial races, were painted with the distinctive circular motifs in bright yellow, red, black and white that make the art of the Gogodala instantly recognizable.[6]

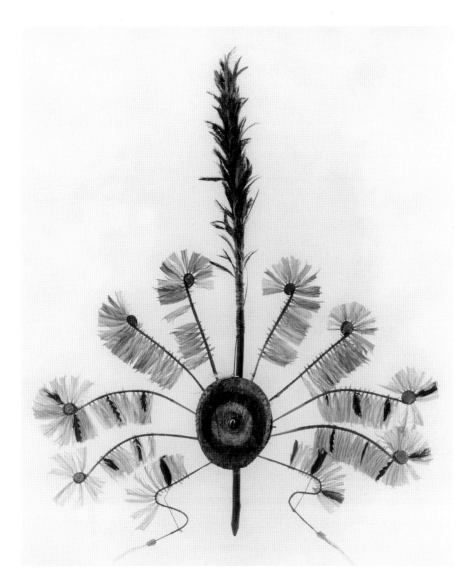

Various anthropologists and administrators, including Gunnar Landtman and A. P. Lyons, made contact with Gogodala in the early twentieth century, and around the First World War men began to be recruited for plantation work in the Port Moresby area, and some also as labourers on pearling luggers in the Torres Strait. But Gogodala life and custom were not substantially disrupted until the mid-1930s. Though the London Missionary Society (LMS) had been active in Papua since the 1870s, it was only in 1931 that the first missionaries attempted to work among the Gogodala. They represented an Australian organization, the Unevangelised Fields Mission (UFM, later known as the Asia Pacific Christian Mission; now, as Pioneers International, it remains active in Melanesia and elsewhere). These missionaries were highly committed and conservative evangelicals. Unlike some of their Methodist and LMS contemporaries, they had no interest in, and they attached no value to, local traditions. Though they succeeded in getting indigenous people involved in building churches, schools and houses, their intimacy with Gogodala remained limited and their awareness of local culture superficial. It was not until late 1935 that the missionaries realized that the peoples among whom they had settled sustained an elaborate religious life, and that each longhouse contained highly valued sacred objects that most of the time were stored out of view in a special loft.[7]

A wave of iconoclasm followed, but the instigators were not simply UFM missionaries. Around the same

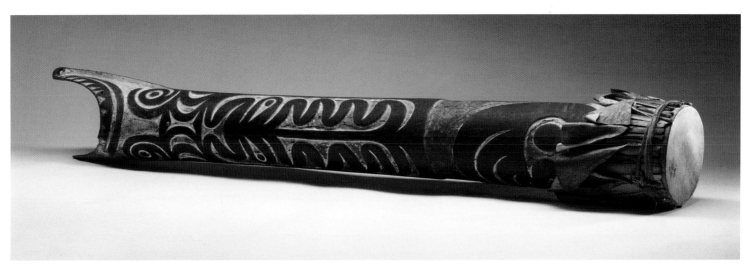

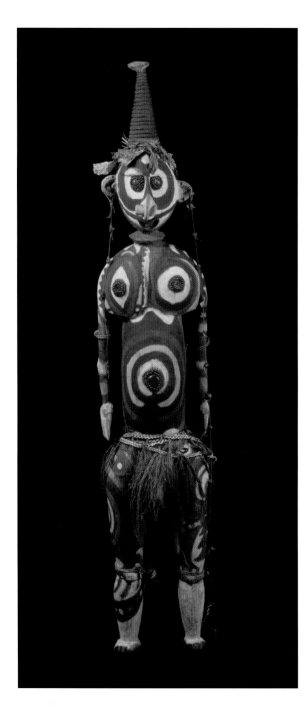

from many other parts of the colony, including some among whom Christianity was well established. They were not formally linked with the UFM and on their return seem often to have worked independently, travelling from village to village, preaching and urging the people to abandon rituals such as *aida*. However, in June 1936, Elemowa went to one of the villages, Isago, accompanied by a white missionary 'with the intent to burn the *aida* paraphernalia', and it was indeed burnt, as were sacred objects at two other villages a few days later.

More detailed descriptions of other burnings leave it unclear whether the local teacher, early village converts, or the expatriate missionaries were the prime movers behind these acts, but the presence of Elemowa on each occasion strongly suggests the first: it was the local Christian, rather than the white man, who had the capacity to push people to destroy the most potent and sacred objects that they possessed. One of the very first Christian converts, Gauba or Gouba of Kimama, wrote to the missionaries asking them to come to his village, claiming that the people wished to burn their *aida* objects. One account published just a few years afterwards reported that:

> The village of Kimama called its old men. So few were in favour of clinging to the old ways that all the dread articles were brought out and a fire prepared. They would henceforth all follow in the 'New Way' – the way in which Gouba was walking. They called forth the women folk ere lighting up the pile, but only Gouba's wife and a few others would come. They came tremblingly, for in the past it had been death to gaze on upon such charms. They saw the rubbish, for it was little else, dirty and begrimed with smoke from a thousand fires, and were relieved to suffer no harm, either then or later.[8]

The later recollections of the same missionary are more detailed, and not entirely consistent with this:

> On the 8th July 1936 which was a Wednesday, Frank [Briggs] and I went to Kimama, and I noticed that Elemowa was also with us. After giving out some medicine Frank talked to the various people and we tried to get the women to come back to the village. They evidently had been told that we were going to do something with the

Male ancestor figure, Gogodala people, Western Province, Papua New Guinea, acquired 1971.
Wood, fibre. Height 149 cm (58⅝ in.). Australian Museum, Sydney.

The painted yellow, red and white circular motifs that characterize Gogodala art are totemic clan insignia.

time, Emo and Elemowa, two Gogodala men who had been away from the area for some time, returned. They may originally have travelled for plantation or other work, but had undergone two years' training with the LMS at their Kwato station, which was hundreds of kilometres away, near Samarai on Papua's south-eastern tip. There, they would have mixed with people

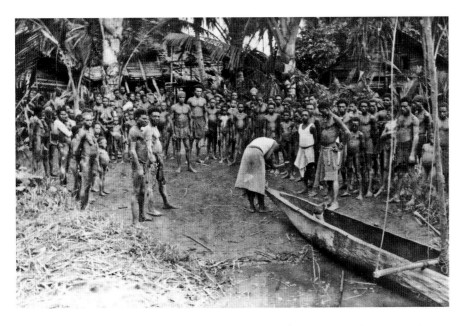

Elemowa, a Christian convert, hacking off the carved ancestral figure of a canoe at Kewa village, *c.* 1936.
Photograph Bernard Lea.

aida gear, and in accord with usual custom they had fled the village. We asked the people who wanted it to be burnt and only one dissented, and he was the village constable. Apparently, though they were not aware of it, he was about the last man who should have held that job because his influence in the village, as we discovered afterwards, was very much in the wrong direction [i.e. against conversion to Christianity]. There was a little urging needed for them to get on with the job. They were, to some extent, rather frightened. Pasiya, it seems was a bit afraid, but Gauba was the one who made the first move, and Elemowa… clambered up to the loft to help him hand it down and Pasiya…was soon helping. The stuff was carried outside at the end of the longhouse and we finally got a few of the women to come.… The younger boys were less frightened than the older ones. This may have been because they had not themselves been initiated and had no idea of just what all this gear involved. Gauba got some of his family to come back first and one or two more came in, in fear and trembling, but we persuaded them to walk past the gear and have a look at it before it was actually burnt.[9]

The missionary, Bernard Lea, went on to describe a large crocodile skull decorated with red and black

seeds – this was again characteristic of Gogodala art – which he presumed had been used to terrify the boys during the rites, and which was likewise destroyed on the same occasion: 'The stuff was burnt and that was it.' Over succeeding days the mission party was invited to the large village of Balimo; they expected that people there might also wish to burn their sacred objects, but when they arrived all the women had absented themselves and they were met by a man they described as the 'head witch doctor'. He and others were concerned to explain that though the use of the objects had once been linked with the killing of men, presumably with the celebration of successful headhunting raids, this was no longer the case.

The implication was that these Gogodala assumed the missionaries had the same interests as the representatives of the colonial administration, whose first priority had been pacification. They seem to have thought that if they made it clear they were no longer involved in fighting, they would be permitted to sustain their rites – they did not realize that those rites were precisely what the evangelists sought to suppress. The Balimo men went on to explain that 'they wanted to keep this gear themselves for the time being. They weren't prepared to get rid of it – it was "their medicine" was their explanation.' Lea claimed – forty years afterwards when public perceptions and perhaps his own perceptions of these sorts of acts had changed – that the missionaries emphasized they would not force locals to burn objects of this sort, but acknowledged that there was considerable suspicion among the people, who evidently believed precisely the opposite. They went on to hide their *aida* objects and instruments in the bush, and it was understood that people in at least one other village did the same. One of the most celebrated groups of New Guinea sculptures, the Lake Sentani double-figure sculpture renowned for a sort of enigmatic equanimity, was recovered along with others in 1929 by the French traveller and art dealer, Jacques Viot, from the lake itself, where they had been submerged, apparently in order to avoid being destroyed during a punitive government raid that had taken place four years earlier (*overleaf*).[10]

In the Gogodala area there were further burnings in the weeks following the events described. On one occasion in August 1936 the missionaries were warned that they might be killed or beaten up, but they

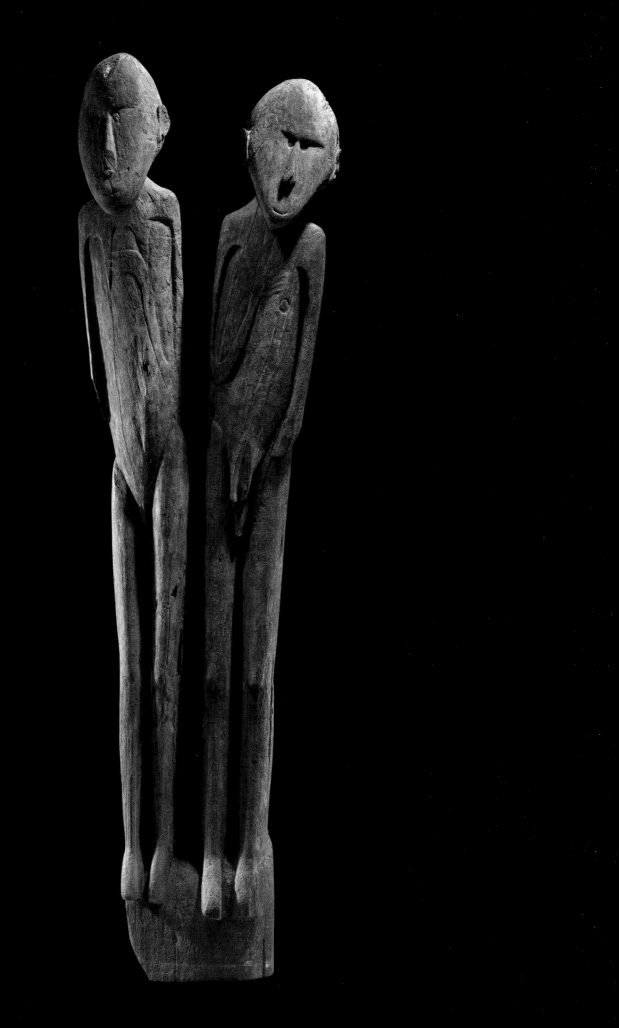

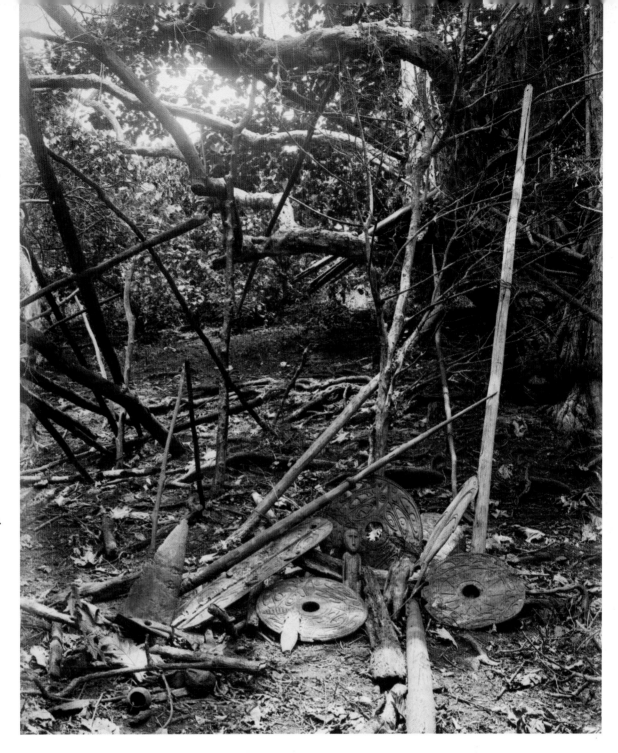

repeated assurances that no one would be forced to destroy objects, and the missionaries suffered no violence. A few days later they went to another village, Kebani, where Elemowa again succeeded in persuading people to burn sacred artefacts. On this occasion, however:

> One of the old men wanted to retain the drum, the *diwaka* – he said he'd made it.... Elemowa after a bit of talking with man, pulled off his shirt

(pretty rare thing in those days) and offered the shirt in return for the drum and the drum was duly pitched into the fire. The old man still said 'I want the drum', but Elemowa pointed out to him that he had paid for the drum and that was it.[11]

These momentous and sad accounts make it clear that there was great ambivalence among communities at the time of these events. In all cases, just two or three

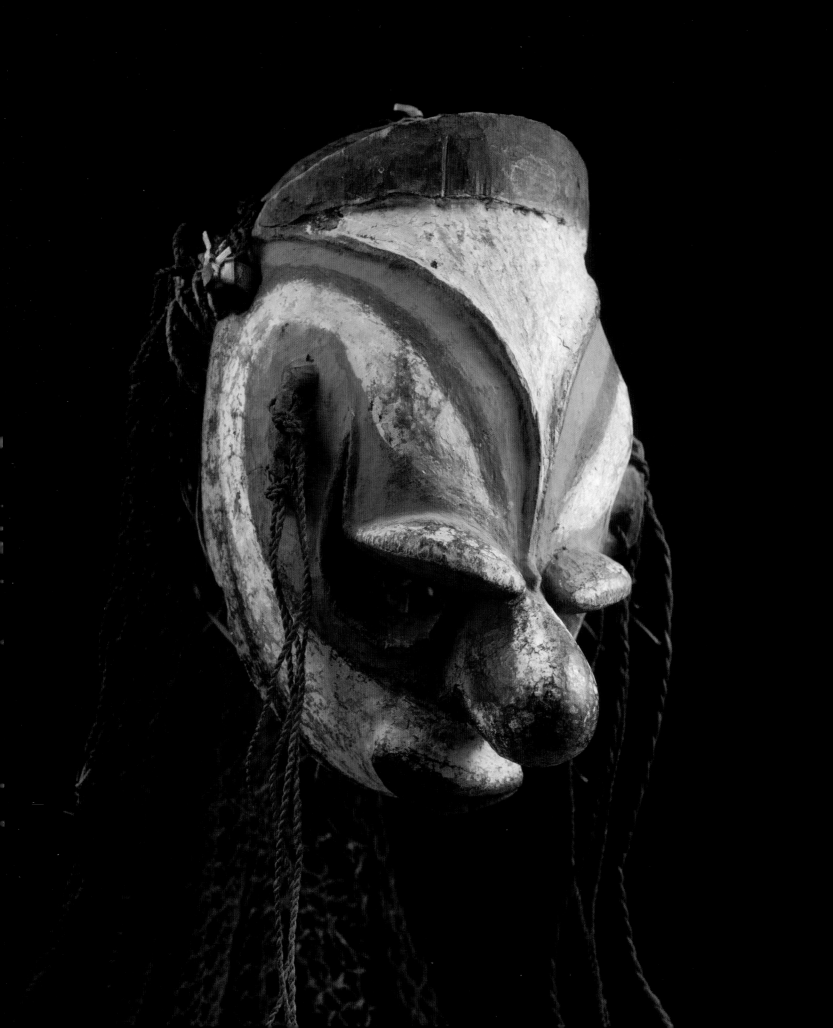

opposite
Gugu mask, Yuat River, East Sepik Province, Papua New Guinea, acquired 1938.
Wood, pigment, fibre.
Height 31 cm (12¼ in.).
Australian Museum, Sydney.

right
Interior of longhouse at Auti, Kiwai Island, Fly River, Papua New Guinea, c. 1911.
Photograph Gunnar Landtman.
The National Board Of Antiquities / The National Museum of Finland.

below
Boy's initiation figure, Murik Lakes area, East Sepik Province, Papua New Guinea, acquired 1928.
Wood. Height 60.5 cm (24 in.).
Australian Museum, Sydney.

younger men were highly motivated in favour of radical change. The narratives suggest that other men were not positively in favour of the destruction of cult objects, but acquiesced when Elemowa and one or two others exposed the works to view and proceeded to destroy them. Quite why he or the other individuals concerned had the capacity to impose their will is unclear. Elemowa had travelled, he knew a wider world, and had the status of links with the colonial authorities. What was centrally important here was a generational struggle – one between elders defending a long-standing, ritually secured gerontocracy on one side, and young and ambitious men cognizant of new, wider forms of status and power on the other.

A fear of what white men might do if displeased may also have loomed large among local attitudes, given people's awareness of the punitive operations earlier undertaken by the administration. Yet it is clear that Elemowa and perhaps the white missionaries too were concerned not only that objects were destroyed also but that they were first exposed to the women. In this effort to subvert the secrecy that had been fundamental to the old ritual order, they were clearly less successful. All but very few made themselves scarce and would have nothing to do with this act of disempowering revelation.

The ethnographer Alison Dundon has pointed out that though missionaries assumed these acts signalled the preparedness of the people to adopt Christianity, sacred objects had earlier been destroyed from time to time, by raiding enemies (who might in some cases also seize images and incorporate them into their own rites) and by accident – longhouses occasionally burnt down. In these cases, drums, rattles and figures were simply made anew, and some people indeed did produce new carvings in succeeding years and also went on to stage one further *aida*. Yet considerable damage appears to have been done, or at any rate men such as Elemowa who were committed to change succeeded in undermining or intimidating those

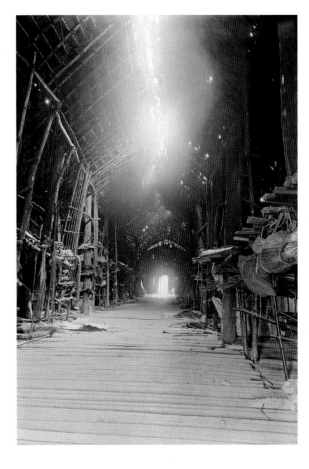

who wished to carry on rites. Hence the making of sacred art was largely abandoned. During the Second World War many Gogodala men worked for the army and gained wider experience. Christianity was securely established in the post-war years, though in the 1970s Balimo would also be the centre of one of the most celebrated revivals of customary culture, facilitated by Anthony Crawford, a museum ethnologist then employed by the Australian government (*overleaf*). This revival was, however, a revival of art-making, particularly of art for sale; it was a project of local cultural development. Those who participated remained Christians and did not restage cult activities that by the late twentieth century few recalled or understood in detail.

From one perspective, what had been at the heart of the culture – above all for males – was gone. And gone too were beliefs that provided the context and value of many of the greatest Gogodala art forms. Though it is important to add that the largest and

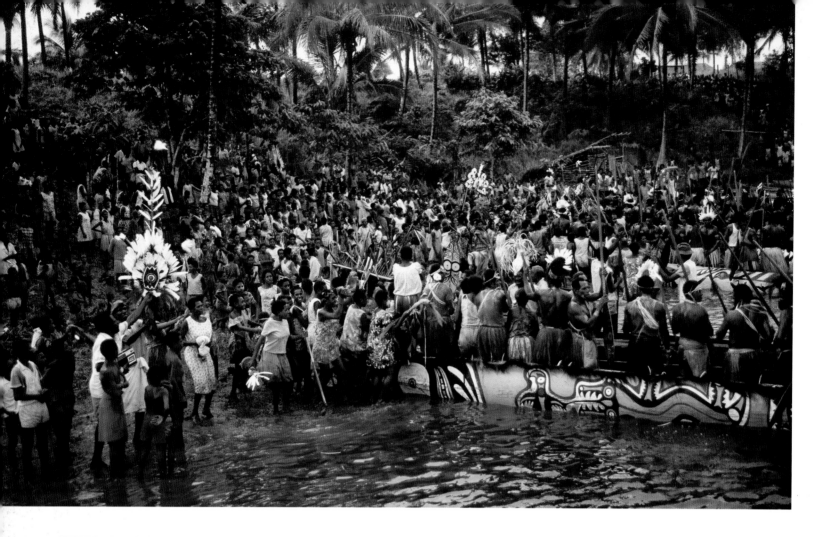

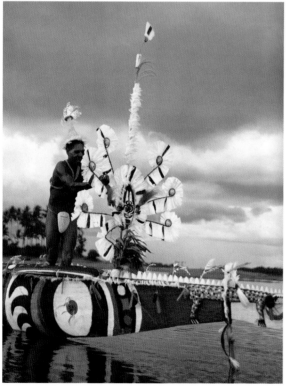

most spectacular Gogodala objects, other than the great longhouses, were canoes that remained in use, and that continued to be decorated with ancestral designs. Canoe races had been held from time to time throughout the colonial period and would be revived again at the time of Crawford's initiatives. (As in the Solomon Islands, the missionaries perhaps saw these as commendable sporting activities, though they were in fact strongly associated with ancestral power, and the paintings on canoes were all of clan and ancestral insignia.) Moreover, as Alison Dundon has argued, Gogodala life 'was based on the daily interaction with the ancestral presence, inherent in the land, water, animals and plants of the area. The original ancestral beings or *iniwa luma* mapped, created and named the local landscape as they moved across it…. The ancestors also established the moieties, clans, and clan canoes that structure the lives of contemporary Gogodala', who nevertheless became and remain firmly Christian. What had been destroyed was a specific cult – if indeed one of paramount importance – not a whole cosmology, not a way of being in an ancestrally constituted world.[12]

above

***Aida* crews disembarking after ceremonial canoe race, Gogodala people, 1970s.**
Photograph Anthony Crawford.

Crawford was appointed by the Papua New Guinean government to facilitate and encourage a cultural revival among Gogodala. It was one of the earliest and most ambitious of such initiatives, and resulted in the recreation of a full-scale cult house. Though the project has had ups and downs since, it has had an enduring legacy in supporting Gogodala concerned to recover and affirm the value of customary ways in the face of an intolerant Christian mission.

left

***Aida* ceremony canoe prow ornament, Gogodala people, 1970s.**
Photograph Anthony Crawford.

ALL THE PEOPLE DIVIDED

In the beginning there was nothing except water,
and the land came out of the water.
It was very dark:
there was no sun
and from the land came a man called Bani.
It was so dark he made the sun,
he made it on the ground
and called it Daligi.
He got some cane and made a circle,
and tied the sun onto the cane and lifted it,
as he did he started singing.
After that, he stood up and stretched his back,
but the sun was not very high;
it was just above the heads of the people.
They could not walk
and were crawling on their bellies.
One day there was a big flood
and those crawling about drowned.
The sun was lifted higher where it is now.
The night came and it was dark:
Daligi called his sister Genasi to follow him
and become the evening star.
But Genasi followed the moon and it was dark.
Daligi called his brother Suli to follow him
and become the morning star.
On the water are the red and white water-lilies;
they are the reflections of the evening and
 morning stars,
Genasi and Suli.
Soon after people came,
they were taller and we came from them.

They came from the land called Salona,
in a big canoe.
The red people and the white people.
They found the mouth of Pedeya Creek
and paddled to the north.
All things belonging to the water and
all things belonging to the ground were
 given names.
The people paddled past Kini to Dogono,
and they built the first longhouse.
One night a woman slept; she had no sago.
In the morn, she went to the bush
and chopped a sago palm.
A voice came from the sago palm
and the people were frightened.
So they left Dogono
and went to their own clan places.
But the men fought,
and all the people divided,
some to Ali,
some to the Bamu,
and some to Binibi.
From Binibi they moved to Kini
where they built a longhouse.
But later the people split up,
some went to Sasapowase
and others to Taliana.
But they split too.
They were the people of Dogono,
who now make up our own tribe,
The Gogodala.

As told by Saliki, a leading storyteller and master
carver of Balimo village, c. 1976 [i]

Prophecy, 'Madness' and Money

In other areas major cults were abolished, or in any case profoundly disrupted, though not directly as a result of any anti-customary campaign led or supported by missionaries. One of the most striking examples is that of the 'Vailala madness', which was described and analysed by F. E. Williams in reports produced in the 1920s and 1930s.[13] It appeared that beliefs and associated activities emerged suddenly in 1919, in the large coastal village of Vailala, but then spread rapidly among other Papuan Gulf communities. The arresting feature of 'Vailala madness' was the behaviour of individual men, who became prone to seizures, shuddering and abnormal movements – there were reports of people striding jerkily about villages, in a state of excitation. They frequently were said to deliver some speech or exhortation, which was invariably unintelligible, but said in some cases to be in German or to incorporate pidgin expressions associated with plantation work. These behaviours were obviously reminiscent of spirit possession, speaking in tongues, and suchlike, though Williams regarded the movement as a collective psychosis and employed medical language, writing of 'outbreaks', 'contagion', 'the infected area' and so forth.

Linked with this, however, were beliefs later seen to be widely characteristic of 'cargo cults'. White men were thought to be the returned ancestors of native people; it was believed that a steamer, or in some cases an aeroplane, was en route, to bring massive quantities of white man's property, which would be distributed among Papuans, or specifically those who committed themselves to the belief. Customary ceremonies had to be abandoned; in their place quasi-Christian rites were introduced; specific preparations had to be made. Feasts on European-style tables, consumed by men and women seated together on benches, represented adapted, colonial-style versions of long-standing mortuary feasts. Novel offerings were left out for the dead in specific places within villages; new cult houses, referred to in some cases as 'offices', were established; flagpoles were almost invariably raised beside them. Mission villages had long featured flagpoles, as LMS teachers raised flags on Sundays to signal that the day

Vailala village, Gulf Province, Papua New Guinea, *c.* **1922.**
Photograph F. E. Williams. National Archives of Australia, Canberra.

In activities referred to by colonial officials as the 'Vailala madness', cultists built European-style buildings to communicate with the ancestors, who transmitted messages to them via the flagpoles.

needed to be observed. Adherents of the Vailala movement, however, considered the pole a channel for messages from the dead, and in some cases took it to work like the radio aerials that some must have seen. Another type of pole, which was not erected but carried by cult adherents, was used in divination, to identify thieves, to find hidden objects, and so forth; both these poles and flagpoles were given specific names and identities.

The dimension of the movement that most repelled Williams – and no doubt accounted for his denigration of it as a 'madness' – was the broad repudiation of customary ceremony with which it was closely linked. Williams was a great admirer of both the physical objects and the drama of the ceremony that surrounded them – for good reason, since the assemblages and performances were indeed extraordinary. It is not surprising that he should write that a visitor proceeding eastwards from Orokolo along the Gulf coast would 'be more and more exasperated to find in every village that the ceremonies have been discarded and the masks and all other paraphernalia connected with them

destroyed'.[14] Here, as in Gogodala, the destruction of objects was less crucial than the manner of their destruction. At the conclusion of *sevese* mortuary feasts, masks had always been piled up on the beach and burned; this was essential to the ritual since their despatch was identified with the final journey elsewhere of the spirit of the deceased, who might otherwise remain among the community and cause trouble. But here bullroarers (*page 145*) and other sacred objects were cast out of their keeping-places in men's houses, revealed to women and to uninitiated boys and girls, and then burned.

Other customary activities, such as the wearing of feathers, and the use of betel and lime-pots, were banned. It was believed in some cases that people would die in great numbers if ceremonies were renewed, yet more importantly, people became, and were encouraged to become, contemptuous of past rites and art forms. 'Throw'em away, bloody New Guinea somethings', was how Williams rendered one informant's view. A man named Lai, a Christian and an adherent of the 'Madness', put it differently: 'the first

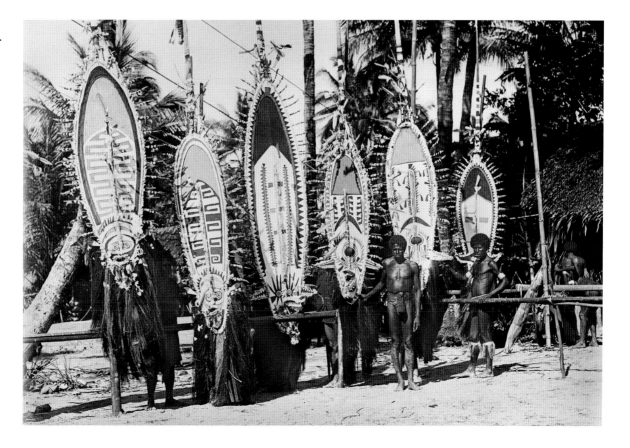

Hevehe masks, painted and feathered ready for initiation. Orokolo, 1932.

Photograph F. E. Williams. National Archives of Australia, Canberra.

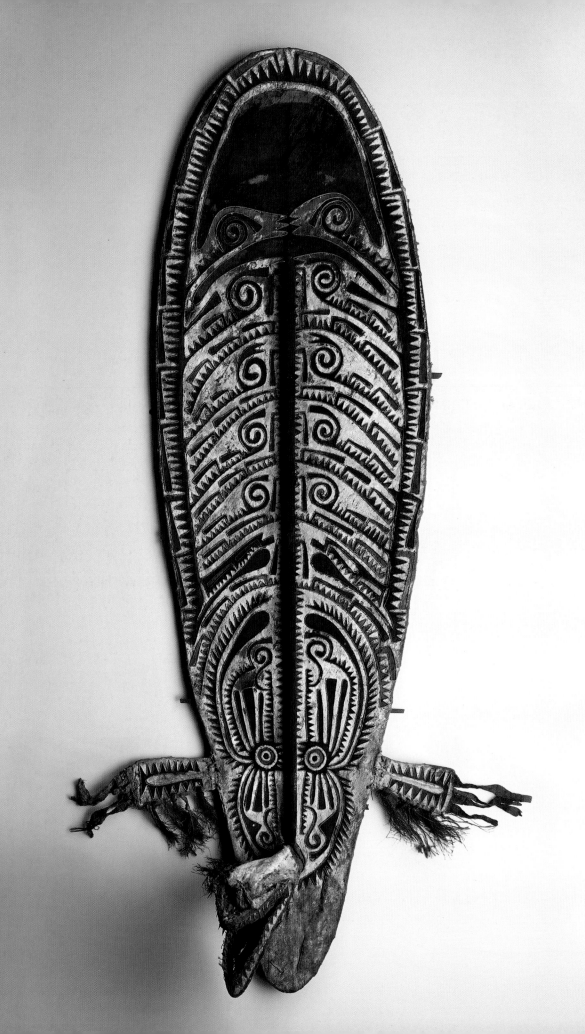

time men [i.e. the ancestors] were bloody fools, no savvy anything'.[15]

The movement in its strong form waned quickly as its prophecies failed to be realized. In some areas ceremonies were subsequently revived. But in others the energy of people moved in a different direction that neither involved a return to custom nor a perpetuation of the new cult. In Vailala itself, people began in the early 1920s to emulate the *hiri* trading expeditions of the Motu, who had ventured westwards with huge cargoes of pots, to return with supplies of sago, and new canoe hulls that they attached to their existing vessels. Peoples such as those of Vailala had earlier been engaged, on a far more limited scale, in seagoing trade in an eastwards direction, exchanging bows and arrows and locally grown tobacco for shell valuables. Their innovation was to export sago, not in return for pots, which continued to be brought to them by the Motu, but for ornaments, trade goods and money. There was thus something decidedly modernist in this venture; it represented a turn towards commerce and the acquisition of new things. But Williams also saw it – in terms influenced by the dominant functionalist thought of the time – as filling a gap, as substituting for the ceremonies and art-making activities that had been abandoned. Whereas the people had once been preoccupied with elaborate preparations for the *hevehe* and *kovave* ceremonies, their 'one thought' now, as one man put it, was to raise money. However, what they seemed passionately dedicated to was the all-consuming business of constructing great canoes, making sails and lashings, and preparing the sago and dyed sago-leaf skirts that formed their cargoes.[16]

Papuan Modernity and the Will to Change

The history of the Vailala movement suggests a way of rethinking the Gogodala events, and indeed the wider pattern of iconoclasm, that represents such a great rupture in the art history of New Guinea, and has parallels elsewhere in the Pacific. Whereas it generally seems obvious that sacred objects are destroyed by advocates of colonizing Christianity, it is clear that in the Vailala case something different, a broader experience of colonial modernity, lay behind the will to change. The participation of men in migrant labour, their experience of a plantation regime, and their contact with colonial authorities, institutions and

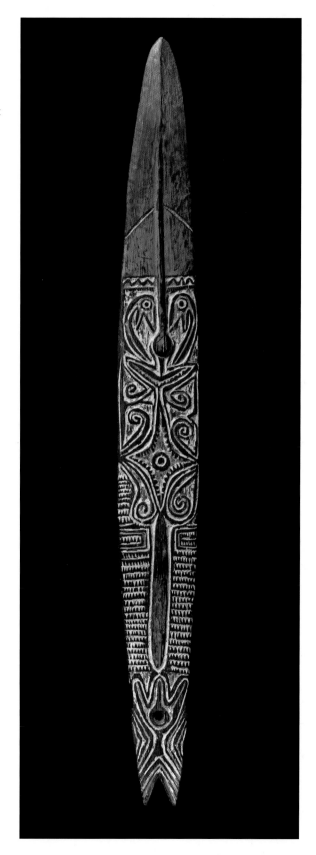

Still from travelogue documentary *Mondo Cane* (Italy, 1962).
Vidcrest/Cyclone Productions.

This controversial, avant-garde documentary featured practices from around the world that the director considered appealing or bizarre. Although some cultists did mock up aeroplanes in this manner, this particular plane may have been created for the film.

symbols all loom large among the precedents of what seem typically to be sudden and sweeping waves of iconoclasm.

'Cargo cults' were much theorized by twentieth-century anthropologists, albeit in terms that have since been questioned.[17] The assumption that they reflected traumatic responses to the might of Western technology was sometimes expressed naïvely or paternalistically, but there is no doubt that local peoples in fact found steamships and aeroplanes extraordinary and impressive. It was inevitable that young men from many communities would see Europeans as bearers of exceptional and unprecedented kinds of power and creativity. This attribution of superiority to whites did not prompt an attitude of inferiority or servility, however, but rather stimulated interests among Melanesians in how they might reproduce or appropriate such capacities. Some myths, in which ancestral powers had long ago been lost, were reinterpreted to account for colonial inequalities – it was supposed that valuables or magic had local origins, but through acts of trickery or theft had been carried off to the West. 'Cults' such as that of Yali on New Guinea's north coast were essentially schemes to repatriate or recover such powers, which had originally belonged to ancestors and belonged properly to the place.

The intention here is not to generalize about millenarian movements, which have too often already been disembedded from local contexts for comparative theoretical purposes. It is rather to draw attention to the ways in which colonial circumstances took young men out of customary milieux and exposed them to entirely different worlds, organized not by clans and distinctions between the initiated and the uninitiated, but by the rigorously disciplined and hierarchical regimes of labour camps and mission stations. These passages brought men from different parts of New Guinea together, who compared their backgrounds, understood their affinities, and perceived the gross distinction between customary lives and Western modernity. Reactions to this wealth of novel and challenging experience no doubt varied. Some, even many, perhaps valued customary life more than they ever had, and were happy to return home, to use earnings to enhance their status in customary terms. But others certainly made comparisons that devalued local practices and ceremonies, which were now stigmatized as old, foolish or backward. The efforts of Elemowa and others among Gogodala were not so much an offshoot of white missionary endeavour as a symptom of a wider 'modernist' sentiment that emerged among Melanesians. For the peoples of the coast and hinterland (as opposed to the Highlands), this was particularly a development of the 1910s to the 1930s, decades over which colonial commerce and migrant labour expanded considerably.

Towards the end of the twentieth century, anthropologists became interested in the emergence and increasing elaboration of ideas of *kastom* (custom) among Melanesians. This was not an 'invention of tradition' – in the sense of the concept of the concoction of what become supposedly traditional practices. It was rather the revaluation of ancestral ways in explicit opposition to those associated with modernity and the West. In some contexts custom was opposed to the Church; but more often it was juxtaposed with commerce, with *bisnis* in pidgin. Diverse practices were rhetorically subsumed to 'ways' associated with past and future, local and foreign, custom and money.[18]

Though this rhetoric became more conspicuous in political debate about the options facing Melanesian peoples and nations during the 1970s, in the years leading up to and succeeding independence, it is very likely that, decades earlier, native people – and particularly the young men who were in effect overthrowing elders – were already thinking in these terms. Ceremonies and ceremonial objects had always had meanings, related to the beliefs around initiation, death and so forth, that they enacted. But they came in

ONE DAY SHE WOULD SEND GIFTS

Hoiri…learned from his father that his mother's spirit would still be with them until the day a feast was made to forget her. It was vitally important that this feast to release her be not delayed any longer than necessary. The earlier she arrived in the place of the dead, the better for her. Besides it was not fair to keep the whole village in a state of mourning. They must be freed to beat the drum again….

The great day came at last…. By night time all the food had been eaten or removed. From now on, any reference to Hoiri's mother would be made in the past tense.

Hoiri was sad to think that his dear mother's spirit was to be leaving for ever early next morning. Once she had passed the villages in which people had known her during her life time, her body and spirit would be reunited. Hoiri was comforted by the knowledge that his mother lacked nothing to enable her to make her trip comfortably. His father had provided her with everything at the funeral. Before she was lowered into her grave she had been given a string bag full of roasted balls of sago and coconuts, a lamp and a knife to defend herself with. The more Hoiri thought about the dangers that lay in wait for her in this journey, the more he wished he could accompany her.

From his father he had learned about the cunning ferrymen and dishonest guest-house proprietors she was likely to meet on her way, who were only too ready to deceive and rob the unwary. But if she survived the journey, she would shed her dark skin and become a European. She would be in a land of plenty and one day she would send gifts to them.

From then on Hoiri kept trying to visualise this land of plenty his mother had gone to. Did she ever arrive there? And if she did, had she forgotten to send the goods to the loved ones she had left behind? Or were they intercepted before they reached their rightful owners? One day, he was sure, she would send these gifts.

From Vincent Eri, *The Crocodile*, 1972[i]

Portrait of a Papuan man from an unidentified tribe, c. 1910–50.
Photograph Frank Hurley.
National Library of Australia, Canberra.

addition to represent something at once more encompassing and quite specific. They became iconic, they stood for ancestral ways, for the 'bloody New Guinea somethings' that Williams's informant disowned. Those 'somethings' were juxtaposed with other somethings, modern ones, that this man and others, young radicals in the context of this society, thought their communities needed to embrace. The work of embracing them necessitated both the demystification of art – the undoing of the secrecy that had empowered it – and the destruction of the objects themselves. Though some missionaries certainly destroyed artefacts, or pressed for their destruction, this was in many areas not primarily a missionary project. It represented rather the price of modernity, a price that some were eager, and some very reluctant, to pay.

These chapters have reviewed the history of art in New Guinea, a history shaped by population movements, shifts in environment, economy and exchange, over centuries prior to European contact, as well as the decades since contact got under way. Art was vital to the dynamics of relations between groups, to the power asserted by some over others. Art was integrally associated with great trading systems, elaborate ritual cycles, and the business of war that loomed large, right across the island. The ramifications of colonial intrusion were more various than might at first be imagined. Colonial pacification shut down certain domains of practice, not only fighting itself, but also the systems of ritual and exchange that were closely linked with it. Some works of art directly associated with headhunting or other kinds of fighting were confiscated or suppressed, or were simply no longer made. Yet pacification also created new conditions, in some cases, in which other activities and the art genres associated with them flourished. In this chapter we've seen that for all the enormous importance of the transformation, conversion to Christianity had an impact on art that was part of the larger effect of modernity, of the ascendancy of labour and the market, of the point when 'European contact' was succeeded by 'capitalist colonization'. These processes have only been sampled highly selectively in this discussion. A great deal more might be said – and has been said in specialist studies – about the complex and uneven interplay of indigenous, regional and global histories upon material culture and art in various parts of New Guinea.

Creating Collections

But there is one further dimension of the history that must be considered briefly here: and this is collecting. The fact that many indigenous art traditions are represented today, not in their countries of origin, but largely in metropolitan museums, is notorious. From the time of decolonization onward it was often argued that unjust appropriation could only be redressed by wholesale repatriation. This view has to some extent been qualified. Weak governance in many of the independent nations is seen to prejudice the longer-term care of artefact collections within nations of origin; some feel it makes more sense that works remain secure in professionally run museums in wealthier nations. More positively, collaborative relationships have emerged between curators and members of indigenous communities, leading to productive exchanges of knowledge, historic documents, images and so forth. The interest here

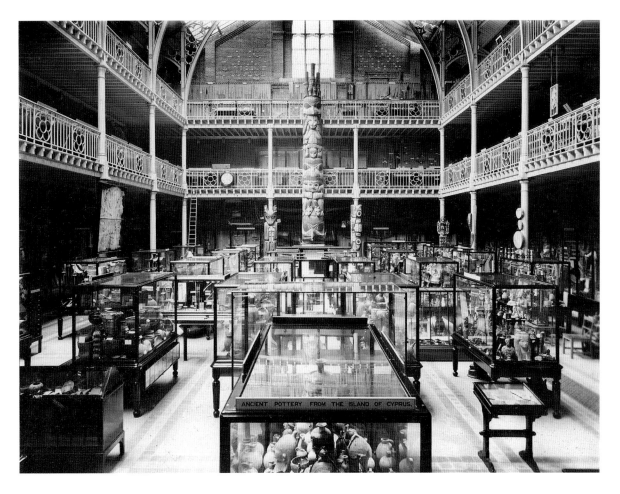

is not in adjudicating the issues, but rather in going behind the debate to consider what collecting actually involved and how it too was a formative process, for New Guinea art history.

The European collecting of New Guinea artefacts began early. Edward Belcher made one of the earliest collections from west Papua during the cruise of HMS *Sulpher* between 1836 and 1842, and in 1846 participants in the voyage of the *Fly* appropriated a number of objects from a longhouse named Buniki, on the Bamu River.[19] Some though not all of these artefacts in due course reached the British Museum in London. But there is an important distinction to be made between the history of collecting in western Melanesia and New Guinea and the pattern and chronology in eastern and northern Oceania. Artefacts from Tahiti, for example, were obtained early on by navigators and subsequently by missionaries and traders. Private collectors and institutions had interests in the material but there

was as yet no academic study dedicated to it, nor were museums yet oriented specifically to the acquisition or analysis of the artefacts of tribal peoples.

Anthropology became more formally defined only in the latter part of the nineteenth century, and it was then that specifically ethnographic museums were established. The Peabody Museum at Harvard University, set up in 1866, was one of the earliest, followed quickly by Berlin's Museum für Völkerkunde in 1873 and its sister institution in Hamburg, in 1879, and the Pitt Rivers in Oxford, and the Museum of Archaeology and Anthropology in Cambridge, both in 1884. These decades, and those that succeeded them, were also the first involving intensive contact in New Guinea and the neighbouring islands. Though collecting continued to be undertaken in a more or less sporadic way by missionaries and other travellers, research teams based in universities and museums began to visit regions, with the making of collections

'EVERY MAN'S HOUSE HERE IS A MUSEUM'

Within one month I have seen the camps of three distinct groups of
investigators from the Berlin Museum – just beyond, in the Solomons,
were three British investigators, one of them collecting for the New
York Museum; the other day I dined here on the S.S. *Peiho*, 800 tons,
chartered for two years by the Hamburg Museum, and fitted up as a
floating workshop and filled with investigators. Practically every German
in the colony is a collector – the higher officials for the love of their local
Museum at home – Berlin, Dresden, Munich, Cologne, Hamburg, Bremen,
Strassburg, etc., etc.; the lesser officials for gain – shipping their material
to dealers at home or in Sidney *[sic]*. Every traveler through here carries
away old 'curios' – a mask, a bundle of spears, a bundle of bows and
arrows, a carved bowl, a carved drum. The missionaries are all collectors
of ethnological material, and the most of them are 'on the make.' Every
man's house here is a Museum. My landlord here at the hotel will sell you
material from St. Matthias where no white man has yet landed. There are
whole regions in New Guinea where everything has been swept away by
missionaries, traders, collectors and investigators.

There is still much to be done. But if we are to play our part we must
be quick! Literally every day, every hour, is precious – this is especially
true of all this region under German rule; they are colonizing with a
vengeance. It is not only now or never, but what costs a fish hook, or
a stick of tobacco today, costs a mark tomorrow, and four marks next
week – and that's the end of it.

George A. Dorsey, curator, collector and anthropologist at the Field Museum, Chicago.
Excerpt from a letter to F. J. V. Skiff, Director of the Field Museum, Chicago, 8 August 1908[i]

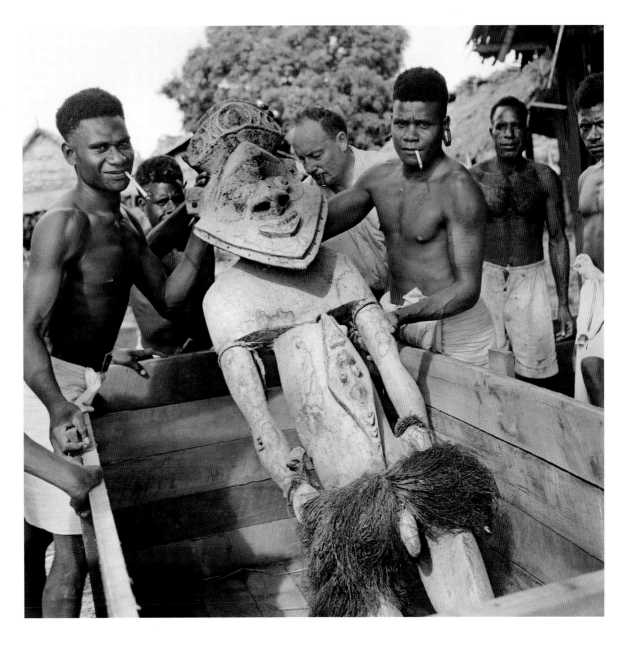

being one of their main aims, or indeed their pre-eminent aim. At the same time, awareness of their activities, and of the considerable sums that the German government, in particular, was investing in anthropology, motivated colonists such as planters and traders to dedicate their own time and energy into making major collections, with a view to selling them on. Some museums also tried to finance their activities by selling so-called 'duplicates' on to other institutions. Large-scale exchanges of specimens were also relatively common. There was a scramble for the art of the South

Seas, and of New Guinea in particular, marked by a potent mix of scientific and commercial motivations.[20]

In the mid-1880s the Neu Guinea Compagnie sponsored a hybrid colonial-scientific expedition under the leadership of Otto Finsch; a major collection of 2,128 objects was in due course sold to the Berlin Museum. The Cambridge 1898 Anthropological Expedition to the Torres Strait obtained nearly 1,300 pieces. Extensive collections were similarly made by the Hamburg Südsee Expedition of 1908–10, which worked extensively in Micronesia as well as investigating the

A. C. Haddon on Decorative Art

|N A LETTER TO HIS YOUNG SON
Ernest, written from Thursday Island in the
Torres Strait in 1888, Alfred Cort Haddon
described a dance performance he had
witnessed and indeed solicited. He made
a sketch of the dancers and in a simple act
of cultural translation he compared their
performance to his son's familiar world back
in Britain: 'instead of a piano, someone beat
a drum'.[i] Then he added a drawing of a drum
he'd acquired, promising to show it to him on
his return. In fact, Haddon acquired some 250
native artefacts from the region, staging a
public exhibition at the British Museum in 1889.

Haddon had spent eight months in the
Torres Strait between 1888 and 1889 as a
zoologist researching coral reefs. During this
time, galvanized by conversations with
missionaries and Islanders about what the latter
did 'before the white man', his scientific interests
turned increasingly towards ethnology. Moved by
a desire to salvage knowledge about ways of life
and material forms he believed were changing
irrevocably, he elicited ethnographic information
from locals, made word lists, recorded customs,
acquired and documented native artefacts, and
coaxed Islanders to demonstrate songs and
dances. A decade later, Haddon would return
to the Torres Strait as the leader of a landmark
anthropological expedition, even more intent on
gathering information 'before it was too late'.[ii]

Between these two visits, Haddon's special
interest as a zoologist-turned-ethnologist (and
eventually anthropologist) was in decorative art
and design. In the mid-1890s, drawing in large
part on his first experiences in the Strait, he
published several papers on the subject as well

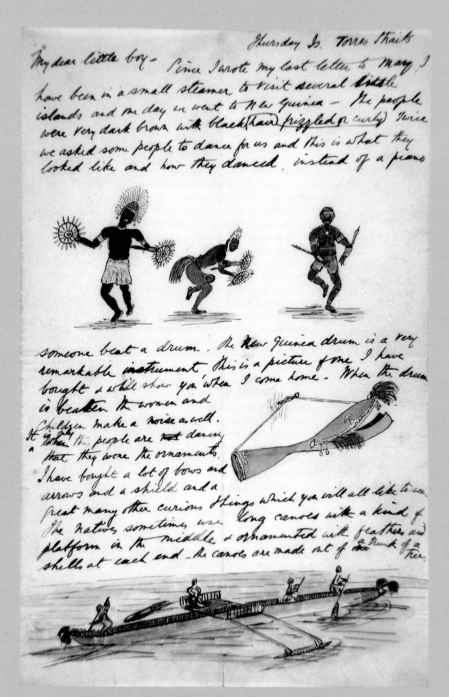

opposite
A. C. Haddon, illustrated letter to his son, 1888.
Haddon Manuscripts, Museum of Archaeology and Anthropology, Cambridge.

above
Bird and Crocodile Designs from the Massim District. Plate XII from A. C. Haddon, *Decorative Art of British New Guinea: A Study in Papuan Ethnography*, Dublin: Royal College of Science, 1894.

as two books: *The Decorative Art of British New Guinea* (1894) and *Evolution in Art: As Illustrated by the Life-Histories of Designs* (1895).[iii] These too were cultural translations: on the one hand, Haddon was meticulous about the accuracy of his facts and the need for more of them; on the other hand, he was deeply embedded in the concerns and questions of his own place and time: the scientific milieu of imperial Britain at the turn of the nineteenth century. Nowhere is this tension more apparent than in his efforts to marshal his ethnographic data to illustrate evolutionary principles. He produced elaborate tables and charts; planned exhibition layouts; coined new terms and concepts ('heteromorphs', 'biomorphs', 'anthromorphs', 'survivals', etcetera); and drew close analogies between biological processes and the transformation of designs. The latter, he suggested, could be 'studied in the same way as a zoologist would study a group of [a region's] fauna, say, the birds or butterflies'.[iv]

A central concept in Haddon's mind was that of the 'life history' of designs, the idea that morphological changes in decorative objects occur in almost organic ways. Premised on the contention that designs first originate in realistic representations of their models in nature, the plate opposite, for example, would show various 'degenerations' of a conventional bird-and-crocodile motif, found on the handles of paddles, spoons, spatulas and the like from the Massim district of south-east New Guinea and its nearby islands, the final image (bottom-right) described as the 'last stage in the decadence of this motif'.[v] These are strange ideas, themselves now in need of historical translation across the gulf of time.

In recent efforts to re-evaluate the legacy of Haddon's work, Anita Herle reinterprets his notion of 'life-history' to refer not just to the transformation of designs over time but to the way objects can mediate social relationships between people across cultures, places and time.[vi] One of the contradictions of Haddon's work was the rich texture of his interpersonal relationships with Torres Strait Islanders – visiting friends, attending funerals, sending letters, giving gifts, sharing meals, etcetera – and their complete omission from his scholarly books. His account of those experiences was relegated to the realm of the private or the popular: to diaries, letters, photo albums, magazine articles, sketches and popular books. Yet ironically, in them he was never closer to the living dynamics of the cultures he otherwise thought were dying. PB

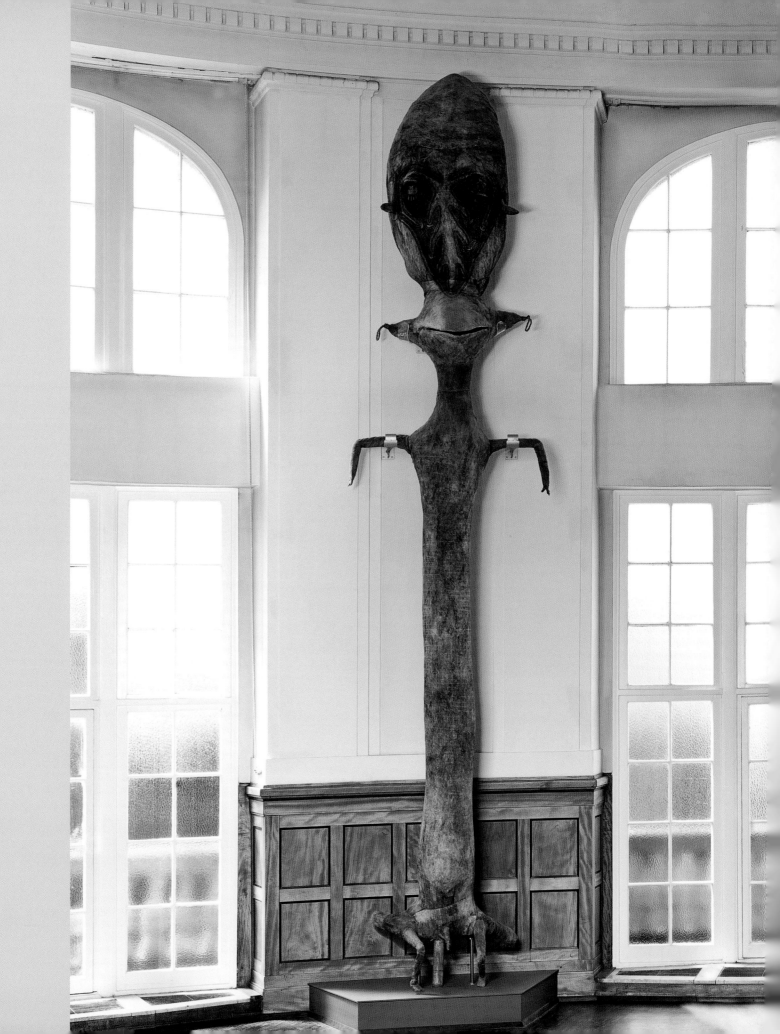

Sepik and the Admiralty and St Mathias Islands. A sense of the ambition of these ventures can be gleaned from the six volumes of reports of the Cambridge expedition, and the thirty eventually generated by Hamburg's. Between 1886 and 1916 one P. G. Black, an agent for the Sydney shipping company Burns Philp, accumulated some 6,200 artefacts that were later bought by the Buffalo Museum of Science in the state of New York. These and similar accumulations were, however, dwarfed by that of Albert Buell Lewis, who obtained some 12,000 objects for the Field Museum in Chicago during an expedition over 1909–12.[21]

At the local level, acquisitions on this massive scale had diverse local consequences that cannot be explored in detail here. But it is clear that in some areas production both for local use (to replace objects that had been sold) and with a view to sale increased. Secondly, objects that were novel, not samples of local material culture in use, began to be made, or were made more systematically. Scale models of things such as canoes and houses that were too large for most collectors were produced on commission, and will be extensively encountered in museum stores today, especially in Germany. These were not unknown in local culture – model canoes had for instance earlier been made for children – but were now made on an unprecedented scale. And ritual objects, or copies of ritual objects, were made on commission if the genres sought by ethnographers were for whatever reason not available at the time. Among the most spectacular objects of this latter kind are a pair of 7-metre-high barkcloth figures made by Baining people of east New Britain for members of the Hamburg expedition (*previous pages*).

In other words, at a time when New Guinea cultures were supposedly dying out, their material culture was acquiring new dimensions and a new complexity. 'Traditional' artefacts were being made anew, objects that were deliberately 'representative' were being created, and complex ritual assemblages were for the first time being 'modelled', their essentials captured on a reduced scale. Each of these operations suggests that local artisans and artists were reimagining what they did. Even when they made the same things, they were making them with new ends in view.

That this process entailed not only creativity, but cunning, is suggested by the extraordinary history of the artefacts known as 'man-catchers', which for a period loomed large in accounts of Papuan weaponry, and were eagerly sought by some collectors.[22] The well-known LMS missionary James Chalmers was one of the first to draw attention to this genre of object, which featured in a spectacular and horrifying frontispiece to the book of missionary propaganda he co-authored with W. W. Gill, *Work and Adventures in New Guinea* (1885). A commentary upon this image asserted that Islanders displayed skill only in fabrication of deadly weapons, such as the man-catcher, which was ostensibly used 'all over the vast island'.[23] The artefact consisted of a rattan loop that incorporated a deadly spike; the former enabled a fugitive to be caught, and the latter was used, presumably with a vigorous jab, to kill him. Numerous commentators cited these weapons as evidence for the esoteric and extreme savagery of the people of the region.

These sound very much like inventions of colonial ideology, but some eighty, and perhaps several hundred, actually do exist in museum collections and most have secure provenances to the region and to the 1880s. Yet, as Michael O'Hanlon has demonstrated in a brilliant investigation, there is something basically implausible in the descriptions of the supposed weapons' use. Their loops are relatively small, in some cases could not easily fit over an adult's head, and in others are too delicately constructed to be used effectively to capture any person who was trying to resist. The operation described is moreover far more difficult to execute than either spearing or clubbing a victim. Even at the time, more astute observers, such as the administrator William MacGregor, who also had less of a stake in the genre of colonial horror stories than missionaries who needed to excite supporters and raise funds, stated that he thought it unlikely that the implements were ever actually used, without clarifying whether he considered them fakes of some sort. Finally, and intriguingly, the handle and spike in many examples are formed from a spear, or a separate spike is made from an arrow; 'this fact of manufacture from surplus weaponry seems anomalous'.[24]

O'Hanlon carefully considers various potential explanations for these objects, such as the possibility that man-catchers were indeed created for the purpose Chalmers attributed to them, but were ineffective, a failed technology, and that they might simply have been misrecognized; they might have been dance

previous pages
Figures, Baining people, New Britain, late nineteenth–early twentieth century.
Painted barkcloth and cane frame. Height 720 cm (23 ft 6 in.). Museum für Völkerkunde, Hamburg. Photograph Paul Schimweg/Whitehall Photographie.

Though shown in New York in the Museum of Modern Art's famous and controversial exhibition, '"Primitivism" and Twentieth-Century Art', these astonishing 7-metre figures, in storage until a few years ago and difficult to photograph, have hence been seldom published and have not become part of the Oceanic art canon, as they might have been.

implements, for example. But it is notable that the bulk are believed to have been obtained from Hood Bay, not far south-east of the later colonial capital of Port Moresby. This area was missionized early, frequented not only by European but also Chinese traders, and considered a topographically beautiful stretch of coast, inhabited by 'fine' natives, in fact a destination for early tourist cruises from Australia. In this context, the unprovable, but most likely, explanation for their existence is that their making was somehow stimulated by European interest. It is clear that the preoccupation of Europeans in Fiji with so-called 'cannibal forks' encouraged Fijians to make forks for sale that were never used to consume any flesh, animal or human, and indeed white men were prompted to fake such artefacts, which visually epitomized Fijian savagery.[25] We can only suppose that some Europeans, seeking after weapons and perhaps also bloodthirsty stories of headhunting days, gave people the idea of creating a headhunting tool, where none had in fact existed.

This contraption probably had a much shorter local life than it would enjoy in colonial representation, though it may briefly have been a lucrative invention for its makers. In a sense it represents an inappropriate ending for a discussion of the arts of New Guinea over extraordinarily fertile centuries and decades, which generated genuine masterpieces of myriad sorts, and in their thousands. But in another sense this singular local experiment provides the right conclusion. What was and is New Guinea, if not a mass of singular and inspired local experiments?

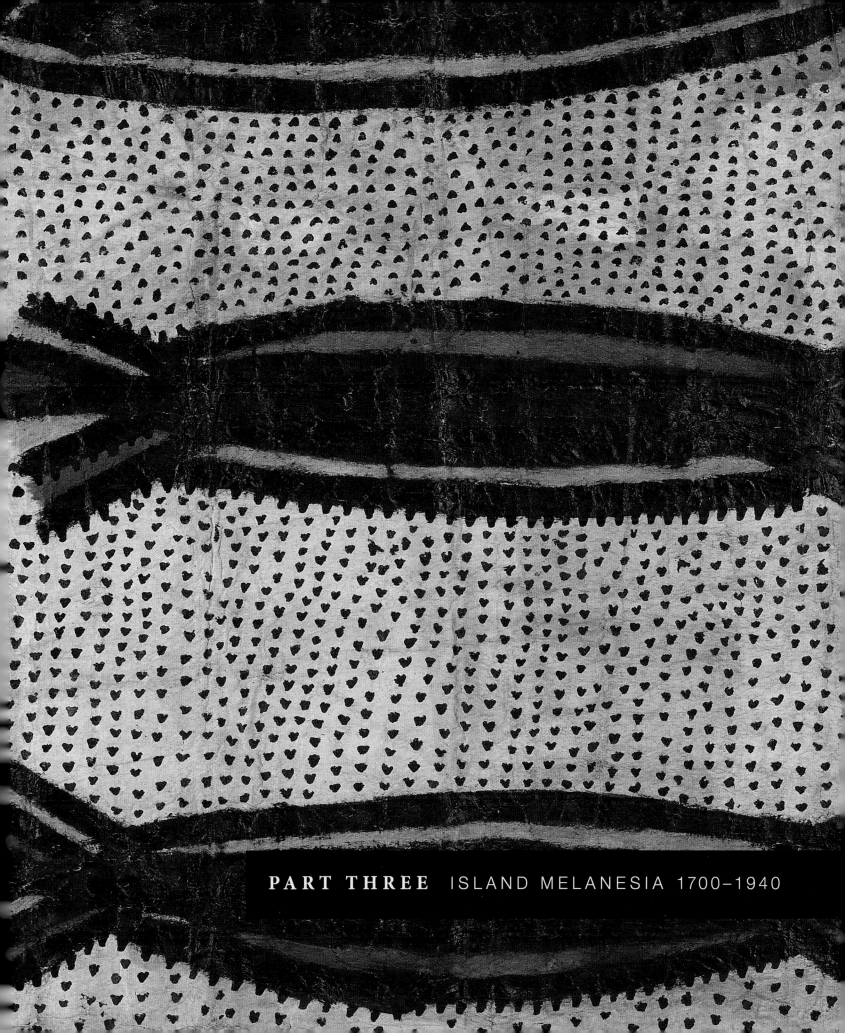

PART THREE ISLAND MELANESIA 1700–1940

Lissant Bolton

PLACE, WARFARE AND TRADE
1700–1840

opposite

Kanak men and women in front of a native dwelling known as a *grande case*, New Caledonia, 1874.

Photograph Allan Hughan. National Library of Australia, Canberra.

Just as churches were once the landmarks and centres of European villages and towns, the human environment in New Caledonia was constituted around great houses and ancestral figures. Adjacent dance grounds were the sites for mortuary and harvest ceremonies among other communal activities.

right

Club, Vanuatu, collected in 1774 on Cook's second voyage.

Casuarina wood. Length 76 cm (30 in.). © Pitt Rivers Museum, University of Oxford.

Participants in Cook's voyages were dealt with cautiously by most ni-Vanuatu. Meetings mostly took place on beaches and only on Tanna were the visitors permitted to venture inland. As a result, objects later considered representative of the art of north Vanuatu, such as *rambaramp* funerary effigies and carved slit gongs, were neither sighted nor collected: the Cook collections from Vanuatu are limited to objects such as weapons and flutes that men carried about their persons.

Island Melanesia has a long and complex history, only parts of which are now known. It has been settled over many millennia, and over time those populations have expanded and contracted, and shifted from place to place. When Europeans first entered the region in 1568, a network of independent polities existed across it: people lived in demarcated and often contested territories, spoke many languages, had many forms of knowledge and practice, and were interlinked in overlapping regions of connection by warfare and trade. Canoe voyaging took people great distances in search of goods, knowledge, land and persons (sometimes as heads and other trophies of warfare), and brought them back to their places of origin. They traded for food and raw materials, and they also traded for valuables, skilfully and artfully made objects that were precious for their rarity, their materials and associations. This chapter considers life in island Melanesia before significant European incursion. It focuses on those aspects of knowledge and practice that disappeared quickly after Europeans arrived in significant numbers, after about 1840. The main themes of this chapter are people's knowledge and use of landscape and place, warfare and long-distance trade connections; and it focuses on the Solomon Islands, Vanuatu and New Caledonia.

As discussed in the chapter 'Aesthetic Traces', the length of settlement in the west of this region is hard to grasp: archaeological evidence suggests that the western Solomon Islands have been settled for about 30,000 years, while the eastern islands of the Solomons, Vanuatu and New Caledonia have been settled over the last 3,200 years. The first Europeans to visit these islands were members of the Spanish expedition led by Álvaro de Mendaña de Neyra, who came upon and named the Solomon Islands in 1568.

Mendaña's expedition was followed by several similar expeditions, most famously those of Captain Cook, who mapped islands in Vanuatu and New Caledonia in 1774 during his second voyage to the Pacific. Cook and other members of his expedition collected a number of objects in these islands, most of which were weapons. Although earlier expeditions may have collected objects, the items acquired by Cook's ships on their landfall at Port Sandwich, south-eastern Malakula, Vanuatu, are the earliest collections now known from the region. These are not the oldest artefacts now found in museum collections, for there are objects collected later that were indubitably made earlier, but they do represent the earliest date of collection.

Part of the Forster collection now in the Pitt Rivers Museum, Oxford, is a club collected at Port Sandwich, Malakula, Vanuatu, in July 1774. Kirk Huffman identifies it as a 'rare type of high-status club' that signifies links between south-east Malakula and west Ambrym, north Ambrym and south Pentecost.[1] Although the club was very likely made where it was collected, it appears that this, one of the first objects ever collected by Europeans in island

161

Melanesia, was an item in a ritual network that linked a number of adjacent islands and regions. This kind of club could be used as a weapon, but also in ceremonies and as a dance club. It was above all an object that related to a complex system of status enhancement: it would have been owned by a high-ranking man, and would have signified his status as someone to be treated with respect.

After Cook, the pace of European involvement increased gradually, as whaling and then sandalwood trading brought European ships into Melanesian waters from about 1820. There was no significant expatriate residence until around 1840, when both missionaries and planters began to settle in the islands. Most collections from island Melanesia were made after 1840, so the objects that illustrate this chapter are rarely from the period it describes. Records made by early visitors, together with indigenous histories, combine to provide a sense of life in the region prior to 1840, and the objects illustrated here are consistent with what is known about life in this period.

The recall of past events varies across island Melanesia. Although in some places people kept short records of preceding generations, allowing history to recede quickly, in other places many generations are remembered. Central Vanuatu histories and songs recount long genealogies.[2] There are three sites on Tongoa, central Vanuatu, where sequences of up to fifty memorial stones represent successive holders of chiefly titles. These are linked to oral histories. Major events – most notably the eruption in 1452 of a volcano on a central Vanuatu island called Kuwae – are recorded in these histories. At one site David Luders counted forty-seven such memorial stones, twenty-six of which were identified for him as representing title-holders whose lives preceded the Kuwae eruption.[3]

Long generational records are also remembered in parts of the western and central Solomons. In Malaita more than twenty generations are recalled. As Ben Burt describes for the Kwara'ae people of Malaita, these genealogies are important for the present in establishing relationships of precedence between individuals and between clans, and, not least, for the validation of claims to land. It is not always easy to translate these genealogies into histories in the Western sense; they are political records that legitimate present positions and privileges. Burt comments that while

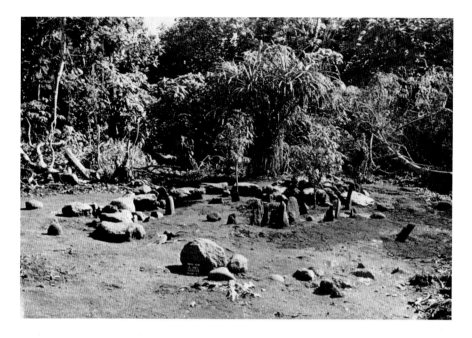

Sacred stones, Mangarisu, Tongoa, Vanuatu.

most Kwara'ae agree on the common descent of their people from one group of founding ancestors, there are many contradictions among the genealogies of major clans with common ancient ancestry. In pre-colonial times Kwara'ae society was 'riven and fragmented' by chronic feuding.[4] The Kwara'ae remembered enmities for as long as they remembered genealogies, but genealogies were kept confidential, so that there were always many contradictions and disputes about the specifics of the relationships that genealogies created for the present. These genealogies were formerly reinforced through the ancestral religion, in which ghosts of the dead were worshipped for the power they held over their living descendants.[5]

Early visitors to Melanesia assumed that Islanders were narrowly restricted to their own immediate areas and had no knowledge of places further afield – that Europeans were the first strangers to land on each island shore. In fact, as the Cook collection club suggests, and as indigenous histories and memories reveal, this region was alive with frequent movement and encounter, which extended well beyond those islands visible on the horizon. The people of the Torres Islands in northern Vanuatu not only had connections to the nearby Banks Islands and to the south-eastern Solomons, but also maintained a trade link to the Loyalty Islands about a thousand kilometres to the south in New Caledonia.[6]

'THE VILLAGE WAKES EARLY'

The village wakes early. On a normal day its people throw back their bark-cloth blankets soon after sunrise, push aside their thatched doors with a rustle and straggle out into the cool morning air. They stroll down the beach or to the lake shore to attend to the calls of nature and to bathe, performing their toilet in full view, though at some distance from each other. The men, as a rule, bathe more thoroughly than the women. After the toilet they return up the beach and chat about the night's fishing or exchange other gossip. On going back to their houses they find the floor cleared of bedding and the smouldering embers of the fire blown into a flame by someone who has stayed behind – a child, an old person, or a woman nursing a baby. A kit of cold food, remnant of the meal of the day before, is lifted down from its hook and anyone who wishes helps himself. Ends of taro or slices of breadfruit are doled out to the children, who run out munching. Their elders eat indoors. This food is eaten quickly and without ceremony, and soon afterwards the able-bodied members of the household scatter to their work. This varies according to season and to whim; personal choice is allowed great play so long as food is procured. Fishing or work in the orchards absorb the men and some of the womenfolk; others stay behind to look after young children, beat barkcloth, or perform household duties. It may take an hour or more up to the cultivations on the plateau or round the crests of the hills, so that the workers start early. The morning passes in this way.

From Raymond Firth, *We, The Tikopia*, 1936[i]

'THE EEL IS *TABU* TO US'

The eel is *tabu* to us and we revere or respect its presence as a guardian of our tribal land and our crops because its protection will yield very good food vegetation, harvests and thus prosperity. I do not know how this came to be, but it is said eel fish can travel underground and make networks of little holes. As they bore in the soil core, this brings the water from the river, so that spreads right under our gardens throughout this land. That is the myth, therefore the eels are not to be killed or disturbed when we come across them…. We regard them as our *tabu* or *kokolo*… [they are] our immediate security to our land, and so to our food gardens.

This eel fish *kokolo* comes through my mother. It has become so much feared as food, we reserve it as something *tabu* for us. If I were to eat it then get a cut it would go watery on top and would not heal. If anyone outside our tribe gets a cut or wound the manner of cure for us is to spit on the wound it causes. Anyone from outside us it won't cure! That is the way we heal people, which also comes from the eel. My boys will not bring any eels to be cooked in my pots, saucepan or oven. It is *tabu* and my children know this. My children have fear and respect for it and must not eat it as the charm came through me to them….

Different lineages have different *tabus*. Some have the turtle, some eagles, to some like my wife Olive, it is the clamshell; to others, it is the coastal white pigeon.

From Lloyd Maepeza Gina, *Journeys in a Small Canoe:*
The Life and Times of a Solomon Islander, 2003[i]

People also moved within islands and across narrow straits of water. In the pattern of residence in island Melanesia, long residence in specific places is counterbalanced by an ongoing shift in populations as people moved and settled and moved again. As Mary Patterson observes for Ambrym, Vanuatu, people's sense of attachment to place is often composed both of an ancestral claim to it and a sense of ancestral claims to other places: in many places ancestors are remembered by their descendants precisely because they had come from somewhere else and had connections to other places.[7]

Landscape and Place

This long history, just because it absorbs a history of movement as well as stasis, contributes to Melanesians' deep knowledge of and attachment to place. This attachment is partly a matter of the way in which history is written onto a landscape as people remember and retell the stories of what happened there. It also reflects people's knowledge of the landscape in all its transformations, and their ability to draw upon its resources. There are also deeper aspects of the identification: in contemporary Vanuatu, one's primary identity is not with a kin or language group so much as it is with the territory from which one comes, one's place. This identification has deep roots in indigenous thought: in many Vanuatu islands, knowledge and practice – culture – is the outcome, the product, of the place itself. Joël Bonnemaison comments about Tanna, south-eastern Vanuatu, that in traditional thinking 'cultural identity is merely the existential aspect of those places where men live today as their ancestors did'.[8]

Language itself embeds people in the landscape. More than two hundred languages are spoken in island Melanesia: all but five of these belong to the Austronesian language family.[9] A common feature of Austronesian languages is an absolute spatial reference system, that is, location and movement are never described in relation to the speaker's location (as in English), but rather in reference to the landscape, so that movement is always expressed as being towards or away from the sea, upwards or downwards across the water.[10] An Austronesian speaker is always positioned in the landscape, the very structure of the language laying a foundation for 'a spatially defined sense of cultural belonging'.[11]

In this environment places also move. Earthquakes, volcanoes and cyclones make regular and sometimes substantial changes to the landscape, and there are many stories about islands that appeared or disappeared, and stones that walked. In Vanuatu there are stories about volcanoes moving between islands, of an island in the strait between Ambae and Maewo that sank beneath the waves, of other major features of the landscape changing their location. People also know the signs that predict some of these changes. Not many people are said to have died in the 1452 Kuwae eruption because a series of preceding earthquakes warned them to leave the island. Equally, people know the signs that herald a coming cyclone. A barkcloth collected in 1907–8 from Simbo, New Georgia, Solomon Islands, has recently been interpreted by Reuben Lilo, himself from Simbo, as being about bad weather. The design depicts frigate birds hovering in layers above the land, which is a sign of a coming serious storm, such as a cyclone.[12] In Vanuatu people still recognize the circling behaviour of certain birds above land as a sign of a cyclone on the way.

Knowledge of the skies, especially of the stars, has been less often retained in the present, but stars were formerly known and used in various contexts, including navigation. Some of this knowledge is retained on the remote island of Anuta, Solomon Islands, which was settled by people from Polynesia. As Richard Feinberg describes, Anutans nowadays sail to the islands of Patutaka and Tikopia, the journey to the latter taking more than twenty-four hours. At night navigators set their courses by a sequence of rising or setting constellations, the positions of the stars above the horizon marking the direction for sailing. In choosing constellations at which to set his course, the navigator takes into account the prevailing wind. Thus, sailing from Anuta to Patutaka with the wind to port, the navigator sets *Taro* (Scorpius) as his goal; when it rises too high above the horizon he aims for *Te Moomate* (probably part of Saggitarius), which rises in the same place, and after that for *Te Kope* (Grus).[13] People also used the movement of the stars to mark the changing seasons. On Lamen Island in central Vanuatu, people marked the time for planting yams by noting when a certain constellation (probably the Pleiades) moves to lie directly above the island.[14]

'Bad weather' barkcloth. Simbo, New Georgia, collected 1907–8.
Museum of Archaeology and Anthropology, Cambridge.

Barkcloths of this kind depict stories associated with marine resources and fishing expeditions. This design depicts frigate birds hovering in layers above the land.

Even more than the skies, people knew the seas. Coastal people, especially in the Solomon Islands, hold considerable knowledge of the fluidities of the coastline and of the sea, and may know the landscape of the sea as well as they know the shape of the land. The seascape, as much as the landscape, is marked by associations with histories, stories and legends. People know where certain fish, birds and other animals live, and they know the places of non-human beings, including spirits and ghosts, which also reside there. In many places the features of the sea – of the sea floor, and of the way the water moves above it – are named in the same way as features of the landscape.[15]

Melanesian knowledge of place is also a very practical knowledge of the various resources of the environment, and of the interrelation between those various factors. Edvard Hviding notes for Marovo Lagoon that 'The times of certain fish to be fat… abundant or…to aggregate in a certain spot for spawning or feeding, are marked with reference to moon, tides and currents, and also to certain visual signs on land, notably flowering, ripening of fruit,

Crescent pendant with frigate-bird motif, probably Malaita, Solomon Islands, before 1938.
Length approx. 25 cm (9¾ in.).
Pearlshell, turtleshell.
© The Trustees of the British Museum, London.

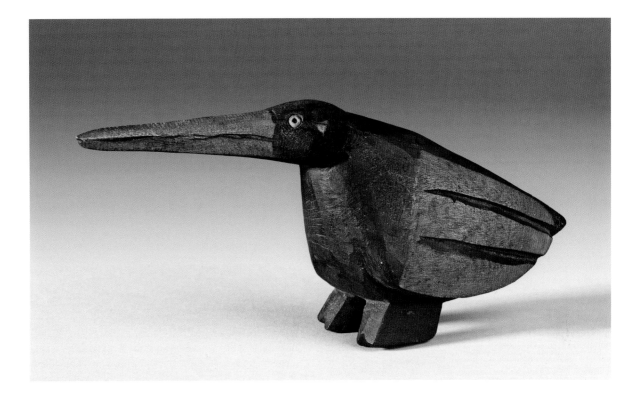

shedding of leaves and other seasonal changes in the vegetation'.[16] Sophie Nempan, from Erromango, Vanuatu, lists the cool weather indicators for starting new gardens:

> When the *narara* [Indian coral tree, *Erythrina* sp] sheds its leaves and its flowers bloom, when the south-east wind (*Noritutto*) blows to the west, and the bush is clear because leaves are falling, when the *nombo* bird lays its eggs, and hens do too, when the tides are low; and when women are cold, and their grass skirts are ragged and broken, when they make barkcloth, mats, grass skirts and baskets because there is lots of sun…these are the signs for men and women to work together to clear their gardens.[17]

Knowledge of fish and birds is also evident in species-specific depiction of birds, fish, snakes and other animals in material forms. Frigate birds were and are of considerable importance to fishermen in the Western Solomons: these birds, like the bonito, prefer certain kinds of prey, so that the presence of a flock of frigate birds is usually a sure indication that bonito are swimming in the water beneath them.[18] The distinctive hooked bill of frigate birds recurs frequently in Solomon Islands imagery, and sometimes the whole bird with its wide wingspan is depicted, as on a breast ornament from Malaita. The shape of the frigate bird in flight is depicted frequently across the Solomon Islands, also giving its name to abstract zigzag motifs. Similarly, a small carving, from the south-eastern Solomon Islands, is unlikely to depict an imaginary or generic bird, but rather to invoke a kingfisher. A barkcloth from Erromango, Vanuatu, has recently been interpreted by Jerry Taki (also from Erromango) as depicting two species of sea cucumber that Erromangans call *Ulrapulpul* and *Nagoti*, lying on the sand under the sea (*overleaf*).

People commonly both altered and marked places in a number of ways. Sacred places are distinguished with both planted and built markers, and trees or shrubs may be planted to indicate an event that occurred at a certain place. More substantially, the layout of villages and the construction of such important buildings as cult houses often reflect a particular perspective on landscape, and impose a model of social relationships on it. This is notably the case in New Caledonia, where the arrangement of a settlement was prescribed and

meaningful. The relationships between the residents of a settlement were formally laid out in the location and relationship of their houses to each other and to the clan house or great house, which dominated the settlement and embodied the presence of the clan ancestor. A broad central alleyway bordered by coconut palms led to the great house. Running parallel through the settlement was another alleyway lined with different plants. The main alley was regarded as masculine, the complementary one feminine. As Maurice Leenhardt recorded, at one end of the settlement, near the great house, a hardy dry vine was planted, while a succulent was planted at the other end. Dry is male, wet is female: the couple were 'inscribed upon the earth'.[19]

Across the main island of New Caledonia the great house (*grande case*) represented the ancestor of the clan in its very form. Towering above the other buildings in the settlement, it signalled the strength of the group and embodied the ancestor of that group in the carvings within it (*page 160*). Rising from the peak of the house's conical roof was a carved pole, depicting the ancestor's two-faced head 'which

contemplates the entire country', as Leenhardt describes it for the Houailou area.[20] This figure was often surmounted by a spire of white shells, the topmost containing a piece of sacred or totemic plant. Figures carved in bas-relief flanked the door to the house, often representing male and female; inside the building are further carved poles. Leenhardt comments that 'although the faces vary the theme is always the same: they are representations of the ancestor and mark his presence.'[21]

This great house acts as the centre of the whole landscape: it is not a retreat from the wilderness but rather an expression of continuity with it. Every part of the landscape is significant. Leenhardt observed that in New Caledonia 'a group's habitat is not delimited by the palisades of the dwelling…[but] includes the whole domain over which radiates the ancestors' power or that of the gods or totems. Landscapes, village outlines, the society, the defunct men, and mythic beings form a single ensemble, not only indivisible but even practically undifferentiated.'[22] Leenhardt's argument is that New Caledonians made no strong distinction

right

**Chief's house spire.
Bourail-Houailou area, New
Caledonia, late nineteenth–
early twentieth century.**
Wood. Height 221 cm (87 in.).
Australian Museum, Sydney.

far right

**Chief's doorway panel, Kuvia
village, Houailou area, New
Caledonia, acquired 1923.**
Wood. Height 191 cm (75¼ in.).
Australian Museum, Sydney.

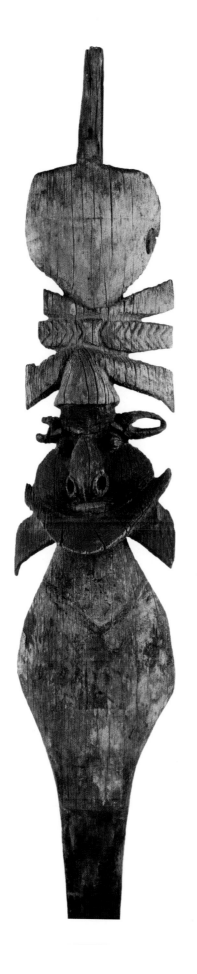

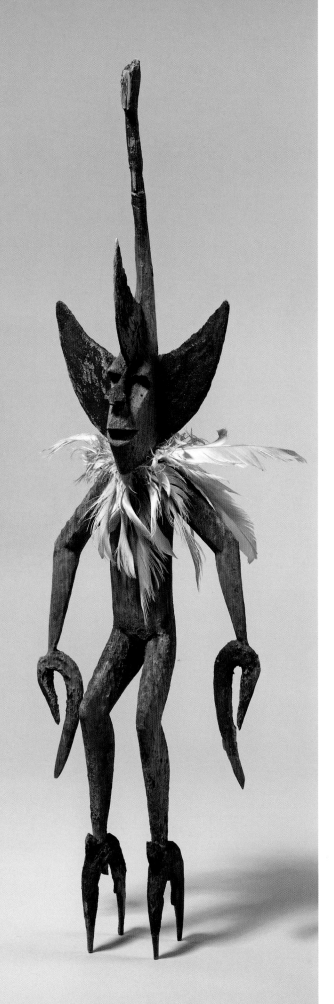

between themselves and other aspects of the world around them: 'There [was] no clear distinction between self and world: the same flux of life circulates in the body, in the sap of a plant, in the colours of a stone'.[23]

In the bush surrounding the settlement and its associated gardens, New Caledonians hid consecrated places – altars or skull sites – where the people could interact with the spirits. Leenhardt argues that the skull place is the true support of the group's spatial and social domain.[24] The relationship between the living and the dead depended on the presence of the mortal remains, which were an essential means for summoning the deceased and asking for their help and good will,[25] and the strength of a community was a reflection of the number of its members, both living and dead. For the dead to add to that communal strength, their remains must be buried in clan land.

The dead were only one group among the many other kinds of beings that all island Melanesians recognized as co-inhabiting the landscape with them. Recent and ancient ancestors, spirits, and other beings were all understood to be co-resident in the landscapes and seascapes, although the specific make-up of these populations varied from place to place. Everywhere, however, the influence of these beings was recognizable to the communities who lived with them, and their characteristics needed to be managed and utilized through a number of different strategies. In 1908 on Simbo in the Western Solomons, the ethnographer Arthur Hocart listed fourteen different kinds of ghosts and spirits, and over twenty different kinds of 'gods' – beings that were creatively or actively powerful. Such beings may have had merely nuisance value – mischievous in the tricks they played on people – whereas others were dangerous and terrifying, and yet others were sources of critical knowledge and creative innovation.[26]

On Ambae, in north Vanuatu, the story about the development of a highly valued textile called *vola walurigi* concerns a kind of non-human person called a *mwae*: invisible beings like people but who had some non-human characteristics. In the story a real woman, Tambetamata's wife, saw a woman *mwae* dyeing a textile with a pattern that was very, very beautiful. Tambetamata's wife asked the *mwae* to show her how she made the design, and the *mwae* showed her, but Tambetamata's wife forgot the details of how to do it.

Sea spirit figure, Makira, Solomon Islands, collected during the cruise of HMS *Royalist*, 1890–3. Wood, feathers. Height 72 cm (28⅜ in.). © The Trustees of the British Museum, London.

**Vola walurigi textile,
East Ambae, Vanuatu,
twentieth century.**
Length 114 cm (44⅞ in.).
Australian Museum, Sydney.

Then the *mwae* appeared to her in a dream and told her that the design was on the beach at a place called Natora – it was, and remains, incised on a rock by the sea there. The *mwae* can be understood, at one level at least, as an embodiment of the landscape – as place made into person. The *vola walurigi* design also depicts the landscape. It is a picture of the hills that go down to the coast, rather like the contour lines on a map showing a ridge that reaches from the volcano to the sea.[27]

In the Central and Western Solomons ghosts of the dead were powerful unseen members of the community who could be invoked to assist the living. They were made into ancestors through a process by which their spirits were captured within a specific place in the landscape: a shrine. Shrines were critical locations for the establishment and maintenance of relationships between the living and the dead as ghosts. In New Georgia, the Western Solomons, a death was a moment of extreme danger, in which the person's non-material aspects left the body, and must be recaptured and properly disposed, so that the soul-shadow departed to the after-world, but the person's worldly efficacy remained as a spirit, safely located with the skull on

a shrine, 'potent and dangerous but trapped and able to confer blessings'.[28] The objects placed on a shrine were put there to 'complete' the body of the spirit so that it could respond to the wishes of the living. Possessions of the dead person might be broken and placed on the shrine to embody his or her continuing efficacy, while the skull was usually encased in shell rings lashed with vine (*overleaf*). The jaw would be tied shut and rings placed over the eye sockets and ears as proxies for the senses, so that the spirit could hear and see the wishes of the living. The shrine became a place where the living could communicate with the dead. Shrines were characterized according to their purpose. The shrine of an ancestor known as an effective warrior would be used specifically in the context of warfare. Shrines were thus not so much burials as sites created for communication with powerful spirits.[29]

Warfare
If in both New Caledonia and in New Georgia, in the Solomon Islands, ancestors were important in strengthening the living, they were often particularly important in supporting the living in warfare. Warfare was widespread throughout island Melanesia until

colonial influences brought it to an end after 1840. The particular kind of warfare practised through the region tended to consist of ambush and other kinds of surprise attack. Nineteenth-century European thought classified this as a cowardly, dastardly kind of way to go about war, but Melanesian warfare was motivated by a different set of ideas and preoccupations.

In mainland New Caledonia, Bronwen Douglas argues, despite an early colonial perception of Kanak as almost constantly at war, there was 'something of a rhythm in indigenous politics, alternating relatively relaxed, peaceful periods and more tense violent times'.[30] Fighting could occur between neighbours of the same tribe, villages of the same tribe, or between tribes, and it could all result in serious damage to villages and gardens as well as in injury and death. Alliances might draw into a war a significant number of groups for whom the immediate cause of the conflict

was unimportant. At the same time, the 'convention of extravagant verbal aggression and bravado, combined with tactical preferences for avoiding open confrontation with a strong opponent and attacking individuals by stealth, usually kept casualties low'.[31] There was a critical need to secure the dead and wounded from the enemy: the physical remains of the dead contained the power to attract ancestors to the places where they were kept. In New Caledonia, as in the Western Solomons, the relation between the living and the dead was dependent on the bodies of the deceased.[32]

New Caledonian warfare was conducted using bows and arrows, clubs, spears and sling stones. Captain Cook's second expedition collected examples of all of these. The sling stones were carefully shaped, with two points, and were sent flying with a rope sling. The stones were stored in a tightly knotted bag, which

had mesh carrier straps by which it could be tied around a man's waist, hanging at the hip, to grant easy access to the contents in the heat of battle. A spear, also collected in 1774, is best described as a light, thin lance made from a single branch, smoothed and polished, which was most probably thrown with a rope spear-thrower. This short rope terminated at one end with a finger-loop, and at the other with a large spherical knot that was used to hold the rope in place around the spear until thrown. William Hodges, artist to Cook's second expedition, depicted a New Caledonian man: a spear-thrower of this kind is tucked into a band around his hat, at a somewhat rakish angle (*overleaf*).

On Erromango, southern Vanuatu, wars generally arose from disputes about land or from the stealing of women. When one leader decided to go to war with another, he challenged him by sending some people to burn down a house, cut down banana trees, or shoot

arrows into his area. The missionary H. A. Robertson, who lived on Erromango for thirty years from 1872, reports that these insults would inevitably lead to battle, and that the attacking party would, if possible, take possession of a height, and rain down their arrows and missiles on the village below. If they had sufficient warning, the defenders would prepare themselves by building stockades around their houses. These wars could continue for many months, and could draw in the wider community, so that sometimes half the island was involved. In the years preceding significant European contact, Erromangans also fought off an invasion from Rotuma, in northern Fiji.[33] Meredith Wilson reports that during widespread conflicts on Erromango, women and children sheltered in the large caves to be found throughout the island.[34] In other places, such as New Georgia in the Solomon Islands, people built strongholds and fortifications of various kinds, such as the hill fort of Nusu Rova discussed by Richard Walter and Peter Sheppard.[35]

But if there was all-out war of this kind, there were also other kinds of combat. Erromangans had a particular kind of star-headed club, which was so highly valued that it was often exchanged as valuables. Star-headed clubs have a flat disc terminating the handle, on which was carved a design of four or sometimes eight leaves (a feature characteristic of all Erromangan clubs), while the head was cut into an eight-pointed star. Star-headed clubs were made in south or south-east Erromango, and were traded around the island and also south to the adjacent island of Tanna. They were treated as heirlooms, kept in the men's house rafters. Robertson reports that every now and then men would take them down and polish them with coconut oil, which, combined with the smoke from the men's house fireplace, gave the clubs a deep black colour and a rich polish.[36] These star-headed clubs were used specifically in a kind of formal hand-to-hand combat reminiscent of duelling. Two men disputing, for example, the adultery of one with the wife of the other, would fight with these clubs on the community plaza with an audience in attendance. The clubs could also be used in formal duels between four men, two against two.[37]

Skill in using weapons of all kinds requires practice, which could be obtained through games of various kinds. On Erromango today, people still recall

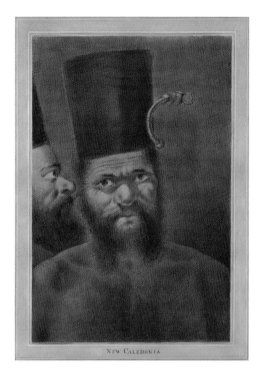

William Hodges,
***Man of New Caledonia*, 1773**
Red chalk, 54.4 x 37 cm
(21½ x 14⅝ in.). National Library
of Australia, Canberra.

Hodges produced numerous large red chalk portraits in this format in the course of Cook's second voyage, some of named individuals, others simply identified as a man or woman of a particular place. Some Islanders are known to have appreciated the artist's interest in representing them, but there is no record of the subject's response on this occasion. Hodges was in part concerned to illustrate the distinctive hat, understandably likened by voyage participants to the North African fez.

a number of competitive throwing or hurling games. In one, played by men, two teams competed to throw short wild-cane lances at a banana spathe (cut from the trunk of a banana palm), which was propped to stand up as a target. In another game for men, teams used rope spear-throwers to hurl longer lances – the winners being those whose lances carried the furthest distance. These games, Jerry Taki reports, used to be played regularly during a quiet phase in the yam-growing cycle, over a period of weeks, and were considered to assist the growth of the yams.[38] The games also provided regular training in hitting a target, and throwing over distances.

If warfare was practised throughout island Melanesia, the frequency of it, and motivations for it, varied throughout the region. In New Georgia, Western Solomons, people living on adjacent islands were often regarded as foreigners, strangers, who could be treated differently to one's own people. In this region warfare was linked to the practice of headhunting. It was argued by early ethnographers that headhunting was motivated by the idea that the head was the repository of power or efficacy, of the capacity to act powerfully. An enemy head was needed at the inauguration of a new canoe or community house, the death of a chief or the release of a widow from mourning, to bring

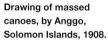

that efficacy to bear on the new object or situation. More recently it has been proposed that the strongest motivation for capturing heads was the humiliation of enemies by depriving them of the relics of their dead, and by showing off political supremacy.[39] Either way, the taking of heads resulted in the escalation of warfare. Arthur Hocart, who was on Simbo (an island adjacent to New Georgia) in 1908, recounts a number of incidents in which a headhunting raid led to further acts of revenge, in an ongoing escalation.[40]

Warfare was never separate from invocations seeking spiritual power to aid the warriors. Such invocations could consist of words – prayers and chants – but there were also objects that acted as charms. In New Georgia charms were often associated with shrines, and were made of shell rings and other valuables. A charm was used by a priest to invoke a warrior ghost and divine the prospects for a headhunting raid. It was carried in the bow of the raiding canoe to give protection, but otherwise kept in a burial shrine.[41]

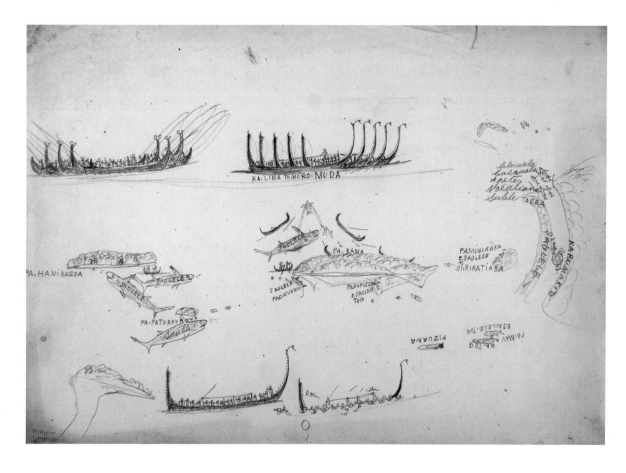

Drawing of massed canoes, by Anggo, Solomon Islands, 1908.
W. H. Rivers Papers, Cambridge University Library, Cambridge.

One of a set of drawings commissioned by Rivers or his co-fieldworker, A. M. Hocart, during their Solomons expedition in 1908.

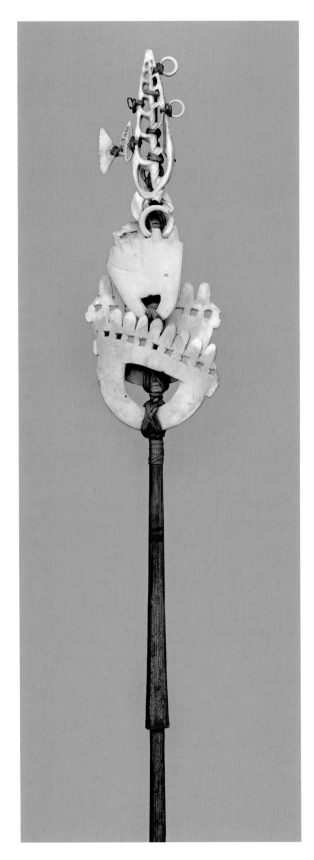

When Europeans first visited the western and central Solomons, they were particularly struck by the large canoes made exclusively for inter-island raiding and warfare. Lieutenant Somerville, writing in 1897, commented of these canoes that 'Nothing can exceed the beauty of their lines and carefulness of build – considering the means at disposal – or their swiftness when properly propelled.'[42] The war canoe was a plank canoe 11–13 metres (36–43 ft) in length, propelled by paddling, which held some twenty to thirty men, and in which New Georgians sometimes covered distances of more than two hundred kilometres. A war canoe had a high prow and stern posts, inlaid with nautilus shell and decorated with cowrie and other cut shells. The canoe was protected by pairs of heads at the top of the prow, stern posts, facing front and back and to both sides to look out for enemies, and a figurehead at the waterline guarding against sea spirits.

Trade

There were many different kinds of canoes in island Melanesia, propelled by paddles and/or wind. In the Central and Western Solomons plank-built canoes had neither outriggers nor sails, but in Vanuatu both sailing and paddling canoes were generally balanced by an outrigger. Large canoes were not constructed from planks; rather the hull was hollowed from the trunk of a tree. The outrigger was attached to the hull by booms and a platform was often built over the booms, adjacent to the main hull, on which some of the passengers could sit. Most small fishing canoes throughout the region were also dugouts with outriggers, driven through the water by paddles. In some areas people did not use canoes at all, but rather rafts.

Sailing canoes were common throughout the region. On Vao, in the Small Islands off north-eastern Malakula, Vanuatu, small canoes had sails made from coconut palm spathes, sewn together to form a triangular shape. Large sailing canoes used sails made from plaited pandanus. Although details varied significantly from place to place, sails were commonly triangular and were suspended between two bamboos or wooden poles, which crossed at one end. One of these bamboos acted as a mast, and was fixed by three ropes which held it immobile, while the other acted as a boom and was adjusted to set the sail to the wind.[43] The sail was not raised and lowered, rather the boom

**War canoe, Roviana,
Solomon Islands, 1903.**
Photograph George Brown.
© The Trustees of the
British Museum, London.

The great war canoes of the
Western Solomon Islands
were, like their counterparts
elsewhere in the Pacific, clearly
intended to dazzle and awe
those who encountered them –
and specifically to intimidate
enemies and intended victims.
In this region the effect was
achieved through an impressive
combination of black stained
wood and bright shell inlay.
This combination, and motifs
including stylized frigate birds
(renowned for their predatory
behaviour), also featured on
feast bowls among other
art forms, also displayed
during what were, in effect,
competitive performances.

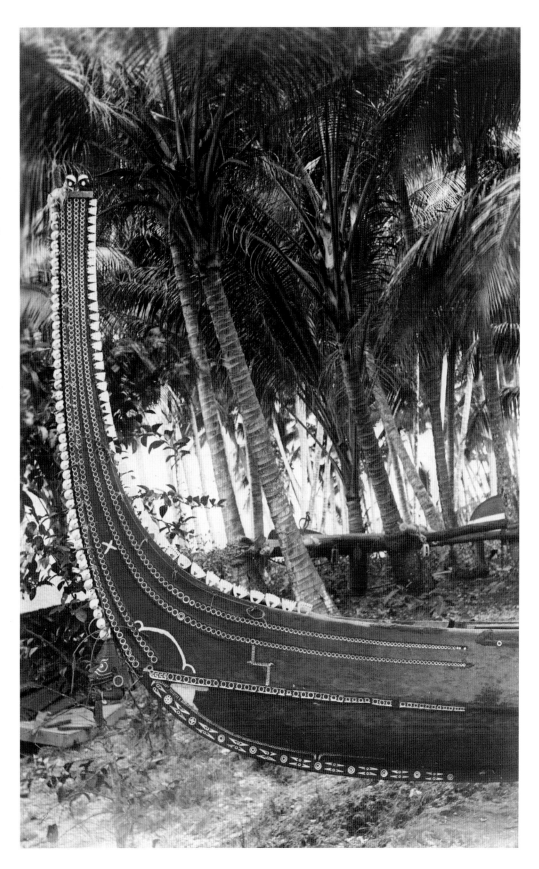

Model canoe, Small Islands, north-east Malakula, Vanuatu, acquired 1881.
Wood, plaited fibre sail, 79 cm (30¾ in.). © The Trustees of the British Museum, London.

Model canoes were made not just as toys but also to teach children about sailing. During the colonial era they were also produced for sale and as gifts to visitors.

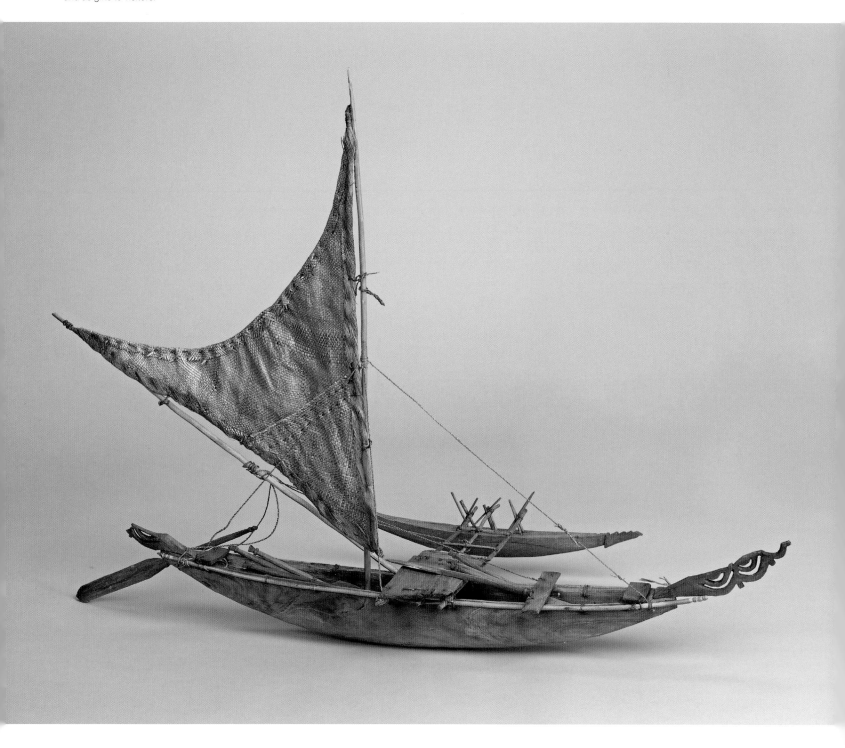

was folded up to the mast, and the sail tied in place. Felix Speiser comments about the small Vao sailing canoe that the ties were left hanging when the sail was unfurled, and that their fluttering in the wind was an additional adornment to the canoe.[44] Richard Feinberg reports a similar style of rigging for pandanus sails used in both Anuta and Tikopia in the Solomon Islands.[45]

By the time of sustained European contact, many Melanesians were using only single-hulled canoes, but in Vanuatu stories record the former existence of large, double-hulled canoes, for example, that were remembered in Vao, north-eastern Malakula.[46] Double-hulled canoes were also used by the people of the Loyalty Islands, east of the New Caledonian mainland.[47] As in the Solomons, in many places large canoes were inaugurated with significant rituals. On Lamen Island, Vanuatu, the double-ended fighting canoes, which died out at the beginning of the twentieth century, were constructed and launched

Aspects of trading and cultural exchange, north-central Vanuatu.

with sacred rituals that gave the canoes a personality and a name. When their sailing days were over a mortuary ritual was performed for them.

The extent of trading links in island Melanesia can now be only guessed at, but a number of specific studies indicate how such links once criss-crossed the entire region. Kirk Huffman has drawn on his extensive knowledge to produce a map of some of the trade links in north-central Vanuatu, observing that specific relationships between neighbouring groups and islands ebbed and flowed over time.[48] Trade links needed to be carefully established with other groups, in an environment where strangers could not be trusted. Quite commonly, people created trade partnerships by intermarrying and maintaining links with in-laws and other relatives. In Vanuatu this was often achieved by sending a woman to marry into the foreign group. In large islands, such as Malakula, Vanuatu, where there were both inland and coastal groups each of which desired the resources of the other, a link between the two groups could be made if a woman from each group married into the other, establishing a road of connection and also helping with language comprehension (since the two groups almost certainly would speak entirely different languages). In Vanuatu the idea that a woman is 'peace' is still widespread, reaching back to this practice of women bravely marrying into a strange community and thereby facilitating new and peaceful relationships.

Not all groups made journeys to trade, some receiving visitors rather than travelling themselves. Other places made a speciality of trading. In many parts of the Solomons, inland people of larger islands seldom travelled overseas but dealt with the coastal people who fished and traded by canoe around and between islands. Huffman reports that the people of the Small Islands off north-east Malakula, Vanuatu, were 'the sea travellers *par excellence* of the area and called themselves "the sea people"', going on to say that the Small Islanders' large canoes, with woven mat sails dyed red, and bird-figure canoe prows, sailed as far south as Lamen Island and Epi, and across Vanuatu's 'inland sea' to Ambrym, Pentecost, Maewo and Ambae. The driving force behind this was the trade in pigs. Each of the Small Islands had specific links with particular areas for specific items. Canoes from Vao, one of the Small Islands, traded woven penis-wrappers

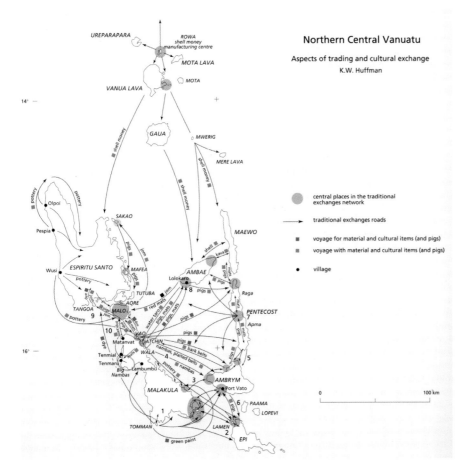

Northern Central Vanuatu

Aspects of trading and cultural exchange
K.W. Huffman

- ⬤ central places in the traditional exchanges network
- → traditional exchanges roads
- ▪ voyage for material and cultural items (and pigs)
- ▪ voyage with material and cultural items (and pigs)
- • village

and tasselled status belts for bark belts with north Ambrym; and traded pigs for pigs with Pentecost (one kind for another); pigs for pigs and rituals with Maewo; and chickens and pigs for plaited textiles, a type of water taro, and rituals with Ambae.[49]

The trade in all these goods was significantly related to rituals and ceremonies of various kinds, which will be discussed in more detail in the next chapter. Pigs were needed throughout north Vanuatu for status alteration rituals by which men and women achieved rank and importance, but the specific nature of these rituals varied greatly across the region, and different kinds of pigs were required in different places: hence the importance of pigs in the trade. Thus, for example, on the island of Malo inter-sex pigs were required for status rituals. These pigs (which were specially bred) were also highly valued in parts of Santo, Ambae, Maewo and north Pentecost. In other areas the most valued pigs were those with tusks. A boar's tusks will grow in a circular shape if the lower incisor is knocked out. Throughout north Vanuatu pigs were carefully looked after in order to obtain the circled tusks essential to the creation and demonstration of rank in many parts of the region.

In the Solomons and north Vanuatu, people made, used and traded items that had fixed exchange values in trade. These items were not purely currency, for they had other uses, for example as ornaments, but they had money-like characteristics. Most commonly, these were a variety of different kinds of shell valuables. In a trade centred on Malaita in the central Solomons, strings of shell beads and dolphin teeth, most produced by the Langalanga sea people, were exchanged. Shell valuables made in the Banks Islands in north Vanuatu were also traded as far south as the island of Santo.

These valuables were often exchanged for other kinds of goods and services. In the remote islands of the Santa Cruz group, eastern Solomon Islands, different areas specialized in making different kinds of objects and in different varieties of produce. People exchanged food, produce and craft objects, including turtle shell, coconut fibre, feathers and cordage, clothing and ornaments. As with central Vanuatu, certain places, such as Graciosa Bay on Nidu Island, were geographically strategic for the flow of trade goods. There were also places with so few resources to trade that they developed other specialities.

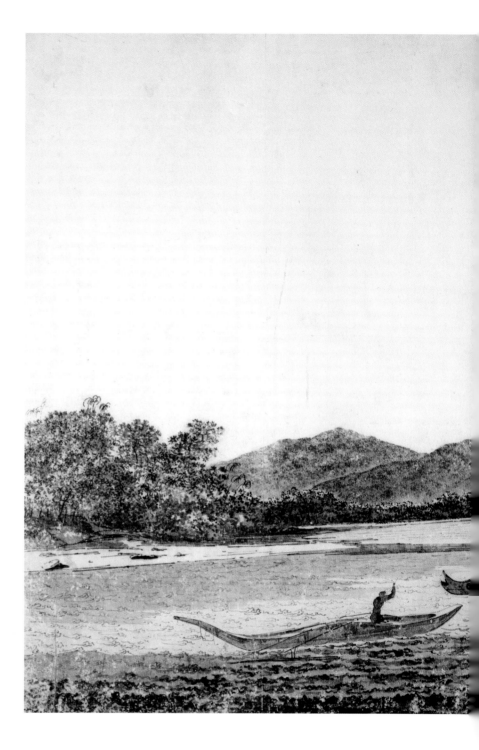

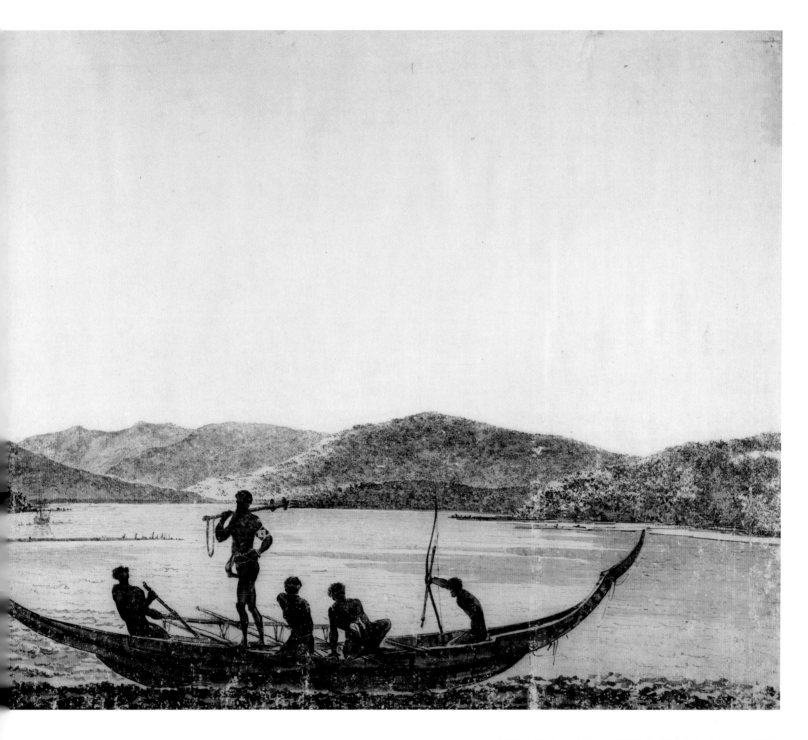

William Hodges, *A view of Mallicolo* [Malakula, Vanuatu], 1774.
Pen and ink wash, laid down on card, 62.2 x 119.4 cm (24⅜ x 47 in.).
British Library, London.

Hodges' evocative wash drawing, very likely created during or soon
after the Malakula visit, suggests a moment of cautious mutual
regard characteristic of the encounter between canoe and ship.
It also gives some sense of the carving and decoration of early
canoes from the region, which never entered European collections.

Pigs as Art

I N MOST OF MELANESIA the importance of pigs cannot be overstated: as one observer remarked of Malakula, Vanuatu, pigs there were more important to men than eating or sleeping.[i] The importance of the animal was not primarily as a source of food, but as a form of wealth – and one that had to be husbanded, managed and adjudicated. Across the region (except in New Caledonia, where there

Double circle pig tusk, Ambrym Island, Vanuatu, collected by Feliz Speiser, 1910–12.
Museum der Kulturen, Basel.

were no pigs) people raised domestic pigs and/or hunted wild pigs in the forest; they killed them for feasts and exchanged them as currency; and they commonly sacrificed them to the ancestors or the spirits in major ceremonials. In thinking about pigs, men were considering their resources: being able to mount a ceremony, or pay a fine, or make the exchanges that would secure a marriage. They also thought about pigs as people always think about livestock, weighing their characteristics, breeding them to achieve a better animal, and holding individual pigs in affection.

In north and central Vanuatu pigs were especially valued. Throughout this region, the upper incisor of young male pigs was knocked out: once it was removed, the lower incisor was able to grow unimpeded, curving out of the jaw and circling back across the cheek to re-enter the jaw further back, cutting through the bone and re-emerging near the point from which it started, thus forming a complete circle. To grow a complete circle took about seven years: the more complete the tusk circle, the more valuable the pig. Each stage of tusk development was named and represented a certain value in exchange or at the moment of death. The tusk could potentially continue growing to form a second circle, but the more advanced the circle, the greater the risk to the pig's life and well-being. It had to be tethered or kept in a pen, and fed soft food lest it break a tusk in a fight with another boar or when rooting in the ground. In Malakula, it was not so much the pig, as the pig with carefully grown tusks, that was the object of people's aesthetic preoccupation.

Tusked pigs were crucial to north Vanuatu graded societies – the sequence of rituals through which a person passed to achieve a higher and higher spiritual, political or economic status and power. In most places in this region the value of the pig's tusk was entirely dependent on the animal being alive to be killed at the climactic moment of the ritual. A dead pig was valueless. Tom Harrisson reports that in Matanavat Malakula there were sometimes pigs whose tusks achieved three circles, but that few men would 'risk leaving their pig so long unkilled, lest it die a natural death'.[ii] The pig-killing rituals were complex dramatic performances, elaborated with music, dance, costume and spectacle. Men achieving certain grades would be invested with the right to wear a full-circle tusk as an armband.

It is the objects relating to pigs that now exist in museum collections, such as the carved stones used in magical procedures to ensure the health and growth of pigs or the carved and painted clubs used to kill pigs at grade-takings. After the pig's death the tusks were kept to mark the grade-taker's achievement: either still embedded in the boar's lower jaw, and stored in a man's cult house, or removed from it and incorporated into masks, headdresses and figures, or made into ornaments. But for the men who made and used these objects, they were secondary: the full glory of the living pig was their creation and their delight. LB

People of the atolls of the Outer Reef islands, for example, having no valued resources, developed the speciality of transporting cargoes and passengers between the islands in large sailing outrigger canoes, specially constructed for this purpose. Lacking sufficient timber to build these canoes, they traded for the canoes themselves with people from Taumako to the north. Wealth obtained through these specialities and exchanges was then expended in rituals and celebrations that brought prestige and authority to their organizers.[50]

By the nineteenth century the whole system of exchange in the Santa Cruz group depended on a particular item of exchange, small plates supporting red feathers, attached together into a long fibre coil or belt. Red feather coils have been described, by William Davenport and others, as acting like a kind of currency. Throughout the Santa Cruz group, red feather coils were used as a standard measure of value, as a means of storing wealth, and as a universal medium of exchange. They were only made in the interior of Nidu Island, and they were perishable, easily damaged and worn with use and age, so that new feather coils were needed to replace old ones in the trade network. However, if the coils came only from Nidu, the necessary red feathers, from a honey-eater (*Myzomela cardinalis*), were collected throughout the islands and were traded with Nidu to be incorporated in the coils. The coils were made in different lengths and widths, which had different values for exchange. Santa Cruz oral traditions recall that originally these feather coils were not made as well as they were by the end of the nineteenth century: they were neither so elaborate nor did they use as many feathers. Indeed, stories record who first made the coils, and how they gradually replaced an earlier trade dependency on shell 'money'.[51]

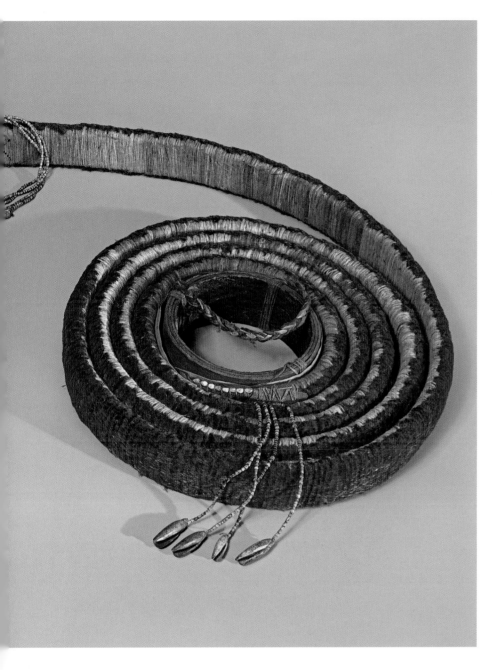

Trade, like warfare, was associated with various kinds of invocations for spiritual support and other kinds of magic. In Vanuatu today, people recall that their forebears had ways to bring about weather suitable for trading voyages, and also to draw islands closer together so that the journeys between them were shorter. Some men also had the means to travel from place to place without needing a canoe – an ability known today in Vanuatu's lingua franca as *kastom plen* ('traditional aeroplane'). Throughout the whole of island Melanesia, people also used less occult means to communicate with trade partners – lighting fires on one island, for example, to signal to trade partners across a stretch of water on the next.

In both trade and warfare, movement was largely the prerogative of men. Women commonly stayed at home, unless they were captured by enemies and taken by force. If they travelled less, however, they made the more substantial move involved in marrying into another community, and in Vanuatu today women see their long-standing capacity to make moves of this kind as a great strength. In general, the different roles of men and women sit within the broader framework of attitudes to other kinds of people, who were often treated far differently to those from a person's own group: strangers whose heads could be taken without thought; prisoners of war who were made into slaves. At the same time, people greatly valued the things that others made, travelling widely to acquire them. They recognized each other's skill and craftsmanship, and what now exists from that period reveals the sophistication and complexity of their social lives.

Feather money, Santa Cruz, Solomon Islands, acquired 1976.
Feather, seeds, shell, leaves.
Length 1064 cm (35 ft).
© The Trustees of the British Museum, London.

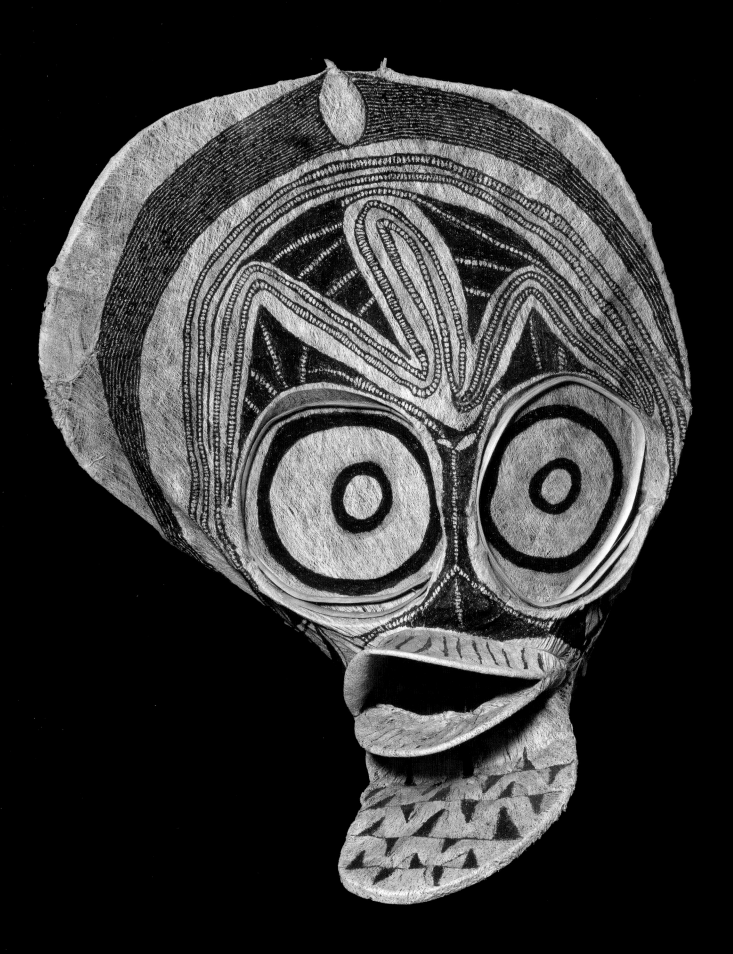

Lissant Bolton

INCURSIONS: LOSS, CONTINUITY AND ADAPTATION 1840–1900

Around 1840 Europeans began to settle in island Melanesia, the date and intensity of settlement varying greatly across the region.[1] In generally small numbers, planters, traders and missionaries acquired land, built houses, and began growing, selling and preaching. With them they brought a whole new range of material goods, and material expectations. They also brought ideas about what was beautiful and what was grotesque, what was useful and what was useless, what was important and what was trivial. Their ideas were often completely inappropriate to the material and social conditions in the places they came to. Popular perceptions of the region today, both within and outside it, are quite often still inflected by the perceptions, and misperceptions, of those early settlers.

The Potential of New Materials

In the nineteenth century almost all Europeans settled at locations close to the sea, establishing beachheads for their various enterprises. Melanesians living inland or elsewhere along the coast heard rumours of the newcomers and sometimes travelled to see them, but in other ways remained independent of their influence. Themselves great traders, many islanders were interested in European goods: in knives and nails for their strength, cutting edges or points; in glass, which could be broken and used like obsidian to cut or shave; in cloth (especially red cloth), which could substitute for fabrics of local manufacture. In an account of his life, George Sarawia from Vanua Lava, Vanuatu, wrote that when the Melanesian Mission's Bishop Selwyn came to his island for the second time (probably in 1852), Sarawia decided to accept an invitation to visit the Mission's home base of New Zealand. Two other youths took fright and jumped ship just as they were sailing out of the harbour, but, Sarawia says:

I had made up my mind to go for I thought that I would collect axes and knives and hooks and clothes and a great many other things. I thought they were just lying about where everything began and that I could collect a great number for myself.[2]

As Sarawia's comment makes clear, in the first decades of European settlement, it was material goods that most interested and affected Islanders. Artists and craftsmen were interested in the potential of new materials and new tools, in the creative possibilities afforded by them. Some European-sourced objects replaced local manufactures very quickly. Indeed, the active acquisition of some goods took place well before the 1840s, as sandalwood traders, whalers and other ship-based visitors provided them in exchange for things they themselves wanted. By 1848, when the missionary John Geddie arrived in the southern Vanuatu island of Aneityum (a region sandalwood traders had been visiting for two decades), iron tools had already taken over from stone axes.[3]

If Melanesians used metal tools brought by Europeans, they also creatively adapted other metal objects to suit their own tool types. In a publication of 1897 Lieutenant Somerville described a technique used in New Georgia, Solomon Islands, for cutting a hole in a clam shell disc. After cutting and grinding the disc, a series of closely adjoining holes were bored in a circle in the centre of the disc. Then, he says, 'a piece of wiry creeper is next taken, introduced into one of these holes, and by using it like a fretsaw, in conjunction with sand and water, (preferably fresh), the complete centre block is cut out'.[4] In the British Museum there is a bow saw, weighted with stone, strung with wire, and used for cutting clam shell rings, collected by Charles Woodford in New Georgia some time between 1884 and 1914. Here

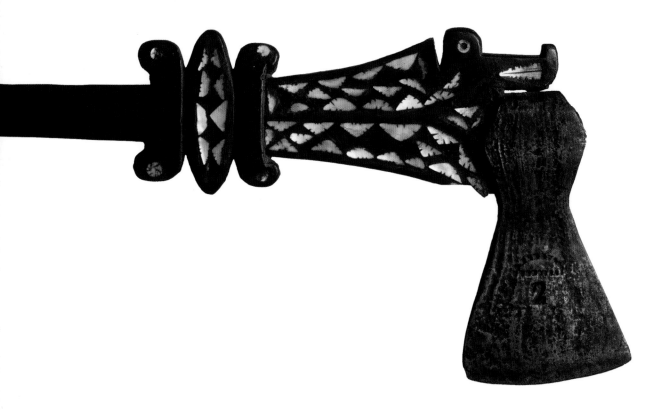

Metal-bladed axe, probably New Georgia area, Solomon Islands, acquired 1884.
Length of decorated area of shaft, 23.5 cm (9¼ in.).
Australian Museum, Sydney.

In the Solomon Islands, metal axes were adapted to incorporate European blades by the mid-nineteenth century and often hafted and decorated in local styles.

someone has seen the potential of wire to improve an existing tool type, and has adapted it accordingly. Shell valuables were and are very important in many parts of island Melanesia, and not least in the New Georgia area.

Metal was used not just in making objects, but in warfare. Axes and axe heads were acquired not only for cutting down trees but also for despatching enemies. Again, these objects were incorporated into both existing regimes of use and existing aesthetic systems. Metal axe heads were set upon the same kind of wooden handle as had been used for stone axe blades. In the Western Solomon Islands the hafting of metal axe blades onto handles was sometimes elaborated with carved and shell-inlaid images. The Australian Museum holds such a decorated metal-bladed axe, acquired in 1884, which incorporates an image of a frigate bird head. In this area, metal axe blades were especially prized for headhunting raids. When Charles Woodford visited the Solomon Islands in 1886–87 he reports that there were 'seven or eight white traders constantly resident in the group', and tobacco, of which the islanders were 'pretty good judges', had become the principal item of trade.[5] Muskets and gunpowder, Snider rifles and ammunition had been sold in considerable numbers, but the supply of these by English traders had been banned by the nascent British administration: traders operating under other national flags continued to trade firearms. Rifles were also decorated with shell inlay. Weapons, whether wood, stone or metal, were and are cherished by their owners, as these adaptations demonstrate.

If people were acquiring objects of value from European traders, they also manufactured objects to suit European desires, offering for trade items that would elicit the goods they wanted. The Admiralty Islanders, for example, seem to have bartered with the crew of whaling vessels for half a century before any European actually went ashore on their islands, going out to the vessels in their canoes to exchange tortoise shell and coconuts for European goods.[6] The first Europeans known to have gone ashore in the Admiralties were from HMS *Challenger*, which visited there over seven days in March 1875. Henry Moseley, a British naturalist who sailed with that expedition, commented that when they arrived the Islanders 'came off at once to the ship in the utmost hurry, in a strong breeze, thinking probably that she was not coming into harbour, and they held up all sorts of articles of barter'. As the visit proceeded, Moseley observed that Islanders 'soon took' to offering trade goods such as shell hatchets, and canoe models, 'which were as badly made as our own trade gear'.[7]

As traders settled in the islands, they introduced further goods to their trading repertoire, including

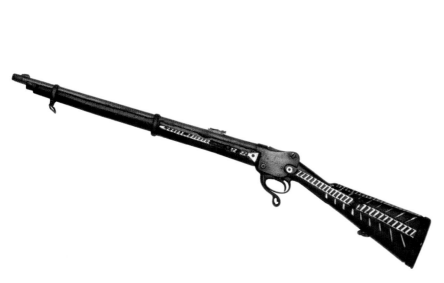

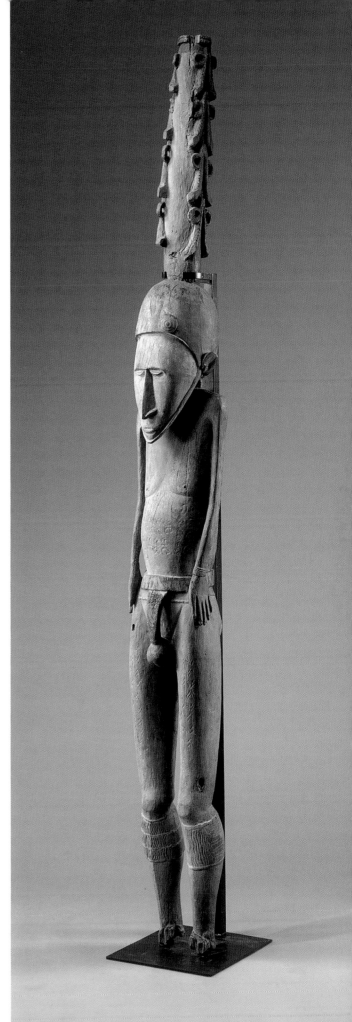

beads, cloth, paints and dyes, all of which were incorporated into object types: glass beads replacing shell beads in body decorations of various kinds, cloth supplanting fabric of local manufacture, and dyes added to the inventory of vegetable dyes already in use. Of these, Reckitt's Blue is one of the most distinctive early colours used. This is a laundry whitener, first produced in Hull in 1852, using a combination of a synthetic ultramarine and sodium bicarbonate. It was introduced to the Pacific within a few decades of its development, and became an item of trade, not for its whitening properties but for its clear blue colour. German traders were certainly selling a washing blue in the Bismarck Archipelago from 1880: in northern New Ireland it was rapidly added to the range of colours used on carved masks and figures in the *malangan* tradition.

One of the most well-known Melanesian objects that makes use of Reckitt's Blue is a figure from Malo, Vanuatu, collected by the *Korrigane* expedition in 1935 (date of manufacture not known). The figure, which stands 3 metres (9 ft 10 in.) high, is carved from a hardwood, possibly ironwood (*Intsia bijuga*). It stood in front of a men's cult house at Savkas village in south Malo and is a 'grade' figure, that is, a figure which was raised to mark a man's achievement of one of the highest ranks in the graded or status-alteration society.

Creating for Collectors in the Admiralty Islands

ONE OF THE MAJOR FORMS of art bartered and sold by Admiralty Islanders and collected by Europeans are striking obsidian-tipped spears and daggers. There are more than 1500 of these objects in museum collections around the world. Admiralty Islanders were quick to realize the potential of the European desire for 'curios'. Ludwig Cohn, who assembled an important early collection of Admiralty Island objects for the Übersee Museum in Bremen, wrote in 1912 that the tourist industry was a 'special difficulty' on Manus, as 'Many things are newly produced, very cunningly made to look old, and offered as old objects; this is a result of the keen competition between the traders to obtain genuinely old objects. What is worse, things are being produced that otherwise would never have been made.'[i]

Admiralty Islands obsidian-tipped weapons demonstrate how producers responded to European demand and the way that they strategically negotiated the process and opportunities of barter, not as innocent and powerless natives awed by the goods of European visitors and settlers but as partners in a process that resulted in a satisfactory trade for both parties. Because museum collections span the period when Europeans first arrived in the islands to the recent past, it is possible to track the shift from pre-market forms of reciprocal exchange to modern capitalism. According to Robin Torrence, while producers started creating weapons for trade and sale to Europeans in the nineteenth century, production was not affected until after 1910 when wage labour made its appearance and 'producers would have increasingly valued their inputs of time, energy and raw materials in monetary and market terms, rather than as currencies in social relationships'.[ii] Efficiency became more important, with producers seeking ways to decrease their investment in the object while ensuring the return remained constant.

Responding to the demands of European collectors, the Admiralty Islanders replaced the less recognizable frigate-bird motif with crocodile and human forms, aligning with the European collector and tourist's preference for obvious and understandable symbols that would more easily evoke the primitive or savage. Daggers gained in popularity and then replaced spears, responding to the growth in the souvenir trade and the need for more portable objects.

Spear head, Admiralty Islands, n.d.
Obsidian, bamboo, sennit, wood, shell, paint. Overall length 247 cm (97¼ in.). Museum of New Zealand Te Papa Tongarewa, Wellington.

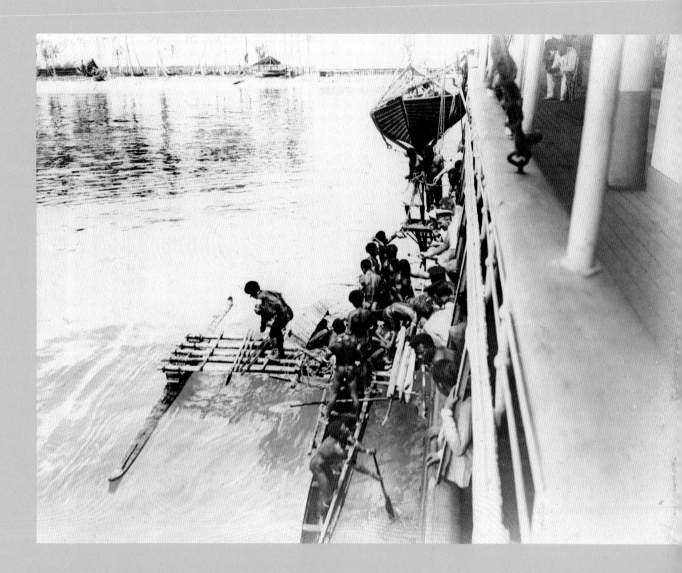

Manus people trading at a visiting ship, 1909.
Photo C. Nauer.
Übersee-Museum, Bremen.

Despite this growing complexity, producers managed to increase efficiency. Quality of workmanship decreased in terms of the bindings, application of paint, and the incising and carving of the *atuna* putty haft or wooden collar. The range of designs became standardized: spears collected in 1875 are all unique; those collected in 1911 have many identical hafts; and overall the range of motifs used to decorate the spears shrunk as well, becoming increasingly simplified. The quality of the obsidian blades decreased as well, producers using discarded and scavenged stone, with little reworking to improve their shape.[iii] A final efficiency measure was to diversify production. As Torrence writes, 'It seems the producers diversified into two classes: a cheap memento or small ornament for the tourists or low-income collector and a large, elaborate, expensive object for the serious collector.'[iv] DS

This society was the primary focus of men's achievement in Malo. The figure is recorded as having a personal name, Trrou Körrou, said to mean 'he who stands before you and looks at you'. Now standing in the Pavillon des Sessions at the Louvre, in Paris, it is remarkable for its gentleness and quiet power, an effect enhanced by its blue colour (*page 189*).

New tools resulted in an efflorescence of some kinds of indigenous object manufacture. Metal tools made labour-intensive tasks, such as clearing forest to make food gardens, or felling trees for house and canoe construction, both easier and quicker. This, it has been argued, gave men more time for other activities, such as making objects for trade and for ritual occasions.[8] Metal tools also made it easier to cut and carve wood and shell, and thus to make the objects men needed to advance in their political and economic ambitions. In several ways, therefore, tools facilitated the intensification of performance in rituals. Much Melanesian ritual involves revelation and transformation: it often involves the dramatic transformation of the everyday with special, elaborate objects, feasting and sometimes the relaxing of rules about interpersonal behaviour. Metal tools made it possible to create more, and more elaborate, carvings, masks, houses, canoes, and so forth.

The Continuity of Ritual

In the first few decades of the European incursion, most communities were able to continue their lives unaffected by forced interventions from government, missionaries or planters. If trade introduced new markets, and new goods, and if some people took the opportunity to travel on ships as crew or as workers for the burgeoning labour trade, for many communities life remained substantially as before. In particular, the ritual cycles that gave shape and meaning to people's lives generally continued, transforming according to usual patterns as leadership changed, and as people made innovations, developed new forms and discarded or forgot old ones. The developments created by new tools were part of that enduring transformation.

The focus of ritual cycles varied greatly from place to place and language group to language group. Rituals were never performance for the sake of performance. Rather they had specific objectives such as the transmission of land and other resources across the

generations, and the education of the young, the acquisition or reinforcement of inherited or achieved rank, the reinforcement of bonds between families and groups, the reproduction of the community through marriage, and the placation and management of spiritual powers. The mounting of major ritual occasions was a significant economic and political achievement, drawing in many resources, and often involving planning and preparation over several years. Just to feed the guests invited to a major occasion necessitated the planting of extra food gardens and the breeding and care of extra pigs. In advance of such occasions leaders might also impose a ban on fishing in a particular reef, or hunting certain birds.

The characteristic common to ritual across the whole of island Melanesia was that it drew in and addressed a whole range of different aspects of people's lives. The kinds of categorical divisions that are characteristic of life in many parts of the world today – divisions between work and leisure, between domestic and public, between the spiritual and the everyday – did not apply in this region. Rather, occasions drew together all these features of life. To mount such rituals people needed to grow food and to obtain it by exchange, they needed to know about spirits and how to deal with them and about the properties of many aspects of the environment, about what could be used to make paint and decorate carvings, masks and other kinds of objects. Men used these occasions to advance themselves politically, to transact land ownership, to shame their enemies. Such occasions sometimes also involved the relaxation of strict social rules, allowing prohibited sexual liaisons to flourish briefly.

These occasions were often highly dramatic. In some cases special places were enclosed and objects and other arrangements installed within them to make an overwhelming impact on those who entered. The figures and masks that now exist in museum collections are but the dry remnants of the installations and performances they were made for. Masks were almost always accompanied by other body decorations, including sweet-smelling leaves and flowers or scented oils for the body, and sometimes fibre skirts that hid the wearer's body. Carved figures were often embellished with leaves and flowers, and were often designed to be seen as a group, in visual interaction

'SUDDENLY THERE IS A RIFLE SHOT'

After these [ritual ceremonies] are completed, the spectacle begins, in the form of mimed dances. Some time previously, the Masters of Ceremony of the *grand pilou* (New Caledonian ceremonial dance festival) have sent a straw dance whisk to their fellow organizers in other communities. This was the invitation to prepare a performance for the next *pilou*. Now each fraternity will show off the piece they have prepared: sometimes it's theatre, sometimes dance, sometimes both at once. The free, creative imagination finds in the symbolism of movement or poetry the richest mode of expression to exalt the glory of the totem or to convey more general concerns of the people....

When a dance is finished, the performers place their dance whisks at the feet of the next fraternity team being sent out by the Masters of Ceremony: 'You wove this straw and sent this [invitation] whisk. For a long time it remained far away while you dreamed: that they will come, bringing a dance to bind our house-beams together.' And indeed it is so – the performances prepared by these brothers weave the framework that unites communities. Sometimes it's a theatrical skit in which a mask takes a part: a child feigns a theft; an adult runs up to thrash him; then a mask appears which terrifies both the adult and the child. Variations on such themes assure the success of these dramatic sketches.

But the dances sometimes betray real concerns. Forty years ago [i.e. in 1895] Dr Vincent once saw a re-enactment of an attack against Europeans: these were represented by battered boxes, discarded suitcases, rags, and some withered old women whitened with kaolin. At a given signal, the warrior horde, full of pride and enthusiasm, swept down on the enemy, annihilated every trace of the debris, and declared the Whites vanquished. The sentiments have changed since then. During one of the last *grand pilous* around Ponérihouen, a Nébaye fraternity devised a totemic dance much remembered since. In it groups of dancers were coming and going gracefully, meeting, stopping, veering, forming a circle in imitation of mullet fish that come from all around to feed on algae carried by the current. Suddenly there is a rifle shot: the dancers lie still, their bellies up. The explosion and falling dancers represent a fatal explosion of dynamite in the midst of a school of fish. A mime of tragedy, it signifies the death of the mullet totem and its group in the dislocation of native society under the shock of civilization.

Excerpt from Maurice Leenhardt, *Gens de la Grande Terre*, Paris, 1937[1]

with each other. Nearly all objects were made to interact with movement, to be inhabited by dancers, or to be empowered by speech-makers, singers or other actors. Some objects were intended to be half-seen at night, lit by flaring torches, by fires, or by the moon. Many were understood to be inhabited by spirits for the duration of the ceremony for which they were made. The impact of these installations and performances is hard to imagine, given the visual overstimulation that characterizes the present century. But in a context where people lived in a known landscape of sea, garden, forest and mountain, without a wide range of man-made visual stimuli, such ceremonial performances made a powerful impact.

The islands of the Bismarck Archipelago were, and to some extent still are, home to a wide and rich range of masking and carving traditions. On the island of New Britain alone there are at least thirty-seven language groups, and a concomitant range of cultural systems and art forms. A number of these focus around

ritual associations sometimes described as 'secret societies', which in the past often explicitly engaged with powerful spirits. In joining these societies men learned how to construct the masks, and gained knowledge of the songs and the rituals associated with them. Only members of these societies could, with proper preparation, wear the spiritually charged masks without harm, and dance with them.[9] Such masking traditions include the Baining barkcloth-covered masks used in initiation and taro harvest ceremonies, and the masks used by the Sulka in their initiation and mortuary rites.

As Monique Jeudy-Ballini describes, the Sulka of east New Britain still maintain their masking traditions, albeit with variations derived not least from their conversion to Christianity.[10] In the past, they began making the masks at the time of planting in the yearly gardening cycle, so that the masks grew with the plants. Right across the western Pacific, the period in which objects were being made was often as highly

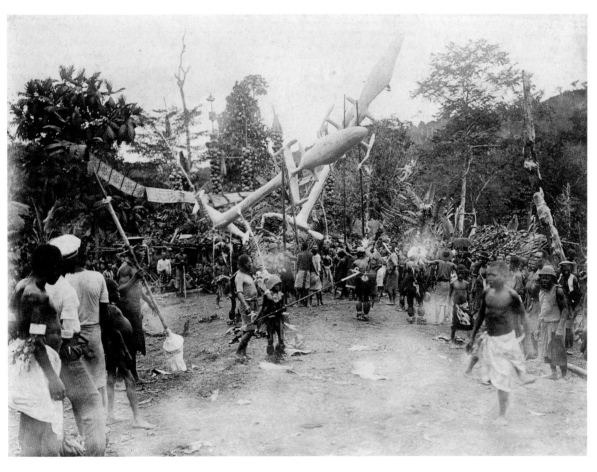

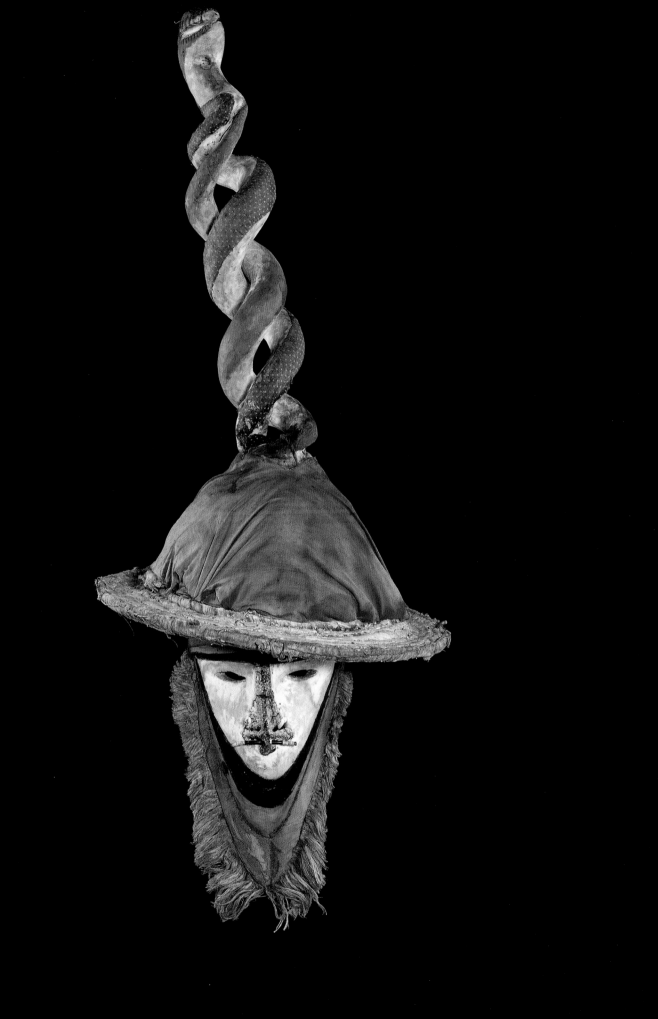

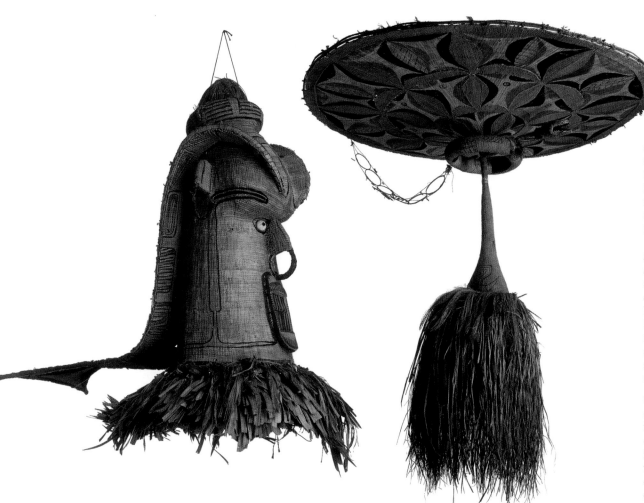

far left
Sisiu mask, Sulka people, New Britain, *c*. 1900.
Rattan, vegetable pith, fibre, feathers, natural pigments. Height 90 cm (35⅜ in.). Museum für Ethnologie, Berlin.

left
Hemlout headdress mask, Sulka people, New Britain, *c*. 1900.
Rattan, leaf pith, fibre, leaves, natural pigments. Height 180 cm (70⅞ in.), diameter of parasol 170 cm (66⅞ in.). Museum für Ethnologie, Berlin.

Originally brightly coloured, extravagant, yet also fragile, fibre and fabric assemblages of this kind were never intended as artworks on their own, but were, like costumes in an opera, part of a vibrant performance.

below left
Wowe mask in performance, Sulka people, New Britain, *c*. 1980s.

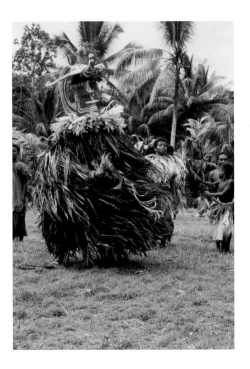

valued as the time when they were completed. The creativity of manufacture was and is very significant: the act of making masks, carving canoes or cooking food was important in itself and was not viewed as merely preparation. Two of the most distinctive Sulka mask types were made by covering a frame with wickerwork made of white pith taken from a species of liana. This surface was painted, and considerable attention was paid to the saturated brilliance of the colours. Sulka aesthetics ascribed the strongest aesthetic impact to vermilion: because this colour fades, it was always applied at the last possible moment, so that it would be at its most brilliant when the mask was performed.

As Jeudy-Ballini says, the appearance of the masks was 'a performance aimed at creating the effect of a revelation'.[11] The dancers, heralded by conch-shell trumpets and shouting men, appeared on the village dance ground where women were already dancing

and singing. Singly, or in a group, the masked dancers emerged from a wall of leaves that had screened their approach, and began to dance, seductively displaying the designs on the mask. The performance lasted only about ten minutes, and then the masks returned to the forest, the conch-shell trumpets reverberating long after their disappearance, while the women continued dancing and singing, waiting for the next mask to appear. The appearance of the masks was designed to make the greatest possible aesthetic impact on those present. This impact, itself effected by the approval of the ancestors, was to create emotional turmoil in their viewers, whether that turmoil manifested itself as 'joy, love, ecstasy, nostalgia, affliction, depression or any other conflicting feeling'.[12]

This emotional reaction itself indicated the momentary presence of the ancestral spirits.

In the adjacent island of New Ireland, the ceremonial focus of a number of different societies was funerary rituals. The art produced for them included the carved wooden *uli* figures from the north-east coast (*overleaf*), the distinctive plaited *malangan vavara* now known from the Tabar islands, and most famously, the complex suite of *malangan* funerary objects from the north. As has been remarked, 'an astonishing number' of objects related to the *malangan* rituals of northern New Ireland were acquired by European and Australian museum collections between 1880 and 1914:[13] that is, an extraordinary number were made, and then collected, in that period. The volume

Malangan vavara, New Ireland, n.d.
Plaited plant fibres, chicken feathers, lime, red and yellow natural pigments and blue pigment (probably Reckitt's Blue). Diameter 140 cm (55⅛ in.), depth 30 cm (11¾ in.). Linden-Museum, Stuttgart.

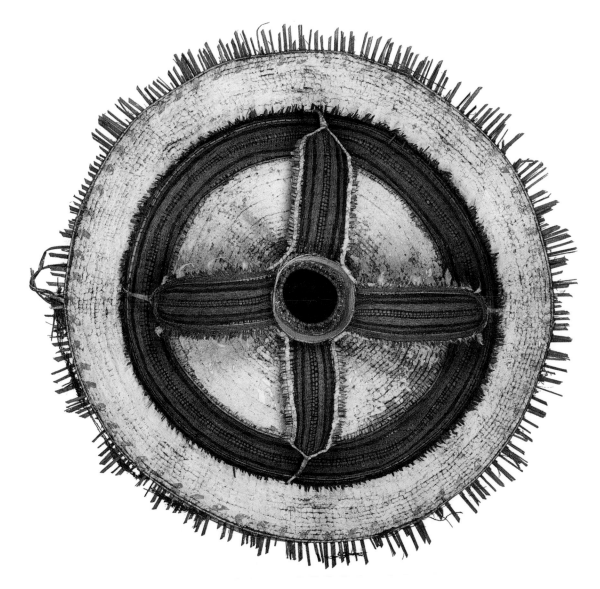

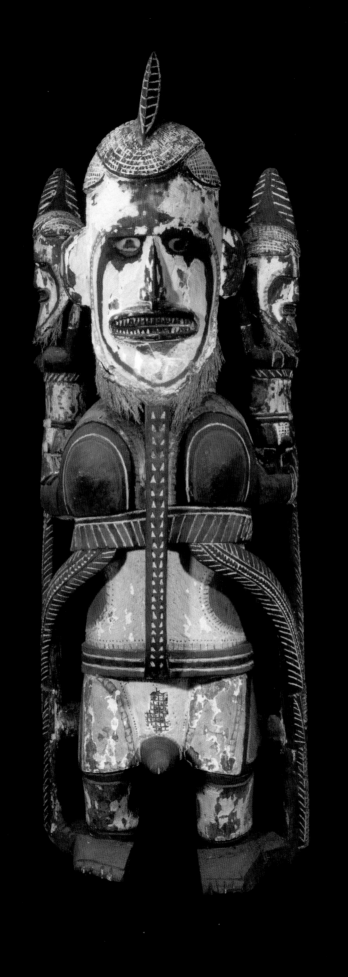

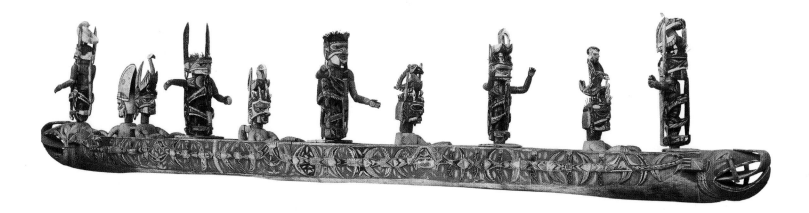

opposite
**Uli figure, New Ireland,
acquired 1917.**
Wood, pigment, lime.
Height 142 cm (55⅞ in.).
Australian Museum, Sydney.

above
**Malangan canoe,
New Ireland, collected 1903.**
Length approx. 5.8 m (19 ft).
Linden-Museum, Stuttgart.

Probably the single largest,
most complex and remarkable
malangan assemblage extant
today, though canoes with
groups of figures occur in
other collections. Created
for the funeral rites of ten
villagers lost at sea, after the
ceremony it was acquired for
the museum by the German
colonial administrator.

of *malangan* collected in this period partly reflects the appeal of these objects to curio collectors and dealers. It also results from the fact that New Irelanders were able to mount many more *malangan* ceremonies, presumably partly because it was now easier to make *malangan*.

The introduction of metal tools also facilitated the elaboration of the objects themselves. *Malangan* art is famous for its visual complexity, involving layers of latticed carving within the one piece of wood. Carvers used metal tools to elaborate and extend the aesthetic and visual complexity of *malangan* carvings, which became highly elaborate. *Malangan* carvers also made quite extensive use of another introduction: Reckitt's Blue. Only three years after Reckitt's Blue was introduced to the Bismarck Archipelago, in 1883, Hugh Romilly collected a mask incorporating the new colour. Now in the British Museum, the mask is a *tatanua* mask, a type that is always decorated asymmetrically: the blue pigment is painted in sweeps around the eyes, emphasizing them (*overleaf*).

Malangan ceremonies operated differently in different parts of northern New Ireland, and have been much studied by many different researchers.[14] They were and are secondary funerary ceremonies occurring over a period of years after a death. Hundreds of people attended the final days of feasting: the height of the ceremony was the dramatic exhibition of *malangan* objects, an occasion that 'finished' the dead, sending the soul into the spirit world. *Malangan* carvings were not representations of the dead individual, rather they incorporated an accumulation of images or motifs. Each clan owned the right to remember and

to make certain *malangan* types, incorporating specific combinations of animal and human figures that referred to the clan's founding myths, and each person, by virtue of his unique kinship history within the clan, owned one or more specific *malangan*. Each *malangan* was an expression of a remembered source image, but was not an exact representation of it; rather it was a specific instantiation, inflected by the specific identity of the dead. Philippe Peltier has written a vivid description of a contemporary *malangan* display:

> The sculptures are installed in a structure made of foliage built near the graves. The construction is cleverly arranged to achieve maximum visual impact. The sculptures are exhibited against a background of alternating matt and glossy leaves, splashes of colour from fruit attached to the uprights, feathers which tremble at the least puff of wind, rays of light flickering over the leaves. The sculptures themselves are arranged according to a symmetrical design so strict that the iconography of some *malangan* objects may be changed to achieve a perfect balance. The beauty of the display is matched by that of the songs and music. Strange sounds like those made from friction drums resonate and give the impression of a supernatural presence, heightened by the fact that the musicians are out of sight of the audience.[15]

The *malangan* themselves are, as Susanne Küchler describes, 'a visual assemblage of parts that slot together like pieces of a puzzle'.[16] Seeing the different motifs makes it hard to see the whole figure, not least because the motifs themselves are often images of

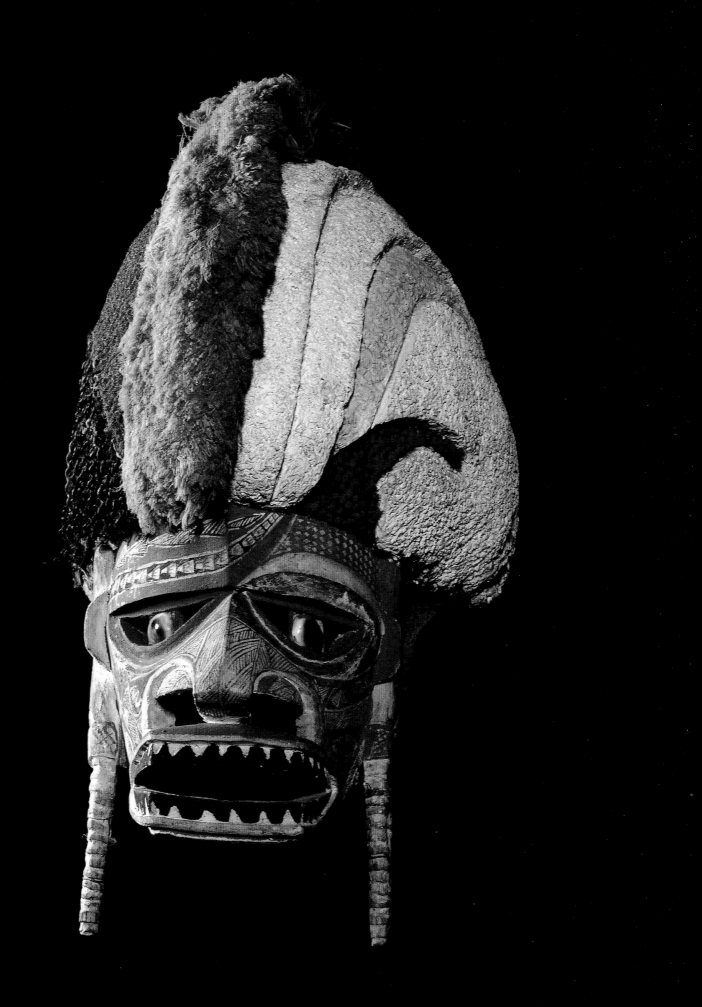

transformation – of a bird that is also a snake, or a bird that is swallowing a snake. This theme of transformation is also embodied, for example, in images of the rock cod, a fish that is known to change its sex, becoming female with increasing age, and being female at death. Flying fish are commonly depicted; most *malangan* human-figure sculptures have a flying fish depicted in front of the body, biting the chin of the main figure. Several knowledgeable men in New Ireland told Michael Gunn that the flying fish represents the speech of a leader, travelling far.[17]

For both the *malangan* carvings and the Sulka masks, the objects people made did not survive the occasion itself. *Malangan* were allowed to rot away in the forest. Sulka masks were formally burned in ceremonies involving the sacrifice of pigs, whenever the organizers found they possessed the resources necessary for their formal destruction. The objects so crucial to the theatre of the ceremony did not need to survive it, for they were not the goal of the occasion, but were instead the means by which the goal was achieved. Rather, by being destroyed they both remained in the memory of an overwhelming experience and disappeared in reality so that the next such performance could freshly overwhelm those present. The volume of *malangan* now in museum collections may also reflect the fact that sale to an outsider was as effective a form of destruction as rotting in the forest. More formal rituals of destruction may not have facilitated the sale of objects to the same extent.

Depicting Europeans

Collectors always make their own judgments about what to collect and what to leave behind. In this era Europeans rarely collected representations of themselves, perhaps failing to recognize the humour in some of those depictions. In southern New Ireland carved figures associated with the *malangan* tradition were made to decorate men's houses, generally portraying, or referring to, persons, events and places belonging to the kin group that owned the house.[18] One image that was collected – of a European man in a pith helmet, sitting on a horse – belongs to that tradition. Horses were introduced to New Ireland after 1902; the figure, collected before 1898, may represent something the carver saw on a visit to New Britain.

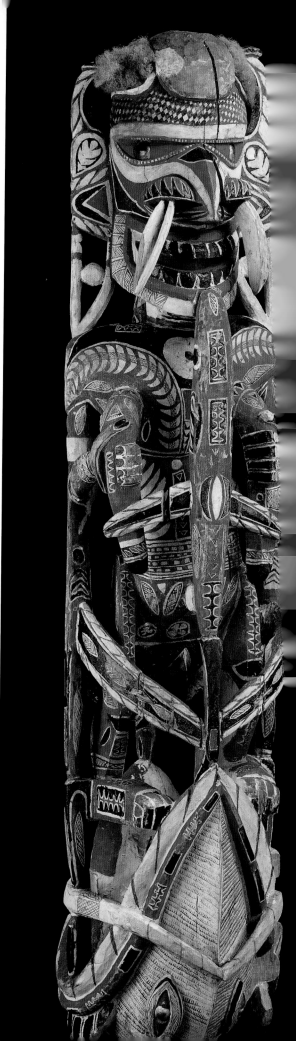

Death and Mourning

I N PARTS OF THE SOLOMON ISLANDS, where ancestors were revered and worshipped, the skeletal remains of important men were kept in special containers, and stored in shrines. On the island of Makira, for example, people kept the skulls of important ancestors in fish-shaped coffins. The coffins were kept with ceremonial bonito canoes in canoe houses, which also served as shrines where people would pray to the spirits of their ancestors.

Mortuary rituals were important across the region for dealing with the social and spiritual consequences of a death. As in the *malangan* ceremonies of northern New Ireland, these rituals often far outlasted the disposal of the corpse itself. Funerary events were commonly spread out over a year or more, allowing the community to come to terms with the loss of the individual, addressing the debts and obligations left by the death, and often establishing a new set of relationships with the deceased as spirit or ancestor.

In south-west Malakula, Vanuatu, men's funerals were marked in detailed ways by their membership of status-alteration societies. The deceased's rank dictated not only the form of the bier on which

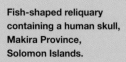

**Fish-shaped reliquary
containing a human skull,
Makira Province,
Solomon Islands.**
Wood. Length 141 cm (4 ft
7 in.). Mid- to late nineteenth
century, acquired 1904.
© The Trustees of the
British Museum, London.

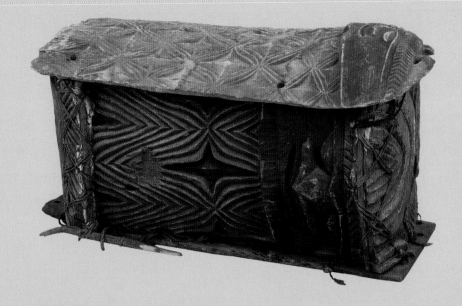

Burial chest and lid made from wooden door panels carved with ancestor figures, to contain the bones of a chief, northern New Caledonia, acquired 1910. Length 113 cm (44½ in.). Australian Museum, Sydney.

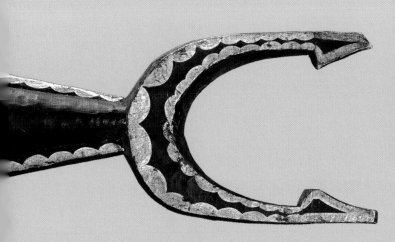

the body was first laid but also the nature of the exchanges and gifts that took place upon the death. Very important exchanges of pigs did all kinds of work of compensation and separation between the families and individuals linked to the person who died, including other members of the status-alteration societies. In south-west Malakula an effigy (*rambaramp*) was made of a deceased man, using his skull overmodelled with his features. The full-body effigy was then decorated to reveal the man's achievements in all the status-alteration societies (both the public graded society and the secret societies) of which he had been a member in life.

In New Caledonia, when a chief died, his house was deliberately destroyed and its door panels were defaced. Sometimes the spire of the house was used to mark the place where his body was laid out before burial to allow the flesh to rot away; afterwards his skull was taken to a sacred keeping place. In northern New Caledonia, in the Mount Aubias area, missionary influence transformed this process around the end of the nineteenth century: house doorway panels carved with images of ancestors were used to make burial chests. After the chief's flesh had rotted his bones were placed in the chest, and white shells were placed inside as a mark of the chief's high status.[i]

In a small-scale society the loss of each individual is likely to be felt throughout the community. Moreover, each individual is linked to others in a web of relationships: when one person is lost all the other relationships in the web need to be readjusted, like mending a hole in a net. Describing New Caledonian society in 1947, Maurice Leenhardt explained that a person, a living entity, 'knows himself only by the relationships he maintains with others. He exists only insofar as he acts his role in the course of his relationships.'[ii] So funeral rituals often acted to reveal and then to deconstruct the kinship, exchange and ritual relationships that the individual had during his or her lifetime.

LB

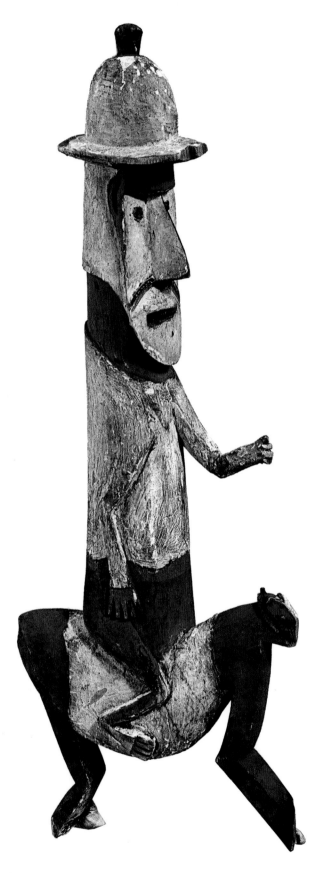

Complete with pith helmet, red belt and Reckitt's Blue trousers, and sporting a curved moustache, it is the very image of a German colonial official.

Europeans are generally recognizable as such in Melanesian depictions of them because of their clothing and the objects they carry. Their jackets, and especially their hats, distinguish them from representations of Melanesians. The narrative images incised on bamboos in New Caledonia sometimes depict with considerable detail the clothing worn by French soldiers and officials, right down to the buttons on their jackets (*page 206*).

New Caledonia was in fact the first part of island Melanesia to suffer substantial impact from European intervention. It became the first part of the region to be formally established as a colony when France annexed it in 1853 with a view to establishing a convict colony. The first of more than 22,000 convicts arrived in 1864, followed by a number of transportations of political prisoners, free settlers and of course soldiers. This substantial population incursion made far more impact and a far earlier impact on New Caledonia than on other parts of island Melanesia. It is not surprising that soldiers feature so consistently on the incised bamboos.

The Art in Dancing

Masking traditions like those on New Britain did not occur everywhere in island Melanesia, and where masking traditions did occur they had different characteristics. In New Caledonia, for example, carved wooden masks were made for multiple occasions, and had individual names even though they all represented the same water spirit (*page 208*). The masks incorporated human hair as a wig and beard: the hair was sourced from men in mourning who grew their hair long, and cut it at the end of the mourning period. The masks also had a black pigeon-feather cloak flowing from them, covering the body of the wearer. The wearer carried a club and some spears. The water spirit lived in swamps and was normally invisible, but appeared at rituals associated with the ancestors, in the form of the mask. (The spirit could also appear as a shark or lizard, or as bubbles at the bottom of a waterfall.)[19]

In some places the performance, the theatre, was focused on dance. Dance in this context involved a

Figure of a European man sitting on a horse. New Ireland, acquired *c.* 1898.
Wood, lime, red ochre, blue pigment. Height 56 cm (22 in.). Néprajzi Museum of Ethnography, Budapest.

'MANY PEOPLE DIED'

The time we were staying on these islands was a time of serious epidemics. Eight kinds of illness occurred: head illness (influenza?), dysentery, illness affecting the knees, abdominal sickness, mumps, sickness affecting the eyes, sickness affecting the back, extreme weakness of the body.

When the sickness affecting the head began, the high chief came to our house to ask where the disease had come from. We told him we did not know. He was very angry. His daughter was sick with the disease and getting worse. He told us not to walk about that day but to remain in our house lest we be overcome by misfortune. Many people were sick in all the houses and some of them died. Great was our sorrow on that day. Next morning the chief told us that his daughter was dead.

Then he told us to go and bury the girl. We said, 'Do not bury her yet. Wait until evening.' But he insisted, so we went to his house where all the priests were assembled and we asked the chief who was to bury her. 'You will,' he replied. We did so, but when we were returning to our house the chief said, 'Beware! Stay inside your house for ways are being sought to kill you.' We thanked God, for it was He who put this kind thought into the chief's heart. The people of the island had demanded that we be killed but the chief had not agreed. This made the people so angry that they refused him food. Then the epidemic abated, and people stopped dying in their houses.

No sooner had that month finished, when along came another sickness, dysentery, and many people died. This sickness caused the chief to leave his house and come to live with us. He did so in case we were killed surreptitiously. The people would not come near us, for they thought that we were the cause of the sickness. This belief was an obstacle to the work of God. Another reason was that we did not know their language well. We could not converse with them because we had not been on their island very long when all the households were overcome by sickness.

When all the people knew we were living with the chief, a household came to him with four things with which to buy us, so that he would deliver us up to them. But the chief kept those things and on the third night he called all the lesser chiefs and the people of his district to a meeting at his house to tell them about the offer made to him. He spread the articles in front of them but not one man spoke. After awhile the chief called out, 'What is your opinion?' A lesser chief stood up saying, 'Return them. Let us decline their offer.' The chief replied, 'They shall be returned.' So two men went to return those things – the *ngolo*, *ui*, *i'i* and the *mie*. They are the things I wrote about. So we were saved from death.

Ta'unga, Rarotongan missionary for the London Missionary Society in New Caledonia, referring to events on the Isle of Pines during the early 1840s.[i]

Humour and History

WHO, AMONG TRAVELLERS to New Caledonia, does not know the engraved bamboo?' The rhetorical question appeared in a work of salvage ethnography, published in 1900.[i]

The objects referred to were variants on a pan-Pacific form. Bamboos were decorated and used as smoking pipes, flutes and lime containers, among other things. Designs were most often geometric or curvilinear, but artists from a number of islands experimented with figures, having been stimulated by exposure, perhaps to European printed engravings, perhaps to the popular arts of sailors, such as scrimshaw (engraved ivory). Only among Kanak, however, did new styles of engraving become an established art form. Frustratingly little is known about the emergence and development of the genre, but most of the bamboos that ended up in museum collections were acquired during the second half of the nineteenth century – they are products of an epoch in which Kanak life was changed forever.

Extant bamboos are remarkably heterogeneous. Some were decorated with compositional skill, others treated like spaces to be filled with a variety of images that do not necessarily go together. In some cases men and women are deftly portrayed; in others figures are stick-like. Some feature irrigation channels and crops that were fundamental to Kanak life. Great tribal houses, ceremonies and sacred

Details, engraved bamboo, New Caledonia, collected nineteenth century.
Museum für Völkerkunde, Berlin.

creatures such as turtles were depicted. Yet the corpus is also a chronicle of cross-cultural curiosity. Colonial ships and guns loom large. A gent in a suit smokes a pipe. The sexual coupling of white men with Kanak women could be taken as a form of ethnographic erotica, created with the tastes of tourists or soldiers in mind. But these images surely also reflect resentments around inter-racial sex, said to figure prominently among Kanak grievances over the period.

One of the most remarkable of all extant bamboos entered the collections of the Museum für Völkerkunde in Berlin near the end of the nineteenth century (*opposite*). It is a metre and a half long and is divided into two sections by the natural node. Half bears a set of related images that are to be viewed horizontally, three scenes of fighting. Two parties of Kanak warriors face each other, one advancing upon the tribal houses and ceremonial ground of the other. Fighting is already taking place in the ground between the houses. An injured or dead man is being carried away. The second scene shows the struggle continuing and one great house burning. In the third image a climbing man has reached the top of another house and seized the ancestral carving from its apex.

The other half of the bamboo is to be seen vertically and is entirely different. It represents the French military hierarchy, with ordinary soldiers at the bottom, those of intermediate rank in the middle, and officers with elaborate uniforms and decorations at the top. There is no story in this section of the work, but it is rich in anecdotal observation. Local women with baskets and babies are in attendance. A *militaire* examines a document. Another is giving orders to a man who salutes.

The juxtaposition between the horizontal and the vertical underscores other contrasts, between the local and the foreign, the customary and the alien, and the past and the present. There is humour in the imagery but the intentions of the unknown artist were surely not comic. This is perhaps one of the most deliberately historical of any nineteenth-century Oceanic works, a great and poignant imagining of a confrontation between two worlds. NT

Detail, engraved bamboo tube,
New Caledonia, acquired 1913.
Length 117 cm (3 ft 10 in.).
© The Trustees of the British
Museum, London.

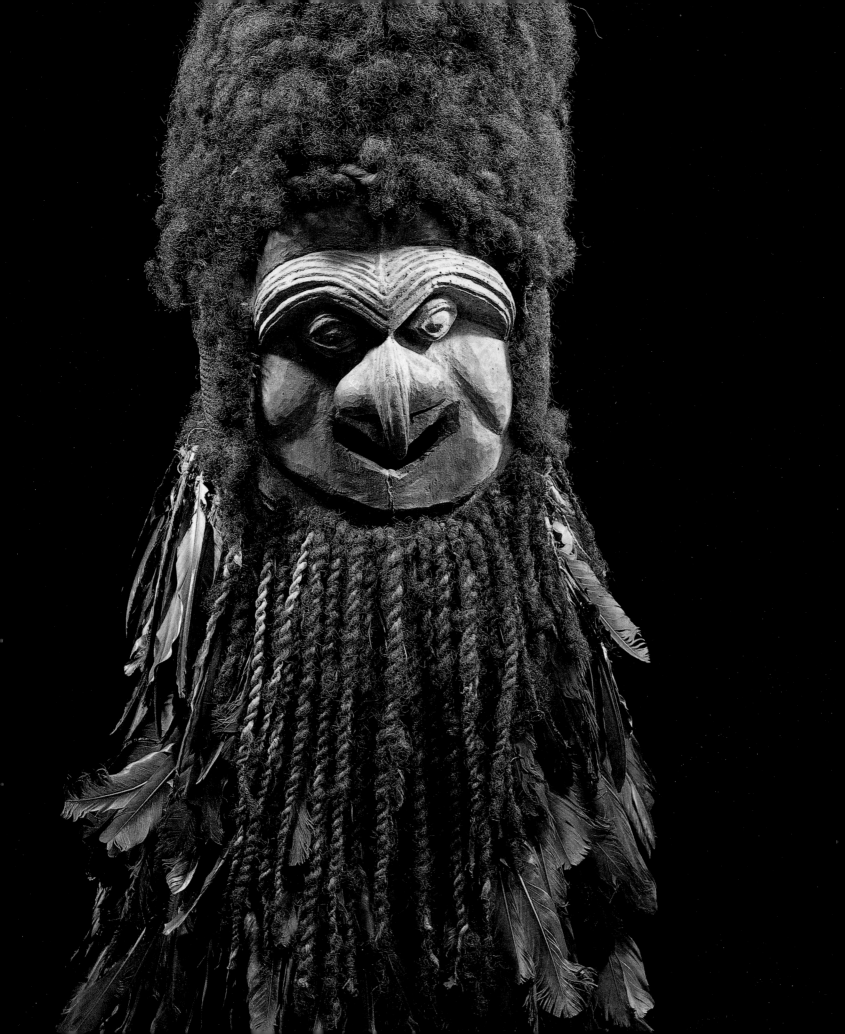

opposite

Water spirit mask, New Caledonia, acquired 1894.

Wood, feathers, fibres. Height 160 cm (63 in.). Australian Museum, Sydney.

right

Dance paddle, Buka people, Solomon Islands, acquired 1913.

Wood, chalk. Length 153 cm (60¼ in.). Museum of New Zealand Te Papa Tongarewa, Wellington.

Though paddles of this type were renowned for variations on schematic anthropomorphic figures, the genre is in fact highly varied and sometimes incorporates missionary-stimulated imagery, for example of devil-figures engaged in sacrificial acts.

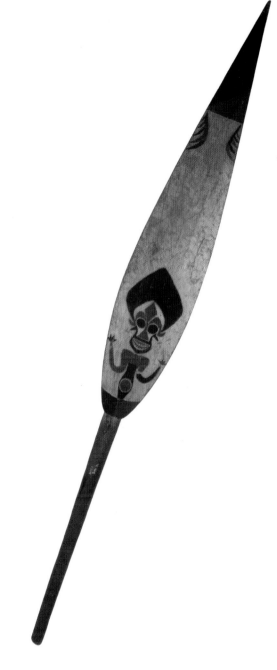

group of people (usually a single-sex group, or two interacting groups, one of women and one of men) performing a fixed pattern of movement: more like the ensemble pieces in a ballet or musical than other kinds of European dancing. These dances, which were generally named, had a set range of songs and drum beats to accompany them, and sometimes enacted, or alluded to, specific events, stories or histories. In performing them, dancers often dressed identically (although the leader might dress quite differently), with painted bodies, and with leaf, flower and feather decorations placed in the hair, or tucked into the belt, or into an armband. These decorations were designed to move and shimmer with the movement of the body, creating a powerful effect when the dancers moved in unison. Dancers often also wore headdresses or carried objects. English has no suitable term for the kinds of objects that Melanesians carry in dances. Called variously dance shields, dance clubs, dance wands, or even just 'dance implements', these objects carried by people in dancing add to the visual impact of the dance, and allude to the histories and stories recounted in the accompanying song: they are like props that enlarge the viewer's sense of the story and the occasion. These objects were generally carried in specific dances; they were not carried every time people danced.

Such objects were created and carried in specific dances in many different places across the region. On Buka and Bougainville islands, at the westernmost end of the Solomon Islands chain, where around twenty-six languages were spoken, a variety of different kinds of objects were carried in dances from district to district. In some areas carved and painted staves like paddles were carried. The staves often depict a face or figure with an apparently bulbous head. This is not a distortion of the human form but rather a depiction of the dressed body. The figures represent young men wearing headgear that marks their status as initiates. The initiates wear this headgear, 'hats' (*upi*) made of a small fan palm leaf perched on their heads, for a number of years, during which their hair is not cut but rather pushed up into the hat. These dance staves make a more general point, which is that often the depiction of the human body in Melanesian art is the depiction of the dressed body, and images that appear to the ignorant eye to be distorted, are often an accurate depiction of clothing.

Although dance objects were often carried by a massed group of dancers, sometimes specific objects were made to be carried by certain actors in the dance. Unlike New Britain and New Ireland, where there were many traders and planters resident at the end of the nineteenth century, who documented local practices and made object collections, there are few records for Bougainville. One set of Buin dance objects refer to a story about the sun, moon and morning star, which the dancers re-enact. In his survey study of the Solomon Islands and Bismarck Archipelago of 1912, Richard Thurnwald published photographs of men holding these objects aloft, or at arm's length, as if in dance.[20] While

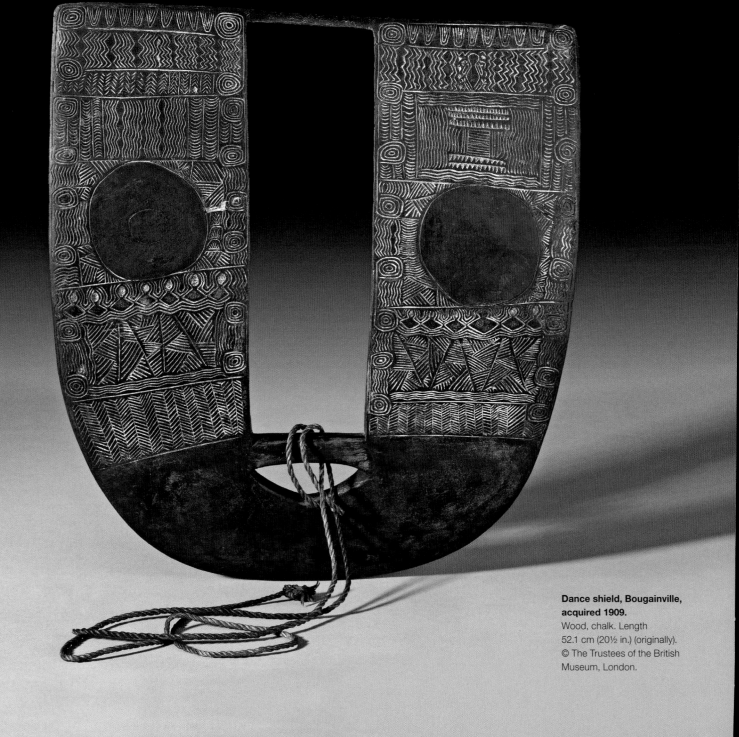

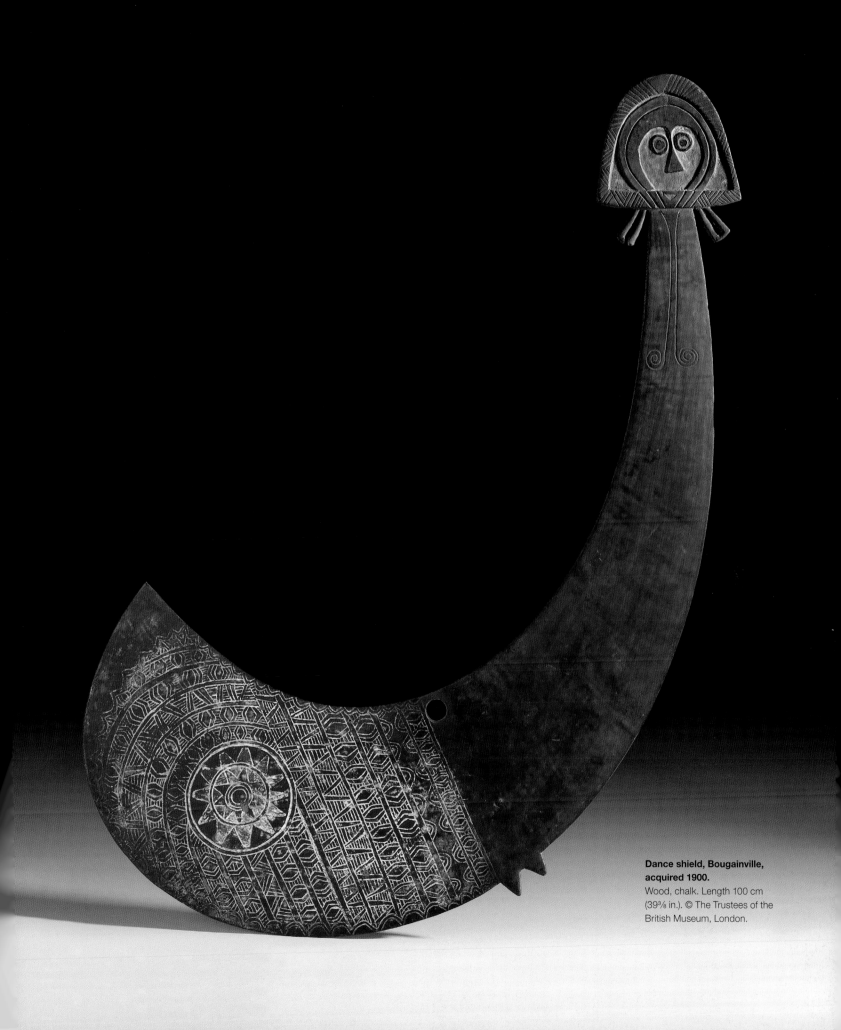

Dance shield, Bougainville, acquired 1900.
Wood, chalk. Length 100 cm (39⅜ in.). © The Trustees of the British Museum, London.

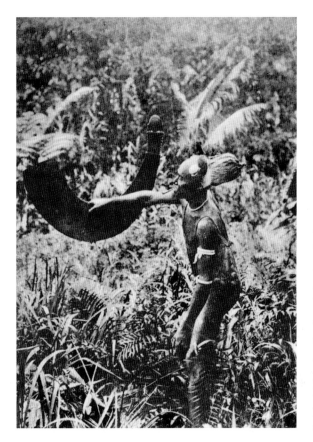

Dancer demonstrating 'crescent moon' dance paddle, Bougainville, Solomon Islands, before 1912.
Reprinted from Richard Thurnwald, *Forschungen auf den Salomo-Inseln und dem Bismarck-Archipel*, Berlin: 1912.

the sun dance shields are found in collections, there are very few moon shields in collections internationally, and this writer is unaware of any morning-star dance shield still in existence. The deeper significance of these objects, the steps of the dance in which they were held, the words of the song and the music to which it was sung, and the question of who had the right to dance with the shields may still be known in Buin but is not more widely recorded.

Political Power and Status

One of the multiple purposes of major ritual occasions was the ambition of individual men to achieve renown: thus the flying fish on the *malangan* carvings that represented men's hope that news of their oratory would travel far and make them famous. In the small-scale societies across Melanesia, there was always a tension between the achievements of an individual and his membership of a group. Independent life was impossible. Everyone depended on others for help in major projects – building a house, for example – and turned to others for food when their own gardens were not producing or for resources not available on their

own land. A leader was dependent on those around him for support and for resources, and very commonly, if he did not lead well, he would find his authority gradually erased as people literally moved away to other places where they also had rights to live, or merely began to ignore his pronouncements. To achieve renown a man needed continually to demonstrate his worth through his participation in the locally determined contexts for such achievement.

There were several avenues for achieving power and reputation in most of island Melanesia. Men could achieve recognition as especially skilled craftsmen. They could become wise in occult and medical matters, becoming feared and revered sorcerers. They could achieve fame for their acts of daring, bravery and cruelty in war. They could become community leaders by virtue of their age or their achievements in ritual or for their economic achievements in formalized exchanges of wealth. These roles were often not mutually exclusive, but rather provided a range of possible routes for men to follow. In some places leadership was connected to descent, but again, a person's ability to take up an inherited role was dependent on their character and political nous. In some places (such as central Vanuatu) women could under certain circumstances become the leader of their entire community, and in most places women had avenues for making themselves known as persons of substance.

In the islands of north Vanuatu both men and women participated in formal status-alteration systems, often known as graded societies. In these rituals men and women achieved rank and status by mounting and performing a sequence of specified rituals, often, but not always, centred on the exchange or killing of pigs. The sequence of the grades, and their achievement, can be compared to the hierarchy of qualifications in the international academic system – that is, there was a standard sequence of public grades, by the achievement of which the grade-taker achieved respect and substance. In many places there were also other grades and sequences – additional qualifications – that men could take. These additional male grading systems are often known as secret societies: their rituals were not performed in public but were hidden, taking place in special places away from villages and hamlets.

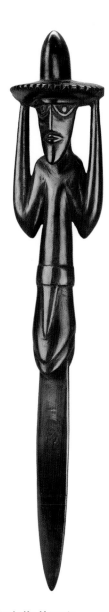

Eating knife, Vanuatu, acquired 1944.
Wood. Length 47 cm (18½ in.).
© The Trustees of the British Museum, London.

The secrecy attached to such north Vanuatu societies before substantial European influence should not be underestimated. In 1891 the missionary ethnographer R. H. Codrington published *The Melanesians*, in which he described aspects of these societies. Several copies of this book were circulated in the Banks and Torres Islands soon after it was published, leading to the collapse of the *tamate* secret societies in the Banks Islands. The publication was thought to reveal too many secrets, and to make freely available, to people who had no right to it, information that they should have paid to acquire.[21] The irony was that this happened in an area in which the Anglican Church was active: ironic because John Patteson, the first Anglican Bishop of Melanesia (1861–71), considered that missions too often tried to make converts into 'English Christians', arguing that too much cultural baggage was imported with the faith.[22] The principle he established for the Anglican Church in Melanesia was 'not to interfere with the institutions of the people, but to leave it to them, when they became Christians, to tolerate or condemn these institutions'. Anglican missionaries were active in the Banks Islands in the nineteenth century, but they allowed status-alteration societies to continue through that period.

Further publications about status-alteration systems did not appear until the twentieth century, and most have focused on men's public rituals rather than on the details of secret societies. What has also often not been documented is that while women sometimes participated in men's public status-alteration systems, commonly, men and women had separate status-alteration systems. These were sometimes paired, and often interdependent. On Ambae a man needed his wife to take a grade in the *huhuru*, the women's system, in order to have the resources he needed to take a grade in the male public system, the *huqe*. On Ambrym island a man's participation in the *fenbi* hierarchy was linked to his wife's participation in *yengfah*. Such interdependencies are not surprising given the interconnected character of all aspects of social life in this region. There is a constant tension between interdependence and difference: in most small-scale societies people value difference, and work hard to create it. This can be the difference of special occasions, of ritual and ceremony that utterly transforms the everyday. It is also difference between

people, created by restricting knowledge and forms of social connection including status, differences that ultimately make life more interesting.

Each status-alteration system used objects in different ways to mark and distinguish achieved rank. Such objects included items worn or carried in dance and ceremony such as headdresses, masks and clubs; they included clothing and body decorations, which only a person of that specific rank had the right to wear; and they could include designs of or decorations on all a person's personal objects, such as weapons, knives, canoes and houses or cult houses. In the Banks Islands, a man's eating knife, used for cutting his cooked food, indicated his achieved rank in the public *sukwe* status-alteration system. Indeed, status or grade in the *sukwe*, as in many status-alteration systems, was expressed partly through eating. The men's cult house was divided laterally by low barriers of wood, bamboo or stone, separating a series of fireplaces that lay from the front to the back of the house. Each fireplace belonged to a certain grade in the *sukwe*, and only men from that grade might eat food cooked on that fire.

Men's eating knives are also divided laterally with small bars, indicating the number of barriers across which the man had already moved. The holes in the knives commonly represent the sacred fires themselves. Men who achieved higher grades had knives that included more complex human or spirit representations on the handle finial.[23] Membership of the higher grades of *sukwe* also entitled a man to wear a loom-woven textile called a *malo saru*, a kind of divided poncho, the number of segments representing the rank of the wearer (and increasing in number from two to five). This is the only place in Vanuatu where loom weaving existed, the skill having presumably been acquired by trade from the Santa Cruz islands to the north: although other textiles were made by women, these textiles were woven by men. Only a few of these textiles now exist (*overleaf*).

In Ambae, Maewo and Pentecost, textiles were also worn to mark achieved rank, along with armbands, feather head ornaments, leaf and flower decorations, and carried objects. On Ambae finely plaited pandanus textiles, worn by men suspended from a belt at the front and by women wrapped around their hips, indicated rank on the basis of the designs. These textiles incorporate technically complex designs, plaited into

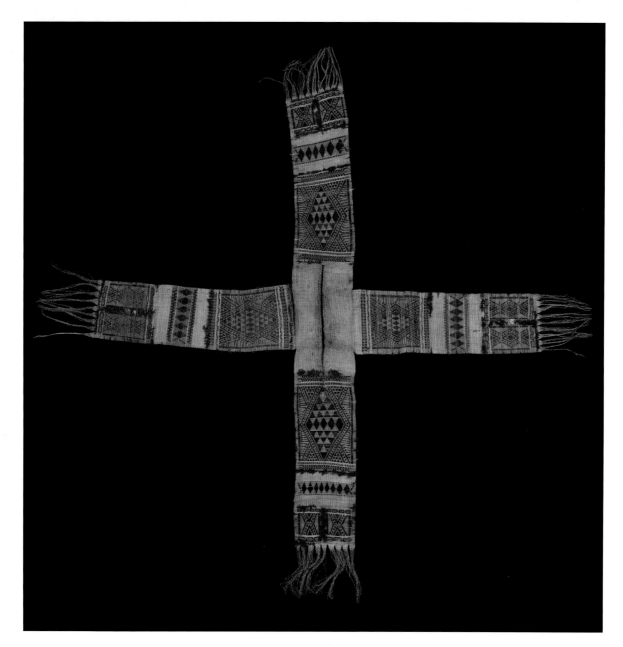

the textile with an overweave technique and subsequently highlighted using a stencil and red dye. The designs comprised a range of different compositions of diamonds, surrounded by zigzagging lines, each type of combination indicating a different achieved grade.

Like *malangan*, Ambaean grade textiles often occur in museum collections. Ambae has a good harbour, making it an easier place for European ships to visit than either Maewo or Pentecost. Women on Ambae today say that in the past their grandmothers did no garden work, but devoted their time to plaiting textiles. Given that these women also say that

previously they did not make so many of the other kinds of textiles – exchange textiles, furnishings and the like – it seems that some of them may have devoted their time to making grade textiles for sale to visitors as well as for use in rituals.

Women's status-alteration systems were often almost invisible to the first European observers. In some cases this was because the associated rituals were less flamboyant than those associated with men's societies, and were perhaps kept hidden from visitors. It seems also to have reflected the assumptions of the observers, who did not expect to find major

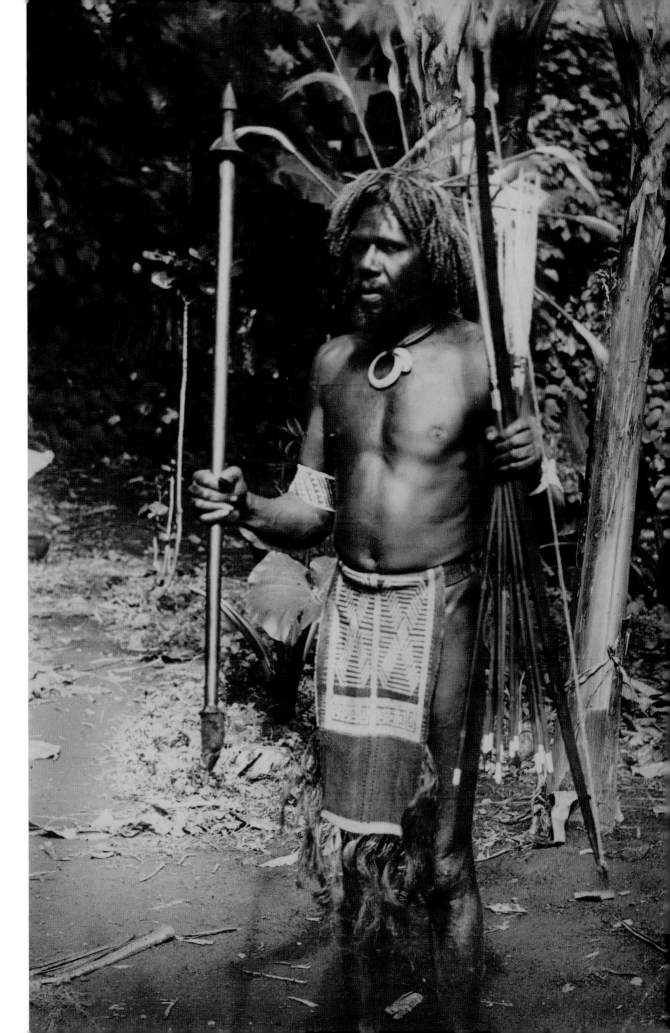

Chief wearing plaited pandanus textile (*singo*) to demonstrate his achieved status, and holding a spear, a bow and several arrows; Ambae, Vanuatu, late nineteenth century.

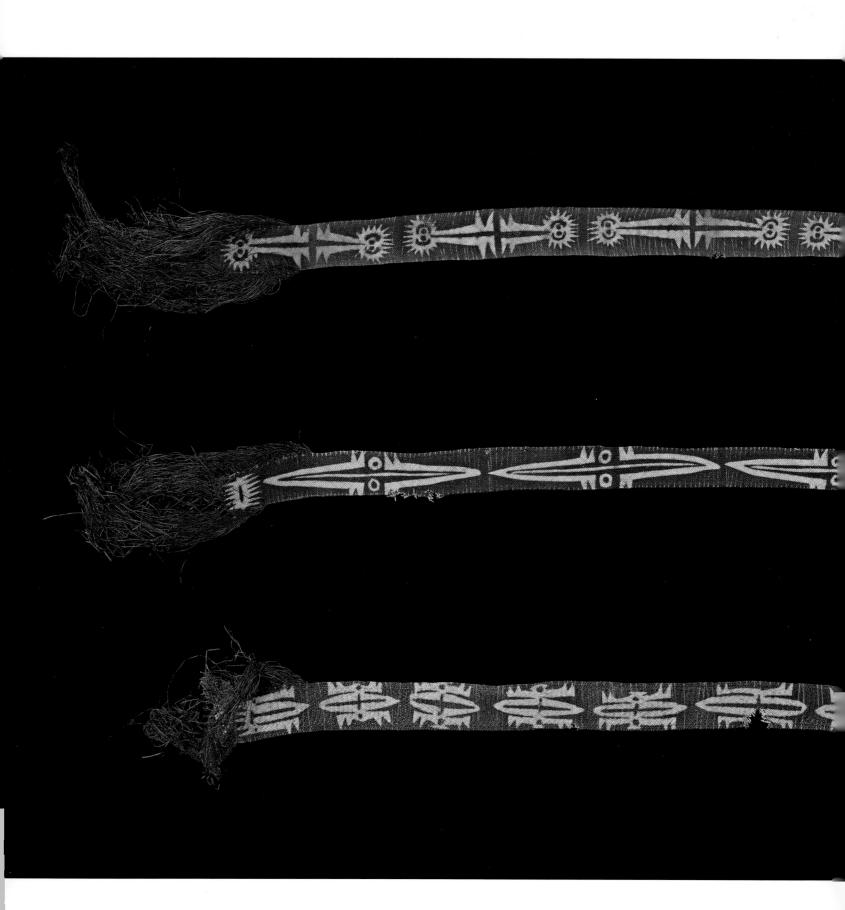

above

Funerary figure, Malakula Island, Vanuatu, collected 1976.

Tree fern.
Height 110 cm (43¼ in.).
Australian Museum, Sydney.

One of many ni-Vanuatu art forms that has been sustained through the colonial period and up to the present.

women's rituals.[24] In his publication of 1891 Codrington remarked that 'although women are completely excluded from the *suqe* of the men, they have something of the sort among themselves'.[25] He acknowledges that by achieving status in this system women became *tavine motar*, women of distinction, and that the symbols of their achievement included tattoos, shell bracelets and ornamented belts. These finely plaited pandanus belts were stencilled with designs that were linked to women's tattoo designs and to board paintings and carvings for women's ritual houses. Carvings were also produced for women's status-alteration systems in Malakula. Few such carvings have been collected, but there is one, produced in 1976, in the Australian Museum. Small Nambas people in Iaptkas village carve such fern-tree figures for funeral rituals: this one (*left*) belongs to the *kalvaro* stage of the women's status-alteration system there.

A wide variety of these rituals was performed across north-central Vanuatu, from Epi to Torres, with constant modifications and transformations. While stressing the importance of adhering to the 'correct' version of a rite, ritual specialists also acknowledged ways in which it might legitimately be varied.[26] Ceremonies were traded from place to place. Indeed, as Huffman points out, 'the rituals themselves were, and are, thought to have a power and spirit of their own that urges them to get up, to move on to other areas, to stay there for a while, and then move on'.[27] Thus it should not be thought that the systems encountered by Codrington and other early European visitors were conservative or unchanging. Rather, in many parts of island Melanesia, and notably in north Vanuatu, innovation was a constant of life. Men traded with each other for new knowledge, new magic and new ceremonies. Christianity was often introduced in this spirit: Melanesian men who encountered it in their travels sometimes brought it back as a new ritual to add to the myriad known already to their communities and ancestors.

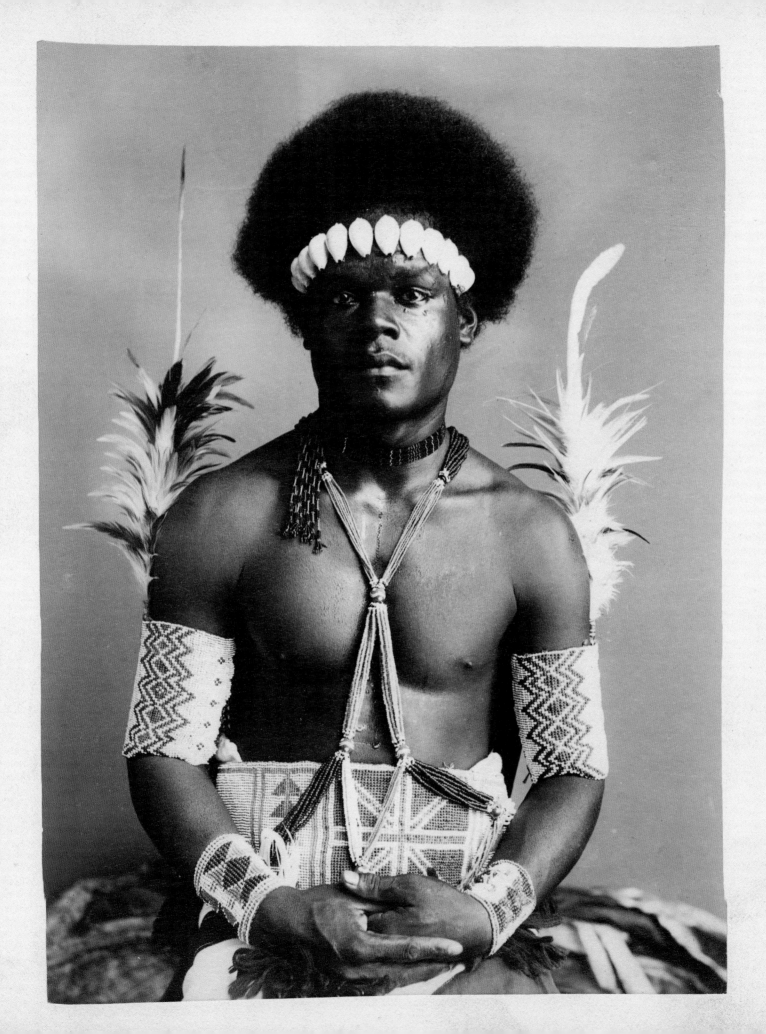

Lissant Bolton

TRANSFORMATIONS 1890–1940

By the turn of the twentieth century, expatriate influence had taken hold in island Melanesia, as European powers established colonial governments in the region. France had taken possession of New Caledonia in 1853; Germany took authority in the Bismarck Archipelago in 1884, extending this to include Buka and Bougainville in 1899; Britain established the Solomon Islands Protectorate in 1893; while France and Britain together founded the Anglo-French Condominium Government of the New Hebrides in 1906. The effect of their increasing intervention was to bring about many transformations in the life and art of the whole region. Initially – mostly in the nineteenth century – the European impact had seemed within Melanesian control: it appeared that people could take from expatriates but also reject what they didn't want. Gradually, however, it became clear that this was not so. A man called Daoumi from the Isle of Pines (in southern New Caledonia) commented on this to Louise Michel in 1885, summing up a process that happened several decades later in most other parts of the region:

> They (the white men) arrived in huge barques and they cut down our trees to fasten their sails to their boats. That was alright. They ate the yam. That was alright. But then they took the land, and the women and the young people.... They must have been very unhappy in their own land, to have come so far.[1]

The French annexation of New Caledonia in 1853 transferred sovereignty over the land from customary owners to the French state: from this point on, as John Connell has observed, the history of New Caledonia is in many respects a history of land tenure.[2] The control and management of land is fundamental to Melanesian societies, and its expropriation caused ongoing

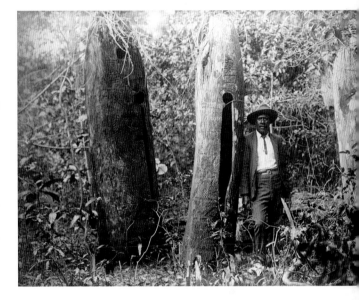

outbursts of violence and resistance that escalated in 1878 into an insurrection. This resulted in many deaths, the imposition of stronger forms of oppression of the indigenous community, and an ensuing steady decline in that population. By the end of the nineteenth century the consolidation of European settlement in New Caledonia, the appropriation of Melanesian land, and the confinement of the Melanesian population to reservations, was firmly in place.[3]

In the Bismarck Archipelago, the Solomon Islands and in Vanuatu, however, it was from the last decade of the nineteenth century that European influence began to make a substantial impact on local people's lives. The labour trade (which took able-bodied men and some women to work in plantations as far afield as Queensland and Fiji), the advent of Christianity, increasing colonial regulation and punishment, and innovations in material culture all became more and

more established, permanently altering the pattern and meaning of people's lives. The pace of this change varied across the region, depending partly on the accessibility of each area to Europeans. While these interventions began in the nineteenth century in most places, it was in the early twentieth century that their permanent impact became widely apparent. The way in which missionaries, colonial officials and others assumed a right to reorder people's lives seems retrospectively incomprehensible, as does their failure to recognize the depth of regional history and the interlinking of different aspects of community life. However, Islanders responded actively to these interventions: sometimes they made use of European power to prosecute local concerns and welcomed social and material innovations, and sometimes they resisted and rejected European control.

Elsewhere in the region, by the turn of the twentieth century, island Melanesians had begun to get the measure of Europeans. Those Islanders who went away to work in the labour trade, and survived and returned, brought news and goods back. The numbers who departed should not be underestimated. Dorothy Shineberg calculates that even in 1882 approximately 14 per cent of the population of Vanuatu was absent working abroad, and in areas where recruitment took place regularly, most men had been to one or other labour destination, sometimes more than once.[4] Many of these workers were recruited to labour in New Caledonia, where, as Shineberg says, the French colonial administration feared the indigenous population, considering that they did not have the resources 'to control them sufficiently to turn them into a workforce'.[5]

Recruiting for labour was prosecuted in a number of different ways and was in some cases a matter of kidnapping and force, often prompting resistance and revenge. Ben Burt has collected stories of such resistance from Malaita, Solomon Islands, and linked each to accounts of the same incident in British government archives. For example, in 1894 some Malaitans decided to try and kill a labour recruiter in revenge for the deaths of family members working in Queensland. Although they were not successful, British government staff decided that a show of force was a necessary response. This was aimed at the warrior Sinamu, who lived at a place called Taradunga. Burt

recorded Samuel Alasa'a's stories of a warship shelling gardens ('we didn't understand about warships'), linking that with the British account, by Commander Goodrich of HMS *Royalist*, who reported that on 20 August 1894, aiming at Taradunga, he 'shelled the district with the ship's guns and a seven-pounder mounted in one of the cutters'.[6] Such shows of force were more common in the Solomon Islands than in other parts of island Melanesia.

If the labour trade involved considerable violence, and much social disruption caused by the absence of so many men, it also had other consequences. Labourers returning to their home villages brought back material goods. The export of seeds and plants from Queensland was prohibited: people were not allowed to take them back, but many labourers did anyway. Enduringly interested in food gardens and in new plants or better varieties, and usually dressed for their return in a new set of European clothes, people took the opportunity, for example, to hide seeds in their socks. In many parts of Vanuatu today people still remember that corn was introduced to their gardens in this manner, and there are still plant varieties named 'Queensland' in acknowledgment of that history. Again, in so doing Islanders were acting in the same way as the first

Recruiting, Pangkumu, Mallicolo [Malekula, Vanuatu], 1890.
Photograph J. W. Lindt.
National Library of Australia.

Contacts between would-be recruiters, who were heavily armed, and Islanders were tense and often deteriorated into hostilities. Yet many Melanesians were keen to travel and work. Trade goods including rifles, axes, knives, scissors, cloth and mirrors were gifted to kin at the time of recruitment, and brought back by returning migrants.

'MALTANTANU WAS A VERY HIGH-RANKING MAN'

My family comes from Dip Point, West Ambrym, Vanuatu, from Lonwolwol village. Lonwolwol was the place where the Gospel arrived. They built the first hospital in the New Hebrides at Dip Point in 1892. The doctor who came there was Dr Robert Lamb, and he was later joined by Dr Bowie. My family were leaders in this place: the senior man at Lonwolwol was Malpuri. Malpuri was father to Maltantanu. Maltantanu was a very high-ranking man. He achieved the highest grade in the status-alteration system – he completed all the ranks. Then he started at the bottom again and rose halfway through the ranks again when he died. His sons were Rarangmal, Wingimal, Awanimal, Malsangivul, and another who was my grandfather – who was able to eat food from a taboo fire (he had started in the status-alteration system) but who didn't achieve the rank of *mal* – Wurwurnaim. He achieved the rank that gave him the name Wurwurnaim before the traders came looking for men. They chased my grandfather on the beach, and caught him and forced him to go to Queensland. They put him on a ship, and he went and worked in the sugarcane fields. There he had the chance to go to missionary school run by two missionaries, Mr and Mrs Young.

When my grandfather finished his contract he came back to Ambrym, to Dip Point. He didn't rejoin the status-alteration system but nevertheless, he was made leader of the people there because he was the son of a senior leader. In the past if you picked just anyone to be a leader there wouldn't be a man to listen to him – he had no power to speak and direct his people. When he became leader – I'm cutting the story a bit here – when he was leader he looked after his people but at the same time, he also taught the Gospel and preached too. He helped with this work but then there was the great trouble that happened at Dip Point in 1913, the volcano destroyed our village, and people fled to Malakula. From Malakula they went to north Ambrym, where they had some family, moving from village to village till they lived in a place called Ranmuhu. My father was born in the hospital at Dip Point, but I was born in Ranmuhu village, in 1936.

Chief Willie Bongmatur Maldo, North Ambrym, Vanuatu, 1997.
Chief Willie was the first President of Malvatumauri,
the Vanuatu National Council of Chiefs, serving from 1977 to 1993.[1]

above

**Belt woven of glass beads
with Union Jack design.
Solomon Islands. 1891.**
Length approx. 90 cm (3 ft).
© The Trustees of the
British Museum, London.

settlers of island Melanesia, who brought food plants as
well as Lapita pottery with them to their new homes.

Negotiating Christianity

Although missionaries went to Melanesia, Christianity
was also introduced to the region by returning
labourers from Queensland. Missions were set up in
Queensland to preach to workers in the sugar
plantations. The Queensland Kanaka Mission, which
later became the South Seas Evangelical Mission, later
expanded its operations from Queensland into the
Solomon Islands. The first Christians in east Kwara'ae
on Malaita were labour migrants who returned home
after 1900. Samuel Alasa'a's father and others went to
Queensland, and on their return they acquired the
right to use some land near the sea on which to start a
mission. When other local men arrived with weapons
to fight them, Alasa'a recalled:

> My father said 'This isn't a fight, this is the gospel'.
> They said 'Where is this gospel?' My father said 'It's
> the death of Jesus.' They said 'Where is this Jesus?'
> They talked on until Sausaungia, Kalakini [and
> other named individuals] said 'Oh it's alright. You
> all go down and live on the sea-side, so whenever
> we come out at the sea we'll come to a clear place'.[7]

People had many reasons for accepting or allowing
Christianity. The men who permitted Alasa'a's father to
found the mission did so because it would give them a
neutral place that they could visit freely – a 'clear place'
– in a social context where one could not freely enter
other people's territory. Similarly, the spirit world and
the power of sorcery were very real to people and in

some cases very oppressive; a religion that gave them
an alternative to turn to was sometimes embraced,
even if that act was seen as one of destruction. Sinamu,
whose land Goodrich tried to bombard, lost his only
son through sickness and blamed the death on
ancestral ghosts that he worshipped. Alasa'a's account
of this event reports that Sinamu said: 'Oh I was
dealing with the ghosts and my son has died. So be
it, I'll go [to the mission] and we'll be defiled.' As
Burt explains, glossing the story, 'for senior men like
Sinamu, Christianity was defiling because of its wilful
breach of the rules of tabu required by the ancestral
ghosts'. Alasa'a's account continues with a conversation
his grandfather had with Sinamu:

> '[Y]ou're a man who's tabu,' he said. 'You can
> lie there and say tree-bark magic for a man
> and tomorrow he's dead, or they've killed him.'
> But [Sinamu] said 'I reject that now, and I reject
> dealings with ghosts, because my children
> have died.'[8]

The transition to Christianity from ancestral religion
was not always as straightforward as this conversion
implies. Another labour migrant who brought
Christianity back to Malaita, Gwagwaofilu, was placed
under considerable pressure by his family to step away
from his conversion. Gwagwaofilu's son Clement 'Au'au
later described how Gwagwaofilu's 'father and the
others bespelled him and he went back to being
heathen, he was backsliding. He returned to live as
a heathen, then he killed someone.' Gwagwaofilu
returned to the ancestral religion for the rest of his life:
'he took over our tabu-sanctum at 'Ere'ere, so he was a

Clergy blessing new buildings for an Anglican school at Maringe on Santa Isabel, Solomon Islands, 1940s.
© The Trustees of the British Museum, London.

The environment and architecture of communities in western Oceania was transformed over the last decades of the nineteenth century and the first half of the twentieth, as cult and clan houses were replaced by churches and schools. Missionaries tried to redirect communal energies toward mission projects.

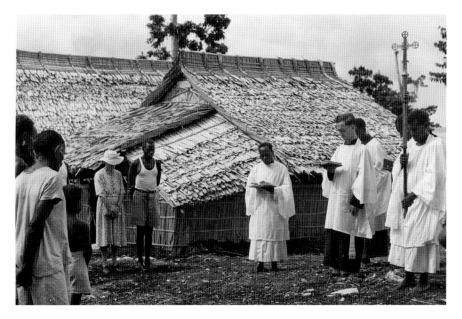

senior man, a tabu speaker'.[9] Through the early twentieth century across island Melanesia, these debates and disputes, with their intellectual and physical challenges and their high drama, gradually faded away. As a result, the continuing production of objects related to local religions and to sorcery was uneven across the region. Even while some Malaitans were building church houses, Gwagwaofilu was maintaining and sustaining the tabu sanctum at 'Ere'ere.

The impact of Christianity varied considerably depending on who introduced it as well as on the internal debates in individual communities. The Anglican Church of Melanesia was tolerant of indigenous ritual, but other missionaries, such as the Presbyterians in southern Vanuatu, were much

more inclined to wipe out local ceremonial forms. In Malaita the church was later taken over by the South Seas Evangelical Mission, an organization with strong nonconformist foundations. This mission insisted on 'a clean break from the heathen and their customs and superstitions';[10] included in that ban were both traditional body ornaments and the festive occasions on which they were worn. Ben Burt observes that this reaction was in fact as much Malaitan as mission-prompted, 'mirroring the equally fundamentalist values imposed by the ancestral ghosts through strict rules of tabu and female defilement'.[11]

If local forms of religion, sorcery and magic were casualties of the European incursion, the casualty rate was not uniform across either the region or across time. Both colonial governments and missionaries were opposed to sorcery and magic used to cause death and illness. They also opposed war and the use of war magic. Some objects made in support of these practices quickly disappeared, such as war charms from New Georgia in the Solomon Islands. Others were hidden from or simply not visible to those who would destroy them.

The new religion brought its own ceremony and its own material culture with it: the cross, the Bible, altars, church buildings and clothes (including religious robes). People made local versions of the material objects associated with Christianity, most notably in building 'church houses', but also in making crosses and other Christian paraphernalia. In the Melanesian Mission collection, donated to the British Museum, there are for example a cross and crozier (or bishop's staff) from the Solomon Islands, made from wood and

From 1867, the Anglican Melanesian Mission had its base on Norfolk Island, building there a church and a boarding school where Solomon Island boys were educated into Christian literacy before being returned to their homeland. Hence the principal church on Norfolk Island features the shell-inlay decoration characteristic of a Solomon Islands aesthetic identity.

above
Christian women of Epi and Paama, Vanuatu, *c.* 1920.
Photograph Maurice Frater.

inlaid with pearlshell in a customary central Solomon Islands style. Such objects may have been made with religious conviction, but sometimes they seem to lack assurance, suggesting that the maker was not confident of the parameters of the material form, and its potential for innovation or variability.

Clothing and Transformation

One of the key material foci of missionary activity was clothing. Many missionaries saw the adoption of European clothing as an outward and visible mark of an inward spiritual transformation – from heathen to Christian. This kind of discrimination also made sense to Islanders, who traditionally used clothing and ornamentation to mark identity. As a result, clothing became a key material signifier by which the transformations brought about by the European incursion were made visible.

The transformations in Islanders' clothing have rarely been traced in detail, and yet by tracing them the acceptance and rejection of colonial imposition, and especially partial accommodations to new regimes, can be made visible. In the pre-colonial era throughout

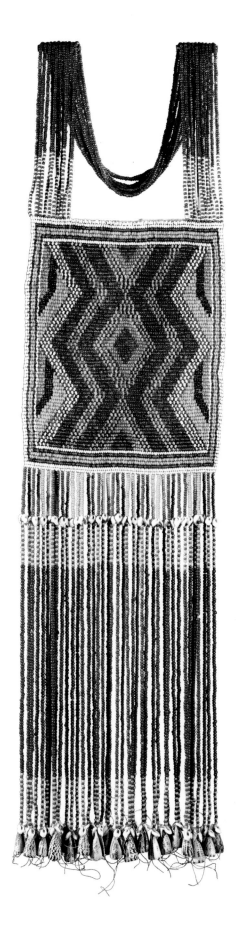

above

Comb, Malaita, Solomon Islands, before 1950.
Split tree fern with decorative fibre plaiting. Length 14 cm (5½ in.). Auckland Museum.

right

Beaded chest ornament for married women, Shortland Islands, Solomon Islands, 1924.
Length 69 cm (27⅛ in.). Auckland Museum.

Imported coloured glass trade-beads became increasingly available in the late nineteenth century.

far right

Kapkap shell ornaments, New Ireland, before 1939.
Diameters 4–10 cm (1¾–4 in.). © The Trustees of the British Museum, London.

Variations on *kapkap* were made over a wide region extending from the Bismarck Islands to the Western Solomons.

island Melanesia, clothing and body ornamentation communicated information about the wearer's social location, the kinds of information conveyed depending on local priorities and preoccupations. As well as marking gender, clothing might convey an individual's kinship affiliations, marital status, ritual achievements, place of origin, rank or role. As Ben Burt observes about Malaita:

> Formerly, in 'traditional times'…Malaitans dressed in very little, but on special occasions they ornamented their bodies with fine and valuable objects. They put on bands and combs patterned with bright red and yellow fibres, rings, pins and pendants of glistening white shell and pearlshell and straps of valuable red, white and black money beads and dolphin teeth, and coloured and scented leaves. By this means they presented themselves as youths and maidens, husbands and wives, men of possessions, priests, warriors and worthy heirs to the ancestral ghosts whose festivals they dressed to celebrate.[12]

The point of indicating one's identity through ornamentation, especially at festivals, is partly to do with the volume of people from the surrounding region who might be participants in such an event. People who rarely saw each other on a day-to-day basis could read from each other's clothing what their status was, noting changes that might have occurred since last they met.

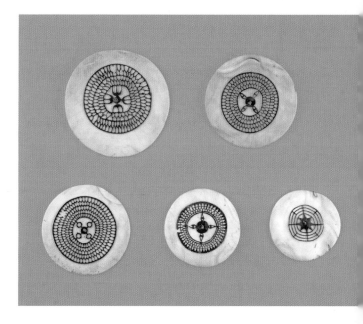

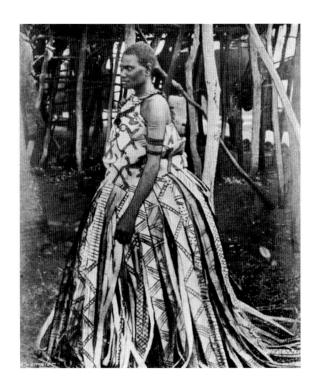

In Erromango, Vanuatu, for example, the length of a woman's skirt indicated whether she was married, single or widowed. (For example, widows shortened their skirts after their mourning was completed, while only the wives of high-ranking chiefs were permitted to wear barkcloth draped across their shoulders.)

Melanesian clothing was and still is not only a matter of communication but also one of aesthetics. This partly reflects the aesthetics of combination – the putting together of a number of different items to create a specific and often colourful effect, as in Malaitan body ornaments. It also indicates the aesthetics of the body in movement. Especially for festivals and dances, clothing and body ornamentation of all kinds was designed to enhance attractiveness of the body in motion – the fleeting scent of sweet-smelling leaves and flowers worn in armbands, light glancing off oiled skin, feathers and other head ornaments trembling and waving, the sound of leg rattles as the wearer dances. Clothing was also often an expression of wealth, for people wore their valuables: shell rings, necklaces, bands and belts.

To adopt European clothing was thus not a neutral act. To wear European clothes was to lay aside a specific aesthetic sensibility and to erase the differences in status marked on the body by traditional clothing. It was to declare an affiliation to new ways and new beliefs. It was also to acknowledge a distinction between Islanders and Europeans. As is demonstrated by many images of missionaries flanked by their converts, and government officials flanked by their subjects, if Islanders were encouraged to wear European clothes, they were not encouraged to wear identical clothes to their colonial overlords. An article in the John G. Paton Fund newsletter, *Quarterly Jottings from the New Hebrides South Seas Islands*, which supported the Presbyterian mission in southern and central Vanuatu, comments: 'An ordinary native dress is made yoke shape. Something like a lady's nightdress, but shorter, with narrow sleeves'.[13] These loose dresses were and still are often called 'Mother Hubbards', a designation that marked them as being specifically 'native' dresses. The shirts and sarongs, the loose dresses given to Islanders may have been European in appearance, and designed to meet European notions of modesty, but they made real a categorical difference between Europeans and Islanders, especially for women. They demonstrated a distinction of race.[14]

Although Europeans found indigenous clothing shockingly immodest (ni-Vanuatu and Kanak penis wrappers, for example, caused particular offence), Islanders nonetheless held onto expressions of modesty and propriety. Visiting Vanuatu in the early twentieth century, Felix Speiser reported that even when wearing trousers men accustomed to wearing penis wrappers continued to wear 'a strap to press the penis to the body. Otherwise, they would feel undressed'.[15] James Lawrie, writing about Aneityum, Vanuatu, in 1880, observed that 'although every woman and girl wears a large print garment, she would have the feeling of being unclothed without the native-made fringes, of which three or four are worn together'.[16] Kathleen Woodburn, visiting Erromango in 1940, photographed women who wore multiple fibre skirts in combination with European clothes. The value that people attributed to their own clothing and their ideas of modesty did not suddenly give way to the values and concepts attached to European clothing.

Over time, Islanders adapted the clothing styles they were allocated. This is especially true of women's

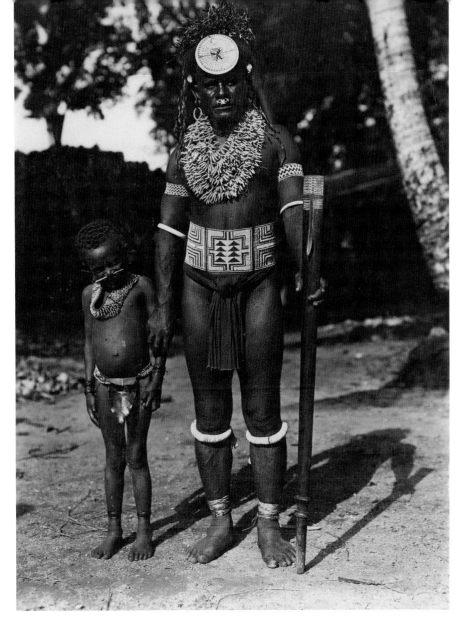

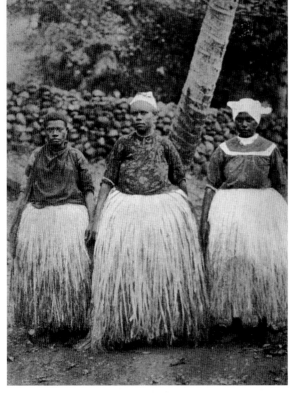

clothes. Mother Hubbards were gradually modified in Vanuatu and New Caledonia in ways that made them instantly recognizable: it gradually became easy to tell in which country such a dress was made. In the Bismarck Archipelago women also adapted introduced clothing, creating what is now known as a *meriblaus* – a kind of blouse worn over a waist-tied sarong.

Food and Feasting

Colonial understandings of indigenous knowledge and practice were uneven, and their attempts to control and alter Melanesian lives were unevenly applied. Whereas government officials and missionaries focused on matters such as pacification, on bringing to an end any rituals and religious practices of which they disapproved, and on introducing clothing, they intervened much less in other areas, such as food gardening and cooking. However, interventions in one area had consequences in others. When major religious rituals were suppressed or given up, it was no longer necessary to prepare gardens long in advance for major feasts. Nonetheless if some major feasts were no longer held, smaller feasting occasions continued and new church-related ones were created, while daily cooking styles were rarely called into question. Cooking and the objects used to serve food were affected by increasing European presence in Melanesia, but only indirectly.

Throughout the region food was carefully prepared, and there were distinctions between everyday meals and the more elaborate and special feast foods, which involved both special ingredients and special forms of preparation. The traditional diet

was based on root crops such as yams and taro, with various leaf greens added as relish, supplemented by fruits and nuts. In some areas people ate sago. Coastal areas depended greatly on fish and seafood, whereas inland people ate small game such as opossum and birds, and where there were rivers they ate eels, freshwater prawns and the like. Pigs, the focus of much attention and interest through the region (except in New Caledonia), were generally a feast food. Coconuts were absolutely central to the diet in most areas, providing among other things pure drinking 'water' when green, and oil and coconut cream when dry. There were many different strategies for obtaining salt. Some people would use salt water, added directly to cooking food. Others would collect salt from dried rock pools at the coast, while some would burn driftwood, carefully preserving and using the salty ashes. Food was steamed in hot stone earth ovens, boiled in green bamboos over a fire (or in a few places in cooking pots), and roasted in or over an open fire. In quite a few areas of island Melanesia people made what Europeans described as 'puddings'. In an insightful article about Polynesia, where similar puddings were made, Helen Leach compares eighteenth- and nineteenth-century English boiled puddings (now remembered mainly in dishes such as steak and kidney pudding) with Pacific cooking styles.[17] In Vanuatu such dishes became known in Bislama as *laplap* and were and are made by grating a raw starch vegetable like taro, and spreading the paste on clean leaves, sometimes dressing it with relishes of leaf greens, fish or meat, wrapping it in further leaves and baking it in a hot stone earth oven. Once cooked it is often also dressed with coconut cream. There are many combinations and recipes for *laplap*, some being specific to certain areas.

Feasting was always important, in some areas being the addition to a ritual but in others the focus of it. Douglas Oliver reports that throughout the Siwai area in south-west Bougainville a man would seek to be renowned, to earn 'the kind of esteem enjoyed by men who gave feasts frequently'.[18] These feasts would generally be tied to 'a house-raising or some other kind of work-bee'; indeed it was customary to begin a social-climbing, renown-seeking career by building a club-house. The best way to do this was to collect as many helpers as possible, to draw out the work as long as possible, and to reward the workers with such a

bountiful feast 'that they would ever after remember the occasion and the club-house with pleasure'.[19] When he had achieved renown in his own village a man would enter into a competitive feasting relationship with a renowned man in another village, the objective being, eventually, to defeat his rival with such a generous feast that the competitor was bankrupted, unable to repay. Feasts involved dancing and playing slit drums and pan-pipes, as well as the food itself. In the Siwai context, feasts did not involve the production of objects of the kind that museums might collect; instead the creativity of the occasion went into the food and the cooking themselves. Feast food included roast and steamed pork, boiled eel and opossum, and vegetable and nut puddings.

In the Admiralty Islands, by contrast, there was a great variety to the vessels in which food was prepared and served, many of which were beautifully made and decorated. This region was under German administration from 1885, but it was the establishment of a permanent government station in 1911 that heralded substantial colonial control of the area, with missionaries beginning work from 1913. At the beginning of the First World War, Australia took over management of the region. After the suppression of warfare from 1911, the major feasts, known as *lapan*, became the principal means by which men from high-ranking families could demonstrate their leadership. Feasting may well have initially increased in importance, but in the 1930s and 1940s the *lapan* feasts were discontinued, abolished in response to pressure from missions and the colonial government, as well as from young men returning from periods working in the labour trade.[20]

Unlike the Siwai, Admiralty Islanders, who were great carvers, made a wide range of wooden bowls. These included smaller bird- and animal-shaped bowls, bowls with figurative handles, and very large feasting bowls with spiral handles, which could be more than a metre in diameter at the rim. By 1931 the Swiss ethnologist Alfred Bühler observed that the large feasting bowls were no longer made, and that the smaller animal-shaped bowls were also disappearing.[21] Different social groups in the archipelago had their own specializations. For example, some clans specialized in a particular product to be distributed at a feast, such as coconut oil. An unusual category

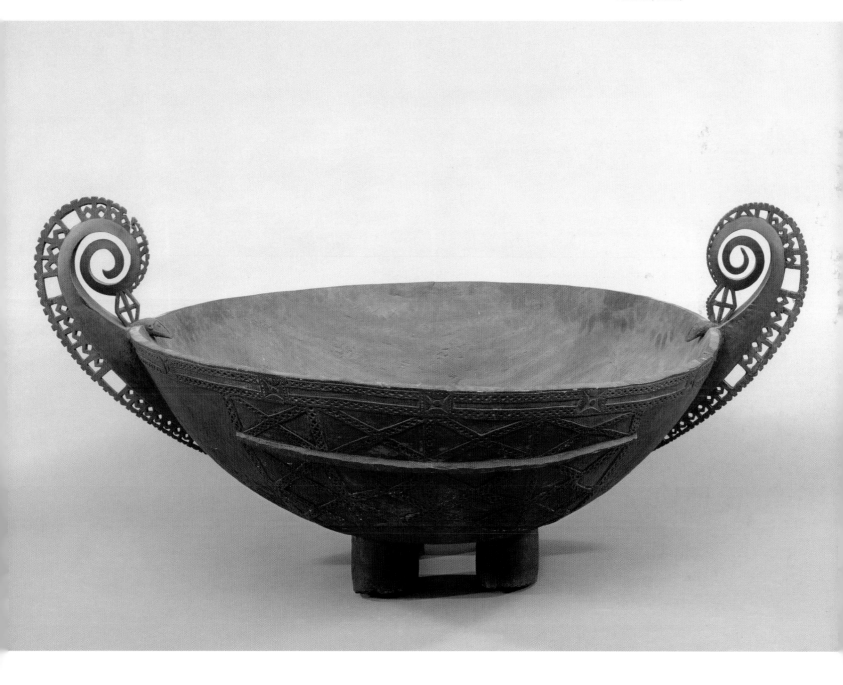

Feasting bowl. Admiralty Islands, collected by Alfred Bühler, 1932.
Carved wood. Length 148 cm (58¼ in.), diameter 114 cm (44⅞ in.). Museum der Kulturen, Basel.

The Kalikongu Feast Trough

THERE ARE MANY GREAT and extraordinary works of Oceanic art that have been seldom or never displayed, and seldom if ever published. One that is surely remarkable is a feast bowl from the village of Kalikongu on the Roviana lagoon in the Western Solomon Islands. A vessel for food this indeed was, but the word 'bowl' is hardly adequate to describe this 8-metre (26 ft) dead-straight trough, which could almost be mistaken for a canoe were it not so narrow. One end features a crocodile's head, a human head poised within its jaws, the other end a human figure that grasps the crocodile's tail; its form and head are reminiscent of the prow figures famously associated with the war canoes of the region. The whole vessel thus represents a crocodile's body; what it would have contained was a mix of taro, yams and nuts, prepared for great feasts that preceded, or celebrated, headhunting expeditions.[i]

Large and elaborate feast dishes are well known from Roviana, and from the Western Solomons generally, but they are far more commonly deep and round, they bear birds' heads and are roughly in the shape of birds' bodies. This work is highly unusual both in its form, and in the manner of its decoration. Bowls typically combine jet-black paint or stain, and brilliant shell inlay. The inlaid motifs and images are often of frigate birds, renowned for their aggression and predatory agility. The approach to this sculpture is entirely different. While the ends are in the round, the sides bear figures in shallow relief that are dark and dramatic against the painted white panel, hence consistent with the customary aesthetic of powerful contrast, but the figures are also varied, individually expressive and naturalistic. They are evidently warriors. They hold clubs, shields and in one case a revolver.

This trough speaks of a colonial history in multiple senses. Roviana societies had long been dynamic and predatory. A ritual economy entailing gift-giving, feasting, shell money, mortuary ceremonies, the construction of great canoes and canoe houses, and headhunting, was potent – and was closely linked

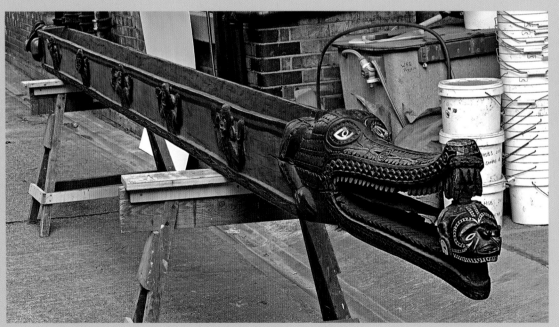

left
Feast trough, Roviana lagoon, Solomon Islands. Collected by Admiral Davis of HMS *Royalist* in 1891. Carved wood, shell inlay, pigment. Length 8 m (26 ft). © The Trustees of the British Museum, London.

opposite
Detail. Feast trough, side decoration.

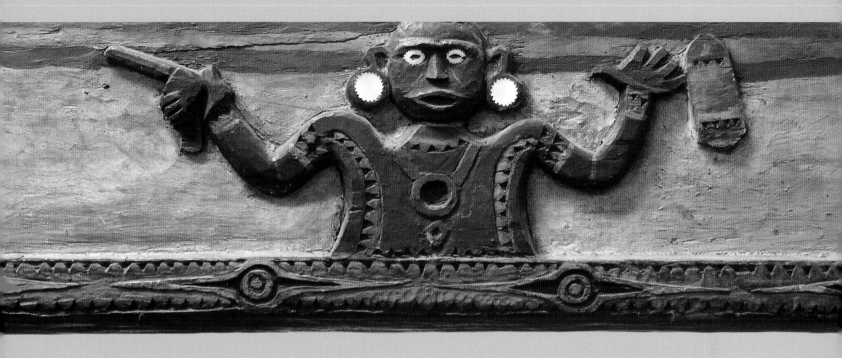

with an elaborate trading network, which connected peoples both around the lagoons of New Georgia and between neighbouring as well as more distant islands. Contact with European traders from the early nineteenth century onwards empowered local leaders who were already ambitious; it added fuel to a dynamic that was already competitive, expansionist. Clubs were replaced with iron-bladed headhunting hatchets, and hatchets in turn by muskets. Other trade goods constituted new values and enticements. The violence of the indigenous order was magnified too by the violence of Europeans seeking to recruit Islander labour for Queensland, Fiji and elsewhere. A cycle of raids and reprisals involving locals and Europeans was intermittently deadly.

The British made only erratic attempts to police the region. The Royal Navy's Australian station, however, undertook a series of cruises. They investigated 'outrages', some perpetrated by labour recruiters on locals, others including the killings of sailors and other Europeans by Islanders. Admiral Edward H. W. Davis made one such cruise, in HMS *Royalist*, between 1890 and 1892. He launched a number of punitive actions, including raids around Roviana on 25 and 26 September 1891. People were killed, villages were shelled, and local artefacts were looted on a considerable scale. The objects removed included this feast trough. Though it was appropriated in the course of an official action, Davis retained it in a personal collection that he later attempted to sell. He also claimed falsely that the cooked bodies of captives were eaten from the dish – thus associating it with the notorious stereotype of the 'cannibal feast'.

This vessel was intended by its maker or makers to be spectacular, and it remains spectacular today. It bears histories of both indigenous and European violence. But it is also an innovative and exceptionally accomplished work of art. NT

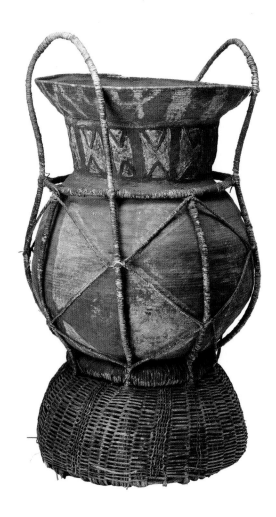

Oil container.
Admiralty Islands.
Fibres, putty, pigments.
Height 127 cm (50 in.),
diameter 70 cm (27⅝ in.).
Linden-Museum, Stuttgart.

a cooking fire, while as water pots they kept drinking water cool because of their permeability.[23] Alfred Bühler reported that in 1931 it was not uncommon to see fifty pots stored on a rack inside a house.[24] Plaited and putty-sealed bowls continued to be made to serve liquid foods such as soup. The putty was also used to decorate coconut-shell water containers: applied, incised and painted, putty was also used to add and reinforce a spout for such vessels.

The Art of Everyday Life

If ordinary cooking and serving vessels continued to be used in many areas through the early decades of the twentieth century, so too did other items in everyday use. For example, Raymond Firth records that in 1928–29, when he spent time in Tikopia in the far east of the Solomon Islands, there were a wide variety of wooden headrests in use, so many, in fact, that he collected about 'two dozen examples'. In an article published in 1973, he considered the question of whether the Tikopia could be said to have art, in the sense of art objects, which he designates as 'plastic arts'. Acknowledging that the Tikopia had significant music, poetry and dance, Firth concluded a study of the headrests by suggesting that the Tikopian aesthetic was 'primarily in the field of geometric design'. His study reflected the specific theoretical concerns of anthropology in the 1970s (his discussion was a contribution to a volume of 1973 called *Primitive Art* edited by Anthony Forge). The difficulty with such questions is the immense diversity in art and aesthetics, and in attempts to pin down the fleeting impact of individual objects. Some Tikopian headrests were no more than a block of wood, and any man could and did make his own headrest, some more elaborately carved and styled than others. (Headrests were used only by men; women and children rested their heads on a soft bundle of rolled barkcloth). Men of high rank, however, slept on a headrest with high 'wings', that is where the flat surface which cradles the head is resolved, at either end, into arms or wings that reach up and away from the head. Firth records that the making of this kind of headrest was 'a job of considerable skill and delicacy' and that examples of this style were always relatively rare. Extremely elegant, the minimalist aesthetic of these headrests is close to the subtle simplicities of much Micronesian material.[25]

of vessels from the Admiralties was plaited containers sealed with vegetable putty. This putty, made from the grated seeds of a local tree (*Atuna racemosa* Raf.), sometimes known as panarium almond, is waterproof, heat-resistant to 100 degrees Celsius, breakage-resistant and also resistant to organic acids.[22] Large plaited jars, sealed with this putty, were used to store coconut oil. As well as being used in cooking, jars of oil would be presented as part of the exchanges of wealth at marriages, or at funerals.

If feasting vessels were no longer made from the 1930s, more ordinary cooking vessels still continued to be constructed. The Admiralties were one of the few areas of island Melanesia where pottery was produced: and here it was made by two specialist groups who traded it to other people in the Admiralty group. Using a highly skilled paddle and anvil technique, women made simple round pottery vessels with very thin walls of a uniform thickness. These pots had good thermal shock resistance when placed directly on the flames of

Other kinds of household objects that might well have considerable aesthetic impact include textiles of various kinds. These involve the aesthetics of comfort as well as issues of visual impact. On cool nights on Ambae in north Vanuatu, people slept on and under long, finely plaited pandanus mats with long delicate fringes. Folded back over the sleeper, the fringes quickly entangled, blocking any draughts and keeping him or her warm. In east Ambae people tell a story, a kind of folk tale, about a young man who walked a long way to a far-distant village, but was then turned out of the house he visited. It was night, and in the hills. He had no textiles with him, and he was cold. He asked a woman for a textile to cover himself so he could sleep, but the woman refused, saying that she had only one (long) textile, that she lay down on one end of it and pulled the other end over to cover herself, and so could

not give it up. The story ends badly. No matter how many textiles each had, the women he asked always refused to give him one. Disconsolate, the young man covered himself with dry banana leaves, but died.[26] The story is not really about being cold; its moral concerns the importance of kinship. The young man dies, not so much because he has no textile as because he has no close relationships of gift exchange by which he could have commanded one. But the tale indicates the importance of textiles in making its more general point.

Other domestic objects such as baskets and bags continued to be made nearly everywhere throughout the region, just as they were in the past. Even once people were wearing cloth and using metal knives, they were still making baskets in which to carry things. Such baskets included quickly made coconut-leaf baskets plaited for carrying garden produce but also

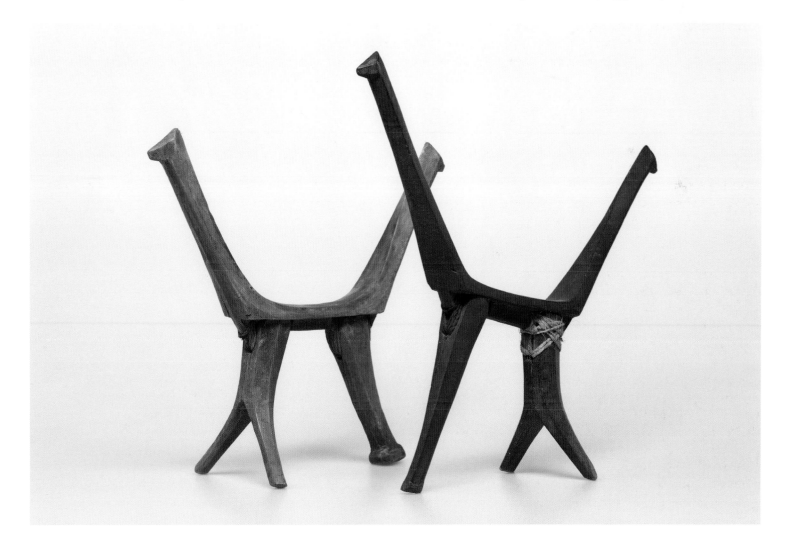

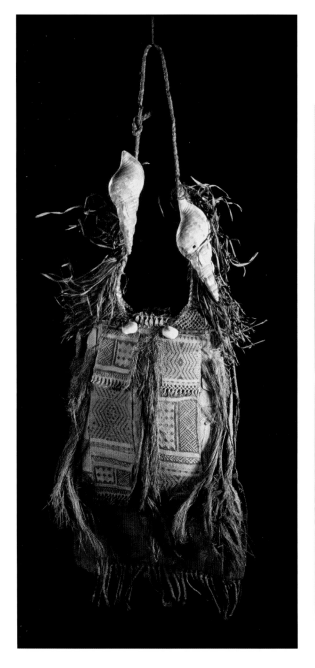

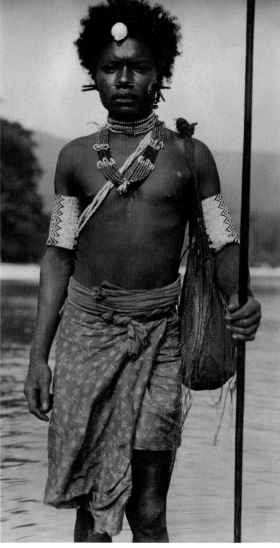

finely made personal baskets such as the banana-fibre baskets of Santa Cruz, Solomon Islands. Here the baskets were made from the fibres of one particular variety of banana palm. The fibres were extracted from the banana palm spathe (not from the fruit), pieces of which were laid upon a slab of wood and beaten to a pulp with a wooden beater; the vegetable matter was then scraped away and the fibre hung up to dry in the sun, before being combed out ready to be knotted together in a long length prior to weaving. The loom was also used to make clothing textiles but these did not continue after the introduction of European cloth.

In the rest of island Melanesia baskets were plaited, usually from pandanus, although sometimes from hibiscus fibre or cane. There were many different kinds of baskets – distinguishable by their shape, size, handles, decorations and designs, as well as by the fibre used to make them. This is so much the case that it is

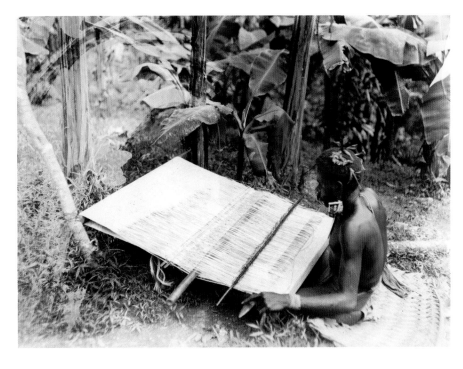

almost always possible to identify where a basket comes from on the basis of these characteristics. Moreover, within each area, different baskets could be distinguished from each other, to the point that, in some places, only certain types of basket could be used by certain kinds of people. Men's personal baskets in the Loyalty Islands were plaited from pandanus in a rectangular flat form with a plied fibre cord handle. Where these were decorated with shells, and the handle made of flying-fox fur, they became a basket for a chief. Smaller plaited pandanus baskets in the same shape were used to store sling stones. In the same area women used a kidney-shaped rigid cane or rush basket to carry garden produce.

Describing Island Melanesia

The increasing involvement of Europeans in island Melanesia led to a number of accounts of the region that now provide invaluable documentation of societies at the turn of the twentieth century, and to the making of several important collections. The accounts of missionaries are very valuable, notably those of Robert Henry Codrington on northern Vanuatu and the Solomon Islands and Maurice Leenhardt on New Caledonia. Codrington published *The Melanesians; Studies in their Anthropology and Folk-lore* in 1891, while of Leenhardt's several publications the most famous is *Do kamo: la personne et le mythe dans le monde melanesien*, published in 1947. Codrington also created an important collection, now divided between the British Museum in London and the Pitt Rivers Museum in Oxford (*overleaf*).

Around the turn of the century, the discipline of social and cultural anthropology became established. This discipline, broadly, sets out to describe what it means to be a human being – that is, a social being – and the many different strategies by which people organize and make sense of their lives together. The discipline was established through the development of fieldwork: spending extensive periods of time living with a group of people and documenting the way their society operated. Much of the early development of fieldwork took place in Melanesia. Although this development is often credited to Bronislaw Malinowski and his extended research in the Trobriand Islands, it was developed through a more complex series of expeditions and experiences, in particular following

A considerable number of
distinctively naturalistic and
Europeanized figures from
this area are found in museum
collections today. They range
from life-size figures, some
in dance postures, to smaller
images, and busts cut off below
the shoulders, as if designed
for display on a European
mantelpiece. The genre is likely
to be the work of more than one
carver, who must have been
encouraged, taught, and/or
commissioned by a European
mentor, in all likelihood either a
missionary or colonial official.

Alfred Cort Haddon's Cambridge expeditions to the
Torres Straits.

Thus in 1907 William H. R. Rivers, Arthur Maurice
Hocart and Gerard Camden Wheeler travelled to the
British Solomon Islands Protectorate to do fieldwork,
following Rivers's participation in the 1898 Haddon
expedition. Originally, the three men were meant
to work together in the New Georgia Islands,
Western Solomons, but Wheeler set off further
north-west to the Shortland Islands and the
Bougainville Straits to work by himself. The
period spent by Rivers and Hocart in the
Solomon Islands, particularly their
residence in 1908 among the inhabitants of
Simbo, is argued to be the first sustained
period of modern anthropological
fieldwork, and resulted in a series of
publications, most notably Rivers's volume
of 1914, *The History of Melanesian Society*.[27]
In 1914 Rivers travelled to Vanuatu with a

student, John Layard, whom he left on the island of
Aitchin, one of the Small Islands off north Malakula.
Layard spent a year living on Aitchin, his fieldwork
more or less simultaneous with Malinowski's in the
Trobriands although his book *Stone Men of Malakula*
was not published until 1942. The various publications
from these expeditions combine to illustrate the
development of the writing of anthropology – the
process of analysis that transforms the fieldwork
experience into a coherent description of a group's
knowledge and practice. Although they did not
necessarily focus on art, the writings of these men
provide important material for understanding the
objects made in these societies.

Making artefact collections is another way of
documenting societies. A number of people made
extensive research-based collections in island
Melanesia, most notably two collections assembled for
the ethnographic museum in Basel (now known as the
Museum der Kulturen). Fritz Sarasin made a collecting

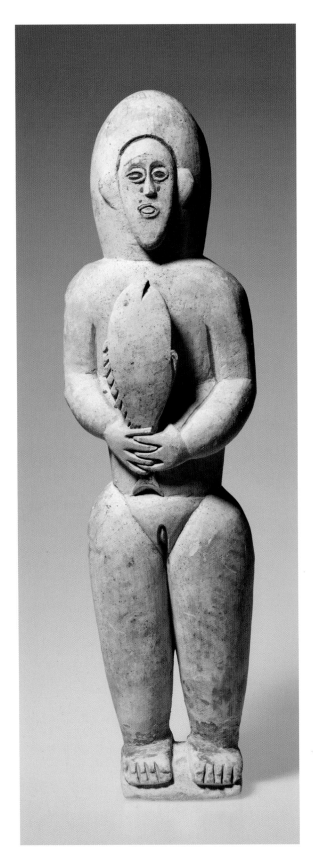

voyage to New Caledonia with Jean Roux, a zoologist. Sarasin's account of *Neu-Caledonien und die Loyalty-Inseln*, first published in 1929, reports on the results of their ethnological collecting, of Sarasin's subsequent studies of available literature, and his analysis of other museum collections in Europe. In 1910–12 Sarasin's student Felix Speiser made an expedition to Vanuatu 'with a view to collecting ethnographic and anthropological material', which he published in 1923 as *Ethnographische Materialien aus den Neuen Hebriden und den Banks Inseln*.[28] The most extensive field collection, made in the same period, was commissioned by the Field Museum of Chicago which sent its assistant curator of African and Melanesian ethnology, Albert Buell Lewis, to Melanesia from 1908 to 1913. His collection, made in New Guinea and Fiji as well as the islands of Melanesia, included more than 15,000 objects.[29]

Observation was not limited to documentation and collection. Photography developed over the same period as anthropology was being established; it was quickly taken up by early field anthropologists as another way to describe aspects of the societies they were studying. Not only Haddon and Malinowski, but also Layard (*previous page*), Sarasin, Speiser and Lewis all used photography, as did other early visitors to Melanesia. Also, some photographers such as John William Lindt and John Watt Beattie travelled through the region to take photographs, which they later sold. Their images often graphically display the processes of change that were taking place throughout the region during the early twentieth century, such as this photograph from 1906 (*opposite*), taken by John Watt Beattie, of a couple outside their house in Mere Lava, Banks Islands. They wear European clothes, but the man is carrying a local basket of produce, and the houses behind them are made in traditional style, the thatched roofs reaching almost to the ground, designed to stand up to the cyclones that occur regularly in this area.

Objects of Value

One of the most significant insights of anthropological analysis for this region was to understand the importance of exchange in Melanesian societies. Gift and counter gift, the regular back and forth of presentations from one person to another and one group to another, is both an enduring feature of societies in this region and a focus of some of the most

Kulap funerary figure, New Ireland, collected in New Ireland, probably 1899.
Limestone, pigment.
Height *c.* 90 cm (35⅜ in.).
Linden-Museum, Stuttgart.

significant anthropological analysis of Melanesian societies. At one level, exchange involves the regular distribution of food resources: a man who kills a pig, for example, will share out the meat to various kin, not only ensuring that all the meat will be eaten before it deteriorates in the heat, but also ensuring that an equal amount of pork will have to be returned to him on another occasion when someone to whom he has given meat themselves kills a pig. Exchange also binds people together in relationships of debt. People in Melanesia often work to make others indebted to them, so that when a clan or an individual wants to organize a ceremony, they can call in the debts owed to them, thus ensuring that they have sufficient resources for the occasion.

As well as exchanging food and other perishable resources, people also exchanged objects of value to them. These objects are sometimes described as 'money', but the term is misleading for these objects are themselves significant and are not merely tokens representing a fixed value. Quite commonly through island Melanesia, such valuables are made of shell: strings of shell discs or beads are widely used through the region as an exchange valuable. Shell valuables were generally exchanged alongside other valuable items, and in most places there were conventions for what kinds of objects could be exchanged at what sort of occasions. In the northern region of the Grande Terre, New Caledonia, shell valuables were exchanged alongside other objects, such as textiles and women's

Village scene with man and woman outside their house in Mere Lava, Banks Islands, 1906.
Photograph by John Watt Beattie. © The Trustees of the British Museum, London.

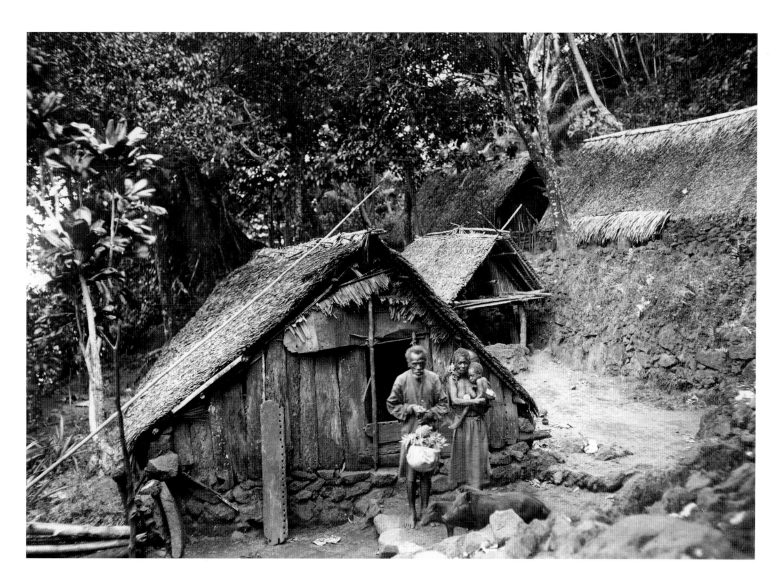

skirts. In the Hienghène area these shell valuables were not simply strings of shells, but were constructions that represented the ancestors, with a small carved or plaited wooden head, a pinch of bat fur attached at the end as feet, and the string of shell beads indicating the backbone. As Patrice Goudon observes, these valuables were used as both a sanction and a benediction, to regulate the relationships between people, and with the cosmos.[30]

There was considerable diversity in the specific form of the shell valuables used across this region. At the end of the nineteenth century strings of shells used as valuables for exchange were produced in three major centres in the south-east Solomons: Hounihu on the south-west coast of Makira, Marau in south-west Guadalcanal, and Langalanga Lagoon on the west coast of Malaita.[31] Speiser notes that in the Banks Islands, Vanuatu, at the time of his visit, shell valuables were so much like currency that Europeans were using them in transactions with local people, but although this suggests that they could be used as a coin might be, the significance of these valuables was much more complex.[32]

In New Ireland, for example, shell currencies consisted of strings of minute, highly polished shell discs, which were an expected component of all transactions involving pigs, land, and other traditional items or rights. In an anthropological account that details long-standing practices among the Barok people of New Ireland, Roy Wagner underlines some of the significance of this currency, which the Barok call *mangin*.[33] The Barok say that *mangin* was originally made on the offshore islands of Tabar, but that later manufactories were established on the Lihir Islands as well. It was made of a small, salmon-coloured shell, probably *Chrystostoma parodoxum* (Trochidae), found on Dyaul Island off the west coast of northern New Ireland. Once the shells were obtained they were given to a trading partner or acquaintance from Lihir, who would undertake to turn them into *mangin* in return for a share of the finished product. Wagner says that *mangin* was denominated by grade, or named variety, and by standardized lengths measured on the body, and he differentiates between two categories: 'heirloom *mangin*' and 'circulating *mangin*'. The former category includes many archaic and unusual varieties, which would be held as a clan treasure, handed down through

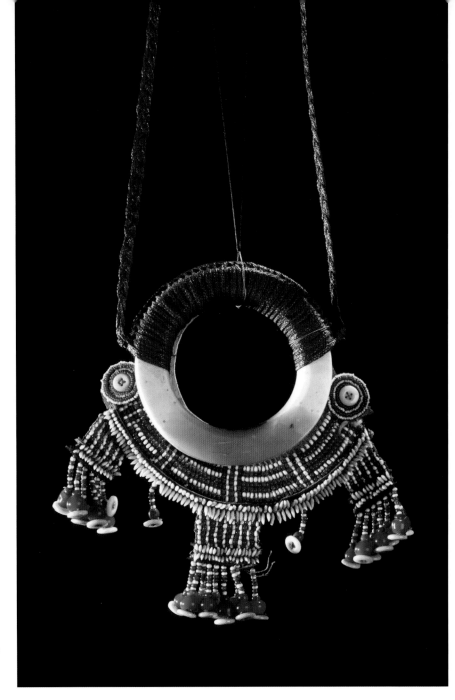

the generations. Such *mangin* was 'priceless' and without exchange value. Circulating *mangin* was colloquially graded into 'fine' and 'ordinary' *mangin*, on the basis of material qualities of the shell, such as size and colour. Wagner identifies three interrelated roles for this valuable – as the principal marker of exchange at marriages and similar occasions, as acting like money to 'buy' things like pigs, and as the preferred medium for locally imposed fines and for all transactions in the men's house – but he argues that its key role was in terms of a moral valuation. He

Bakiha breast ornament, a chiefly display of wealth and authority, New Georgia group, Solomon Islands, early twentieth century. Diameter approx. 11 cm (4¼ in.). Clam and turtle shell, shell money beads, imported glass beads and shirt buttons. Auckland Museum.

Shell currency, New Caledonia, collected late nineteenth–early twentieth century. Shell, fibre. Length 102 cm (40⅛ in.). Museum of New Zealand Te Papa Tongarewa, Wellington.

says that the store of *mangin* (both the heirloom *mangin* and the circulating variety) that a Barok leader held for his clan was a visible objectification of the many diverse events and transactions in which it had been engaged, and which amounted to a hoard of social merit, reflecting the honourable standing of the clan.

Such an understanding of Barok *mangin* makes clear some of the complexity of objects in this region. While museums and other collectors sought to acquire the dramatic masks and carvings that were props for major ceremonies, and markers of events, for people in this region, other kinds of objects were equally or even more valuable, not only for what could be obtained in exchange for them but also for the way in which they represented the values and the importance of a kinship group. Objects could have a moral significance for their owners that would not necessarily be appreciated by their collectors. One effect of this was that in quite a few places through the twentieth century, while European influence and colonial regulation brought to an end many of the great ceremonies and events of island life, some of the core values remained, held tight by the diminishing population and embodied in apparently humble but powerfully meaningful objects.

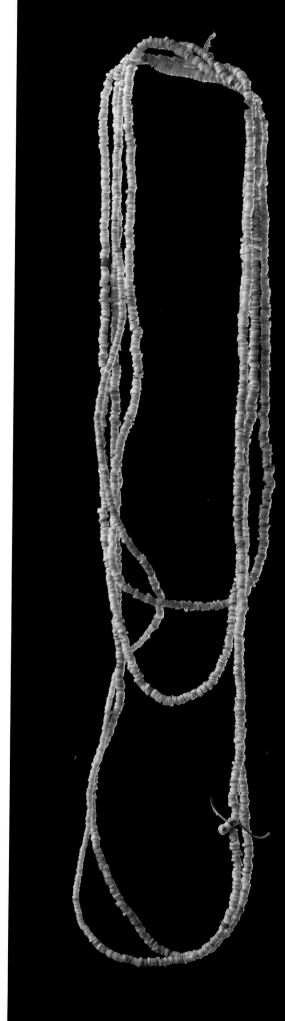

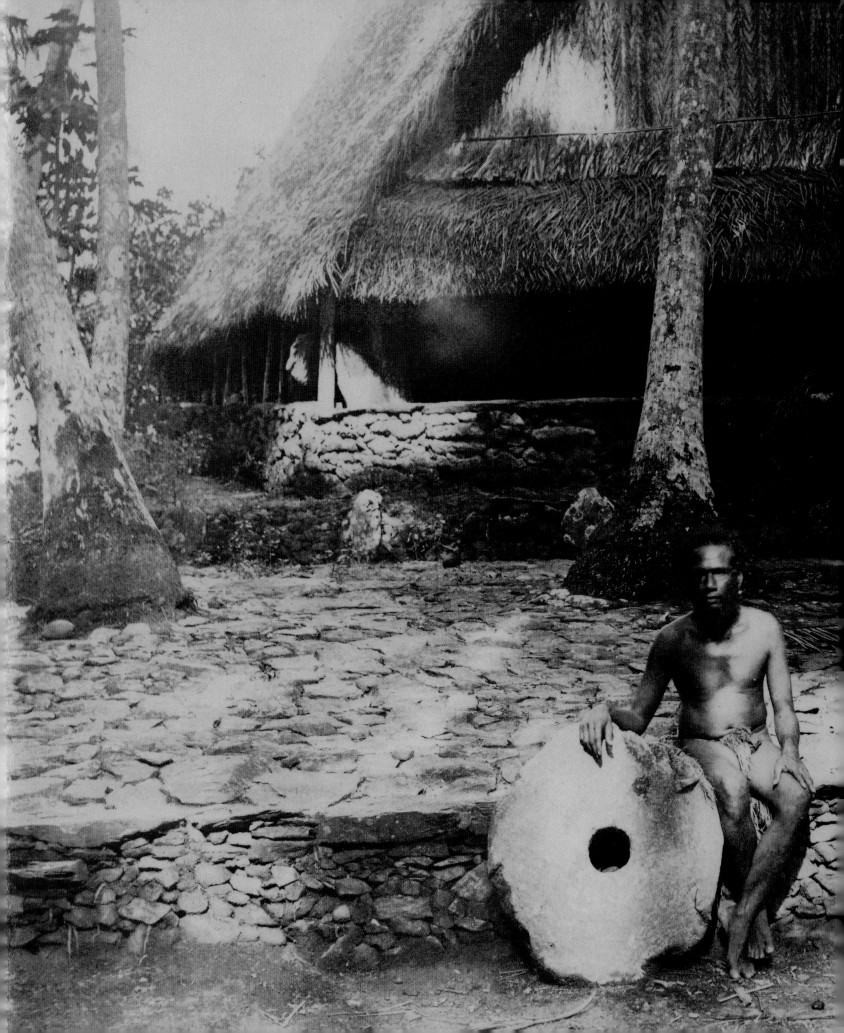

PART FOUR EASTERN AND NORTHERN OCEANIA 1700–1940

Deidre Brown

POLITICAL TRANSFORMATIONS: ART AND POWER 1700–1800

Taputapuātea *marae*, Ra'iātea, Society Islands.

The political transformations that took place across Polynesia and Micronesia in the eighteenth century were diverse. In some archipelagoes chiefly aristocracies consolidated their power and extended their reach. Elsewhere, hierarchies tended to fragment, undergoing a sort of 'devolution'. Within so-called 'tributary' societies, in which common peoples and local chiefs offered goods and services up to higher, or paramount, chiefs, status was demonstrated as much through the acquisition and revelation of art objects as by strategic action. In Tahiti and Hawai'i, feather garments were symbols of divine lineage and prestige, while in Yap *machi* (ceremonial woven textiles) and stone money performed a similar function. Political transformations involving art as an agent were apparent at this time in other Polynesian tributary societies, such as in the Tonga Islands.[1] Rank, authority and lineage were important customary traits of a leader, who was obliged also to cultivate enduring and favourable connections to deities responsible for abundant and sustainable food supplies and continued well-being. In the eighteenth century the desire for political power was manifest in Tahiti, Hawai'i and Yap with the consolidation of chiefly titles exercised through marriage, warfare and the acquisition of other chiefs' sacred objects. But those chiefs in the ascendancy were often challenged by others, typically through the possession and rival promotion of sacred garments and objects.

The Role of 'Oro in Tahitian Unification

In Tahiti the rise of the *maro 'ura* (feathered sash) symbolized the dramatic spiritual and social changes that followed the arrival of the cult of 'Oro in the mid-eighteenth century from Ra'iātea in the nearby Leeward Islands. 'Oro was claimed to be the son of the paramount pan-Society Islands deity, Ta'aroa,

and the goddess Hina-tu-a-uta. On Ra'iātea, 'Oro was represented by a sennit *to'o* (god effigy) figure, adorned with red and yellow feathers, and a red feather *maro 'ura*, which resided at Taputapuātea *marae* (ritual complex) at Opoa, with district-level versions located at other *marae*. Across the Society Islands, *maro 'ura* were also used by some chiefly families to identify their most senior member.

The cult of 'Oro arrived in Tahiti, bringing with it the belief and art systems that supported him.[2] Priests from Ra'iātea were demonstrating the close ties between the two islands, and therefore bonds larger than those at district level, through their establishment of *marae* dedicated to 'Oro on Tahiti. The arrival of 'Oro, in the guise of a unifying deity, inspired a series of events that would, ironically, undermine the pre-existing social, political and spiritual structures of the island for the rest of the century. The first *marae* dedicated to 'Oro was in Tautira and also named Taputapuātea. A *to'o* effigy for 'Oro to inhabit was provided that was approximately 1.8 metres (6 ft) long, covered in sennit and red, yellow and black feathers (*overleaf*).[3] From here, the observation of 'Oro – through belief, the construction of *marae* and the creation of *to'o* – spread across Tahiti. More importantly, the recognition of divine authority within chiefly families was demonstrated through the weaving and wearing of *maro 'ura* that incorporated a sample of red feathers from 'Oro's *to'o* at Opoa. Thus the divine, genealogical and political status of the most important chiefs was activated though a direct connection to 'Oro. It is perhaps this clear connection between the deity and the chief, as verified by *marae* and *maro 'ura*, that made the worship of 'Oro more appealing to Tahitian chiefs than worshipping his father, Ta'aroa, who they had previously observed as the supreme deity.

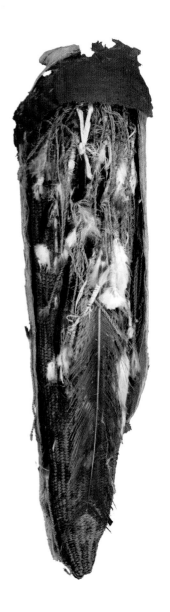

Wrapping, binding, feathers, foreign materials and the colour red had divine associations in the eighteenth-century Society Islands. Major Tahitian gods such as 'Oro were represented by portable staffs wrapped in sennit called *to'o*. This *to'o* was one of three found wrapped together in a bundle in a bluff shelter in the Orofere Valley. Both the bundle and the *to'o* were wrapped in layers of pandanus leaves and *tapa* (barkcloth), bound and sewn together with cord. Red cloth covered the *to'o*'s eyes, and its sennit-packed body was adorned with tassels of red and yellow feathers and human hair.

Indeed, the once-valued pre-'Oro ritual adornments of the Tahitian elite, such as mourning costumes and the towering wickerwork and feather *fau* headdress, were eagerly exchanged for the red feathers brought from Tonga when the *Resolution* returned to Tahiti during Captain Cook's third voyage in 1777.[4]

Some surviving *to'o* have a wooden core exposed at one or both ends, some have their wooden core completely encased within sennit (coconut fibre) and occasionally feature anthropomorphic sennit details, and others are completely made of sennit and sometimes covered in feathers. Adrienne Kaeppler has noted that *to'o* collected early, during the voyages of Captain Cook, have a wooden core exposed at both ends, whereas *to'o* collected later, by missionaries and other Europeans, originally had fully enclosed cores, which have sometimes protruded due to wear, or no wooden core. X-rays of *to'o* of the earlier type have shown that they are filled with barkcloth, sennit-like material and sometimes teeth. Clearly the sennit elements of the *to'o* were their most important, and typologically unifying, element, which has led Kaeppler to speculate that the sennit might contain 'the entangled prayers that make the *to'o* divine.'[5] She has suggested that another layer of barkcloth and/or pandanus leaves was wrapped around the *to'o*, and it was this additional element that was removed and replaced during the *to'o*'s use in ritual.

Much less is known about the fabrication of *maro 'ura*, since no eighteenth-century examples appear to have survived beyond the Christian mission period of the following century. Teuira Henry, in her account of Ra'iātean *maro 'ura*, recorded that they comprised

a fibre foundation garment that was usually adorned with feathers.[6] The foundation garment was woven from the fibres of the *ro'a* plant, which she described as a type of flax, and a 'background', presumably a backing, of barkcloth made from the *'ora* (*Ficus prolix*; banyan) tree. Feathers were individually inserted into perforations and then sewn together using a needle made of human bone. The feathers were rotated in groups to create patterns, which were mostly rectilinear in shape. According to Henry, the patterns were abstract accounts of the chief's personality and life, and as such could be likened to an external form of *tatau* ('tattooing'). The needle remained inserted in the garment on its completion, further lappets being attached each time the *maro 'ura* was passed on to a new chief.[7] Human sacrifices, Henry claimed, were made at various stages of the garment's construction. One *maro 'ura* belonging to the Tamatoa family measured over 6 metres (19 ft 8 in.) in length and around 70 centimetres (2 ft 4 in.) in width. Although this was considered unusually large, these dimensions suggest that size may have indicated rank and that *maro 'ura* were probably carefully wrapped several times around the bodies of their wearers, in a practice reminiscent of the wrapping of deity figures.

Maro 'ura were the most important part of the chiefly costume worn for special events that were usually only attended by other chiefs. These events included the inauguration of a chief, the marriage of an heir apparent to the chiefly title, the reception of chiefs from other districts, observances at the conclusion of conflict, and the *pa'iatua* service in which *to'o* were unwrapped and rewrapped as a form of renewal. *Maro 'ura* were also exhibited during the *pure ari'i* ('prayer for the sovereign') ritual conducted before the commencement of battle.[8] It has been argued that, most significantly, *maro 'ura* associated with 'Oro enabled their wearer to claim a new level of divine status and command the sacrificial execution of their subjects in the name of the deity. Human sacrifice is thought to have previously been a restricted practice, but when the *maro 'ura* was worn it was a mandatory ritual, which further increased the prestige of its wearer. In the Tahitian district of Papara these sashes featured yellow or lightly coloured feathers and were known as *maro tea*; no known examples survive. Although there is some conflict in oral accounts,

at least one suggests that the first *maro tea* was brought to Tahiti by the legendary ancestor Te'eva, who eventually settled in Papara and began a dynasty of local chiefs distinguished by their right to wear this garment.[9] However, other narratives suggest that the use of *maro* as rank insignia only became prominent on Tahiti in the eighteenth century with the rise of 'Oro worship.

On a territorial level the expansionist tendencies of district chiefs may have made 'Oro, as a deity associated with unification, attractive as a deity, while adoption of 'Oro as a supreme god may have also been a cause for war. The complex political transformations associated with the guardianship of 'Oro's *to'o* and the *maro 'ura* are reflected in their relative status and individual significance during the eighteenth century. Before the arrival of 'Oro there were around fourteen districts in Tahiti, each led by a chief with *maro*-wearing rights. However, the arrival of the new deity – embodied by his *to'o* and the *maro 'ura* that represented his delegated spiritual authority – initiated a process of political ambition where chiefs sought to legitimate their connections to 'Oro, through genealogy and the acquisition of the emblems of his identity, in order to assume supreme political authority over Tahiti. The Pomare family, the chiefly rulers of the Pare district, acquired the first 'Oro *to'o* and *maro 'ura* through a maternal connection to the Tamatoa dynasty, who had the longest association with 'Oro on Ra'iātea. Pomare appointed his son Tu, who was later known as Pomare II, to be its wearer.

The second *maro 'ura*, and accompanying *to'o* image, to arrive from Ra'iātea was brought to Tahiti around 1760 by Maua, who had a more senior connection to the Tamatoa line than the Pomare's. His choice to live in the Papara district, where he had maternal connections, enabled the chief of that district to assert superior spiritual, and hence political, authority. This *maro* was known as Te Ra'ipuatata – the Sky of the Aurora – and is most likely the one that local people joined to a red pennant left by the British to claim Tahiti in 1767 (*page 249*).[10] The conjunction of the two items was an appropriation of external prestige rather than of colonization and subjugation, as the *maro 'ura*'s remarkable journey from here on was very much governed by customary action. A large *marae* known as Mahaiatea was built to host the investiture of

Teri'irere, a local chief, as the wearer of the *maro 'ura*. However, chiefs from the Teva-i-tai district, who were covetous of the status about to be bestowed, launched an attack during the ceremony and seized both the *maro 'ura* and the *to'o*. With the deity and his investing *maro* lost, Teri'irere's ambition to achieve supreme chieftainship over Tahiti could not be realized.

The captured *maro 'ura* and *to'o* were taken to 'Utu'aimahurau *marae* in the Puna'auia district. Although the chiefs here believed Tu to be the rightful wearer of the *maro 'ura*, it appears they wished to centralize his power within their district for their own spiritual and secular benefit.[11] Therefore, not only would Tu have to travel to their district in order to wear the *maro* and participate in 'Oro ceremonies, which included human sacrifice, but also other chiefs within Tu's dominion would have to present their *to'o* for rededication as well as present tribute offerings at 'Utu'aimahurau *marae*. Captain Cook, James King and William Anderson, who saw this *maro 'ura* during a ritual ceremony on the *marae* in 1777, described it as

being between 3 and 4.5 metres (9 ft 10 in. and 14 ft 10 in.) long and 38 centimetres (1 ft 2 in.) wide, and covered in yellow, red and green feathers, with a preponderance of the former, arranged 'in square compartments ranged in two rows'.[12] One end featured eight attachments, which may have been the lappets described by Teuira Henry, that were like a horseshoe in shape and size and fringed with black feathers. The *maro 'ura* appears to have been largely unchanged when Captain William Bligh of HMS *Bounty* sketched it on its exhibition in 1792 at Taraho'i *marae* in the Pare district. His illustration shows how the pennant was joined to the *maro* in order to make it longer, and hence probably more prestigious, and how it too had lappets at this, as well as the feathered, end. Red stripes separate yellow sections on the feathered side of the *maro 'ura*, the 'two rows' described by Cook perhaps represented by this alternating pattern unless the *maro 'ura* had undergone a significant alteration in the previous fifteen years. The dominance of yellow feathers somewhat contradicts received understanding about the association between red feathers and 'Oro. It is possible

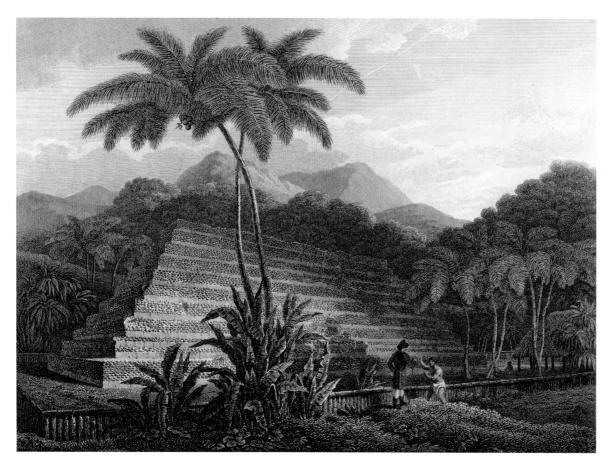

Mahaiatea *marae*, 'GREAT MORAI of TEMARRE at PAPPARA in OTAHEITE', from *A Missionary Voyage to the Southern Pacific Ocean*, 1799.

J. C. Beaglehole Room, Victoria University of Wellington Library.

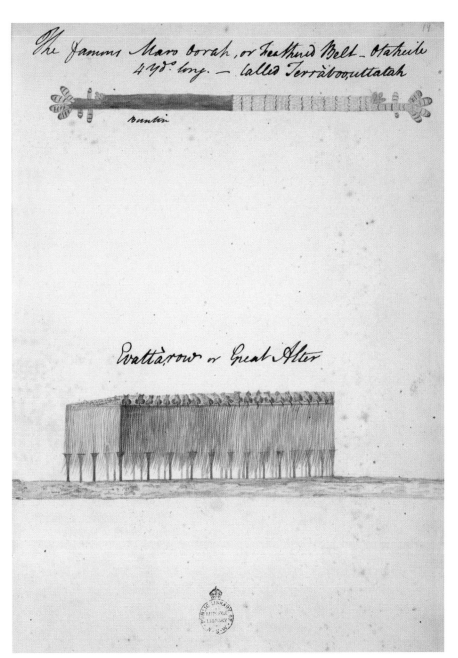

The James Maro oorah, or Feathered Belt - Otaheite 4 yds. long. - called Terrâbooultatah

bunten

Watta row or Great Alter

left

William Bligh, 'Maro Oorah [maro'ura] or feathered belt', Tahiti, 1791–93.

In an album of 58 watercolour sketches, 32 x 21 cm (12⅝ in x 8¼ in.). State Library of New South Wales, Sydney.

The red feather sash in this drawing was probably Te Ra'ipuatata, a coveted textile that invested its wearer with divinely-sanctioned chieftainship. To embrace and appropriate the prestige of a world much expanded after the arrival of Europeans, it was extended with part of a red pennant left in 1767 by Samuel Wallis, thereby becoming one of the most powerful objects in the region.

below

John Webber, 'A Toopapaoo [tupapau] for a Chief, with a Priest Making his Offering to the Morai', October 1777.

Pencil, pen, wash and watercolour, 32 x 50 cm (12⅝ x 19⅝ in.). Dixson Library, State Library of New South Wales, Sydney.

that 'ura may have progressively lost its original meaning as 'red', at least in the making of *maro*, and became a term associated with divinity and 'Oro. Alternatively, the use of yellow and red might have symbolized the combination of the *maro tea* and *maro 'ura* chiefdoms and belief systems,[13] which raises the possibility that Te Ra'ipuatata might have been refashioned after its arrival from Ra'iātea but before it was seen by Cook and his crew. Certainly this *maro 'ura* was subject to future change. Between April and July 1792, the latter being the occasion of Tu's investiture, the *maro 'ura* was ornamented with red

hair said to have belonged to the *Bounty*'s barber and mutineer, Richard Skinner.[14] The hair must have been taken from Skinner some time before and kept for a special occasion or purpose, for he had drowned the previous year as a prisoner on the *Pandora*, which ran aground on the Great Barrier Reef.

Te Ra'ipuatata was treated with utmost respect up until the mid-1790s. Like ritual objects from earlier times across the Polynesian region, it was wrapped. William Anderson observed that the *maro 'ura* was produced from, and returned to, a bundle of barkcloth. When the *maro 'ura* was wrapped at the conclusion of

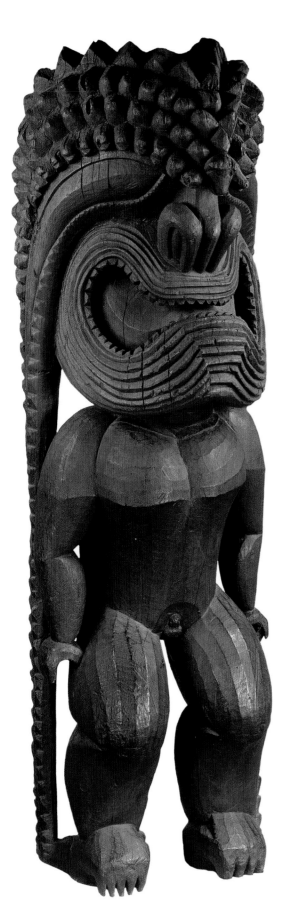

the 1777 ceremony, the bundle was adorned with a few feathers taken earlier in the ceremony from the *to'o* effigy of 'Oro by a priest and given to Tu while he was still wearing the garment. Other chiefly attire, such as his cape and hat, were also wrapped in barkcloth and all were then individually wrapped in a protective mat for storage in the *fare-ia-manaha* ('house of sacred treasures'), where the custodians of the *marae* lived, and where they made and stored ceremonial *marae* costumes, drums and deity images, including *to'o*.[15] In this way the prestige of the *maro 'ura*, through successive ritual containment, was recognized through wrapping, feathering, further wrapping and storage within a *tapu* house on an important *marae*.[16]

A third *maro 'ura* arrived into Tu's custodianship in 1788 when its bearer Ha'amanemane – a relative, chief and senior 'Oro priest – arrived from Ra'iātea. This is most likely the *maro 'ura* described by the *Bounty* mutineer James Morrison, in 1791, as being about 2.7 metres (8 ft 10 in.) long, covered with red and yellow feathers, and with red, black and yellow feather lappets each named after protective deities associated with Tu.[17] Interestingly, Morrison said that the *maro 'ura* was placed inside a 'sacred box', rather than wrapped, before it was placed in the 'sacred house', which was presumably the *fare-ia-manaha*.

Tu was eventually able to unite all three *maro 'ura*, including the *to'o* taken from Papara twenty-two years before, within his home district in 1790. By this time he was regarded as the *ari'i rahi* ('supreme chief'), whose rank was recognized on Tahiti, Moorea, Me'etia, Tetiaroa and Huahine, and he was looking to extend his influence to Ra'iātea and Taha'a in the Leeward Islands. Yet, once his status was symbolically consolidated, Tu's interest in wearing the *maro 'ura* in important 'Oro ceremonies seems to have waned, while the use of the *to'o* at the same events, and on at least one occasion in the absence of Tu, appears to have waxed. In creating such a large dominion through his religious authority, Tu had also sought to exercise more political power in Tahiti by claiming secular supremacy over the other chiefs. This created some disquiet. Perhaps in order to decentralize Tu's secular power while continuing to recognize his spiritual authority, the *to'o* was stolen and returned to 'Utu'aimahurau *marae* in 1801. Over the next two years the *to'o* was recovered and stolen again on two more occasions.

The *to'o*'s status grew with each exchange, to the point where, reacting to one of Tu's threats to recover the *to'o*, a chief suggested that 'Oro assume his role as supreme chief.[18] The *to'o* was increasingly a potential threat to Tu's authority and ambitions for power. So it was around this time, at the beginning of the nineteenth century, that Tu began to style his rule on the dynastic tradition of European royalty, supported through Tahitian custom. This would herald a new age in which art objects were symbols of political power rather than instruments of sacred authority, and as a consequence a great iconoclasm, led by Tu, would end the worship of 'Oro and the veneration of his *to'o*.

The Role of Feathered Objects in Hawaiian Unification

Feathered objects were important agents of religio-political transformation in the Hawaiian islands. The remarkable similarities between the Tahitian and Hawaiian spiritual and artistic experience at this time can be attributed to their related cultures, since Hawai'i was probably settled from the Marquesas between AD 300 and 800 with two-way voyaging

possibly continuing between Hawai'i and central Polynesia up until about 1200.[19] In both island groups, political transformations leading to unification during the eighteenth century were triggered by the elevation of a particular deity above others in a pantheon. In the case of Tahiti this was 'Oro, championed by chief Pomare; in Hawai'i it was one particular manifestation of the major god Kū – the war god, Kūkā'ilimoku, by chief Kamehameha. Elaborate feathered deity figures, helmets, cloaks, capes, staffs, sashes, woodcarvings and temples were used to indicate the presence of Kū's authority, and that of other deities, as chiefs throughout the Hawaiian islands sought to protect or expand their territories in a period of spiritual and political instability.

Hawaiian deities of the eighteenth century were sometimes represented by *akua hulu manu*, which were large figures with anthropomorphic heads made of feather-covered wickerwork and long bodies wrapped in barkcloth. They were therefore similar to other contemporary and earlier deity figures in their wrapped and feathered form, some of which also had exposed 'heads', but *akua hulu manu* were unique in their size, since their heads were between 60 centimetres (2 ft) and 1 metre (3 ft 4 in.) in height. Only the feathered heads of *akua hulu manu* survive today in museum collections. Following the customary method of feather work, a foundation element, in this case a wickerwork of '*ie'ie* roots (*Freycinetia arborea*), created the principal structure onto which feathers were attached. The 'skin' of the deity was a covering of red feathers, usually taken from the '*i'iwi* honeycreeper (*Vestiaria coccinea*), although it is quite possible that the Hawaiians conceived of the deity as being feathered, as the Society Islanders had similarly believed Ta'aroa to be before he shook off his coat. A large number of these birds would have been required to decorate each of these heads, and fortunately the '*i'iwi* was and still is plentiful in parts of Hawai'i. This is not the case with the now extinct '*o'o* (*Moho* species) and *mamo* (*Drepanis pacifica*), whose yellow feathers were used to delineate the lips, collar and – where represented – ears of the deity's head. The '*o'o*'s black feathers were also used to create the eyebrows. The harvesting and use of feathers were undertaken under the authority of chiefs, whose control of these processes ensured the status and ownership, for personal use or tribute, of feathers and feathered objects.[20]

God images, Hawai'i, late eighteenth century.
Wicker, olona fibre cord, feathers, human hair, pearl-shell, seeds, dog teeth. Heights L–R: 100 cm (39 in.), 62 cm (24½ in.), 107 cm (42 in.). © The Trustees of the British Museum, London.

The Birdman Cult

Petroglyphs at Orongo overlooking Motu Nui, Motu Kao Kao and Motu Iti.
Photograph David C. Ochsner
© Easter Island Statue Project/
Jo Anne Van Tilburg.

FOR SOME FIVE HUNDRED YEARS the famous *moai* statues of Rapa Nui embodied the continuity of a metaphysical order of deified ancestors that sustained the authority of clan chiefs, defined the nature of social roles and gave religious meaning to the world.

At some point in the sixteenth century, however, there was a profound cultural breakdown, leading to the collapse of *ahu moai*-building and the rise of a warrior class known as the *matato'a*. The dominance of the *matato'a* reflected the expansion of warfare and social fragmentation on the island, precipitated by the dire impact of ecological disaster and overpopulation.

But the *matato'a* found their own response to the grim conditions that came to prevail on the island. It took the form of a new religion – or a reformulation of elements of the old religion – commonly referred to as the 'birdman cult'.[1] Under the patronage of a deity known as Makemake, who would become identified by the eighteenth century as the supreme god on Rapa Nui, the birdman cult gave divine sanction to the militant culture of the *matato'a*. It also devised a new means for establishing political sovereignty – via a ritual given to the

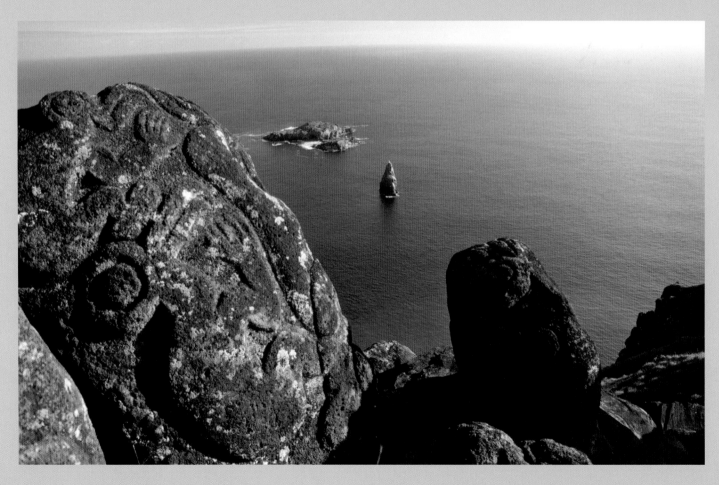

energies of competition, strength and augury, rather than genealogical entitlement.

Each year warriors of the most powerful clans competed for one of their number to become *tangata manu* (birdman) for a year. The bearer of this title was determined by an annual cycle of ceremonies culminating in the ritual village called Orongo on the crater-topped mount of Rano Kau at the south-west point of the island. There leading warriors, fortified by the prayers, chants and predictions of priests and shamans, vied to be the first to discover (usually through the efforts of their servant representatives) the sacred egg of the *manutara*, a species of bird (sooty tern) that nested in the southern spring on the islet of Motu Nui just off the base of Rano Kau. The title of *tangata manu* endowed its holder with great *mana* (prestige), entitled him to receive tributes of food and valuables, and legitimated the deeds and exploits of his clan. Like many usurping belief systems and ideologies (Christianity in Rome, Communism in St Petersburg), the birdman cult appropriated the sacred sites of the order it replaced and superimposed its iconographic signature on their monuments. *Tangata manu* seclusion houses, for example, were situated on the slopes of Rano Raraku near scores of prone and standing *moai* and at certain *ahu* such as Tongariki and Anakena. Similarly, there are moai with the signature image of the *tangata manu* carved on their backs: a crouching figure with the head and beak of a frigate bird – including the one known as Hoa Hakananai'a, originally located at Orongo and now in the collection of the British Museum, London. Taken by HMS *Topaze* in 1868, it has since become an iconic symbol of that institution.[ii]

The cult projected its dominance in other ways as well. Images of Makemake – a skull face with staring eyes – were painted inside caves and numerous birdman petroglyphs were carved on rocks at Orongo. One group of rocks was part of a stone enclosure situated on a narrow ledge between the crater mouth and a cliff descending to the sea – the precariousness of its location echoing the precariousness of the social order it served to uphold.

The birdman cult persisted well into the nineteenth century, long after first European contact in 1722, with the last birdman taking the title in 1867. Three main forces brought about its end: the eventual success of Christian missionaries; slave raids in 1862 that captured up to a thousand Rapanui to work in Peruvian guano fields; and the death of much of the population when a handful of those captured were repatriated, bringing smallpox.[iii]

PB

O KU, YOUR MANY FORMS

O gods; O Ku-the-striver,
O Ku-of-the-long-cloud, O Ku-of-the-short-cloud,
O Ku-of-the-hanging-cloud,
O Ku-of-the-intensely-dark-clouds-of-heaven,
O Ku-of-the-thickets, O Ku-who-spreads-greenery,
O Ku-of-the-*ohi'a*-tree
Your many forms, O Kama of the heavens,
O Kanepua'a,
Here is 'food', here is 'fish'.
Here is food, O gods,
O Kahela, woman who lies supine,

O Moe-a-Hanuna, Milika'a-a-ka-lepo-ahulu,
Pahukini, Pahulau, Kulana-a-ka-pahu,

O 'Olekahu,
O Ka-papa-ia-laka, Ka-papa-nui-a-lei-moku,
Awake!
Awake O rain, O sun, O darkness,

O mists creeping upland, mists creeping seaward,
O violent sea, mild sea, mad sea,
Delirious, numbing sea.
The islands are surrounded by the sea;
The sea foams
With small billows, low-lying billows,
Turbulent billows that float from Kahiki.
Grant life, grant life to the king,
Grant life to the chiefs,
Grant life to the masses, to the commoners,
Grant life to me, the mighty farmer,
Grant life to my family,
Grant life to my household
Grant life to the dependents of the mighty farmer;
From the depths grant life to the earth.
'Amama, the kapu is freed; the prayer has flown.
Eat, eat.

Chant collected by Hawaiian scholar Samuel M. Kamakau.
First published in the Hawaiian-language newspaper
Ke Au 'Oko'a in 1869 and 1870.¹

Webber's watercolour documents the sacred art and architecture of a *heiau* on the island of Hawai'i. A stone wall demarcates a sacred precinct, while various material objects – an altar for offerings, carvings tied with *kapa* (barkcloth), a tower, and a house for drums or ritual objects – serve to facilitate communication with the gods.

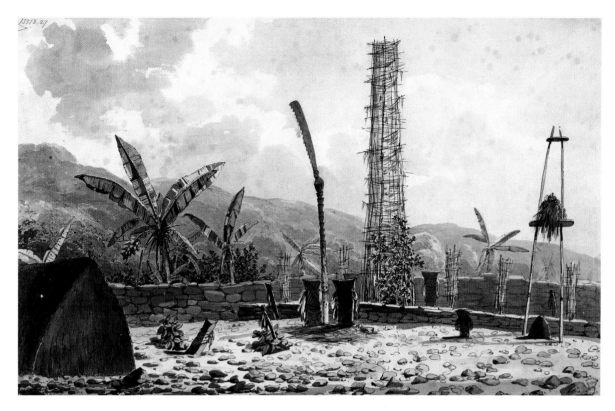

overleaf
John Webber, *Tereoboo [Kalani'ōpu'u] King of Owyhee bringing presents to Captain Cook,* 1779.
Pen, wash and watercolour, 40 x 63 cm (15¾ x 24¾ in.). Bishop Museum, Honolulu.

It follows that the feather workers, of whom little is known, were likely to have been persons of social stature who enjoyed the patronage of the local, or commissioning, chief.

In keeping with other forms of Polynesian sculpture, the *akua hulu manu*'s eyes were inset with mother-of-pearl irises. Their mouths were lined with dog teeth. Some *akua hulu manu* have heads of real human hair, short at the sides with a much longer 'mohawk'-style mane. A similar raised crest, represented in feathers, can be seen on others while a few have smooth and low or domed foreheads (*page 251*). The feathers and hair were acquired through ritualized ceremonies, and those used to cover and re-cover the *akua hulu manu* may have been part of the district tribute brought to paramount *heiau* (a Hawaiian ritual complex, equivalent to *malae* and *marae*) during important ceremonies. Polynesians also cut their hair as part of their mourning rituals, and so it is possible that the hair on the Hawaiian feathered heads was originally from the heads of mourning chiefly families.[21] Its inclusion would strengthen the connection between the supernatural deities and their mortal chiefly descendants, and would have also been a powerful indication of the object's sacred nature as chiefly heads were highly *tapu*. Given earlier practice in other parts of Polynesia, it is likely that ritualized activity accompanied the attachment of the feathers and the wrapping of the *akua hulu manu*'s body in barkcloth below the neck.

Akua hulu manu appear to have been involved in ritualized activity both within and away from the *heiau*. As the deity of war, Kūkā'ilimoku was taken into battle, either carried by a priest who would stay close to the chief, or planted into the ground, in order to provide divine protection and authority for the war party and its leadership. The deity's prestige and power was such that it would be taken, rather than destroyed, by the opposing group if they were the victors.[22] *Akua hulu manu* were also carried in procession to the *heiau* for the seasonal Makahiki festivals and, as part of the festivities, one would later be carried on a stick by a priest to a designated tree where the *akua hulu manu* presided over the construction of a wooden deity image from the tree's timber.[23] Three *akua hulu manu*, with feathered heads and bodies wrapped in barkcloth, were

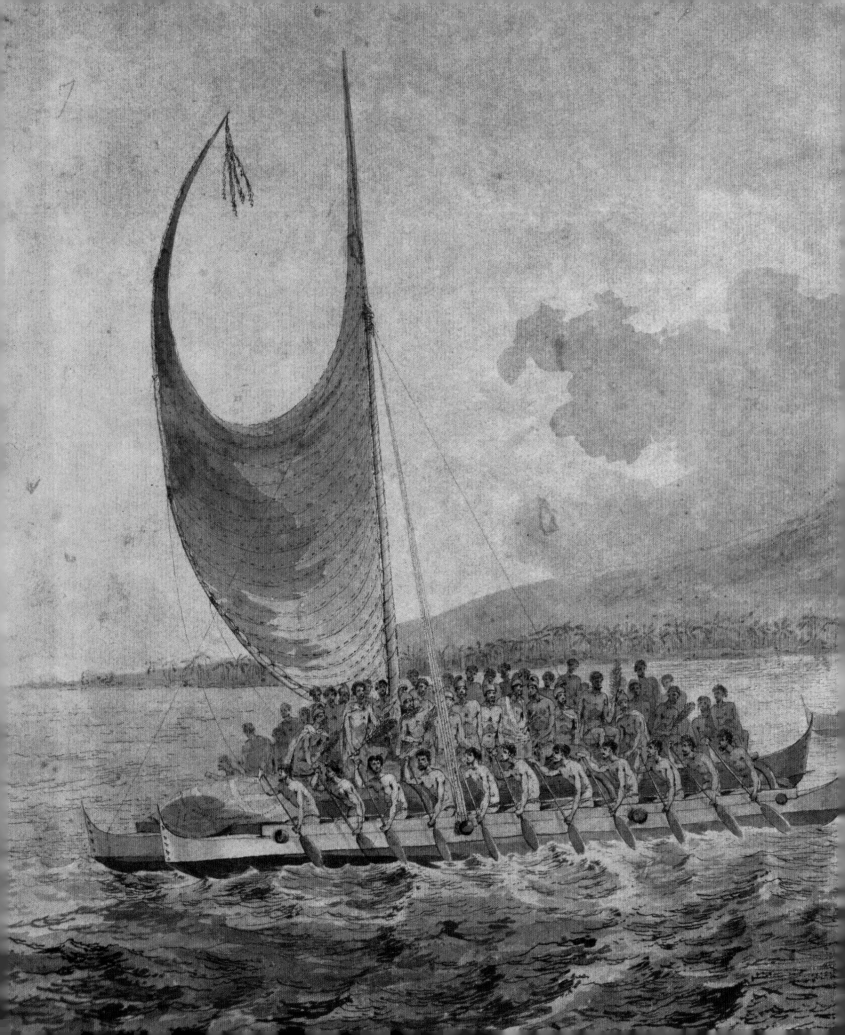

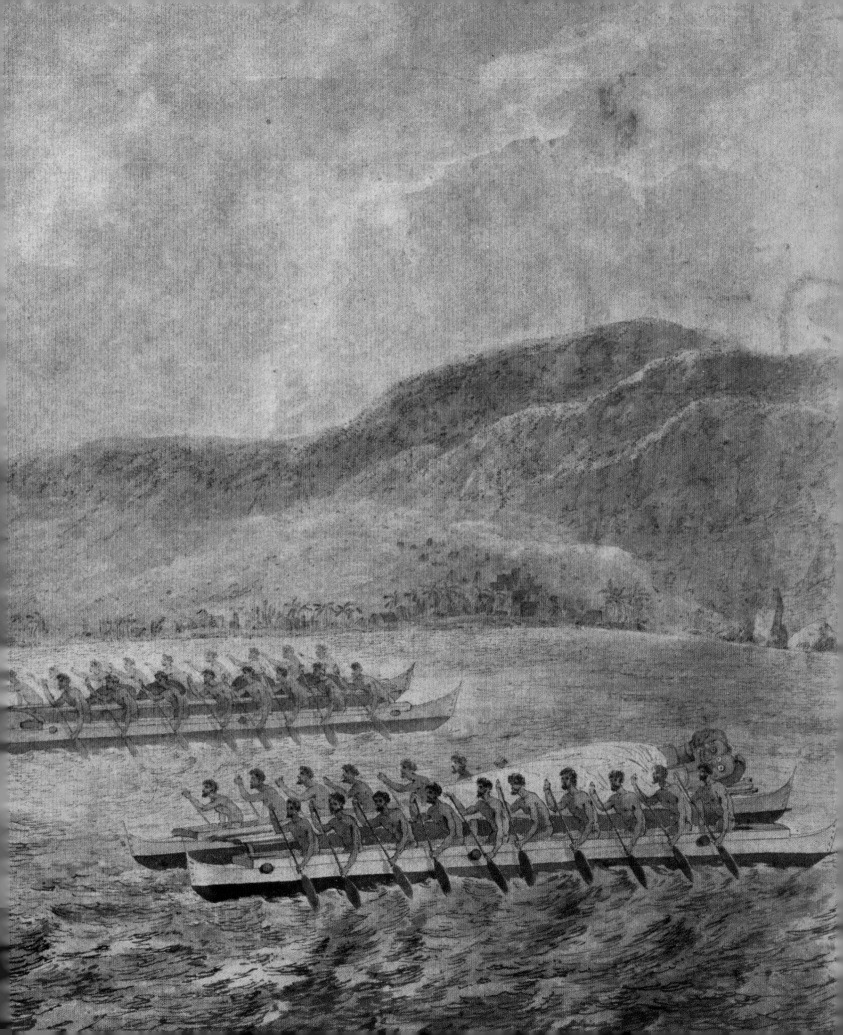

laid on the deck of a double-hulled canoe and taken in a fleet, led by the chief Kalaniʻōpuʻu, that met Cook's ships during his final voyage to Hawaiʻi in 1779. The arrival of the Europeans would have been made explicable within the context of Hawaiian spiritual tradition, and thus the presence of the chief and the deity were required to receive, if not challenge, the visitors.

While much has been made of the feathered heads' naturalistic appearance, the features can be compared to more abstract examples in contemporaneous Māori figurative woodcarving, where faces are comprised of splayed nostrils, wide-open or almond-shaped eyes, low or dipping forehead, and sometimes drawn-back lips. The same expression was used by the priest who bore the god that accompanied Hawaiian warriors in war,[24] and has also been likened to the faces of the dead. Thus *akua hulu manu* could be considered to represent the cusp between the mortal and ancestral realms. With reference to Hawaiian woodcarving and *akua hulu manu*, Adrienne Kaeppler has called this countenance the 'mouth of disrespect' and has also noted that such an expression was permissible only for people who were highly ranked or participating in battle. She has proposed that *akua hulu manu* with the mouth of disrespect and crested heads are representations of the Kū war gods, whereas those with a less pronounced grimacing mouth and a head without a crest might be images of Lono gods.[25] Lono, in his various manifestations, was a deity associated with peaceful pursuits, such as agriculture, and together with the Kū gods he represented the complementary aspects of Hawaiian spirituality. They were both called upon at major ceremonies. This complementarity provided political and social stability up until the turbulent eighteenth century, when Hawaiian chiefs such as Kamehameha sought to expand their island dominions by force. It follows that Kamehameha's devotion to the Kū god Kūkāʻilimoku purposefully introduced instability into this relationship and therefore allowed him to seek power on a previously unimaginable scale. The exaggerated mouth of disrespect shown on the *akua hulu manu*, and some figurative deity carvings associated with his reign, indicates a disdain for the prestige of other leaders and a desire to subjugate them in order to demonstrate their weaknesses and their abandonment by their deities.

Around 1790 Kamehameha received advice from a priest that in order to unite the Hawaiian Islands under his leadership he would have to rebuild a large *heiau*, formerly dedicated to Lono, at Puʻukoholā near Kawaihae and rededicate it to Kūkāʻilimoku.[26] The project was a large undertaking that, in a time of conflict, had to be completed quickly. The population was mobilized accordingly: all classes from commoners to chiefs, including Kamehameha himself, and in some accounts even children and women, participated in the *heiau*'s reconstruction under the direction of an expert *heiau* builder.[27] Once completed, Puʻukoholā *heiau* featured three terraces at different levels, which were enclosed on three sides by tall tapering rock walls. Although the *heiau* was open on the seaward side, it was not possible to view the proceedings closely inside the compound from anywhere outside. Access was permitted by a break in one of the walls. The precinct featured many alcoves, still visible today, which are thought to have housed deity images, and Kamehameha and his attendant priests were said to have kept houses on one of the terraces.[28] Kamehameha was, at that time, the ruler of one of the two districts of the island of Hawaiʻi. His rival chief during this period of conflict was his cousin Keōua from the neighbouring district of Kau. Perhaps the extraordinary feat of the reconstruction of the *heiau* at Puʻukoholā was so

Puʻukoholā *heiau*, Hawaiʻi.

In the 1790s, Hawaiian high chief Kamehameha rebuilt the *heiau* Puʻukoholā and dedicated it to Kūkāʻilimoku, the god of war, in order to sanction a campaign of conquest over the island of Hawaiʻi and ultimately over the entire Hawaiian archipelago.

significant, politically, architecturally and spiritually, that Keōua had to believe that Kamehameha had Kūkāʻilimoku's full sanction, and that therefore he himself was condemned to inevitable defeat. Whatever the case, Keōua chose to go to Kamehameha's stronghold, fully aware that he would be killed. Afterwards, Kamehameha offered Keōua's body as a sacrifice to Kūkāʻilimoku at the *heiau*. As Kaeppler writes, with these acts, 'Kamehameha and Kūkāʻilimoku rose together, eclipsing the power of other chiefs, other aspects of the god Kū, and the war gods of other chiefly lines.'[29] The *heiau* and its principal sacrifice enabled Kamehameha to consolidate the leadership of the island of Hawaiʻi under his rule and validated his deity as supreme. From this position, he looked towards conquering the other Hawaiian islands of Maui, Oʻahu, Lānaʻi and Molokaʻi, with some chiefs on those islands also seeking to expand or protect their own territories.

William Ellis was told by chiefs on Maui that before Kamehameha conquered the island in 1795 their most important deity was Keoroeva, who was represented as a wooden figure, wrapped in barkcloth, with a wickerwork head and neck that was covered in red feathers. The head had a wide and distended mouth and its crown was adorned with a helmet that featured tresses of long human hair that hung below the deity's shoulders. This *akua hulu manu* was kept inside specially dedicated *heiau* and behind an altar where offerings were presented and pigs were blessed. Further departmental deities were represented in stone and wood on Maui and other islands in the Hawaiʻi group, and they may have continued to have been venerated even after Kamehameha had installed Kūkāʻilimoku as the paramount deity. Ellis's informants told him that Kamehameha kept a representation of Karaipahoa, a formidable deity that originated on the island of Molokaʻi during the reign of Kamaraua, under his pillow at night. This wooden figure typically had extended arms, with fingers splayed, a head of human hair, and a mouth of shark's teeth. The image manifested itself in dreams but resided inside the figurative carvings.[30]

When Kalaniʻōpuʻu approached Cook's ships in 1779, he and his supporting chiefs wore feathered cloaks and helmets as indicators of their rank,

Feathered cloak, ʻahu ʻula, Hawaiʻi, eighteenth century.
Fibre and feathers, 152 x 245 cm (59⅞ x 96½ in.). Presented to Captain Cook, January 1779. Museum of New Zealand Te Papa Tongarewa, Wellington.

Captain James Cook's arrival in Kealakekua Bay, Hawaiʻi, on 26 January 1779, coincided with the Makahiki seasonal festival. Receiving him as the deity Lono, the chief, Kalaniʻōpuʻu, greeted Cook in a ceremonial convoy laden with sacred feathered objects, removing his own cloak, shown here, to drape over Cook's shoulders, placing a feathered helmet on his head and laying more cloaks at his feet.

a demonstration of their religious authority and spiritual protection. This divine costume had a stunning aesthetic effect. Kaeppler has argued that the ultimate objective of eighteenth-century Hawaiian chiefly costume was to make chiefs appear as an assembly of crescents, indicated by their sweeping cloaks that sometimes featured curved patterns, and their crested helmets as well as other adornments.[31] Feathered cloaks, known as *'ahu'ula*, were the mantle of the most influential chiefs. They could be up to 1.6 metres (5 ft 2 in.) long. Shorter feather capes, of 30 to 70 centimetres (12 to 27 in.) in length and of similar design and fabrication to the *'ahu'ula*, were worn by less powerful leaders.[32] Many *'ahu'ula* must have been in circulation as over thirty were given to Cook and members of his crew between 1778 and 1779 (*previous page*).[33] These cloaks were highly prestigious garments that were as jealously fought over as the *maro 'ura* of Tahiti. For example, at around the same time as Cook's visit , an *'ahu'ula* was at the centre of the overthrow of Kahahana, the paramount chief of the islands of O'ahu and Moloka'i, by Kahekili, the chief of Maui and Kahahana's former guardian. On the advice of his high priest Kaopulupulu, Kahahana had refused to surrender land to Kahekili since this would have effectively extended his political authority to their islands. Among other measures Kahekili took to make Kahahana doubt his priest's competence and loyalty, he is claimed to have had Kahahana's *'ahu'ula*, which was securely kept under the guardianship of Kaopulupulu, secretly copied by weavers from Maui. The fake *'ahu'ula* was produced as the real version when Kahahana made a visit to Maui. Enraged by the thought of Kaopulupulu allowing his *'ahu'ula* to be removed, Kahahana alienated his former high priest and later engineered his murder.[34] Kahekili then used the period of unstable rule on O'ahu that followed as an opportunity to conquer it and consolidate his rule over seven Hawaiian islands. This dominion eventually fell to Kamehameha in 1795 in the campaign that would see him assume leadership of all the Hawaiian islands by 1810.

Although *'ahu'ula* were similarly constructed, each had an individual identity provided by its unique patterning and accumulated history. They all comprised a fibre foundation layer woven from a double-ply cord made from the *olona* (*Touchardia latifolia*) plant. Since weaving could produce only rectilinear forms, the figure-contoured curved form

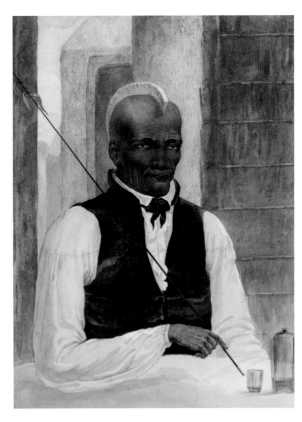

Mikhail Tikhanov, *Kamehameha, King of the Hawaiian Islands*, 1818. Watercolour over pencil, 46 x 33 cm (18⅛ x 13 in.). Scientific-Research Museum of the Art Academy, St Petersburg.

of the *'ahu'ula* was produced by joining cut segments of weaving together or, more rarely, cutting a single piece of weaving to shape. Bundles of feathers were then attached to this foundation garment. Prayers most likely accompanied this work, not only in recognition of the sacred nature of making divine clothing but also to imbue the garment with special spiritual qualities.[35] The entire process would have been both time-consuming and painstaking, and the required commitment of human, animal and plant resources was a formidable demonstration of group wealth. Peter Buck has claimed that although women sorted the feathers and arranged them in bundles, only men could manufacture the completed garment, a gendered division of labour that in other parts of Polynesia was often an indication of *tapu*.[36] In many examples of *'ahu'ula*, red feathers formed the base colour, accented with crescent, triangular, square and diamond-shaped patterns made from yellow and sometimes black feathers. The name *'ahu'ula*, literally 'red garment', remained nevertheless since *'ula*, like *'ura* in Tahiti, was associated more with *tapu* than with pigment in

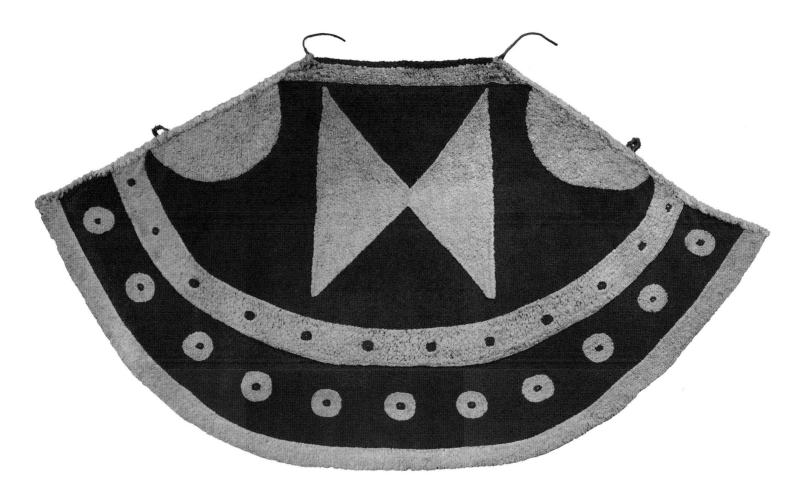

this context. No information remains as to whether these patterns had specific meanings, but it has been observed that circles were a shape associated with Kahekili of Maui and Ka'eo of Kaua'i, and triangles were associated with Kalani'ōpu'u and Kamehameha from Hawai'i.[37] Since yellow feathers grew only as a highlight on the 'o'o and *mamo* birds, they were more difficult to source and therefore more valuable as a commodity. It is perhaps not surprising then that Kamehameha was distinguished by possessing a cloak made from approximately half a million yellow *mamo* feathers, harvested from around 80,000 birds.

Oral histories that accompanied each *'ahu'ula* recounted their role as mantles acquired by inheritance, conquest, gift or seizure. When Kiwala'ō, the chief of Hawai'i, was killed by Ke'eaumoku at Moku'ohai in 1782 as part of Kamehameha's expansionist campaigns, Kamehameha received the vanquished chief's *'ahu'ula* in order to indicate the transferral of divine rule over the island.[38] It has been suggested that Kiwala'ō's *'ahu'ula* incorporates parts of other garments.[39] Such a practice might have

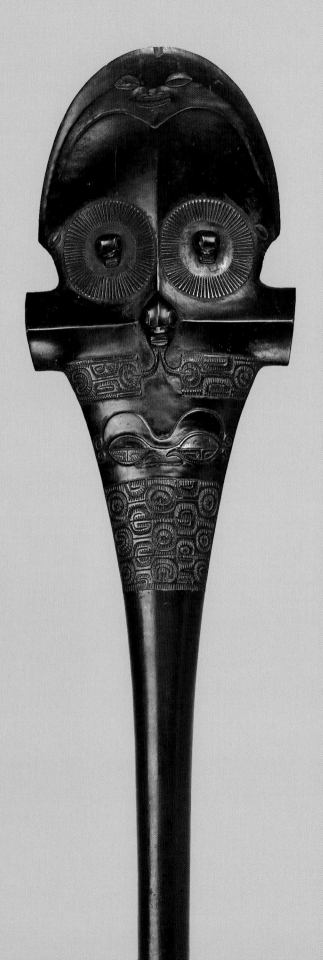

Marquesan Style

PAUL GAUGUIN said it best when he described the character of Marquesan style as 'always the same thing and yet never the same thing'.[i] He was referring to the repetition of conventionalized *tiki* (godling) figures and schematic patterns across the entire range of Marquesan material culture and body art (tattooing, adornments, statues, clubs, bowls, food pounders, fan handles, etcetera), and at the same time, the ingenuity of artistic play: of small formal variations, witty inventions, visual puns and ironic allusions that kept the endless iteration of the same alive with the constant slip and surprise of minor differences.

The stylistic logic is exemplified by the much-collected war clubs, called *u'u*. Made 'functionally' to inflict or threaten death or injury, they were psychologically potent objects, literally conglomerates of *tiki* heads and faces, powerful both through their metaphysical nature and their multiplicity. Made from heavy ironwood, each club is slightly different, yet carved in an utterly conventional fashion. The business end comprises a Janus face – turn it around and the same configuration confronts you – with large startled eyes, its pupils popping out and doubling as smaller *tiki* heads. Further heads are, in some examples, inscribed at the side and on the ridge of its brow. Yet another head typically protrudes from the centre of the crossbar where it doubles as a nose and the head of a *tiki* whose body has been transformed into the pattern bands that surround the club's tapering neck. These abstractions are themselves 'transforms' of *tiki* motifs. Upon completion, *u'u* were buried in taro patches to darken them and then polished with coconut oil.[ii]

The character of the club also extended to the body of those who wielded them. A drawing by Wilhelm Gottlieb Tilesius von Tilenau, who was part of a Russian expedition that spent twelve days at Taiohae Bay in Nuku Hiva in 1804, depicts a warrior, or *toa*, holding an *u'u* in his right hand and a staff (presumably) in his left. While rendered in the style of Western classical naturalism, this act of cultural translation still captures something authentic about the extreme aestheticization of the body and importance of display in Marquesan society. For the *toa* is also covered from head to toe in a bilateral patchwork of tattooed *tiki* motifs and designs: faces, 'eye spots' and integrating patterns that transform him, like the weapon he holds, into a *tiki*-laden and magically charged

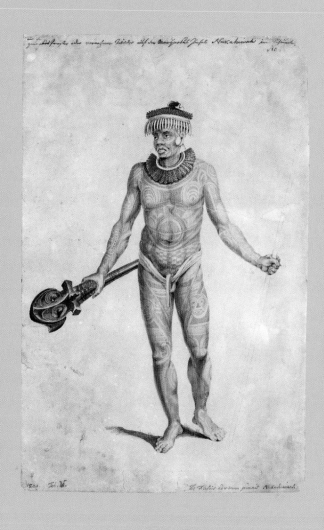

being. Indeed, the Marquesan term for tattooing was *patu tiki*, 'to tattoo' or 'to make *tiki*' – a term that Alfred Gell justly translates as 'wrapping in images'.[iii] The warrior is further adorned with an elaborate headdress, ear ornaments and a gorget encrusted with red beading.

The point of this fusion of aesthetic refinement and metaphysical enchantment was directly related to war, which, in the Marquesas, had been endemic since probably the fifteenth century.[iv] Unlike Polynesian societies such as Tonga and Hawai'i, the Marquesas were never united under a single ruling chieftainship, neither the archipelago as a whole nor its individual islands (with the exception of Ua Pou). Rather, as Greg Dening writes, there was 'endemic warfare' between 'conglomerates of mutually antagonistic valleys, which warred singly against one another or in groups united in brittle alliances'.[v]

The question is: how is Marquesan style, not just in the prevalence of war clubs, tattooing and body adornment but also in the very logic of its formal language – 'always the same thing and yet never the same thing' – to be related to the temper of warfare and social instability that characterized Marquesan society until the mid-nineteenth century?[vi] PB

recognized the reign of earlier chiefs within Kiwalaʻō's descent line, in addition to that provided by supporting regional chiefs through the supply of feathers as tribute. Short capes are known to have sometimes been extended or received additional feathers in a practice reminiscent of the ritual renewal of feathered *tiʻi* and *toʻo*.[40] Even though garments could pass between hands under many different circumstances, they may not have been worn by their receivers, since the personal *tapu* of the original chiefly wearer would have been embedded in these objects and made them dangerous items.[41] After Kiwalaʻō's death, Kamehameha used negotiation, rather than force, to unite the last of the major islands of Hawaiʻi under his rule, which was achieved by 1810. This date marks the beginning of the Kamehameha dynasty and the 'Kingdom of Hawaiʻi' that was, like those of the Society Islands and Tonga, modelled on the European monarchies. Within this new political framework, feather work continued to support leadership as royal regalia that, like their wearers' authority, was partly reliant on both their customary and contemporary status.[42]

Textiles and Stone Money of the Yapese Empire

Textiles, along with stone money, were also major elements in a Micronesian exchange system that maintained an extensive chieftainship from the outer atolls of the Yap group across to Palau, from at least the seventeenth century until the imposition of colonial rule in the early twentieth century, when long-distance voyaging was prohibited. Similar to Tahiti and Hawaiʻi, outer atoll Yapese textiles were the means by which chiefly lines were deified through a tribute system, known as the *sawei*; however, whereas textiles provided a stabilizing influence on leadership structures during the eighteenth century, Yapese expansionist objectives were realized through the increased artistic production and use of stone money. By the eighteenth century, the latter process was being facilitated using Micronesian long-distance navigation technologies, although it would completely collapse with the appropriation of European technologies in the following century.

The exchange of such items through this tribute system occurred in two interrelated steps, which demonstrate a chain of increasing chiefly authority from the outer atolls, to Yap and then to Palau. In the eighteenth century the *sawei* custom comprised an exchange chain that every two or three years started from the Yapese outer atolls and moved steadily westwards towards the Gagil region of Yap.[43] Voyaging vessels bearing locally produced bamboo, shells, nuts, turmeric, fish, coconut-derived products, tools, canoes and textiles, along with atoll representatives, were progressively attached to the water convoy. Yapese families hosted the outer-atoll Islanders, whose rank and status were not considered so significant on Yap, but in exchange for their tribute to the Gagil chiefs and their deference to the Yapese these Islanders received cultivated foods, turmeric, combs, bamboo, timber, ceramics and possibly other materials not available on their atolls. The earliest archaeologically established date of Yapese influence in the outer atolls, based on the presence of plain ware ceramics on Ulithi, is AD 620, but this is not evidence in itself of the *sawei* system in operation, which may have developed as late as the seventeenth century.[44]

Among the textiles given were sennit rope, pandanus sails and mats, and different types of loom-woven cloth.[45] 'Back-strap' loom-weaving is a practice thought to have been obtained from southeast Asia, in particular the Philippines and eastern Indonesia, and to have spread through northern Oceania by prehistoric long-distance voyagers from the Caroline Islands.[46] In this type of weaving the weaver sits with legs outstretched or tucked under their body so that they can face a loom that is suspended and tensioned between a strap that runs behind their back and posts in front of them. Tension on the warps is adjusted by the weaver bending either forward or back. Among the loom-woven textiles, *machi* garments from the Yapese outer island of Fais were the most prestigious. To this day, *machi* are distinguished from other types of loom-woven textiles on Fais by their use as ceremonial, and in particular chiefly, clothing, and through their composition consisting of supplementary weft pattern bands at the two ends of the textile. Although no eighteenth-century examples of *machi* have survived, early nineteenth-century examples, including one now in the Kunstkamera, St Petersburg, feature patterns that are still in use today, indicating a continuity of design. Following later tradition, eighteenth-century *machi* were probably made from multi-ply and single-ply yarns composed of sinews removed from scraped banana stalks and soaked hibiscus bark. For

the decorative end details, fibres could be dyed black, red, yellow and blue using pigments manufactured from nuts, roots, leaves, mud and turmeric. The intricately arranged motifs on the St Petersburg example include diamonds, triangles, 'herringbone'-style compositions and complex geometric forms, some of which may be abstracted figures. It is tempting to liken these to other patterns found in tattoo and even on pottery, although in the absence of eighteenth-century examples this link is difficult to prove.

Women in each noble household on Fais were required by the island's chief to produce one _machi_ every year as their contribution to the tribute. The hierarchy of leadership within the island group, and possibly the relationship of these leaders to the deities, was demonstrated through the use of _machi_ mantles as an insignia of rank for the investiture and burial of Fais chiefs, and the initiation of boys. Once received, these mantles were placed as an offering to the deities on the chief's 'spirit-shelf' for a number of days. During inauguration ceremonies, as the chief received the _machi_ mantle, incantations were recited that also

called on the deities.[47] The status of the _machi_ as a spiritual object was such that even though it was a wrap-around skirt, it was never worn in that manner.

As has already been demonstrated, the maintenance of contact between Oceanic islands was a means by which Islanders could gain access to exotic or significant resources or goods, and sometimes power over their own and other islands through exchange or tribute systems.[48] Although tribute textiles were important for the maintenance of chiefly structures within the Yap group, the Yapese also engaged in long-distance voyaging to Palau in order to quarry limestone discs, weighing many tons, that were used as stone 'money' in Palau (_page 267_). This practice appears to have been active for several hundred years and continued for some time after the arrival of Europeans. Production of this money, known as _rai_ or _fei_ in Yap and _balang_ in Palau, was increased by Yapese chiefs from the Rull and Tomil districts during the eighteenth century and, with the assistance of Europeans, into the next, in order to assert political superiority over the chiefs of the Gagil district. The

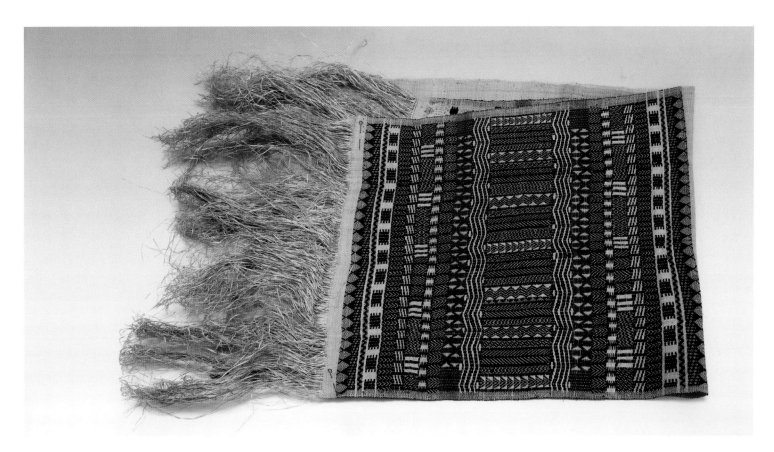

'THIS MAN IS ABOUT TO COME UNDER YOUR MANTLE!'

Look here from over there, all you ancestor spirits of the lodge!
I am about to spread out this fellow's mantle!
You, Soolal, gaze up, and you, Yalulap, gaze down!
And you,–! And you,–! And you,–!
Look here, for now this man is about to come under your mantle!
You will watch over this man!
I spread out his mantle, and you shall grant him long life!
Grant him good fortune!
Grant him happiness during his tenure as chief!
Eastward your children, until the distant rising!
Westward your children, until the distant setting!
You, you who are to be chief, and mother of this island,
What you receive, though small, is your fare!
What you do not receive, though large, is not your fare!
You shall be as the reef's coral shoulders!
The waves may pound, pound, yet you will stir not!
Keep your ears stopped, but keep your ears sharp!
Keep your eyes covered, but keep your eyes clear!
Do not rival against others!
All of you, grant him happiness during this man's term!
Grant him long life in his chieftainship!
Grant him long life! Grant him long life!
Grant that his heart be good!
And if his heart be good, grant him long life!
And if his heart be evil, remove him!

A chant used during the investiture ceremony
for paramount chiefs on Fais Island and Ulithi Atoll,
in which the *machi* functioned as an inaugural mantle.[i]

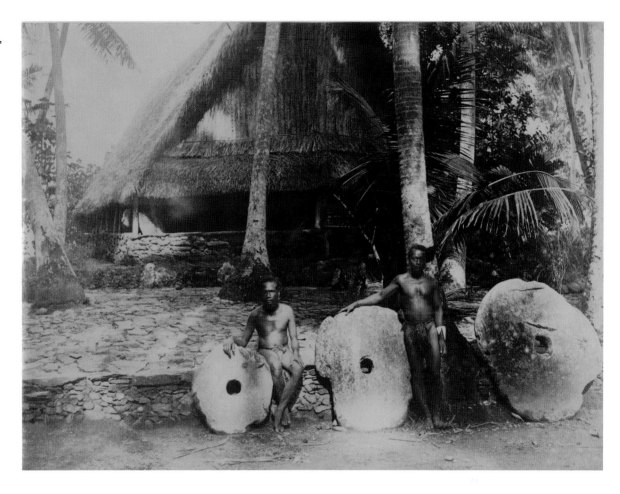

Gagil chiefs in turn exacted more tribute from outer-atoll Islanders through the *sawei* in order to maintain their authority over the people in their dominion and demonstrate their power to those outside the region. Mark Berg suggests that the spiritual dimension of the *sawei* was developed between the sixteenth and eighteenth centuries to maintain good weather for the production and movement of tribute items, and possibly to galvanize those participating in the process.

Stone money carried significant prestige in Yap, even if it did not possess the same direct association with the deities as *machi*. It did have a prestigious foundation in oral narrative, having been discovered in a Palauan cave by the navigator Anagumang, who ordered that it be cut and shaped into a fish form and then a full moon, before taking it back to Yap where it was very favourably received. Limestone was not available in Yap, and had an exotic value. Furthermore, the Yapese regarded the Palauan chiefs as being more

highly ranked than their own, and therefore Palauan-derived stone was held in significant esteem. Nineteenth-century observations, which may reflect the situation in the previous century, indicate that Yapese islanders would purchase the stone money landed on their island with taro (*Colocasia esculenta*), the chief assuming possession of the larger discs, which were displayed in the open as a sign of chiefly and village prosperity, together with a significant proportion of the smaller ones (*overleaf*). The smaller discs could purchase food and crafts, the mid-sized pieces buildings, and the largest could secure interregional alliances and settle debts.

The stone was shaped into discs as it was removed from the surfaces of limestone caves and rock shelters, in the Airai district of south-eastern Babeldaob Island, using fire and shell adzes; this may have required the labour of hundreds of people. A hole was drilled through the centre of heavier discs for the insertion

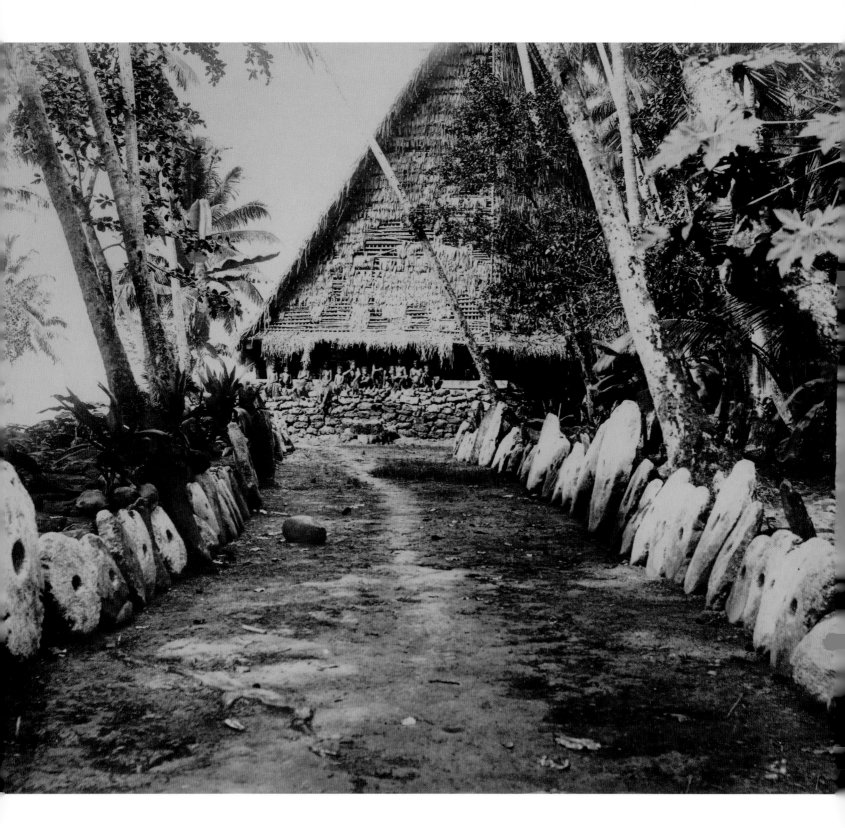

**View of pathway lined with stone money,
Yap, Caroline Islands, 1884.**

© The Trustees of the British Museum, London.

of a large bearer that allowed each disc to be carried to the shoreline. Some of the discs weighed up to nine tons and spanned 4.5 metres (14 ft 8 in.) in diameter. There are nineteenth-century accounts of the bearer being placed across the hulls of two canoes, which would suggest that the stone was partially submerged in the water. The return journey was over 800 kilometres (500 miles) and the discs are thought to have been some of the heaviest objects transported on the ocean by Pacific peoples. While this is a remarkable feat, the stones' submergence would have had a buoyant effect, and made it much easier to transport them on water than on land. Pacific artists and navigators may have been devout followers, but they were also pragmatic practitioners.

This pragmatism alludes to the possible reciprocal benefits of the Yap presence in Palau. It has been speculated that the Palauans may have received, in exchange for rights to their stone, Yapese assistance in stone construction (particularly roads and platforms), the glass beads that formed their currency, or even metal tools. The temporal, manufacturing and artistic origins of Palauan glass-bead money are yet to be identified, but one possibility is that the trading link between Yapese outer-atoll navigators to Guam and the Philippines, who were also engaged by the Yap stone-money importers to lead the stone-money voyages, may have facilitated the glass beads' journey to Palau. The outer-atoll Islanders were already voyaging to Chuuk in the eastern Caroline Islands of Micronesia to acquire *thauai* (shell necklaces) and the highly valued *gau* shell currency used by the Yapese, which may have also formed part of the exchange for Palauan limestone quarry access, along with *kereel* (coconut-fibre cord) and *chesiuch* (oyster shell used as Palauan women's money). The introduction of these currencies may have assisted in the settling of land disputes that had arisen within Palau, all of which underlines the importance of stone, shell and glass money in maintaining and transforming the political situations here and in Yap. Palau had little engagement with Europeans and their tools before 1783, when the *Antelope,* a packet ship captained by Henry Wilson of the British East India Company, was shipwrecked off its coast; the local people hosted the crew during an extended stay while repairs to the ship were carried out. The movement of stone adzes and spouses from Yap to Palau has also been proposed as part of the symmetrical exchange network, which appears more similar to the extensive tribute system in operation in Samoa, Tonga and Fiji than perhaps the localized versions practised in Hawai'i and Tahiti.

The value of stone money, and its role in maintaining the associated Yapese chiefly system, declined in the nineteenth century due to over-supply when the Yapese began engaging European sailing vessels to import larger quantities (in size and number) of discs. The appropriation of metal tool technology for the quarrying process may have also accelerated production and therefore contributed to the currency's destabilization. Further political transformations occurred at the end of the nineteenth century, as the German colonial administration decided to support the Gagil division of Yap, thus diminishing the status of Rull and Tomil, and revitalizing the *sawei* system until it was eventually extinguished by the ban from successive Japanese administrations on long-distance indigenous voyaging.

In summary, in eighteenth-century Tahiti, Hawai'i and Yap, textiles and stone money demonstrated the chief's control over resources and production, and their divine right to rule through inheritance or conquest. As a resource in themselves, textiles and stone money were important tribute elements that maintained class and leadership structures, and exchange items that facilitated intertribal and, later, intercultural alliances. The same objects could be used to destabilize social organization, as was the case with feathered manifestations of 'Oro on Tahiti, Kūkā'ilimoku in Hawai'i and stone money on Yap. Unlike Tahitians' and Hawaiians' view of chiefly insignia, Yapese people did not regard their chiefs' *machi* and stone money as objects of manifest divinity; however, the connection to chiefs and deities was just as absolute. By the beginning of the nineteenth century, the employment of artistically elaborated objects to consolidate the Tahitian, Hawaiian and Yapese empires was all but complete and, one might argue, exhausted as a consequence. The incursions of Europeans – with their new God, royal dynasties, maritime empire and technologies – just at this time would provide a new impetus to the completion of these political consolidation projects and the colonial validation of the chiefly lines of Pomare in Tahiti and Kamehameha in Hawai'i, and the Gagil chiefs of Yap.

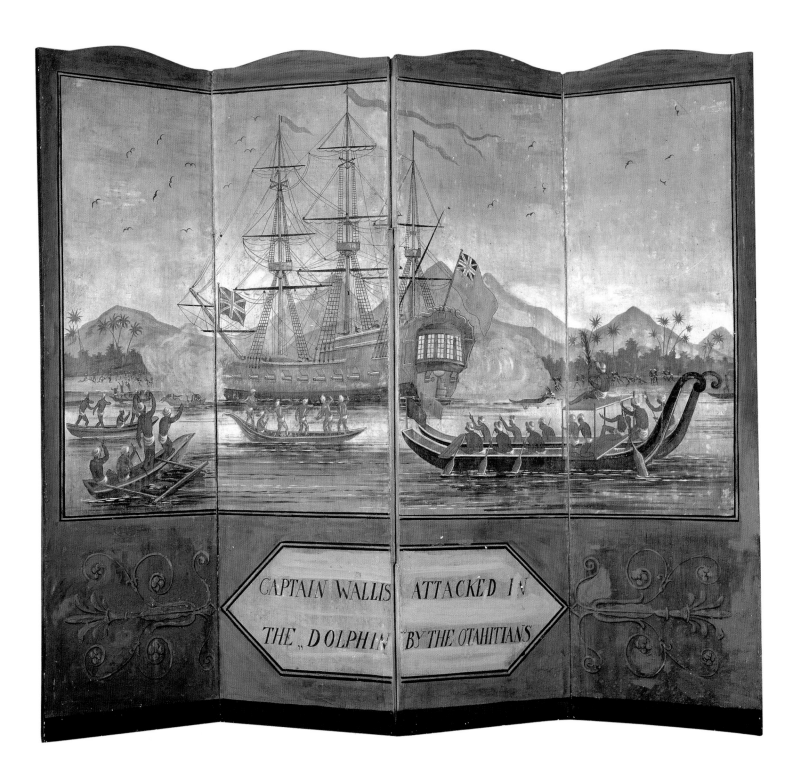

CAPTAIN WALLIS ATTACKED IN THE „DOLPHIN" BY THE OTAHITIANS

Nicholas Thomas

EUROPEAN INCURSIONS 1765–1880

From the sixteenth century onwards European ships passed through the Pacific, but voyages were few and far between, and human contacts generally fleeting, until well into the eighteenth century. The notable exception was on Guam, where, from the 1670s to 1690s, Chamorro people were brutally subjugated. The island became in effect a dependency of the Spanish colony in the Philippines, though it was seldom called at, and never became a base from which other Micronesian peoples were contacted or engaged with. Otherwise, European contact gained momentum only from the 1760s onward. A period of peace in Europe, commercial ambition and scientific inquisitiveness stimulated British, French and Spanish voyages. Tahiti, violently 'discovered' by Captain Samuel Wallis in June 1767, was swiftly identified as a desirable port of call. The island was visited by Louis-Antoine de Bougainville and on all three of Cook's voyages. It provided the base for Cook's observations in 1769 of the transit of Venus, was missionized unsuccessfully by the Spanish during the 1770s, was later the source of the breadfruit seedlings that Captain Bligh intended to transport to the West Indies – prior to the mutiny on the *Bounty* in April 1789 – and was otherwise called at frequently.[1]

Over the same period, the Marquesas, the Hawaiian archipelago, the Tongan group and New Zealand were visited by Cook and his successors, and – in the wake of the realization that furs easily obtained on the American north-west coast were highly valued in Chinese markets – Hawai'i soon became a staging-point for a lucrative trans-Pacific trade. From 1788 New South Wales was settled, the port of Sydney became a base for a range of commercial ventures, and the pace of contact and intrusion stepped up.[2]

Contact and Commerce

It is striking that throughout the region, and from the earliest stages of these encounters, new artefact and art forms were stimulated by contact. Islanders were quick to embrace beads, ironware and manufactured cloth, all valued both for associations with prestigious foreigners and for particular material and technical properties. These imports had both obvious and more subtle ramifications. Iron tools enabled woodcarving to be done more quickly and more finely, and their introduction facilitated something of a technological revolution in the Pacific. Similarly, metal scissors enabled fabrics, and particularly barkcloth, to be cut in new ways, allowing novel aesthetic effects to be produced.[3]

Some changes of style and technique were complex and continuing; other innovations were dramatic, and dated from the very earliest stages of contact. The first extended European visit to Tahiti was that of Cook's *Endeavour*, which anchored in Matavai Bay from mid-April to mid-July 1769. The primary purpose of the stay was the observation of the transit of Venus, but the lives of Polynesians proved of greater interest; indeed they fascinated the visitors. Interactions were at times tense, but also rich and intimate, and the ramifications for both parties far-reaching. This is not the place to review these much-discussed encounters.[4] From the perspective of Oceanic art history, one of the most arresting features was the interest of the Ra'iātean priest and navigator Tupaia in European drawing.

Tupaia had been exiled from his home on the neighbouring island of Ra'iātea, was closely associated with the prominent chiefly woman Purea, and was clearly a formidably intelligent and curious man, as inquisitive about the European visitors as they were about the lives of Islanders. During May and June he

spent an increasing amount of time with Joseph Banks's entourage, among whom Sydney Parkinson and Alexander Buchan were constantly sketching. During this period he began to use pencil and watercolour, depicting subjects such as the remarkable costume of the 'chief mourner', the principal performer in a dramatic funerary ritual that Banks's draughtsmen were also illustrating. In Tahiti, Tupaia also drew a group of musicians, a dancer, a village scene, and *marae* or temple precincts.[5]

It is surely remarkable that an Islander might so quickly embrace unfamiliar materials – paper, pen and paint – and acquire some facility with them, and with the basic conventions of two-dimensional, naturalistic representation. Although eastern Polynesian sculpture incorporated moderately naturalistic human heads, this was more the case in Mangareva than Tahiti, and while rock art and tattooing employed two-dimensional imagery, motifs were more typically schematic or abstract. In other words, what Tupaia

This image, published by Anne Salmond in *Between Worlds* (1998), has recently become an icon of cross-cultural contact, and been drawn upon by contemporary artists such as John Pule and Michel Tuffery.

The seven-stepped structure here is almost certainly the *marae* Mahaeiatea, constructed at the behest of Tupaia's patron, the ambitious aristocratic woman Purea in the mid-1760s. A European view, published as an engraving in William Wilson's, *A Missionary Voyage to the Southern Pacific Ocean* (London, 1797), provides some insight into the architecture, while treating the site as an antiquity, which it had not yet become.

was doing amounted to a radical departure from any customary convention. But the real distinctiveness of his work lies at another level. Tupaia's drawings are literally illustrative: he did not merely depict people, objects or scenes, but he produced genuinely documentary works. He also produced a view of a typical settlement (*page 272*) showing, in the foreground, different types of canoes, and the Society Islands's style of naval combat – warriors stood on raised platforms and engaged each other with clubs and spears. The plants and trees either side of the carefully defined open house are not those that happened to be there, but the useful Polynesian flora – a sampling prompted perhaps by Joseph Banks's botanical inquiries. From the left, they include pandanus, breadfruit, bananas, the coconut palm and taro; where appropriate, the fruit are clearly drawn.

In Tupaia's images of *marae* (*page 272*), the features salient to Tahitian ritual life are similarly identified. The structure in the centre of the upper row is a *fare atua*, literally the 'house of a god', the repository for a woven deity image, referred to sometimes by European observers as an 'ark'. Other platforms feature sacrifices of fish and a pig; the infants shown are deceased, perhaps stillborn or aborted (in any case highly *tapu*), not sacrifices.

Polynesian art had never before been strictly descriptive in this sense. Works invoked deities, affirmed status, and marked genealogy and sovereignty; they existed to express presence and power, not to communicate information. It would perhaps be overstating the case to say that Tupaia had embraced the ethnographic attitude exhibited by some among the Europeans, who pursued inquiry into Tahitian custom with a curiosity that appeared insatiable. Yet this is almost so. His engaging images did not merely show a drum or a canoe; they showed what a drum or a canoe *looked like*.

As is well known, Tupaia sailed with the *Endeavour*, prepared a map of the islands of Oceania known to him, and, importantly, acted as a go-between in dealings with Islanders elsewhere. His depiction of an exchange of gifts between Banks and a Māori man wearing a feather cape has become an icon of encounter imagery (*page 273*), one quoted by contemporary artists such as John Pule. Tupaia's drawing of Aborigines in a canoe in Botany Bay

provides an intriguing sidelight upon this foundational moment in Australian colonial history – we are reminded that indigenous Australians encountered not only the British but also the Polynesians for the first time, on this much-celebrated and much-lamented occasion. This drawing in Australia was the last that Tupaia produced, at any rate among those that are extant in the Banks collections in the British Library, London. Tupaia and Taieto, a young man described as his servant, both died of some sort of fever, along with many members of the *Endeavour*'s crew, at Batavia in the Dutch East Indies in the last weeks of 1770.

The ritual arts of the Society Islands were part of a public culture: they marked environments, signified power, and touched people's lives. Tupaia's works, in contrast, had no presence in Polynesia. They left the Pacific and left public view altogether for over two hundred years. Yet they nevertheless tell us something about visual culture in eastern Oceania at this time. Tupaia's may be the only extant eighteenth-century works on paper by an Islander. It is clear, however, that Māori, Hawaiians and Palauans as well as Society Islanders were intrigued by European drawing, especially by portrait sketches made by voyage artists such as William Hodges and John Webber (on Cook's second and third voyages respectively), and Arthur

Devis (among the group marooned on Koror, Palau, after the 1783 wreck of the *Antelope*). In a number of instances it is noted that locals were themselves prompted to experiment with a pencil.[6] If it appears unlikely that any Islander within the Pacific produced more than a sketch or two prior to the missionary period, we do know that two Islander travellers, Kualelo of Molokai and Tapioi of Tahiti, both drew a good deal while resident in England, the former from 1789 to 1791, the latter from 1806 to 1810. Kualelo 'seemed fondest of those rude pictures called Caricatures & frequently amused himself in taking off even his friends in imitation of these pieces'.[7] In neither case does the work seem to have survived, but the fact of its creation is important: we see that Polynesians were not only capable of but interested in embracing forms of art that might have been considered alien to them.

If Tupaia's practice exemplified an early interest in Western drawing, there is evidence too that Islanders were excited by, and indeed wished to possess, Western portraits. When, during Cook's final visit to Tahiti in September 1777, the navigator asked the high chief Pomare whether Webber might paint his portrait, Pomare was pleased, but wanted his own portrait of Cook as part of the bargain. Though what was evidently a small framed and glazed oil painting disappears from view at the beginning of the nineteenth century, it was carefully preserved until then, in the care either of Pomare or of other chiefs in the locality. The painting was shown to various visiting mariners, a number of whom inscribed their ships' names and the dates of their visits on the back, thus turning the object into something like an artefact of British or European genealogy, from the Islander perspective.[8]

Lieutenant George Mortimer, of the trader *Mercury*, visited for a few weeks in August 1789 and was eager to see the portrait. He remarked that 'Though we went several times to see this picture, we could never discover where it was kept, as we were always conducted to Poneow's house, who desired us to wait there till it was brought to us. He then despatched two of his servants for it, who used to bring it wrapped up in a cloth; and after we had viewed it, carried it back again in the same manner.'[9] This painting was unwrapped, decorated and displayed on *marae* during ritual occasions, which also featured European flags; the Cook image was said to have sacrifices presented to it. This may or may not be correct, but the painted portrait had certainly become something other than what it had been in British minds. It was a sacred artefact, maybe even an incarnation of the chiefly voyager, who had become a mythic figure for Tahitians even before he was one among Europeans.

Mortimer's *Mercury* narrative is interesting, not only for his observations on the Cook portrait. This generally obscure voyage occurred in the immediate aftermath of the *Bounty* mutiny against Captain Bligh. Now under the command of Fletcher Christian, the *Bounty* had returned to Tahiti on 6 June 1789. It left again ten days later with supplies of pigs and provisions, and some twenty-eight Tahitians, for the island of Tubuai, where Christian hoped to settle and live out his life beyond the reach of British power. The curious colonial venture was resisted and the plan abandoned; the *Bounty* returned to Tahiti in late September, and Christian then vanished, together with a party of Tahitians and some of the mutineers, to Pitcairn.[10]

The *Mercury*'s time at Tahiti came after the *Bounty*'s first post-mutiny visit but before the second. An unidentified Tahitian man showed Mortimer a club:

that he told me had been brought from a place he called Tootate by one Titreano, who he said was Captain Bligh's chief officer, and that he returned to Otaheite in the Bounty about two months after she had first sailed without Captain Bligh, who was left at Tootate…. Where Tootate could be, or who they meant by Titreano, we could not then conjecture; but I have now no doubt that the principal part of this strange relation is true: the club I purchased, with some others; but a beautiful high-polished spear, in the possession of Poneow, he could not be induced to part with.[11]

Titreano's, that is, Fletcher Christian's, Tongan club (*overleaf*) had almost certainly been obtained just two days before the mutiny, on the morning of 26 April 1789 when, according to James Morrison, 'as this [Nomuka] was likely to be the last Island where Iron Currency was the most valuable, evry one got rid of their trade as fast as they could, purchacing Matts, Spears & many Curiositys…what with Yams and Clubs in all Quarters…there was scarcely room to stir in any part'.[12]

It appears that many of these Tongan weapons and artefacts were distributed as gifts when the *Bounty*

returned, after the mutiny, to Tahiti, where the ship arrived early in June 1789. They would soon be joined by two god figures from Tubuai, 'decorated with Pearl Shells, Human Hair teeth & Nails cut in a very Curious manner, [surrounded by] a kind of Grove of red feathers from the tail of the Tropic bird'. These Christian had looted from the house of a hostile chief and brought back to Tahiti to present to Pomare. The figures were offered up in the course of a great ceremony, and produced 'a general exclamation of wonder when they were held up to Publick view'.[13]

Another notable innovation of the period was among the many gifts that had flowed between Tahitians and Europeans during Cook's last visit to the island. Pomare had presented Cook with what seems to have been a large-scale model of an elaborately sculpted war canoe, thought to be represented in a sketch by Webber.[14] This was not exactly a forerunner of the much smaller model canoes that would later become the basis of a cottage industry on many islands, one sustained in some places from the late nineteenth century through to the present. But it is notable that the vessel was purpose-built, commissioned as a major gift, a sort of specimen or souvenir on a grand scale appropriate to international diplomacy. Diplomacy was nothing new, for Pomare or his ancestors, but inter-island gifts would previously have taken the form of feasts, or occasionally of sacred items or emblems of authority. To make a presentation out of a sample of material culture was surely unprecedented.

While the European collecting of indigenous art and artefacts has commonly been considered a highly problematic if not a deplorable project, what is unfortunate in this case is that Cook considered the canoe too big to bring home. Though small dugout fishing canoes, very similar to those in use in the eighteenth century, are still made today, no larger vessel survives, either in the Society Islands themselves or in any museum in any part of the world.

These instances of innovation are disparate, perhaps confusing. Which indeed is the point: over the last thirty years of the eighteenth century, art in the Society Islands had embraced new forms and notions, but in many particular ways. European-style drawings and portraits had entered local visual culture, or at

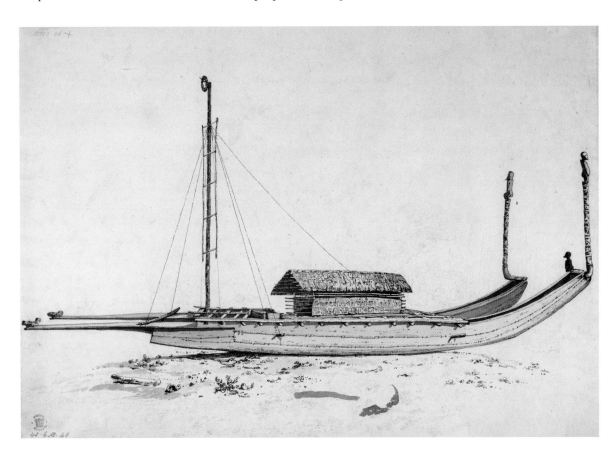

any rate had been made by Islanders. Imported Tongan weapons, Tubuaian god images and European flags had all been accepted and apparently highly valued – the Tahitians would give away their Tongan clubs to Mortimer but the chief Poeno (Poneow) would not part with a spear. At the same time, novel ideas informed the creation of new kinds of gifts.

This list in no sense exhausts the range of early-contact innovations. The plates from Jacques Labillardière's *Voyage à la recherche de La Pérouse* (1799) depict two singular, presumably wooden 'clubs', carved in the forms of a European sword and cutlass. The Samoan *nifo'oti* similarly appear to be modelled on the big blubber knives of European or American whaleships, and date probably from the early nineteenth century.[15] Whereas the latter are heavy enough to have been effective weapons, the former, going at least on the visual images, were surely not useful for fighting as it was customarily conducted,

and may rather have been used performatively, like the dance clubs and dance paddles reported from many Pacific cultures. But both types mark an interest in the appropriation of European weapons and implements, which evidently predated the notorious interest in the acquisition of guns.

Imported materials influenced design and decoration. It is clear from the Cook voyage collections that early Tahitian barkcloth was either undecorated or stained, or bore only simple stamped motifs, such as circles made by a cut bamboo stem. Inspired probably by floral designs on manufactured textiles offered in trade by mariners, leaves, ferns and flowers began to be used to print directly onto cloth, an extension of the stamping practice.[16] Though barkcloth-making itself would be largely abandoned by the mid-nineteenth century, plant and floral motifs were carried over to the sewn textiles known as *tivaivai*, and breadfruit and other leaves are still used today to decorate the

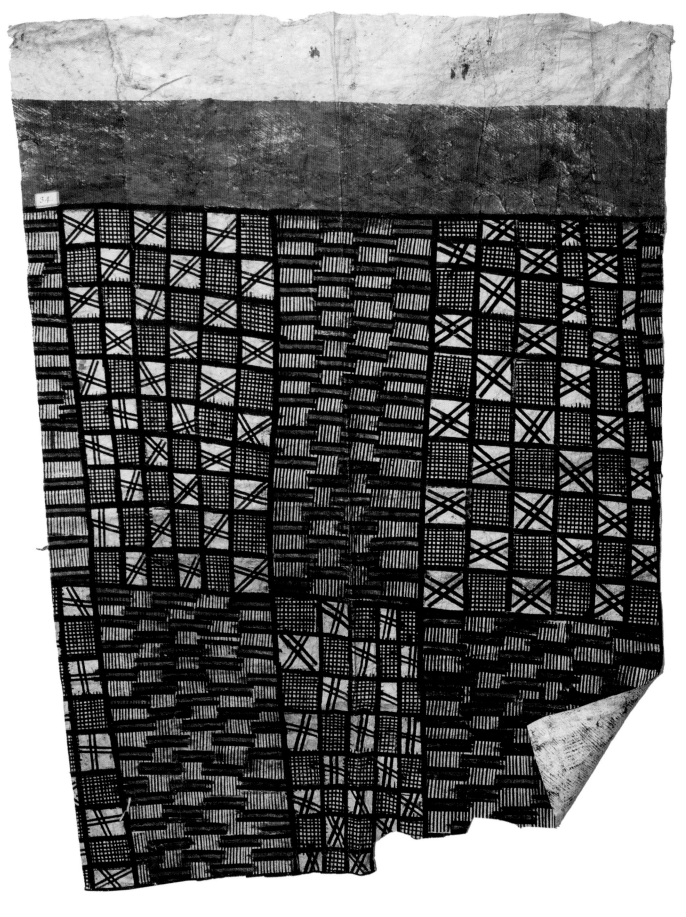

opposite
Ngatu, barkcloth, Tonga, collected 1773–74 on Captain Cook's second voyage.
Length 110 cm (43¼ in.).
University of Göttingen.

right
Ta'ovala, mat, Tonga, collected 1773–74 on Captain Cook's second voyage.
Plantain leaf strips. Length 165 cm (65 in.). University of Göttingen.

dyed sarong-style fabrics known as *pareu* in the Society Islands and by other names elsewhere. Hence certain continuities are notable, despite the loss and rupture that otherwise marks the history of eastern Polynesian art over the last two hundred and fifty years.

In many cases, gaps in collections and the uneven and fragmented character of the historical record make it difficult to chart changes precisely. In both the Hawaiian and Tongan archipelagoes, there are marked differences between the barkcloth (*tapa*) collected during Cook's voyages and the styles that became well established during the nineteenth century. What might be called 'modern' Tongan barkcloth is distinguished by the use of *kupesi* – design templates upon which the cloth is placed, to be rubbed and at the same time dyed a rich brown. The design is thus present rather like a watermark within the material, and as a visible pattern. Sheets are felted and pasted together to make wide and

sometimes very long cloths, which bear structured sets of geometric and often also figurative motifs. Some of the extant Cook voyage pieces (of which there are only around twenty, excluding small samples) seem to have been rubbed, but others are quite different, featuring vigorous designs incorporating striped or cross-hatched lines that virtually fill the sheet of *tapa* (insofar as this can be established, given that many of the pieces in collections are cut from larger works).[17] Nothing like this style is found in collections made later, but after Cook's voyages little barkcloth was collected until around 1840, when ships from Charles Wilkes's United States Exploring Expedition spent just under a fortnight in the island group; pieces obtained during this visit are of the familiar *kupesi* type. Further research on currently poorly documented collections from the intervening decades may clarify when the distinctive early forms were abandoned, what styles

A'a: The Fractal God

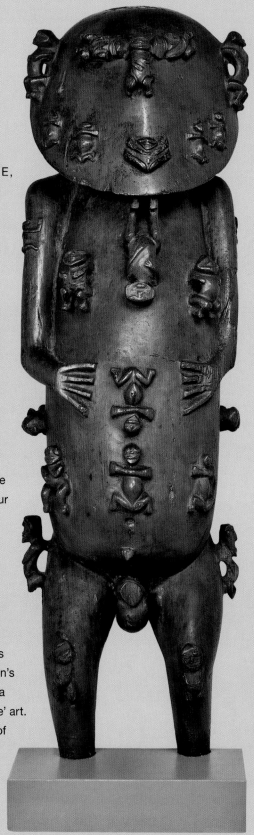

A'A IS AN ICON OF POLYNESIAN SCULPTURE, a great and extraordinary work that has been recontextualized, not once but several times, over the last two hundred years. It was made probably around 1800, on the island of Rurutu, but then given to John Williams of the London Missionary Society (LMS) in 1822. Described as the 'national god' and founding ancestor of Rurutu, the figure's proper identification has been much debated.

The most arresting feature of A'a is the proliferation over the body of subordinate figures, exemplifying a generative capacity. Such a 'fractal' relationship between a larger image and a plurality of smaller ones, in some cases between a constituted whole and its constituent parts, is manifest in a range of Polynesian genres such as Marquesan *u'u* (war clubs) and Cook Islands works in which a stack of carvings are thought to represent a genealogy. A'a is in fact a hollowed-out casket figure with a removable back, most likely intended to house ancestral bones.[i] However, at the time of its acquisition by Williams it was said to contain some twenty-four smaller gods.

The people of Rurutu were among the considerable number of Islanders who adopted Christianity independently of white missionaries. A party travelled to Ra'iātea with god figures that they wished to offer up and repudiate. On many occasions of this kind the missionaries were delighted to preside over idol-burnings, but A'a was among sculptures sent back to London, evidence of Christianity's Pacific triumph. The figure was displayed in the LMS's Missionary Museum, then transferred, with the bulk of the institution's collections, to the British Museum in the early twentieth century. A'a was soon caught up in the modernists' growing interest in 'primitive' art. The figure's renown was facilitated by the production of a number of casts, later acquired by artists such as Pablo Picasso and Henry Moore. One such cast was also returned to Rurutu in the early 1990s, and is displayed in the island's town hall.

In 1985 the ethnographer Alain Babadzan published a singular local account of the work's identity and history.

A'a, deity figure, Rurutu, Austral Islands, before 1821.
Carved wooden figure.
Height 117 cm (46⅛ in.).
© The Trustees of the British Museum, London.

In this understanding A'a was carved by a hero-traveller named Amaiterai who visited London as part of a quest to win the hand of the Rurutuan king's daughter. While in England Amaiterai encountered a god of wisdom, whose image he replicated in the carving of A'a. The sculpture was said to contain three other god figures: Te Atua Metua, god the father, Te Ataua Tamiti, god the son, and Te Atua Varua Meitai, god the holy spirit, in other words, the Holy Trinity. It was therefore Amaeterai who brought back Christian belief, long before the time of the missionaries, and A'a is recast as a figure who enabled the local people to be taught the religion of Jehovah. This history posits a particular symmetry – A'a from Rurutu is in London, while Christianity from London is in Rurutu.[ii]

Though clearly a post-conversion invention – dating perhaps from the late nineteenth century – this story is congruent with deep-seated Polynesian investments in places of origin. Though we cannot know the thoughts or motivations that Islanders had nearly two hundred years ago, it suggests another way of seeing the supposed surrender of idols. Were Rurutuans and other Polynesians giving, rather than giving up, and endeavouring to project their own sociality and renown over space and time? Were they perhaps struggling, via the uncomprehending English evangelists, to insinuate their ancestors into sites in and around what they saw as the ancestral home of Christianity in London? Either way, the narrative speaks to the enduring potency and sanctity of A'a, perhaps now truly the 'national' god of Rurutu. NT

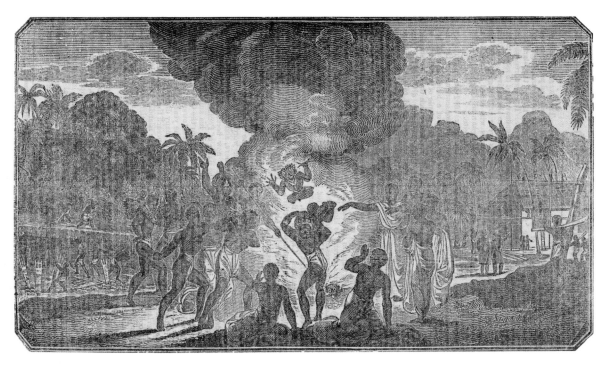

'Burning idols', *Missionary Sketches*, no. 6, July 1819.

were in fact representative of Tongan *tapa*, in say 1800 or 1820, and what prompted these various shifts.

Conversion: Iconoclasm and Innovation

In popular understandings, the missionary intervention in the Pacific is notorious. The imposition of Christianity is perceived to have stifled the liberty and romance of indigenous culture, put an end to great rituals and beliefs, and largely eradicated what was distinctive in the cultures of the Pacific. Art looms large in this story: the repudiation of heathenism was marked by the burning of 'idols' that were held in contempt by evangelical philistines, who appear as the chief authors of the destruction of hundreds if not thousands of great images and sculptures of Oceanic divinity.

It is not surprising that the burning of god images has become the hallmark of the evangelical enterprise in the Pacific. Proudly foregrounded in their own propaganda, the practice was certainly widely engaged in. For example, on 24 June 1822 Auna, a Tahitian teacher who travelled with members of the London Missionary Society to Hawai'i, provides us with a glimpse of the works, not as 'idols' in general but as personifications of particular ancestral figures. These incidents and others make it clear that while white missionaries certainly encouraged the destruction of

Title-page vignette from John Williams, *A Narrative of Missionary Enterprises in the South Sea Islands....* London, 1837.
National Library of Australia, Canberra.

Before David Livingstone, Williams was the celebrity among British missionaries. He counted himself as an explorer as well as an evangelist in the Pacific, but made the removal or destruction of 'heathen' gods emblematic of his achievement.

'THE CHIEF THEN ORDERED HIS PEOPLE TO MAKE A LARGE FIRE'

Thursday 20th [June 1822]. To day the chiefs & people of Tona brought presents to ~~Taumuarii and Kaahumanu~~ Taumuarii consisting of baked dogs 400 cloth mats and other kinds of property 4000 the feasting continued with great confusions thro the day there was a dance of 41 men who danced in 4 lines behind whom sat 31 musicians beating the sticks & behind them were 5 large drums. The people also drank a good deal of an intoxicating liquor made of the juice of sugar cane they frequently brought to us & wished us to partake with them but we always refused and told them we used formerly to be as fond of it as they were, but now we knew it to be a bad thing to drink intoxicating liquors, and wished not to drink it, we also endeavoured to dissuade them from drinking it but in vain.

…Monday 24th In the morning Miomisi a man belonging to Kaahumanu was sent on board one of the vessels to fetch 8 of the idols that had been brought from the other side of the island, and were intended to be brought to Oahu to the King. The reason they were sent for was, the man who had been left on board to take care of the goods was taken ill in the night and brought on shore the chiefs immediately said it was the spirits of the idols that were going to kill him, 'Let us send for them & burn them.' In the afternoon he returned with Teraipaloa, Tetoremota, Paparahaamau, Hatuahia, Kaunaraura, Maiora, & Akuahanai, who were all soon after consumed in the fire, at which I greatly rejoiced.

Wednesday 26th – Early this morning Kuakinia's men, who had been sent on board the ships for the gods, returned. The chief then ordered his people to make a large fire and then set to work himself and with his people assisting him burnt one hundred and two idols. I thought of what I had witnessed at Tahiti & Moorea when the idols there were burnt particularly the idols burnt at Papietoai by Patii and with my heart praised Jehovah the true God that I had witnessed these people following our example Taumuarii and Kuakini talked with me a good deal this day about our burning the Idols at Tahiti.

From the journal of Auna, a Society Islands missionary, during a voyage to Hawai'i in 1822. [The crossings-out and the underlines are in the manuscript original].[i]

figures, the work was usually done by Islanders who were not being coerced. The reasons behind their seemingly sudden and violent repudiations of customary religion and art are neither easy to fathom nor the same in all cases. Between the late eighteenth and the mid-nineteenth century the overwhelming majority of Polynesians became Christians in at least some nominal sense, but the chronology and pattern of these conversions varied considerably.

On Tahiti the missionaries' progress had been painfully slow. The initial group was established on the island in March 1797, but it was fifteen years before Pomare, son of the chief well known to Cook, told the missionaries of his decision to turn to Jehovah, which might have meant little, since the king's position was at the time highly insecure and his opponents were hostile to the Church. In late 1815, however, Pomare's party won a decisive battle against their rivals at Atehuru, on Tahiti's west coast, and during 1816 the missionaries finally declared that Christianity was the religion of the Tahitian nation.

In this case, the missionary message was accepted during a time of despair, marked by severe depopulation. If ordinary Tahitians understood widespread malaise as the direct result of European contact – they well remembered which outbreaks of disease had followed swiftly upon which explorers' visits – it had become apparent that their old gods and *tapu* had no capacity to protect or re-empower them. But these circumstances were utterly unlike those in the Cook Islands, for example, where Islanders accepted the new *Lotu*, as the Church was called, quickly, and before having suffered any great disruption. In that archipelago, and in many other parts of the Pacific, Christianity was introduced by Islander missionaries, not white missionaries, and – it may be broadly asserted – was embraced as a new cult, as various new indigenous rites and gods had been embraced previously. In some places, too, the Christian injunction to end war was positively welcome to communities fatigued by long-running feuds, though fighting often resumed after the initial appeal of the Church faded.[18]

Jules LeJeune, *Costumes des habitants de l'île Taïti*, 1823.
From an album of drawings and watercolours from the voyage of Duperrey (Coquille, 1822–25). Service Historique de la Marine, Vincennes.

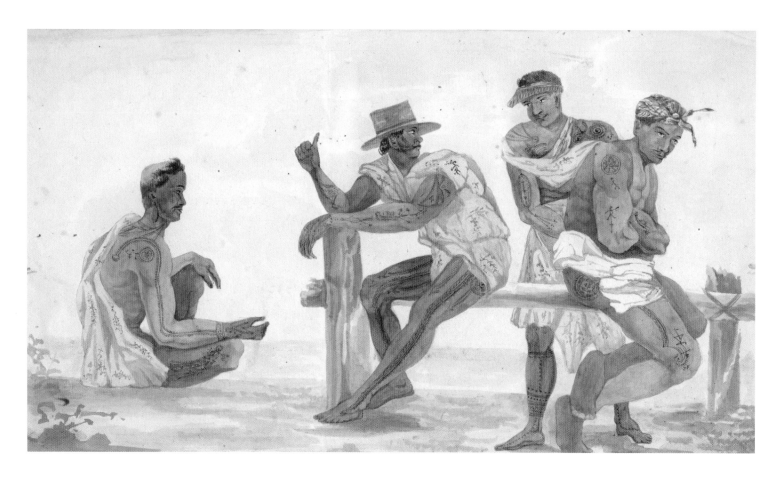

**Tufuga tatatau, Samoa,
late nineteenth century.**
Photograph Thomas Andrew.

While images of gods were paramount among missionary targets, many other indigenous practices and art forms were proscribed or altered. Tattooing was considered sinful and it was evidently on the wane in Tahiti as early as the 1810s, though anti-missionary movements in the 1820s revived the practice and featured new European-influenced motifs. Over the same years individuals came to bear names in European script, but customary tattooing was widely abandoned by around mid-century, other than in Samoa, where it was embedded in status politics rather than ritual, and was less vigorously opposed by the missions.[19]

It is important to add that missions were creative as well as destructive. The missionary project was genuinely revolutionary in that it changed, or tried to change, not merely religion but every aspect of people's lives, every institution. Not only sexuality but work, dress, eating, architecture and the organization of time were reformed along evangelical lines.[20] Islanders were receptive to some changes, much less so to others, but the ramifications were profound.

Swords were not made into ploughshares, but in the spirit of Isaiah 2:4, spears were refashioned into walking sticks in Tonga in the 1830s, according to the Methodist David Cargill. Later, in New Zealand, customary carving styles were extrapolated to walking sticks, termed *tokotoko*, the word used for orators' staffs and similarly deployed as emblems of male status.[21] But it was in fibre and fabric arts that Church-inspired innovation was most conspicuous. Although in Islanders' terms, barkcloth, or some forms of barkcloth, was deeply associated with ritual, these associations were generally unrecognized by missionaries, who instead saw a worthy women's craft, to be positively encouraged. European cloth was also actively promoted and keenly desired, but for decades was relatively scarce and expensive. Hence Islanders also made garments on a European pattern, such as so-called Mother Hubbard dresses, out of barkcloth and occasionally out of woven pandanus also (*pages 286–87*). These clothes were being made from perhaps the 1830s until the 1880s, if not later.

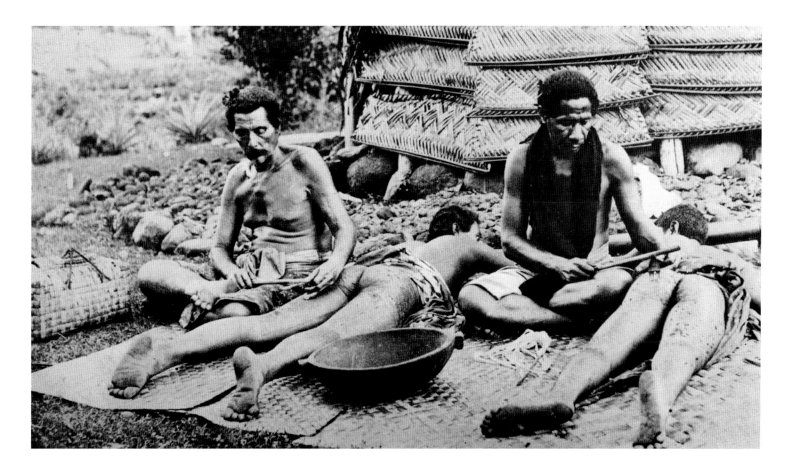

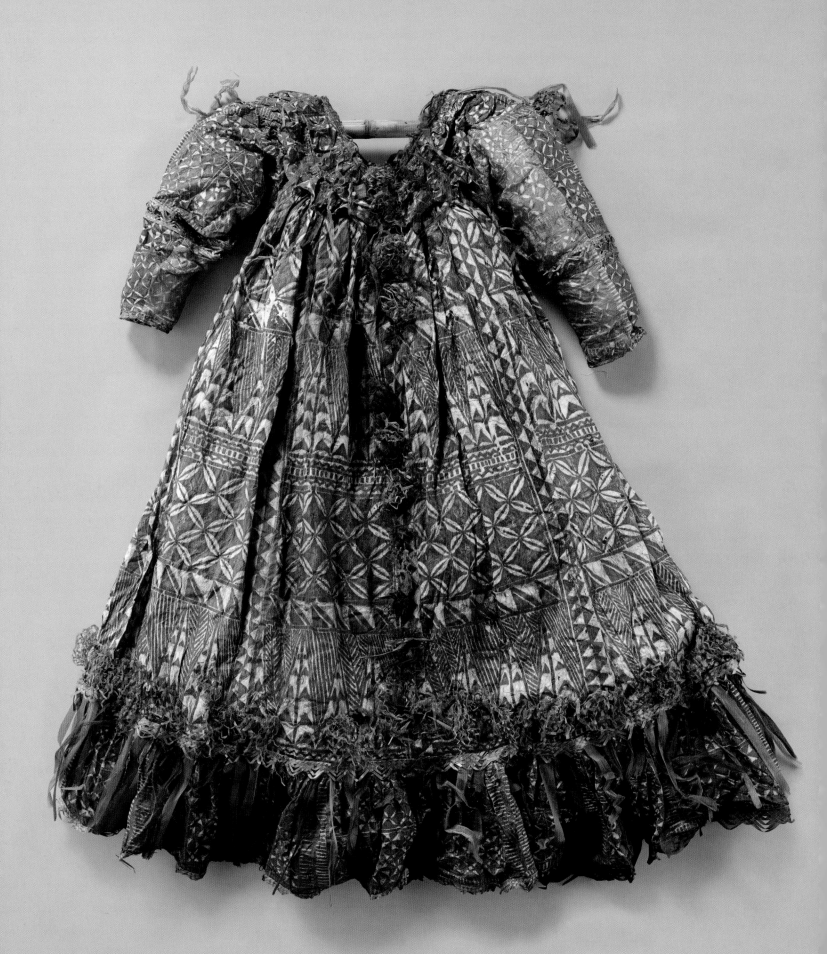

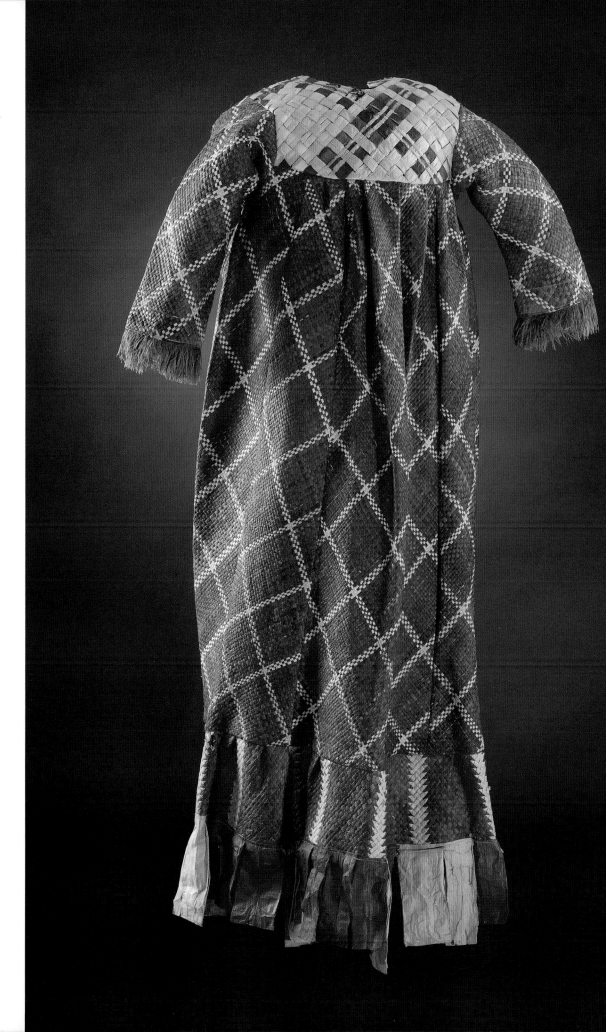

opposite

Samoan *tapa* dress, *c.* 1870.
Length 130 cm (4 ft 3 in.).
Macleay Museum,
University of Sydney.

right

**Dress, probably from
Tuvalu, 1900s.**
Pandanus leaf, cotton.
Length 145 cm (4 ft 9⅛ in.).
Museum of New Zealand Te
Papa Tongarewa, Wellington.

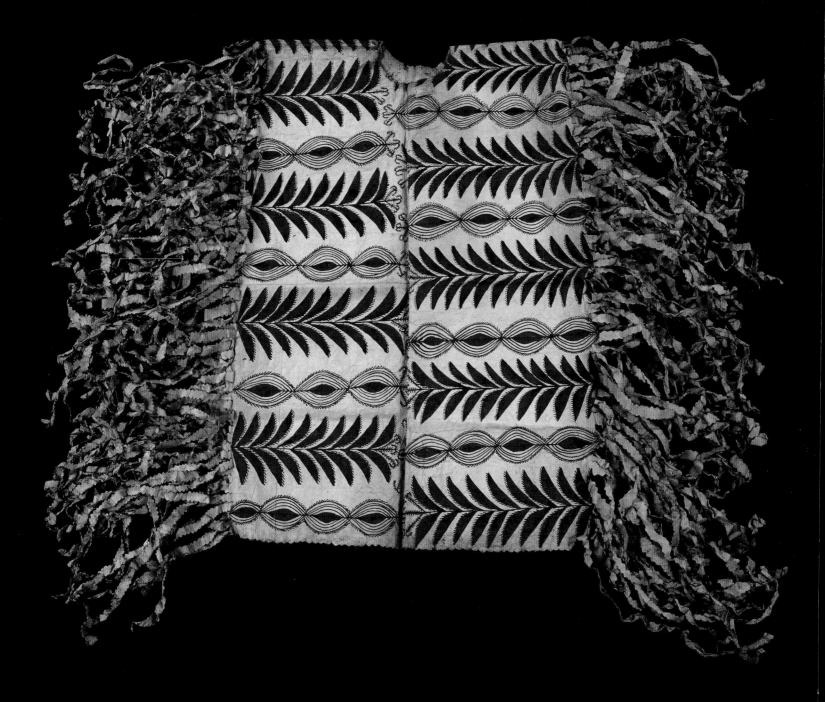

Earlier, as the London Missionary Society extended its operations from eastern to western Polynesia, the garment usually referred to as a poncho – the Tahitian *tiputa*, also made in Mangaia if not elsewhere in the Cook Islands – was introduced into Samoa in the 1830s and 1840s, and to Niue in the 1850s and 1860s. While they permitted wearers to cover their upper bodies in conformity with a Christian sense of decency, *tiputa* were decorated in Samoan and Niuean styles respectively. These garments were new, they were dazzling, and they enabled a presentation of self in 'Sunday best' that was consistent with a long Pacific tradition of adornment for ceremonial occasions that remains strong today.[22]

In this context, too, the woven pandanus hat, often featuring fibre tassels, seeds and other decorative features, emerged as an element of women's formal wear. There are diverse Samoan examples in the missionary George Brown's collection, dating to the 1870s and 1880s, but they may have begun to be woven decades earlier.[23] Like the Papua New Guinean *bilum* (looped string bag), the form has remained salient over the long run: fine hats will be seen at church in many parts of the Pacific today.

Missionaries were against idleness and encouraged the production of craft for both local use and sale. In Niue they appear to have stimulated a new school of barkcloth painting. The earliest extant pieces of *hiapo*, Niuean cloth, date from the 1860s and bear dynamic but basically linear designs. However, the bulk of extant examples have quite a different look, evidently influenced by a Samoan freehand style, possibly introduced through formal classes given by the wives of Samoan mission teachers to local women in Niue. Niueans took the freehand approach in a highly inventive direction of their own, however. A range of remarkable paintings dating from the late 1880s feature a wonderful mix of dynamic pattern, botanical motifs and figurative elements, ranging from portraits of Europeans to dancing groups and beetles. Ships and compasses – the vehicles and instruments of global commerce and colonization – are conspicuous.[24]

It may popularly be assumed that tourist art is a phenomenon of the last fifty years or so. In the Pacific, as well as native North America, it dates back much earlier; Fanny Stevenson was among the visitors who bought Niuean *hiapo* in the last decade or so of the nineteenth century; the many model canoes attributed to Niue and elsewhere in museum collections were probably made for sale over the same period. The well-known ceremonial adzes from Mangaia in the Cook Islands are similarly a post-missionary elaboration of an ancestral form. They frequently feature an integrated pedestal, and intricate, indeed baroque, carving (*page 291*); they proliferate in collections no doubt because they were being made in considerable numbers for sale.[25] From the eighteenth century onward, pieces were occasionally made specifically in order to be traded, but the systematic production of particular genres for sale begins much later – typically after 1850 and probably generally after 1870.

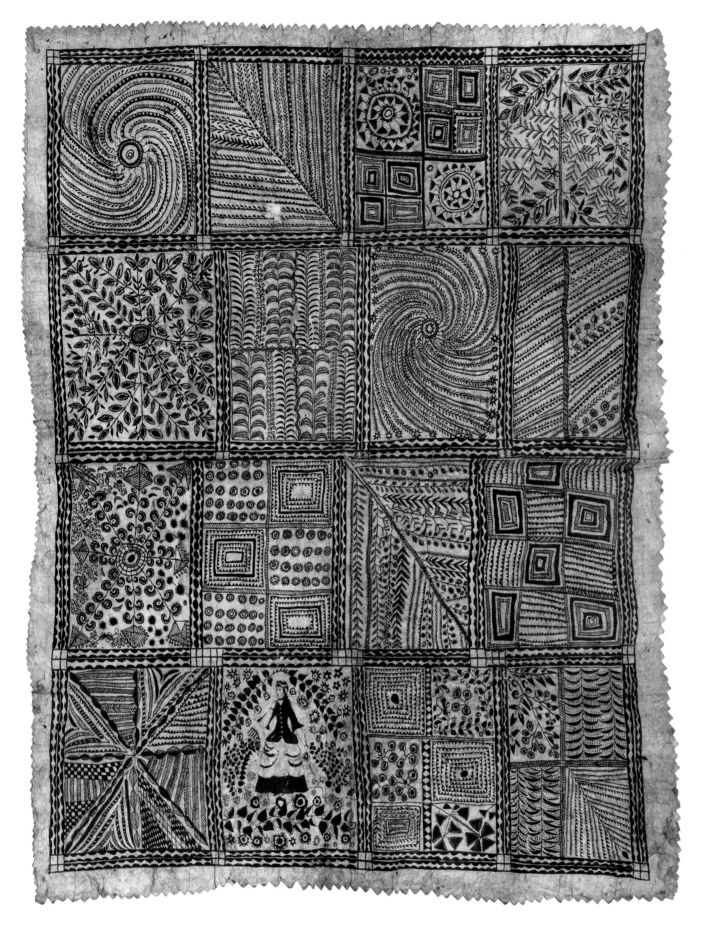

The *Mana* of Script

While Rapa Nui, Easter Island, will always bring the great statues, the *ahu moai*, to mind, another of the island's art forms has from time to time sparked intense interest among anthropologists and students of Oceania. *Rongorongo* boards bear a kind of script that came to the attention first of Catholic missionaries, who had only recently established themselves on the island in the 1860s, and then of the international ethnological community (*overleaf*). This script appeared unique, a genuinely indigenous Oceanic writing system, which excited the theorists of the epoch, for whom the fundamental questions were the evolution of culture and the migrations of peoples.[26]

Though certain motifs were clearly related to those of Rapanui rock engravings, among other art forms, the missionary-ethnographers and other researchers were immediately frustrated. The abduction of a large proportion of the Rapanui population in the early 1860s by Peruvian slavers and a catastrophic measles epidemic that followed the repatriation of a few survivors had between them an appalling impact, resulting in great trauma and great loss, not only of life but of Rapanui customary knowledge. By the time enquiries were made, it appeared that no Rapanui individual, on the island or elsewhere, was capable of reading a *rongorongo* board. Some investigators, such as the US government surveyor William Thomson, cajoled generally unwilling local men to interpret boards, with at best ambiguous results. On being tested, his main informant was unable to give meanings for individual motifs. He and others could recite stories they associated with particular boards, but could not in a strict sense read from them.

While various efforts have been made to decipher the script over the century and a half since the boards' identification, it was assumed until recently that *rongorongo* were elements of customary Rapanui culture that predated European contact. However, this made it puzzling that there were no counterparts in other, closely related cultures of eastern Polynesia. More significantly, it is hard to explain why no European visitor mentions or remarks upon boards at any time before 1860. Admittedly, Rapa Nui was far less often visited than islands in the Societies or Marquesas, and those who did visit it tended to do so only briefly – the lack of reefs and the poverty of the environment

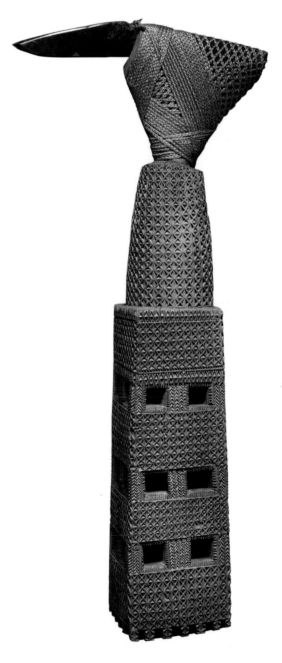

'IMMEDIATELY AFTER FOOD, TRADING BEGAN'

Immediately after food, trading began, as the people had had timely warning of my needs, and the whole evening through, clubs, spears, bows and arrows, dishes, dresses and ornaments kept pouring in. I had settled myself on a mat near one of the narrow doorways of the house, and through it I could catch glimpses of an ever increasing and moving throng of dusky figures which had gathered around it. They had managed to pack themselves into an incredibly small space. In the front were men, in the background women and children; the nearest squatting on the ground, the further crouching, the farthest standing, all with eyes intently fixed on the doorway, keen on getting a sight of us and our stock-in-trade. The closely packed crowd prevented my seeing much of the articles which were going to be offered for sale; indeed the people did their best, though why I could not make out, to hide from view what they had with them, but I could see here and there the head of a club protruding from under a man's arm or a fringe dress lying neatly rolled up in some woman's lap.

Having now untied my bales of coloured calicoes and unlocked my boxes, trading commenced. Carew first made the people a little speech, explaining that I had plenty of trade, that I wished to deal fairly with everybody and that as I would stay with them as long as they had any goods to sell there was no need for a rush. The manner of our proceeding was as follows. Through the opening would be thrust a club or a spear held by a black arm, which vanished as soon as the club or spear was taken from it. I would then examine the article and Carew would ask the price, which I handed to one of my boys to put on the doorstep. The black arm reappeared forthwith, seized the exchange and again disappeared, so that from first to last I never saw the person with whom I was dealing. Prices varied from one shilling to eighteen pence, or in cloth from one to two fathoms. So as to encourage trade I bought everything, consequently a good deal of trash, that was offered to me tonight. Some dancing again through the night, but it did not differ at all from that of last night.

From The Fiji Journals of Baron Anatole von Hügel, 1875–77[1]

meant that few refreshments were to be obtained. But parties from Cook's and La Pérouse's expeditions had spent full days on the island, had considerable interaction with people, and had described or collected various sorts of artefacts. It is unthinkable, in particular, that such anthropologically minded natural historians as the father and son team of Johann Reinhold and Georg Forster, on Cook's second voyage, could have seen anything like a tablet bearing a native script and not been prompted to acquire it, describe it and reflect upon it.

While the detail of the argument cannot be fully reviewed here, the balance of evidence suggests that the *rongorongo* boards are a post-contact innovation, and were stimulated by some sighting of European documents or books, possibly aboard a ship, or by one or more Rapanui who travelled elsewhere and were perhaps exposed to writing in missionized milieux. It should be noted in this context that the art of writing had certainly intrigued and captivated other Polynesian peoples. Indeed, in Tahiti it drew Pomare and many others into mission schools, well before they had any intention of converting. Writing was a practice that they identified early on with tattooing, that they took to be charged with power, and that they were keen to master. Whereas many Islanders nearer mission stations simply solicited teachers, it is reasonable to suppose that Rapanui, who could not do so, instead emulated the practice by creating their own kind of writing.

It is well known that Rapanui ritual changed dramatically during the eighteenth and nineteenth centuries – a celebrated, in fact a sensationalized 'bird man' cult replaced a more hierarchical order that had formerly centred on sacrifices to the high chiefly ancestors commemorated by the *ahu moai*. In the fertile but unstable years of the mid-nineteenth century other cults no doubt came and went. The *rongorongo* boards are very likely to have been linked with one of these. Given that negative evidence cannot ever be conclusive, the possibility that they were made prior to the 1770s, and were somehow unnoticed by European voyagers of the period, cannot be absolutely excluded. But it is far more probable that the boards were a new form of the nineteenth century, most probably one dating from as late as the 1850s. They were singularly

modern forms, expressions of the turbulent time that immediately predated the slave raids of the 1860s, and the crisis of the Rapanui people.

Gain and Loss

The conventional understanding of Oceanic art history presumed that great customary art forms belonged to the precolonial period. Cultures influenced by the West were thought to have been either swiftly destroyed or corrupted. Post-contact art forms were considered largely inauthentic, self-evidently lacking originality or merit.

It is increasingly clear that the late eighteenth and nineteenth centuries were remarkably fertile periods for art in Oceania. A host of new materials, influences and social contexts – such as new Christian milieux – stimulated and required distinctive and different art forms. The ramifications were extraordinarily diverse. New connections among Islanders encouraged the spread and adaptation of indigenous styles. New objects emulated, appropriated and depicted Western genres and technologies. Some of these innovations were the work of quirky individuals, not necessarily styles embraced by whole communities.

Yet the epoch was also one of much destruction and loss. It is important to recall that depopulation, caused by introduced disease, had catastrophic effects on many Pacific populations. The complexity of estimating pre-contact and early-contact numbers makes it impossible to state definitively whether the populations on particular islands declined by 50, 75 or 90 per cent. But any of these scenarios represents horrendous loss, and implies not only the deaths of individuals but also the end of particular families and lines, and inevitably the loss of much cultural and practical knowledge. Some art forms simply went out of favour; weapons suffered disuse, to some extent with the introduction of guns, more definitively with missionary or colonial pacification; and as has been discussed, many ritual figures were destroyed or exported, at the time or in the wake of conversion to Christianity. A new understanding of this epoch in the history of Oceanic art must grasp these contradictions, of collapse and creativity, of revolutionary destruction and unexpected continuity.

'Kiribati Bob'

I N THE PHOTO ARCHIVES of the British Museum, there is a set of portrait photographs of a man identified simply as 'Bob' or 'Bob, a Micronesian man'. There are nine altogether, not counting copies. Some are clearly related to each other as part of the same photo-session, but others are quite different. The photographs are datable to somewhere between 1863 and 1871 on the basis of an inscription on a subset of *cartes-de-visite* identifying a photographer: 'A. Pedroletti of the Anthropological Institute of London'. Other inscriptions further describe 'Bob' as 'aged 18 years' and 'a native of Tarawa' (an island in what is now the nation of Kiribati), although one inscription says he is from Rotuma.[i] Otherwise, nothing is known about him.

There is both pathos and irony in this statement, of course. For while it is true that his name and story are lost, and with them the choices and circumstances that brought him to these photographic junctures, as well as the links that might connect him to possible kin in the present, the point of these photographs in another sense was precisely to know him. In most of them he is the object of scientific scrutiny. Several are anthropometric studies, a form of photography designed to serve the evidentiary purposes of medical or anthropological inquiry into comparative physical anatomy and racial typology. To this end the bodies of racialized 'others' – 'usually from the polyglot crew of some sailing vessel then in London'[ii] – were photographed according to a standardized formula: naked; at a fixed distance from the camera; shot from the front, side and rear; against a neutral background; beside a metric measuring rod. A subset of 'Bob's' portraits is of this order, including the profile illustrated here.

What is intriguing about the set, however, is the variety of portrait types 'Bob' inhabits. In another he is an ethnographic subject, dressed in a costume – a form of body armour made from coconut fibres – that identifies him with his place of origin and the specificities of its language, social roles, technologies, religion and so on. In yet another, a *carte-de-visite*, he appears as a young Victorian gentleman, dressed in a shirt and tie, a coat and a buttoned-up waistcoat. This is the most intriguing photograph in the series. The *carte-de-visite* was an invention of the mid-nineteenth century that spurred a lucrative commerce in ersatz portraiture. They were cheap and easy to produce, and members of the bourgeoisie and petty bourgeoisie in metropolitan capitals paid en masse to have their likenesses captured in a manner that vaguely imitated the conventions of old aristocratic portrait paintings. Did 'Bob' choose to have his portrait taken in this manner?

It would be nice to imagine 'Bob' as a kind of nineteenth-century postmodernist *avant la lettre*, assuming different social guises in order to confound the dominance of any one of them. But this would be wrong for obvious reasons. These photographs were made to circulate within professional societies, clubs and institutes of an academic and exclusively male nature. Even the possible exceptions – the *cartes-de-visite* – are nonetheless explicitly inscribed with the name of the 'Anthropological Institute of London'. And while it may be that the authority of these photographs is most unstable in the differences between them – it is there that arguments and anxieties that animated the discourse of human origins, social development and class hierarchies are most apparent – it was a discourse from which 'Bob' and his like were totally excluded. He is the object of these representations. Although he presumably consented to the photographic exercise for whatever small advantage it may have given him, he has no control over, or voice in, these representations, even as they are ostensibly about him – a powerlessness and absence reflected in the evacuated look with which, in another portrait, he confronts the camera. PB

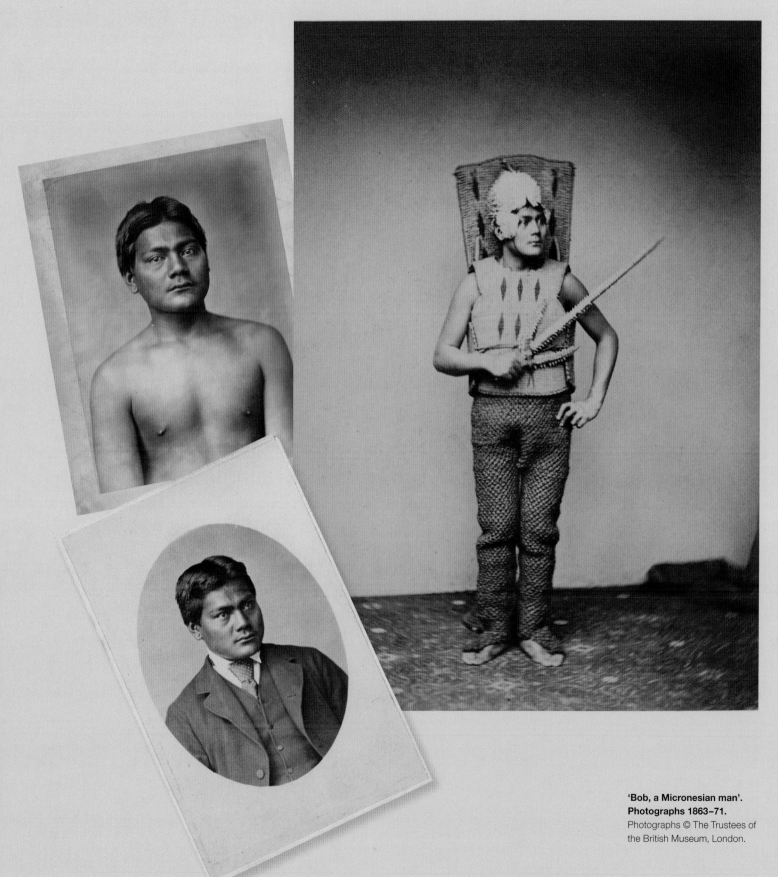

'Bob, a Micronesian man'.
Photographs 1863–71.

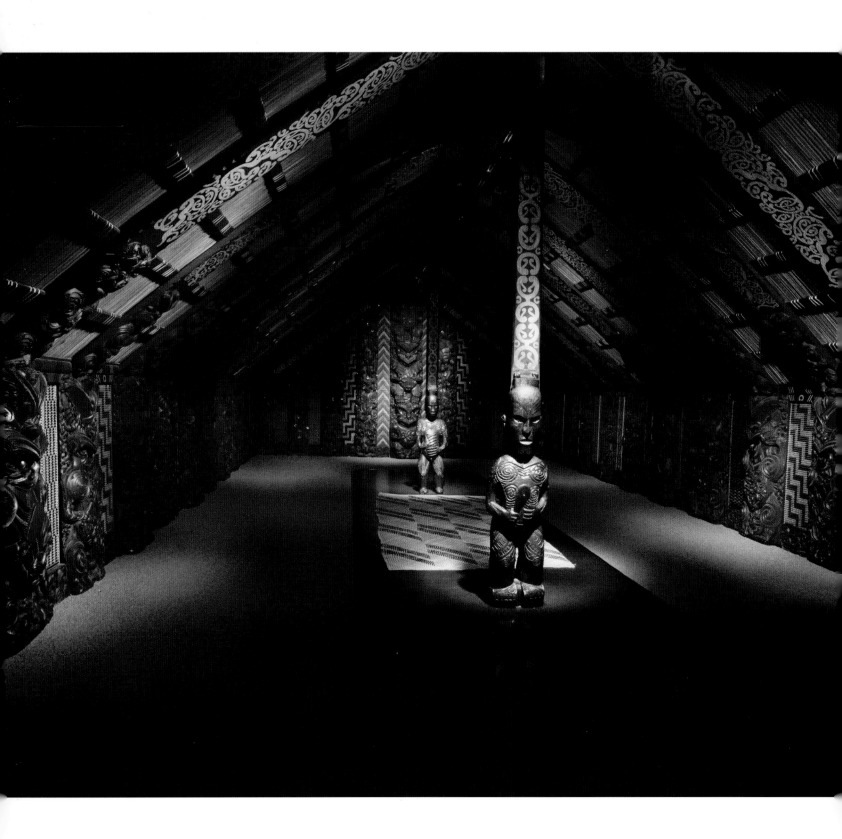

Deidre Brown

COLONIAL STYLES: ARCHITECTURE AND INDIGENOUS MODERNITY

During the nineteenth and early twentieth centuries, indigenous Polynesians and Micronesians experienced unprecedented change as they sought to respond to the challenges of a much expanded world. The new Christian God would eventually replace their deities, custom had to be reconciled with Western technologies and economic systems, and land ownership and political power were under threat. While there were new means and concepts for artistic expression, the destructive effects of colonization reduced the opportunities for this to occur to those arts required for survival. Indigenous art histories of different Pacific Island groups start to diverge from customary models around the beginning of the nineteenth century, due to unique local relationships with, and reactions to, the different colonizing powers and settler populations. In Māori, Palauan and Samoan architecture this period was characterized by the rapid appropriation of new technologies, religious ideas, compositional techniques and aesthetics to meet indigenous needs. By the interwar period, indigenous architecture and its associated arts had branched into two distinct aesthetic programmes: one aesthetically Western and sometimes associated with spiritual salvation; the other a revival of tradition.

Technological Appropriation

During the first half of the nineteenth century, the most significant change to Polynesian and, to a certain extent, Micronesian art as a result of contact with Europeans was the adoption of Western tools and materials. Although they were received in cross-cultural exchanges of goods and services, these technologies and materials were purposefully acquired for use within customary cultural systems and employed in ways that enhanced traditional methods

of production. Metal was the earliest of these new acquisitions, and by the nineteenth century many Polynesians were able to purchase a range of metal tools from travellers and settlers. In Micronesia there was much more enthusiasm for metal tools on the major islands than on some of the outer islands where stone, bone and metal technologies were all used in combination up until recent times.[1]

Since the eighteenth century, metal tools acquired from, or manufactured from goods exchanged with, European explorers had been used by New Zealand Māori woodcarvers living in coastal areas. The strength and sharpness of these tools increased the output of carving, and as a consequence the external panels of raised *pātaka* (storehouses), the customary symbol of chiefly prestige and group wealth, were embellished with detailed depictions of *tiki* and *manaia* ancestors, the prized resource of beached whales, and deities.[2] It soon became apparent in the first few decades of the following century that inter-subtribal and inter-tribal rivalries had to be overcome in order to facilitate dialogue about pressing issues

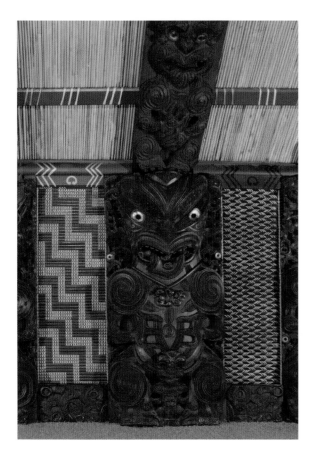

left
Te Hau-ki-Tūranga meeting house, interior *poupou* detail.

intricately lashed *tukutuku* lattice wall panels. The arrival of the Christian God, with the establishment of an Anglican mission in Tūranga in 1840, was quickly accommodated within the Rongowhakaata world view. Evidence of mission influence, through literacy instruction, was apparent in the carved inscription of personal names on the ancestral *tiki* of the interior walls and the use of paper or cloth templates to transfer, reflect and rotate the *kōwhaiwhai* patterns.[3]

Similar artistic and architectural developments took place on Palau after the crew from the shipwrecked vessel *Antelope* left behind metal tools that they had used to construct a replacement vessel, the *Oroolong*, in 1783. The artist Arthur Devis and possibly two or three other amateur artists who were crew members also impressed locals with naturalistic watercolours of people and places.[4] Devis completed a watercolour of an elaborately carved and painted *bai*, a type of decorated meeting house associated with chiefs and their male councils, and men's clubs, in which the crew may have stayed on the island of Koror. (Women also had clubs and sometimes separate *bai*.)[5] The *bai* was most likely made with local technologies, as this particular archetype had been built in Palau over a number of centuries, but within eight years of the crew's departure it was either replaced or joined by another one constructed using the metal tools (*page 302*).[6] This new *bai*, known as Bai er a Meketii, featured a similar decorative system on the horizontal boards of its exterior gable end to that of the earlier building, consisting of painted, and perhaps bas-relief carved, representations of shell money and semi-abstract faces. These embellishments demonstrated the community's wealth and possibly its descent lines, and therefore its *mana* among other villages; also, in certain instances, its ability to commission highly regarded *bai* artists and builders from related communities.[7] A point of difference with the earlier *bai* may have been the extensive carving of the interior tie beams, possibly with flowers and figurative motifs, which were mentioned in an 1803 account of the building.[8] Interior decoration was not described for earlier buildings of the type of *bai* observed in 1783, although this does not necessarily mean it was not present. There is not enough evidence to suggest that the *bai* was itself an architectural response to the European presence, which was the case with the development of the New Zealand

such as Christianity and land sales to Europeans. The *pātaka*, which had represented the distinctions between groups, became less relevant in this context and a new building of *mana*, the meeting house, was developed as a forum for discussion. The meeting house was a stylistic amalgam of the chief's house from earlier times, a gabled building that had a front porch and limited decorative devices, with the ornamentation of the *pātaka* extending from its exterior to its interior. One of the earliest meeting houses was Te Hau-ki-Tūranga, built at Tūranga (also known today as Gisborne; *page 298*) in the North Island of New Zealand in the early 1840s for the Rongowhakaata tribe under the supervision of one of its leaders, the legendary carver Raharuhi Rukupo. The building was embellished inside and out with metal chisel-carved *tiki* wall panels representing ancestors from Rukupo's tribe and the neighbouring Ngāti Kahungunu tribe with whom he may have wanted to form an alliance, as well as complex repeating *kōwhaiwhai* scroll paintings on its rafters symbolizing ancestral descent, and

opposite
**Arthur William Devis,
A Palauan *bai* on the island of Koror, *c.* 1783.**
Watercolour, 25 x 19 cm
(10 x 7½ in.). National Library
of Australia, Canberra.

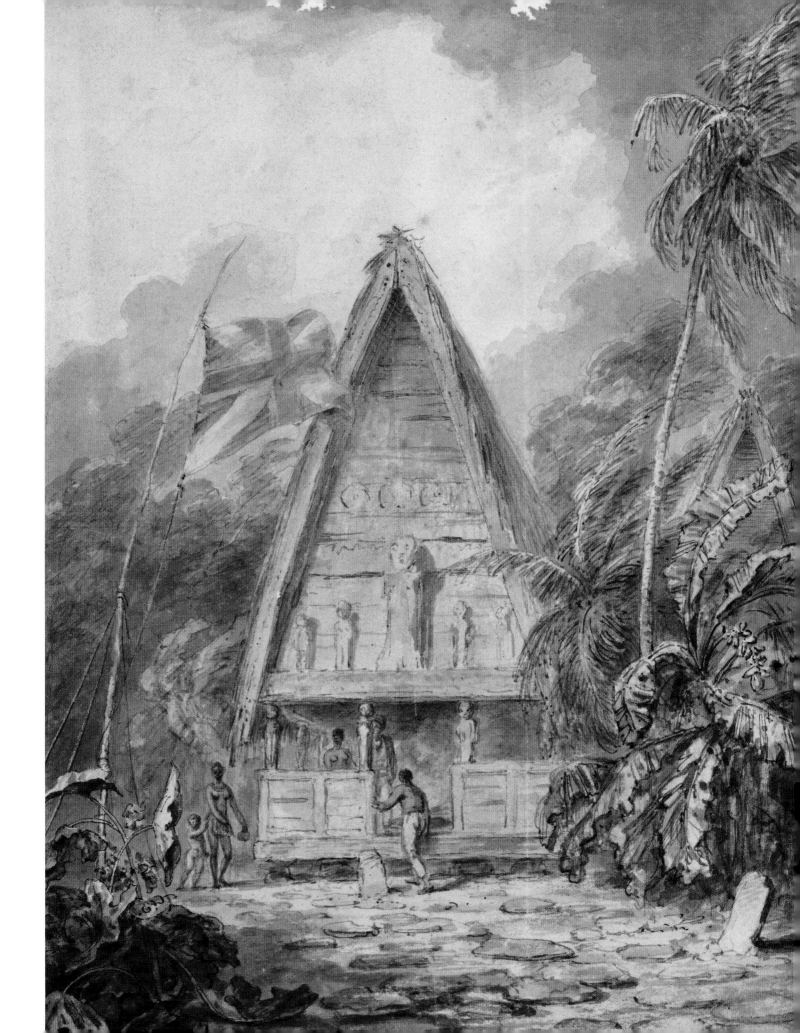

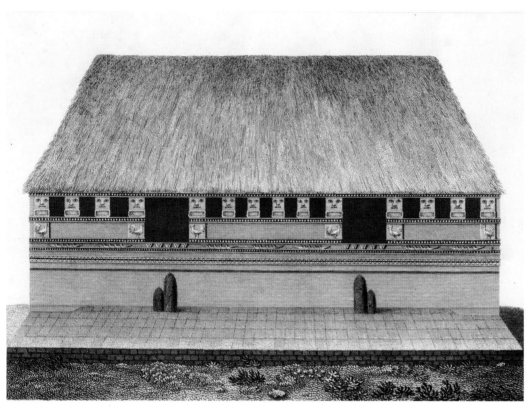

above
'The side view of the Pye A Ra Muckitee [Bai er a Meketii]', engraving by R. Reeve, 1803.
From John Pearce Hockin, *A supplement to The account of the Pelew Islands: compiled from the journals of the Panther and Endeavour…in the year 1790*, London: Printed for Captain Henry Wilson by W. Bulmer, 1803. National Library of Australia, Canberra.

below
'The end view of the Pye A Ra Muckitee [Bai er a Meketii]', engraving by R. Reeve, 1803.

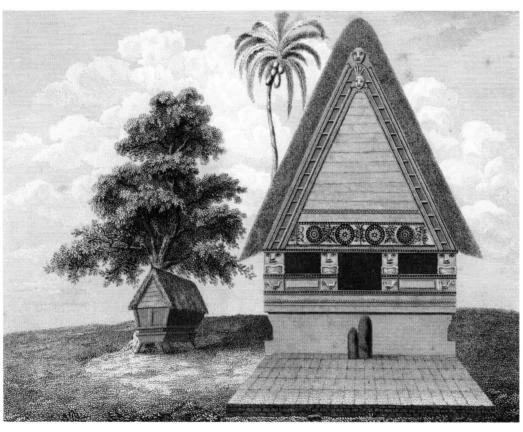

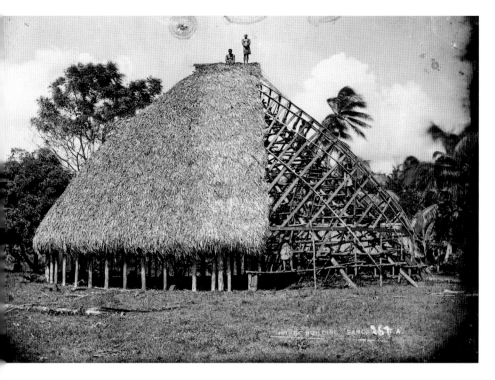

Faletele, Samoa, 1890–1910.
Photograph Thomas Andrew.
Museum of New Zealand Te
Papa Tongarewa, Wellington.

Most prestigious Pacific
buildings have ridgepoles and
gables and are built from the
top down. Although it appears
oval in plan, the Samoan
faletele shown here has a short
ridgepole and rounded roof
ends that cover the gable. The
scaffolding is assembled inside
the building.

settlement 3,000 years before. Records from the 1830s document that each village had at least one or two *faletele* that functioned as council houses, community performances spaces and the guest houses of local chiefs.[9] They were located on the edge of the *malae* (open assembly space). The *faletele* was fundamentally a gabled structure with a short ridgepole and two round ends that made it appear oval or circular in plan. Around the perimeter of the floor was a row of columns that supported a curved, leaf-thatched roof supported by an intricately lashed lattice framework. Genealogies and ancestral stories were illustrated in the colours and configurations of the *faletele*'s lashings in much the same way that painting and carving recounted ancestral lineages, relationships and stories in Māori meeting houses and Palauan *bai*. The roof was supported on one to three columns in the centre of the building and a colonnade of posts, about 1.5 metres (5 ft) high, supported the end of the eaves. Each post of the colonnade was also the assigned seating position for chiefs meeting inside the building, and the *va*, or space of potential between them, activated the house as a place for formal discussion. The chiefs on opposing sides of the house, who were of equal rank, never formally addressed each other on these occasions and so the internal columns also functioned as a visual barrier between them.

These internal columns, however, would prove to be an issue following the arrival of the London Missionary Society in Samoa in 1830. It has been argued that the missionaries would have required a clear central processional aisle and direct line of sight between the pulpit and the congregation. The converts, who regarded themselves as the hosts of the missionaries, did not want the *faletele* as the venue for Christian services because it was a building type associated with customary oratory and performance.[10] Thus the *faleafolau*, a long oval-planned structure that used tie-beam and king-post construction and a double internal colonnade with a free space down the centre, was developed at this time to overcome these difficulties. Knowledge of this form of construction was most likely provided by Tongan converts living in Samoa or Samoans who had recently returned from living in Tonga, since the column arrangement of the *faleafolau* was similar to the customary Tongan *fale hau*, with one significant

Māori meeting house. Nevertheless, the fact that Europeans were so readily welcomed into these *bai* as guests indicates a local willingness to engage with Western culture, perhaps for mutual benefit. The Bai er a Meketii shared with Te Hau-ki-Tūranga, and no doubt early contact-period buildings in other parts of Polynesia and Micronesia, a role as a building situated between two technological worlds, but still functioning within a largely customary society.

The Influence of Christianity

Whereas European-derived technologies and materials enhanced customary systems of building, the arrival of Christianity had a more profound impact on the conceptualization and use of Polynesian art and architecture. Aside from iconoclasms associated with the acceptance of the Christian God, the acceptance of missionaries into some communities as guests under the patronage of local chiefs influenced the form and scale of Polynesian-made buildings.

The need to accommodate mission services in a building with a processional space led to the introduction of a Tongan archetype to Samoan architecture. The customary Samoan *faletele* (big house) had been constructed in the island group since

difference. The *faleafolau* retained the Samoan *so'a*, or sequence of paired horizontal beams, that are fixed above the tie beam. In the *faletele* the number of *so'a* indicates the owner's status, and so their use in the *faleafolau* churches may have illustrated the customary endorsement of the new religion. Archaeological and historical evidence also supports the claim that the *faleafolau* was a recent construction, although by 1930 Samoan elders were identifying the first house ever built as a 'long' house in their ancestral narratives.[11] Certainly as the nineteenth century progressed, *faleafolau* were also being constructed within Samoan villages (*below*) to host communal, rather than church, activity. Its additional length, when compared to the *faletele*, accommodated larger meetings that assisted in the consolidation of Samoan identity after colonial annexation at the end of the nineteenth century, in the same way the contemporaneous meeting house contributed to the identity of New Zealand Māori.

Although many *faleafolau* were built in the first twenty years of the Christian mission in Samoa, by 1835 there were at least seven lime-plastered churches, and in 1841 the first stone church was built at Solosolo. From the 1850s enclosed-wall masonry buildings designed in the Gothic, and more specifically the Romanesque, revival style increased in popularity. These churches were constructed at the centre of villages, often as part of a *malae* complex, and they heralded a new style of building known as the *fale Palagi*, or 'European house', which was distinguished from customary architecture by its enclosing walls.

From the earliest stages of its mission in New Zealand, the Anglican Church Missionary Society (CMS) encouraged Māori to construct churches that were physically and aesthetically separate from their other community buildings. The earliest Māori churches were simple unadorned buildings, but by

Interior of a Samoan faleafolau, **Samoa, 1914.**
Photograph Alfred James Tattersall. Alexander Turnbull Library, Wellington.

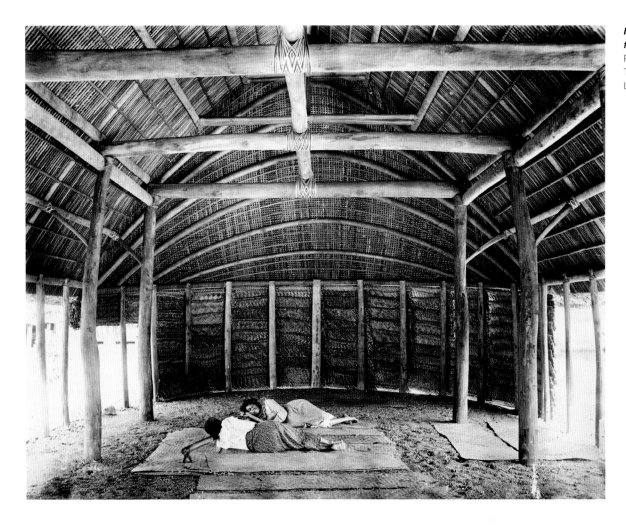

St Mary's Catholic Church, Safoto, Savai'i, Samoa.
Photographs Mark Adams, 2008.

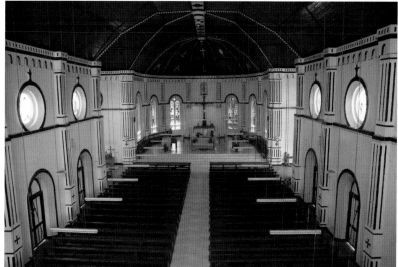

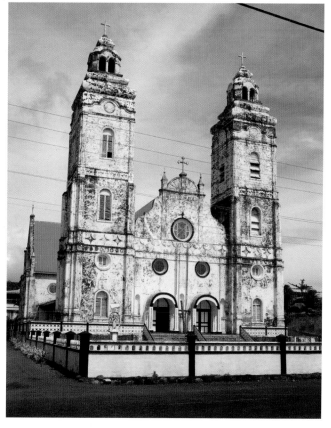

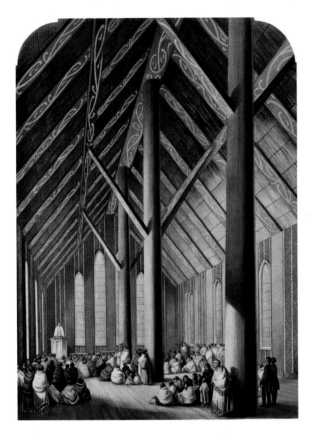

the mid-nineteenth century the CMS had started to work with Māori chiefs to construct Gothic-revival churches in the North Island, the largest of which were at Waikanae (completed in 1843), Manutuke (begun in 1849 under the supervision of Raharuhi Rukupo) and Ōtaki (completed in 1851). They were of an unprecedented scale, and were formally different from earlier Māori architecture through the use of steeply pitched roofs, large internal spaces, side windows, and higher walls that allowed people to move around inside the building. The Waikanae and Manutuke churches featured carvings, *tukutuku* and *kōwhaiwhai*, although missionary distaste for the depiction of *atua* led to the abandonment of *tiki* carvings made for the latter church. Only *kōwhaiwhai* was used inside the church at Ōtaki, which was known as Rangiātea. Unlike the Samoan *faleafolau*, Māori builders retained their technique of using ridgepole support columns and did not adopt the more complex technique of tie-beam construction in order to accommodate the central procession and sight lines. The progressive expansion of meeting

house and *fale* scale during the second half of the nineteenth century can be attributed to the experience that Samoan and Māori people gained from working on and using these churches as congregational spaces.

Naturalism and Figurative Painting

Christian belief systems and methods of worship were well established in many Polynesian and Micronesian communities by the mid-nineteenth century, and as a consequence Western architectural ideas were increasingly becoming part of the oeuvre of indigenous design. People within the region were also beginning to experiment with Western artistic concepts, which they had become accustomed to seeing, in original and print form, through publications and illustrative material brought by mariners, missionaries, travelling artists and settlers. The difference between Western and Pacific art was as startling to Pacific people as it was to European observers. Whereas Polynesian and Micronesian figures were usually ancestors and deities represented without reference to time or location, indicative of the Pacific perspective of time and space, Western art generally placed historical and contemporary people from all stations of life within instants and episodes of time at specific locations. While working between these two artistic traditions must have seemed to offer almost limitless potential for Polynesian and Micronesian artists, colonization presented other more restrictive challenges. The second half of the nineteenth century was also a time of political and social change, and often struggle, for some Polynesian and Micronesian communities whose resource base was under pressure from European settlement. Many communities were no longer able to support artisans, and therefore their artistic innovation was demonstrated through architecture, one of the few artistic media required for daily survival.

The meeting house's centrality to Māori life and identity was established in the late nineteenth century during a bitter and protracted period of inter-cultural and inter-tribal warfare in the eastern, western and central regions of the North Island from 1860 to 1872, which were part of the 'New Zealand Wars'. Significant changes to the meeting house's design and its representational arts were made by one of the early Māori leaders to emerge during the wars, Te Kooti

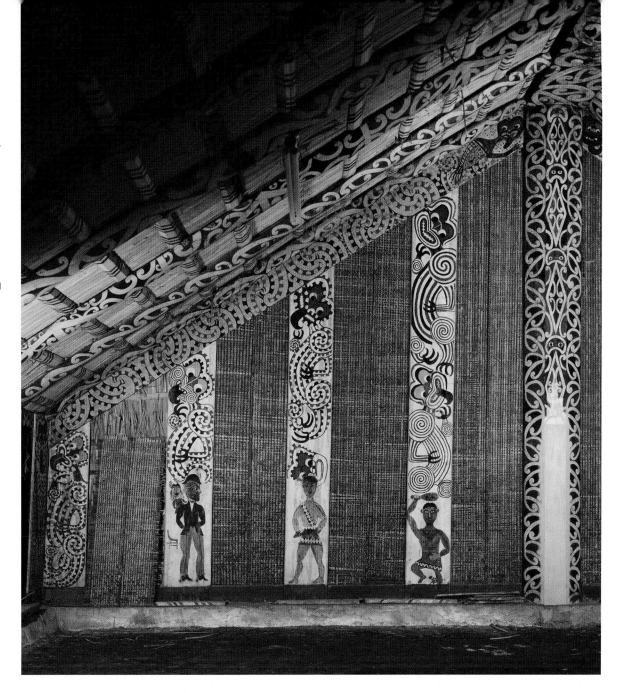

Rongopai meeting house, rear wall. Constructed 1887–88.
Photograph Trevor Ulyatt, 1976. Museum of New Zealand Te Papa Tongarewa, Wellington.

Made for the Māori leader Te Kooti, Rongopai is one of the most radically innovative Māori meeting houses of the late nineteenth century. Its creators made extensive use of paint (instead of wood carving and woven panelling), experimented with naturalism and the repertory of Māori motifs and designs, and combined timeless ancestral figures with contemporary portraits.

Arikirangi Te Turuki. He was a former apprentice of Rukupo,[12] leader of a guerrilla-style resistance campaign from 1868 to 1872, and founder of the Ringatū Church, which combined Anglican and customary Māori religious concepts and practices. Te Kooti was responsible for, or influenced, the design of over forty Ringatū meeting houses built mostly in his home district of the East Coast of the North Island between 1869 and the mid-1890s. (These houses also had their own tribal associations, and were related to Ringatū through a variety of reasons – some were worshipping places, some were originally built for the tribe and later remodelled to be associated with Ringatū, others were opened to accommodate Te Kooti on his travels but were also intended for ongoing community needs, etcetera.) Most of these buildings perpetuated the style of decorated meeting house developed in the region by Rukupo earlier in the century, and some were also innovative due to their expanded church-like scale that accommodated political debate and religious worship, polychromatic carvings and naturalistic figurative paintings.[13] All of these features have come to characterize the Ringatū 'style,' although it is the last that signalled a significant conceptual shift in the way

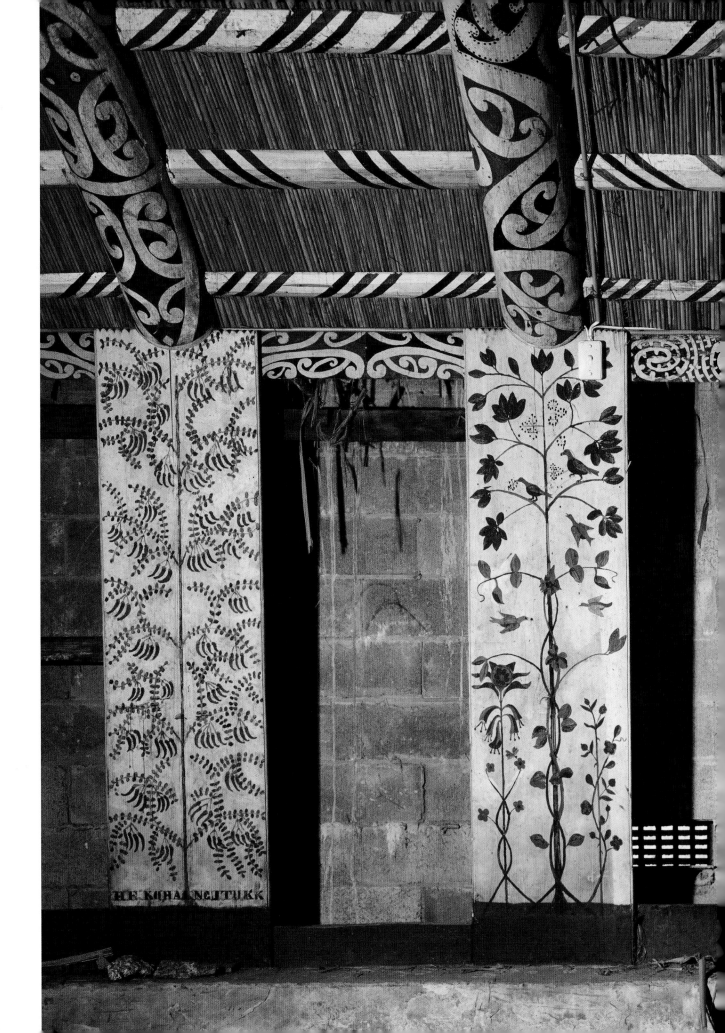

THE KOHA NGUTUKK

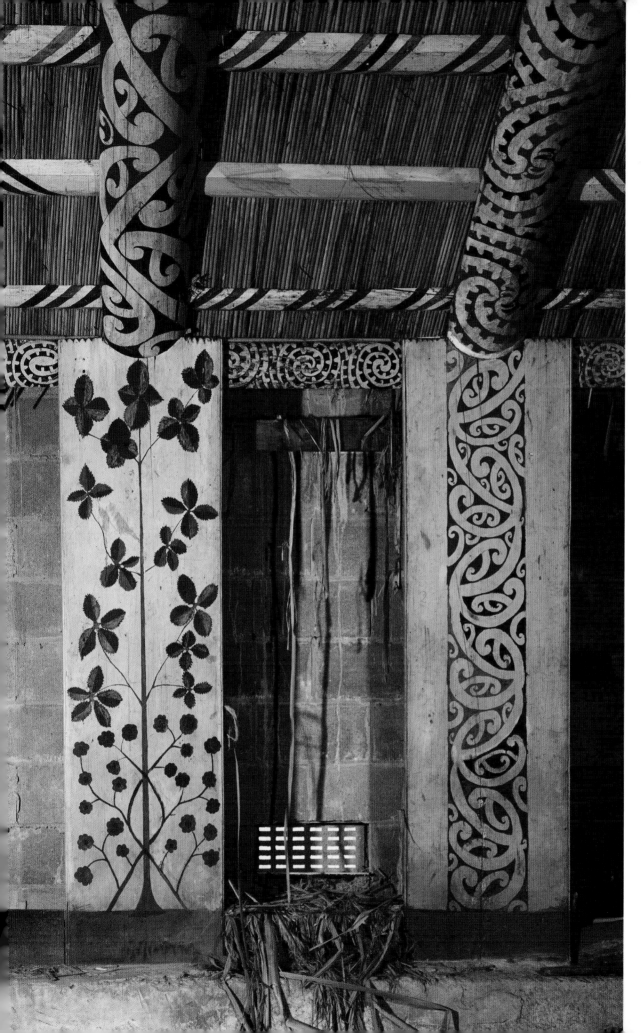

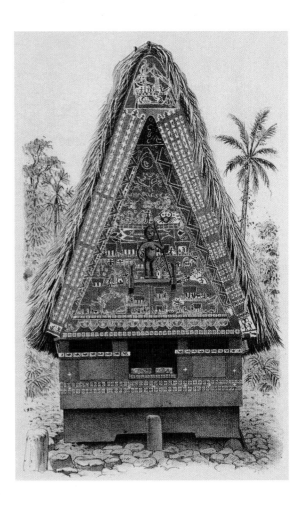
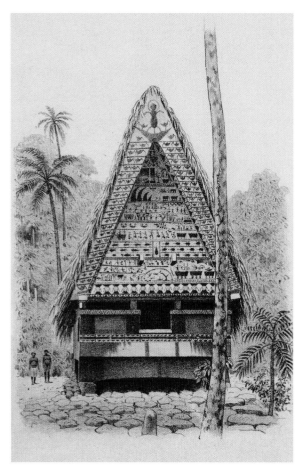

**Decorated *bai*,
Palau Islands, 1889.**
Plates from *Ethnographische Beiträge zur Kenntnis des Karolinen Archipels / von J. Kubary*; Leiden: P. W. M. Trap, 1889. National Library of Australia, Canberra.

Bai storyboards illustrated local ancestral narratives and thus a community's collective knowledge and cosmology. In the nineteenth century, however, certain cultural meanings were lost, although the stories themselves continued.

that Māori were thinking about art and their colonial situation. In some Ringatū meeting houses abstract and naturalistic portraits, scenes and playing-card symbols, painted on porch and interior panels (*previous pages*), took the place of carved *tiki* and *manaia*. Painting was less time consuming than other forms of Māori art, particularly when pre-prepared Western paints were used, and it appealed to Ringatū followers who wanted to complete their houses quickly, sometimes in anticipation of Te Kooti's arrival in their district, and to communities who did not have an expert to oversee their projects.[14] The painted motifs, landscapes, plants and animals were often photorealistic, an aesthetic technique influenced by the engravings and photographs that Māori observed in illustrated Bibles, missionary periodicals and posters, and newspapers. The change from abstract to natural representation was as temporally and spatially significant to Māori as the reverse modernist development – from naturalism to abstraction – was for Europeans at that time.

Narrative painting was also a feature on bas-relief carvings on mid-eighteenth-century Palauan *bai* gables and tie beams. There is not enough documentation of earlier painted carvings to be sure that a change from timeless abstract to episodic natural representation had taken place since European arrival, although early travellers to Palau had only mentioned the presence of symbolic and stylized decoration rather than the 'storyboards' described by later visitors. During his stay in Palau between March 1862 and January 1863, the ethnologist Carl Semper was told by locals that ships and Europeans had been illustrated on *bai* storyboards in at least two villages while the chief of a third insisted that only 'old' – presumably pre-European – stories were painted in his village *bai*. The conscious acceptance and rejection of historic themes indicates that deliberate artistic innovations were the outcome of colonial contact, and not the result of subliminal Western influence.[15] Semper was also informed on more than one occasion that many of the storyboards showed ancestral narratives which were no longer remembered. He was offered the explanations that they were still being reproduced since it was the custom to replicate the storyboards

of derelict *bai* on replacement houses, and also that the stories remained culturally important, even when their detail was lost, because they had originally come from the gods.[16]

Architectural storyboard painting may have started to supersede other forms of carving as the main vehicle for Palauan artistic expression by the 1860s. Semper had noted that many of the elaborate objects carved with stone tools, observed by earlier Europeans and still retained as heirlooms within villages, were no longer made as the knowledge to produce them had been lost.[17] Augustin Krämer suggested subsequently that these changes in art production were the consequence of depopulation.[18] The decline in carving was hastened by the German administration and missionaries who, by the beginning of the twentieth century, were discouraging the use of traditional embellishments on *bai* in order to provoke social and religious change.[19]

As in New Zealand, architecture had become the main vehicle for artistic activity in Palau by the end of the nineteenth century, since other artistic practices were no longer relevant or had been made redundant through the availability of ready-made Western goods. The development of naturalistic figurative painting, in New Zealand and Palau, was both the result and representation of a rapidly changing indigenous world that was finding innovative ways of combining new and customary concepts of time and space.

Appropriating the West

By the beginning of the twentieth century, the colonial influence on Polynesian and Micronesian art and architecture was evident in the appropriation of Western technology, materials and conceptions of time and space. Western architectural aesthetics, first introduced by the missions and later by colonial settlement, were also influencing indigenous communal and residential architecture, although these buildings were being used for culturally specific purposes.

In New Zealand's South Island and northern and western parts of the North Island, traditions of woodcarving and other forms of Māori decoration had not flourished to the same extent as on the East Coast.[20] In some of the areas these arts had declined for complex reasons, including iconoclasm associated with Christian conversion, depopulation from introduced diseases, and inter-tribal (and inter-subtribal) warfare following the introduction of muskets. Meeting houses, however, were just as vital to the unity and survival of these communities, and in the late nineteenth and early twentieth centuries they were largely unadorned weatherboard structures that were similar in appearance to simple Christian churches and settler halls. In some southern and western North Island communities, large weatherboard complexes housed dining, meeting and sleeping facilities. They were called *pā* and could be considered a late nineteenth-

below left
Meeting house at Papawai Pā, Greytown, New Zealand, twentieth century.
Alexander Turnbull Library, Wellington.

below right
Looking over Parihaka Pā towards Mount Taranaki, New Zealand, *c.* 1890.
Alexander Turnbull Library, Wellington.

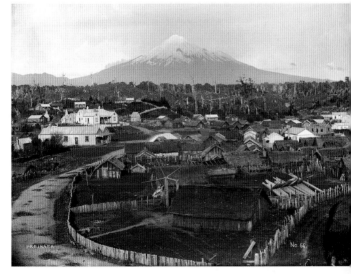

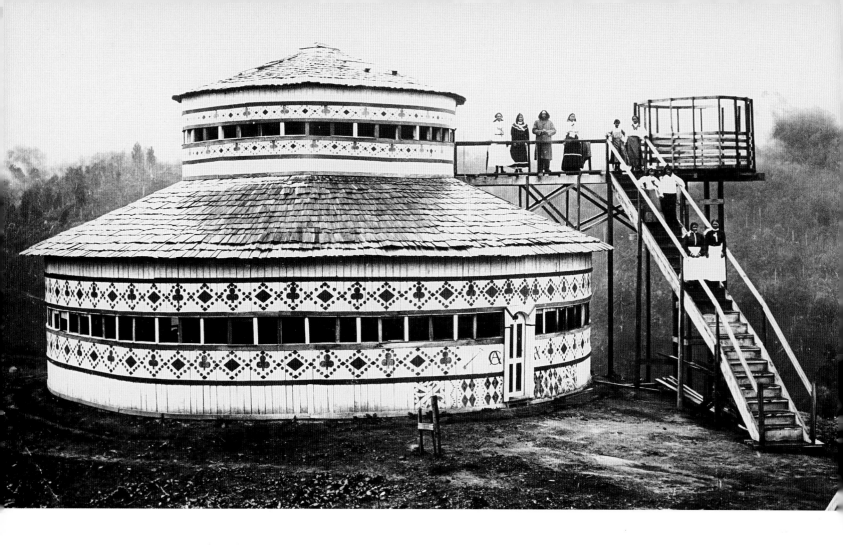

century development of the earlier *pā* fortified-settlement concept, which had also previously been valued for its demonstration of *mana* and group proprietorship over land. Two of these communities, Papawai Pā, north of Wellington, and Parihaka Pā, in the Taranaki region, became the focus of intense religious and political activity for Māori from around the country (*page 311*). Although their prestige buildings accommodated specific Māori needs, such as the separation of *tapu* meeting and sleeping areas from food areas, and the desire to congregate in large groups, they assumed the appearance of Western buildings and did not feature customary Māori embellishments apart from the use of woven floor mats. Not all of the Western influence on Māori architectural aesthetics was derived from church and hall architecture. The remarkable Hīona (the transliteration of Zion) council house, built in 1907 by the religio-political leader Rua Kēnana for his followers at Maungapōhatu, was one of a number of buildings in the community inspired by the Old

Testament. The proportions of, and colours used on, Hīona closely followed those mentioned in biblical descriptions of Solomon's Temple, although its overall appearance was most likely based on a lithograph of Jerusalem's Dome of the Rock, another rotunda-style building, mistakenly identified as Solomon's Temple in some nineteenth-century illustrated Bibles.[21] Hīona was a unique Māori building, being both circular in plan and double-storeyed, which eliminated customary seating arrangements on the ground floor, while the mezzanine above was reserved for Rua and his family, in keeping with the Polynesian observation of the roof as the most *tapu* part of a building.[22]

The same interest in appropriating colonial architectural aesthetics was apparent in early twentieth-century Samoa, although it was deployed to enhance the *mana* of elite families rather than engender a sense of community. The *fale Palagi* style of building, first developed for Christian churches, was adopted by elite Samoan families for their residences. The integration of Western elements – such as

windows, weatherboards and other milled timbers – within customary systems of building may have been associated with the assertion of political power and economic influence by people of this class. The colonial economy had developed rapidly since the mid-nineteenth century, from which time many Europeans had settled in the capital, Apia, and German plantations and trading operations had begun throughout the Samoa island group. The success of these operations made Samoa the most important trading post in the Pacific. Many Samoan families who had customary power saw partnership with Europeans, through business dealings and sometimes marriages, as a way of consolidating their status in the new colonial world. Their hybrid architecture therefore reflected their bicultural status. The process was reciprocated, with Germany, England and America becoming involved in Samoan political processes as a way of seeking trade advantages.

Outside the commercial and political capital of Apia, there was very little evidence of Western influence on Samoan residences and guest houses until after the Second World War. This may have been a conscious rejection of colonial influences by ordinary people who wanted to retain their Samoan identity.[23] Perhaps mindful of the association of the *faletele* with Samoan identity, even the elite families of Apia who

lived in *fale Palagi* residences retained customary *fale* as their meeting/guest houses where they owned land. This way they could be seen to be retaining their traditional standing by providing meeting places that were built in the customary model. Architecturally, they were living in two worlds. By the 1920s paints and dyes obtained from Western merchants were also being used to colour lashings in *faletele* and *faleafolau*, extending the range of colours employed.[24] The appropriation of other Western technologies by Samoan builders to reduce construction time prompted a decline in customary building knowledge. Nails were used instead of lashings. Furthermore, milled timbers and roof iron did not require any preparation, unlike harvested timber that needed to be dressed, and thatching that had to be harvested, dried and bundled. The application of figurative art to *fale* elements would, however, not occur until later in the twentieth century.[25]

In Palau, Western-style *bai* were literally rising from the ruins of customary *bai*. Within fifty years, typhoons, earthquakes and warfare had led to the destruction of almost all of the 150 Palauan customary *bai* in use at the beginning of the twentieth century. This process accelerated the customary attrition of such buildings that had been apparent in previous centuries, since inter-tribal warfare had involved the destruction of community property, including meeting houses. Remaining *bai* were damaged beyond repair during the intense and extended ground battle between attacking American troops and occupying Japanese forces in 1944. New community buildings were erected. Like other community buildings at this time, these were concrete-walled and tin-roofed structures constructed without customary adornments and in a Western style.[26] Along with these formal transformations, the Western-influenced community *bai* were more inclusive in function than their customary precedents in accommodating women and untitled men, albeit within a defined area of the house.[27] Their presence may be indicative of a need to embrace all sections of society within a single meeting forum.

As had been the case with late nineteenth- and early twentieth-century architecture in other parts of Polynesia and Micronesia, these types of appropriations did not necessarily indicate a desire to become Western so much as facilitate the rapid

A chief's house at Lepea, Samoa, 1889.

The house of Samoan chief Faumuina Fiame Mulinu'u and his wife Fa'amu at Lepea combines traditional forms of Samoan house construction with weatherboard sidings, stairs, railings and a well-tended garden. In the 1920s when Samoa was under New Zealand colonial administration, Lepea was rebuilt as one of several 'model villages' incorporating European-style houses.

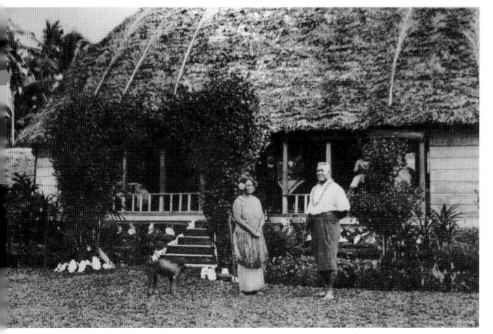

Gauguin's House of Pleasure

ONE OF THE MOST SINGULAR DWELLINGS in Polynesia in the early twentieth century was Paul Gauguin's hut in the colonial town of Atuona on the island of Hiva Oa in the Marquesas. Built with the help of two local carpenters in late 1901, the house had two levels, a ground level comprising an open dining space, a kitchen and a woodworking shop, and an upper level enclosing a small bedroom and a studio, sided with woven bamboo cane and roofed with thatched pandanus leaves. Entry to the upper level was via an exterior staircase perpendicular to the front facade and door, which Gauguin framed with five decorative wood panels, now in the Musée d'Orsay in Paris.

The panels were roughly carved in relief with a medley of images recycled from the artist's recent oeuvre: Polynesian faces, nude *wahine* (women), esoteric animal symbols and exotic fruits and flowers drawn together by winding branches. Three texts punctuated this imagery: *Soyez mysterieuses* (*Be mysterious*) and *Soyez amoureuses vous serez heureuses* (*Love and you will be happy*); and on the lintel: *Maison du Jouir* (*House of Pleasure*).

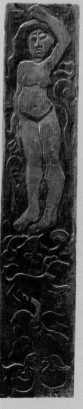

The House of Pleasure was an anomaly in Atuona. Sited near the main street in a neighbourhood of trade stores, churches, schools, residences, colonial offices and a smattering of native huts, it was unlike any of these buildings. Essentially, it was an outpost of the French avant-garde, a gesture in the artist's ongoing bid for fame and distinction in the Parisian art world. Only there, in the metropolitan centre, did its eccentricity on the margins of the French colonial empire make sense or become legible. Indeed, Gauguin's entire adventure in the South Pacific was split between the messiness of his social entanglements, bodily needs and declining health in the tropics, and his reputation in France, the destination of his entire artistic and literary output. In his final years in the Marquesas, Gauguin suffered from painful lesions on his legs and was harassed and distracted by many local troubles. In 1902 he wrote to his friend Daniel de Monfreid suggesting he might return to Europe, possibly to Spain, where at least he could obtain medical care. Monfreid's reply was unequivocal: 'In returning you will risk damaging that process of incubation which is

taking place in the public's appreciation of you. At present you are a unique and legendary artist, sending to us from the remote South Seas, disconcerting and inimitable works which are the definitive creations of a great man who, in a way, has already gone from the world…. You are so far away. You should not return…. You are already as unassailable as all the great dead; you already belong to the history of art.'[i]

All of this lends a certain pathos to the House of Pleasure, the final coordinates of Gauguin's restless quest for a place that was truly 'savage'. As in Tahiti, he embroiled himself in local politics, opposing tax laws, Catholic schooling practices and corrupt officials, and fighting enemies in the gendarmerie and Catholic Church who saw him as a meddlesome troublemaker. Moreover, he suffered miserably in the House of Pleasure, to which he was confined, unable to walk, during his final months, and where he died on 8 May 1903. Two details in a drawing of the house give evidence of its embodied life in Atuona. Out the back, a fishing pole that Gauguin used to retrieve cooled absinthe bottles from a well; and at the front, at the base of the stairs, a pair of sculptures satirizing the local Catholic bishop, to the amusement and consternation of the locals. One sculpture, called *Father Lechery*, portrayed the bishop as a horned devil, the other his alleged paramour. Within months of Gauguin's death, however, the door panels and sculptures had found their way to an auction in Papeete, where they were purchased by French travellers aware of Gauguin's rising star in the history of art.[ii] PB

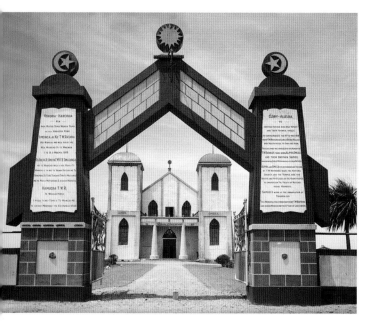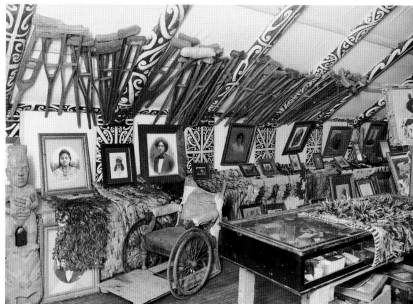

construction of buildings required promptly for indigenous purposes.

Modernity and Traditionalization

At the end of the First World War, Polynesian and Micronesian art and architecture were at a turning point. Many customary arts were no longer practised and could only be perpetuated by being actively revived. What had replaced them was a concept-based approach to indigenous representation, where the essence of custom had been retained but was being expressed through Western technologies, materials, compositional techniques and aesthetics. In many Pacific countries the end of the war was also followed by a sense of uncertainty as well as depopulation caused by the influenza epidemic of 1918. These challenges provided a new impetus for Pacific leaders to form pan-tribal organizations or organizational systems that could function within a Western economy, but still retain an indigenous sense of identity. Two approaches to Pacific modernity developed in the interwar period, the first continuing the reliance on Western aesthetic ideas, the second reviving customary arts through processes of traditionalization, and both promising political and economic self-determination.

Māori continued to build Western-influenced congregational spaces to support religio-political movements, the most popular of which was the Rātana Church, founded by Tahupōtiki Wiremu Rātana in 1925 following a period of visions and faith healing that had begun in 1918. Approximately one-third of the Māori population converted to the Church, which was founded on Methodist and Māori interpretations of the Bible, and there was significant Māori support for the Rātana Political Party, established in 1928, which had captured all four Māori parliamentary seats by 1943. In 1927 Rātana built a large twin-towered Romanesque-style church on his property, Rātana Pā, in the western North Island, which became the model for a number of other branch churches, and was the inspiration for meeting-house murals produced over the next three decades by his followers around the country. Rātana's vision for the future involved the abandonment of *tapu* practices and objects, many of which were kept 'safe' in a building on the Pā known as the *Whare Māori* ('Māori House'), and the rejection of tribal identities in favour of regional identification.[28] Rather than an abandonment of custom, Rātana's replacement of earlier art and belief systems with his own was in keeping with traditional Māori leadership practices, and his treatment of customary objects can be understood within the context of other Polynesian iconoclasms.

The practice of perpetuating customary uses of space within Western-influenced congregational settings is also apparent in the Modekngei churches of Palau. Like the Ringatū and Rātana churches, Modekngei was a counter-colonial movement that developed Christian beliefs and practices within a customary spiritual and social framework. The German and subsequent Japanese administrations had tried to suppress customary religion during the first half of the twentieth century in the face of determined opposition from some Palauan leaders.[29] An alternative faith – with a godhead consisting of a single supreme creator, a Christ-like local deity known as Ngirchomkuul, and a mission to abandon many *tapu* practices – was devised and led by the Chol village chief and faith healer Tamadad and was continued, after his death in custody (variously recorded as either 1924 or 1928), by his associate Ongesi.[30] The latter leader politicized the movement, discouraging followers from engaging in the Japanese educational, health and military system, and encouraging them to eat customary foods using traditional implements and vessels. He was most likely the leader responsible for requiring all followers to keep *skors* (walking sticks), which represented Christ/Ngirchomkuul. These were made by the adherents themselves, and could be straight or crooked. After being blessed by Ongesi or one of the movement's other officials, *skors* were worshipped inside followers' houses and sometimes soaked in herbal infusions that were then consumed to cure certain illnesses. By 1937 this movement was the most significant influence on customary Palauan political systems, and it provided much-needed hope during the American bombardment of Palau during the Second World War.[31]

Modekngei churches were divided in two along their long axis, with worshippers from villages regarded to be more 'senior' seated, when facing the altar, on the right 'superior' side, associated with the supreme God, and those from 'junior' villages seated on the left, associated with Christ/Ngirchomkuul the Son. These seating positions were probably influenced by the seating orders within *bai* used by men's councils, in which chiefs of different lineages had assigned places next to doors or associated with corner posts. The *bai* was conceived of as having complementary sides, divided down the long axis of the building, with pairs of chiefs facing each other across the house. When

congregating in houses, followers also divided their living space from their place of worship, in the *elden*, or customarily semi-sacred end of the house where spirits reside and valuables are kept, by hanging a piece of white cloth with a red cross, or a red cloth with a white cross, as a partition. This complementarity, as observed in Modekngei churches and followers' houses, was a reflection of that which determined the sexual division of labour as well as the division of the village and islands into 'sides'. Space was therefore regarded as an essential agent of social organization even in the most challenging of times.

Not all Polynesian and Micronesian people shared the same vision of the future promoted by followers of movements such as the Rātana and Modekngei churches. Some saw value in reviving selected customary practices that had once united communities before the colonial presence had become politically and economically overwhelming. This was not simply a return to traditional lifestyles, since that was not possible within an entrenched colonial political and economic system. It was a process of traditionalization, whereby elements of customary culture were reified and secularized and used to support new economic initiatives.[32]

In New Zealand the revival of customary Māori architecture and architectural arts – such as woodcarving, *kōwhaiwhai* and *tukutuku* – was led by Sir Āpirana Ngata, who was a highly regarded anthropologist and Member of Parliament for Eastern Māori by the time he established the School of Māori Arts and Crafts in Rotorua in 1927. Ngata believed that there was an urgent necessity for such a school as there was only one carver still working on the East Coast, an area once famous for its decorated meeting houses, and the arts of *kōwhaiwhai* and *tukutuku* had almost ceased to be practised. His scholarly and personal understanding of Māori culture, and work from within the New Zealand political system, led Ngata to believe that Māori could retain their identity if they could consolidate their remaining landholdings within tribal land incorporations that would operate farming ventures. Central to this plan was the revival of the *marae* and decorated Māori meeting house, with associated dining hall, as a focus for tribal and sub-tribal community activity and a visual manifestation of Māori culture that was distinct

TO THE MINISTER OF MĀORI AFFAIRS

I am a person well known to the people of the Government for my carving, that is Mr T. E. Donne and Mr Lawrence Birks, much of my carving work has been done on their supervision. My hapu is Ngati Tarawhai, the hapu with a great name for carving from our ancestors down to our elders, to our parents, to me and my children the knowledge of carving has descended with no part of carving knowledge missing. I have been a pupil to most of the people known from their carving.

Among the experts, Wero was a very great expert with a great name among Te Arawa for his carving. Te Amo also was a very great expert before Anaha Te Rahui, a great expert well known to the Government. From these elders and experts in the knowledge of carving, these elders taught me the ways of the Maori for teaching the knowledge of carving. I have developed their knowledge and therefore it is my belief that I am the person best suited to present the explanation of carving to the children so that they will understand the treasures of the Maori especially carving. There are still two other people apart from myself who would be suitable to teach in this place of carving study – Te Ngaru Ranapia and Eramiha Neke. We are the only ones among Te Arawa like this.

Tene Waitere, Rotorua master carver, a letter to the Minister of Māori Affairs
dated 22 September 1926 offering himself as an instructor for the
planned School of Māori Arts and Crafts.[i]

from Western culture. The School of Māori Arts and Crafts was based on Western and Māori educational principles and it trained dozens of carvers and four to five hundred *tukutuku* workers on around forty real projects paid for, in materials and wages, by their communities with some government assistance.[33] The School was able to revive, as well as creatively construct, a number of tribal styles based on the students' study of carvings fixed to older meeting houses and held in museums, and the knowledge of Eramiha Kapua, one of the instructors and few remaining expert carvers. In order to attract the attention of Māori youth, the School's buildings were also able to host Western-style dance gatherings through the employment of clear spaces, made possible by industrial structural systems, wooden floors, seating and raised stages. These functional developments initiated the partial secularization of Māori communal space. Ngata's artistic programme was ambitious, and although it was not fully realized within its greater socio-economic context by the time he lost his seat to the Rātana Party in 1943, the School did manage to train a new generation of Māori customary artists who had been instructed to pass their knowledge on to subsequent generations. This training was culturally based, and involved a level of artistic discipline and commitment that was not apparent in the building projects undertaken by Rātana's followers or other Māori building in the Western style. The School's educational goal ensured that, within the space of one generation, the customary meeting house – embellished with woodcarvings, *kōwhaiwhai* and *tukutuku* – had supplanted other forms of Māori communal architecture as the building style of choice for Māori communities.

Although the Palauan *bai* had become more Western in appearance, storyboard-making was the subject of a revival, albeit in the context of the production of art objects rather than architecturally. During the 1930s a crafts training programme was established by Hisakatsu Hijikata, a Japanese artist and scholar who had an interest in primitivist modernism, particularly the work of Paul Gauguin.[34] Hijikata was perhaps following a parallel path to that of the French artist, when he decided to move from Tokyo to Palau in 1929, where he became interested in *bai* storyboards while teaching carving in the *kogakko* (local public

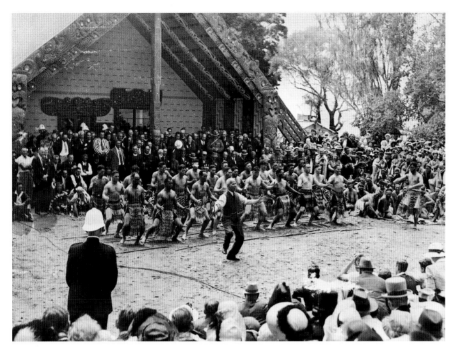

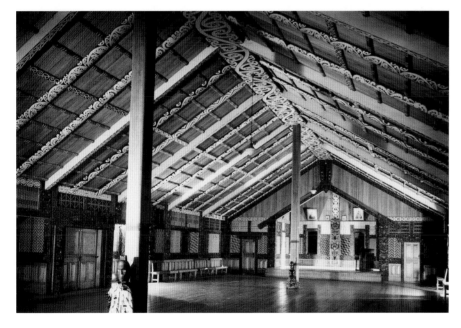

top
Āpirana Turupa Ngata leading a *haka* at the 1940 centennial celebrations, Waitangi, 1940.
Alexander Turnbull Library, Wellington.

above
Interior of Te Poho-o-Rāwiri meeting house, Kaiti, New Zealand, *c.* 1930–40.
Photograph William Hall Raine. Museum of New Zealand Te Papa Tongarewa, Wellington.

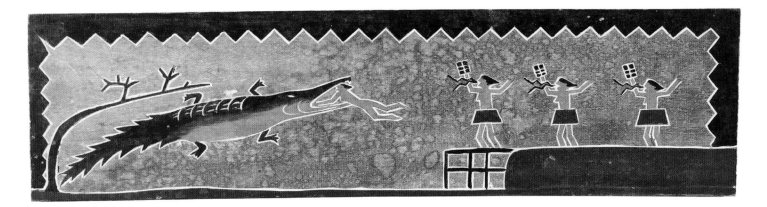

Bai **storyboard depicting
an alligator eating
a woman, collected
by Yoshio Kondo in
Palau, 1936.**
Wood, pigment. Length
59.5 cm (23½ in.). Bishop
Museum, Honolulu.

schools). While there is no indication that Hijikata was aware of Ngata or the School of Māori Arts and Crafts, Hijikata shared with him a belief that customary craft could be developed within a paid economy to facilitate indigenous economic independence, although he did not have Ngata's political influence or wider programme for self-determination. Shortly after his arrival, Hijikata began to recruit young men for participation on his local crafts training programme, and among his students were Osiik, Sbal Francisco, Skedong Ngiraibuuch (or Ngiraibuuch Skedong) and Antonio Riumd, who all went on to develop careers as professional artists. The artists created small storyboards, known as *itabori* in Japanese, for sale to Japanese settlers and tourists, thus changing the function and form of the boards from significant elements within a larger architectural context to aestheticized art objects. Hijikata's influence on storyboard-making can be seen in a return to a traditional colour range, the use of borders, and the repetitive depiction of a restricted number of customary stories (between twenty and fifty from at least two hundred regional and shared narratives). He also developed the practice of compressing narratives previously shown on long architectural elements onto short and portable timbers; however, precedents exist for this practice, since there are at least two earlier examples.[35] In 1862 Semper was presented storyboards willingly cut by local chiefs from the *bai* at Ngebuked, and in 1910 Augustin and Elizabeth Krämer were given a specially made storyboard, showing their dog and the *bai* in which they had resided at Dngeronger.[36] Figurative changes include fewer representations of supernatural creatures, a loss of stylistic variation for human figures, and the disappearance of the nude

figure, which was presumably to make the work more palatable for the Japanese market and Christian Palauans. Like contemporaneous Māori woodcarving, Palauan woodcarving was undergoing a secularization process. There were similar changes in the spatial formalism of the storyboards as the artists progressively introduced the Western compositional concept of depth, through foreground and background, following their formal training in drawing by Western-influenced Japanese teachers.

The Second World War introduced many long-term changes to Palauan art and architecture, among them the almost total abandonment of customary *bai* construction and the movement of some indigenous artists to Guam, which became an important urban economic centre when the United States assumed control over Japanese Micronesia. After the war storyboard-making continued to be a mainstay not only of Palauan souvenir art but also of cultural expression, and many examples from this period can be found in private and public international collections. The adapted recovery of the Palauan storyboard is one example of artistic revival within Micronesia, although similar social, political and economic conditions had also inspired similar resurgent activities in Polynesian New Zealand and Samoa that reified selected, and often politically and spiritually neutral, elements of customary culture.

In summary, the history of art in Micronesia and Polynesia could be characterized as a movement from 'tradition' in the early nineteenth century to 'traditionalization' by the mid-twentieth century. Yet as we have seen, the early arts of Oceania were never really 'traditional' in the commonly understood sense: they were continually dynamic, responsive to

local political initiatives and transformations, and
to fertile encounters within archipelagoes as well as
with strangers who appeared from beyond them. Nor
was 'traditionalization' just a process of reifying or
standardizing custom, as theorists of 'the invention
of tradition' have maintained. Reinvention involved
genuine creativity and the diversification of art.
The history considered here was made up of an
extraordinary range of challenges. It was a period
of appropriation and experimentation with new
technologies, religious ideas, compositional techniques
and aesthetics, appropriations from within and beyond
the Pacific. In examining the indigenous arts of New
Zealand, Palau and Samoa, it is clear that makers
quickly changed from using Western tools to embellish
the pre-existing art culture, towards applying them
and other appropriations to enable their survival under
colonial rule. Although Christian conversion had led to
the destruction of so many Pacific art objects and had
destroyed a good many art practices, it also inspired
the creation of counter-colonial movements in New
Zealand and Palau that used Western, and in the latter
instance also Eastern, technologies, techniques and
concepts to make customary culture relevant to the
contemporary situation. The adoption of Western
architectural aesthetics exemplified a Pacific modernity
that embraced the greatest of modernity's ideological
hallmarks – 'progress'. Yet 'progress' was understood
on Pacific Islanders' own terms.

Perhaps the most significant change in Polynesian
and Micronesian conceptions about the role of art in
representing cultural ideas was one of the most subtle
in expression: the temporal and spatial shifts occurring
in figurative art. That this occurred at the same time as,
yet completely separate from, the modernist

appropriation in the West of Oceanic forms from
museum-held examples of Pacific art, indicates the role
of the artist, in any culture, as innovator and explorer.
In Palau the cross-fertilization of temporal and spatial
cultural ideas was made even more complex by the
active influence on storyboard production of a
Western-influenced Japanese artist, Hijikata, whose
contribution can be understood within the context
of orientalism and primitivism. The example of the
Palauan storyboard demonstrates how appropriation
was an important practice within twentieth-century
traditionalization movements, as is also obvious in
the buildings of the School of Māori Arts and Crafts.
When compared to 'traditional' models, the work of
these movements uses a restricted range of archetypes
and concepts that were 'revived' and were more secular
in purpose in that they were part of larger projects
concerning economic self-determination.

As for many Pacific people living in this period
of change, survival for New Zealand Māori, Palauans
and Samoans involved reconciling the colonial world
within a framework of understanding that was
indigenous. This 'conceptual' approach to survival is
most clearly apparent in architecture as an essential
artefact of daily life. Up until recent times, many
commentators mistook the progressive abandonment
of customary aesthetics, and the need for resurgent
initiatives, to have been evidence of cultural decline or
even assimilation with the colonial culture. However,
it is now recognized that customary concepts were
still fundamental to the understanding and function
of the new Westernized and traditionalized art forms.
Indeed, the aesthetic and technological appropriations
that had taken place were more a demonstration of
counter-colonialism than colonization.

Fabricating Society

NO ONE QUITE KNOWS WHEN QUILTING started in the Cook Islands, but what is clear is that the stitching of pieces of cloth into large rectangular sheets was taken up across the whole of eastern Polynesia almost as soon as fabric became available, as one of the key trading items imported by Europeans.[i] The earliest records of quilting are from Hawai'i, where Russian and Chinese trading ships landed huge quantities of cloth and where missionary wives seized on the keen interest of Hawaiian women in working with cloth to spread Christianity through the conviviality of sewing groups.[ii]

As Polynesian women took charge of fabricating the new cloth, it was given the form of large rectangular patchwork quilting called *tivaivai* (*tifaifai*), whose production and circulation have remained an essential part of life in Tonga, the Cook Islands, Tahiti and Hawai'i to this day.[iii] Cook Islands patchwork has remained the most varied and expressive art form, sewn to be gifted at all important life-cycle events: boys sit on a *tivaivai* for their first haircut; *tivaivai* are gifted from mothers to daughters and sons at weddings; and *tivaivai* are reverently wrapped around the dead at death, to be buried with the body in the grave.[iv]

As women were also the keenest converts to Christianity, quilting, and the economy of exchange it supported, prospered under the tutelage of the Church. Patchwork quickly became an icon of modernity and an index of an emerging national identity as it fruitfully entangled cloth and clothing with existing conceptions of wrapping the body.[v] Design innovations flourished, making full use of the material and technical potential inherent in plain-coloured fabric and thread.

Every patchwork is made to be gifted, and is often sewn with a specific occasion and even a person in mind as recipient. Such relationships and events, which may fan out in various ways during a woman's life, are externalized into iconic patterns. Patterns related to specific events may be repeated later on in life from memory, recalled in terms of the flower depicted, the symmetry used, and in the case of a piecework or *taorei* quilt, the number of coloured pieces of cloth to be joined to one another to make up the nucleus (*pu*) of the design. Repeated across the surface of the quilt, the *pu* consists of amalgamated replications of itself; while within each *pu*, the image is replicated on a smaller scale. Like the fractal image of personhood presented to us in the historic sculpture of A'a, the Cook Islands quilt is an entity with relationships integrally implied in the way motifs are serially enchained, 'budding' out of one another in a depiction of human life. Constructed from layers of criss-crossing strips of fabric that are cut and stitched into regular crystalline patterns on a plane, the Cook Islands patchwork presents the equivalent of a temporal and spatial map, a lattice of possible worlds. As such, patchwork makes tangible a notion of personhood as the aggregate of external relations and its social effects, creating a society without boundary able to embrace life in the diaspora in the most positive of ways.

We do not know for what occasion the quilt illustrated here was made, but it is from the Cook Islands and may have been purchased by Agnes Stewart née Neilson of Tasmania (originally from Norway) in the early 1900s in order to benefit the Melanesian Mission (the Anglican mission to the Solomon Islands and New Hebrides). The Bishop of Tasmania, who had visited the Solomons in 1892, was a warm promoter of the Mission, and Agnes Stewart may well have bought the quilt in response to his call for support. SK

***Tivaivai, taorei* type (patchwork quilt), Cook Islands, late nineteenth–early twentieth century.** Length 225 cm (88⅝ in.). Museum of New Zealand Te Papa Tongarewa, Wellington.

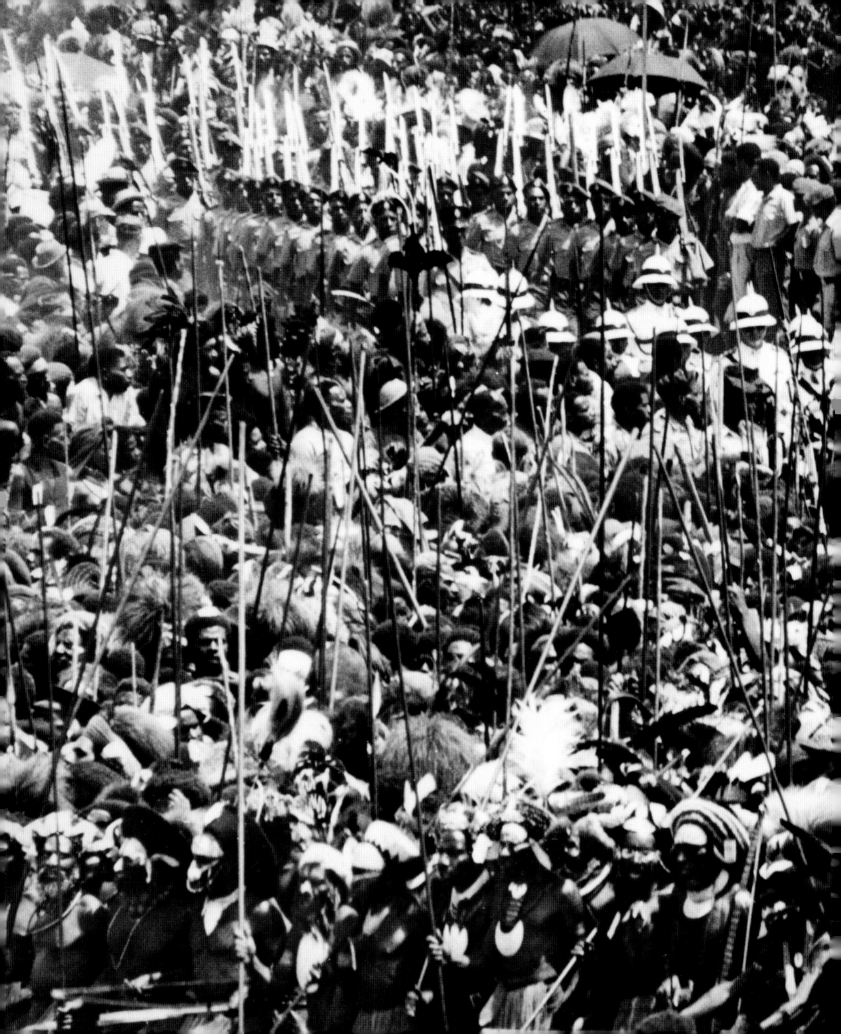

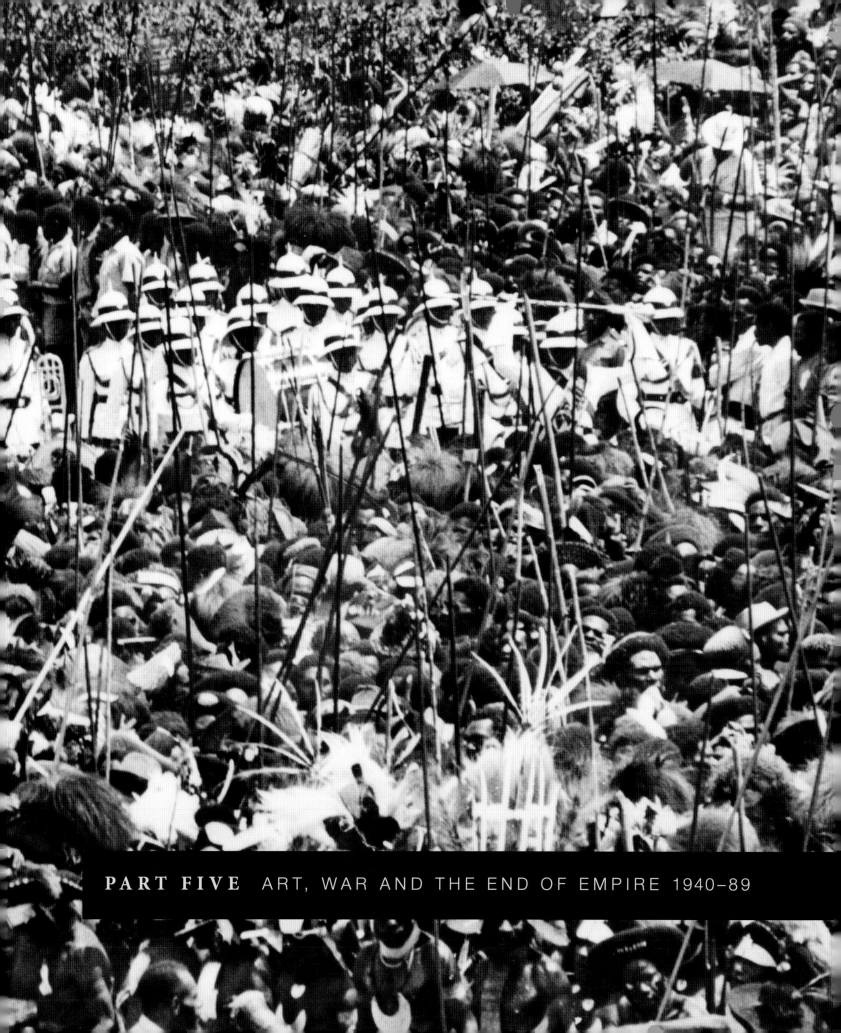

PART FIVE ART, WAR AND THE END OF EMPIRE 1940–89

Sean Mallon

WAR AND VISUAL CULTURE
1939-45

The Second World War was a formative period in the history of the arts in Oceania. Whereas the work of nineteenth-century missionaries witnessed a great deal of change in the minds and cultures of Pacific peoples over many decades, the intensity of change in the five years of the Pacific war brought together people, ideas, new products and technology on an unprecedented scale. Indeed, war has been described as one of the principal mechanisms of globalization,[1] a set of processes bringing seemingly disparate groups of people together in interactions of collaboration and conflict. However, globalization and war are invariably experienced by people differently, depending on where they are located. They are processes that are uneven in their implications and effects. Globalization can strengthen the interconnections between places and groups; however, it can also create distinctiveness, conflict and division within and between groups.[2] For some communities in the Pacific, the Second World War devastated them, scattering their members and permanently transforming their way of life. For others, war isolated them, disrupting existing patterns of travel, communication and social interaction. It was a time of great loss and hardship, but for some people it was a hardship that ultimately created opportunities to acquire new knowledge and ideas, to travel, and to expand their view of the world. A history of visual arts in Oceania reveals the social, cultural and economic forces at work during this turbulent period.

The impact and experiences of Pacific Islanders during the Second World War have been well documented.[3] The war left a strong impression in the print and photographic record, but also in the memories of those people who experienced and lived through it. At this time in Oceania and especially in Melanesia, most societies were primarily oral cultures with very low rates of literacy. Performance, storytelling, song, dance and sometimes art were the primary media for representing the past. The published studies use archival and published sources, oral histories and photography to construct rich and diverse narratives of courage and survival. When the visual arts are mentioned in these histories, it is usually in relation to the trade in handicrafts between Pacific Islanders and foreign troops. These stories of entrepreneurship and trade are small but critical markers in Oceania's art history. However, art production in the Pacific theatre of war encompasses more than these transactions, and its relevance extends well beyond the years 1939–45.

The war changed social and cultural life in the Pacific. People responded to new forces of change that both inspired art production and suppressed it. How did the presence of major industrial nations in the Pacific influence artistic and cultural transformation? What did they create themselves that is now part of an Oceanic art history? What were the processes that would accelerate change in the Pacific and engage it more fully in the global economy? The Second World War involved traffic in ideas and culture between the island nations of the Pacific and the larger and more powerful industrial nations along its rim. New pathways were set in place for the two-way movement of people, information and commodities. Many of these interconnections have continued and expanded, remaining relevant to the present day. For contemporary people in the Pacific, the experiences of the war are recalled in many fields of artistic endeavour, popular culture and tourism.

Influx: Disruption, Creation and Enterprise
The war was a destructive process and disruptive to established patterns of social and cultural life.

The movement of troops into the Pacific region required the building of airstrips, roads, accommodation and other infrastructure. It was essential to have military forces within striking distance of the battlefield and in a position to ensure the security of captured territory. The deployment of soldiers and their equipment transformed Pacific island landscapes both physically and culturally. For example, in Wewak, a small pre-war district headquarters for the Sepik region in Papua New Guinea, the influx of Japanese and the establishment of a military base there saw the town's population rise to more than 32,000.[4] Further to the east, more than one million Americans passed through the Admiralty Islands in the course of the war. It was the site of the biggest United States base between Guam and Hawai'i's Pearl Harbor.[5] Around half a million Australians passed through Papua New Guinea in wartime.[6]

The mass arrival of military forces often required the resettlement of indigenous communities. The recruitment of workers and the subsequent movement of people from their home territories to support the military machine changed local economies. The frequency of ceremonies, rituals, art and other forms of cultural production fluctuated in these conditions. The success of the Allied Papua New Guinea campaign depended on civilians who were the only major labour force available. However, within the island the demands for labour differed. In the Sepik area labour recruitment was not unfamiliar and had occurred since the German colonial period. In the Highlands, in 1943, war involved the large-scale recruitment of over four thousand Chimbu people in a period of only three months.[7] Labour recruitment on this scale put community life on hold as people moved across territories, leaving families and villages behind them. In these circumstances, women would tell a very different story from men of their experiences of the war.

War altered local economic relations in other ways. The influx of troops and their equipment changed local

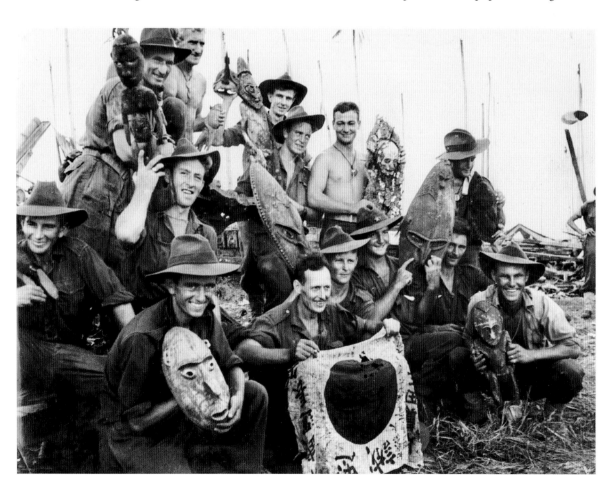

Australian troops after the capture of Alexishafen with the spoils of war, Papua New Guinea, April 1944.
Australian War Memorial, Canberra.

For centuries cultural artefacts have been collected or created as part of the spoils or economics of war. Less widely known is that in the Pacific theatre human skulls and other body parts were sought after and taken home as war trophies.

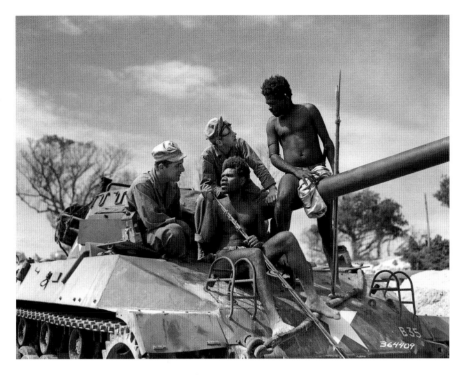

Men on an M-18 tank, Espiritu Santo, 1945.
US National Archives, Washington, DC.

people's perceptions of the world. Many Pacific Islanders were shocked to see black American troops working alongside white Americans, and were awestruck by the new machines, tools and equipment they saw, often for the first time. The quantity of food and supplies available to Allied troops seemed unending. In these circumstances, the circulation of indigenous cultural valuables and trade goods was drastically altered. Local valuables and raw materials were usually circulated on extensive trade networks and exchanged with people in other regions for goods they specialized in creating. It was a measured and well-established state of relations. In wartime there was large-scale movement of valuables such as shell from coastal to inland regions that disrupted existing networks of exchange and the contexts in which they were created. In Port Moresby labourers were paid in 'trade goods such as tobacco, hatchets, knives, cloth, canned goods or candy, and trinkets'. Even razor blades and costume jewelry were popular.[8] In the Bena plateau country these types of trade goods were replaced by a more popular currency, in the form of gold-lipped pearlshell that was acquired on the south coast. Workers earned one shell a week for their labour. It was also reported that an American general went

to the trouble of having a ton of shell flown in to pay them, thus 'alarming the Australian Commissioner lest it should be stolen or dispersed too quickly'.[9] Another account says that in June 1943 the Australian New Guinea Administrative Unit had to fly in 1,500 pounds of shell to settle worker unrest among Chimbu working parties.[10]

At the heart of island social life in some parts of Papua New Guinea are ceremonies and festivals, for which masks, costumes, exchange valuables and other goods are produced in abundance. The destruction of land and property, the movement and slaughter of people, and the uncertainty of war had implications for these activities and the social structures that existed around them. A study of male initiation and European intrusion into the Sepik highlights the way initiation rituals were affected by the war.[11] For example, initiation ceremonies in the Yangoru area of the Sepik were disrupted because of fighting and later because of the time required 'to build up a surplus of crops and pigs from depleted stocks of seed tubers and a ravaged bush'.[12] In the Timbunke area, Japanese killings of large numbers of young men meant few were left to ensure the continuation of initiation rituals. Later, restrictions set in place by missionaries meant that initiatory ceremonies in Timbunke did not recommence until 1975.[13] In the upper Markham valley in Papua New Guinea, the commandeering of pigs by Japanese soldiers reportedly caused real hardship and curtailed ceremonial festivities for the Ngarawapum villagers:

> Apart from the care and attention required in raising the animals, they are the principal source of meat in the diet, and complex ceremonial and social values are attached to them. Major festivities cannot be held without them, and they are the main item in brideprice and are exchanged by contending parties in settling disputes. The constant order to hand over pigs thus created more resentment than any other single action... the shortage of meat meant a restricted social life. Ceremonies were frequently cancelled or cut short because there was no flesh available.[14]

In the same report on the Markham valley, the arrival of Japanese forces in one group of villages was the cause for the holding of 'a festival and killing a large

number of pigs. Two years later, one of the reasons given for holding the dances then was a desire to prevent the pigs from falling into the hands of the Japanese.'[15] These events disrupted the production of cultural valuables, artefacts and trade goods associated with important cultural events in community life. They had devastating effects on the production of masks, dance costumes and other accoutrements, not to mention the transmission of cultural knowledge associated with them and their contexts of performance.

However, people's experiences of the Second World War varied across the Pacific region. The impact of the war on initiation rites and associated ceremonies in this area, and indeed Papua New Guinea as a whole, was not homogenous. In contrast to the experiences of the Yangoru and Timbunke mentioned above, other groups in the Sepik suffered no long-term disruption to their ceremonial practices despite the war.[16] Further eastward in the Santa Cruz area of the Solomon Islands, the minimal contact with Americans and Japanese and the scarcity of Western trade goods during the war caused a rejuvenation of craft specialization, and interaction between the islands. Ocean-going trading canoes were built and indigenous forms of trade flourished.[17] Prized cultural items such as feather money were exchanged and crafts such as weaving, and carving associated with seafaring, were sustained. Similarly, in south-west Erromango, Vanuatu, there was a local revival of barkcloth-making due to shortages of European cloth.[18] In Pohnpei in Micronesia, the disruption of trade by the war led to dire food shortages. By the end of hostilities, local people 'were living in rags and had reverted to coconut oil lamps and traditional cooking methods'.[19] The movement of people and the great loss of life also meant that specialist knowledge relating to the arts and associated customs was lost. People who were experts in certain spheres of cultural production were sent to work in new occupations far from home. Some never returned. For those who survived there were further obstacles to overcome. Men who were leaders in their communities before the war would find themselves challenged by younger men who had been living in different circumstances during the war. These men had new experiences and world views and were no longer

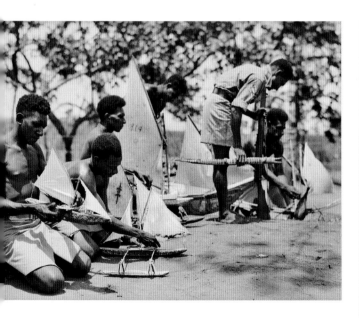

far left
A sergeant of the Papuan Infantry Battalion examining toy sailing canoes, Lae, Papua New Guinea, March 1944.
Australian War Memorial, Canberra.

left
Corporal N. Akers holding a souvenir model canoe made for her during her period of service at Lae, Papua New Guinea, February 1946.
Australian War Memorial, Canberra.

interested in the pre-war structures or pattern of life.[20] In other island groups the contexts for art production coexisted or were only partially disrupted by war. Localized clan warfare continued in some remote areas of Papua New Guinea against the huge backdrop of international conflict. It was both a way of life and a locus for artistic production.[21]

War set new conditions for creative responses from local peoples and the establishment of new patterns of social and cultural life. The increased production of cultural artefacts in some regions is an example of this. A market for artefacts in the Pacific was already established through various colonial and missionary enterprises before the Second World War. It greatly expanded as thousands of troops moved into the Pacific and artefacts were mass-produced to meet the demand from soldiers for souvenirs of their travels. The trade was intense and widespread. Catholic missionary Emery de Klerk wrote in his diary of observing 'a whole fleet of native canoes travelling toward Lungga to trade with American soldiers'.[22] This was a journey from Tangarare in western Guadalcanal to north-central Guadalcanal – a distance of approximately 100 kilometres (60 miles). Popular items included baskets, weaponry such as clubs, arrows and spears, and other portable handicrafts such as fans, hats, walking sticks and model canoes.

In Marovo Lagoon and Gatokae in the Solomons Islands, Islanders saw that they could get cash for the items they produced. This led to a revival of woodcarving and the reproduction of older artefact forms as well as the development of new ones.[23] Manufacturing processes were streamlined to increase the volume of products and profit. Mass production meant that items were created for purposes beyond their customary contexts of use. Fighting in the region led to restrictions in movement and disruptions in the usual networks of trade. Artists who could not source the quantity of material (such as shell) required were forced to use alternative materials and finishes. Workmanship was of variable quality because not all producers were skilled, and shortcuts in setting inlays, carving motifs and shaping wood were taken to speed up production.

In some places objects were created to meet foreign tastes. In Vanuatu servicemen 'asked for specific curios such as "grass skirts" that were not made or used by

Christian ni-Vanuatu of Efate and had to be reinvented'.[24] Likewise, in the Solomons, American soldiers asked locals to make grass and leaf hats although Solomon Islanders had never made either before.[25] On a local level, the outcome of these developments was that specialists with a reputation for creating certain objects competed with less-skilled opportunistic producers – indigenous and non-indigenous. This reduced the specialists' own local market and their ability to exchange their crafts skills for other goods and services. Sometimes producers were as young as fourteen years old and 'actively involved in making walking sticks, combs and grass skirts'.[26] Furthermore, in the Solomon Islands, locals may have produced some of the artefacts but they did not always control the price. As one person said: 'Well, we fished some and then when they said "make handicrafts", we made them…. The soldiers came and took necklaces and shells and they themselves set the price of these things, and then, they paid us.'[27]

Objects once rare and valued were assessed differently as the market became flooded with countless numbers of mass-produced examples. Objects made to serve foreign tastes could conceivably replace or transform indigenous categories of locally produced objects altogether.

The economics of local art production and trade was straightforward, but not always determined by

ERSATZ CURIOS: A FLOURISHING TRADE IN POLYNESIA

The article of commerce popularly known as the Hawaiian grass skirt, is not compounded of grass. In these islands, it is fashioned from the inner bark of the Fau tree (*Hibiscus tiliaceus*). The process, from the tree to finished costume, is long, complicated, and requires skill and patience.

Actually, this 'Ahu More – as the skirt (and the corselet and headpiece which usually go with it) is named – is the only 'curio' available in the islands which is not ersatz. Most of the other objects offered as 'curios' are manufactured by Chinamen and Europeans with the aid of noisy, power-driven machines....

The 'Ahu More are now in great request, as souvenirs, by men of our armed forces. This 'curio' commerce has brought considerable (so-called) Dollar Prosperity to the islands. Unhappily, most of the gain has stuck to the fingers of predatory middlemen. We learn from the radio that the proprietors of the several Hollywood honky-tonks have been 'brought before the beak' on charges of scandalously overcharging men of the armed forces. That, precisely, is what is going on in the islands of the Pacific.

War profiteers are an undying race. As often as not, they are the very men who radio to our soldiers and sailors overseas – 'We are behind you 100 per cent.' So they are; but the percentage is usually very much higher!

The notorious 1920 decade in the United States was a saturnalia of war profiteers – a prolonged Witches' Sabbath of ghouls and harpies fattened on the blood of battlefields.

During this war, the vampires appear to have been frustrated. The little leeches, however, swarm merrily in the jungle growth of the wilderness through which we are passing.

Pacific Islands Monthly, March 1945[i]

A Seabee and an Island worker weaving coconut leaf mats used for house walls and thatching, Espiritu Santo, 14 January 1943.
US National Archives, Washington, DC.

ethnicity or indigenous knowledge. David Akin cites an account of the entrepreneurial spirit of the American soldier, especially those in the construction battalions of the United States Navy such as the Seabees (*page 331*), whose unofficial motto was 'Can Do!':

> Japanese souvenirs were the big item at first, and the Seabees at Guadalcanal had a regular factory for turning out Japanese flags and other items of war booty. But the trade in Japanese trinkets waned with the passing of the Japanese and the major market turned to native souvenirs. A good war club or cane brought five to twenty-five dollars each, native baskets one to five dollars, cowrie necklaces ten to fifteen dollars, etc.

> Ebony when first cut is not black and it was necessary to stain it with shoe blackening in order to satisfy the customers, who wanted their ebony black, as it was supposed to be. When the supply of seasoned ebony ran short it was only natural that inferior woods received an administration of shoe blacking, for the market demanded ebony....

> Seabees discovered that prices increased when their 'native souvenirs' were sold for them by real

Solomon islanders. The Americans then [began to act as] manufacturers and wholesalers.[28]

The account goes on to say that the British tried to start their own trading post dealing in authentic native crafts, but it was unsuccessful. 'The Seabees made better goods and sold them cheaper.'

American troops were particularly remembered for their generosity and willingness to trade. Wherever they went they were admired and relations were generally good. On Kiribati, the scene of several torrid battles, 'the relationships with American troops were so good that some Kiribati people petitioned for American sovereignty'.[29]

Cross-Cultural Exchange

As well as intensifying local levels of artistic production and the revival of some art forms, the Second World War introduced new ideas and images that inspired local artists. Performance arts such as music, songs, hymns and chants had long been fertile territory for cross-cultural exchange. Lamont Lindstrom and Geoffrey White have documented more than one hundred songs that incorporate introduced guitar styles and reflect on the new relationships and

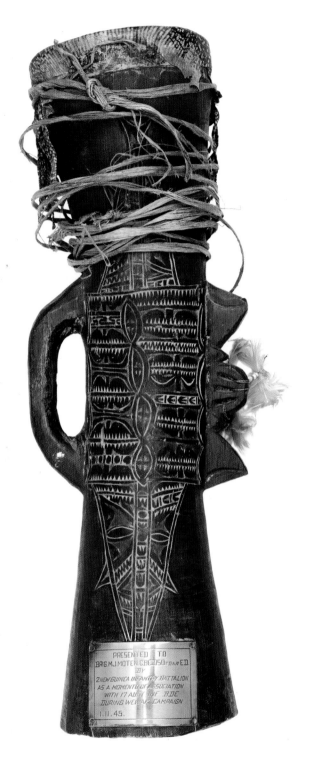

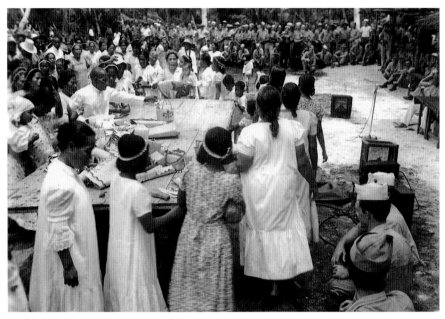

experiences of the war. Some songs lament the destruction that the military brought with them, some record impressions of events, and others are songs of appreciation for and farewell to the Allied and Japanese troops.[30] As with the missionaries and colonial administrators, ceremonies and other types of formal events were created to mark the new relationships between local people and the arrival of foreign military personnel. They occurred on occasions such as welcomes, the opening of buildings and, at the end of the war, the departure of troops and their leaders. Sometimes there was gifting of objects to honour new relationships, but on other occasions the tributes could be monumental. For example, on Guadalcanal in the Solomon Islands a chapel was built in 1943 (*page 336*) by locals and dedicated as a memorial to the 1,600 Americans that lay buried in a cemetery nearby. It was constructed from carefully hewn native timbers and had a 9.1-metre (30 ft) high grandly arched roof, woven matting walls and a bell tower. At the time it was considered by observers to be the finest known example of Solomon Island artistry and craftsmanship.[31] It also highlights the importance of Christian churches and church art in mediating relations between indigenous communities and the occupying forces. These encounters and exchanges not only stimulated art production – they enhanced the prestige and status of locals as well as foreigners.

WAR SONGS

Our temporary quarters makes us really lonesome
It's worse than being in jail.
Because we have assumed the appearance of frogs
Creeping on all fours, gathering,
Tearing up, looking straight ahead.

A Pohnpei song laments the miserable conditions of women
conscripted to work on Japanese military farms. Caroline Islands.

Tears are shed when one thinks
Of the way Funafuti used to look
And of today's scarred land.
We are worse off for America's deeds.
America, America, the rich nation
Loads of money.
But there's one problem –
They buried the taro pit.

A song from Funafuti complains of American destruction
of community gardens. Tuvalu.

The American ship came
Bringing freedom
A lot of food they carried.
Everyone was given some
Cans of eggs,
Cans of hash.
There was also cheese and candy.
Eat and remember.

A Kosrae song commemorates American abundance. Caroline Islands.

Japanese people, remember us and think of us,
As we are staying among you, filled with sadness.

A song of farewell to the Japanese leaving Kiribati.

America your plane circles the island.
When it turns to go, my heart swoons.
When [they] walk to climb [into the plane] I cry.
We have not yet said goodbye.

A song of farewell to American pilots leaving Sikaiana.
Solomon Islands.

Leluh people went away from Leluh;
Half to Fohmseng, half to Puhtuhk;
A few to Lukef, to Limes;
A few to Sihktef, Puhkuhsrihk, and Insief.

Another Kosrae song describes the social fragmentation
caused by enforced evacuation.

War has come.
The young men are leaving
To defend alien land.
The foreigners will be saved.

What has called
The young men away
To become enemy victims?
The conquerors will be happy.

The mother is deserted
Lonely without her son
A barren beggar
Abandoned to heartache.

A Binandere lament for the absence of sons and husbands
recruited as military labourers. Papua New Guinea.

Songs collected by Lamont Lindstrom and Geoffrey White.[i]

The incorporation of foreign elements into these events and other indigenous art forms was not imposed, nor was it always merely for decorative effect or to satisfy some temporary creative whim. Foreign elements were incorporated deliberately by indigenous artists into their performance and design structures, their aesthetic systems. Likewise, foreign soldiers made attempts at incorporating indigenous elements into their artistic endeavours. When the 55 Field Company of Australian Engineers built a theatre stage at Malmal village, Jacquinot Bay, in July 1945, they used locally

carved figures representing a female and male to adorn each side of the newly constructed stage.

Anthropologist Adrienne Kaeppler has documented pieces of Tongan *ngatu* (barkcloth) in museum and private collections that reference the presence of American military forces in the Tongan Islands and Tongan contributions to the war effort in Europe. One of these distinctive pieces features the image of a Lockheed P-38 Lightning fighter plane used by the United States Air Force. The P-38 is usually associated with the 44th Fighter Squadron of the 18th

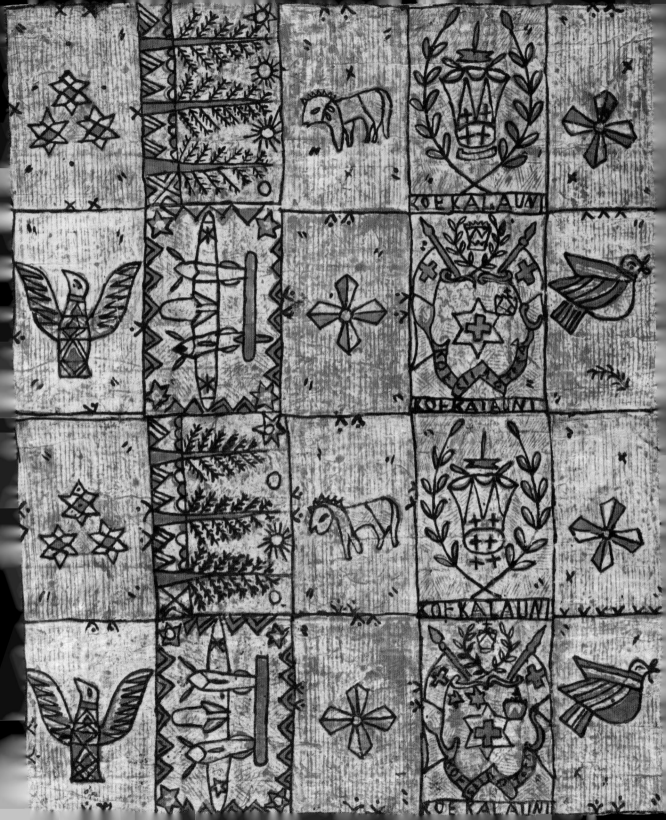

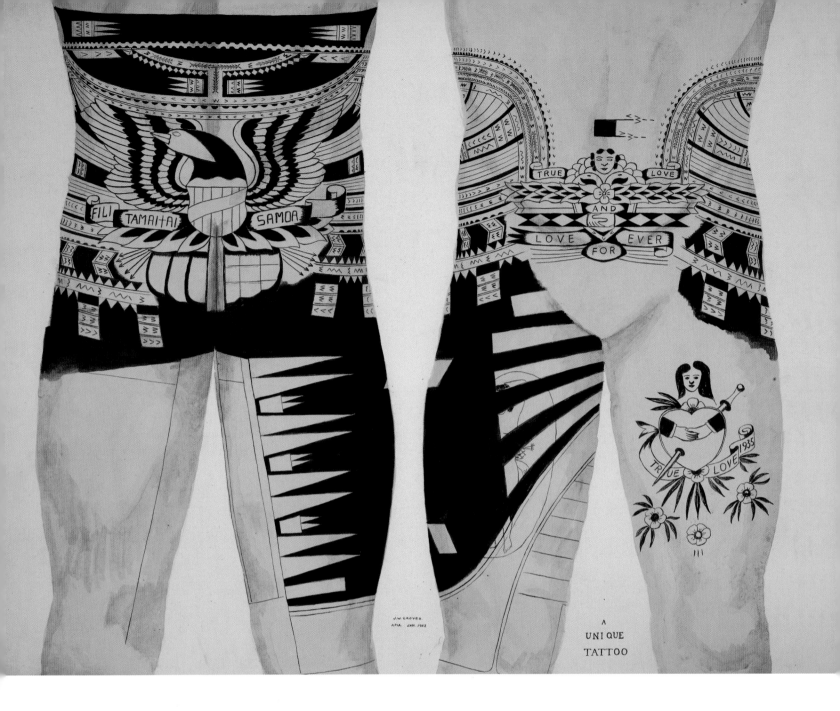

TRUE LOVE

LOVE FOR EVER

FILI TAMAITAI SAMOA

TRUE LOVE 1935

J.W. GROVES. APIA. JAN. 1952.

A UNIQUE TATTOO

Fighter Group, which operated out of several stations in the Pacific throughout the war. It is not clear from the records whether the squadron was based in Tonga, but with its long range the Lightning was used to devastating effect in the Solomon Islands, Vanuatu and Papua New Guinea. It is possible that Tongans who served in the Solomons campaign with the British military may have encountered P-38s there.[32] In this *ngatu* the image of the aircraft sits alongside the well-established *hala paini* (road of pines) motif. Kaeppler has also recorded details about British Spitfire aircraft that have featured on *ngatu*. Under

the influence of Queen Salote, Tonga raised money to purchase four Spitfire aircraft to help Britain during the Second World War. Two of them saw service in battle.[33]

Many United States marines were also stationed in Samoa in the 1940s and 1950s, where extensive body tattooing was a well-established practice. Samoa experienced a huge influx of foreigners as the threat of Japanese attack became a concern. It was a central strategic location and the Americans had formally raised their flag there in 1900. By 1942 there were hundreds of United States marines stationed in Samoan islands. A remarkable series of fifty-two

drawings of Samoan tattooing made in the 1950s by Jack Groves offers insight into the cross-cultural entanglements that emerged from the American presence in wartime Samoa. As elsewhere in the Pacific, the marines' presence introduced new infrastructures, improved roads and communications. War and its associated activities were significant not only for the new technology and entertainments they introduced but also for the exposure to new ideas, markets and products, some of which persisted long after the war. In a manuscript in the British Museum, Groves writes:

> There is a strong tendency nowadays to display the American Eagle in a tattoo design usually as the whole or part of the 'punialo'. This would seem to be the result of occupation of the American troops during the war. There seems to be nothing incongruous to the Samoan mind in a spread eagle appearing in what is entirely a 'fa'asamoa' [*sic*] decoration and it is quite impossible to convince them of it.[34]

Although there is a lack of precise contextual information about Groves's drawings, their very existence raises several questions. The types of images that appear in the drawings suggest that American troops stationed in Samoa during the Second World War were an influence. The incorporation of the American eagle as part of the *punialo* (a tattoo element situated above the groin), and Groves's report that there seemed to be 'nothing incongruous to the Samoan mind' as to whether it is a *fa'asamoa* (Samoan customary) decoration or not, suggest that Samoan tattooists were inspired by new imagery at this time and readily incorporated elements into their own well-established iconography. This may have occurred purely for decorative purposes or to satisfy an individual creative exploration by a particular artist (or client). However, the choice of symbols perhaps signals a patriotic sentiment and commitment to the Allied cause. It is notable that an American eagle with a crest in front was also part of the sign outside the barracks of American Samoa's Fitafita Guard in 1944.[35]

This localized incorporation of foreign imagery into Samoan tattooing occurred alongside an efflorescence of tattooing in the United States military. Tattooing was very popular among United States

marines and sailors stationed in the Pacific region. According to one commentator, the Second World War helped revive tattooing in the West. Although a tradition of tattooing among seamen was already established, war brought thousands more men into the maritime environment and its associated professions. For new servicemen tattooing was a means of marking their rebirth into the military and signalling their association with certain ships, battalions or regiments.[36] Tattoos were markers of ports visited, battles fought and the ships on which people served. Before the war the two-bluebirds tattoo was typically associated with sailors stationed in Hawai'i. A single bluebird was worn by sailors who had completed five thousand miles at sea; two bluebirds for ten thousand miles.[37] The more tattoos a sailor was wearing the longer his service and experience.

The collecting of tattoos by Americans continued in the post-war period in Samoa and influenced change and development of new forms of tattooing. Samoans not only appropriated foreign cultural forms into tattooing, they also modified tattooing to suit non-Samoan demand. Since the Second World War a small American presence in the Samoan islands has persisted. In the late 1960s American Peace Corps

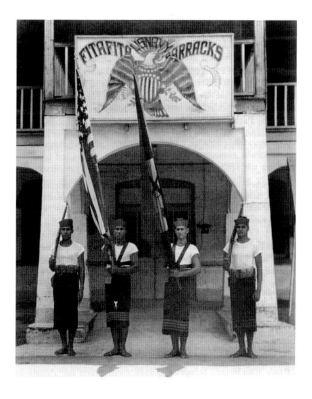

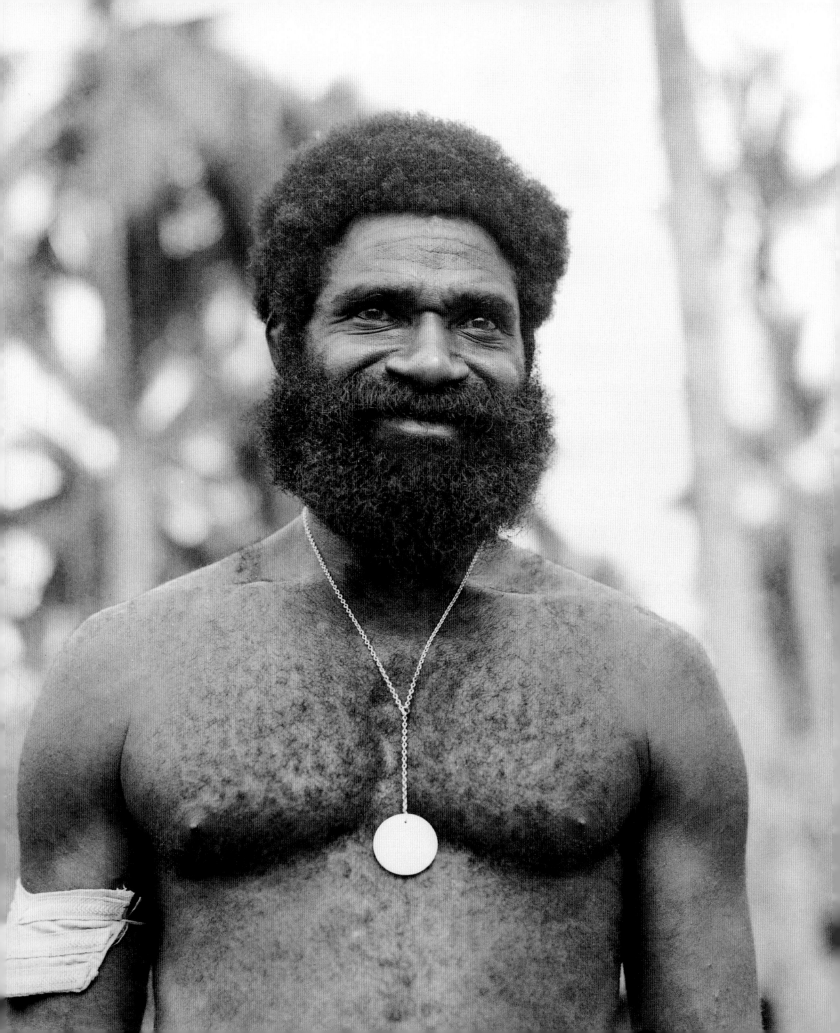

volunteers in Samoa were behind the emergence of tattoos known as 'Peace Corps tatts', or *pe'a pisikoa*. These *taulima* (armbands and wristlets) and *tauvae* (anklets) are to this day popular souvenirs of Samoa for the tourists who can get them, and have become adopted as a significant form of tattooing for people of Samoan descent living overseas.

Military Traditions and Iconographies

Accounts from the nineteenth century record that the iconography of Samoan tattooing was associated with warrior traditions just as it was among Māori and Marquesans. In the twentieth century, warfare inspired the development of a new iconography that incorporated Pacific Islanders into Western military traditions. The largest force for social and cultural change in the Pacific since the arrivals of Christian missionaries was the military. The closest interactions between Islanders and soldiers were on the battlefield and its fringes. This is where Islanders worked as scouts, guides, stretcher-bearers, labourers and fellow combatants. The most formal association of Islanders with the military was in the organization of men into combat or support units. These units had their own identities and were associated with larger formations of Allied troops. People from the Pacific islands had served in the First World War, most notably with New Zealand forces in Europe. Niueans, Fijians, Cook Islanders, I-Kiribati (Gilbertese) and Tuvaluans, among others, were attached to the Māori Pioneer Battalion (New Zealand). During the Second World War, Pacific Islanders were again part of the military. Islanders from across the region and including Tongans, Hawaiians and Fijians were attached to various military units in the Allied forces. The New Zealand army raised the 28th Māori Battalion, which had many other Pacific Islanders serving in its companies.

Military traditions are strong in many indigenous Pacific societies. The clothing, body art and adornments of warrior bodies are culturally distinctive. During the Second World War, Pacific Islanders became part of a new military hierarchy, through their actions but also through a 're-clothing' or a 're-branding' of their bodies. For example, in Papua New Guinea the Native Constabulary wore 'a khaki uniform of shorts, sweater and a peaked cap'.[38] This uniform immediately set them apart from other

locals, creating a role for a select few that was representative of the power and authority of the Allied forces. The indigenous constabulary found themselves acting under instruction and in a position of delegated authority. They played an influential role in maintaining order and recruiting indigenous civilians into working for the military.[39] Like the basic khaki uniforms, Western military insignia of rank, as simple as corporal's or sergeant's stripes, became part of the visual world and were elements that skewed local models of social status. A memorable image is that of Sergeant Yauwika, a chief from the Sepik River district and a member of the native constabulary. In the photograph he is wearing the loyal services medal but also a set of chevrons denoting his rank as sergeant, not sewn into the cloth of a khaki shirt but attached to his bare right arm.

The development of badges and insignia played a critical role in recognizing Pacific Islanders' involvement in the war. Their design combined visual elements that located Pacific Islander signs within the visual schema of the Western military. As in other historical theatres of war and conflict, these badges and insignia served as organizational devices that not only signalled political alliances but also enhanced personal prestige.[40] They highlighted associations between individuals and groups and situated identity in 'visual signs and audible mottos'.[41] They are popular collectibles today because of their associations with history and the dramatic actions of groups and individuals. The iconography compresses shared values and meaning, capturing the essence of people and the groups with which they associate themselves. We can see the synthesis of imagery in the insignia of the Māori Pioneer Battalion (New Zealand) in the First World War and later in the Papua New Guinea battalions of the Second World War.

The Māori Pioneer Battalion badge appropriated the carved Māori head, perhaps a *tekoteko* (carved figure) from a *whare whakairo* (decorated meeting house). Later the Cook Islands Regiment utilized a similar figure of a head that appears more New Zealand Māori in design. The badge of the Pacific Islands Regiment (*overleaf*) of the Australian Army featured the coconut tree, which also appeared in New Zealand Army insignia for the Samoan Expeditionary Force of the First World War and has long been an icon

of Pacific tourist imagery. These images and their
reproduction in other forms of media created imagery
we now recognize as 'Pacific'. In the military they
operated as signifiers of group identity, and, in the case
of the examples cited above, the geographical theatre
of operations. The Western militarization of Pacific
people was a process that worked across several spheres
of society. Badges, insignia and other motifs of the
military are a visual representation of these processes,
some of which were transformative in the region's
history. They are images people rallied behind and
through which they created identities and earned the
sense of citizenship and nationhood. Many Pacific
Islanders were decorated for their bravery and services
during the Second World War. When the courageous
exploits of Papua New Guinea troops and stretcher-
bearers became known in Australia, it transformed
the image of the native from 'savage' to 'soldier'. The
formation of the 28th Māori Battalion (New Zealand)
in the Second World War and the sacrifice of many of
its men on the battlefields of Europe and the Middle
East were later cited by Māori leaders as 'the price
of citizenship'.

If war is a globalizing process, a history of art in
Oceania during the Second World War must branch
out along its many trajectories of interaction and
connection. The art of the Pacific war was produced
at the heart of the conflict by Pacific Islanders but also
by people from nations within and along its rim –
especially the United States, New Zealand, Australia
and Japan. The Pacific war had far-reaching
consequences in the region and beyond. It is worth
mentioning in detail one instance here. For Japan,

its imperial ambitions in the Pacific had consequences
for ancient coveted art forms at home. As part of the
Japanese military machine, production in core
industries and technology increased on a massive
scale. A notable example related to cultural artefacts
was the revival of one-thousand-year-old sword-
forging techniques alongside the mechanical mass
production of swords. Historically, the making of
swords in Japan was closely associated with samurai
warriors. Although not practical in modern warfare,
the sword was symbolic of this warrior class of former
times. Large numbers of what are termed Gunto
swords were made for Japanese military campaigns in
the late nineteenth and early twentieth century and the
Pacific war. However, at the start of the Second World
War the manufacture of swords had to increase to meet
the huge demand of the military. The mass production
of swords led to the stereotype of the Japanese sword in
the war as cheap and inferior; Gunto were so-called

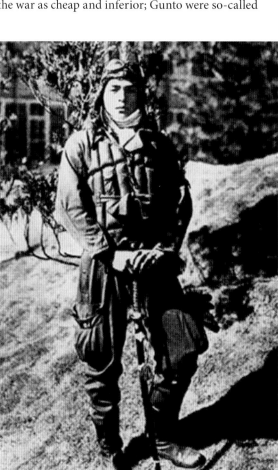

Crew of B24J-80–CO (42–100230) 'Island Queen', c. 1944.

Showa-to swords that were produced from mass-produced Western steel.[42] These types of swords were produced in their thousands for the military. There are records of one factory equipped with twenty-five machines that produced one thousand Gunto every month.[43] However, expertly crafted forged Yasukuni-to swords also appeared at the beginning of the war at the request of the military, in reaction to the Showa-to swords of lower quality and out of a desire to preserve time-honoured forging techniques.[44]

Also part of Oceania's art history are the many non-indigenous artists trained in drawing, sculpture and painting whose skills were put to use in the Pacific war. The Japanese and Allied nations commissioned war artists who worked in the field. The Allied war artists were required to capture the everyday lives of soldiers, to show the people at home that their boys were 'doing okay'. One writer has argued that photography was seen as too harsh a reality for most people at home, although the essential nature of the artists' work was still documentary in nature.[45] Japanese artists who joined the military found no shortage of work and were given officer treatment. Artists at home were required to produce works that supported the war effort.[46] Their work appeared in posters, cartoons and textiles where it was used as propaganda on the home front. The study of civilian wartime textiles with wartime motifs shows us that American examples were mainly items of women's clothing such as headscarves, blouses and dresses. In Japan propaganda images appeared mainly on men's clothing such as *nagajuban* (long under-kimono) or the linings of *haori* (jackets worn with kimono). Kimono for young boys also included military imagery. Themes and motifs found on propaganda textiles relate to modernity, empire, militarism, patriotism, sacrifice, heroes and leaders, text (slogans, words and songs), alliances (Allies and Axis) and victory. They were an important 'reiteration of the military and political objectives of countries in a state of total war'.[47] These forms of war's visual culture 'embraced the participation of ordinary citizens as well as artists and designers…in the furtherance of war and the attitudes of war'.[48] Significantly, film would prove to be another visual medium important for propaganda, fundraising and morale building. Shot on location by US navy film crews and shown in American

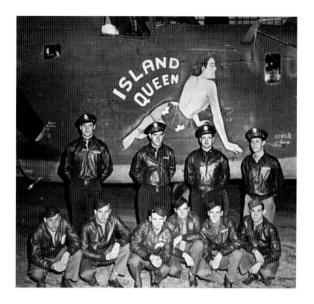

neighbourhood theatres, the war was clearly fought in the hearts and minds of people at home as much as it was in the islands and among the people of the Pacific.

Images of the Pacific and the experiences of war travelled through the region and across the world in various forms of media. Visual elements already long established in nineteenth-century art, and the postcard trade of the late nineteenth and early twentieth centuries, included hula dancers swaying, reclining 'island belles', orange sunsets and coconut trees hanging over sandy beaches. Images of hula girls with slogans such as 'Shakes all over', 'Honolulu Tina' and 'Island Queen' were conspicuous decorations on the noses of aircraft in the Pacific campaign. The written word, newspaper reports, diaries and letters to loved ones at home recorded experiences of fighting men. Images of the Pacific also made their way through advertising and artefacts created by servicemen such as pins, brooches and trinkets. One soldier sent home a Christmas card on a biscuit that perfectly captured the elements of an island paradise amidst the horrors of war (*page 346*). The increasing commercialization and mass distribution of these images were a precursor of things to come.

Memories, Ruins and New Beginnings

The art of the Second World War is not confined to the period of the war or the years immediately afterward. The scars of war run deep in people's memories as well

War Art

N THE TITLE SEQUENCE OF THE HBO television series *The Pacific* (2010) about the fate of a handful of American soldiers during the Second World War, the making of charcoal drawings is combined with black-and-white cinematic recreations of marines in the heat of combat. Drawing merges with the realism of film as film merges with the artifice of drawing. The sequence paid homage to the work of war artists, while at the same time raising questions about the constructed nature of representations of the war: how are they made, who are they for, what messages do they convey, and what do they omit? The series itself is a case in point. For in focusing exclusively on the experiences of American soldiers (and their general enemy), it elided the role of other relevant actors. Indigenous people, for example, are nowhere to be seen. Guadalcanal, New Britain, Peleliu – these places were depicted as if they were empty arenas rather than the homelands of Islanders caught in the clash of empires.

The absence of Islanders from representations of the war was also characteristic of art made at the time. Although it would seem that war artists would be a rich source of images of Pacific people, this is not borne out by the works they produced. What stood out, rather, was the environment – the forest or the beaches.

Australian war artist Sali Herman's *Natives Carrying Wounded* (1946) is one of the few exceptions. Based on sketches made in either Bougainville or New Britain, and painted in the artist's Sydney studio, the painting demonstrates the important role that New Guinea men played in the war effort, as carriers of wounded Australian soldiers from the front lines. As Herman put it: 'Many a man owes his life to the speedy action of the carriers. Each time I saw it, it was a dramatic and impressive sight.'[i]

The painting won the Sulman Prize in 1946 and was one of many public tributes to the so-called Fuzzy Wuzzy Angels. Herman's painting avoids the sentimentality and paternalism of some of these tributes. Nevertheless, it remains charged with racial and colonial tensions that it does not quite overcome. As Stewart Firth points out, native labour under colonial administration typically consisted of roles such as 'carrier and fetcher'. During the war, thousands of New Guinea men were conscripted to serve in that capacity by the Australian military government whether they wanted to or not, carrying ammunition and supplies to the front lines and wounded soldiers back again. The job was often onerous. Men were overloaded and overworked. Some deserted when they had the chance. New Guineans were forced into similar roles for the Japanese, depending on their location. Firth also points out the heterogeneity of this conscripted labour force. Men were forced to work alongside men from other tribes, sometimes with traditional enemies – a disagreeable situation that could erupt in conflict.[ii] Moreover, colonial hierarchies and racist attitudes persisted in relations between Australians and New Guineans in the first decades after the war.[iii]

Such tensions sit just below the surface of Herman's painting. He focuses on the strength and vulnerability of human bodies, and the basic moral act of aiding someone different who is wounded – historical conditions notwithstanding. But perhaps it is the surface itself that conveys the theme of difference most convincingly. Colour and texture are the most striking formal aspects of the painting: the proximity of brown and white bodies; the impasto treatment of the forest and track; the vibrant hues and near-autonomous shapes, bordering on the abstract, of the New Guineans' coloured sarongs. The sarongs echo the chromatic harmonies of Paul Gauguin and code the men as exotic, perhaps as different from each other as they are from Australian soldiers. It is through such abstract harmonies of colour, shape and form that the painting attempts to sublimate its historical and ideological undercurrents. PB

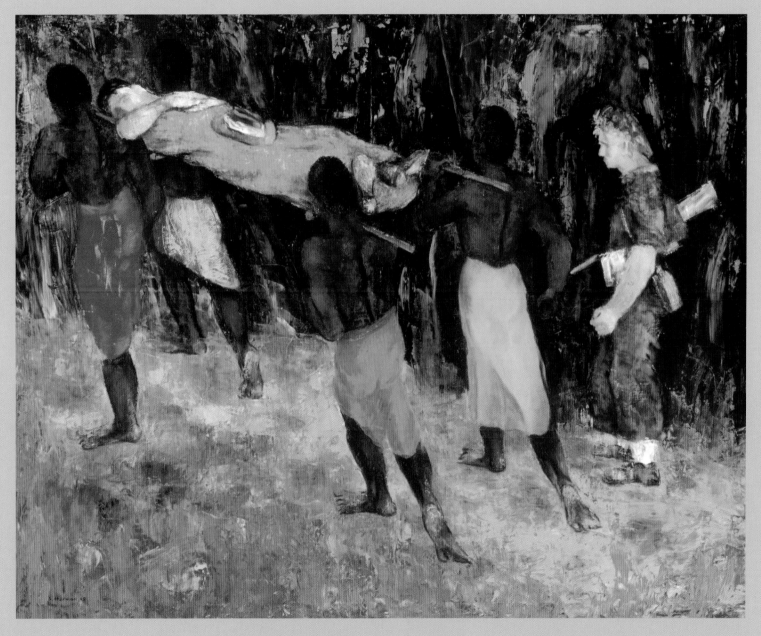

Sali Herman,
Natives Carrying Wounded, **1946.**
Oil on canvas, 102 x 127 cm
(40⅛ x 50 in.). Australian War
Memorial, Canberra.

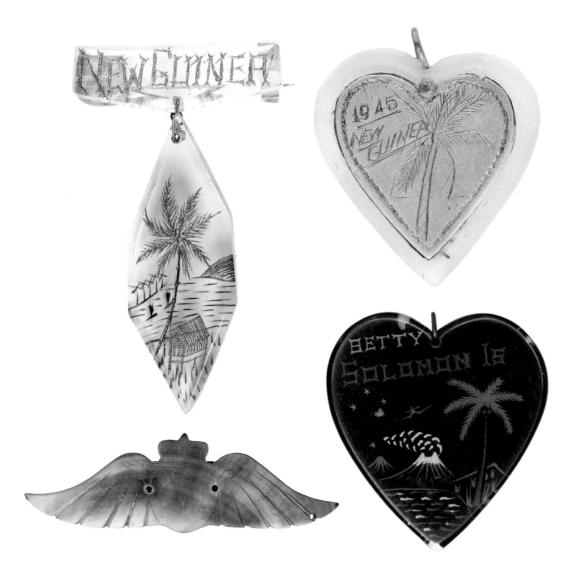

left

'Sweetheart' pendant and brooches, 1943–45.
Clockwise from top left: 'Sweetheart brooch', Papua New Guinea, perspex, *c.* 1943–45. 'Sweetheart pendant', Papua New Guinea, perspex and aluminium, 1945. 'Sweetheart pendant', Solomon Islands, Sergeant J. E. Patterson, 9 Australian Infantry Battalion. 'Mother-of-pearl wings brooch', shell, *c.* 1943–45. Australian War Memorial, Canberra.

The production of the visual culture of war was fuelled by boredom, creativity and small scale entrepreneurs both indigenous and foreign. Objects made from recycled materials from battlefields are now called 'trench art' and are highly sought after by contemporary collectors.

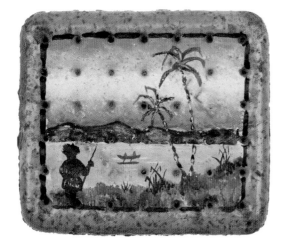

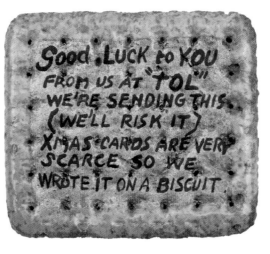

left

Victor John Robertson, 'Christmas card made from a biscuit', Bismarck Archipelago, New Britain (Papua New Guinea), December 1945.
Biscuit and paint.
Australian War Memorial, Canberra.

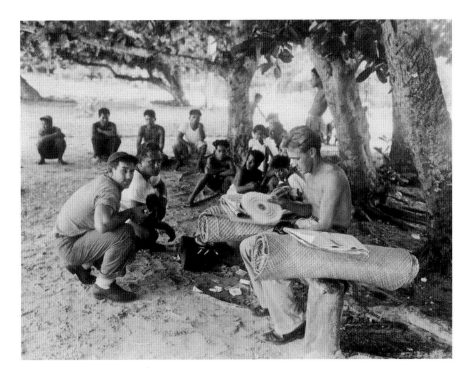

as the landscape and environment around them. The
experiences of the war live in the imagination of people
who were born years after the last shots were fired on
their shores. Today contemporary artists in the Pacific
reflect on their ancestors' experiences of the First and
Second World Wars, using their work to lay claim to
the past and make commentary on it from their own
knowledge of history. It is significant when we look at
their art that much of it centres on death and sacrifice
as a means of claiming citizenship or nationhood.
Both wars are still very much part of the lives of Pacific
Islanders in the northern Pacific and Papua New
Guinea through songs, chants and performances.
These art forms extend the memory of many Pacific
Islanders and ensure stories are passed on. Abandoned
planes, vehicles and other machinery are now relics of
the Second World War that are visited by veterans
returning to old battlefields. Prefabricated quonset huts
are still a prominent part of the architectural landscape
of Honiara and Guam, and discarded materials and
equipment are still repurposed in villages and
townships. Today the tourist imagery of the islands
often features the wreckage of ships or the bush-clad
remains of crashed military aircraft. If the rest of the
world has moved on, the remnants of war are literally
embedded in the shorelines and jungles of the Pacific

(*page 326*). In the twenty-first century many tourists
to the islands are retired or serving military personnel.
There is still a strong United States military presence
in Hawai'i and in the Federated States of Micronesia.
Indigenous activists would say it is an occupation.
Further south there is a recent history of violent conflict
in places such as Bougainville and the Solomon Islands
and New Zealand, and Australian military forces have
maintained military ties to several territories.

In many ways the activities of war sowed the seeds
for the region's recovery after the conflict had passed.
Roads and infrastructure, new technologies and
materials, access to new ideas and forms of business,
all saw local and international communications
improve. Opening up the Pacific on a much wider scale
enabled the further development of local economies
and businesses. The world would connect to the Pacific
region in new ways, but the world would also become
more familiar with the Pacific as its people, cultures,
resources and imagery flowed outward and around
the globe. It was the beginning of a period in Pacific
history when the influence of colonizing nations would
be eroded and self-determination would become
a focus of art, activism and the rebuilding of island
nations from the ruins of war.

ARTS OF THE
SOUTH SEAS

Peter Brunt

DECOLONIZATION, INDEPENDENCE AND CULTURAL REVIVAL 1945–89

In 1946 the Museum of Modern Art in New York City mounted a watershed exhibition entitled 'Arts of the South Seas'. The topicality of the exhibition reflected the remarkable prominence of the Pacific Islands in American consciousness in the aftermath of the Second World War. For the Pacific had been a major theatre of American participation in that conflict, with hundreds of thousands of soldiers stationed in the south Pacific, and numerous islands the scene of fierce battles, in the long campaign to drive back the Japanese. The encounter between Americans and Islanders deeply affected their perceptions of each other. The awesome might of the American military complex transformed the consciousness of many Islanders, in places igniting imaginings of a specifically American future, filled with the promise of unlimited wealth, material goods and powers over nature.[1] Conversely, the American perception of the Pacific was equally ecstatic, inspiring

popular musicals such as Rodgers and Hammerstein's *South Pacific*, which opened on Broadway in 1949, and exhibitions such as 'Arts of the South Seas'.

Mounted the year following the establishment of the United Nations General Assembly, which would oversee the dismantling of colonial empires in the following decades, the exhibition placed the subject of art in Oceania on the agenda of that imminent political future. The show comprised objects selected from ethnographic collections in mainly American museums, which it famously redisplayed as 'works of art', emphasizing their formal qualities by careful selection, lighting and placement. At the same time it supplemented the aesthetic experience of the exhibition with a scholarly catalogue about the region's history and artistic traditions.[2] The aesthetic appreciation of Oceanic art was not new. Since the early twentieth century, European modernists and anthropologists had

collected, emulated, written about, and admired it within the category of 'primitive art'. What *was* new, according to art historian Robert Goldwater, was the broad public acceptance of such objects as art, occurring in Western metropolises in the mid-twentieth century in large part through the sanction of institutions such as the Museum of Modern Art.[3]

But in view of the show's historical moment, the significance of the recategorization was ambiguous. On the one hand, it signalled the liberality of modernist aesthetics, drawing objects previously regarded as curiosities, idols or ethnographic documents into a discourse about the universality of artistic form and feeling. Their new status challenged centuries of racial prejudice about art as an exclusive index of European superiority. On the other hand, becoming art carried more problematic implications, particularly for the cultures whose art was on view. As Goldwater pointed out, writing in 1966, the 'trend' towards 'complete aesthetic acceptance' coincided with the process of global decolonization. It was 'hastened by the establishment of the former colonies as independent nations and the transformation of their traditional cultures under the impact of modern technology and economy. The result was that with only a few exceptions the primitive arts became arts of the past (in some cases the very recent past), and thus lost part of their previous function as documentation of contemporary primitive cultures.'[4] In other words, becoming art in the modern sense was allied to a narrative of modern nationhood in which 'traditional cultures' and 'primitive' life forms were destined to obsolescence.

Behind Goldwater's statement is a fundamental modernist narrative about the fate of art in modernity, encapsulated in the nineteenth-century philosopher G. W. F. Hegel's famous dictum that 'art, considered in its highest vocation, is and remains for us, a thing of the past'.[5] Written in the wake of the French Revolution, the 'us' Hegel refers to are Western Europeans caught up in the turbulence of their own transition into modern nationhood more than a hundred years earlier. The dictum summarized what he saw as the destiny of art in the modern world, in which the power of art to give 'sensuous immediacy' to human worlds (its 'highest vocation') is eclipsed by the state's rational, secular, legalistic and bureaucratic

character. Art is rendered obsolete and marginal to the operations of the modern state. However, it is revalorized as something essentially aesthetic and historical. Hence the birth of the two dominant institutions of art in Western modernity: the art museum and art history. Moreover, the continuance of art in Western modernity was premised on this sense of its historical nature and marginal social status – as the history of Western modernism and the avant-garde, with their rapid succession of 'isms' and 'movements', has shown.

'Arts of the South Seas', poised on the threshold of global decolonization, was thus a deeply loaded exhibition. Its objects, gathered from museums, pointed to the impact of colonialism and the imperial order on Pacific societies, while its occasion pointed enigmatically to a postcolonial future. It begged the question of the future of the societies that its artworks displayed. For Goldwater, they must give way to the irresistible transformations entailed in the making of modern nation states and the spread of 'universal civilization', summed up by Paul Ricoeur in 1955 as the ineluctable forces of democratization, capitalist economics and science and technology.[6] In this context, the artistic traditions of these societies were fated to become arts of the past, as many already had. But the history of decolonization in the Pacific would prove less punctual, more contradictory and ambiguous, than Goldwater's stoic aestheticism allowed.

The Lull: Kitsch, Spectacle and the Lament for Lost Authenticity

The first decade or so after the Second World War was marked by a kind of lull in the Pacific, a pause between the demise of the imperial system and the political restructuring that dominated the region from the 1960s to the 1980s. This was a period of anticipation but uncertainty. Many developments clearly pointed to a postcolonial future. The 'great powers' had signalled their intention to reorder the world system at various summits after the war. Colonies in Africa and South Asia were already crumbling. More locally, indentured labour laws were lifted in Australian New Guinea; France granted greater political autonomy to its Pacific territories; independence parties formed in Tahiti and New Caledonia; preparations for independence were under way in Western Samoa; and so on. Nonetheless,

opportunities to collect genuine 'primitive art', given the proliferation of art produced for the market and the disruptive effects of the war, Christianization, commercial enterprise and colonial bureaucracy on the kind of societies that produced it. The rhetoric of the 'vanishing primitive', which had always accompanied European collecting habits, was becoming a reality. The anthropologist Claude Lévi-Strauss gave voice to this fear in his popular book *Tristes Tropiques*, published in 1955, in which he laments the end of anthropology's quest for knowledge of the 'primitive', given the pervasiveness of Western civilization throughout the world.[7] Sharing this anxiety, museums mounted collecting expeditions like last-ditch efforts to acquire – 'Before It Is Too Late', as one headline put it – what remained of authentic 'primitive art'.[8]

Take, for example, Michael Rockefeller's ill-fated expedition to the Asmat in Netherlands New Guinea in 1961 ('ill-fated' because he lost his life under obscure circumstances after his catamaran overturned).[9] Rockefeller, son of New York governor Nelson Rockefeller, was a wealthy young adventurer, collector and photographer who undertook the expedition to acquire examples of Asmat art for the recently established Museum of Primitive Art in New York, where he was also a trustee. The Asmat, who had only recently and very partially come within the control of Dutch administrators and the persuasions of Catholic priests, were among the most fascinating of New Guinea's tribes because of their spectacular art traditions associated with a culture of ritualized headhunting. While headhunting had been largely abandoned by 1961, much of its ritual and material culture was still thriving, though clearly affected by the interests of missionaries, administrators and anthropologists – all of whom played a role in facilitating Rockefeller's expedition. Indeed, much of what was seen by him and his entourage – the dances, the spectacular canoe races, the river journeys, and the array of shields, ceremonial poles, drums, etcetera laid out for bargaining – was staged for his benefit and his cameras (*page 353*). In fact the expedition, whatever its ethnographic value, could be more usefully seen in terms of the importance for both parties of creating relationships. Western 'big men' with powerful fathers from prestigious art institutions in one of the world's superpowers were clearly worth entertaining. Such

the future of imperial rule was still unclear. Pre-war governance structures were restored in many places after the war. Racial ideologies of white superiority and right to rule remained in place (and would not definitively crumble until the 1960s or later). Settlers in colonial towns expected reform but not necessarily the complete dismantling of the imperial order. And in places where 'development' was minimal – in much of New Guinea and the New Hebrides, for example – indigenous self-government seemed a long way off.

In this liminal state the subject of art in the Pacific was largely inchoate, dispersed in a variety of aesthetically ambiguous contexts. One of these lay at the intersection between art museums, cultural anthropology, the tribal art trade and an uncounted number of small hamlets and villages, particularly in New Guinea and island Melanesia, which still produced or possessed the 'authentic' or 'quality pieces' that primitive art collectors and museums desired. 'Arts of the South Seas' exemplified this intersection. While this nexus of activities was certainly continuous with practices before the war, the post-war period was marked by a growing anxiety about the shrinking

'WHY DID MY PEOPLE ABANDON THEIR FESTIVALS?'

When the *Hevehe* masks finally came out of the *eravo* they danced in the village for a month. In the end the spirits had to be driven back into the spirit world after staying with us for so long. This was accomplished ceremonially by the slaying of the *Hevehe*, in which a young man was selected to shoot an arrow at the leader of the masks and 'kill' it. After that the masks are ceremonially burned and the ashes and all other remains from the *Hevehe* festival are thrown into the sea where the great spirit of all *Hevehes* resides, who will swallow them up.

Unfortunately, this ceremony was discontinued just before the war and even the Kovave itself was abandoned some twenty-five years ago. My own Kovave initiation was the one before the last.

Why did my people abandon their festivals? The missionaries got a lot of the blame. It is true, of course, that they did not like the initiation rites and rather tended to discourage them. But at that time their influence was not all that great in Orokolo.

I believe that taxation was a major factor. Even though the tax was only ten shillings per head at first, and one pound later on, the young men had to go out and earn it for themselves and their fathers. So they drifted off to Kerema and maybe Moresby, seeking employment in shops or with white masters. While they were earning the money nobody remained at home to take an active part in the ceremonies. Many of them lost interest when they saw other, more 'respectable' ways of life.

Excerpt from Albert Maori Kiki, *Kiki: Ten Thousand Years in a Lifetime:
A New Guinea Autobiography*, Melbourne, 1968[i]

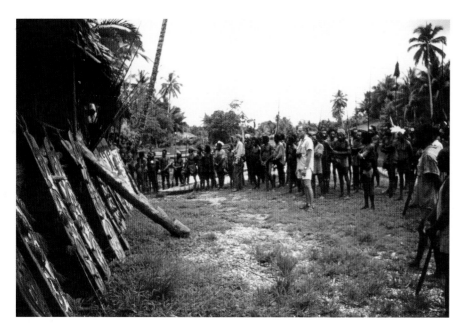

relationships were vital to the future of Asmat culture. Nonetheless, tropes of the 'last' and the 'vanishing' were indomitable and widely recycled in documentary films, illustrated magazines, television features, newspaper articles and so on.

The counterpart to this lament for lost authenticity in the immediate post-war decades was the proliferation of tourist art and Oceanic kitsch. As discussed in the previous chapter, the presence of hundreds of thousands of soldiers in the Pacific during the Second World War created a lucrative trade in artefacts and souvenirs – 'ersatz curios', as one writer called them.[10] The impact of that exchange reverberates in the post-war popularization of Oceanic art within the visual culture of the American leisure industry. Hotels, motels, restaurant chains and cocktail lounges with names like 'Trader Vics', 'Tiki Bobs' and 'Aloha Joes' multiplied across the American suburban landscape in the 1950s and 1960s. Their decor schemes and advertising graphics appropriated Oceanic art forms from art books and exhibition catalogues. Masks and figurines became lounge ornaments, while entertainment shows mimicked cannibals, headhunters and hula dancers in a vast burlesque of Lévi-Strauss's historical lament.[11] Although the genre has its charms, the translation of god figures and ritual sacra into paperweights and saltshakers represents, at its furthest

Art of the Abelam

THE ABELAM ARE ONE OF THE LARGEST groups in lowland Papua New Guinea. They live in villages of up to 900 people in the foothills of the Prince Alexander Mountains, north of the Sepik River. The Australian administration first established a government post in their territory in 1937, re-establishing it in 1948 after the Japanese occupation. Thus it was only from the Second World War that the Abelam were significantly affected by colonial influence, and only after that time that their art came to the attention of the wider world. The energetic, brightly coloured carvings and paintings made as part of the long yam cult, displayed on and in the cult houses, have since attracted substantial international interest, especially on the part of museums. Whole cult house facades and the carved and woven displays within them have been collected by a number of museums, the Australian Museum and the British Museum among them. A number of anthropologists, notably Anthony Forge and Diane Losche, have worked with Abelam communities and have been drawn by that engagement into discussing the anthropology of art, to questions about the meaning and significance of specific designs and images and into broader questions about the nature of art in those societies where such a category does not exist.

Abelam art is displayed in the village, in and in front of men's cult houses. Abelam hamlets are built on ridges; the houses are built around a central plaza, the forest behind them. Many hamlets have a cult house, which towers over the domestic houses. Houses have an A-frame construction dependent on a long ridge pole, supported close to the ground at the back of the house and sweeping up at the front; cult-house ridge poles can rear up to 18 metres (59 ft) high.

The sides of the house, sloping away from the ridge pole to the ground, are at the same time its roof, thatched with sago palm leaves. The Abelam see the roof-sides of the house as being like the folded wings of a bird, enclosing the space within.[i] The facade of the cult house is painted in a range of reds, yellows, black and white, in designs that often represent the clan spirits, or *ngwalndu*.

The long yam cult focuses on the growing, display and exchange of special yams, single straight cylindrical tubers that are carefully and ritually cultivated to reach lengths of more than 2.5 or 3 metres (8–10 ft). To be a man of substance a man must be able to grow such yams: as the anthropologist Phyllis Kaberry observed, there is a great deal of identification between a man and his yam; there is also a great deal of identification between the yam and the supernatural.[ii] Initiation rituals, focused on the long yam cult, involve the manufacture of woven and carved painted figures, representing clan spirits, which are displayed inside the house, decorated with leaves, flowers and fruit. This process of making – the production of yams, of carvings and paintings – draws man and spirit together. The Abelam see paint as crucial to that process.

The Abelam do not think about art, but about the power of images and especially of paint itself. All Abelam magical substances are classed as paint, various colours being suitable for various purposes; red and a sort of purple, the colours of the substances used for sorcery and long yams, are regarded as the most powerful.[iii] For the Abelam, painting is a sacred activity: in ritual contexts the paint itself is the medium through which the benefits of the ceremony are transferred to the initiates and to the village as a whole. Paint is the essential magical substance of the yam cult.　　LB

**Decorated men's house,
Abelam tribe, Sepik District,
New Guinea.**
Photograph Anthony Forge, 1962.

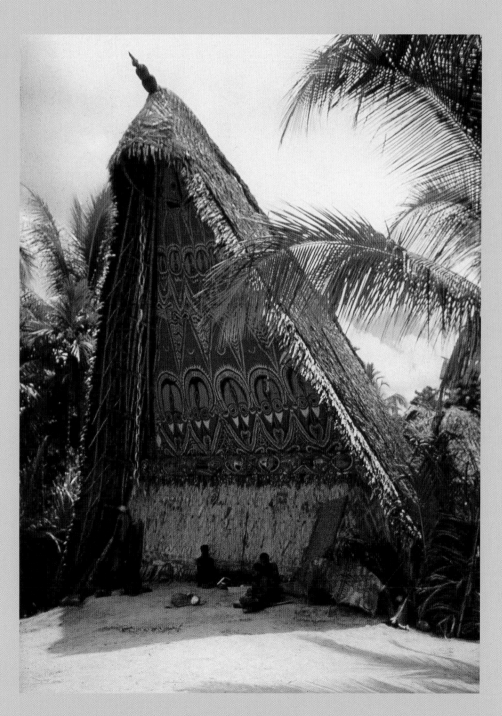

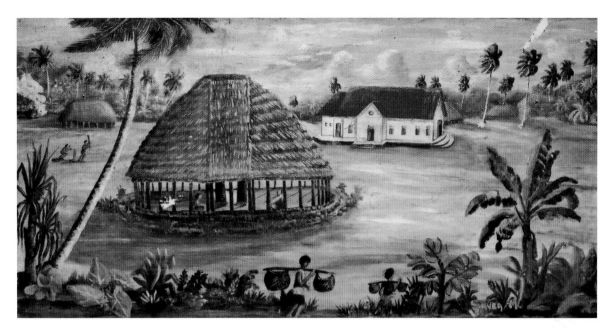

extreme, the radical dissemination of Oceanic art into mass-produced commodities, unredeemed by the quasi-sanctity of the art museum. The phenomenon was not confined to the United States. It extended into Oceania as well, in towns such as Honolulu, Papeete, Apia, Rotorua, Port Vila, Agana and elsewhere. Indigenous artists made carvings and handicrafts for commercial enterprises overseas and Islanders provided performers for entertainment shows in hotels and tourist parks. The Pacific was also translated into countless pictorial variations of noble chiefs, sunset beaches, dusky maidens, palm-tree villages and other clichéd variations of the erotic and picturesque – a set of genres produced by a host of travelling artists, amateur painters and Islanders as well. As Sima Urale demonstrates in her documentary film on the velvet painter Charles McPhee, the heyday of these popular genres corresponded with the twilight years of the colonial Pacific, when its visual stereotype reigned unchallenged.[12]

Customary arts were also increasingly bound to tourism and media spectacle. From the late 1940s the Pacific Islands upgraded or built new airfields and hotels, and linked into international airline routes in order to capitalize on the economic opportunities of an expanded tourist industry in the looming 'jet age'. In 1956 the first Goroka show was staged in the New Guinea Highlands as a spectacular event featuring

some 10,000 native performers assembled for dances, games, mock fights and the like, dressed in dazzling displays of traditional costume. Although the show was conceived by the Australian administration in order to build regional unity across rival tribal groups, its success was inseparable from the attendance of hundreds of European visitors 'with expensive cameras, exposure meters and tripods...taking movies or expensive colour stills'.[13] In 1961 a similar event, the Mount Hagen show, also in New Guinea, described by *Pacific Islands Monthly* as 'the greatest native show on earth', featured a staggering seventy thousand participants and was attended by over a thousand European visitors, including documentary filmmakers and editors of international magazines such as *National Geographic* and *American Reader's Digest*, people flown in on chartered aircraft.[14] In other words, the Pacific was bound up in what Guy Debord called the vast 'spectacularization' of society in the post-war era, dominated by consumer capitalism in which the image itself, in a variety of media, was the primary object of production and consumption.[15] Exoticized and stereotyped, Pacific Islanders were part of that spectacle, but they were also among its producers and consumers. The Pacific had its picture theatres and magazines, and Islanders were as familiar with John Wayne and Mickey Mouse as other consumers of the global 'culture industry'. And if society was turned into 'spectacle' by post-war capitalism, 'spectacle' could be turned into society, as occurred in numerous ways in the Pacific.

Yet the expansion of tourism and the commercialization of Pacific cultures as the predominant vehicles for Oceanic art also prompted a growing anxiety within indigenous communities, particularly among their leadership elites. As movements for political decolonization picked up in the 1960s and 1970s, there were calls to reassert control over the production, value and meaning of their artistic legacy. Consider, for example, the case of the Institute of Māori Arts and Crafts in Rotorua, New Zealand. Rotorua had been a tourist destination since the

Mount Hagen show, 1965.
Photograph David Beal/ANTA, State Library NSW, Sydney.

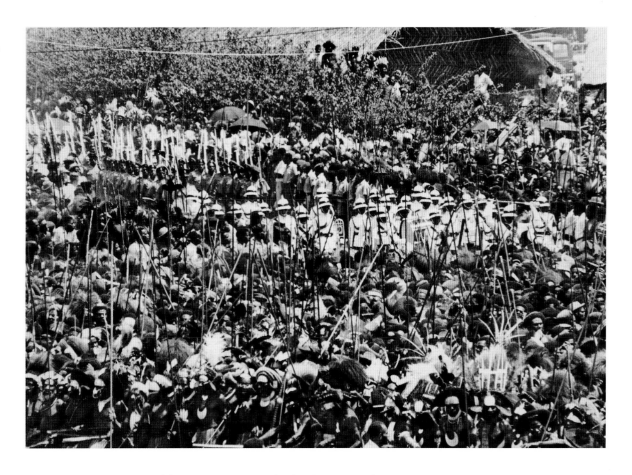

nineteenth century, featuring Māori cultural performances, tours in geothermal parks and souvenirs for sale. It was also where Sir Āpirana Ngata established the School of Māori Arts and Crafts in 1927, which spearheaded the recovery of the art of carving from near oblivion and did much to rehabilitate *whare whakairo* (carved and decorated meeting houses) and Māori ceremonies among tribes and sub-tribes in the 1930s and 1940s.[16] The School had waned after the war but was re-established by an Act of Parliament in 1963 as the Institute of Māori Arts and Crafts, and placed under the Department of Tourism. But while the School had managed to balance its services to the tourist industry with the goals of cultural preservation, the Institute found itself increasingly dominated by tourism. It became a closed system, producing qualified carvers to produce high-end souvenirs for a very limited market, effectively centred around the Institute itself. However, in a telling shift, the Institute was criticized by other Māori. Some Māori modernists (to be discussed later in the chapter) saw the Institute as irrelevant and out of date, while Māori academic Hirini Moko Mead felt that its educational functions had been compromised by its placement under the Department of Tourism. Pointing to the 'fenced and raised walk-way' provided for tourists to 'look down in safety upon the curiosities working at their benches' (*see page 402*), Mead concluded: 'The trainees and their instructor are exhibited like prize animals in a zoo.'[17] Such critiques indicated a new assertiveness about the value and meaning of indigenous art and culture. The lull was over.

Nationhood, the Arts and Cultural Revival

The drive for independence and political re-empowerment, which galvanized the Pacific from the 1960s to the 1980s, refocused the relevance of art and the arts in Oceania. Above all, the prospect of new nationhood brought about a dramatic resurgence of customary culture and tradition, recoded in national terms. The ethos of revival was encapsulated by Sir Āpirana Ngata in 1947 (the year New Zealand became formally independent from Great Britain) when he predicted that 'a great future lay ahead of the Pacific' and admonished Māori to 'take a bigger part in the economic, social and commercial life of New Zealand, and *to keep alive their native traditions and bring about*

a full revival of Māori culture'.[18] Ngata's philosophy of reviving 'native traditions' while embracing the conditions of modern nationhood would be echoed by indigenous leaders across the Pacific as decolonization became a political reality, beginning in the 1960s.

The political history of decolonization is complex and cannot be fully recounted here, but a few salient points are worth making. One is the dramatic nature of imperial withdrawal from the Pacific (as from other parts of the world). At the end of the Second World War the entire region was under some form of direct imperial or external rule. By the end of the 1980s imperial governance had largely been dismantled, leaving in its wake a host of new Pacific states. Bar some exceptions, most were fully independent nations or independent 'in free association with' their former colonial power. Where independence had not been achieved, or stalled or formally rejected, those continuing territories nonetheless enjoyed significantly greater political autonomy than existed in the pre-war era.[19] In other words, however qualified by the messy specificities of particular situations, decolonization was part of a concerted process to restructure the global political, social and economic order. (Decolonization in this sense should not be confused with myriad struggles against colonialism, which certainly made the most of the opportunities of formal decolonization, but have much older histories and continue into the present.)

A second point is the uneven, incomplete and contradictory character of decolonization in the Pacific. The possibility of national independence was undoubtedly the dominant political ambition of Pacific leaders, though it played out differently across the region and no simple generalization is possible. In territories administered by anglophone powers (Britain, Australia, New Zealand and the United States), independence was generally agreed upon as the mutually preferred outcome. (However, this was not true in all cases: American Samoa and Guam elected to remain territories of the United States; and there were many people – in Fiji, Tonga and Australian New Guinea, for example – who felt independence was being foisted on them whether they wanted it or not.) Western Samoa got the ball rolling when it became independent from New Zealand administration in 1962. An impressive succession of new states followed: the

Cook Islands in 1965; Nauru in 1968; Tonga and Fiji in 1970; Niue in 1973; Papua New Guinea in 1975; Tuvalu and the Solomon Islands in 1978; Vanuatu in 1980; the Marshall Islands and the Federated States of Micronesia in 1986; and Belau in 1994. The list testifies to the supra-national forces driving decolonization. But it also obscures the difficult business of actually achieving nationhood, and the precarious nature of many of the states thus created. It obscures too the many disputes – about the timing of decolonization, the geography of borders, the nature of constitutions and parliamentary structures, the continued exploitation of islands used as naval bases and nuclear testing sites in the politics of the Cold War, etcetera – that complicated and interfered with decolonization's inexorable outcome.

In the French Pacific, independence was a much more contested objective. France saw decolonization differently from the anglophone powers.[20] While it granted French citizenship rights and significant political autonomy to its Pacific territories soon after the Second World War, it stopped short of full independence and generally opposed and even obstructed political movements in that direction, seeing decolonization rather as transpiring within the greater francophone republic. Moreover, loyalties to France among local settler, 'demi' and migrant populations made the indigenous struggle for independence a matter of intense, and sometimes violent, political dispute. Only in the case of the New Hebrides (Vanuatu), which France had jointly ruled with Britain since 1906, did a French colony become fully independent. Nationhood and independence were also complicated in the anglophone settler states of Hawai'i, New Zealand and Australia, where nineteenth-century colonization and massive settler migration had reduced indigenous people to minorities in their own land. Indeed, the weight of this history led to the Hawaiian Islands becoming an American state in 1959. In these places settler withdrawal was impossible and decolonization played out rather as a struggle for rights, recognition, return of illegally expropriated land, and social, political and economic re-empowerment.

The contradictory character of decolonization is also illustrated by the fate of West Papua, formerly Netherlands New Guinea, which found itself caught up in the opportunistic desires of its western neighbour, Indonesia, and the politics of the Cold War. After winning its independence from the Dutch in 1949, Indonesia laid claim to Netherlands New Guinea as part of its national territory and demanded the Dutch quit the colony and hand over control. Holland disputed the legitimacy of the claim and a stand-off developed between the two countries throughout the 1950s. Recognizing the end of imperial rule, the Dutch frantically struggled to prepare Papuan elites for the tasks of self-government. On 1 December 1961 the national flag of West Papua, called the Morning Star, was raised in the territorial capital and a target date set for independence: 1 December 1970.[21] Meanwhile Indonesia pressed its claims on the international stage. President Sukarno invoked a timely anti-colonial rhetoric against the Dutch and manipulated Cold War fears to neutralize opposition from nations such as Australia and the United States, both anxious about the rise of communism in Southeast Asia and reluctant to make an enemy of Indonesia. By 1961 Sukarno was threatening to take Netherlands New Guinea by force and indeed he invaded the territory the following year. With little international support and unwilling to go to war for the colony, the Dutch capitulated and formal control of West Papua passed – with the sanction of the United Nations – to Indonesia in 1963, which promptly renamed it West Irian (later Irian Jaya). In the epilogue to this affair, Indonesia staged a promised referendum on self-government in 1969 under highly dubious circumstances in which just over 1,000 selected

No Nukes in the Pacific

FROM 1946 TO 1996, the American, British and French governments conducted atomic and hydrogen bomb testing in the atolls and islands of Micronesia and Polynesia. Nuclear testing destroyed environments and contaminated ecosystems already struggling to recover from the effects of the Second World War. In the 1950s international calls began for nuclear disarmament, and by the 1970s activist groups such as Greenpeace had initiated highly visible protest campaigns within the region and the international media. In the post-war period the visual art generated by these protest movements played on iconic tourist images and the vocabulary of the mass media.

No Nukes in the Pacific (1984) is a memorable example of the type of visual art produced by individuals and groups opposed to nuclear testing. Made by Australian artist Pam Debenham, the shirt in this poster was inspired by one of the rarest Hawaiian-style shirts from the 1950s, supposedly produced in celebration of the United States testing on Bikini Atoll. In Debenham's version of the Hawaiian shirt, the fabric design is dominated by mushroom clouds each titled with the name of a nuclear testing site from across the region. The distinctive atomic explosions over the atolls of Moruroa, Bikini, Enewetak rise above the coconut palms and islets of the blue ocean. The protest yacht Pacific Peacemaker sails between these sites, signifying the voyages it made with a multinational crew in 1982.

The image of the shirt is ambiguous. Is it a celebration or a protest? Is the tanned person wearing it an Islander or a tourist? The face is cropped from the image, so we don't know their identity. The juxtaposition of the iconic Hawaiian shirt and atomic explosions evoke another tourist icon – the bikini. The irony is that both garments are made for the tourist, to cover the tourist's body and mark or celebrate a fleeting moment or experience of the Pacific; in doing so, both garments obscure the infamous history of Bikini Atoll as a key site in the history of nuclear testing and the displacement and suffering of Pacific people.

The visual art and culture of anti-nuclear protest took form in a range of popular media including banners, T-shirts, button badges and pins. These were accessible mass-produced objects, easily disseminated and effective in conveying important political messages. Slogans such as 'If it's Safe – Test it in Paris, Dump it in Tokyo, and Keep our Pacific Nuclear Free', 'Ban the Bomb' and 'Stop French Testing' were key slogans of the anti-nuclear movement. Mass media were critical to the success of anti-nuclear activists. However, indigenous artists such as Ralph Hotere have been inspired to respond to the nuclear threat through their art and have exhibited in galleries within and beyond the Pacific. The work of these activists and artists has drawn worldwide attention to the environmental costs of nuclear testing in the Pacific region and put pressure on governments about their activities.

In the nuclear age the region's peoples would confront a new set of political, cultural and environmental challenges. In the post-war period of decolonization in the Pacific, nuclear testing galvanized indigenous resistance toward colonial powers. Pacific governments rallied on anti-nuclear issues; when few other issues can, this is what has brought them together with a common cause. A significant achievement was the Treaty of Rarotonga (1985) prohibiting the location or testing of nuclear weapons in the region.

In the twenty-first century, concerns about nuclear energy and its risks remain high on the agenda of the region's environmental activists. Nuclear-powered navy vessels still sail on and under the Pacific Ocean's surface. Uranium ore is still moved between the region's ports. For some experts nuclear technology is the answer to servicing the planet's future energy needs. The art of protest and activism remains important in asking questions and maintaining vigilance. SM

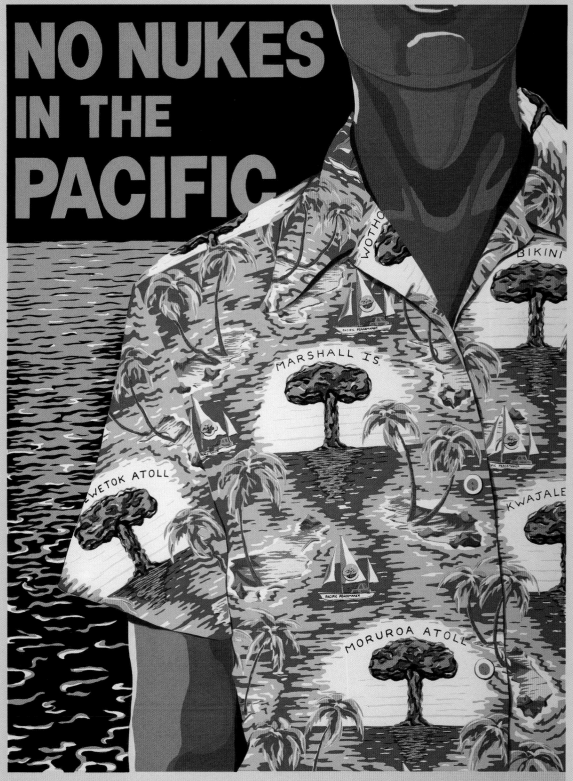

Pam Debenham, *No Nukes in the Pacific*, **1984.**
Screenprint poster, 88 x 62 cm
(34⅝ x 24⅜ in.). Image
courtesy of the artist.

Papuans 'voted' on behalf of the entire population to remain part of Indonesia. Although bitterly condemned by Papuans as the 'act of no choice', the referendum was controversially ratified by the United Nations (with the support of the United States), thus sealing West Papua's fate as a province of Indonesia. Decolonization in the Pacific had not got off to a good start.[22]

The subject of art in the context of these complex political histories was both central and marginal. Nations are obviously more than the machinery of modern states. They depend on the mediation of material signs and symbols, and the affects and ideas they are designed (or co-opted) to evoke or communicate about the nation. *New* nations, forced more or less willingly into being, are faced, in addition, with the task of bridging their past and their historical novelty. Every new Pacific nation, every movement for national sovereignty emerging from the colonial era, faced this troublesome challenge. The Morning Star flag, for example, galvanized West Papuan hopes for independence in December 1961, using the most conventional of modern national symbols: the flag. That flag, however, was banned by Indonesia when it took control of the country in 1963 and has since become the rebel sign of dissident nationalism in the province, the symbol of West Papua's stolen nationhood, all the more powerful for the absence of that which it had been promised by the Dutch. Conversely, Indonesia was faced with the enormous task of remaking this strange, culturally heterogeneous and, as they were thought of at the time, still 'primitive' people, into 'Indonesians'. Among its strategies in the 1960s was to suppress the role of art in many of the country's tribal groups. It banned customary body adornments such as penis gourds worn by the Dani people in the Baliem valley; prohibited traditional feasts, festivals and rituals among the Asmat; and systematically destroyed Asmat carvings and men's houses[23] – iconoclastic strategies both colonial and modern that aim to erase tradition, creating a blank slate on which a new national consciousness may be written. Thus, in 1963 Sukarno commissioned a series of national monuments in Jakarta, the capital of Indonesia, to commemorate the origins of Indonesia's modern nationhood in a narrative of anti-colonial struggle against the Dutch. Among them was a monument to the 'liberation' of West Irian,

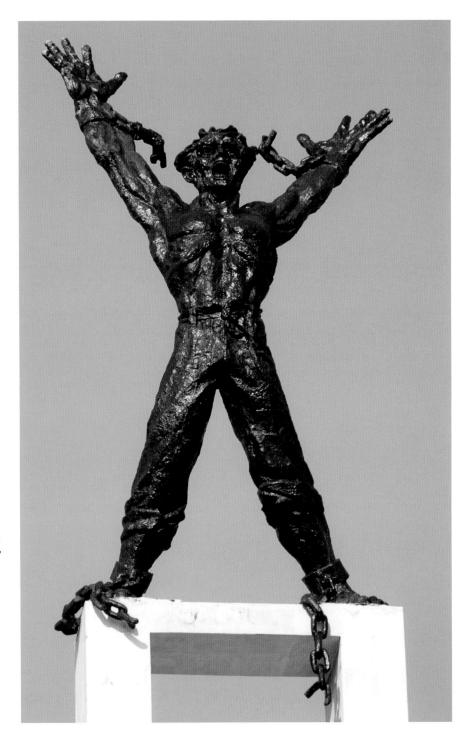

Monument to the liberation of West Irian, Jakarta, Indonesia, bronze, 1963.
Sculptor Edhi Sunarso, designer Frederik Silaban.

No modern sculpture in the Pacific captures the irony and contradictions of decolonization in the region better than this monument to the 'liberation' of West Irian, now the Indonesian province of West Papua.

a bronze statue of a man of ambiguous identity (is he Papuan, Indonesian, both or neither?) exclaiming his freedom from oppression with his arms outstretched and broken chains dangling from his wrists and ankles.

As the momentum of indigenous decolonization picked up in the Pacific from the 1960s, the semaphore of postcolonial nationhood turned increasingly to the sanction of customary culture, translated into national terms. As already noted, the arts in the immediate postwar years were in a somewhat nebulous state: dispersed in the opportunities of commercial production, dominated by foreign discourses about 'primitive art', politically unfocused, and uncertain of their future. Many arts had been suppressed or were lost under colonial rule, or abandoned in the wake of Christian conversion. Lacheret Dioposoi, a contemporary Kanak carver from New Caledonia, for example, recalls the complete absence of carving in his country until the 1960s and 1970s: 'Nothing, nothing, nothing at all, you don't find any carving between the arrival of the whites and the 1960s or '70s.'[24] The promise of nationhood changed this situation, giving rise to concerted efforts to revive lost or languishing art forms. For example, Dioposoi and French anthropologist Roger Boulay (among others) began to compile a complete photographic inventory of Kanak sculpture scattered in the world's museums, with the idea that the resulting document would form the basis for a contemporary revival of Kanak woodcarving.

Similarly, Kanak independence leader Jean-Marie Tjibaou conceived and organized in 1975 a pivotal cultural festival in Noumea, the capital of New Caledonia, called 'Melanesia 2000' (named for its many participants and forward-looking vision). The purpose of the festival was both psychological and political. It aimed to counteract the desultory effects of the previous decades, to restore pride and confidence to the Kanak population. Here is how Tjibaou described those decades: 'These were years I lived like years of misfortune, when it was clear that we had a really deep crisis; chefferies [chiefly offices of a clan] and tribes abandoned, along with most of custom. There are some people who opted to become "naturalised" French citizens in the 50s in order to buy alcohol; this had become the symbol of accession to full humanity…. In fact, people abandoned a lot of things.'[25] In its attempt to address the crisis, the festival gathered Kanaks from across the country to Noumea for several days of custom ceremonies, oratory, musical performances, traditional building demonstrations and an epic theatrical production dramatizing the colonial history of New Caledonia (*overleaf*). But the purpose of the festival was also political, a means of rallying the Kanak population to the settler-dominated capital of Noumea in order both to affirm Kanak culture and identity and also broadcast them to the world as the basis of a mounting campaign for political independence. It was, as Tjibaou called it, a 'spectacle', but one turned to political ends: 'We wanted to put on a big show, a really grand, significant spectacle…. The aim of 'Melanesia 2000' was to do a "commercial" on our culture for the White world, and to get the Melanesians involved in a great people's celebration where they would learn about themselves and awaken to their own heritage.'[26] In many places across the Pacific the arts were conceived to serve a similar purpose. In December 1979, on the eve of its independence, Vanuatu staged its First National Arts Festival as 'a realization of the importance of preserving and developing culture, custom and tradition as a means of reinforcing national identity' and to show 'to the world at large their identity'.[27]

But attitudes to culture, custom and tradition were shifting across multiple fronts in the postwar decades,

Roger Boulay, *Sculptures Kanak* documentation project, Office Culturel Scientifique et Technique Canaque, New Caledonia, 1984.

Chambranles

1. Musée de l'Homme Paris N° 59.90.1. 162 × 70

2. Museum Für Volkerkunde Bâle N° VB 2633 165 × 96 Ouébia Cap. Colnett.

3. Museum Für Volkerkunde Bâle N° VB 2634 165 × 108 Ouébia Cap. Colnett.

4. Musée du Vatican Rome N° 3452 134 × 67 Pouébo + St Joseph.

5. Musée de l'Homme Paris N° 45.5.2. 160 × 60

6. Musée du Vatican Rome N° 3454 150 × 72 Pouébo

7. M.N.A.O. Paris N° 0.66.15.2 128 × 36 Ouébia

8. M.N.A.O. Paris N° 0.68.3.3. 174 × 68

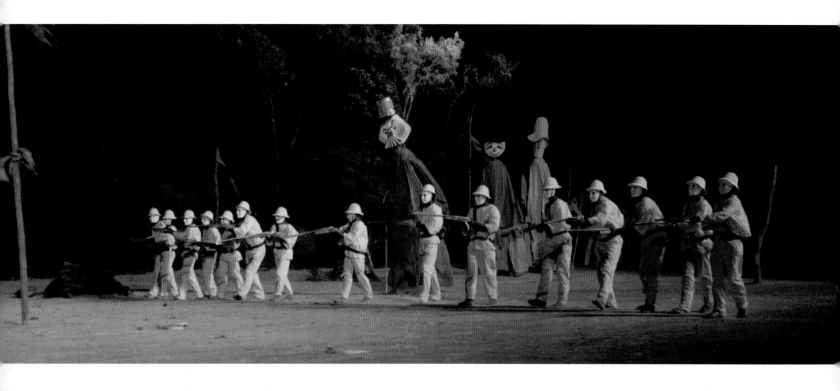

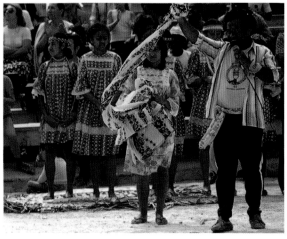

top

Scene from stage play, *Kanaké*, written by Georges Dobbelaere and Jean-Marie Tjibaou for the festival 'Melanesia 2000', New Caledonia, 1975.

'The dance of the arrival of the Whites' from the historical pageant *Kanaké*. The Whites are played by masked Melanesians while behind them are giant figures representing the missionary, the merchant and the military officer.

above

Jean-Marie Tjibaou at the festival 'Melanesia 2000', New Caledonia, 1975.

signalling a broad ideological sea change. While colonial attitudes still persisted (to be broken down), the revival and preservationist aspirations of Islanders increasingly converged with the decolonizing objectives of international organizations, departing empires, reforming Churches, publicity-conscious corporations and new nation states – all seeking ways to accommodate the postcolonial future. 'Melanesia 2000', it should be noted in this context, was staged with the aid of French funding. Indonesia reversed its draconian policy towards Asmat culture in the late 1960s, permitting the United Nations to establish the United Nations Asmat Art Project in 1968 and a group of Catholic missionaries to establish the Asmat Museum of Progress and Culture in 1971. In 1972 the South Pacific Commission, an alliance of states overseeing regional development, inaugurated the quadrennial South Pacific Festival of Arts (later the Pacific Festival of Arts) in Suva, Fiji, which enshrined the ethos of cultural preservation and identity as a national theme across the region (*pages 366–67*). New museums and cultural centres, established across the region at various points after the Second World War, signalled the same idea: the imperative to preserve traditional arts as part of a national heritage.[28] In 1976 the sailing of the *Hōkūleʻa* between Hawaiʻi and Tahiti re-enacted the ancient art

'BUT WHAT IS ALSO VITAL...'

The present situation that Melanesians in New Caledonia are living through is one of transition, characterized by much hesitation. The elements of modernity are there, but we lack models combining the traditional and the modern. So it is a time of debate between opting for modernity and the fear of losing one's identity. This debate will be a long one, and we shall have to overcome this contradiction. The symbiosis between the traditional and the modern comes about in fact by the force of things. The new forms of expression do it by incorporating material: sounds come out of the guitar, for example, but accompanying specifically Melanesian poetic or contemporary themes. In the same way, the *manous* [traditional skirts], the rhythmic whistles, paint and decorative powders, the harmonica and the drums used today in our dances, our *pilous*, all these draw modernity into our traditional activities. Less obviously perhaps, we are incorporating elements of the cultures around us into our choreography.

Finally, there is use of linguistic material – French and for that matter, English – in poems and songs, alongside borrowings from other Oceanian cultures. You could say that there is movement by Melanesian society, on an historic scale, to win for itself a new identity, based on its tradition, but mobilizing borrowed material elements and using standard elements from the universal culture on offer everywhere but especially in the media....

We should doubtless be looking to a new flowering of poetic and literary creation, which will set new models with their roots in Kanak tradition but adapted to the contemporary environment of Melanesians, which is that of the town. Along with regular pay, acculturation to this new frame of reference is vital. But what is also vital is the need to create for ourselves an environment in which the modern is incorporated into the life breathed into us by the ancestors, without which we cannot reconnect with our roots.

Jean-Marie Tjibaou, Nouméa, March 1984.
From an interview by Jean-François Dupon.
Jean-Marie Tjibaou (1936–1989) was a statesman and leader
of the Kanak Independence Movement in New Caledonia[i]

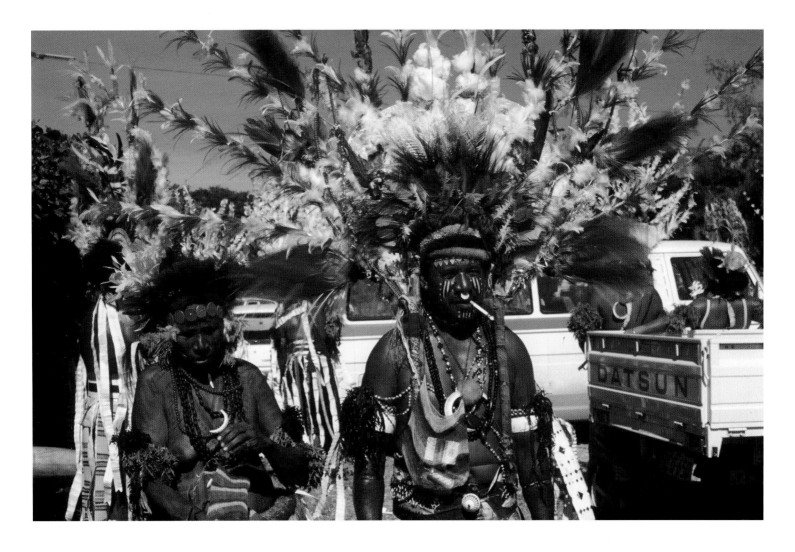

of Polynesian voyaging, further galvanizing (through much publicity) a region-wide pride in the heritage of the past. The upshot of all this was a profound reversal in the status of customary culture. 'Kastom', as it is called in island Melanesia, went from its colonial meaning of old ways and old things given up in the process of Christian conversion or mission schooling, to a postcolonial term implying cultural sanction and legitimation.[29]

Yet behind this theatre of revivified customs and traditions lay many conflicts and tensions. The resurgence often sat awkwardly with the complex social realities of post-war Oceania, with the expanded currents of migration and urbanization, for example; from rural villages into towns and cities; from small islands into large Westernized and industrialized countries; between islands in the region; and into

the islands from places like France, Japan, South Asia and Southeast Asia. The rhetoric of revival also expressed an ongoing anxiety about the massive inroads of commercialization in the Pacific, including that of the arts. As stated in the programme of the 1976 South Pacific Festival of Arts, 'strenuous efforts are needed to prevent these age-old arts from succumbing to the pervading sense of sameness that exists in much of our society, of being swamped by commercialism or cheapened to provide mere entertainment for tourists.'[30] The authority of custom and tradition also played a significant role in the nature of the hybrid democracies being created in the Pacific, empowering traditional chiefs and educated elites. The elevation of customary art forms to national traditions often reflected particular class and political attitudes, while glossing over historical losses and social differences.

South Pacific Festival of Arts, 1980, Port Moresby, Papua New Guinea.
Photograph Gil Hanly.

South Pacific Festival of Arts poster, 1972.
National Library of Australia, Canberra.

Consider, for example, a lecture given by Bernard Narokobi, a Papua New Guinean political leader, during a symposium at the University of Papua New Guinea in 1975, the year that his country became independent from Australia. Entitled 'Art and Nationalism', the lecture reflected on an exhibition staged at the Creative Arts Centre in Port Moresby entitled 'The Seized Collections' – a selection of items from among thousands of artefacts seized by police at ports in Madang, Wewak, Angoram and Rabaul in 1972, destined for markets in Australia and the United States (*overleaf*). Ordered by acting Prime Minister Michael Somare in the lead-up to independence, the police raids were described as a 'brake applied to the illegal trade in cultural property'.[31] (The brake did not intend to stop the trade but to regulate it and ensure that Papua New Guineans shared more equitably in its profits.) Contemplating these 'works of art', Narokobi remarked on their role in mediating the spirituality of local communities (forgetting for a moment their origin in police raids on the tribal art market):

> Today, no true student of our art would deny that a glimpse into the enchantment of our lives can be got by an awareness of the life and power of even a single work of art. A finely carved piece of wood becomes a being, the guardian spirit of an entire clan. A mask becomes the power behind all the great deeds of the tribe. A figure with varying colours from the mother earth becomes the centre place for meditation and serenity.... Through their fine art they can, and do, communicate with the divine. Through their art they realize their humanity.[32]

From this idealized and nostalgic perspective, the depredations of modern commercialism could be seen only as 'spiritual death':

> At this historical vantage point, I can see all our forms of art converted into cheap, popular and bare artistic styles. There is a danger that in our desperate search for political and constitutional unity we might create cheap theories, base paperbacks and dramatic expressions as true representations of our rich, varied and unique art forms. Nothing could hasten our spiritual death more than to embark upon a popular Cowboy-and-Indian or the more recent Kung Fu culture.[33]

'The Seized Collections of the Papua New Guinea Museum', exhibition poster, 1972. Screenprint, 41 x 71 cm (16⅛ x 28 in.). National Gallery of Australia, Canberra.

In fact, Narokobi is in two minds about the value of these popular cultural forms. Having condemned them as 'spiritual death', he considers the possibility of embracing them, recast with the content of Papua New Guinea's vast cultural legacy:

> Our myths, legends and histories are enough to provide material for millions of novels, comic strips and cheap films that will make Cowboy-and-Indian and Kung Fu films look unimportant.[34]

But the suggestion is only half-hearted. In the end Narokobi upholds these traditional arts as the 'genuine art' of Papua New Guinea, by virtue of the social and spiritual role they served. He then admonishes its contemporary artists to create 'new forms of expression' that remain true to these spiritual and communal purposes but with respect to the nation. That challenge was taken up in its own way by another strand of art-making in the Pacific, more secular in its orientation but no less ambivalent about art's high calling and its troubled place in modern society.

Modernism and the 'New Oceania'

These were practices influenced by Western modernism. The latter enters the post-war Pacific primarily through its large anglophone settler states – Australia, New Zealand and Hawai'i – where settler cultures had established art galleries, art societies and art collections in the late nineteenth and early twentieth centuries, laying claim to the legacy of European 'high culture' as a civilizing influence in the colonial situation. These settler 'art worlds' provided the context for the emergence of indigenous modernisms in the 1960s and 1970s. Elsewhere in the Pacific, where there were no 'art worlds' in the Western sense, the advent of modernist practices was more improvised and sporadic, though no less significant for post-war nationhood.

Several social factors contributed to this development. One was the nurture provided by the establishment of tertiary educational institutions. The late 1960s saw the inauguration of the University of Papua New Guinea; the University of the South Pacific in Suva, Fiji (with satellite campuses in other islands); and the University of Guam. Along with universities and teacher-training colleges in New Zealand, Australia and Hawai'i, these institutions provided a milieu that cultivated a variety of experimental ventures into art, literature and theatre – art forms derived from the West but used to express

a contemporary, postcolonial consciousness. The first exhibition of modernist Māori art in New Zealand, for example, was held at the Adult Education Centre, Auckland, in 1958, organized by Matiu Te Hau, who worked for Continuing Education at the University of Auckland.[35] The exhibition showed the work of five Māori artists – Selwyn Wilson, Ralph Hotere, Katerina Mataira, Muru Walters and Arnold Wilson – all of whom had been educated either in teacher-training colleges or university art schools. Other exhibitions, such as the one held at the Hamilton Festival of Māori Arts in 1966, followed. Similarly, the new Pacific universities became hubs for a variety of new artistic expressions, mounting exhibitions, staging plays, publishing literary journals, holding art workshops and so on.

Another factor was post-war urbanization. All of the Māori modernists exhibited in 1958 were urban migrants from rural backgrounds. The same was true in a different sense of the first contemporary artists in

Papua New Guinea – 'different' because they came within the ambit of the university not as students but either as villagers who had ventured into Port Moresby as adults or as part of the town's local working class. Timothy Akis, for example, was a village man from Tsembaga in the Simbai valley, an area with only a generation of contact with the outside world. Akis was brought to Port Moresby by anthropologist Georgeda Buchbinder, for whom he had produced remarkable drawings while working as her assistant. Mathias Kauage was a Chimbu man from the Highlands – another region with only recent contact with Europeans – who had ventured into Port Moresby on his own account, where he worked as a cleaner. By contrast, Ruki Fame and Marie Taita Aihi had been alienated from their ancestral cultures since childhood after their villages had converted to Christianity and renounced their respective traditions. Fame worked at various jobs in Port Moresby, while Aihi, raised by nuns, worked as a nursing assistant at a Catholic

mission.[36] In New Caledonia artist Aloï Pilioko was a villager from Wallis Island (part of French Polynesia) working as a migrant labourer in Noumea where he came across an improvised art gallery in 1959, set up in a colonial villa by French-Russian émigré Nicolaï Michoutouchkine. These snippets of biography are mentioned only to indicate the social complexity from which indigenous modernism emerged in the Pacific.

A third factor was the influence of expatriate Europeans or white settlers who acted as 'talent spotters', mentors and conduits for modernist values and concepts. It is commonplace in New Zealand, for example, to speak of the 'Tovey generation' when describing the contemporary Māori artists who emerged in the 1950s and 1960s. Gordon Tovey was a white New Zealander, appointed National Supervisor Arts and Crafts in 1946 and in charge of the 'art specialist' scheme that employed art educators within the New Zealand school system. In this context Tovey met and befriended several Māori modernists employed in the scheme, introducing them to many of the beliefs that fed modernist art in the twentieth century. He was, for example, a follower of Carl Jung and his theory of the collective unconscious and shared mythic symbols. Tovey believed that 'Western civilisation had become over-intellectualised and that the natural well-springs of innate drives had dried up.'[37] Like other modernists, he saw those 'natural well-springs' exemplified in 'primitive' art, including Māori art, and the art of children.

Similarly, the origins of indigenous modernism in Papua New Guinea were inseparable from the influence of European expatriates Ulli Beier and Georgina Beier, who shared an admiration of indigenous art and a belief in the innate sources of artistic creativity. The Beiers arrived in Port Moresby in 1967 where Ulli Beier had taken a position teaching literature at the University of Papua New Guinea. Both were previously resident in Nigeria where they had played an influential role in that country's artistic life over several years spanning its independence in 1960. Born in Germany, Ulli Beier was a literary scholar, translator and critic, while Georgina, British-born, was an artist, printmaker and art educator. They were charismatic figures, sensitive to the intricate social dynamics of Port Moresby and keen to engage with its indigenous inhabitants, who had an historic sense of their role in

introducing modern modes of artistic expression in Papua New Guinea. The Beiers sought out the artistically gifted among the people around them – individuals like Akis, Kauage, Fame, Aihi and others – introduced them to new media and techniques, and encouraged them in the novel vocation of being 'artists' on their own *individual* terms, making 'art' as a potentially saleable commodity. They also orchestrated around their protégés an improvised world of art workshops, commercial ventures in making and selling art, and exhibitions in university classrooms and abroad that presented their work as 'contemporary art' from the young nation of Papua New Guinea. Their impact on students at the university was equally galvanizing. Students were challenged to turn not to Western models of literature, art and theatre, but to the oral, performative and visual traditions of their own natal villages – traditions that could be renewed and reinterpreted in contemporary ways. Although modest in origin, these artistic experiments were quickly incorporated into the discourse of Papua New Guinea's imminent nationhood. They were institutionalized through the creation of the National Art School in 1973 (along with corollary initiatives such as the National Theatre Company and the Institute of Papua New Guinea Studies) and used to signify the

Martin Morububuna, *The Young Nation of Papua New Guinea,* poster, *c.* 1978. Screenprint poster, 56 x 75 cm (22 x 29½ in.). Collection of Flinders University Art Museum, Adelaide.

Papua New Guinea Banking Corporation building, Port Moresby, c. 1975.
Architect James Birrell, façade panel designs David Lasisi.

new nation in exhibitions, civic architecture, public sculpture and so forth.

In New Zealand in the 1960s Māori modernism was also engaged in the discourse of nationhood. There, decolonization had two trajectories: one driven by settler culture, concerned to 'reinvent' New Zealand as a culture independent of Britain and the Britishness that pervaded settler society;[38] and the other driven by Māoridom, increasingly asserting its cultural claim on the national future. The Māori modernists, exhibiting in the Pākehā art world, clearly saw their movement as contesting the terms of the representation of nationhood. If there was to be a modern art reflecting the unique character of New Zealand society, they argued in one exhibition, it surely would draw its inspiration from the country's indigenous art since that is what made New Zealand society unique.[39]

Aloï Pilioko and Nicolaï Michoutouchkine are interesting in this period because of their eccentric relationship to nationalist discourse in the absence of an institutionalized art world. After meeting in Noumea, they formed a life-long partnership, with Michoutouchkine nurturing Pilioko's 'natural' artistic gifts. In 1962, after a period on the tiny island of Futuna, they set up a permanent home and studio base in Port Vila in the then New Hebrides (Vanuatu).

Together, they pursued an extraordinary life of travel and adventure both in the Pacific and beyond. Michoutouchkine was a voracious collector who used his privileged access to the islands, particularly in the late 1950s and 1960s, to amass an enormous personal collection of Oceanic artefacts. However, unlike most collectors, who lived in Western metropolises, Michoutouchkine and Pilioko resided in the Pacific. For over three decades they mounted exhibitions of 'Oceanic art' *in the islands* – in places like Noumea, Port Vila, Papeete, Suva and Honiara – drawn from Michoutouchkine's collections and including their own modernist experiments. Thus they played a major role in introducing into Pacific towns and among its motley inhabitants a sense of art's contemporary relevance, excitement and potential. Both became regional personalities and Pilioko in particular was featured in magazines and local newspapers. Works such as *Tattooed Women of Bellona, Solomon Isle* (1966), a tapestry made of coloured wools embroidered into sacking from copra bales in Pilioko's distinctive style, exemplified the creative freedom and individuality of the modern Pacific artist (*overleaf*). As independence dawned in Vanuatu in 1980, this unusual couple – migrant citizens from wildly disparate cultural backgrounds, Polynesian and Russian – came to serve

as quasi-ambassadors for the new nation when they organized, of their own accord, further exhibitions of Oceanic art at multiple venues in Europe, the Soviet Union and Japan.[40]

As contemporary artistic expressions burgeoned across the Pacific, Samoan novelist Albert Wendt drew their various manifestations together in a visionary essay entitled 'Towards a New Oceania', published in the first issue of a literary journal called *Mana Review* in 1976. For Wendt, they represented a fresh, independent voice in the Pacific that re-posed the question of cultural tradition, not just as revival and preservation but as a resource from the past – a 'fabulous treasure house,' as he put it – for imaginative *re*-creation by contemporary artists in and for the present.[41] Wendt endorsed the essentially individual character of the modern artist whose freedom as an individual stood apart from the social norms and traditional hierarchies that still held sway in the Pacific; indeed, which were reasserting their authority in the hybrid democracies taking shape in Oceania. For Wendt, the individual artist could function in a new role as a critic of decolonization. Here he speaks of writing, but the same is true of other forms of post-colonial art: 'Our writing is expressing a revolt against the hypocritical, exploitative aspects of our traditional, commercial and religious hierarchies, colonialism and neo-colonialism, and the degrading values being imposed from outside and by some elements in our societies.'[42]

In fact, indigenous modernists had complex and ambivalent relationships with their ancestral cultures and visual traditions. On the one hand, the artistic freedoms of Western modernism could challenge the conventionality and relevance of those traditions. Paratene Matchitt's *Whiti te Ra* (1962; *page 374*) and Buck Nin's *The Canoe Prow* (1965), for example, appropriated visual forms from traditional Māori carving in paintings that used the figurative distortions of Picasso and the disarticulated syntax of cubism. Their aim, in simple terms, was to update Māori art and bring it into dialogue with Western modernism and Māori life in the contemporary world. Selwyn Muru's *Parihaka* series (1975), for example, used the idiom of European Expressionism to create a set of narrative paintings based on an episode of anti-colonial resistance in the nineteenth century that would resonate with the Māori struggle against the state in the late 1970s. Likewise, Arnold Wilson's *Tane Mahuta* (1957; *page 374*) challenged the conventions of Māori woodcarving by interpreting its avatar – the god of the forest – in modernist abstract form. Māori modernism was thus a sophisticated dialogue with both Western modernism and Māori visual traditions, from which, as Damian Skinner has argued, it sought to mark a critical distance.[43] Wilson's critique was made explicit in the 1960s when he attacked the preservationist ethos of the Institute of Maori Arts and Crafts: 'Reviving so-called Maori arts and crafts is a dead loss…. All they're doing is reviving something that doesn't apply to the Maori's present-day attitudes and way of life…it's time they scrubbed it'.[44] For the modernists, there was a sense that Māori art could no longer be bound and defined by this ethos, which had been reified in the visual conventions of the 'traditional' meeting house. Māori art was entering – indeed, had long ago entered –

Aloï Pilioko, *Tattooed Women of Belona, Solomon Isles*, 1966.

Wool tapestry on jute (copra sack), 68.5 x 222 cm (27 x 87⅜ in.). Collection of the artist.

Encouraged to pursue a career as a modern Pacific artist by his friend, French-Russian émigré Nicolaï Michoutouchkine, Wallis Islander Aloï Pilioko found his expressive voice with the invention of his 'needle paintings', made with coloured wool sewn into sacking. Together, the two artists travelled and exhibited widely in the Pacific Islands, Europe, Eastern Europe and Asia.

'THE QUEST SHOULD BE FOR A NEW OCEANIA'

Like a tree, a culture is forever growing new branches, foliage and roots. Our cultures, contrary to the simplistic interpretation of the romantics among us, were changing even in pre-*papalagi* times, through inter-island contact, and the endeavours of exceptional individuals and groups who manipulated politics, religion and other people. Contrary to the utterances of our elite groups, our pre-*papalagi* cultures were not perfect or beyond reproach. No culture is perfect or sacred even today. Individual dissent is essential to the healthy survival, development and sanity of any nation – without it our cultures will drown in self-love. Such dissent was allowed in our pre-*papalagi* cultures: what can be more dissenting than using war to challenge and overthrow existing power – and it was a frequent occurrence. No culture is ever static nor can it be preserved (a favourite word with our colonisers and romantic elite brethren) like a stuffed gorilla in a museum.

There is no state of cultural purity (or perfect state of cultural goodness) from which there is decline: usage determines authenticity. There was no Fall, no sun-tanned Noble Savages existing in South Seas paradises, no Golden Age, except in Hollywood films, in the insanely romantic literature and art by outsiders about the Pacific, in the breathless sermons of our elite vampires, and in the fevered imaginations of our self-styled romantic revolutionaries. We, in Oceania, did not, and do not, have a monopoly on God and the ideal life. I do not advocate a return to an imaginary pre-*papalagi* Golden Age or Utopian womb. Physically, we are too corrupted for such a re-entry! Our quest should not be for a revival of our past cultures, but for the creation of new cultures, which are free of the taint of colonialism and based firmly on our own pasts. The quest should be for a new Oceania.

Albert Wendt, 'Towards a New Oceania', *Mana Review* 1, 1976[i]

secular, public space. Their work accepted the reality of that dissemination as they created works for art galleries, libraries, radio stations, airports, government buildings and so forth.

On the other hand, the revival of customary culture was a powerful political force by the 1970s, and many contemporary artists began to turn to it as a source of anti-colonial resistance and alternative value. In Hawai'i, for example, where Native Hawaiians began to contest the exploitation of their islands and the hegemony of American culture, artist Rocky Jensen established an artists' collective called *Hale Hauā III*, which sought to ground itself in traditions of Hawaiian knowledge. (The collective took its name from a precolonial institution of instruction that had been revived in the nineteenth century by King Kalakaua in a prior moment of cultural resurgence, and which Jensen revived a third time in the 1970s.)[45] In New Zealand the resurgence of Māori culture coincided with the assertion of land and political rights, and prompted a call among Māori artists and writers to 'return to the *marae*', the customary home of Māori art. The new relation is exemplified in Paratene Matchitt's mural *Te Whanaketanga o Tainui* (1975) in the dining hall at Turangawaewae Marae, Ngaruawahia. Located in the *marae* complex, the mural explores the history of the Tainui people in a way that has much in common with the *whare whakairo* (meeting house), linking people together and explaining cultural origins.

right

Rocky Kaʻiouliokahihikolo ʻEhu Jensen, *He Ipu Maʻona (The Never-empty Bowl or The Plentiful Platter)*, 1977. False kamani wood with abalone shell. Length 102 cm (40 in.). Hawaii State Museum of Art, Honolulu.

below

Cliff Whiting, *Te Wehenga o Ranginui rāua ko Papatūānuku*, 1969–74. Mixed-media mural, 2.6 x 7.6 m (8½ x 25 ft). National Library, Wellington.

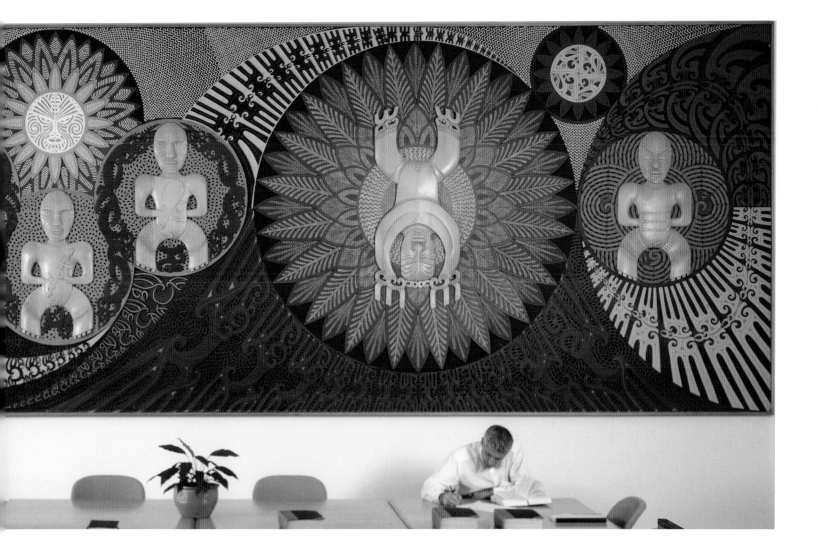

Ralph Hotere

THE MAJORITY OF MĀORI ARTISTS who were experimenting with modernism in the 1950s and 1960s followed a kind of modernist primitivism, in which the artistic lessons of European artists such as Pablo Picasso and Henry Moore were used to interpret customary Māori motifs. The modernism of these artists depended on a staging of difference from customary Māori art – an unadorned surface, a reliance on sculptural depth, or the adoption of a radically flattened pictorial space from which modelling and the illusion of depth were banished; yet also, in order to declare their difference from what went before, it depended on an appeal to Māori art and subject matter. These artists were Māori and modernist, and it was the frisson of the two identities that fuelled their art.

One artist who stands apart from this approach is Ralph Hotere. Beginning his career as an art specialist with the Department of Education under the auspices of Gordon Tovey, Hotere was part of the beginnings of contemporary Māori art. Missing some of the early exhibitions of modern Māori art because he was studying art in England and Europe, Hotere took part in such events after his return to Aotearoa New Zealand in 1965, and he rapidly became a celebrated member of the contemporary Māori art movement.

Notably, though, Hotere refused to adopt the more usual position of his Māori art colleagues. There is no 'and' linking the identities of Māori and modernist within his practice. His attitude is informed by a resolutely modernist belief in the autonomy of art. 'No object, and certainly no painting, is seen in the same way by everyone, yet most people want an unmistakable meaning that is accessible to all in a work of art,' said Hotere in 1973. 'It is the spectator which provokes the change and meaning in these works.' And this, which has proven to be a controversial stand within the contemporary Māori art movement: 'I am Maori by birth and upbringing. As far as my works are concerned this is coincidental.'[i]

Seen in this context, Hotere's comment about denying a Māori identity in his art is part of a broader refusal to participate in simplistic art-historical readings of his work. The artist does not have to validate certain interpretations, and biography does not offer a framework for understanding a complex cultural production such as a painting. Yet there is another meaning in Hotere's comment, which rubs against the larger trajectory of Māori art in the 1970s and 1980s. As his colleagues began to respond to the Māori Renaissance of the 1970s, in which cultural and political developments made it urgent for them to declare their identity as Māori in a direct manner, and to replace critical distance with an appeal to communication and a bridging of difference, Hotere remained resolutely modernist. He continued to work within the space of Māori modernism, in which Māori art did not need to operate in terms of Māori social or cultural practices, but rather could gather its operational procedures from contemporary art, staging and maintaining its critical difference and distance from the art production of the recent past, a context where Māori identity was not necessary, or key, to the production of artwork. Hotere remained a (Māori) modernist, and it explains why his work has assumed a place in Pākehā/New Zealand art histories, while that of his peers has not. DS

Ralph Hotere, *Requiem for M.L.K.*, **1969.**
Lacquer on hardboard,
122 x 186 cm (48 x 73¼ in.).
Collection of Dunedin Public
Art Gallery.

Moreover, the mural involved the labour of hundreds of people, redefining the artist as a kind of supervisor, playing a similar role to the master carver in the production of meeting houses. Conversely, the Western art gallery could be appropriated as a Māori cultural space, as occurred, for example, during the opening exhibition of Muru's *Parihaka* series at the Dowse Art Gallery in 1979, when the gallery was transformed into a space that drew its protocols and meanings from the *marae*. The transformation was a recognition not only of a Pākehā need to come to terms with Māori cultural values and Māori narratives, but an indication of the way in which, by the 1970s, a European genre like oil painting could be understood to embody ancestors just like the carvings in a *whare whakairo*.[46] In Papua New Guinea, artists also were drawn towards clan and village on the one hand, or nation and the world on the other. Akis, for example, produced an extraordinary series of drawings during his first six weeks in Port Moresby under the tutelage of

Georgina Beier. These drawings were exhibited at the university library in what Ulli Beier describes as 'an historic occasion':

> A New Guinean had – to a point – stepped out of his own culture; he had made drawings that were of no particular relevance to the people in his own village, even though they expressed his feelings about the village and about the forest that surrounded it, and the animals and birds that inhabited it. It was a very personal statement; the drawings spoke of Akis himself and did not fulfil any ritual or even decorative function in his own community. They appealed more to the white man, whose world he had been the first to penetrate from his village.[47]

While this exhibition could be said to have initiated a Papua New Guinean contemporary art world, Akis himself remained with the 'world' of his village. Although he returned to Port Moresby to work with

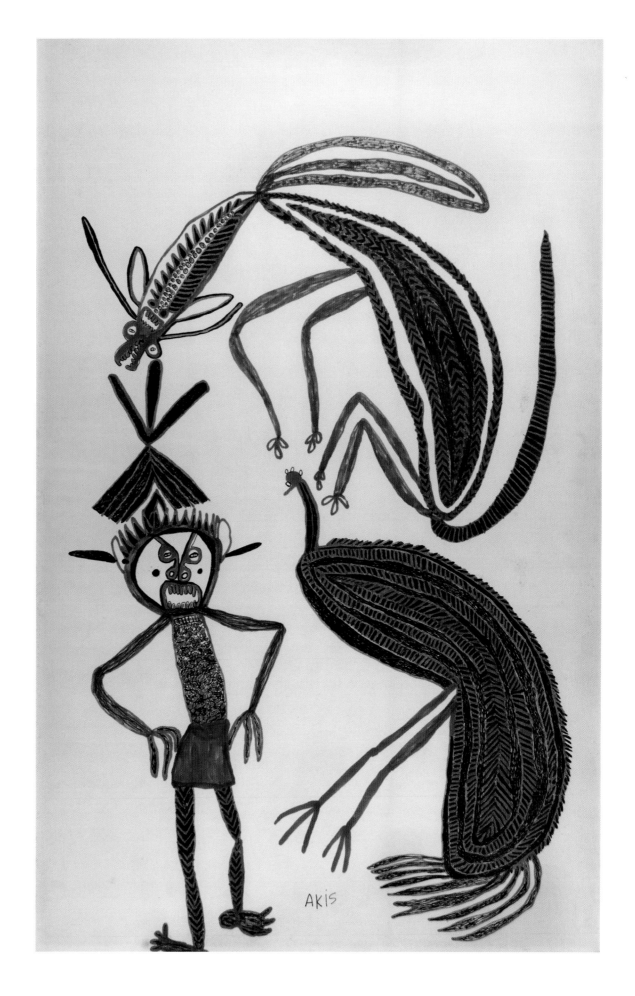

Akis, *Untitled, c.* 1970–73
Ink on paper, 84 x 69 cm
(33⅛ x 27⅛ in.). Collection
of the University of Cambridge,
Museum of Archaeology and
Anthropology.

Georgina again in 1971, producing yet another remarkable series of drawings and prints, and returned occasionally thereafter to make work at what became the National Art School, he never stayed in Port Moresby. He enjoyed the fame (and cash) his work gave him, but always returned to the social and ritual obligations of his village life where he lived as a gardener and subsistence farmer, eventually stopping making art. For Kauage, on the other hand, the trajectory of his career flowed in the opposite direction, away from his natal village towards a fascinating world defined by the historical novelty of Papua New Guinea and his extraordinary life as a citizen of it. His experience of the latter is reflected in the chromatic brilliance of his paintings, prints and drawings, and their unique iconography of flags, aeroplanes, helicopters, buses, political events and the doings of modern Papua New Guineans, himself chief among them. Kauage's aesthetic sensibility and perceptions were no doubt formed by his life as a rural man from the Highlands, but the trajectory of his unprecedented career – its novelty indicated by the way he would often sign his work 'Kauage – artist of PNG' – took him into an urban, national and international world that redefined what it meant to be a Chimbu man from the Highlands.

Towards the Postcolonial

By the late 1980s the political decolonization of the Pacific was winding down. Although the goal of independence in several places remained an unrealized ideal, the momentum of decolonization as a global movement had gone. For the former imperial powers, the business was largely done. And where it remained undone, it was leftover business from a passing era. Furthermore, the end of the Cold War in 1989 and the 'triumph' of neo-liberalism and Western democracy dissipated political imaginaries that had animated political struggles since the end of the Second World War. The aura of nationhood also lost its hold in a world that was rapidly diminishing the power of nation states, reorganizing global economies to the advantage of multinational corporations and borderless capital, and redefining the nature of social identities through global media networks, fluid labour markets and ideologies of cultural pluralism.

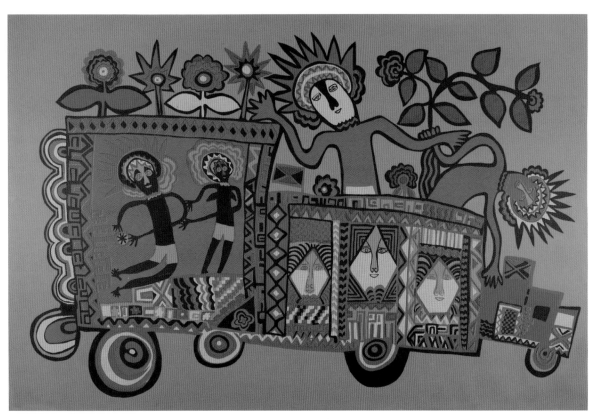

Mathias Kauage, *Independence Celebration 4*, **1975.**
Screenprint, 50 x 76 cm (19⅝ x 29⅞ in.). Collection of the University of Cambridge, Museum of Archaeology and Anthropology.

Mathias Kauage (c. 1944–2003) was a founding figure of modern art in Papua New Guinea. His earliest works of 1969–70 featured strange creatures of his imagination, but he quickly moved on to become an artist of the Port Moresby urban scene and – beginning with this work – of public political events and historic encounters. A number of painters working in Port Moresby today aim to make a living, painting Kauage-style works for sale to tourists and art dealers.

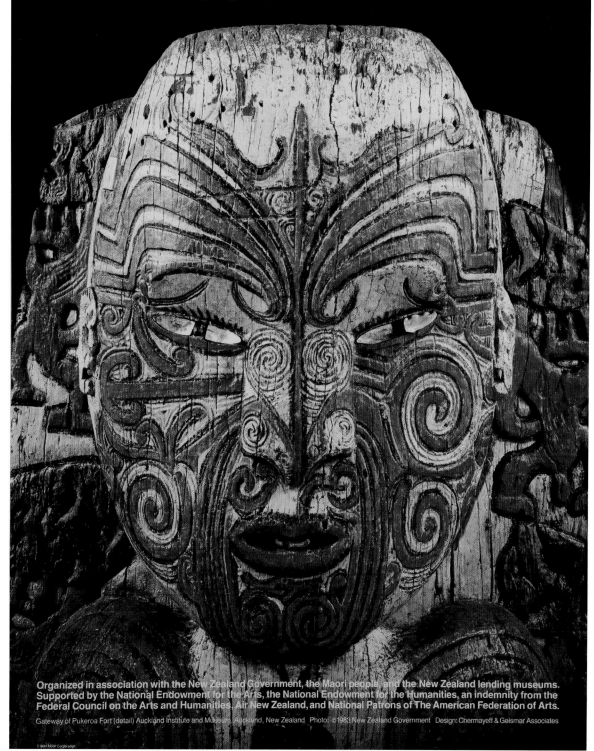

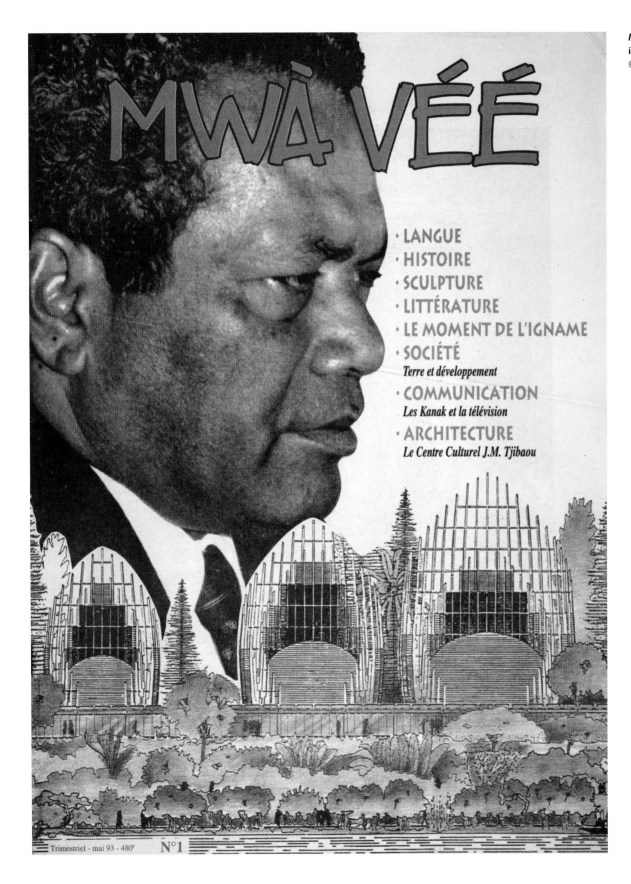

MWÀ VÉÉ

- LANGUE
- HISTOIRE
- SCULPTURE
- LITTÉRATURE
- LE MOMENT DE L'IGNAME
- SOCIÉTÉ
 Terre et développement
- COMMUNICATION
 Les Kanak et la télévision
- ARCHITECTURE
 Le Centre Culturel J.M. Tjibaou

Trimestriel - mai 93 - 480ᶠ N°1

Two events in the 1980s could be said to mark this ambiguous turn in the history of decolonization. One was the exhibition 'Te Maori' (*page 381*), which opened at the Metropolitan Museum of Art in New York in 1984 – a bookend to 'Arts of the South Seas' with which this chapter began. 'Te Maori' is a culminating point in the history we have sketched in this chapter because of its success in realizing the potential of art and ancestral culture to achieve the goals of decolonization. Conceived in the 1970s and staged with the cooperation of tribal leaders from across New Zealand, 'Te Maori' was a striking demonstration of the re-empowerment of colonized cultures over their art and representation in the world. The exhibition's American success enhanced the global prestige of Māori culture, and its triumphant return to New Zealand in 1987 coincided with watershed political successes of that decade for Māori: official recognition of the Treaty of Waitangi (originally signed by tribal leaders and 'the Crown' in 1840), the establishment of a Māori land-claims tribunal and the introduction of official biculturalism. At the same time the conditions of the exhibition – sponsored by a grant from Mobil Corporation, part-funded by the New Zealand government, toured to major American museums and galleries – demonstrated the nature of the postcolonial 'culture game' in a post-imperial world (or a different kind of 'empire') in which Oceanic art was now entangled.

The second event was the tragic assassination of Kanak independence leader Jean-Marie Tjibaou in 1989, which followed the signing of the Matignon Accords in New Caledonia in 1988. The Accords brought to an 'end' the militant struggle of Kanaks for independence that had begun in earnest in the 1960s. By the 1980s that struggle had spiralled into violence, culminating in an episode of hostage-taking and political killings in 1988. Given this tragedy, the signing of the Accords was a means to prevent further polarization and violence. They deferred the question of independence to a later referendum (when it was deferred again) and initiated a set of structural changes to rebalance colonial inequities in the country and re-empower the Kanak population, including the agreement to recognize and develop Kanak culture. Tjibaou was assassinated by a fellow Kanak, embittered by this compromise. In the wake of Tjibaou's death, the French government undertook to construct a memorial cultural centre, which would give expression to his vision of a revived Kanak culture. The figure of Tjibaou and the cultural centre constructed in his name therefore lie at the precise turning point between decolonization as a pan-Pacific movement for nationhood and independence, and postcoloniality as the set of liberal, democratic and cultural conditions ushered in at the end of the 1980s.

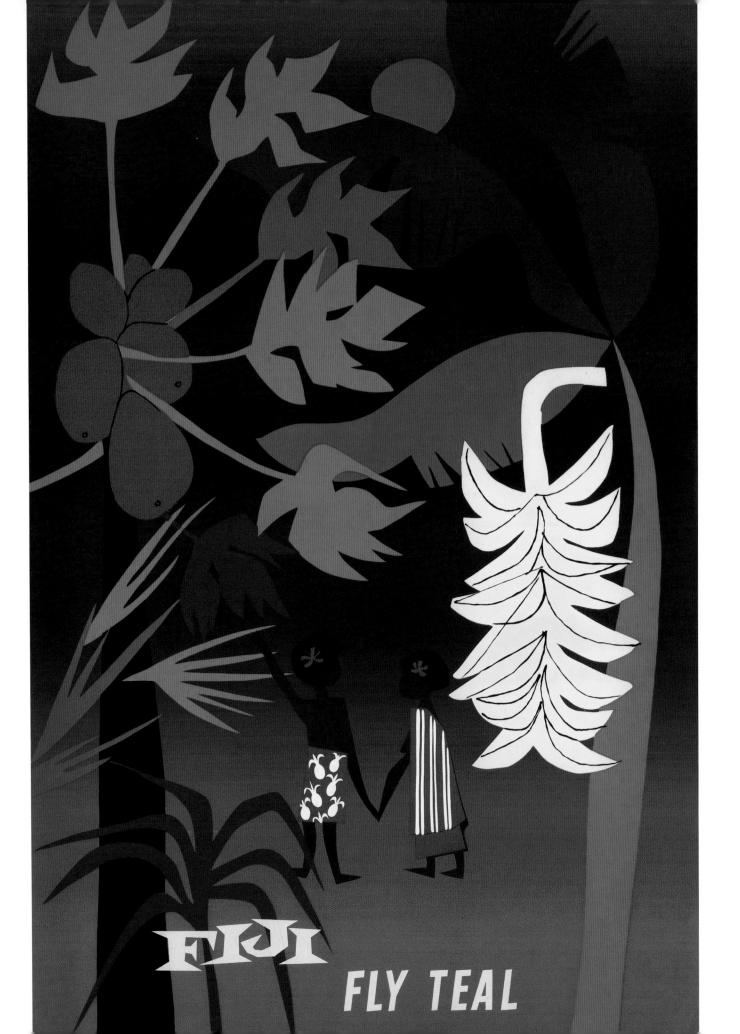

Sean Mallon

TOURIST ART AND ITS MARKETS
1945–89

TEAL advertising poster,
1950s.
97 x 63 cm (38⅛ x 24¾ in.).
Museum of New Zealand Te
Papa Tongarewa, Wellington.

The Second World War accelerated cultural and economic change in the Pacific. The machinations and machinery of war transformed the environment, lives and cultures of Pacific peoples. New roads, airfields and military architecture were built to support the war effort. New music, clothing, food and resources travelled with troops to their new postings. Artefacts, images, writings and memories went home with those fortunate to survive the war. From the late 1940s through to the 1980s the intensive development of infrastructure, the influx of new ideas, and the movement of people and resources continued at a quickening rate. Old transportation and communication channels deepened and expanded. The flow of commodities, people and ideas ran both ways, and in the calm of peacetime movement of all kinds was unhindered by hostilities. A new era of change was in motion.

The history of tourist art in the Pacific between 1945 and 1989 documents an increasingly unequal but interdependent relationship between people producing tourist art and those who consumed it. Tourist art and its markets in the Pacific were a co-construction of tourists and indigenous peoples. As in earlier periods of Pacific history, tourism was a phenomenon that entangled indigenous and non-indigenous people in the imagining and imaging of the Pacific: postcards and tourist brochure photographs; posters for cruises and air travel; the motifs of mass-produced carvings and textiles; the grass skirts, coconut-cup bikinis, and songs and dances of 'Island Nights' in hotels and resorts; the dangerous-looking clubs and weapons on sale in airport and market stalls; and in the floral motifs on *pareu* (wrap-around skirts), shirts and hats. Tourism had created a rich catalogue of visual culture that served economic purposes and represented individuals, communities and nations. The visual arts of tourism originated within and outside the region, and circulated through it and beyond it. There was a diverse range of experiences of and reactions to tourism in this period.

The markets for handicrafts and cultural artefacts from the Pacific were well established before the Second World War. The emergence of tourist art has its origins in the early nineteenth century, although systematic collecting of artefacts was an enterprise that commenced earlier, with the first European explorers in the region. Early nineteenth-century Christian missionaries were key hunters and collectors of all kinds of cultural treasures. They wanted to have evidence of their evangelizing missions and trophies of their success.[1] Whalers and early traders exchanged trinkets, nails and other European goods for items of native manufacture. Some sailors collected tattoos. Anthropologists, geographers and scientists gathered artefacts for their universities or museums, and made images and detailed studies of the peoples they encountered. Officers of colonial administrations were active and passive collectors, and sometimes dealers and agents for the development of markets for artefacts outside the Pacific. Their activities were published in academic and popular literature and engaged the imaginations of people in the West. These drawings and writings of early explorers created a catalogue of images of 'noble savages', 'native belles' and island environments that were foundational signifiers in tourism's visual culture. By the 1880s Burns Philp and Company of Queensland, and the Union Steamship Company of New Zealand, had established tourist cruises in the region. Later, the Matson Navigation Company would be an important United States-based connection to Hawai'i that would extend to Fiji, Samoa

and French Polynesia.[2] The establishment of tourist cruises commercialized the recreational travel practices of the Western wealthy and social elites. By the mid-twentieth century, tourist art in the Pacific was developing as a small part of a much larger global phenomenon that emerged from the gaze of Westerners and their experiences of travel and interactions with Pacific people.

Infrastructure, Image and Opportunity

The lines of communication established during the Pacific war did not go quiet. Tourist art and its markets expanded because infrastructure and access to the region had improved. A key market for tourist art and other forms of cultural production was the people travelling through airports or visiting hotels and resorts. These often long-established locations of economic activity were reinvigorated after the war as modern centres for travel, communication and trade. Commercial airlines and shipping took goods, cargo and people in and out of the region. Traffic on shipping routes increased to service local and overseas markets, and hotels hired dancers and performers. Artisans were attracted to these centres to sell model canoes, carvings, weapons, necklaces and other souvenirs. In Fiji of the 1970s, ship day in Suva was a day of excitement and commercial activity. In 1980 Jese Sikivou wrote:

> For a few hours the streets throng with tourists hampering local people, hampered in turn by curio and handicraft vendors. Little boys are seen running with plastic bags of flower leis, usually in the opposite direction from the police. Sword sellers, among others, see this as their chance to make a dollar.[3]

Commercial activity around the arrival of ships was common in major ports across the region. Like shipping routes, air routes became increasingly important to the opening up of the Pacific, particularly after the disruptions of the war. Attempts were made to start commercial flights in the 1930s, but it was not until the late 1940s and early 1950s that regular flights were scheduled by Pan Am (Pan American Airways based in the US) and TEAL (Tasman Empire Airways Ltd) owned by New Zealand, Australia and Britain. A famous run by TEAL airlines was the Coral Route

that flew between Tahiti, Aitutaki and Fiji, and then later Western Samoa and Tonga.[4] The marketing of the Coral Route captured the imagination of many New Zealanders and Australians who wished to escape the winter. The trans-Pacific air routes inspired the creation of a significant range of products drawing on the artistic heritage of the Pacific and the well-established visual tropes of the photograph and picture-postcard trades that emerged in the late nineteenth and early twentieth centuries. The emergence of tourism and the development of photographic technology had created a popular taste for exotic Pacific postcards and photographs that provided 'a surrogate gratification for those that could not afford the luxury of an island cruise'.[5] Photographs of the Pacific region, its peoples and customs were sold at cruise stops, and then airports. They appeared in popular journalism, and were used to promote commercial opportunities in newspapers, magazines, books and brochures. By 1945 the Pacific had a long history of representation as a region where Westerners could expect to go to seek adventure and economic opportunity.

Airlines played a key role in marketing the Pacific to the West and used visual tropes and stereotypes to advantage. In the case of TEAL, their advertising posters combined stereotypical signifiers of Pacificness – exotic, mysterious women with flowers in their hair,

MELANESIAN MISSION PICTORIAL POST CARD—Serie

A Place of Bar

Moanalua Gardens,
Honolulu.

No. 416 Samoan Family.

Well come I see you again
The family has deceased - have caught five...

PHOTOTYPE A. BERGERET & Cie. NANCY.

FIJI. - Sea turtle

G. Jac—ken's Kunstanstalt, Altenburg, S.-A.

Gruss aus Yap.

'WHERE SHALL WE GO THIS WEEKEND?'

It is not easy to remain yourself and to practise tolerance towards
other civilizations. However much we may be inclined toward foreign
cultures – whether it is through a kind of scientific neutrality or through
a curiosity and enthusiasm for the most remote civilizations, or whether it
is caused by a nostalgia for the abolished past or even through a dream
of innocence or youth – the discovery of the plurality of cultures is never
a harmless experience. The disillusioning detachment with respect to our
own past, or even self-criticism, both of which may nourish this exotic
feeling, reveals rather well the kind of subtle danger which threatens
us. When we discover that there are several cultures instead of just
one and consequently at the time when we acknowledge the end of a
sort of cultural monopoly, be it illusory or real, we are threatened with
destruction by our own discovery. Suddenly it becomes possible that
there are just others, that we ourselves are an 'other' among others.
All meaning and every goal having disappeared, it becomes possible
to wander through civilizations as if through vestiges and ruins. The
whole of mankind becomes a kind of imaginary museum: where shall
we go this weekend – visit the Angkor ruins or take a stroll in the Tivoli
of Copenhagen? We can very easily imagine a time close at hand when
any fairly well-to-do person will be able to leave his country indefinitely in
order to taste his own national death in an interminable, aimless voyage.
At this extreme point, the triumph of the consumer culture, universally
identical and wholly anonymous, would represent the lowest degree of
creative culture. It would be scepticism on a world-wide scale, absolute
nihilism in the triumph of comfort. We have to admit that this danger is at
least equal and perhaps more likely than that of atomic destruction.

Paul Ricoeur, French philosopher, 1955[i]

the sea, fruit, forests and *pareu*-clad figures – with the blocks of bright colours and stylized lines that constituted a distinctly modern 1950s advertising aesthetic (*page 384*). In 1965 TEAL was replaced by a new airline, Air New Zealand. Māori motifs appeared on the airline's crockery and livery as a means of visually branding the airline of a nation. Merchandising and souvenir items included plastic versions of Māori *hei-tiki* (*page 386*) – adornments usually made from *pounamu* (New Zealand jade). Despite their ephemeral nature, the TEAL posters of the 1950s and early 1960s are now highly collectable; and the Air New Zealand merchandise of the 1970s regularly finds its way into auction houses and websites as collectable kitsch.

The building of a modern airport in Samoa in 1969 and improved air and ferry services within the archipelago through the 1970s increased international tourist traffic to Samoan islands.[6] These changes in infrastructure encouraged hotel development and tourism, and consequently revived interest in the building of Samoan *faletele* and *faleafolau* (two large house types) as key structures in resorts. Large *fale* are noted for their distinctive roofs and fine lashing of long rafters and support posts. In a tourist context they were statements about the artistic sophistication and culture of the Samoan people. Significant examples were built

at Aggie Grey's Hotel in 1968[7] and the Hotel Kitano Tusitala in 1974. The *fale* were made to accommodate dining areas and performance spaces within the hotels. In particular, the Tusitala *fale* were built to very large dimensions and were considered a massive undertaking at the time. When the hotel was opened it was described by the board chairman as being a 'showcase for Samoan architecture', its great structure and fine detailing a testimony to the work of a group of skilled builders.[8] In the 1990s the owners of the Sina Lei Reef resort on Samoa's south coast constructed three *fale* in part for reasons of cultural revival and the preservation of skills. The projects provided work for local *fale* builders (formerly a specialized trade), and facilitated short-term localized activity in weaving, sennit-making, timber-milling and the skills of actually lashing a house together. Confined largely to well-funded public building projects and coast-hugging resorts frequented by tourists, such *fale* represent an idealized Samoa and remain key motifs in Samoa's tourist image despite their diminishing presence in the village landscape. The *fale* at these resorts and hotels not only represented culture but were also sites for the staging of culture. Both Aggie Grey's and the Hotel Kitano Tusitala held regular evening floorshows in their *fale*. Guests were entertained by performances of Samoan singing and dancing and served local cuisine. From 1968 the Hangi Room at the Kingsgate Hotel in Rotorua, New Zealand, held similar events, showcasing Māori culture with a nightly concert party in a themed dining room (see Feature box on pages 390–91). Visitors to New Zealand could enjoy a packaged cultural experience to complement their day's tours without leaving the comfort of their hotel. In Hawai'i the Waikiki hotels offered indoor/outdoor Hawaiiana decor and the famous *luau* dinner shows (*page 392*). On Rapa Nui similar experiences were available on a less formal level. Householders 'developed "bars" and "discotheques" in their lounge rooms or in specially built adjacent buildings' as destinations for visiting foreigners. In the late 1960s these venues provided Tahitian–inspired cultural shows for the enjoyment of Chilean and United States military personnel based on the island.[9]

In California and other American states in the 1950s and 1960s, the 'cult of Tiki' arose in an effort to commercialize and almost transplant the imagined

Fale at Aggie Grey's hotel, Apia, Samoa, 2011.

The *fale* at Aggie Grey's Hotel in Samoa was made to accommodate dining areas and performance spaces. It is presented to international visitors as a fine example of Samoan aesthetics and architecture.

Staging Māori

THE HANGI ROOM at the Kingsgate Hotel in Rotorua,
Aotearoa New Zealand, dates from 1968, when the hotel
complex was built and opened by the original owner, DB
Breweries. Whereas other parts of the hotel have been
substantially remodelled, the Hangi Room remains in original
condition, offering a fascinating glimpse into the staging of Māori culture
for tourists in Rotorua in the late 1960s.

A large rectangular space with high ceilings, the Hangi Room
still offers guests the chance to experience 'a Maori Cultural Concert
after a traditional style Maori feast'.[i] A shallow stage decorated with
carvings and *kōwhaiwhai* scroll paintings suggesting the *whare whakairo*
(decorated meeting house) dominates one end of the space; the two
walls flanking the stage are food serveries. The dessert station features a
naturalistic painted mural of a sweeping, steaming geothermal landscape
and *whare whakairo* sited majestically on a hill, while the hot-food area
features a carved relief mural of mythological subjects (also naturalistic),
and a set of carved sliding wooden screens that divide the servery from
the dining area. The final wall features a model *pātaka* (food storehouse
raised on posts) with two painted *hoe* (canoe paddles) wall-mounted on
either side. The upper levels of each wall are decorated with a series of
wire constructions that represent various styles of carved faces found
in Māori art, and *kōwhaiwhai* scroll patterns are painted onto the beams
that run along the ceiling.

The Hangi Room represents the most flamboyant use of Māori art
in the Kingsgate Hotel. It is also the site that most obviously declares
itself as non-traditional and, perhaps, inauthentic. The Hangi Room owes
as much to 1960s interior design, or theatrical stage design, as it does to
Māori architecture and art, and elements such as wire constructions are
clearly not part of the customary repertoire of the Māori artist. Indeed,
the Hangi Room represents a particular historical interaction of tourism
and Māori culture that led, in the post-war boom of tourist activity in
Rotorua, to the nightly concert party.

As Ngahuia Te Awekotuku has pointed out, early concert party
performances were staged on *marae* (community meeting places) in
whare whakairo, so stage props and sets were not required. But as
performers moved to Pākehā environments such as theatres and hotels, it
was necessary to develop a setting within which guests would experience

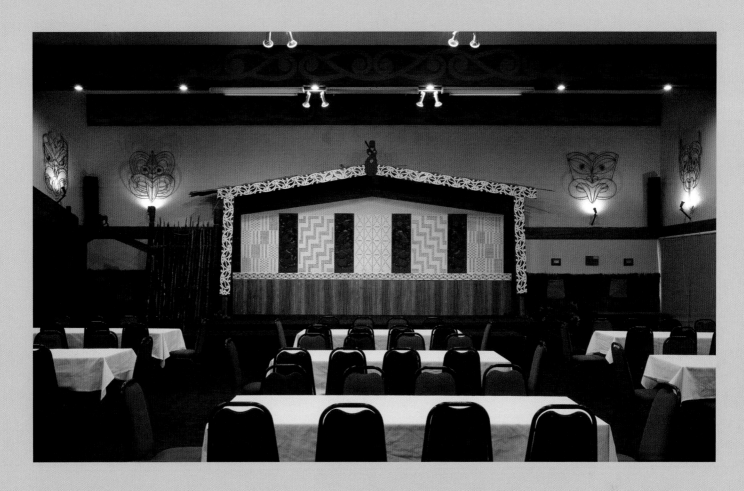

The Hangi Room, Kingsgate Hotel, opened 1968.
Photograph Studio La Gonda, 2007.

the dancing and singing. Thermal effects were a very popular subject, and remained so in the postwar period, but as Te Awekotuku writes 'the most popular stage environment, however, is the "village scene"'.[ii]

The Hangi Room is not easily dismissed as evidence of tourism's degenerate effect on Māori culture, as elements of the environment undercut such easy conclusions. Aspects of this installation – the carved sliding doors and the carvings behind the stage – were produced by the New Zealand Institute of Māori Arts and Crafts under the aegis of Hone Taiapa, one of the leading master carvers of the twentieth century. Strengthening this connection are the plaques by the top graduates from the Institute that hang along one of the walls in the Hangi Room, marking the relationship between DB Breweries, who funded the award for best graduate, and the students of the Institute, who would carve the plaque celebrating their achievement. And then there is the situation of the Māori performers, who use such opportunities to gain economic advantages and employment, as well as cultivating and maintaining aspects of Te Arawa performing arts. It is not always straightforward to identify where agency sits in a complicated site such as the Hangi Room, and indeed in the wider context of Rotorua itself, where Māori and tourism have interacted for over one hundred and fifty years. DS

Pacific into American suburbs. While images of the
Pacific were being made in and transported out of
the region on bodies and in suitcases, they were also
sprouting around its rim. Highly stylized, almost
cartoon, versions of Pacific Island architecture,
carvings, decor and environments were built as
entertainment venues in towns and suburbs.[10]
Museums built dioramas of Pacific locales, fairs
brought dance troupes, and musicals, books, sound
recordings and films offered another kind of
immersion experience for the armchair traveller. The
images found their way into living rooms via shows
such as the 1950s radio programme *Hawaii Calls* and
television series such as *Hawaii 5-0*,[11] and into cinemas
through films such as Elvis Presley's *Blue Hawaii*
(1961). Californians managed to create their own
quasi-Pacific paradises and played in them on
weekends and holidays.

Often tourist art sold in airports, hotels and
cruise-ship stops was produced in villages and islands
outside urban centres. Some of these locations had
long histories as centres of trade within their respective
regions. Others became important as more people and
products moved through them. For example, in Tahiti,
the opening of Faa'a airport in 1961 and the French
nuclear-testing programme brought thousands of
foreigners to Tahiti. Between 1960 and 1970 visitor
numbers increased from four thousand to fifty
thousand a year.[12] Carol Ivory suggests that the
growing tourist market in Tahiti in the 1960s
influenced and expanded the repertoire of carving
from the nearby Marquesas and encouraged the
production of artefacts from the Tuamotus, Austral

and Gambier Islands. Most tourist articles for sale in
Tahiti originated in other parts of French Polynesia.[13]
In Tahiti they represented individual communities
where the artefacts were manufactured, but in airport
environments and in overseas markets such as Fiji they
represented Tahiti as a singular synthesis of local
cultural influences.

Fairs, Festivals and Museums
The traffic in objects and art forms within and beyond
island groups contributed to the emergence of other
contexts for the sale of artefacts and exhibition of
cultures. For example, the development of tourist art
was connected to projects of nation building and the
assertion of local and regional identities in fairs,
festivals and museums. Fairs encouraged handicraft
production. They were supported by local businesses,
cultural institutions and government, and they
attracted tourists and expatriates working in the
territory as well as locals. For small businesses and
individual producers these events were major sources
of income and provided opportunities to find new

markets for their work. Some entrepreneurs sought such opportunities internationally. For example, Pitcairn Islanders held an exhibition of their work at the New York World's Fair in 1964–65, in order to find markets for their handicraft and boost their income.[14] The Trust Territory Economic fair held in Guam in 1960 featured the best of the handicrafts produced in the region, although items of so-called 'handicraft' included a full-size outrigger canoe and a 'great piece of stone money from Yap weighing more than a ton'.[15] A feeder into the Trust Territory Economic fair of 1960 was the Palau District Fair that had been running for nine years. Other districts held their own shows and activities that promoted their own local cultural activities and crafts. The fair attracted local producers and business people, and institutions invested in promoting culture. The Palau Museum, which had only opened five years earlier, hosted an art show at the fair, and a blowgun shooting competition for local experts.[16] These were events that facilitated economic and cultural development and where regional distinctions were celebrated and put on display. In Papua New Guinea the first Eastern Highlands Agricultural Show in 1956, subsequently called the Goroka Show, was one of several introduced by the administration to enhance the 'social cohesion of the area' and to stimulate 'interest in native agriculture and handicrafts'.[17] Organizers achieved

some success. The first prize winners of the 1957 Goroka Show were the now internationally recognized Asaro Mudmen (*overleaf*).[18] Similar festivals, such as the annual Mount Hagen Show in the Western Highlands, were later established throughout Papua New Guinea, and remain highlights of the nation's cultural calendar.

In cultural festivals, representations of the nation in performance and portable tourist art were made visible to a Pacific-wide and global audience. The first South Pacific Festival of Arts in 1972 took the role of festivals and fairs to a scale that engaged the entire Pacific region. Held in Suva, Fiji, this event saw village and district identities subsumed by the need to represent individual nations. This occurred through both cultural products sold to tourists and various forms of mass media for international audiences. Both processes were crucial when projects of decolonization were on the regional political agenda.

Although fairs and festivals were events linked to tourism and its markets, they could also be occasions to push back against tourism's dominance in cultural production. In 1969 art forms of all descriptions were the focus of the first Micronesia Arts Festival hosted by Saipan. Categories included sculpture, weaving and textiles, jewelry, painting, drawing, mixed media, photography and children's art. One reviewer, lamenting the lack of Palauan carvers in a sculpture category dominated by Yapese, said, 'Where are the

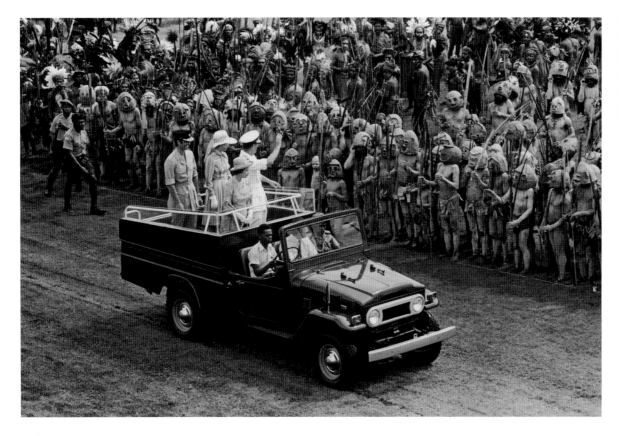

Mark Phillips, Princess Anne, Queen Elizabeth II and Prince Philip waving to Asaro Mudmen from a jeep during a royal tour of Papua New Guinea, February 1974.
Photograph Serge Lemoine/ Getty Images.

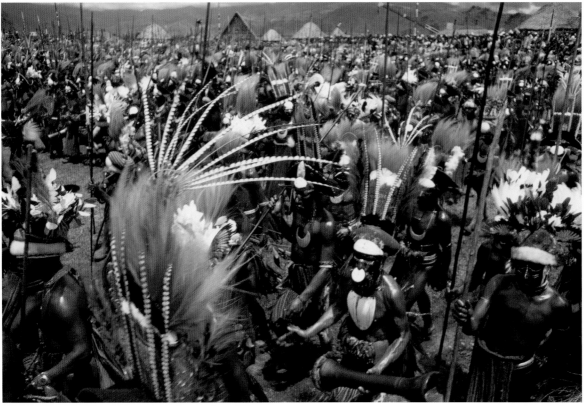

Papua New Guinean warriors in ceremonial dress, Mount Hagen, Papua New Guinea, c. June 1966.

Cultural festivals are key events that are often initiated and marketed to attract tourists. However, they are important for the opportunities they create for innovation as well as the persistence and display of local art forms and identities.

Palauans? Too busy grinding out tourist junk to be concerned with art?'[19] However, in contrast to these large, stimulating contexts for the assertion of identity and innovation, the assertion of identity could involve an artistic conservatism that was equally powerful. For example, writing about the Abelam people of Papua New Guinea in 1967, anthropologist Anthony Forge argued that the revival of ritual artistic activity since the late 1950s, despite virtually having ceased during the Pacific War, was 'a symbol of a withdrawal from excessive contact with European values and a reaffirmation of traditional values.... The art was reinforced in its conservatism by taking on the additional value of acting as a symbol of Abelam culture in the face of colonial culture.'[20] (See Feature box on pages 354–55.)

As museums and cultural centres became established, for example in Papua New Guinea (1954), Palau (1955), Vanuatu (c. 1959)[21] and the Solomon Islands (1969), they played a key role in creating space for preservation and heritage projects and disseminating information for cultural revival. In 1962 the Palau Museum distributed to local craftsmen a publication featuring drawings of items collected on German anthropologist Augustin Krämer's visit to Palau in 1908–10. The drawings were intended to inspire contemporary craftsmen, some of whom may not have seen 'objects of this nature in their lifetime',[22] to produce artefacts for the tourist market that people felt were important to their cultural identities or were at risk of losing.

Tourist Art, Development and the 'Pan-Pacific'
Development agencies focused on tourist art production as an opportunity for small-business projects that would help village and rural people survive in the cash economy. Regional organizations such as the South Pacific Commission, which sponsored the South Pacific Festival of Arts mentioned above, actively promoted and developed markets for handicrafts. The Commission was an intergovernmental advisory body set up to support and advance the welfare of Pacific peoples in social, health and economic development. In 1964 it published an illustrated guide, *Handicrafts of the South Seas*. The aim of the publication was to provide a review 'of such handicrafts of the South Seas as might give pleasure to

people of metropolitan countries'.[23] The country-by-country overview was well illustrated and provided prices and contacts for prospective customers. Regional distinctions and specialities were noted in some entries. Tahiti had products representing a synthesis of local cultural influences and European style; their neighbours in the Austral Islands – Rurutu, Rimatara and Tubuai – were noted for their weaving in pandanus; and the Marquesas for their distinctive woodcarving. It was noted how Fiji was a 'focal point of handicrafts from all the central Pacific', including items from Tonga, Niue, Kiribati, Tuvalu and Samoa, but also how this situation had the potential to give an uninformed tourist a distorted picture of what Fijian handicraft itself comprised.[24] Handicraft catalogues were published in various forms and European languages. They responded partially to 'increases in enquiries from overseas' and were strategically developed marketing tools within the development and aid projects of the Australian and New Zealand governments.[25] Importers outside and within the region could select and order from a smorgasbord of Pacific handicrafts without actually having to set foot in the region.

Another outside agency that supported enterprises for the handicraft and tourist art market were Peace Corps volunteers. They shaped tourism in ways similar to their military countrymen who had lived and fought in the region only twenty-five years earlier. Indeed, they were almost a demilitarized version of soldiers. In the late 1960s Peace Corps volunteers were involved in many small business ventures, including the setting up of handicraft cooperatives.[26] They influenced tourist art production in Palau, the Marshalls Islands, Northern Marianas and the Federated States of Micronesia. By 1968 there were more than 700 Peace Corps volunteers assigned to the region. They helped develop the tourist industry in very hands-on ways, but they were also consumers of it. The interest of Peace Corps volunteers in permanent souvenirs from their island experience started a phenomenon in Samoa that spread to Samoan communities overseas and the tribal tattooing circuits of the United States and Europe. Travellers had been acquiring tattoos as a form of souvenir since the earliest days of European exploration in the Pacific. From around 1967 American Peace Corps volunteers eager for permanent reminders of their time in Samoa were behind the development of

far left
US Peace Corps Volunteer Jim Carr receiving a wrist tattoo, Samoa, *c*. 1973.

Tourist art and its markets transformed the motivations of cultural production. The social life associated with the visual and performing arts incorporated new influences and economic processes. Trends and transformations in artistic and material culture in the Pacific have been well documented by development consultants, business people, economists and anthropologists. Their findings highlight how tourist art and handicraft production are central to the economics of nation and community. Tourism impacted communities throughout the region at different levels of intensity. It affected some parts of the Pacific more than others and its cultural and economic impact was unevenly spread. In Hawai'i tourism was and remains a multi-million dollar industry, whereas in the atolls in Micronesia and Polynesia it is sometimes important but more often economically marginal. In some locations markets for handicrafts were unreliable. Many small atolls and islands were not on major shipping or aircraft routes, and visits by cruise ships and aircraft were intermittent. If there was a major development project such as the blasting of a reef or the building of a hospital or school, visiting engineers and consultants would provide a temporary clientele. A patrolling navy ship, a cargo ship or a yacht on a Pacific cruise might stop en route. On the raised atoll of Niue, in the 1970s, the impact of tourism was considered too small to be beneficial or harmful. However, in the 1950s and 1960s even seemingly remote islands like Pitcairn could be visited by ships up to forty times a year. For individual Islanders, their only source of cash income came from the sale of their painted sea shells, weaving and carved flying fish and birds.[31] Sometimes their carvings would be exchanged for tinned foods, milk powder or other barter and

tattooed armbands known as Peace Corps tatts, or *pe'a pisikoa*.[27] Despite late nineteenth-century precedents for tattooed armbands known as *taulima*, Samoan *tufuga ta tatau* (tattooing expert) Su'a Sulu'ape Paulo II claims he invented the *pe'a pisikoa*.[28] Some volunteers received full Samoan tattoos. One elderly woman named Elsie Bach, who became friends with the Sulu'ape family, was tattooed with a *malu* (the female form of tattoo) across both legs and bestowed with the Sulu'ape title.[29] Later in the 1970s well-known American tattooist Lyle Tuttle also visited Samoa, leaving with a sample of Samoan *tatau* and a *matai* (chiefly) title.[30] As Samoan tattooists travelled overseas and their work was seen in magazines and other forms of mass media, the tattooed ethnic armbands spread in tattooing circles. *Taulima* and *tauvae* (anklets) are still popular souvenirs of Samoa for tourists who can get them, and they have become a symbol of ethnic identity for people of Samoan descent living overseas.

left
Painted spider conch shell, Pitcairn Island, acquired 1986.
Length 28 cm (11 in.). Museum of New Zealand Te Papa Tongarewa, Wellington.

Moai kavakava **(ancestor figure), Rapa Nui, 1996.** Carver Bene Pate. Wood. Height 60 cm (2 ft). Museum of New Zealand Te Papa Tongarewa, Wellington.

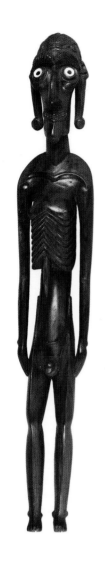

luxury goods. When archaeologist Thor Heyerdahl visited Rapa Nui in 1955, the needs of locals were more basic. A group of raggedly dressed locals surprised him and his crew by coming out to their ship in the dark. They arrived with:

> bags and sacks full of curious things…. The most bizarre wooden carvings began to circulate from hand to hand…. There was one particular weird figure…that reappeared in all the men's wood carvings. It had a strikingly curved aquiline nose, a goatee beard, long hanging earlobes, large deep set eyes and a face convulsed in a devilish grin…. All the carvings were masterly, faultlessly executed and so highly polished they were like porcelain to the touch. Here indeed we had been received by a whole team of admirable wood carvers.[32]

On this occasion the carvers wanted to barter their work for clothes and shoes with which to cover themselves. Thirty years later, in the 1980s, carvings on Rapa Nui were still being exchanged for clothing such as jeans, and items like radios, sunglasses and watches that were difficult to acquire on the island.[33] Tourist art could be exchanged for cash as well as the fashionable products of an increasingly desirable and Western material world.

As more peoples of the Pacific became reliant on a cash economy, small businesses and industries around tourist products became more important. In the manufacture of objects there are several processes that emerged as typical of the tourist art producers and consumers at this time. Depending on supply and demand, mass production of artefacts for tourist markets often involved streamlining production. In this approach to artefact manufacture, a craftsman would prepare the basic shape, another would rough out some detail, a skilled carver would put in the finishing touches and perhaps inlay some shell, while another person would finish and polish the piece. Foreign consultants would advise on product marketing and sometimes the upskilling of local craftspeople. New products could be introduced as well as new styles and ideas. In 1976 the YWCA (Young Women's Christian Association) in Suva, Fiji, brought in two Filipino handcraft specialists to teach Fijian women how to make new products.[34] However, artisans could find their inspiration in books and magazines or their own imagination. There is a sense in which the artefacts could embody the 'interacting stereotypes of consumers and producers', as they do in other tourist destinations.[35] Modifications in form and style often accommodated tourists' tastes for the miniature or gigantic, the grotesque and the risqué. There are some notable examples. Cook Islands Tangaroa figures come in a range of forms, including examples featuring 'pop-up' penises. In the detailing of weapons, bowls and other wooden artefacts, dark dyes were used on artefacts to make them look older or more exotic, or to provide a contrasting surface so that incised patterning would stand out. Some weapons were given extra spikes or cutting edges, anything to make them look more 'savage' or 'exotic'. Kava bowls were made in a range of sizes, from finger bowl to a size too heavy to lift. However, artefacts were also modified for practical reasons, to make them robust for transit or small

Marquesas. The pan-Pacific woodcarvings emphasized a 'grimacing mouth, which would appear to have its origins in Hawaiian carvings, such as those of the *atua* Kūkā'ilimoku'. Similar composite works feature a Tahitian style blended with Marquesan forms. Hawaiian-style carvings and pseudo-Marquesan *tiki* had been carved and sold in Samoa since 1965 and in Tonga by at least the 1970s.[36] A Tongan handicraft guide published in 1980 states:

> The carvings in Tonga have a chunky, stolid power about them that says clearly that they come from the South Pacific. Although those for sale are not sacred images, many are reminiscent of such ancient origins…. Although many of the pieces they carve follow traditional designs, many carvers have their own specialities. One may see carvings of splendid dragons and many varieties of tiki, the Polynesian god image…. But some of the better carvers concentrate on making excellent copies of intricately incised wooden linen chests and lampstands…for which there is a market.[37]

Although these items were examples of the skills of Tongan artists as woodcarvers, they were not part of any previously documented tradition of woodcarving in those islands. A dragon carving may be inspired by a picture from a book and be part of a Tongan

enough so they could easily fit into a suitcase or travel bag. Items made from lighter, less dense timbers would sell better than heavier items. In Hawaiian stores one could choose from rows of variously sized *akua* (god) figures made in woods, plastics and other lightweight synthetic materials.

Philip Dark described the emergence of what he considered a pan-Pacific style of carving in the 1960s and 1970s. He writes about a group of Hawaiian craftsmen who were copying old Hawaiian sculptures as well as those of other Pacific countries including the

above
Ahu Tahai with tourists, 2006.

Although there has been a steady stream of tourists to Rapa Nui for decades, numbers mushroomed in the 2000s. The per-capita ratio of tourists to locals now exceeds that of any other Pacific island entity, including Hawai'i. The implications now affect debates about the future political status of the island and control over the production of tourist art.

left
Two woodcarvings by David Fifi'ia and two by Niu Tuitupou, Nuku'alofa, Tonga.

Philip Dark has described a pan-Pacific style that emerged in the 1960s and 70s. It was most evident at the time in Tonga, where carvers incorporated Hawaiian and Marquesan forms in their work.

Masi kesa (tapa) cloth, Fiji, 1971.
Barkcloth. 30 x 47 cm (11¾ x 18½ in.). Rijksmuseum voor Volkenkunde, Leiden.

The images that decorate this *masi kesa* were made with stencils. Once cut from leaves, from the 1970s stencils were often made instead from pieces of x-ray film, a more durable material.

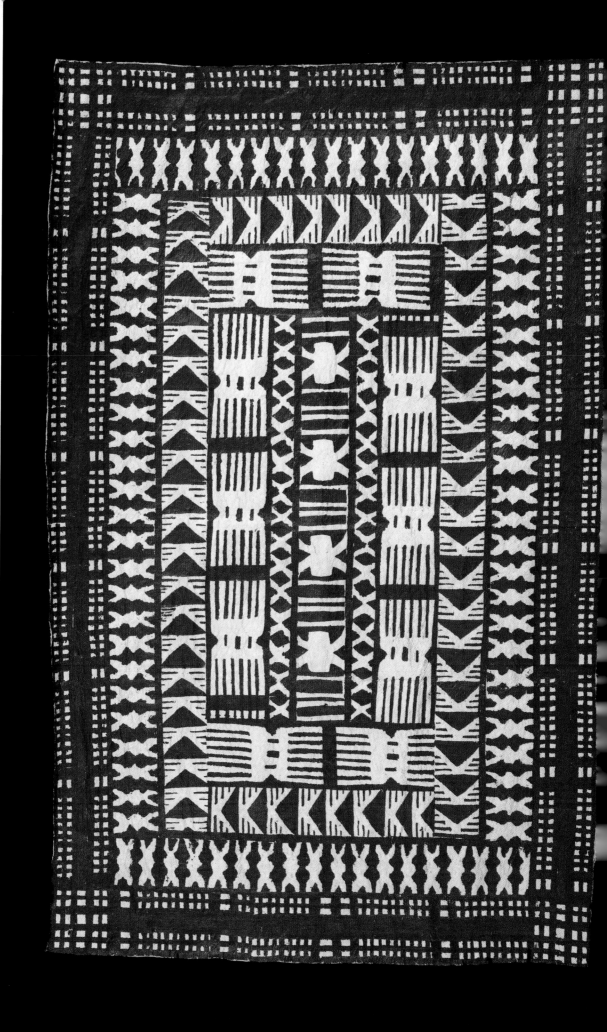

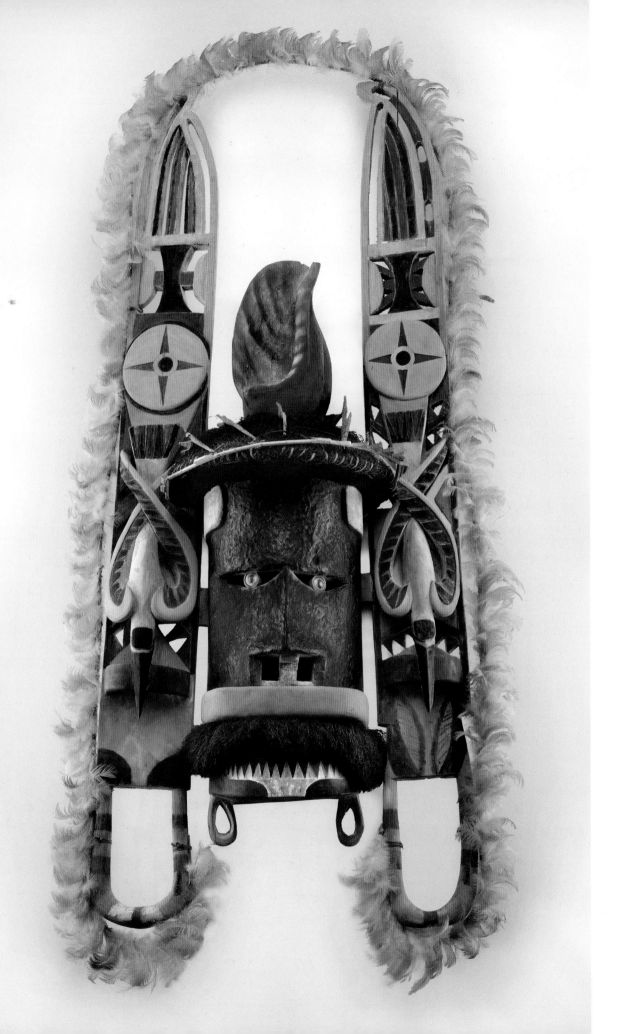

Nit kulegula **mask with pair of carved ears and paddle, New Ireland, Papua New Guinea, 1970.**
Wood, beeswax, chicken feathers, rattan, aerial root fibre, shell, paint, cotton cloth. Height 73 cm (28¾ in.). Field Museum, Chicago.

woodcarver's record of work; it may well represent his skills as a carver; but it did not represent a carving form present in the Tongan repertoire until the late 1970s. These objects were made for tourist markets, but artists worked in and across Western and indigenous systems or modes of production. The objects could be purchased by locals as well as tourists. Pacific peoples were no strangers to incorporating products of foreign origin or design in their visual and cultural worlds. Dark also noted a pan-Pacific element in dance and song performance involving the adaptation of other songs and forms (not to mention instruments such as the guitar and ukulele) to a local idiom.[38] Indeed, the practice of borrowing in Cook Islands and Tahitian dance has a long history relating to indigenous travel and cultural exchange.[39]

Artists created some classes of object (and performance) that circulated in both tourist and non-tourist contexts. For example, a basket or bowl made for exchange or use in a village could equally find a buyer in the souvenir store. Or they could make the same class of object differently, depending on the destination. In 1973 in Moce, Fiji, the production of *masi* (barkcloth) involved producing different qualities of cloth depending on whether it was destined for foreigners at the market in Suva or the local community and villages.[40] The Hawaiian *hula* is another art form enacted for tourists and non-tourists, by Hawaiians and non-Hawaiians across the Pacific region in this period.[41] Indeed, the cultural and artistic fluency of producers could be ambiguous. For example, in New Zealand, Pākehā artists dominated production of Māori arts and crafts for the tourist trade.[42] In Fiji many of the famous sword sellers were not artisans at all, but rather opportunistic businessmen.

What is Authentic?
For the collector or museum curator, the variable quality, cultural influences and discontinuities in the production of tourist art inevitably raise issues of authenticity. As Nelson Graburn has argued, '[a]rt historians and museum curators have worried about authenticity most because their professional standing and authority depends on their powers of discrimination'.[43] Issues of authenticity and therefore collectability played a significant role in the construction of meaning around tourist art objects,

the markets for them and the paths on which they circulated. Graburn suggests that 'authenticity is a concept that tourists carry with them in their heads, a concept…never to be found in other times, places, or peoples – or at least not until the tourists arrived!'[44] However, he also points out that authenticity is also becoming increasingly important for producers and their understanding of what is authentic has become part of the language of selling.[45] The question of authenticity was not an issue restricted to late twentieth-century tourism. Anthropologist Roger Neich speculated that very few figurative canoe carvings from nineteenth-century Samoa were collected, possibly because they were considered 'non-traditional' and not worthy of preservation.[46] Today, the few examples of figurative canoe carvings from nineteenth-century Samoa in German museums offer a valuable insight into the decoration and significance of *taumualua* (canoe with two bow-shaped ends). We are fortunate that some collectors could see past the tribal art market's fetish for authenticity. However, this situation has undoubtedly repeated itself in the twentieth century. For example, a club created for the tourist market in the 1980s may currently have little cultural or aesthetic value to a collector, a museum or connoisseur of nineteenth-century and early twentieth-century Pacific art, but it could become significant for the future insights it may offer into Oceania's art history. This is not to say that cultural loss or degradation of art forms in the tourist milieu was only a concern of tourists and other outsiders seeking the authentic. Indigenous producers also experienced and reacted to a sense of cultural loss and recognized the value of investing in 'authenticity'.

The composite images of 1960s and 1970s pan-Pacific carving coexisted alongside earnest attempts at cultural specificity and revival initiated by indigenous people and foreigners alike. Some collectors commissioned 'quality' objects in a market flooded with what they considered mediocre and inauthentic items. Sometimes these commissions were copied from photographs. In 1981 Phillip Lewis documented the work of an artist named Lingi from New Ireland who in the 1970s was commissioned to make a replica of a 5.8 metre (19 ft) long 'soul boat' *malangan* (funerary carving). The original was collected in 1903 and ended up in the Linden-Museum (*page 199*). In 1970 Lewis

himself commissioned a reproduction of a *nit kulegula* mask that he had seen in the area in 1954 but had not been allowed to purchase. The replica is now in the Field Museum, Chicago (*page 400*). As Lewis notes, although Lingi was not working for a stream of tourists he had found a way, like the *masi* makers on Moce, to create work within the local *malangan* system but also for markets outside it.[47]

Indigenous artists took advantage of their skills and hereditary claims to craft specializations in the face of changing economic circumstances. Tourism has provided some of these opportunities. Writing about tourism and its impact on Fijian woodcarving in 1980, Cema Bolabola reflects on how tourism affected the Jafau clan of carvers. This occupational and status group have a long history as carvers in Kabara and Fulaga in the eastern Lau group of islands. In the 1960s they were carving for local chiefs and village purposes, with occasional orders from sellers in Fiji's capital, Suva. By the 1970s they were working for two Hawaiian-based American businessmen and added animal figures, lampstands and Melanesian masks to their repertoire. Most of their products went to the American and Hawaiian markets. The tourism boom attracted other clan members to Suva, and through the business they supported their children through school and built houses for their families. Although both businesses were highly commercial and working beyond the usual repertoire of items made for local ceremonial use, Bolabola highlights how the Jafau clan of carvers successfully commercialized their skills and status as carvers. They moved from an economically unproductive situation in the village to a highly productive situation in the urban environment of Suva.[48] However, although this movement ensured the occupational role and status of the clan, it changed village economies and social dynamics in their original rural setting. Furthermore, while commercialization maintained the clan's status as carvers, it may not have been within a range of products distinctive to their culture and traditions. There are other cases where artists from recognized groups produced work for commercial purposes, and 'specialization [could continue] or even be concentrated on those who [could] meet demand, raising their status and income'. One such group were the Māori carvers of the Institute of Māori Arts and Crafts in Rotorua, New Zealand, discussed in the previous chapter.[49]

The production processes of tourist art were streamlined to meet the demands of the marketplace, and to cut costs. This led to the decentring of the historical centres for production.

below left
Tourists watching carving apprentices at the Māori Arts and Crafts Institute, Rotorua, November 1968.
Photograph Ralph Anderson, National Publicity Studios. Archives New Zealand, Wellington.

below right
Squatting figure carving, Yap, Palau, twentieth century.
Wood, mother-of-pearl shell, paint. Height 10.4 cm (4 in.). Burke Museum of Natural History and Culture, University of Washington.

'FROM A NATIVE DAUGHTER'

Our people who work in the industry – dancers, waiters, singers, valets, gardeners, housekeepers, bartenders, and even a few managers – make between $10,000 and $25,000 a year, an impossible salary for a family in Hawai'i. Psychologically, our young people have begun to think of tourism as the only employment opportunity, trapped as they are by the lack of alternatives. For our young women, modeling is a 'cleaner' job when compared to waiting on tables, or dancing in a weekly revue, but modeling feeds on tourism and the commodification of Hawaiian women. In the end, the entire employment scene is shaped by tourism.

Despite their exploitation, Hawaiians' participation in tourism raises the problem of complicity. Because wages are so low and advancement so rare, whatever complicity exists is secondary to the economic hopelessness that drives Hawaiians into the industry. Refusing to contribute to the commercialization of one's culture becomes a peripheral concern when unemployment looms.

Of course, many Hawaiians do not see tourism as part of their colonization. Thus tourism is viewed as providing jobs, not as a form of cultural prostitution. Even those who have some glimmer of critical consciousness don't generally agree that the tourist industry prostitutes Hawaiian culture. To me, this is a measure of the depth of our mental oppression: we can't understand our own cultural degradation because we are living it. As colonized people, we are colonized to the extent that we are unaware of our oppression. When awareness begins, then so too does de-colonization. Judging by the growing resistance to new hotels, to geothermal energy and manganese nodule mining which would supplement the tourist industry, and to increases in the sheer number of tourists, I would say that de-colonization has begun, but we have many more stages to negotiate on our path to sovereignty.

My brief excursion into the prostitution of Hawaiian culture has done no more than give an overview. Now that you have heard a Native view, let me just leave this thought behind. If you are thinking of visiting my homeland, please don't. We don't want or need any more tourists, and we certainly don't like them. If you want to help our cause, pass this message on to your friends.

Haunani-Kay Trask, native Hawaiian academic, activist and writer.
Excerpt from 'Lovely Hula Hands: Corporate Tourism
and the Prostitution of Hawaiian Culture', 1993.[1]

Improved manufacturing technology made it easier to have handicrafts and souvenirs mass-produced thousands of kilometres from where they would be sold. Production of artefacts primarily for money meant that art forms and the relationships between historical centres, regions and families who dominated production were transformed. However, there was some continuity in established practices. In the 1970s, Yap was a centre for handicrafts sourced from the outer low-lying atolls falling under Yap's political influence. This was not a new development. According to Lynn Martin, products from the outer atolls had been sent to Yap as gifts and tribute for centuries and were part of Yapese life. Handicrafts from Fais, Woleai, Sorol, Ifaluk, Eurepik, Ulithi and Satawal were distributed through the Yap Handicraft Store run by a group of thirty women representing the municipalities of Yap. Loom-woven garments, pandanus, coconut and turtleshell products and distinctive squatting figure carvings were typical products (*page 402*).[50]

Despite the movement of production to other places, and marketing to external visitors or organizations, tourist art usefully reflected local concerns or political goals. Art made for the tourist often captured the symbols of nationhood, the reified images that symbolized a community or its 'traditions'. In the mid- to late twentieth century, the symbols of nationhood became more important in the context of political independence, as well as the marketing of culture and campaigning for political if not economic self-determination. The promotion of national icons was increasingly important to the processes of decolonization. The now famous *tamtam* (slit gongs) of Ambrym are no longer localized products symbolic of an island, village or district in Vanuatu, but items that represent ni-Vanuatu people as a nation on a regional and global stage. Other examples include the Samoan *fale*, the Fijian *bure* (indigenous Fijian house), Māori *hei-tiki*, the Hawaiian *hula* and the Cook Islands Tangaroa figures. The involvement of government agencies in tourist art projects highlights the economic drivers behind tourism as well as a desire to manage the quality and forms of national representation.

Indigenous Agency and Critique

Historically, Pacific Islanders have been active agents in tourism as much as they were victims or exploited

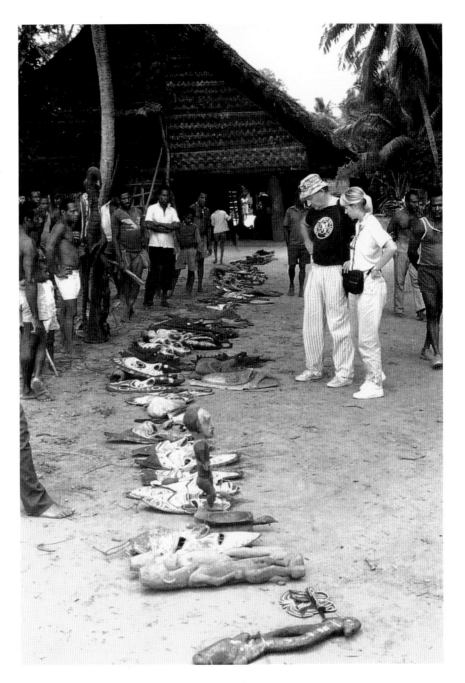

Tourists looking at art in Tambunum village, Papua New Guinea, c. 1994.
Photograph courtesy Eric Silverman.

Anthropologist Eric Silverman compares the encounter of Iatmul villagers with tourists to a long history of negotiating relationships with outsiders. Villagers aggressively peddle their art, the worldwide fame of which enhances the tribe's local prestige. Nonetheless, there is an 'economic asymmetry' in the relationship, apparent in this photograph of villagers and tourists facing each other across a line of carvings for sale.

by some of the larger commercial enterprises. Tourism could have devastating effects on local customs and practices, and local industries. In the 1980s and early 1990s some indigenous activists criticized big-business owners and local and foreign consumers of the tourist industry. In 1991 indigenous intellectual and activist Haunani-Kay Trask blamed the destruction of Hawaiian land and 'the prostitution of our culture' on 'multinational corporations (both foreign-based and Hawai'i-based) and…collaborationist state and county governments'.[51] (See Voice box on page 403.) As an activist in colonized territory, her writing conveyed a strong sense of loss as she witnessed economic benefits moving offshore, and Hawaiian land, people and cultural assets transformed beyond recognition. However, it was recognized by indigenous intellectuals that indigenous Pacific people were complicit in tourism's culture across the region. Writing in 1980, Stephen Rex Horoi observed that in the Solomon Islands '[m]any of the carvers are preoccupied with quantity rather than quality and many lack the expertise of the traditional artist. As the need for cash increases among urban dwellers many people, irrespective of their artistic skill, produce handicrafts for sale'.[52] In 1983 Samoan author Albert Wendt lamented how 'most of our artists are imprisoned in tourist artefacts shops aglitter with masks, lampstands, spears, tikis, warclubs, miniature canoes, crocodiles and turtles and snakes (and other creatures such as monkeys, not often of the country), swords, grotesque carvings of every size and shape, and copy upon copy of African and Asian carvings'.[53] The complicity of indigenous artists in Hawai'i was based on an economic reality where people were (and still are) struggling to make a living – to feed and educate their children and maintain their homes. If there was indigenous agency in the West's domination of the tourist industry, it was often in the hands of indigenous business owners, the rich or the cultural elites. As Trask argued for Hawai'i, 'wages are so low and advancement so rare, whatever complicity exists is secondary to the economic hopelessness that drives Hawaiians into the industry'.[54]

Since the 1980s, research relating to tourist art has recognized agency among indigenous producers in recent times and historically.[55] For example, the work of Ngaire Douglas and Eric Silverman complicates and disturbs the centre–periphery models of tourism's ebbs and flows and highlights the fact that tourism is a phenomenon that changes over time. The expansion and mobility of Pacific migrant communities in New Zealand, Australia and the United States saw more frequent traffic to and from metropolitan centres and between the islands themselves. A new group of consumers of tourist art thus emerged: second- and third-generation transnationals visiting their parents' or grandparents' homelands, and identifying strongly with being culturally Hawaiian, Tongan, Fijian or Samoan. Anthropologist Eric Silverman documented developments in the Sepik region of Papua New Guinea, noting that Sepik people exercised self-conscious agency in creating contemporary identities for themselves through tourist art. He noted that among the Eastern Iatmul of Tambunum tourist art could express 'new concepts of self and ethnicity' and that 'tourism in Tambunum fosters the emergence of complex identities that blur the local and global'.[56] Together with the observations of tourist art in the decades and markets surveyed above, such observations usefully draw attention to the localized responses to this global phenomenon. In the mid- to late twentieth century, tourist art and markets were the most visible and transformative loci of cultural change. There is no denying the ongoing and often negative economic and social impacts of tourism on the Pacific, its peoples and environments. In historicizing these events it is worth remembering Ngaire Douglas's point that '[t]ourism and its requirements are merely the most recent aspect of a relentless continuum of change'.[57] By the end of the 1980s, tourism and the rapid transformations it was bringing to the social and cultural life of the Pacific signalled the advent of globalization. The tourist industry had brought loss and hardship and great change, but was itself continually evolving, setting conditions and offering further opportunities for people to travel, to resist, accommodate or engage with the world. In the 1990s these developments seemed set to envelop the Pacific in an intense tide of rapid change, but they just as quickly provoked localized responses to new cultural forms and media, much as the local population had responded in other eras of the region's history.

Cannibal Tours and the Postcolonial Turn

DENNIS O'ROURKE'S FILM *Cannibal Tours* (1987) follows a group of Western tourists on a packaged excursion up the Sepik River in Papua New Guinea. There they photograph villagers, take in the surrounding landscape, enjoy various amusements (such as having their faces painted in Sepik style) and bargain for local arts and crafts. Such is the 'experience' they have purchased.

But O'Rourke's film is more than the simple documentation of this activity. It is a cinematic essay on the phenomenon of tourism in ex-colonial countries such as Papua New Guinea that are saddled, for good or ill, with old Enlightenment myths of the 'exotic', the 'primitive', the 'state of nature' and so forth. Once core ideas in the imagination of Western imperialism, they are now the currency of postcolonial tourism.

The film emphasizes our distance from the colonial past. It begins with river shots overlaid with the sound of radio static tuning between UB40 and a contemporary news broadcast. Yet *Cannibal Tours* portrays the tourist experience as if its defining character was to live precisely in the echo of the colonial past, as its re-enactment, repetition or simulacrum. The luxury boat that brings the tourists upriver is called the *Melanesian Explorer*; a German man wears a safari hat and counts off the countries he has visited, like a tour through the empire; an American woman expresses her admiration for primitive art and sees herself following in the footsteps of young Michael Rockefeller; the villagers – cultural critic Dean MacCannell calls them 'ex-primitives'[i] – play their former selves for the benefit of the tourists' cameras. The haunting of the colonial era is made even more explicit by the juxtaposition of black and white photographs of colonial New Guinea – portraits of missionaries and their converts, of colonial social clubs, of 'first contact' natives gazing at the camera – with the activities of the contemporary tourists.

In one sequence towards the end of the film, highlights from the trip are reprised in silence except for the sound of a Mozart string quartet. The effect is to turn the entire encounter into a kind of masque, a dumbshow in which all players – tourists and villagers – are co-participants in the same drama, each with their appointed roles to play, their costumes and make-up, the show facilitated by discrete and efficient 'stage hands' who bring the players on and off, attend to the clock and the machinery (drive tour boats, fly planes, service cabins)

and ensure the extravagant fiction is not disturbed. This is, after all, big business.

Yet the film never objectifies tourism as a global economic system, a national industry or the main source of village income. There is no voice-over about the disparities in wealth or the commonalities of the profit motive. Corporate airlines, travel agents, tour operators, advertising companies, government ministries, tribal councils and the like are kept offstage. Only interviews with the film-maker permit some reflective commentary by the villagers and tourists about themselves and each other, and the awkward 'exchange system' that brings them together. The film focuses on face-to-face encounters of the personal, if not exactly intimate, kind. A man gives a bottle of cologne to a villager as a gift 'for your wife'; a woman gives a coin to another for a snapshot she has just taken of him; a man asks for the 'second price' while bartering for a wooden carving; a woman complains to her peers and the film-maker that the tourists don't buy her stuff.

Watching this is painful. We are not usually audiences of this spectacle, only audiences (or performers) within it. Rarely are we able to see ourselves in the 'play' as a whole. To our intense discomfort, this is what *Cannibal Tours* forces us to do. PB

Movie still from
***Cannibal Tours*, 1987.**
Photograph by Dennis
O'Rourke. © Copyright
Camerawork Pty Ltd.

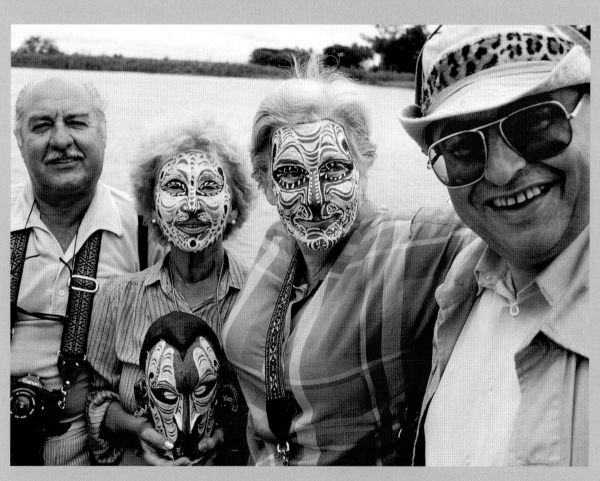

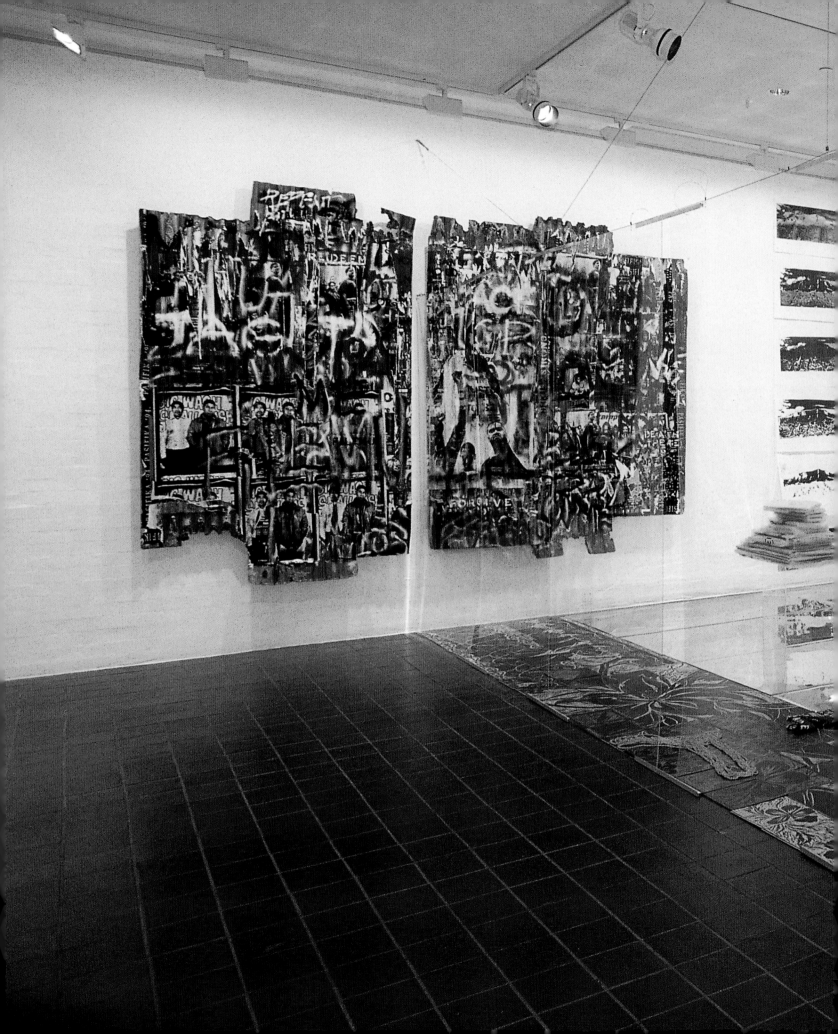

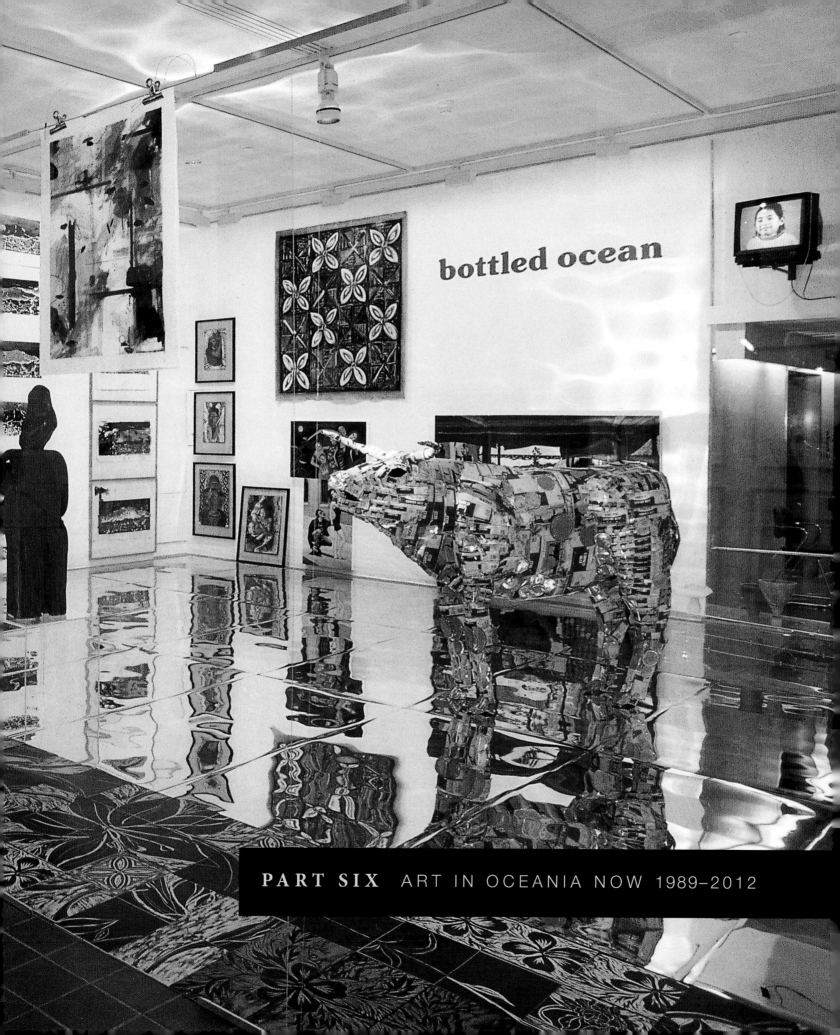

bottled ocean

PART SIX ART IN OCEANIA NOW 1989–2012

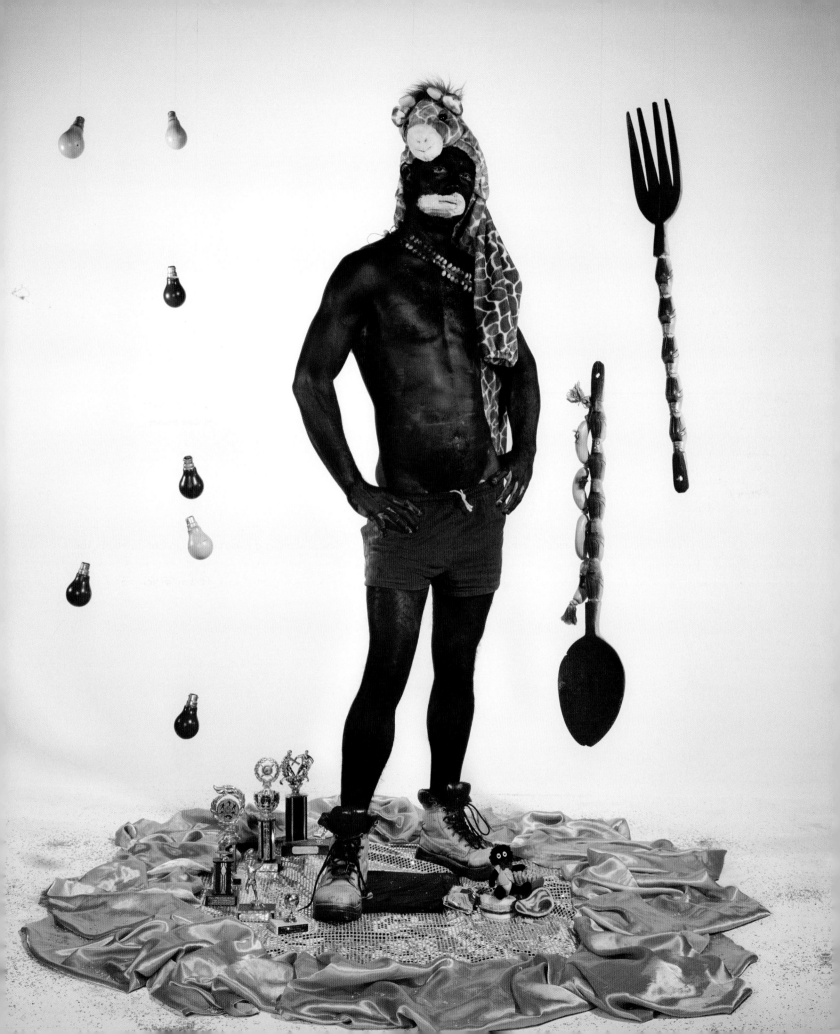

CONTEMPORARY PACIFIC ART AND ITS GLOBALIZATION

Peter Brunt

opposite

Eric Bridgeman, *Wilma Jr. (Blacky)*, from the series *The Sport and Fair Play of Aussie Rules*, 2008–9.

Inkjet print on silver rag paper, 140 x 120 cm (55⅛ x 47¼ in.).

Multi-media and performance artist Eric Bridgeman was born in Brisbane with heritage from the Chimbu province in the Papua New Guinea highlands. His work theatricalizes and subverts stereotypes of race and masculinity.

In 1999 a group of artists called the Tahiono Arts Collective, based on the tiny Polynesian island of Niue, exhibited an installation entitled *Tulana Mahu* – meaning 'shrine to abundance' – at the Third Asia Pacific Triennial in Brisbane, Australia. The shrine was a 6-metre (20 ft) shipping container fitted with electric lights and stacked to the gills with an eclectic assortment of objects – rubber jandals (flip-flops), flax baskets, shell and plastic necklaces, scrap metal, figurines of various kinds and so on. Some of this material was composed in smaller shrines within the container's interior walls, suggesting a vaguely religious theme or purpose. The shrines were not tied to any particular dogma or tradition but evocative of the reverential attitude generally associated with shrines. Nonetheless, *Tulana Mahu* drew specific inspiration from indigenous concepts of Niuean spirituality. The

container, for example, evoked a *fale peito* – an external cook house – built over an earth oven where food was prepared. And the eclectic character of its objects recalled the way in which materials of almost any kind were once used to embody Polynesian deities.[1]

However, *Tulana Mahu* also belonged to another economy of objects and desire: the global world of contemporary art for which it was made and within which it was circulated and displayed. After its exhibition in Brisbane it was sent to Sydney to be shown as part of the Sydney 2000 Olympic Arts Festival. Then it went to New Zealand where it was shown at the Contemporary Pacific Art Gallery in South Auckland. It was supported on its travels by the New Zealand and Australian High Commissions, the Niuean government, the Queensland Gallery of Art, the Sydney Organizing Committee for the Olympic

right

Tahiono Arts Collective (Al Posimani, Ahi Makaea-Cross, Sale Jessup, Moira Enetama, Mark Cross, *et al.*), *Tulana Mahu*, Niue, 1999.

Mixed-media installation.

Games and the Pacific Island Business Development Trust. Indeed, a promotional flyer touted the work as 'a benchmark for other island states showing what can be achieved in this cultural area', even claiming that 'contemporary art…will be *the future of cultural expression* and an important ingredient of self-reliance for developing countries'.[2]

The Space and Time of Contemporary Pacific Art

Tulana Mahu's bold entry on behalf of Niue into the Third Asia-Pacific Triennial exemplifies a remarkable phenomenon to have emerged in Oceania since the 1980s: an exponential increase in the number of Pacific artists working in Western and hybrid modes of visual art making, and participating – or beginning to participate – in the institutions and discourses of the contemporary art world, 'that social, economic and cultural world organized around museums, galleries and the art press with its legions of artists, critics, collectors, curators and audiences who have truck with such sites'.[3] Since the 1980s, and particularly during the 1990s, the contemporary art world has expanded into the Pacific as the Pacific has expanded into it. Today, its institutions and practitioners can be found in many parts of Oceania where they did not exist before, while contemporary Pacific artists have turned up everywhere from the Venice Biennale to the art galleries of New York City.

The expansion has not been even. There are massive disparities in the distribution of contemporary art practices across the region, and many places where they are socially marginal or non-existent. The phenomenon predominates in wealthy, industrialized, highly developed settler states such as New Zealand, Australia and Hawai'i, where established art worlds following Western models (a legacy of settler colonization in the nineteenth century) have given rise to flourishing movements in contemporary Pacific art, both indigenous and migrant.

But elsewhere in the Pacific – in the Cook Islands, Niue, Fiji, Samoa, American Samoa, Vanuatu, Solomon Islands, French Polynesia, Guam, Palau and elsewhere – active local 'art scenes' have sprung up as well. Some have histories that go back to the 1960s and 1970s involving the influential presence of expatriate Europeans or local elites returning to island homes after studying art overseas, typically in the former colonial

Brett Graham and Rachel Rakena, *Aniwaniwa*, 2007.
Installation at Venice Biennale, 2007.

Aniwaniwa is a multi-media sculptural work by two contemporary Māori artists that was installed at the 2007 Venice Biennale in a thirteenth-century salt store. Part of the 'collateral' section of independently submitted projects, the work bypassed the bureaucracy of national representation. The installation is inspired by the submersion of Graham's ancestral village of Horahora by the construction of a hydro-electric dam in 1947.

'mother' country. Momoe Malietoa von Reiche, for example, daughter of the late Samoan head of state, studied art and design in New Zealand in the 1970s before returning and setting up the Madd Gallery in Apia in 1983. The gallery served as her painting studio as well as a multi-purpose venue for art classes, exhibitions, poetry readings, modern dance performances, discussion groups and the like, patronized by members of Apia's cosmopolitan middle class. Embracing Western art forms, these activities marked a deliberate alternative to the customary practices that otherwise pervade Samoan life. Other ventures followed a somewhat different pattern. In 1987 expatriate Italian artist and long-time resident of Samoa Ernesto Coter established the Leulumuenga Fou School of Fine Arts in Apia, sponsored by the Congregational Church, the largest Christian denomination in Samoa with a long history of adapting itself to the local culture. In this vein the school offered an Italian Renaissance style of 'master–apprentice' instruction to Samoan youth – an anachronistic approach in most Western contexts but well suited to Samoan social hierarchies and ways of teaching and learning. Coter left Samoa in 2003, but his student and protégé, Penehuro Papali'i, established his own school on a similar basis and has

become Samoa's most prominent local contemporary artist. He and his 'apprentices' have carried out commissions for churches, government buildings and local businesses.[4] More recently the National University of Samoa began to offer art instruction by professional locally based artists trained in metropolitan art schools while successful emigrant artists like Fatu Feu'u, who made his reputation in New Zealand, have established studio 'residencies' for temporary stays by artists based overseas.

In Vanuatu the origins of contemporary art go back to the early 1960s and the influential presence of expatriate French and anglophone artists such as Nicolaï Michoutouchkine, Robert Tatin, Jacqui Bourdain and Allan Thornton, to name a few. Port Vila was the focus of a thriving 'art scene' with artists staging exhibitions in the Vila Cultural Centre, as well as in hotels, public buildings and private residences. 'What was noticeable about this period, however,' writes ni-Vanuatu artist Ralph Regenvanu (*overleaf*), 'was the absence in the contemporary art scene of indigenous artists.'[5] That situation began to change following independence in 1980, when the vitality of the art scene shifted from Europeans to a growing number of ni-Vanuatu and migrant Islanders aspiring

to serious artistic vocations. In 1989 local artists Emmanuel Watt, Sero Kuautonga, Juliette Pita, Ralph Regenvanu, Fidel Yoringmal, John Fai and others established a collective called the Nawita Association of Contemporary Artists, launching their inaugural exhibition in the Exhibition Room of the French Embassy – since then an annual event.

But it would be inaccurate to describe contemporary Pacific art as the sum of so many 'local scenes' and 'micro-histories'. Today artists in Oceania work within transnational networks of galleries, museums, cultural centres, workshops and residency programmes that are both regional and global. Furthermore, the burgeoning of contemporary Pacific art cannot be seen apart from well-known historical changes in the contemporary art world in general: the collapse of the so-called 'centre–periphery' model of contemporary art (its final flourish exemplified by the exhibition 'Magiciens de la terre' at the Pompidou Centre, Paris, in 1989) and the rise of a dispersed,

pluralistic, multi-centred contemporary art world, institutionally expressed by the proliferation of biennales and triennials around the world – including locations in the Pacific.[6]

The paradigmatic nature of the biennale in a globalized contemporary art world was the subject of an intriguing installation by Mladen Bizumic at the Govett-Brewster Art Gallery in New Plymouth, New Zealand, in 2003 called *Fiji Biennale Pavilions*. Now Fiji is not – or not yet – a biennale-hosting nation, and the point of Bizumic's proposal was that any place in the world is a potential candidate for this quintessentially globalizing institution. The fact that he chose Fiji, however, could not help but raise questions about the convergence of the institutional art world and the Pacific Islands. The installation consisted of three main parts: a large topographical map of the Fijian archipelago drawn in chalk on a grid of sixteen blackboards and scrawled with the artist's handwritten notes; a tabletop on which sat nine scale models made

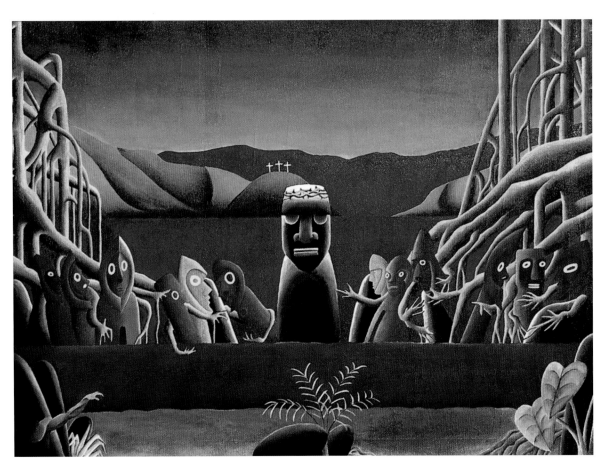

Ralph Regenvanu, *Las kakae (the final feast)*, *c*. 1986.

Acrylic on canvas, 100 x 70 cm (39⅜ x 27⅝ in.). Artist's collection.

Recasting Leonardo Da Vinci's *Last Supper* with *tam tam* figures, Regenvanu's youthful masterpiece, painted while he was a high-school student, poses the question of devotion and betrayal to the place of custom and religion in postcolonial Vanuatu.

Mladen Bizumic, *Map of the Fiji Biennale*, 2003.
Sixteen panels, chalk-pen on blackboard, 234 x 315 cm (92⅛ x 124 in.). From *Fiji Biennale Pavilions* installation, Govett-Brewster Art Gallery.

from translucent Perspex of classic modernist pavilions by famous modernist architects; and nine proposals by nine contemporary artists of hypothetical works for the show. The map recalled cartographic representations of the colonial era when the Pacific Islands were divided up among imperial powers and exploited for their natural resources and strategic military position. In Bizumic's version they have become the locus of contemporary art production and art world discourse. The model pavilions by architects like Le Corbusier and Marcel Breuer, there to house the biennale, gave it a melancholy historical note, recalling as they did the abandoned social utopias of twentieth-century modernism. Simon Rees, curator of the exhibition, said they looked like 'a ghost town'.[7] Thus the Fiji Biennale would occupy the spectral shell of those lost ideals. The proposals for the show by nine international artists – none of them Fijian – focused without exception on Fiji as a tourist destination or

consumerist fantasy. And all were pitched in the register of postmodern irony: Sam Durant (USA) proposed a year-long stay in the 'dark continent of Fuji' (sic), culminating in a series of beauty pageants with 'paradise-native girls and boys'; Kathy Temin (Australia) proposed a room painted pink with fifteen mirrored palm trees that represented her 'girlie or childish fantasy of exotic locations in music videos'; Björn Dahlem (Germany) proposed an outdoor light show to attract aliens from outer space, who would then be hosted at a Fijian resort hotel and introduced to 'tourist customs' such as drinking at the bar; and so on.[8] Bizumic's project was an amusing caricature with some serious points to make. But how accurate is it in modelling the fate of contemporary art in Oceania?

Creating Contemporary Art Worlds in Oceania
Negotiating their place within the contemporary art world has been a difficult challenge for Pacific artists.

The Asia Pacific Triennial of Contemporary Art

NDER THE LABOUR LEADER Paul Keating (Prime Minister 1991–96), Australians were urged to consider their country as part of Asia. The nation's future, it was argued, would be more closely linked to the societies and economies of the region than to those of Europe, notwithstanding the historic ties of the bulk of the white-settler and immigrant populations. It was in this context that Brisbane's Queensland Art Gallery inaugurated the Asia Pacific Triennial (APT), a biennale-style showcase of contemporary art, made up of selections from specific nations, yet in this case limited to the Asia-Pacific region.

The term 'Asia-Pacific' was at the time employed mainly by political scientists, economists and experts in international relations. It conjured up a region of economic dynamism linking the southeast Asian nations with China, Japan and the Pacific 'rim'. The exhibition programme was ambitious and had considerable strength; it responded, for example, to the growth of contemporary art practice in China, which was yet to reach broad audiences in the West. But in another sense the APT was marked by geopolitics and cultural diplomacy. For each nation, artists were selected by curators from the country itself and from the Queensland Art Gallery working in partnership. The process of creating the exhibition was an example of the engagement and reciprocity that would ideally be enacted more generally in social and political spheres. Yet of course the art itself spoke to a whole variety of issues and agendas that exceeded or superseded the political ones. Hence the Triennials have been fertile and have deservedly secured broad recognition as an important site of debate around art practice and its diversity, not from 'the' perspective of the Asia-Pacific region but from the multiplicity of perspectives that region embraces.

The Pacific fell within the scope of the project, though those who spoke of the Asia-Pacific region seldom if ever had the islands of the Pacific in mind. Indeed scholars in Pacific politics coined an unfortunate expression, the 'hole in the doughnut', intended to capture the sense in which the islands lay in the centre of a dynamic region but did not partake of the wealth or growth that defined it.

It is not surprising that the representation of the Pacific within the APT was initially awkward. How could nations such as Papua New Guinea, Vanuatu, Samoa or Niue, which lacked institutions and markets for contemporary art, generate works that might be selected for an expo in a decidedly avant-garde idiom? What was on show in Brisbane consisted of mixed-media installations, new digital art, and other genres that would not have been out of place in any other biennale. The folk arts of the countries represented were not included. There was a notable tension between the commitment to Aboriginal art of the Australian institutions and an unpreparedness on the part of Taiwanese selectors, for example, to consider aboriginal Formosan work relevant.

The early Triennials revealed the mismatch with varying degrees of discomfort. However, in 2006–7 the fifth APT negotiated it considerably more deftly and productively. The 'Pacific Textiles Project' presented a collection of Polynesian fabrics embracing both woven mats featuring knitted woollen overlay, and *tivaivai* and *tifaifai*, appliqué quilts from the Cook Islands and French Polynesia. One or two of these individually would have got lost, their sheer difference from the bulk of what was on display again prompting bafflement as to why they should be present. But the grouping, and the essays dedicated to the grouping in the catalogue, made it clear that these works bridged the customary and the contemporary. They spoke of attachments to place and identity but they were also new forms. NT

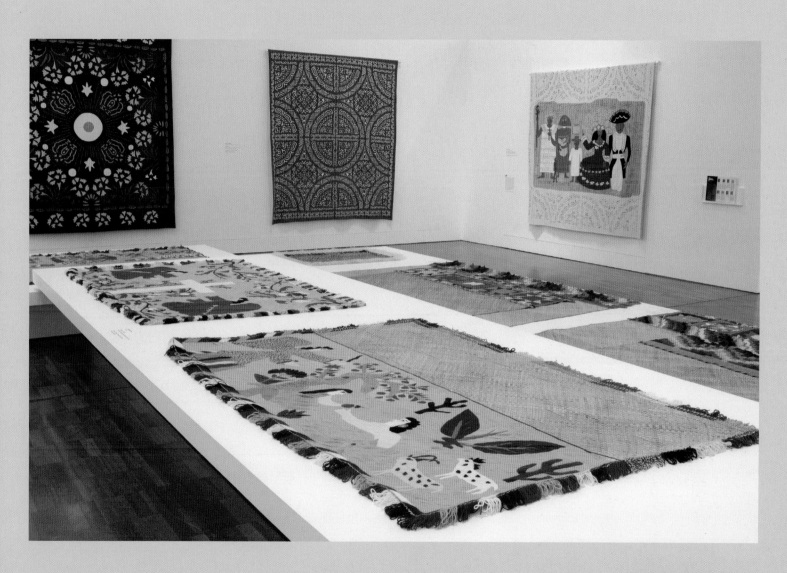

**'Pacific Textiles Project',
installed for the fifth Asia
Pacific Triennial of
Contemporary Art,
Queensland Art Gallery, 2006.**
Photograph Natasha Harth.

417

One strategy for some constituencies has been *to create their own art world* within the larger one. This was the aim, for example, behind the establishment of the Oceania Centre for Arts and Culture on the campus of the University of the South Pacific in Suva, Fiji, in 1997. The Oceania Centre was the initiative of charismatic writer, scholar and intellectual Epeli Hau'ofa (1939–2009). Tongan by ethnicity, born and raised in Papua New Guinea, well-travelled in the region and a long-time resident of Fiji, Hau'ofa had taught at USP since 1981. In a lecture inaugurating the Centre entitled 'The Ocean in Us', Hau'ofa outlined a *regionalist* vision of Oceania as both a place and an idea. The lecture began by taking stock of the historical situation facing Pacific Islanders in the late 1990s.[9] Hau'ofa pointed to the formation of new economic, political and cultural alliances between powerful nation states and corporate interests around the 'Pacific rim' – alliances that did not include them. He confronted the dubious legacy of decolonization and national independence, which had isolated Islanders and led to new forms of 'neo-colonial' dependency. The ideals of nationhood were clearly inadequate to a world being redefined by devolving states, globalized economies and mobile populations, including diasporic Pacific Island populations. The lecture also followed two iterations of the Asia-Pacific Triennial, an international showcase for contemporary art from the region, in which the Pacific Island presence had been minor and tokenistic.

It was in this context that Hau'ofa proposed the necessity for an artistic response, to be nurtured by the Oceania Centre, and gave as its defining theme the idea of 'the ocean in us'. The ocean would be a metaphor for reconceptualizing Islander identity in ways that transcended national boundaries and drew inspiration from the region's rich historical legacy of seafaring exploration, inter-island trading networks and riverine exchange systems. Ultimately the ocean was a metaphor for actively and creatively embracing the contemporary conditions of living in a global world. It was imperative, Hau'ofa argued, in the face of other people's constructions of the Pacific, for dwellers in Oceania to artistically create the region for themselves: 'A new sense of the region that is our own creation, based on our perceptions of our realities, is necessary for our survival in the dawning era.'[10]

In practical terms, the Oceania Centre modelled itself on an earlier experiment at the University of Papua New Guinea in the late 1960s and early 1970s, initiated by European expatriates Georgina Beier and Ulli Beier (see page 370). It would be established within the University of the South Pacific but at arm's length from its usual institutional requirements. (For example, there would be no formal enrolments or structured teaching and assessment programme.) Rather the Centre would function like an open studio or professional workshop where serious-minded artists across a range of art forms, committed to the Centre's vision, could be supported by the environment and community it provided. It was in this way that the Centre quickly became the base for a group of visual artists known as the Red Wave Collective.[11]

Like countless other postcolonial artists, the Red Wave Collective embraced Western media and artistic conventions in order to express indigenous perspectives. Most of the group are painters working

Lingikoni Vaka'uta,
The First Human Beings of Tonga, **2006.**
Oil on canvas, 188 x 199 cm (74 x 78⅜ in.). Private collection.

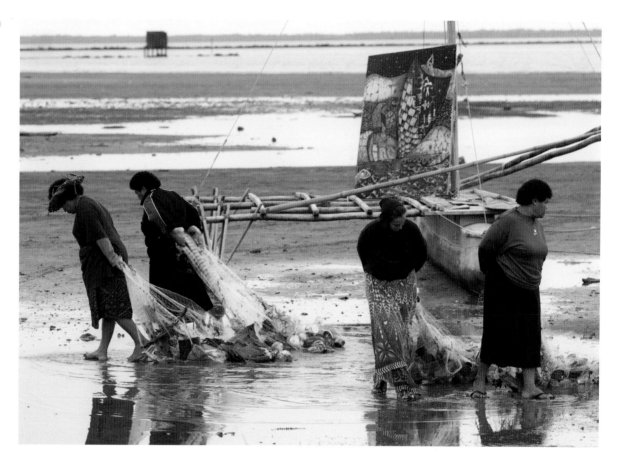

with oil or acrylic on canvas. Some are woodcarvers and
conscious in that respect of certain continuities with the
work of forebears, but see themselves as contemporary
artists working in individual, not 'traditional', terms.
Their work is often densely patterned, brightly coloured
(in the case of paintings), and freely borrows from the
'treasure house', as Albert Wendt called it, of Oceanic
myths, legends and stylistic traits, as in Lingikongi
Vaka'uta's painting *The First Human Beings of Tonga*
(2006). But the distinguishing feature of Red Wave,
like the Tahiono Arts Collective in Niue, is its desire to
affirm the spiritual legacy of Oceania, however merged
with Christian values and beliefs. One could draw a
stark contrast, for example, between the breezy irony
of the proposals for the *Fiji Biennale Pavilions*, revelling
in the culture of tourism and advertising, and the
earnestness of the Red Wave Collective, for whom
tourism is anathema. But contemporary art in its own
way is also a touristic system and a market of
specialized commodities. Hau'ofa was leery of this fact

but he celebrated one of Red Wave's first international
successes when it exhibited at the October Gallery,
London, in 2006.

But consider another painting by Lingikongi
Vaka'uta, Jake Lagi and Irami Buli, called *The
Navigator*, perched on an outrigger canoe as one
component in a three-day performance-art event
called *Mara-i-Wai*, in 2007. *Mara-i-Wai* (meaning
'lost at sea') was a collaborative project involving
Red Wave artists from the Oceania Centre, a dance
choreographer, a composer, students from the USP
Pacific Studies programme, and members of an urban
migrant squatter community called Korova, in Suva.
The project was inspired by the story of this community,
a large extended family who had relocated to Suva from
the island of Moce (in the Lau group) in the 1990s,
travelling, remarkably, by outrigger canoe. Making
several journeys and without a compass, they were led
by a few elders who still possessed ancient navigational
and seafaring skills, relying on knowledge of the stars

and sea currents to find their way. The journeys were not without risk, however, and tragically, two members of the group died when they got into trouble in the course of making a return voyage to Moce without their main leader. *Mara-i-Wai* was a tribute to this community, to the fact that it had maintained these traditions, and therefore its identity. But it was also a lament for loved ones lost at sea.

The performance, advertised in local newspapers and attended by members of the public watching from the shore, took place over three days. It involved people from the Korova community, for whom it proved an emotional experience, and consisted of a sequence of ritualized events 'to re-sanctify' the space (such as collecting urban debris in fishing nets from Queen Elizabeth Drive) and climaxed in a choreographed dance in the sea, focused around a canoe called the *Senilata* adorned with Red Wave's painted tribute, *The Navigator*.[12]

The attempt to create an Oceanic art world within the global art world also lies behind the establishment of the Tjibaou Cultural Centre on the outskirts of

Noumea in New Caledonia. Opened in 1998 and designed by world-renowned architect Renzo Piano (famous for the design of civic art galleries around the world), the Cultural Centre is a spectacular statement of the contemporary idea of the Pacific. But it also bears the memory of its conflicted historical origins, rooted in the violence of the struggle for independence from the 1960s to the 1980s between the Kanak independence movement, loyalists to France, and France itself. These struggles culminated in the mid-1980s in episodes of political murder, hostage-taking and bloody reprisals that led to a détente between these factions known as the Matignon Accords of 1988. However, the Accords also precipitated the tragic assassination of Kanak independence leader Jean-Marie Tjibaou (and his compatriot Yiewené Yiewené) on 4 May 1989 by a fellow Kanak embittered by this political outcome. The Cultural Centre was born from those tragic deaths.[13]

Since 1988, the question of political independence has been formally deferred to future referendums, while the impetus of decolonization has shifted, as it

Tjibaou Cultural Centre, New Caledonia.
Renzo Piano Building Workshop, 1998. © ADCK-Centre Culturel Tjibaou/RPBW, photographer Claude Beaudemoulin.

Comprising ten stylized 'chief's huts', the Tjibaou Cultural Centre's striking architectural profile is unrivalled in the Pacific. The structures pay homage to indigenous architectural forms while making something symbolic of progress, flexibility and openness.

were, to the realm of culture, with an unprecedented emphasis on the idea of the contemporary. Among the terms of the Matignon Accords, for example, was the establishment of the Agency for the Development of Kanak Culture (ADCK), which, with the aid of French funding, systematically set about creating the conditions for, and fostering the revival of, Kanak arts in a deliberately innovative way. In the 1990s the agency organized art exhibitions, inaugurated the Noumea Biennale of Contemporary Art, sponsored a new culture magazine called *Mwà Véé* (*page 382*), invested in the purchase of a foundational collection of contemporary Pacific art from the region, and oversaw the design and construction of the Tjibaou Cultural Centre, which would be the hub of this artistic resurgence and the iconic symbol of its ethos of contemporaneity.[14]

Given its troubled origins, however, the Centre has been an object of deep ambivalence, betraying persistent divisions in New Caledonian society. As Caroline Graille explains:

> Because of the ongoing political conflicts between ethnic groups, many Europeans will not even go to the Cultural Centre 'because it is too Kanak'

and rarely go to art exhibitions at all because they equate an interest in art and culture with being left-wing, which implies support for the idea of Kanak political independence.

On the other hand, most Kanak people with no real connection to the urban environment see no point in going to the Tjibaou Cultural Centre, even the 'customary sacred area' designed for traditional ceremonies and situated a reasonable distance from the main buildings, because it stands for modernity and cultural commoditization: *'C'est un truc pour les Blancs'* ('This is a white people's thing').[15]

Such attitudes clearly undercut the project of creating a contemporary culture in New Caledonia – or at least show what the project must overcome in order to succeed. On the other hand, the tensions Graille identifies – between ethnic groups, between rural and urban Kanaks, between the past and the future, between 'tradition' and 'modernity' – are precisely what fuels the creation of contemporary art in New Caledonia. For those who are involved, the task is a

Denise Tiavouane,
Les Taros qui Pleurent
***(The Crying Taros)*, 1996.**
Installation of taro plants, bamboo, wooden sticks, sign and audio components. The Second Asia-Pacific Triennial of Contemporary Art, 1996, Queensland Art Gallery.

Pain, loss and memory lie at the emotional core of many contemporary Pacific artworks. As part of the 'shrines' project at the 1996 Asia Pacific Triennial, Kanak artist Denise Tiavouane created this moving work in a grassed area of the gallery grounds, supplemented by the recorded sound of weeping women.

long-term one, with its sights set on the future. In the meantime, the Tjibaou Cultural Centre provides an institutional base that supports artists, facilitates dialogue, outreaches to Melanesian and francophone neighbours as well as to artists and institutions in the wider Pacific region, and places New Caledonia firmly within the global milieu of contemporary culture.

Contemporary Pacific Art and the Politics of Representation

If the objective in New Caledonia was to create the conditions for contemporary art production where previously they did not exist, in other parts of Oceania where they did exist – namely in settler states such as New Zealand, Hawai'i and Australia – the challenge for indigenous artists, and in a different way for migrant Pacific artists, was *to be represented in the discourse*. For contemporary Māori artists in Aotearoa New Zealand, that struggle goes back to a seminal group of Māori modernists exhibiting in urban art galleries in the 1960s and 1970s.[16] In these decades the group was a relatively minor part of the New Zealand art world, which was dominated by white settler artists and a discourse of national identity – though a discourse increasingly challenged by a plurality of new movements and ideas coming from various parts of the world.[17] Contemporary Māori art was among that plurality, though it had a particular purchase on the politics of the country in the 1970s and 1980s, spurred by Māori land marches and other political challenges to the New Zealand welfare state, attacked as still colonial in many of its attitudes and policies. By the late 1980s these challenges culminated, as they did in New Caledonia, in a series of major political, economic and ideological changes that transformed the nature of the nation state to synchronize with 'free market' economics, while accommodating indigenous political demands that had been gathering force since the 1960s. The 1840 Treaty of Waitangi was recognized as a foundational national document; legislation was enacted to empower the Waitangi Land Claims Tribunal to vet land claims against the 'Crown' retroactive to 1840; and 'biculturalism' was established as official state policy.

In this context, contemporary Māori art came to assume an unprecedented national prominence in the New Zealand art world. As Rangihiroa Panoho put it,

'Māori art was moving from the margins to the centre.'[18] Its new status was exemplified by an exhibition staged at the National Art Gallery, Wellington, in 1990, called 'Kohia Ko Taikaka Anake: Artists Construct New Directions'. This show featured three generations of the contemporary Māori art movement and effectively canonized its founders within New Zealand art history. Each of them created major works for the exhibition, installed in the gallery's most prestigious rooms. Moreover, the exhibition was a political assertion of Māori control over its representation and an affirmation of the movement's philosophical grounding in the concepts and values of Māori society and culture. The exhibition, for example, was organized by tribal area and generational seniority; it also was deliberately inclusive, based on a system that allowed new works by many artists to come into the gallery on a rotating basis.

At the same time, however, the late 1980s and early 1990s gave rise to a different voice among a younger

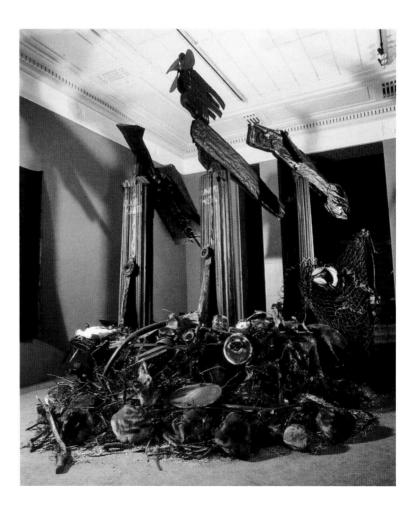

Selwyn Muru, *Whatever we do, the Gods are constant,* **1990–91.** Installation for 'Kohia Ko Taikaka Anake: Artists Construct New Directions'. Mixed media. National Art Gallery, Wellington, 1990–91.

'Choice!' was significant for a number of reasons. One was the exhibition's relationship to the contemporary art world. It was not, like the Wellington exhibition, rhetorically storming the system as if comprising marginalized outsiders. Rather, 'Choice!' was a product of the art world, articulate in its language games and comfortable in its institutions, but intent on expressing in that context a unique set of Māori viewpoints. Equally significant about the exhibition was its polemical challenge to what it saw as the constraints on contemporary Māori art, burdened with ethnic clichés and commercial and institutional expectations regarding the nature of Māori art, including clichés and expectations within Māoridom. As expressed by Hubbard and Robin Craw in a short essay published as an exhibition flyer:

> Constricting societal modes of artistic regulation have never allowed Māori artists to become more than bearers of tradition and children of nature, never more than re-presenters of the land and the past. Perhaps it is time to rework the givens of the political and theoretical analyses that surround and govern orthodox notions of 'Maoriness' in artistic practice.[20]

Clearly wrestling with these 'orthodoxies', 'Choice!' claimed for contemporary Māori artists the radical freedom of contemporary art, in which art can be literally anything. The exhibition drew on postmodernist critiques of the sign (which argued that any sign was arbitrary with respect to its meanings) to call into question the persistence of an 'ethnic signature' in Māori art, still present in the work of its modernist predecessors. A third reason for the significance of 'Choice!' was its remarkable cognizance about its own historical moment. Take, for example, Michael Parekowhai's conceptual sculpture entitled *'Everyone Will Live Quietly', Micah 4.4*, consisting of four rows of block letters made from Formica that spelt out the word MICAH four times on the gallery floor. The work was a pun that played with several meanings, among them a biblical reference to a prophecy in the book of Micah foretelling the coming of 'Zion'. The citation recalled the centrality of Old Testament prophets to Māori prophets who resisted colonialism in the nineteenth century, and implicitly asked whether the new era of neo-liberalism was to be taken as the

group of Māori artists, exemplified in an exhibition entitled 'Choice!' ('Choice!' is a pun on a colloquialism for expressing delight in something's quality.) Curated by George Hubbard, an urban-bred and somewhat maverick figure in the contemporary Māori art milieu of the time, 'Choice!' was staged at a leading-edge contemporary art gallery in Auckland a few months ahead of 'Kohia Ko Taikaka Anake' (but aware of its planning). It featured seven artists of various aesthetic persuasions, some just out of art school experimenting with film and conceptual sculpture, some street artists, but all conversant with the historically conscious discourses of contemporary art and popular culture.[19]

Gordon Walters and the Cultural Appropriation Debate

IN AOTEAROA NEW ZEALAND THE CULTURAL appropriation debate has most forcefully gathered around the Pākehā artist Gordon Walters. Familiar with the modernist experiments of European artists who looked to African and Pacific art in order to critique the conventions of European art, Walters developed a local version of primitivist modernism. Aspects of Māori art, such as the curvilinear patterns of *kōwhaiwhai* (rafter painting), or the unfurling spiral of the *koru*, were transformed into modern art. By 1960 Walters had arrived at the geometric bar-and-circle motif that became his signature, which he deployed in complex compositions where background and foreground are rendered unstable in an optical shimmer.

When Walters first exhibited paintings in his mature style in 1966, he presented them as abstract modernism, with little or no connection to the Māori art that had been one of his starting points. 'My work is an investigation of positive/ negative relationships within a deliberately limited range of forms', he wrote. 'The forms I use have no descriptive value in themselves and are used solely to demonstrate relations.'[i] But as *Kahukura* demonstrates, the artist did use Māori titles for some of his works, and in the 1970s these paintings came to be known as the '*koru* series' – in part because of the modernist experiments of a generation of Māori artists, some of whom paid attention to what Walters was doing and began to incorporate the bar-and-circle motif into their own work, thus transforming it into a modern version of the *koru*. With its connotation as Māori art, Walters's geometric motif has had a very visible life in the culture at large. Liberated from the realm of high art and the gallery, it has been used widely in the world of corporate logos and graphic design, precisely because it is such an elegant visual device, and richly symbolic as a statement of New Zealand identity. (Two cultures, Māori and Pākehā, are locked into a relationship that never settles into a hierarchy but remains dynamic.)

In the 1980s Walters's *koru* series began to attract the charge of cultural appropriation, a criticism that carried most weight when levelled by Māori art historians. Ngahuia Te Awekotuku described Walters's use of the *koru* as insensitive and 'an irrefutable exploitation and colonising of that symbol'.[ii] And Rangihiroa Panoho suggested that Walters's *koru* series was a formalist programme of abstraction which divested the *koru* of meaning and distanced it from its cultural origins, ultimately demonstrating a 'residual colonialism' that is inherent in Western, and especially Pākehā New Zealand, attitudes to art and culture.[iii]

The response to the accusation of cultural appropriation has taken many forms, from the inevitability of cross-cultural borrowings to the suggestion that Walters's appropriation is a form of homage.

Of course, the best conclusion to draw from the cultural appropriation debate is that it has no answer. As Nicholas Thomas suggests, 'The heat of the debate arises from the fact that what is a laudable interest in indigenous art from one point of view is unsanctioned borrowing, an act of theft, from another.'[iv] Appreciation and appropriation are two sides of the same coin. And in settler societies such as Aotearoa, this debate gains further energy because it concerns two groups who are both vying for control of the same things: land, and political and cultural power. Walters's *koru* series has become central to the cultural appropriation debate because it is a sophisticated visual statement that renovates old binaries, refusing the typical graphic or artistic device where the elements of Māori art are pushed to the margins. In Walters's paintings, black and white are suspended in a dynamic relationship in which neither dominates the other. Walters's work reinvigorates settler self-fashioning, creating a powerful visual symbol precisely because Māori are not relegated 'to a folk-lorised or anachronistic space'.[v] DS

Gordon Walters,
***Kahukura*, 1968.**
Acrylic and PVA on canvas,
114 x 152 cm (44⅞ x 59⅞ in.).
Victoria University of Wellington
Art Collection.

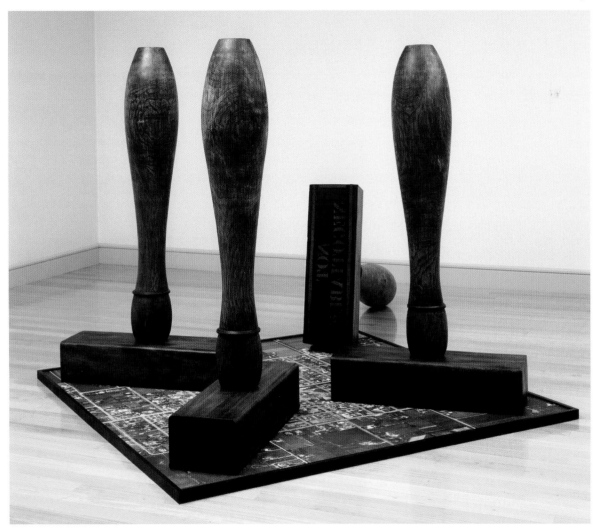

Robert Jahnke,
***Ta Te Whenua*, 1995.**
Exotic timber, custom board,
photographic paper, rubber,
200 x 200 x 150 cm
(78¾ x 78¾ x 59 in.).
Auckland Art Gallery Toi o
Tāmaki.

Māori dispute over the legacy
of colonial expropriation of land
has long been – and remains –
at the centre of politics in
Aotearoa New Zealand. Robert
Jahnke's work *Ta Te Whenua*,
meaning 'to strike the land',
carries this dispute into the
arena of the contemporary
public art gallery. The work
is the artist's response to
controversial settlement
deals in the 1990s.

fulfilment of Micah's prophecy (when everyone would 'live quietly')? The sculpture's bearing on the present was also given a personal edge in an autobiographical reference (for Michael) to the artist himself.

During the 1990s and early 2000s, contemporary Māori art figured large in the public discourse of the New Zealand art world. Exhibitions examined it as a movement and explored its relationship to themes such as biculturalism, identity and new media. Māori art began to be taught in universities and art schools (including Māori universities called *wānanga*); curatorial positions were established with responsibility for contemporary Māori art at major civic art galleries; individual artists rose in reputation and market value; while hundreds of new artists expanded the movement in their individual ways.

For Native Hawaiian or Kānaka Maoli artists, the local Hawaiian art world was also a settler institution that augmented the hegemony of the main colonizing culture: the United States. However, their situation was different from their New Zealand and Australian counterparts. New Zealand and Australia were British dominions that eventually became independent nations. As Britain withdrew from the Pacific, settler cultures galvanized around nationalist aspirations to culturally dis-identify with their colonial origins. This led to some searching engagements with indigenous art and eventually to the entry of indigenous art and artists into the contemporary art worlds and national discourses of Australia and New Zealand. Hawai'i, on the other hand, moved towards incorporation into the United States after the Second World War, becoming a state in

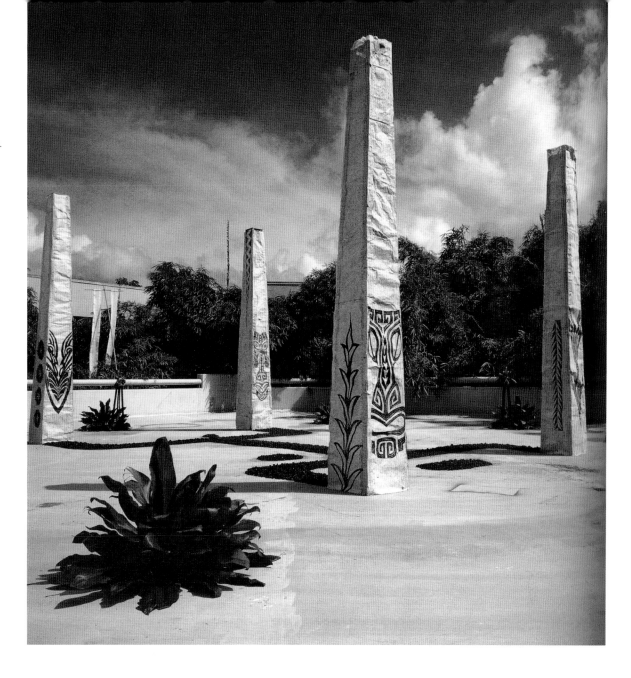

Herman Piʻikea Clark,
***Hoʻokumu Hou*, 1996.**
Mixed-media installation,
University of Hawaii, Honolulu.

1959. Its art institutions have generally remained local satellites of the US and followed American/Western models of collection and exhibition, emphasizing art in its universality (from all times and places) and cosmopolitanism. There was no settler movement to decolonize Hawaiʻi, nor was its indigenous art a meaningful source of settler quests for a local identity.[21]

In this milieu Native Hawaiian artists have generally occupied a minor place, despite the individual successes of a few artists since the 1970s. However, things began to stir in the 1990s in the context of the American 'culture wars' when the question of representation and cultural difference assumed a polemical edge. In 1996, for example,

a reviewer of the inaugural exhibition of a new branch of the Contemporary Museum (a contemporary art gallery) in downtown Honolulu, posed what she called the 'burning question' as to 'why native Hawaiian expression and consciousness, as well as native Hawaiian artists, do not figure prominently in the exhibition. Native cultural forms are featured in Polynesian-inspired McDonalds' art and in a hotel lobby, but are missing in the more serious exhibition venues.'[22] In the same year, and in the same vein, artist Herman Piʻikea Clark mounted an installation entitled *Hoʻokumu Hou* at the University of Hawaiʻi for his MFA degree, re-creating sacred *anuʻu* towers from pre-Christian Hawaiian *heiau* (temple sites) on the

grounds of the university, thus provocatively juxtaposing Western institutions of secular knowledge with Hawaiian institutions of pre-Christian religion and spirituality. The more immediate point of the work was made explicit in an accompanying wall text demanding that the university art department increase its number of Native Hawaiian professors and make native culture a core part of its teaching programme.[23] Predictably, the polemics of representation and the challenge of other forms of cultural knowledge, prevalent in the American art world and universities in the 1980s and 1990s, elicited resistance and criticism.[24] The outcome of these clashes was at least twofold. On the one hand, they led to the partial accommodation of Native Hawaiian artists in galleries and exhibitions as the 1990s advanced. On the other hand, they prompted a withdrawal, to some extent at least, from the institutions of the 'mainstream' contemporary art world and the creation of alternative institutions, teaching programmes, exhibitions and cultural networks (with Māori and other indigenous artists, for example).

Contemporary Pacific art has especially flourished in urban migrant communities that developed in large numbers in the wake of massive migrations to cities in New Zealand, Australia, the United States and elsewhere after the Second World War. The scope of that diaspora, especially among Polynesians and Micronesians, is immense. And it has not only flowed out of islands but between them as well, into cosmopolitan towns like Suva, Port Vila, Agana and Honolulu. Indeed, existentially, no condition has been as generative of contemporary Pacific art as that of the urban migrant's or the progeny of migrants. In numerous ways, historically uprooted migrant communities in various metropolitan cities have

Edith Amituana'i,
Gallony Avenue, **2008**
Type C print.

Edith Amituana'i was born and raised in west Auckland, the child of migrant parents from Samoa. This experience informs her photographic subjects, which tend to be intimate yet probing studies of migrants and migrant homes. In this example of a suburban interior in Auckland, family mementoes and objects of cultural identity commingle with products and icons of global consumption and communication, creating a strangely poignant aura.

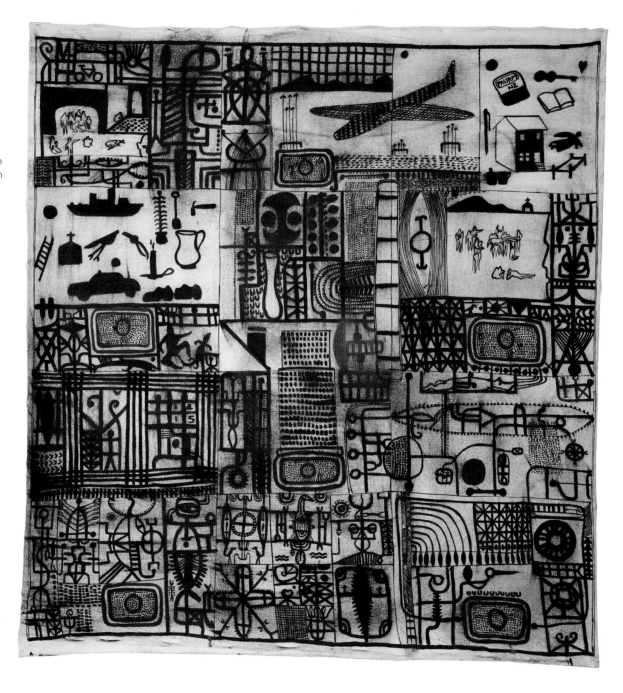

John Pule, *Take these with you when you leave*, **1998.**
Oil on canvas, 188 x 185 cm (74 x 72⅞ in.). Chartwell Collection, Auckland Art Gallery Toi o Tāmaki.

Echoing the tonalities, structure and graphic invention of Niuean *hiapo* (barkcloth), John Pule's painting creates a personal but evocative visual language to speak about migration, loss and survival.

produced, and are continuing to produce, artists whose work draws inspiration from the peculiarities of their spatial and temporal displacement.

The seriousness of this existential condition is paralleled by the remarkable rapidity of its rise to prominence as a popular theme within the contemporary art world. In the 1970s and 1980s only a handful of migrant Pacific artists were active in the metropolitan centres of New Zealand, Australia and the United States, and their significance in those contexts was marginal to non-existent. That situation changed dramatically in the 1990s and 2000s under the rubric of multiculturalism and the contemporary art world's own fast-growing appetite to exhibit cultural difference and hybridized urban identities. In Australia the Asia-Pacific Triennial provided an increasingly sophisticated platform for exploring contemporary Pacific art in curated shows in the 1990s and 2000s, while umbrella events like the biennial 'Pacific Wave' festival in Sydney (1996–2002) and city-sponsored projects like 'News from Islands' at south-west Sydney's Campbelltown Arts Centre in 2007 and 'Pacific Storm'

'I'M LIKE A SEABIRD'

Dan Taulapapa McMullin: If I paint for anyone they are my mother, my grandmother, my great-grandmother and all my grandfathers, great-grandfathers. Even if I'm drawing or painting something erotic – even something pornographic or something ironic, surreal, funny – I know there's someone in my blood who is having quite a good laugh, enjoying the flesh, so to speak, through me. Maybe painting is how I connect with the dead, and how the dead connect through me....

[...]

Sia Figiel: Who are your western influences?

DTM: Da Vinci, Watteau, Gauguin and Picasso. Da Vinci because he was the first to use optics, the camera, while at the same time he exaggerated physiology in the classical manner. Watteau because he avoided the camera before the modern camera was even invented – he was in that sense the precursor to modernism because he was all about expression, to my way of seeing. Gauguin – in spite of postcolonialism and his orientalism, his exoticism, his assimilationism, in spite of all that or maybe because of that – he seduces me. Isn't it awful? I really should do a series based on Gauguin, but with a twist of lime or lemon and a dash of acid, but maybe I do that anyway. And Picasso because he really was the half-child of Da Vinci and Michelangelo, but the native got in bed with the mistress of the house and the children are also half African, half Pacific Islander, half Native American. He was global, he was consciously global, but now we're all hardly aware of how global we all are as artists.

SF: What else influences and inspires you to create?

DTM: 'Native' sculpture – the kind of artmaking that is not defined as art; the making of gods and goddesses, totems, idols, idol worship, graven images, pagan images – this for me is the future. For me our future as artmakers is in our past. And in an odd way this relates to my early experience with conceptual artists who are concerned with making art that is not art. I've chosen what is in western culture a traditional path, but my viewpoint on it is both native Pacific Islander and conceptual, therefore I cannot say where my art is going, except that I find inspiration in the forms of artmaking that are not artmaking; that instead there were and are for us ways of relating to life and to something beyond.

SF: How would you describe, more generally, your connection to the past?

DTM: Growing up, we were whisked away to snowy landscapes, to desert bases, to the tropics and all around again. In that sense I'm like a seabird and I suppose a lot of Samoan lives are lived that way these days; that's how we all began, as Polynesians sailing from one place to another. The flying fox, too, has wings but it stays in one place, so maybe my soul has wings but my spirit is in Samoa....

Dan Taulapapa McMullin, 2009.
McMullin grew up in Japan, Germany, California, Hawai'i and American Samoa. He resides in the hills of Laguna, California.
From an interview with Sia Figiel.[1]

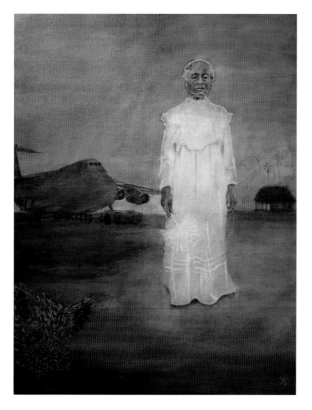

Dan Taulapapa McMullin,
O le Lo'omatua ma le Pua'a
'i Samoa Amelika, **2007.**
Oil on canvas, 76.2 x 101.6 cm
(30 x 40 in.).

at Bundaberg Regional Art Gallery in 2009 gave exhibiting platforms to Pacific artists in Australia.[25] Similar exhibitions incorporating migrant Pacific artists within multicultural groupings occurred in other countries as well.

But nowhere has contemporary Pacific art burgeoned as prolifically, or achieved the level of public support and financial investment, as in Aotearoa New Zealand.[26] The latter has become the leading centre of contemporary Pacific art in the region with its own network of civic galleries, dealers, curators, patrons, professional organizations, links into the wider region and so on. But the rapidity of this success should not obscure the struggle of migrant artists to enter the New Zealand art world. The first exhibition to focus on contemporary Pacific art in a civic gallery in New Zealand was 'Te Moemoea no Iotefa, The Dream of Joseph: A Celebration of Pacific Art and Taonga', curated by Rangihiroa Panoho at the Sarjeant Gallery, Whanganui, in 1990. The exhibition thematized the presence of Pacific culture in New Zealand society, introduced community-based arts like *tivaivai*

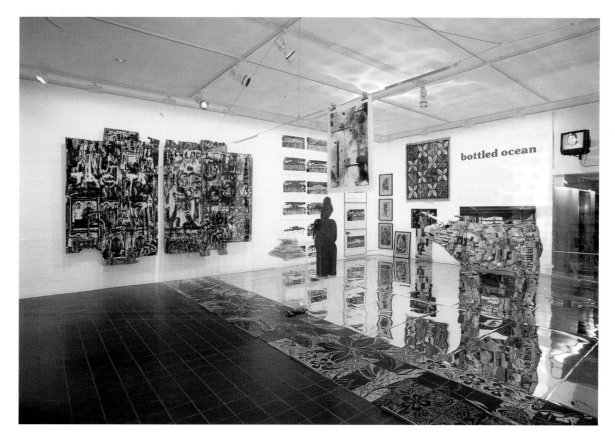

'Bottled Ocean',
New Zealand, 1994.
Exhibition curated by Jim Vivieaere. Installation image of the exhibition as displayed at the Auckland Art Gallery Toi o Tāmaki (2 December 1994–6 February 1995).

(quilting) into the contemporary art gallery, and canvassed the work of migrant artists like Fatu Feu'u, Johnny Penisula, Michel Tuffery and others, only then beginning to garner serious public attention. But it was perhaps the title of the exhibition that was most prescient about its own historical significance. The title was borrowed from the title of a *tivaivai* it showed, and refers to the biblical story of Joseph sold into slavery in Egypt by his brothers, eventually to rise to a position of power in the Pharaoh's court. Joseph's dream turns out to be an allegory of the moment of recognition when, as an exile, he reveals himself to his brothers as the important person he has become. The ambiguity of the allegory lies in the question of whether recognition in Egypt or escape from Egypt (if we can pardon the Orientalism) is the preferable goal.[27]

The ambiguity was even more apparent in the next major exhibition of migrant Pacific art, a show called 'Bottled Ocean', curated by Jim Vivieaere for the City Gallery, Wellington, in 1994 and subsequently for the Auckland Art Gallery in 1995 (*previous page*). 'Bottled Ocean' made the 'arrival' of contemporary Pacific art in the elite galleries of the New Zealand art world a problem to be reflected upon, rather than simply a triumph to celebrate. Having been invited to survey the work of Pacific migrants, Vivieaere turned the exhibition into something of an installation, a work of art in its own right, in which he used various exhibitionary devices to make the desire for 'cultural difference' and 'otherness', which had become broadly topical in the art world, the implicit subject of the exhibition. He divided the gallery with a clear Perspex wall and placed works on its far side, like objects in a shop window. Some sat on a mirror glass floor where they dissolved into their own reflections. Vivieaere ran obligatory information like names and titles through a digital LED-light box, like stock-market points on financial indexes. He left works half-unpacked in their shipping crates, as if to expose the 'backstage' business of contemporary Pacific art as so many objects to be crated, shipped, insured and handled.[28]

At the same time the exhibition captured something poignant about the situation of the urban Islander as someone whose cultural identity is not straightforward. Its title, 'Bottled Ocean', is a striking reformulation of Epeli Hau'ofa's existential metaphor of 'the ocean in us', shifting its emphasis from something

that is deep, immanent and collective to something fragmentary and transportable, a sample that can be capped, labelled, sold, put in a bag or a pocket and taken anywhere.

Contemporary Pacific Art in the Global Art World

By the end of the 1990s the politics of representation and identity within settler national contexts began to lose its critical edge, partly because the cause of cultural difference was readily accommodated by pluralistic neo-liberal states, and partly because the nation, as a particular concern of contemporary art, was rapidly dissolving before the heterogeneity of actual national populations and the expansion of possibilities for human connection and communication to global proportions. Instead of a local bastion to be conquered by under-represented minorities, the contemporary art world became a planetary sphere with almost unlimited possibilities for new audiences and markets, and a new discourse in art about globalization itself. In this situation, according to art theorist Boris Groys, there arises a 'third option' for the politics of cultural representation: 'beyond suppressing it, or finding a

Exhibition catalogue cover, 'Paradise Now? Contemporary Art from the Pacific', Asia Society, New York, 2004.

'IKI and thanks for all the IKA', 2003–4.

Postcard invitation for exhibition of Pacific art, curated by Tobias Berger. Exhibited at Artspace, Auckland; Contemporary Art Centre, Vilnius, Lithuania; and Cook Islands Museum.

representation for it in the context of existing political and cultural institutions', the 'third option is to sell, to commodify, to commercialize this cultural identity on the international media and touristic markets'.[29]

Pacific artists were well aware of this 'option' and to various degrees both exploited and critiqued it in their work. For example, Peter Robinson's 'strategic plan' paintings from the mid-1990s lampooned the ways in which cultural difference had become part of the rhetoric of corporate intercourse and national marketing strategies within global exhibition circuits. 'First we take Manhattan, then we take Berlin' (citing a famous Leonard Cohen song), read one of the texts in *Strategic Plan* (1998; *overleaf*). As it happened, two major exhibitions of contemporary Pacific art during the 2000s were 'Paradise Now? Contemporary Art from the Pacific', shown at the Asia Society in New York City in 2004, and 'Dateline: Contemporary Art from the Pacific', shown at the NBK Gallery, Berlin, in 2007. Both were ambitious shows initiated by curators from their host institutions, accompanied by glossy catalogues (one with an introduction by the prime minister of New Zealand), and supported by an international combination of government and corporate sponsors.[30] Such exhibitions are routine of course, and by no means confined to wealthy settler nations. The Vanuatu Cultural Centre, for example, organized an exhibition of contemporary art from Vanuatu by the Nawita collective that toured cities in New Zealand, Australia and New Caledonia between 1999 and 2001, supported by the Pacific Development and Conservation Trust and the Australian government.

But not all travelling exhibitions of contemporary Pacific art are conducted in a major key, as cultural ambassadors of nation states. A show called 'IKI and thanks for all the IKA' took the more modest tack of playing the global art world not as a set of metropolitan centres to be conquered but as a social network of informal exchanges between artists and galleries exploring their common condition as members of the global art world. 'IKI and thanks for all the IKA' – a title taken from Douglas Adams's famous comic sci-fi novel *So long and thanks for all the fish*, but substituting the Lithuanian word for 'so long' (*iki*) and the Polynesian word for 'fish' (*ika*) – was curated by German curator Tobias Berger, appointed director of Artspace, Auckland, in 2003, and conceived as a farewell gesture to the Auckland Māori and Pacific visual arts community at the end of his term in 2004. The exhibition travelled to the Contemporary Art Centre in Vilnius, Lithuania, where Berger had previously worked on the Baltic Triennial, then went to the Cook Islands Museum in Rarotonga, now part of the global art world, before returning to Artspace in Auckland where it originated, with the addition of works by artists from Lithuania. But unlike 'Paradise Now?' and 'Dateline', which were costly affairs involving major works and serious freighting costs, 'IKI and thanks for all the IKA' was comprised of small-scale works – CDs, videotapes, rolled-up sheets of paper, small canvases, etcetera – that could be packed into a suitcase and taken as luggage on an economy-class airline ticket. And not to New York or Berlin, as one might expect, but to Rarotonga and Lithuania, of all places. These were unlikely exchange partners, linked through the pure contingency of relationships within the contemporary art world, yet they exemplified the constant interplay of hosts and guests that underlies the continuous circulation of contemporary art.

The final realm of contemporary Pacific art exhibitions to be considered in this chapter is the global network of ethnographic museums, including art museums with ethnographic collections. A continuing distinction remains in force between ethnographic institutions and collections and the realm of the 'high art' gallery, including contemporary art galleries. Ethnographic museums, on the other hand, have recently become new institutional patrons

Peter Robinson,
Strategic Plan, **1998.**
Oil and acrylic on canvas,
2.5 x 5 m (8 ft 3 in. x 16 ft 6 in.).
Auckland Art Gallery Toi o
Tāmaki.

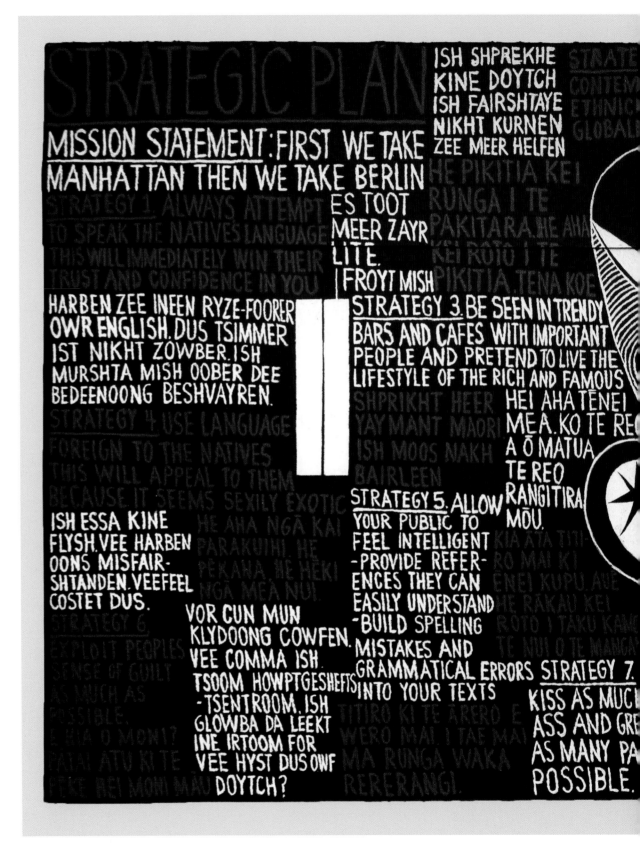

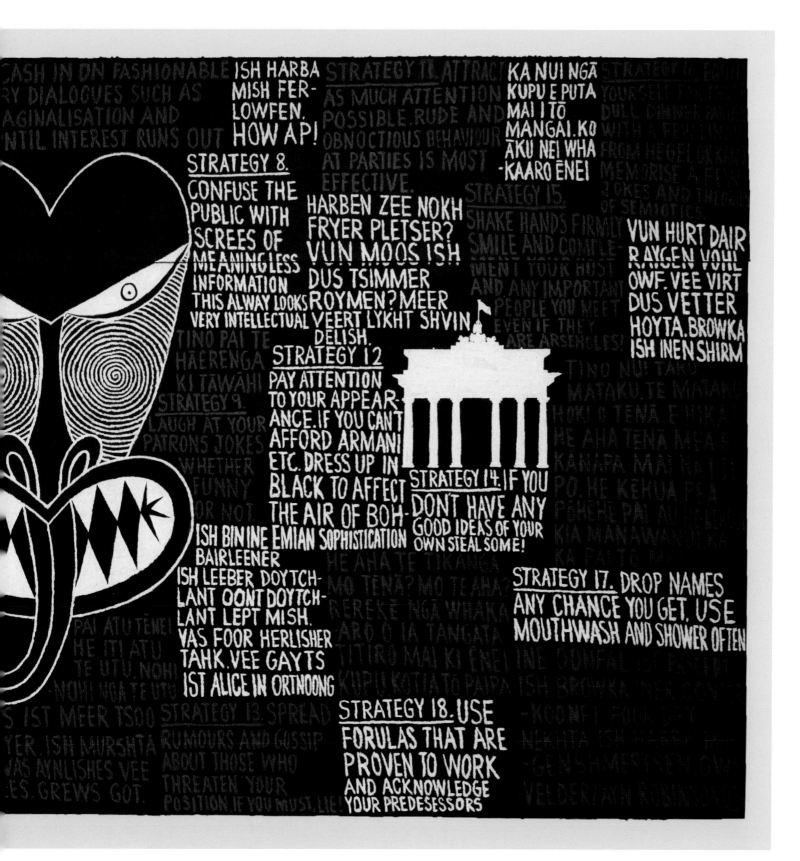

CASH IN ON FASHIONABLE ISH HARBA STRATEGY TL ATTRACT KA NUI NGĀ STRATEGY
RY DIALOGUES SUCH AS MISH FER- AS MUCH ATTENTION KUPU E PUTA YOURSELF FOR THE
AGINALISATION AND LOWFEN. POSSIBLE. RUDE AND MAI I TŌ DULL DINNER PARTY
NTIL INTEREST RUNS OUT HOW AP! OBNOCTIOUS BEHAVIOUR MANGAI. KO WITH A FEW LINES
AT PARTIES IS MOST ĀKU NEI WHA FROM HEGEL OR KANT
STRATEGY 8. EFFECTIVE. -KAARO ĒNEI MEMORISE A FEW
CONFUSE THE HARBEN ZEE NOKH STRATEGY 15. JOKES AND THEORIES
PUBLIC WITH FRYER PLETSER? OF SEMIOTICS
SCREES OF VUN MOOS ISH SHAKE HANDS FIRMLY
MEANINGLESS DUS TSIMMER SMILE AND COMPLE- VUN HURT DAIR
INFORMATION ROYMEN? MEER MENT YOUR HOST RAYGEN VOHL
THIS ALWAY LOOKS VEERT LYKHT SHVIN AND ANY IMPORTANT OWF. VEE VIRT
VERY INTELLECTUAL DELISH. PEOPLE YOU MEET DUS VETTER
TINO PAI TE EVEN IF THEY HOYTA. BROWKA
HĀERENGA STRATEGY 12 ARE ARSEHOLES! ISH INEN SHIRM
KI TĀWĀHI PAY ATTENTION
STRATEGY 9. TO YOUR APPEAR- TINO NUI TAKU
LAUGH AT YOUR ANCE. IF YOU CANT MATAKU. TE MATAKU
PATRONS JOKES AFFORD ARMANI HOKI O TENĀ. E HIKA!
ETC. DRESS UP IN HE AHA TENĀ MEA
WHETHER BLACK TO AFFECT KANAPA MAI I TE
FUNNY THE AIR OF BOH- STRATEGY 14. IF YOU PO. HE KEHUA PEA
OR NOT. ISH BININE EMIAN SOPHISTICATION DON'T HAVE ANY POHEHE PAI AU HEI
BAIRLEENER GOOD IDEAS OF YOUR KIA MANAWANUI KA
PAI ATU TĒNEI ISH LEEBER DOYTCH- OWN STEAL SOME! KA PAI TE NGA
HE ITI ATU LANT OONT DOYTCH-
TE UTU. NOHI LANT LEPT MISH. HE AHA TE TIKANGA
VAS FOOR HERLISHER MO TENĀ? MO TE AHA? STRATEGY 17. DROP NAMES
NOHI NOA TE UTU TAHK. VEE GAYTS REREKE NGĀ WHAKA ANY CHANCE YOU GET, USE
IST ALICE IN ORTNOONG ARO O IA TANGATA MOUTHWASH AND SHOWER OFTEN
S IST MEER TSOO STRATEGY 13. SPREAD TITIRO MAI KI ĒNEI INE OONFAL
YER. ISH MURSHTA RUMOURS AND GOSSIP KUPU KOTIA TŌ PAIPA ISH BROWKA
AS AYNLISHES VEE ABOUT THOSE WHO
ES. GREWS GOT. THREATEN YOUR -KOONEI FOUR DRT
POSITION. IF YOU MUST, LIE! NEKHTA ISH
STRATEGY 18. USE -GENSHMESSEN OVF
FORULAS THAT ARE VELDERZAYN ROBINSONS
PROVEN TO WORK
AND ACKNOWLEDGE
YOUR PREDESESSORS

AM I BLACK OR WHITE?

Pamela Rosi: Yesterday, your performance at the de Young Museum's symposium on New Guinea art had the provocative title *Am I Black or White?* This suggests a dialogue challenging dominant histories and categories of PNG art. What were these histories and what interests you about them?

Michael Mel: First of all, these objects have entangled histories. The de Young Museum houses one of the best collections of New Guinea art, but I'm not going to label it traditional or contemporary art. It's PNG art that reflects the extraordinary creativity and vision of individuals in PNG history. As an artist following in their footsteps I am amazed, honoured and privileged to look at and experience this art. But performing at the de Young Museum has also given me the opportunity to disentangle some of the myths and restrictive structures that dominant cultures have put in place to constrain and contain PNG people and histories. So to answer your question, it is my responsibility to 'liberate' these objects and create new opportunities between PNG and Americans to understand our shared histories. These objects help bring about this dialogue.

PR: How did these histories unfold through your performance?

MM: By having the performance achieve engagement, confrontation and dialogue, because these affect the positioning of the individual. In a western context, when you talk about dialogue or engagement in a museum context, objects are locked in glass cases and people are supposed to walk by quietly, observe them and walk away thinking 'ah … wonderful art'.

I wanted to destabilise that idea by having people look beyond the art to engage with the histories that the objects represented – or were made to represent. For this, the performance needed to be confrontational and because some histories are deep-seated and traumatic, the dialogue had to be immediate and challenging....

[...]

PR: Your performance involved placing PNG objects on stage as voiceless participants. What did their presence signify for you and other Papua New Guineans present?

MM: First of all, these objects are not dead but alive because, for Papua New Guineans, they provide a point of connection to our heritage, our histories and our ancestors. And our ancestors are not ancestral as in the past; they are part of us – of me – now. Bringing those objects into the performance was to encounter and connect to my ancestors. I did this by providing an oration...oratorical skills are very important for invoking not only concepts of place and ancestral relationships, but to build bridges to present realities and situations. The PNG objects in the de Young Museum are not objects alone; they are spirits that are here and connect America to PNG....

Michael Mel, artist, 2007.
Mel is from the Mogei tribe of the Mount Hagen area
in the Central Highlands of Papua New Guinea.
He has a PhD from Flinders University, South Australia
and is Director of the Department of Expressive Arts and
Religious Studies at Goroka University, Papua New Guinea.
Excerpts from an interview with Michael Mel by Pamela Rosi.[i]

Michael Mel,
L IAMB NAI? POMBRAL
MOLGA KUNDUL AL?
WHO IS THIS PERSON?
BLACK OR WHITE?.
Performance at the De Young
Museum, San Francisco,
28 April 2007.

of contemporary Pacific art. Many of them – the Quai Branly in Paris, the de Young Museum in San Francisco, the British Museum in London, the Berlin Ethnographic Museum, the Metropolitan Museum in New York, the Australian Museum in Sydney, the Auckland Museum, and others – now support, exhibit and collect contemporary Pacific art. The reasons are various: in order to revitalize their exhibition programmes, to affirm their connection with the continued existence of the cultures represented in their collections, to reframe the significance of their collections for contemporary audiences. For the artists, these institutions and collections confront them with the particularities of colonial history in often moving and intimate ways.

One of their most adventurous collaborations was a project staged at the Museum of Archaeology and Anthropology at Cambridge University in the United Kingdom in 2006–8 entitled 'Pasifika Styles'. Its

curators invited fifteen contemporary artists from New Zealand, mostly of Māori and Pacific Islands descent, to develop 'site-specific' projects that engaged with particular objects in the museum's collections. Artists supplemented cabinet displays with contemporary works; domesticated small corners of the museum with lounge furnishings decorated with handicrafts and floral coverings (*overleaf*); 'reawakened' long-dormant treasures, like musical instruments and ceremonial clubs, by using them (for the first time in two hundred years) in opening ceremonies; and so on. These gestures touched profound ontological questions for the artists in which an earlier era of cultural fragmentation and alienation reflected, briefly, their own. It was not by accident that many explored the idea of 'home' and the 'homely'. One moving work in this regard was a project by Māori artist Lisa Reihana. As part of her work Reihana selected from the museum's collection a *tekoteko* figure (conventionally placed at

the apex of Māori meeting houses) that originated from her own tribe, but which otherwise was unnamed and unprovenanced. Drawing her title from the Māori concept of *he tautoko*, meaning 'to support someone', she installed the figure in a glass vitrine and gave 'him' (never 'it' for the artist) a set of headphones that played recorded songs by a Māori choir and the tap-tapping sound of a contemporary carver, compiled by the artist as 'gifts from home', and which the museum visitor could overhear on three Nokia phone sets. To the same end, the vitrine was also installed with a plasma screen that played digitally altered film footage of the New Zealand landscape, decorative patterns derived from Māori meeting houses, and treasures from the museum.[31]

Reihana's work exemplifies two preoccupations of contemporary Pacific art. One is the desire to re-examine colonial history, to excavate, remember and re-present countless micro-histories and counter-memories in formally experimental ways. The second is the desire to draw inspiration from the 'life-worlds' of cultural communities in the present. The globalized contemporary art world is a novel place in the history of art in Oceania, no more than a couple of decades old. But it is an increasingly important place, the 'future of cultural expression' from the region. The art it generates is often poised between intimate local experiences of globalization, like the *Mara-i-Wai* project discussed earlier in this chapter about an extended family moved to abandon an ancestral homeland, and itinerant cosmopolitan experiences, like those of the artists who flew into Cambridge in the course of their busy lives to make works for 'Pasifika Styles'. In their desire to 'revivify' and 'connect' with alienated objects (or 'kin') in an old colonial museum, the pathos of their project is evident in its attempts to bridge the gaps of time, place and self. But so too is its wit and humour.

Ani O'Neill and Tracey Tawhiao,
***The Living Room*, 2006.**
Mixed-media installation in 'Pasifika Styles: Artists inside the Museum', Museum of Archaeology and Anthropology, Cambridge, 2006–8.

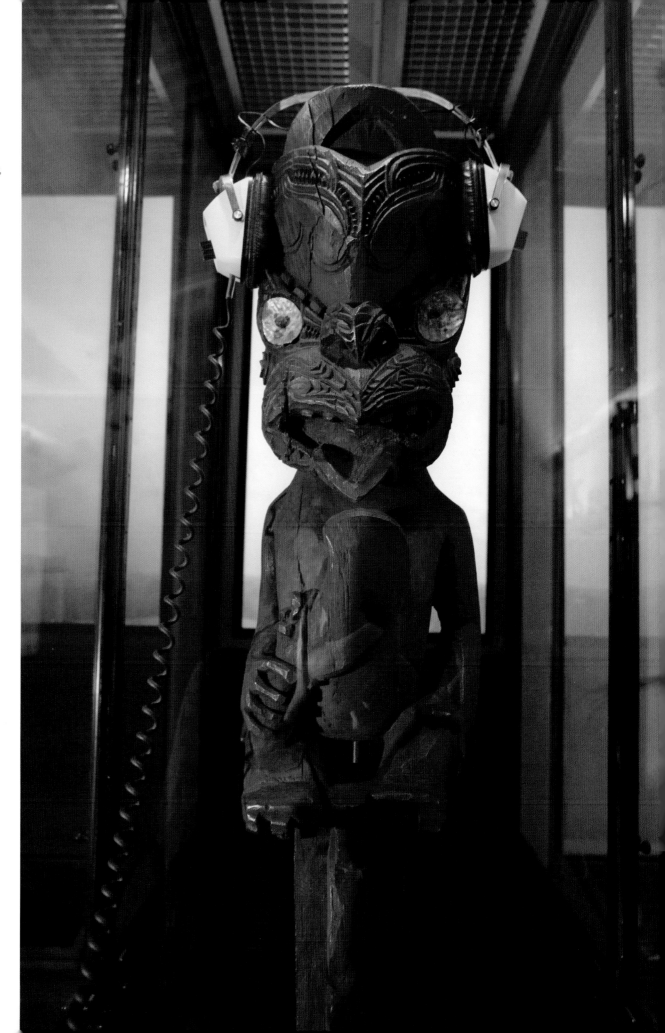

Lisa Reihana,
He Tautoko, **2006.**
Mixed-media installation in
'Pasifika Styles: Artists inside
the Museum', Museum of
Archaeology and Anthropology,
Cambridge, 2006–8.

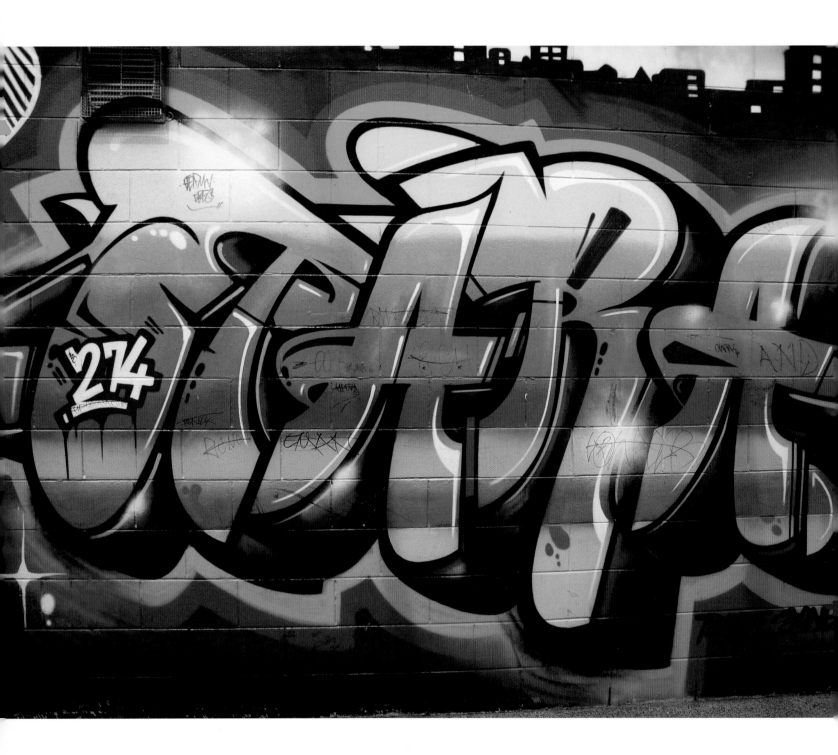

Sean Mallon

URBAN ART AND POPULAR CULTURE

Otara 274, graffiti (detail).
**By Charles (phat1) and
Lady Diva from the TMD
(The Most Dedicated)
crew, Otara.**

In South Auckland in a side alley off a shopping mall, the number 274 is painted on a slick graffiti-style rendering of the word 'Otara'; in Pape'ete a tattooist adjusts his homemade tattoo machine, listening for the right pitch, for that familiar sound that will keep his ink flowing; in an apartment in Honolulu, a ukulele is strummed as a DJ messes around with beats on a drum machine; in Hagatna, Guam, a T-shirt designer prints T-shirts for the annual Chamorro Festival in California…

Today, urban centres in the Pacific are connected in more complex ways to each other than ever before. The people who live in towns and cities are exposed to all kinds of visual and technological media. The visual culture of people living in urban centres gives material form to social, economic and political concerns; it reflects and draws on history, and facilitates processes of identity making. In the twenty-first century urban contexts are conduits for the ever-quickening traffic in culture. These conditions challenge the way we create, think and write about art in Oceania.

Pacific Islanders' earliest contacts with Europeans and others took place at sea or on the beaches of islands and atolls. These meeting points have been important for the way scholars of history in the Pacific have thought about encounters between people. Historian Greg Dening has used the metaphor of 'islands and beaches' for the many ways in which people 'construct their worlds and for the boundaries they construct between them…islands are everywhere and beaches must be crossed to enter them or leave them, to make them or change them'.[1] Just as islands and beaches are contact zones and sites of transaction, so contemporary urban centres facilitate similar exchanges and interactions.

It is easy to think of urban centres in the Pacific as a twentieth-century development linked with improved transportation and communication technology. But the Pacific has long been an ocean of connected islands and archipelagoes. As settlements became established, people walked and paddled along those beaches, to these developing economic and cultural centres – the ports and small towns. Voyagers from within and beyond the Pacific had criss-crossed the region so much that by the late 1800s the presence in Samoa of people from the Solomon Islands, Bismarck Archipelago, Hawai'i, China, Sweden, Germany, America, Britain and New Zealand (among others) compelled Richard Gilson to title his history *Samoa 1830 to 1900: The Politics of a Multi-Cultural Community*. Small settlements such as Apia and larger ones such as Honolulu, Auckland and Pape'ete are examples of multicultural urban centres that were established in the Pacific 150 years ago through the activities of imperial and colonial powers from outside the region. They were meeting places of many cultures and destinations, and departure points for all kinds of people, commodities and ideas.

Historically, the processes of urbanization in the Pacific have been uneven. While urban centres could be multicultural, in early colonial towns in parts of Melanesia indigenous people were physically segregated or had curfews imposed on them. Today some urban areas remain fragmented by ethnicity, clan, language or class.[2] In the first decade of the twenty-first century, populations of urban centres in the Pacific range in size from the tens of thousands to large metropolises such as Honolulu of more than 900,000 people and Auckland with more than 1.3 million. Cities such as Sydney, Los Angeles and Salt Lake City have also become home to Pacific peoples. Families who have settled in these cities are increasingly transnational in the ways they communicate and

interact. These urban conditions shape and inspire the visual culture of contemporary Pacific peoples. They allow us to think about visual culture as a phenomenon that is entangled with people, ideas, products and media from beyond and across the beaches of what Epeli Hau'ofa has described as a 'sea of islands'. This chapter examines urban street art and visual culture largely produced beyond the purview of art institutions and galleries. It highlights how meaning and cultural production relating to politics, ethnicity, class, nationality and other collective identities are played out in the street and urban centres of the Pacific.

Protest, Power and Politics

By the 1970s, in Auckland, New Zealand, migrants from Samoa, Tokelau, Niue and the Cook Islands had established large communities. There were also people from islands such as Fiji, Tonga and Tuvalu. As part of New Zealand's post-war industrialization, people from these island territories had been encouraged to migrate to New Zealand in order to address labour shortages in factories and light industry. Some had come on government work schemes and various types of scholarships and apprenticeships. Migrants were away from their home islands, outnumbered and in many cases underprivileged.[3] In these social conditions they formed communities with a visual culture expressing both their specific cultural attributes and the social and political concerns particular to the Auckland urban context. They were inspired by an international catalogue of imagery and driven by a worldly view of politics and social justice.

In 1971 a group of Samoans, Tongans, Cook Islanders and Māori founded the Polynesian Panther Movement. Its membership consisted mostly of New Zealand-born young people of migrant parents. The Panthers were primarily concerned with the general welfare of Pacific people in New Zealand cities. A major focus of their activity was a controversial campaign by the New Zealand government against migrants who had overstayed temporary work permits. The campaign targeted Pacific Islanders while ignoring 'overstayers' of other ethnicities. Police raided workplaces and homes (often at dawn) and undertook random street checks. Eventually, public pressure led to a change in enforcement methods, but Pacific people remained stigmatized as overstayers.

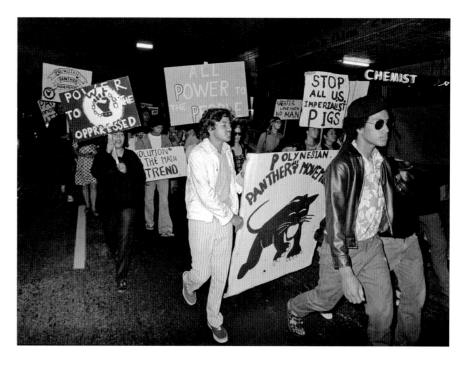

In 1972 the Panthers became a political party – the Polynesian Panther Party – named after the Black Panther Party in the United States. Like that of the Black Panther Party, the logo developed for the Panthers featured a pouncing Black Panther. In their appropriation of the imagery and public image of the high-profile Black Panthers – the black turtlenecks, leather jackets, afros and berets – the Polynesian Panthers signalled it was a group that was against racial injustice and like its counterpart was serious about its objectives. As one member recalls '[t]here was great pride in being a Panther and wearing the appropriate garb. We stood out, looked the part (loved the berets) and, I suppose, looked quite intimidating...'[4] While their image was derived from the politics of civil rights in the United States, it represented a group of Pacific people with very local concerns.

This identification with black culture is observable elsewhere in the Pacific and continues into the twenty-first century. The political struggles of the 1970s and 1980s coincided with Māori and Pacific Islanders' adoption of Rastafarianism and reggae music.[5] In Hawai'i the fusion of a reggae sound with Hawaiian music created a style now known as Jawaiian music.[6] Both developments created a link to the music and cultures of the African diaspora. Similarly, in the

Polynesian Panthers Protest, Auckland, 1971.
Photograph John Miller.

mid-1980s, Kanak independence activists in New Caledonia were attracted to Bob Marley's songs of freedom and resistance. Art historian Susan Cochrane writes that a local version of reggae-style music called Kaneka emerged in New Caledonia 'affirming Kanak culture and protesting against colonial dominance and inequality'. The colours of the Kanak flag, Kaneka music and Marley T-shirts became key elements of Kanak popular culture alongside mural portraits of Kanak leader Jean-Marie Tjibaou and figures such as Che Guevara.[7]

Reggae emerged alongside other more intimidating forms of resistance and grass-roots politics. In the 1960s and 1970s two prominent gangs emerged among young people in New Zealand – the Mongrel Mob and Black Power. At this time their membership consisted of mainly young Māori and Pacific Islanders facing unemployment, boredom, broken homes and disconnection from their homeland or communities. Gang members developed various intimidating images to wear as patches on the backs of leather jackets and waistcoats. In addition they were often heavily tattooed. The insignia that gangs developed were highly visible representations of their group identities and usually featured the gang's name and the city where they were based. The gangs had a hierarchical militarized structure, and used military imagery and paraphernalia including the swastika, chains and boots. The Black Power gang patch features variations of a forward-facing clenched fist; the Mongrel Mob patch shows a British bulldog wearing a Second World War vintage German helmet (*overleaf*). However, in contrast to the military, both gangs fostered an unkempt physical appearance. Ex-Mongrel Mob gang leader Tuhoe 'Bruno' Isaac explains that:

> The bulldog was a symbol of the British colonial oppression that consumed the Māori people. The guys figured if you put that image on a Māori's back, with the dog wearing a German helmet with a swastika attached to it, then you had a dual symbol of contradiction and hatred. That is what we stood for – that was who I was.[8]

Bus shelter in New Caledonia with graphic portrait of Bob Marley.

The sentiments, images and sounds of reggae and Rastafarianism have become a deep-rooted part of the music and visual culture of the Pacific. Musicians such as Bob Marley inspired people to use reggae music as a vehicle to voice their concerns about the world.

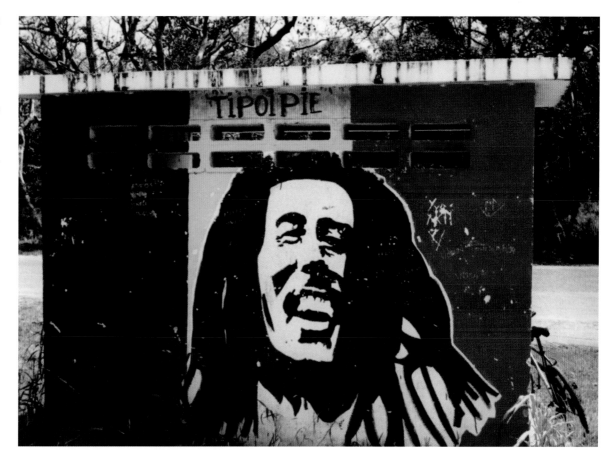

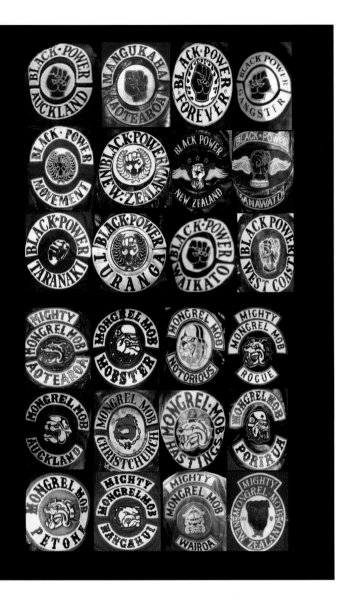

live in urban environments. This imagery is part of the iconography of Pacific and Māori people in New Zealand – not the social and cultural elite, but those who are economically or socially marginalized or who marginalize themselves through their criminal activity.

However, contemporary artists have seen the relevance of these social groups and have used the motif of the gang patch to explore themes of marginalization, social tension and identity that reflect the experience of people in urban centres. For example, the gang patch motif in *Blackout Movement* by Māori artist Shane Cotton has been described as underscoring 'a search for identity, for a sense of belonging… camaraderie';[10] and Nick McFarlane's three works, *Savaged Culture* (2004), *Domestic Violence Cycles* (2004) and *Wealth Gap Division* (2004), highlight the other kinds of social dysfunction from which gangs emerge.[11]

Social struggle and political resistance were manifest in other forms of visual culture in urban centres in the Pacific. Some of these locations came to

The Mongrel Mob, Black Power and a third gang, the King Cobras, are the longest-established gangs dominated by Māori and Pacific Islanders in New Zealand. Today, in areas such as South Auckland, gangs and colours such as the 'Bloods' (red) and 'Crips' (blue) have some prominence. Although they share names and colours with street gangs from Los Angeles, Belinda Borell argues that the gang experience for young people in South Auckland remains localized and is more closely linked to familial or territorial ties to the Mongrel Mob and Black Power.[9]

For a history of art in Oceania, the significance of gang-related visual culture is that it emerges from the conditions and the experiences of Pacific people who

right

Nick McFarlane,
Savaged Culture, **2004.**
Hand-stitched leather,
broken glass, frame.

represent symbolically the state and nation and their connections to the wider world. They were often focal points for political and social activism. In 1980 Port Vila on Efate was an important location for the people of Vanuatu, who were anticipating the country's impending political independence and name change (from New Hebrides) in July of that year. An account of tattoos on the arms of two New Hebrides men highlights the positive mood in Port Vila at the time. Photographer Steven Ball interviewed the men in the 1990s. The first man's tattoo depicted a hand tearing at barbed wire, 'in reference to removing the shackles of Vanuatu not being self-governing'. The second man's tattoo depicted a bomb about to be ignited. He explained to Ball that people were getting ready for the change and that Port Vila was 'going to blow up', although with what was unclear.[12] Themes of 'self-reliance and strength through unity were prominent in popular discourse' and the arts community in post–independence Vanuatu. This shared vision among

Carrying Cultures

AT THE DOWNTOWN MARKETS and bus station in Apia, Samoa, multicoloured buses crowd the asphalt close to stalls where tourists buy trinkets and souvenirs and where locals drink their *koko-samoa* or eat their *panikeke*.
In quiet villages you can sometimes hear the buses before you see them, the roar of their hardworking engines barely discernible above the speakers pumping out heavy music bass lines. Painted in bright hues the buses create a colourful flash among the predominant greens of the

cross-island roadways. They have become tourist attractions, conspicuous examples of local humour and tributes to the style, creativity and flair of their owners and drivers. They bring together global technologies and a range of visual and popular cultures.

Several models of buses are used in Samoa. They include the Chinese-made FAW and Lifan, but most common are Hino, Nissan and Toyota truck chassis from Japan. Around the sturdy chassis and its factory-produced cab, a locally made passenger cabin is constructed from a wooden or metal frame

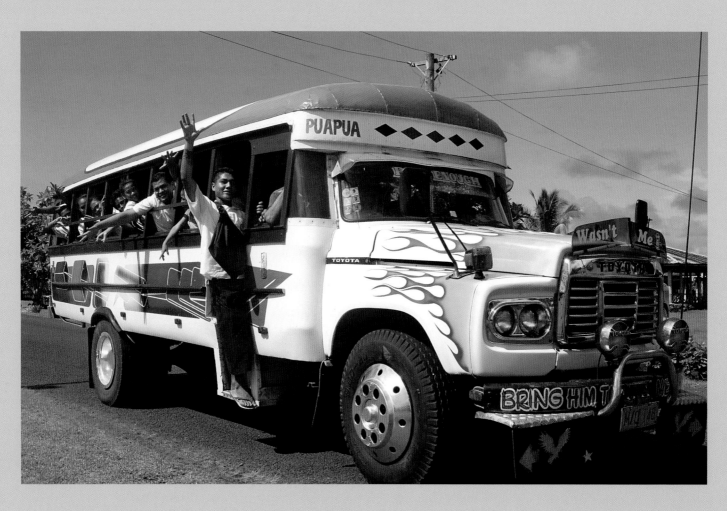

with timber walls. The seats are small, low, and made from planks bolted together. The engines are loud and powerful, and the tyres are workhorse grade. The buses run the length and breadth of the islands of Upolu and Savai'i on what are sometimes rough roads. The glassless window frames in the passenger cabin let the wind flow through freely. Some are equipped with squares of transparent acrylic for sliding into the window spaces when it rains. People sit crammed shoulder to shoulder, they stand hunched over in the aisles beneath the low roof, and they sit in strangers' laps amid cardboard boxes, plastic carrier bags and coconut-leaf baskets full of produce. The situation appears chaotic but surprisingly is very organized.[i]

Inside the bus, the passenger area is sparsely decorated. However, the driver's cab can be heavily adorned and personalized with photographs, shell necklaces, flower leis, or customized upholstery. The dashboard and windscreen edges can resemble a miniature display, an assemblage of bits and pieces offering an insight into the personality or interests of the driver. In one bus, a black velvet painting of Bob Marley might dominate (along with reggae music); in another, photographs of wrestler and actor Dwayne Johnson (The Rock) might embellish the cabin among a box of cigarettes, an *ili* (woven fan), flower lei, small American flags and CDs of music.

The bus exteriors are marked with village destinations like Mulivai, Solosolo and Moamoa. They are usually painted in bright colours that include combinations of yellows, oranges, pinks and reds. The detailing may include Mack truck brand chrome mud flaps, bull-bars, elaborate typography, and all manner of accessories such as lights, flags and mirrors. Some of the racier buses have licks of red and yellow hot-rod flames streaming back from the curved roof of the passenger cabin or across the bonnet, alongside carefully rendered or adhesive monikers such as 'Ghost Rider', 'Road Star' and 'Bon Jovy' (sic). The side panels of the bus display company logos such as Ah Lam Transport, Jungle Boys, Janes Beach Fales, Sunrise Transport and Queen Maggie. The rear tailgate might feature an idyllic beach scene, a Disney character, or, in the case of an American Samoa bus – the Incredible Hulk and slogan 'Tsunami Survivor' referencing the devastating 2009 tsunami.

Samoa's buses capture the cosmopolitan nature of these island urban areas in their composite colours, sounds, technologies and names. They transport people and goods, but they also carry culture, news and images of the outside world. The buses, their passengers and their music race through the villages of the islands, keeping urban and rural links and lifelines strong – they are a little vision each day of the urban in the rural, the global in the local. SM

Samoan bus, 1990s.
Photograph R. Eime /
Travel-Images.com

local artists led to the establishment of the Nawita Association of Contemporary Artists in 1989, which, in the name of unity, built a membership of expatriate and ni-Vanuatu people.[13]

Street Culture, Typography, Tagging and Territory
In the 1980s and 1990s the scale of movement of people from rural to urban areas, and from islands to larger metropolitan centres like Honolulu and Auckland, had changed the dynamics of these locations. People who had settled in earlier decades raised extended families, and with arrivals of new migrants and travellers, new identities and forms of cultural production emerged. From the 1990s urban centres in the Pacific were highly connected sites for the global traffic in culture. These processes were hurried along by the development of new technologies, the proliferation of print media and improved access to forms of entertainment such as film and recorded music. In the first decade of the twenty-first century the social and cultural transaction zones for Pacific peoples in urban areas included desktop and portable computers, mobile phones and the internet.

Today, people access media through radio and television transmissions, the internet, optic cable, satellite feeds – every home is a potential 'beach' – a transaction zone. The visual culture created in these transaction zones is difficult to pin down, its specific circumstances and processes of production elusive.

Our ideas about contemporary urban and street art in the Pacific today are inevitably shaped by high-profile international figures such as the United Kingdom's Banksy, Shepard Fairey of the United States and Blu of Italy. Street art and urban art are genres that have particular meaning in the art worlds of the United States and Europe. The artists in this milieu work on the fringes of the contemporary art world and attract attention from writers, film-makers, art historians and pop-culture academics. Their work comments on the social and political issues of urban and particularly metropolitan contexts, and strives to be relevant, witty, visually interesting and often provocative. In the Pacific indigenous artists in urban contexts work in similar media but do not necessarily share the same concerns nor the same profile as their European and United

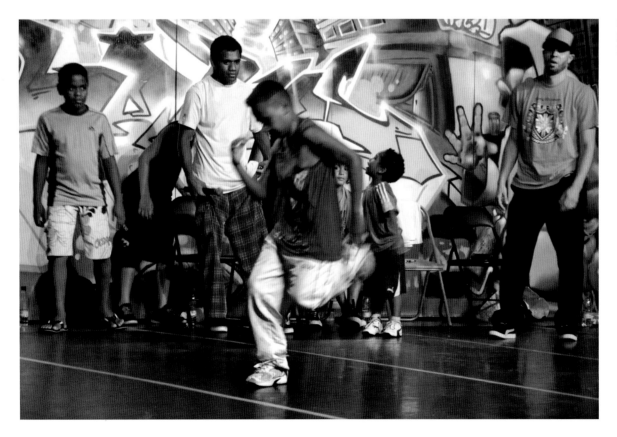

Hip hop, 'Battle Of The Year International 2011', Noumea, New Caledonia.

E A

(chorus:) To all my people tell me what you want. Ea!

Hawaiians tell me what you need. Ea!

Trying to take what the kanaka maoli got. Ea!

Just to satisfy the government's greed. ʻAʻole!

Hawaiians tell me what you want. Ea!

Kanaka maoli tell me what you need. Ea!

We must never forget what our kupuna taught. Ea!

Even if I have to bleed.

The educator, manaʻo deeper than a crater.

You should've known by now that I'd be

Back sooner or later with even greater mana.

You know they didn't wanna ever go

Down while they see us rising like an elevator.

But it's time for the indigenous up-rise!

I see the fire burning in the children's eyes.

Another freeway, another heiau dies.

It's time to make the government choke on their lies.

The term Hawaiian Homes is a joke to me

Coz every piece of land is Hawaiian homes to me.

But in order to be a resident your blood must be fifty percent,

Whoever thought of that law is an idiot to me.

So we're living on the beach and they call us

Squatters. Because we're living off our own land,

Fishing from our own waters. I promise

Our fight will never be over.

Just try and run us over with your damn bulldozer.

I rap for my people.

I cry for my people.

I live for my people.

I die for my people.

What you see is what you get

Take me as I am.

And I ain't never had an uncle named Sam.

(chorus)

Yo they think it's a battle zone.

But they're damn sure right.

Coz this here's also my home

And I'm prepared to fight. …

Rap lyrics by Sudden Rush, 2002.ˡ

'Ea' means sovereignty, rule or independence in Hawaiian. To see Sudden Rush

perform 'Ea', search 'Sudden Rush Ea' on YouTube.

States-based counterparts. The appreciation of urban art in the Pacific is well behind the trends of Europe and the United States. However, as art institutions become familiar with hip hop, graffiti art and street fashion, they will find it difficult to ignore these artists and remain relevant to their audiences.

Indeed, hip hop culture is arguably the most significant genre of cultural production for the most recent generations of Pacific peoples. The visual style of much contemporary street mural and graffiti work is connected to hip hop. Originating in the United States, it is a music- and dance-oriented subculture that has four key elements of practice: DJ-ing, MC-ing, B-Boying and graffiti art. Over the past forty years, the language, fashion, dance moves, lyrics, graffiti and even the typography of hip hop have widely influenced Pacific youth. The vocabulary of hip hop has introduced new slang, body language and ways of speaking and interacting with others. Fashion has been dominated by sports apparel, baseball caps, baggy pants and sports shoes; dance moves have drawn on many influences and inspired new moves and choreography. In Samoan dance repertoire in New Zealand, hip hop styles have been integrated with the customary dances *siva patipati* and *taualuga* or included as part of larger performances. Lyrically, hip hop MCs and DJs have used indigenous language and instrumentation in their work. Graffiti art has covered city walls, and influenced graphic design and composition across many forms of media in popular culture. Hip hop researcher April Henderson has pointed to music videos and film as being important for hip hop's pan-Pacific transmission – with films such as *Style Wars* (1984) and *Beat Street* (1984) being particularly influential.[14] However, the traffic in ideas was not all digital or electronic. As Henderson has also demonstrated, hip hop and its culture travelled most effectively in the minds and bodies of people as they moved within the Pacific diaspora.[15]

Mainstream news media opinion has long been critical of hip hop culture, connecting it with street-gang lifestyles in cities such as New York and Los Angeles. Social workers and community leaders have lamented the Americanization of local youth culture. However, while hip hop shares some affinities with its American origins, hip hop scholars argue that the cultural transactions have been selective, and hip hop has been indigenized to reflect very local concerns, stylistic variations and political and cultural needs. For example, in the 1980s Māori elders hosted breakdance competitions at *marae* 'as a way of encouraging young Māoris back to their cultural roots'.[16] Other practitioners have used hip hop to raise awareness of indigenous issues, just as their predecessors and contemporaries do with reggae music. Hip hop music has mediated localized knowledge and forms of expression, and the practitioners and artisans of hip hop cultural forms are prolific producers.[17]

Often associated with hip hop culture are forms of graffiti and tagging. These seemingly random, careless marks have significant meaning attached to them, albeit in a vernacular unfamiliar to outsiders. In the inner suburbs of Suva, Fiji, on a concrete wall smothered in old paint in an abandoned property you will find the letters RRA scrawled in pen. Some people will know this as an acronym for the Raiwaqa Revolutionary Army. However, these letters are not a reference to another military faction in the troubled arena of Fiji's contemporary politics, but they are perhaps a marker of a militant sense of connection between young people, a sense of belonging to a particular place, a particular neighbourhood at a particular time. Like the gang patches of Auckland, these letters often speak to economically disadvantaged people who have a sense of community and are struggling to survive in the urban landscape of Suva.

The graffiti of the Raiwaqa area reminds us that typography has long been a characteristic of urban environments in the Pacific. From the first outposts of merchants and businessmen to the work of Christian missionaries, typography has been in the literature, the architecture and material culture of Pacific peoples. The written word has long been an important part of the visual world. Shop fronts, newspapers, notices, proclamations and contracts were the evidence of social, cultural and economic transactions. The visual presentation of words and the letters that comprise them continue to be an important part of what is meaningful and how it is communicated in contemporary urban environments.

For most people the letters RRA on a building in Suva are a random scrawl that constitute nothing more than a form of vandalism. The inscription of these

Concrete water tank, Newtown, Wellington, 2011.

The seemingly random, careless tags and marks of graffiti are the most visible signs of a complex subculture in which style, words, status and 'fierce critique' drive the creativity.

letters, names and acronyms in public spaces is part of an art form known as tagging, which in most places is considered a crime and destruction of property. But tagging does have an aesthetic index and a culture that is shared and understood by taggers. Henderson, who has done extensive research among self-described 'writers, aerosol artists, and taggers' in New Zealand, says they have their own codes of operation and engage in 'fierce internal critique' in the creation of their work.[18] Tagging and its messages communicate claims to territory; they can be signatures, mark claims to larger artworks, and they can intimidate other taggers merely by their presence. Tagging is part of contemporary youth culture, and references a shared visual style and history. These signatures and marks that are so much part of the visual culture of our cities give voice to those seldom heard by local government, welfare agencies and the brokers of art and culture.

Micronesian journalist Jaime Vergara has lived and travelled throughout Micronesia and attributes the spread of graffiti there to widespread feelings of alienation in communities:

> where the feeling of belonging to the geography and the economic, political, and cultural processes abiding in them have excluded many who have been dulled into being recipients of someone else's expertise, or worse, dole. The resulting lash of anger takes a mild form in the graffiti writing on our walls.… A malaise from rapid urbanization is the alienation of those who do not participate in the decision-making processes that affect their lives. Indeed, today's revolution is still democracy, and the leaders of the Micronesian water continent, with its fast diversifying populace…will be well to heed their indigenous people's cry, not to fan their despair, but to find ways to recover and engage their hopes.[19]

Vergara's analysis of the social conditions that give rise to graffiti in Micronesia may be accurate for the communities in which he works and their experiences of urbanization. However, graffiti is made in circumstances across the region where the age, ethnicity and cultural and socio-economic backgrounds of its producers can vary. April Henderson has found that taggers in New Zealand can have a range of motivations behind what they do and come from diverse ethnic and class backgrounds. They may not always be from disadvantaged families or in trouble with parents or the law. For some artists tagging may be about making a

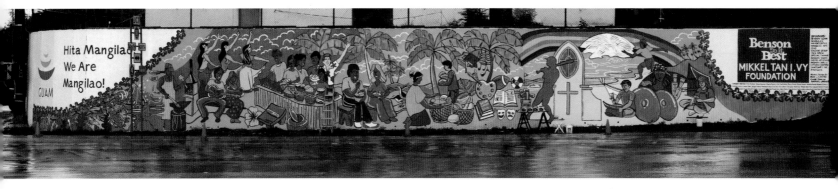

political statement, for others it may be about a 'love with letters; the way they slope and curve and dance and lean.'[20]

Connected with tagging but visually distinctive are forms of mural painting. Street murals and graffiti art have obvious affinities to tagging and the forms of street art produced in metropolitan cities. In Guam the art of the street has been critical in the revitalization of village identities. In 2009, as part of the 'We Are Guam' campaign initiated by the Guam Visitors Bureau, people from around Guam were encouraged to paint murals to beautify and enhance their villages. On an island heavily dominated by the presence of the US military and tourists, the mural campaign was an exercise in building village pride and distinctiveness. It was a medium for village histories and identities to be recalled and transmitted to locals amidst a strong and transient foreigner presence. In January 2010 the first village mural was painted in Mangilao. It was designed by Ron Castro and depicted the institutions, people and artists associated with Mangilao, and it included celebrated master blacksmith Tun Jack Lujan. In August 2010 the twelfth village mural, 'We Are Sinajana', was unveiled. Vice Mayor Robert Hofmann talked of a 400-year history that the people of Sinajana had shared together. Local artist Rafael Unpingco worked with volunteers to create a mural featuring images from the Spanish occupation in the sixteenth century to the Second World War. Hofmann told reporters that 'The stories painted here are just a glimpse of the many stories we all share as a Chamorro people. They are distinctive highlights among many untold stories.'[21]

In Hawai'i and Tahiti murals convey social and cultural messages and boost self-esteem, particularly

among youth. In both island groups there are crews of artists who create murals inspired by the visual style of hip hop culture. Hawai'i's 808 Urban Art Collective uses murals to improve the environment and provide an outlet for communities to express their views on issues affecting their lives. A measure of the support they get is that they are funded by the Hawai'i People's Fund – a community fund that provides grants to progressive grassroots social-change organizations working in Hawai'i. Since 2006 in Tahiti, 'kreativconcept - L'association graffiti de Tahiti' has also used graffiti art in youth activity programmes and efforts to enhance the urban environment. Its members organize events around creating murals, skateboarding and hip hop culture. A striking feature in some of the crews' murals is the fusion of indigenous images and motifs with contemporary graffiti style.

top
'We are Guam' community mural, Mangilao, Guam.

In Guam, the painting of street murals depict local histories and reassert indigenous village identities at a time when urbanization and US militarization of the island is accelerating.

above
Mural, Hawai'i, 808 Urban Art Collective.

Disjuncture, Continuity and Transnational Connections

Urban environments in the Pacific bring disparate groups of people together. In urban communities visual media are very important for how people lay claim to various cultural identities. The art they make can reflect specific identities connected to their ethnic origins, the social or cultural groups they associate with, the places where they live and the activities they pursue in everyday life. But these identities differ depending on context and are often fluid and situational.

Today, Pacific people move between urban centres within islands and between archipelagoes. They have family and friends in the large metropolitan centres around the Pacific rim. The fact that urban centres are well connected across the Pacific diaspora means that

communities have become less bounded by geography and are mobile and transnational in nature. Their cultural practices and art forms move with them. They are mechanisms through which much cultural knowledge, however partial or contested, is transmitted, preserved and transformed. Indigenous art forms might be made in village contexts for local use, for tourists or the gallery market overseas, and they can circulate to overseas urban areas where they can find similar consumers. However, as with hip hop and music, there can be disjuncture between the creation, practice and meaning of these art forms between one location and another. In cities where migrants may not be the dominant culture, this disjuncture can be manifested in the way visual culture incorporates new materials and practices to suit new circumstances. Adaptation is

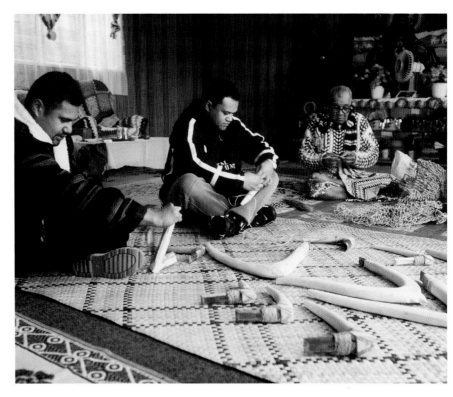

essential in urban environments to keep distinctive cultural practices alive. An example of this process can be seen in the production of artefacts by Tokelauans who have settled in New Zealand and live in circumstances different from those in the atolls of Tokelau. In 1991 a small weaving group called Ko Fatu Paepae o Lower Hutt made a *kie tau* (a type of mat) from pandanus imported from Nukunonu in Tokelau. For the women, weaving together as a group and using the mat in a culturally significant way imbued the *kie tau* with value and aided the continuation of Tokelau cultural practices in an environment far from home. While it took significant effort to get the pandanus to New Zealand, the weavers had to find a viable alternative to replicate a kanava bark-fibre fringe distinctive to the mat. They demonstrated their pragmatism and innovation by using packing-case materials from a car assembly plant.

Similarly, in 1997 two men of Tokelau descent in Wellington made a set of *toki* (hafted adzes) in a process that bridged generational and physical distances between themselves, their grandfather (an expert craftsman named Fuli Fati) and the distant

atolls of Tokelau where they were born. The *toki* were made from locally sourced fallen willow and the steel blades of chisels and wood planes lashed together with coconut-fibre sennit from Tokelau. For the makers, Kupa Kupa and Jack Kirifi, the *toki* were constructed not with the intention of ever actually carving wood, but to mediate a particular kind of relationship between themselves and their grandfather. Making *toki* was a process that facilitated the transfer of knowledge between the expert and themselves as apprentices. In the conversations of the workspace they accessed Tokelau history, values and cultural practice that are usually the preserve of older generations. Although *toki* are primarily a woodworking tool, in this situation they were a medium to negotiate the politics of relationships, knowledge transfer and cultural identity in the diaspora.[22] *Toki*, like other cultural products such as woven mats, dance performances and song, can become devices in 'the mediation of ruptures of time and history – to heal disruptions in cultural knowledge, historical memory, and identity between generations',[23] to bridge distances between islands.

Chamorro Cultural Festival Billboard at Market Creek Plaza, San Diego, 2010.

The diasporic and transnational character of many Pacific Islands societies has seen cultural festivals in urban centres become important events for the expressions of identity, but also for the creation of dance costumes, songs, choreography, language and other art forms that come with performance. Cultural festivals were important events in the postcolonial Pacific for consolidating the idea of the nation. Across the contemporary transnational milieu they maintain a sense of culture and community but allow for new, transnational and localized imaginings of how these concepts can be materialized. Marketed as the largest Pacific dance festival in the world, Polyfest, hosted by Auckland high schools that take turns, is an intense competition between dance groups representing the major Pacific populations in New Zealand. It is an example of the institutionalization of multiculturalism in the education system, in which the strong representation of Samoans, Tongans, Niueans and Cook Islanders sit alongside performances from Fijians, Fiji Indians, Asians and other local ethnic communities that wish to take part. In urban contexts cultural festivals can facilitate the expression of the multicultural nature of a nation, but they also provide valuable opportunities to assert the distinctive cultural identities within it. Ironically, the blurring of boundaries between places and localities somehow makes '*ideas* of culturally and ethnically distinct places become perhaps even more salient'.[24]

Across the diaspora, festivals in urban centres highlight that cultural practices can be created and enacted beyond their point of origin in meaningful ways. Popular ideas of nation are contested and maintained across territorial borders. Urban and transnational sites are not peripheral or marginal sites – they play a critical role in sustaining the cultural life of the nation. The first Chamorro Cultural Festival held in Vallejo, California, in 1989 is an example of how Chamorro people in the United States maintain a connection with their homeland through song, dance, cuisine and other cultural practices. It has been held annually throughout the state, growing in size each year. Vince Diaz argues for the cultural vitality, authenticity and viability of this event, and for understanding Chamorro history and culture as contested sites comprising local spaces within and

far left
Sportsman Sonny Bill Williams, 19 April 2008.

left
'Body Pacifica' poster, 2010.

sometimes outside of Guam. Diaz suggests that often it is the 'Children of far flung Chamorros' who will 'hold the resources for reinvigorating Chamorro culture'.[25]

Indeed, it is among the children of migrants and transnationals that Samoan tattooing has been invigorated and new pan-Polynesian styles have developed in the contemporary Pacific. From the early 1990s through to the twenty-first century, tattooing has become an increasingly conspicuous marker of identities for urban-based Islanders. Tattooing is practised in a variety of forms, reflecting the varying skills of tattooists and the wide range of customers with specific needs and abilities to pay for the work. In Apia's downtown food and produce markets you can be tattooed with a Western tattoo machine, customary Samoan tools or needle points inserted in short sticks of bamboo. In Honolulu, Auckland and Papeʻete people are 'inked' in tattoo shops, prisons and private homes. Polynesian-style tattooing is commissioned and made by people who have no indigenous connection to the Pacific. People can be tattooed by a culturally recognized tattooist, any tattooist who knows how to use a tattooing machine or by a friend with a homemade machine.

In urban centres established indigenous contexts of tattooing persist alongside new ones. People often imagine and construct their own meanings for the tattoos they wear. A tattoo may look Samoan, but the meanings the wearer may associate with the images and the way they use them in their life may have little to do with specific Samoan cultural values or contexts. In Samoan communities tattooing is widely seen as a marker of commitment to culture and is displayed in ceremonial situations and cultural events. It is often linked to specific social roles and status. Outside these situations, tattooing can be a public expression of various values, no longer confined to title bestowals, cultural performances and ʻava (kava) ceremonies, or even to Samoan bodies. When Samoan tattooing is viewed on people (Samoan and non-Samoan) outside Samoan cultural contexts, it can be many things – a marker of ethnic identity, machismo, a fashion accessory, or an indication of the wearers' love of tattooing.[26]

Like sports apparel branding or fashion labels, the motifs of tattooing are crucial for communicating identities. It is on bodies and in media such as books,

television and the internet that cultural forms make their way effectively through space.[27] In the twenty-first century, Samoan, Māori and pan-Polynesian tattooing styles are given visibility in televised professional sporting codes such as rugby union, rugby league and American football. These sports are played by significant numbers of players of Pacific descent, especially in New Zealand, Australia and the USA. The tattooed arms of high-profile players like Māori Benji Marshall and Samoan Sonny Bill Williams can be seen weekly on television in the Pacific and Europe. In the United States, Samoans such as Rey Maualuga who play in the gridiron in the National Football League display Polynesian-style tattooing on their arms and legs. In 2010 the Casula Powerhouse Art Centre in south-west Sydney hosted Body Pacifica, a festival with exhibitions celebrating Island culture. In association with the festival, Sydney-based Samoan photographer Greg Semu produced a calendar of tattooed rugby league stars styled in a pan-Polynesian wardrobe of weapons, adornments and other accessories. In the contemporary Pacific, tattoos socialize the body and allow wearers to participate in various indigenous social contexts, but as the body travels and is seen in new forms of media the tattoo is socialized and made familiar to people of non-indigenous backgrounds. The production and meanings associated with tattooing forms become less fixed and circulate outside their cultures of origin.[28] However, cultural transaction and change occur within the cultures of origin. In Samoa in the 1990s the multinational sports brand Nike was being incorporated into indigenous forms of *tatau* (tattooing) and personal adornments such as combs and earrings. Whereas 'authentic' branded products such as basketball shoes may not have been easily accessible, the brand logo and its associations were replicated by local entrepreneurs and artisans. This incorporation of global sports-apparel branding onto everyday objects perhaps reflects the same longing among Samoans that Western consumers have for these products.

In this way, urban centres produce new circumstances that shape the visual and cultural world, and highlight the circulation of ideas and products between sites that are oceans apart. In Papua New Guinea gangs of criminals known as Raskols are part of the squatter settlements of the capital, Port Moresby.

In 2004 Sydney-based photographer Stephen Dupont created a portfolio of striking portraits of the 'Kips Kaboni' or 'Red Devil' gang members. These photographs offer a glimpse of the Raskols' visual world and personal style, one that is heavily influenced by the West. This is evident in their poses, their choice of clothing, their tattoos and accessories. T-shirts featuring images of Osama Bin Laden, Bob Marley and a tourist shirt from the Fiji Islands bring disparate personalities and images together in an ensemble that is difficult to unravel. There is a familiarity in the manner with which they brandish their weapons and wear their garments and accessories. It is clear that there has been a transmission of style and imagery from film representations of gang subcultures in the United States, but it is difficult to ascertain the authenticity of the performance. These are trappings that highlight contemporary patterns of interaction and the types of cultural transactions taking place in the Pacific. They offer insight into a type of 'street fashion' but also the circumstances of life in a sprawling and challenging urban environment. While the gangs in larger cities of New Zealand and other places are arguably the product of disaffected and economically marginalized Pacific Island youth, Michael Goddard argues that the Raskol lifestyle in Papua New Guinea draws men in from a wide range of socio-economic backgrounds; these men are engaged in an economy and social relations that are 'stubbornly rooted' in very local kin-ordered modes of production, despite the superficial Hollywood-inspired trappings.[29]

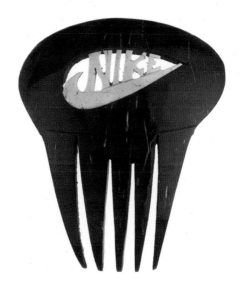

Selu (comb) with Nike™ logo; maker unknown, Samoa 1999.

Coconut shell. Length 9.7 cm (3¾ in.). Museum of New Zealand Te Papa Tongarewa.

The Nike logo is just one of many global corporate symbols that artists and cultural producers in the Pacific appropriate, critique and celebrate.

overleaf
Stephen Dupont, *Raskol Series #20* and *#28, c.* 2005.

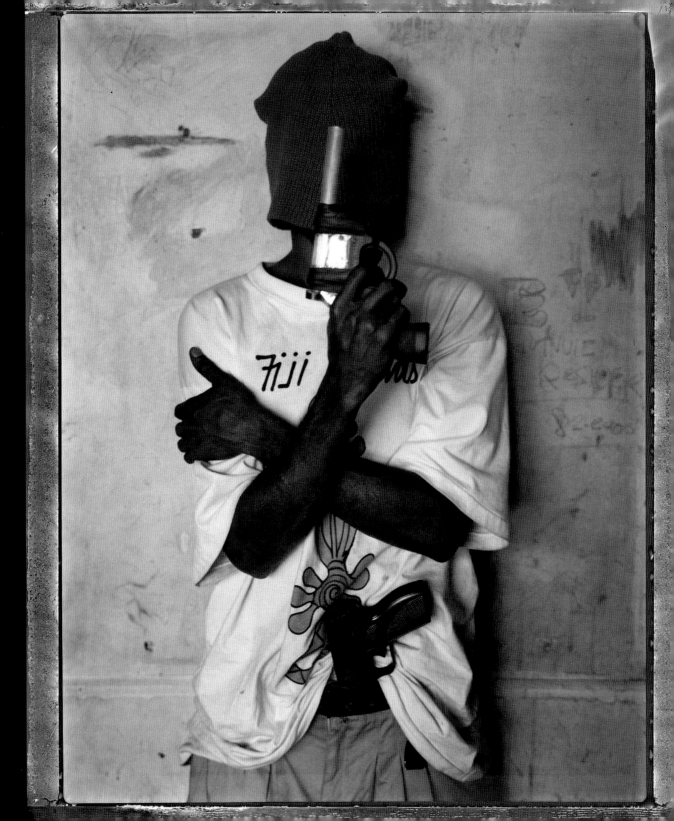

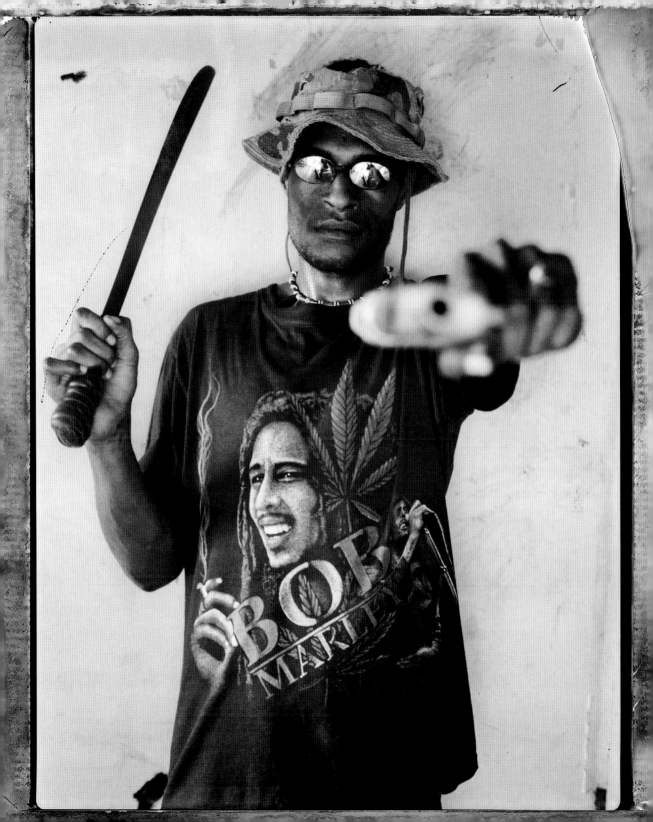

T-shirts as Wearable Art

T HE URBAN BODY IN THE PACIFIC is covered in
T-shirts – an inexpensive and mass-produced form of clothing
that is a canvas for artists to promote their causes, ideas and
identities. T-shirts are ordinary everyday garments, seemingly
insignificant in the region's material culture. However, T-shirts
and the images that appear on them lay claim to culture, imagination,
history and space in the urban landscape.

Marjorie Kelly has documented the significance of T-shirt images
in Hawai'i, where they serve 'as badges of social identity, expressions of
political allegiance, and symbols of communal values'.[i] Locals will wear
T-shirts that reference themes such as Hawai'i's plantation heritage, its
island food and Hawaiian pidgin. Images will be cartoon-like or nostalgic
in nature and often use a local sense of humour that has limited appeal
to outsiders.

In New Zealand, T-shirts created within and for Pacific communities
also use humour, language and culturally specific 'in jokes' to convey
messages. Long-established racist terms for Pacific Islanders such
as 'bunga' and 'coconut' are represented as positive and political
statements of ethnic solidarity. Siliga David Setoga produces a T-shirt
that simply says '*palagi*', which is a Samoan term for 'European'. He also
reworks brands ranging from fast food to medicine and laundry products
to convey humorous re-readings of negative stereotypes. One example
is the transformation of a well-known laundry detergent advertisement
'*Cold Power: Outstanding in cold water wash…*' to '*FOB Power:
outstanding on the football field, the factory floor, and the footpath
brawl*' (FOB referring to new Pacific Islander immigrants who are
'fresh off the boat').

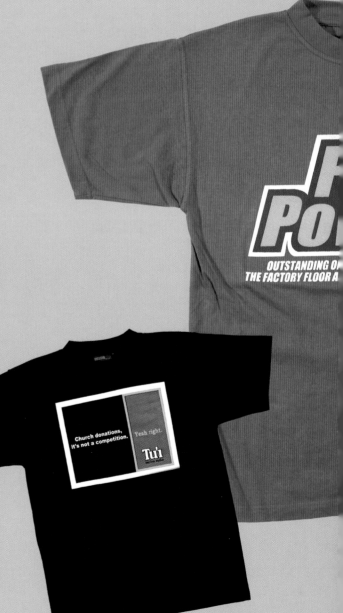

For Native Hawaiians T-shirts can express political and cultural messages, or highlight historical or upcoming cultural events. Kelly notes that designs are often developed in collaboration with commissioning groups or organizations; designers will consult the community on the accuracy of images and language. Craig Neff, a prominent member of the Hawaiian sovereignty movement, created a T-shirt reading *'Radical Hawaiian Taroist: Without One's Roots, One Becomes Ruthless!'*, but he also designs T-shirts relating to indigenous knowledge of fishing and phases of the moon. Kelly concludes that making T-shirts can be a consultative process that ultimately represents a collective vision of culture, history or politics. T-shirts can have a spiritual significance for Native Hawaiians, as the very public statements they make can carry *mana*. As she puts it:

> The feather capes of traditional Hawaiian nobility contained *mana* and so do today's T-shirts, odd as that may seem to non-islanders. In a culture where intent counts for a lot and verbalized blessings and curses still carry weight, the public statements T-shirts make can have a spiritual significance for Hawaiians that may well be lost on others.[ii]

T-shirts can assert claims to distinct spaces in the urban milieu and give material form to identities that people connect to 'specific neighbourhood and even street locations'.[iii] For example, the numbers in the slogan '*274 Otara fo' life*' refer to the first three telephone-number digits of the Otara area, a suburb in Auckland, which has a high population of Māori and Pacific Islanders.

T-shirts can also provide social commentary on the communities within them. For example, Setoga uses the graphic design of the nationally popular sardonic Tui beer advertisements to draw attention to contentious issues such as church donations and the pressure some families feel to make contributions they cannot afford.

The images that decorate T-shirts in Auckland are different aesthetically but just as significant as those on more precious textiles such as *tapa* (barkcloth) or *tivaevae* (Cook Island quilts) produced in the same neighbourhoods. SM

T-shirts. Designs by Siliga David Setoga, Dawn Raid Entertainment, and Craig Neff, *c.* 2003–4.
Museum of New Zealand Te Papa Tongarewa, Wellington.

461

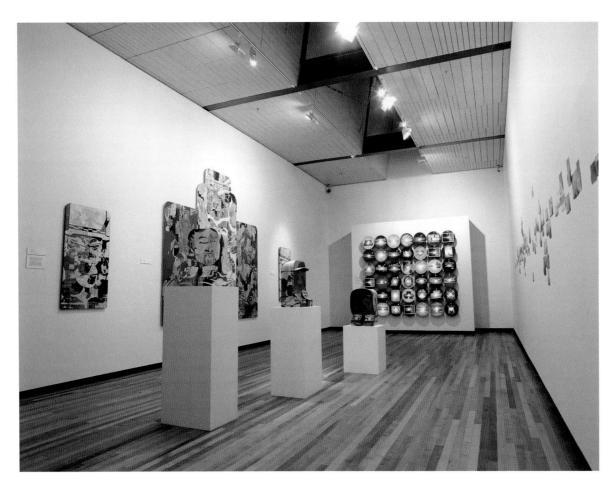

Pacific Art, Transnational Communities, Urban Contexts

There have been several exhibitions of art by urban-based artists for art gallery audiences. Artists from the Oceania Centre in Fiji have exhibited locally and internationally; artists and curators from Papua New Guinea, Vanuatu, Australia and New Zealand have played a significant role in taking contemporary art from the Pacific to new markets overseas. Many of these artists have formal training in art schools or have attracted the interest of dealers or public art galleries. New Zealand-based curator Giles Peterson has successfully used the term 'urban' to market group shows including 'Urban Pasifika' (2007) and 'Samoan Art:Urban' (2010). Urban art in exhibition spaces has also been presented to New Zealand audiences, with The New Dowse Gallery in Lower Hutt, Wellington, developing the groundbreaking 'Respect – Hip Hop Aotearoa' (2003).

Another exhibition at City Gallery, Wellington, is a recent example of the presentation of 'urban art' for art gallery audiences. Titled 'Urban Kāinga' (2009), it was developed by curator and artist of Māori heritage, Reuben Friend. 'Urban Kāinga' featured an all-male group of artists – Reweti Arapere, Siliga David Setoga, Terry Koloamatangi Klavenes and Nick McFarlane. They are of Māori, Samoan, Tongan/Norwegian and Pākehā descent respectively. The choice of the term *kāinga* is significant. For Māori *kāinga* means dwelling or village. In Tongan *kāinga* relates to extended family, and in Samoan, where the term is *'aiga*, it refers to the land or residence where one lives and, as Friend points out, a much broader network of family ties and obligations. The art in the exhibition reflected on experiences of 'transplanted cultures, and the process of identity construction under the pressures of urban life'.[30] Significantly, the exhibition included a Pākehā artist, a reminder that urban spaces are multicultural spaces and

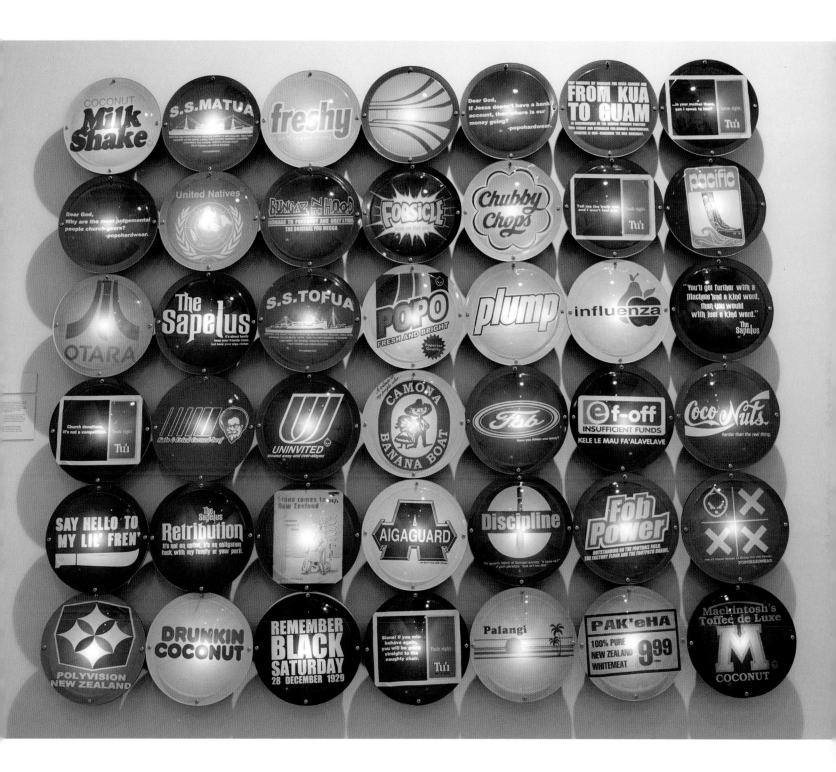

It Is Itself, **Siliga David Setoga, 2009.**

Digital prints, acrylic lightboxes. City Gallery, Wellington.

The relationship between high art and the common culture is given
a fresh workout in this installation of T-shirt designs by Setoga for
a contemporary art exhibition. Brand recognition is overtaken by another
kind of recognition, based on the experiences of urban Pacific Islanders.

that visual culture in the Pacific is produced by the people who live there, regardless of ethnic background. The exhibition space within the City Gallery for 'Urban Kāinga' was the Deane Gallery, which is dedicated to Māori and Pacific artists. Its ethnic focus in the context of a major gallery in New Zealand's capital city supposedly creates an entry point for Māori and Pacific artists into larger art conversations. In this regard it is useful to note Setoga's career evolution from market vendor of T-shirts to a significant art-gallery exhibitor. However, the need for a gallery with an ethnic focus might also signal that art by *some* Māori and Pacific artists is still somehow marginal. As much as the art in 'Urban Kāinga' seeks to give the urban demographic and visual culture visibility in the cultural mainstream, it is still 'outsider' in some way. Accomplished artists (such as Setoga) who already have street-cred in their own right are nonetheless regarded by the mainstream art industry as only 'emerging'. There is a politics of inclusion and exclusion at play.

A significant precedent to the Deane Gallery and the 'Urban Kāinga' exhibition is a small but prolific art-gallery project in South Auckland. Since 2006, Fresh Gallery Otara has fixed upon the fresh, contemporary work of young artists in the context of their urban location and community. This humble venue, originally a small retail store, is located in the heart of an open-air shopping mall in Otara, where New Zealand's largest concentration of Pacific Island peoples are settled. The curatorial vision for the space is driven by Fijian Ema Tavola, who has worked with artists exploring themes such as identity, the impacts of colonialism, cultural change, youth culture, history and migration. These issues are relevant but not exclusive to South Auckland as they reflect the diversity of New Zealand's growing multicultural population. Fresh Gallery Otara has maintained a high-volume programme of exhibitions that have been as eclectic and culturally diverse as their host community. In 2009 exhibitions included 'Koloa et al: your art is my treasure', featuring the weaving and barkcloth work of Tongan women; and 'MyFace', a provocative exploration by artist Janet Lilo of photography from social-networking platforms. However, as we have seen throughout this chapter and as Tavola has written, 'the gallery does not confine or define contemporary Pacific art. It is found in many places, made and defined by Pacific people and Pacific realities.'[31]

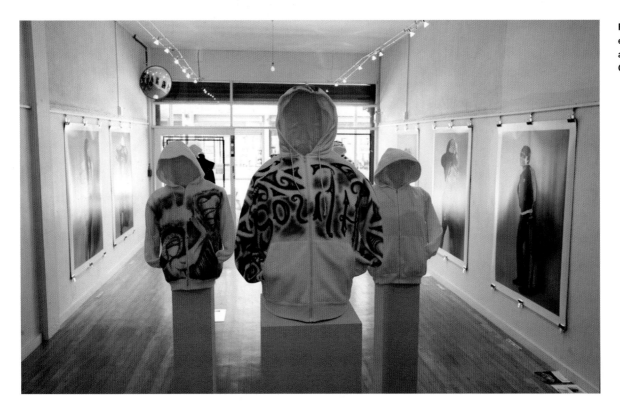

Fresh Gallery Otara, exhibition 'South Style', artworks by Vinesh Kumaran, Ofa Mafi, Allen Vili, 2009.

Visual culture is clearly the most visible evidence of interactions between people within the Pacific and people elsewhere. Part of the significance of the art-making processes outlined in this chapter is that they highlight how the struggles around ethnic, class, national and other identities exist beyond the very public and celebrated expressions of art, literature and performance. They are found in forms, objects and creative processes that, ironically, are all around us, but not so prominent in the public and mainstream art world's gaze. Visual culture across the transnational and urban diaspora can be understood as both cultural product and a social process through which people produce aesthetic values, ideological perspectives and identities.[32]

The twenty-first century offers increasingly mobile, urbanized and technologically interconnected lives for Pacific peoples. As the Pacific has become increasingly global in its interconnections, it is more difficult to demarcate, separate and contain cultures. With the flow of people to urban centres, cultural attributes once considered specific to certain islands, villages, districts and other localities are also on the move. The visual cultures of urban environments are diverse in practice and eclectic in their inspiration – they are activated by new locations and the circumstances specific to them. If urban spaces are important locations for contemporary transnational communities, how do we describe Tongan visual culture, or Chamorro visual culture, if these 'however persistent they may be, cease to be plausibly identifiable as spots on the map'?[33] – or if they are produced in non-indigenous materials and media, or created and circulated in cyberspace? As Vince Diaz argues for contemporary, urban and transnational Chamorro people, claims on Chamorro culture will often 'work through the materiality of things and ideas that are non Chamorro in origin'.[34] In rethinking indigenous art in urban, transnational and multicultural spaces, we have to reconsider the whole spectrum of visual culture in terms of its aesthetics, its materiality and locality – how it is connected to, yet disconnected from, the homeland. Will there ever be another book on Tongan art, if Tonga exists in cities such as Auckland, Los Angeles and Sydney?

Richard Gilson described nineteenth-century Samoa as a multicultural community. If contemporary urban spaces in the Pacific are multicultural spaces, can we ignore non-indigenous producers who play active roles in the production and development of hip hop, tattooing, graffiti, music and other fine arts? They are part of these genres, but more importantly they are also *in* the Pacific. How do we describe these contributions, and the cultural politics of who owns what, who creates, who is included and not included? Who can police the porous borders of these contemporary transaction zones? These interconnections mean that it is perhaps more useful to concentrate less on where cultural boundaries are and more on the cultural flows that cut across them. Rather than a global mosaic we should conceive the world, as Ulf Hannerz argues, as more of a global ecumene, 'an area of persistent interaction and cultural flow'.[35] People in urban centres create new islands and beaches that must be crossed to enter or leave them. People are more adept at doing this now, and like their cosmopolitan ancestors have continued to travel physically (and now virtually) across the world. Internet and telecommunications allow for a type of situated cosmopolitanism, where people can be staunchly rooted in one place while actively engaging with and cross-cutting the borders and islands of others.

In addition to his islands and beaches metaphor, Greg Dening made some remarks about history writing in the Pacific that are relevant to how we think about art in urban contexts *in* the Pacific. In a short article published in 1989, he asks historians to be 'much more tolerant of all the varieties of history there are'. Art produced in urban contexts in the Pacific forces us to do the same. As Dening puts it, '[h]istory surely is our expression of our understanding of some part of the past in whatever way it is pertinent to our present. History surely is the narration of our lives in its roles, in its structures, in its symbolic environments.' To contemplate urban art *in* the Pacific is to look beyond the essentialist, the bordered, the ahistorical representations of our arts: 'it needs to be vernacular and vernacularly tolerant of great variety'.[36] For artists in the Pacific and particularly those in urban environments, islands and beaches are everywhere and they are constantly being crossed as we enter and leave them, as we remake them and change them, as they challenge the way we create, think and write about ourselves.

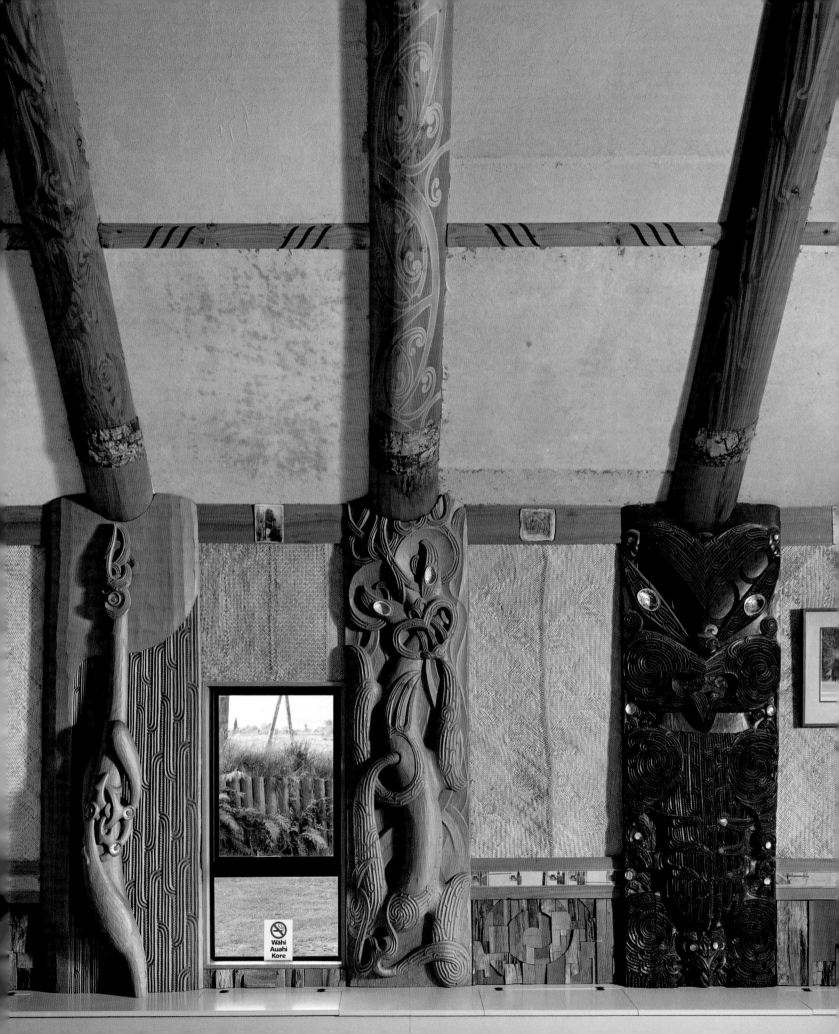

Wahi
Auahi
Kore

Damian Skinner and Lissant Bolton

CONTINUITY AND CHANGE
IN CUSTOMARY ARTS

Customary art is thriving in the contemporary Pacific. Made by a wide variety of producers, customary art represents the ongoing relevance of the past in the present, and the continuation of older art forms within contemporary social contexts. We use the word 'customary' rather than 'traditional' precisely because these practices are not static but represent processes of adaptation and change. The past does not appear in the present in an unchanged state, but is reinterpreted according to the needs of contemporary makers and the various audiences for whom they produce art.

It is difficult to generalize about customary art in the Pacific because of significant differences between the western and eastern Pacific, for example, or between independent nations and settler societies. Customary art is intimately tied to political processes such as decolonization, since it is a visible and powerful sign of ethnic identity and cultural resistance, and it is affected by global forces such as tourism, and the various art worlds that have an investment in indigenous art. And, because it depends upon a relationship to the past, to knowledge transmitted across generations, customary art is particularly sensitive to ruptures in social and cultural structures, to the effects of modernity. Because these processes have not unfolded in a homogeneous way across the Pacific, the forms that customary art takes, and its various meanings, are diverse.

The term 'art' can imply certain things that prove tricky when it comes to objects and practices that activate the relationship to the past. Does the value and identity of customary art reside in how it is made, and what it is made of, or does it reside in its function, the way it is used and understood? Michael O'Hanlon talks about the way in which plaited leg bands previously made by women in the New Guinea Highlands as gifts

for men are being replaced by ribbing cut from the tops of socks and worn in exactly the same way as the older form of material culture.[1] Can a readymade of this sort be considered customary art, or must the object in question exhibit certain skills or processes of making, certain aesthetic traits, which anchor material innovations? Customary art – despite a sometimes direct appeal to continuity in a conceptual or visual sense – is a dynamic process.

Motivations for Change in Customary Art

There are many reasons why customary art forms undergo change, and parallel processes of innovative shifts in material culture with strong links to the past can emerge from radically different circumstances. This point can be demonstrated by looking at two kinds of objects that belong to the term 'customary art' as we are using it here: a *kumptapi* (shield) created by the Wahgi of the New Guinea Highlands in the 1980s for use in warfare; and a *whare whakairo* (decorated meeting house) created by Māori carver Lyonel Grant in Aotearoa New Zealand in the 1990s as an expression of group identity.

The shield, now in the collection of the Pitt Rivers Museum in Oxford, is made

of wood, and its surface is decorated with a painted illustration of The Phantom, an American comic-book character created by Lee Falk in the 1930s. The Wahgi of the New Guinea Highlands stopped making shields like this after pacification, which began in the 1930s and gathered pace with growing European settlement and the influence of Christian missionaries. Warfare emerged again in the 1970s, and by the 1980s shields were again being produced in large numbers, as an outcome of social change. The new shields featured technical innovations such as the use of metal rather than wood, and acrylic paints rather than ochre.

Shields of this type were not so much a product of artistic innovation as they were responses to changes in the form of warfare, and the introduction of guns and bullets, which rendered wooden shields ineffective. As The Phantom clearly shows, there was also a significant change in the sort of decorative elements applied to the shields. The older, apparently abstract, patterns gave way to explicitly figurative motifs, and the use of words and numbers. According to Michael O'Hanlon, the new type of shields represents the Wahgi encounter with modernity – with literacy, advertising and product images (the source of the new motifs),

Ihenga, *whare whakairo* (decorated meeting house), Waiariki Institute of Technology, Rotorua, New Zealand. Carved by Lyonel Grant in 1996. Photograph Studio La Gonda, *c.* 2007.

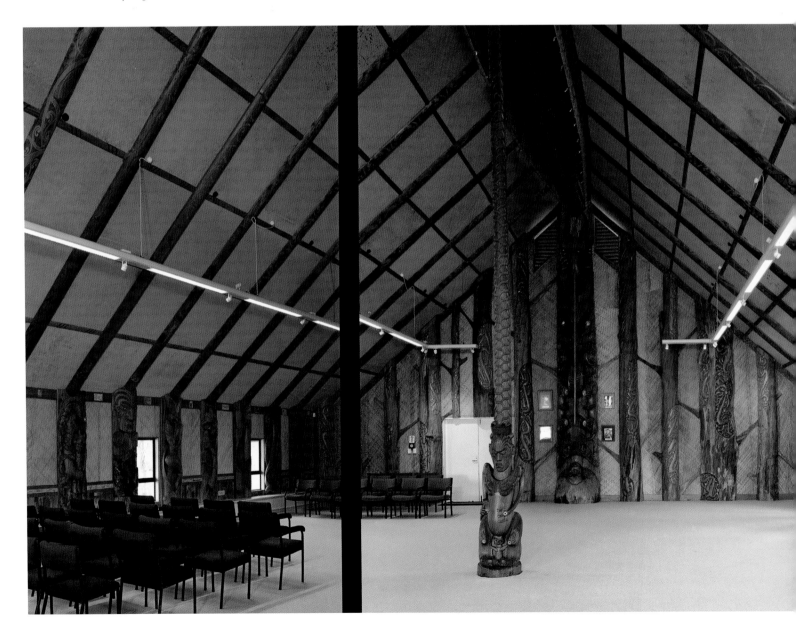

and also with the processes of symbolism involved in reading and interpreting graphic images.[2] This marks a shift in the way shield designs were interpreted; before pacification, shield decoration was meaningful, but not in terms of its graphic character.

The shield does depart radically from the objects made for the same purpose before pacification, in both materials and decoration, but as O'Hanlon makes clear, these differences obscure the ways in which this shield bears significant continuity with its prototypes from the early twentieth century. As he writes, 'moral virtue can now also be registered through incorporating

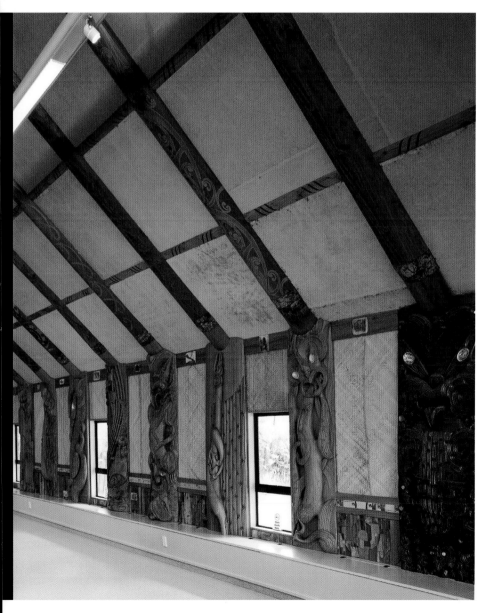

images of "good guys" like Superman or Phantom; ancestral support can be alluded to through written inscriptions; the ideal of clan unity, previously marked through common charcoal body covering, can now also be expressed through the adoption of a common shield design, on the analogy of a team or squad.'[3] Importantly, the novel graphic means and new materials used in this shield do not mark a rejection of or break with customary themes and functions. The shields made in the 1980s by Wahgi warriors may look very different but in fact they operate in substantially the same manner as earlier examples. In some ways, this process would be best described as one of cultural continuity, or the ongoing assertion of cultural practice, rather than cultural revival, since the primary motivation here is not a self-conscious restoration of practices used to anchor cultural identity. Warfare begins again, and so the Wahgi begin making shields, adapting customary forms to most appropriately fit the circumstances of the new warfare.

Lyonel Grant's *whare whakairo* stands on the grounds of the Waiariki Institute of Technology, a tertiary training institution in Rotorua. Called Ihenga after one of the ancestors of the local Te Arawa people, the building is elaborately decorated with *whakairo* (carving), *raranga* (weaving) and *kōwhaiwhai* (painted patterns). Although Ihenga incorporates 'new' materials such as steel, corrugated iron and glass, the structure and the arrangement of art forms inside and out is customary. Created in the 1990s, Ihenga incorporates a *poupou* (ancestor carving) that was created in the 1870s, and Grant has organized Ihenga in such a way that all the new art forms refer back to the old carving. Now called Ngatoroirangi (*page 466*) after another important Te Arawa ancestor, this *poupou* guarantees the customary credentials of Grant's work by providing a 'classic' model of Māori art to which the rest of Ihenga is held accountable.[4]

In some ways the proximity between the nineteenth-century *poupou* and Grant's new carvings obscures the self-consciousness with which he engages with the artistic past. The requirement that Grant actively interpret the carving motifs and compositional devices of the old *poupou* is a sign of the distance between him and the artists who produced this carving. This distance is a product of the impact of modernity on Māori art and includes the effects of

John Hovell and the Art of *Kōwhaiwhai*

MĀORI ARTIST JOHN HOVELL recalled in 2006: 'For several years [in the 1970s] I had been making a detailed study of the relationship between natural forms and *kōwhaiwhai* and had been building up a lexicon of semi-abstract forms related to all the environmental niches of Tai Rawhiti [the East Coast]; and then finding the relationship between the shape and *te reo* [Māori language], the natural experience and the codification of experience in the proverbs of Tai Rawhiti.'[i]

Hovell's unique contribution to *kōwhaiwhai*, a form of painted pattern applied to the rafters of *whare whakairo* (decorated meeting houses), is based around his use of semi-abstract or schematic silhouettes of flora and fauna to create elaborate designs on the ceilings of meeting houses and dining halls. His ceiling mural in the dining hall of Te Aute College, a Māori boarding school in Hawke's Bay, demonstrates the potential of Hovell's novel approach to a notable form of Māori art.

Each panel is inscribed with a *whakataukī* (saying), demonstrating the relationship between food sources and cultural knowledge that Hovell was exploring at the time. Sometimes these sayings are also directly related to the flora and fauna painted above them. For example, *kōura* (crayfish) and *pāpaka* (crabs) are painted above the *whakataukī*, 'He manaku te koura i kore ai', which Hovell translates as '"Do not overly set your heart on things." The crayfish have ears, and can hear the boastful diver.'

Including a panel that was painted by a teacher and students from Rarotonga, in recognition of the important role that students from Pacific societies have played in the history of Te Aute College, the mural is about hospitality. As Hovell puts it: 'These ideas of foods, food-gathering, feasting and feast-preparation, ceremony and hospitality and the idea shared by both host and visitor that these things are not easily done; there has been care, there has been selection, gratitude and respect for nature, and these are Pacific-wide thoughts and feelings.'[ii]

Although this mural relates quite strongly to *kōwhaiwhai*, it is applied to flat panels of rectangular or triangular shape rather than the elongated bands of the *heke* (rafters) commonly found in the *whare whakairo*. This allows Hovell a great deal of flexibility in design, and it gives the mural in the Te Aute College dining hall a visual impact that more customary forms of *kōwhaiwhai* would struggle to match. Yet Hovell is careful to engage with *kōwhaiwhai* motifs explicitly. The success of this mural turns on how skilfully he constructs visual associations between *kōwhaiwhai* and the food resources that ebb and flow over the ceiling, and many of his junctions are surprising and delightful. Hovell's primary point of reference is the *kape rua*, a crescent motif found in *kōwhaiwhai* from the East Coast of the North Island, and in this mural he demonstrates its adaptability and versatility, as fecund nature moves between figurative and abstract states.

Hovell's explorations of *kōwhaiwhai* renew the artistry and vibrancy of a visual art form that has been stereotyped by art history and anthropology, and sometimes overlooked within the meeting house in comparison with the more spectacular arts of carving and weaving. While departing from the customary appearance of *kōwhaiwhai*, Hovell remains committed to the spirit of the practice, revealing that it is about process, a shorthand summary of the passage of life, and a space within the *whare whakairo* for the Māori artist to express his wry and droll view of the world.[iii] DS

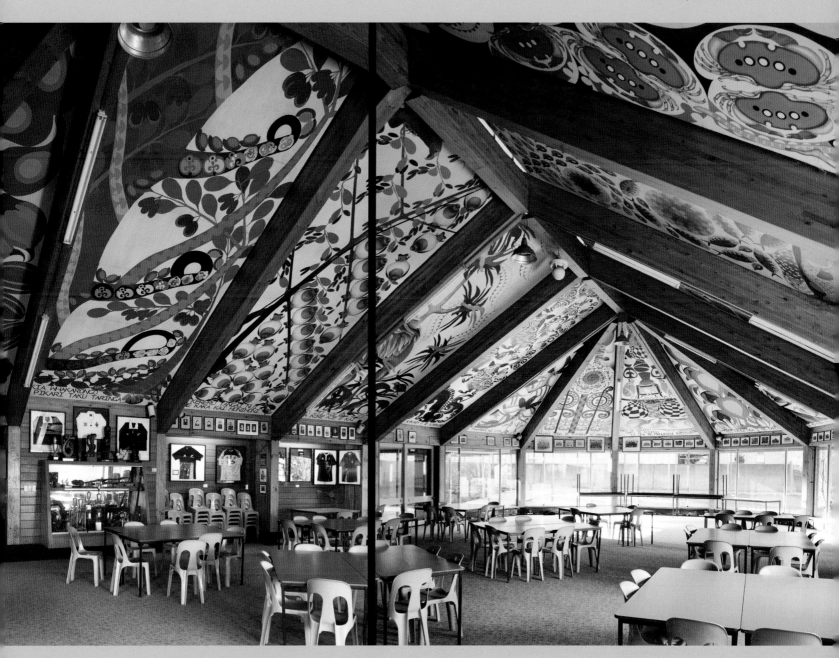

John Hovell, Te Aute College dining hall mural, 1983–84. Acrylic on board. Te Aute College, Hawke's Bay, New Zealand. Photograph Studio La Gonda, 2010.

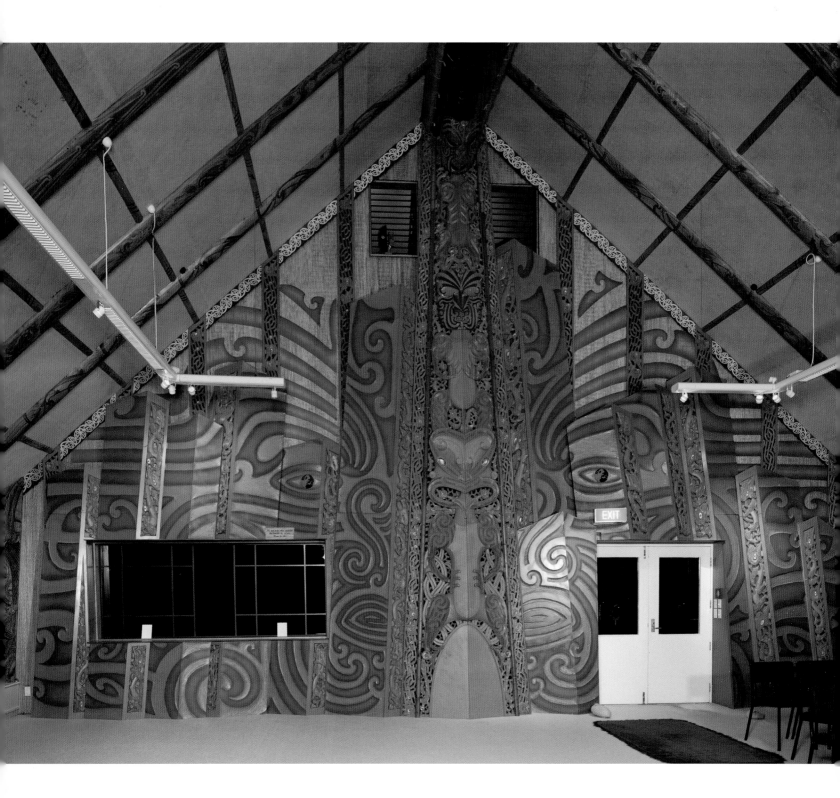

Te Ao Hurihuri,
front inside wall, Ihenga.
Carvings by Lyonel Grant in
1996. Photograph Studio
La Gonda, 2007.

Chamorro dance troupe Kutturan Chamoru Foundation, performing at the Pacific Island Festival in San Diego, 2010.

Western perspective systems that forced Māori artists to become aware of their particular representational framework (based on frontal, aspective representation), and consciously to suppress any evidence of alternative systems such as perspective, thus fixing Māori art into a static form. In the early twentieth century, in a time of rapid and dramatic social and cultural turmoil, the unchanging appeal of customary art to the past provided an anchor and sense of security for Māori audiences, and performed an important cultural and political function in asserting Māori identity. Ihenga is, in fact, Grant's attempt to escape this legacy, to reconnect customary Māori art with the time and place in which it is made. One of the ways he achieves this is through a consciousness of Māori art made outside the *whare whakairo*, namely, the modern art movements discussed in the chapter 'Decolonization, Independence and Cultural Revival'.

Grant is concerned with *whakapapa* (genealogy), the connections between the different ancestors represented in Ihenga, which is what makes this *whare whakairo* customary; but he is also concerned with artistic *whakapapa*, a lineage of ideas about art making that have shaped Māori art in the twentieth century. Despite the visual similarities to *whare whakairo* of the past, Ihenga is a product of a series of ruptures or discontinuities, shaped by a self-consciousness that is more characteristic of revival than an example of cultural practice surviving unchanged into the present.

A Culture of Revival

In 1993 Philip Dark wrote that, 'If the image of the new and the old can be linked with what has passed, then it is possible to revive an art form, albeit one which is different from its forerunner…. Direct connections of the present with the past may not be there, but the new connections made, within the limits of observable relations between present and past style, give a revived art form its validity.'[5] Revival is an important concept within customary art production in the Pacific. It is stimulated by various factors, including local desires for continuity, tourism, anthropological intervention, demand in the art world and political considerations. Customary art has great power as a symbol of ethnic distinctiveness, hence its importance to both tourism and government policy, and within decolonization movements customary arts become statements of

cultural survival and persistence. Although some cultural practices manage to adapt to the conditions of modernity without significant disruption, others are put under great stress, to the point where notions of continuity do not apply. In these cases, revival is a tool to link contemporary art production with ideas of the past, and to reclaim the value of old art in the present.

Judy Flores, for example, has written about the revival of Chamorro dance in the Mariana Islands. Revival in this case means the creation of new dances that are 'based on perceptions of an ancient past that has been lost'.[6] Dance masters such as Frank Rabon, who worked as a professional dancer in Guam and Hawai'i, have recreated Chamorro dance by setting movements borrowed from other customary practices such as *hula* (Hawai'i) to local music and chants. A set of symbols shared by all Chamorro dance troupes has developed, and these symbols are important in constructing links to the past. These include skulls (ancestors), staffs (warriors, clans and status) and canoes (ancient culture).

Since Chamorro dance disappeared in the late 1600s, following the Chamorro-Spanish wars, genocide and Catholic missionary activity, the new forms of Chamorro customary dance draw on historical accounts written by Europeans. They also rely on elements such as Māori singing styles and Hawaiian instruments, dance costumes and movement. Close contact between Chamorro dance leaders and other Pacific groups encourage such borrowings, which are also fostered through the Festival of Pacific Arts, held

Robert Brown's
contemporary Cook Islands
tatau, combining motifs from
Mangaia and Atiua,
his parents' home islands.

discontinuities such as Hawaiian instruments or clothing do not affect the power of these reconstructed dances as a form of customary art.

As Dark suggests, the validity of customary art depends on convincing links between past and present practice. This requires sufficient knowledge of the past, often recorded in ethnographic accounts, and the ability to generate sufficient knowledge about the practice in the present. The revival of Cook Islands *tatau* in the 1990s is a good example of this process in action. It is a political gesture, 'a symbol of nationalism and identity for those countries which remain under an umbrella of de facto, if not actual, colonial rule', as Jean Mason puts it.[9] And, as with Chamorro dance in the Mariana Islands, the practice is embedded in a wider context of Pacific relationships. According to Mason, 'This rebirth of the art in the Cook Islands was stimulated and legitimized by the presence of tattooists from other Pacific nations exhibiting their techniques and designs at the 1992 South Pacific Festival of the Arts held on Rarotonga.'[10] It is difficult to talk about Cook Islands *tatau* without acknowledging other revivals of tattooing throughout Polynesia, which in some cases has resulted in a pan-Pacific style, a fusion of different *tatau* traditions arising from the way in which tattoo revivals have unfolded across the Pacific.

Yet Cook Islands *tatau* exists as a distinctive customary practice apart from Polynesian *tatau*, because there are sufficient designs with specific Cook Islands cultural and historical points of reference to sustain it. Mason, for example, is able to name many different patterns and provide interpretations that work on multiple levels to construct and maintain Cook Islands identity. Not all of these appeal to the ancient past. The *maurua*, a star tattooed on the wrist or thumb of the Mangaian men who dug phosphate in the 1940s and 1950s on Makatea, an island in French Polynesia, is not clearly or obviously an old design and yet is welcomed into the repertoire of customary *tatau*.[11] The contemporary form of Cook Islands *tatau* is not exactly the same as the old, but enough points of connection to the past – whether conceptual, aesthetic, technical or material – exist to justify its status as a customary practice.

Revivals require an audience, which is often not the same group that was responsible for the development of the art form in the first place.

every four years. Indeed, festivals have been a critical element in stimulating the revival of Chamorro dance, as Chamorro seek a way to demonstrate their political and cultural rejection of Guam's colonial relationship with the United States. 'While dances from the colonial heritage are still performed to point out a distinctly different Chamorro historical background, an "ancient" indigenous Chamorro heritage has been *foregrounded* in an effort to project a Pacific image in keeping with other Pacific Island presentations.'[7] Chamorro dancers are actively adopting elements from other Pacific cultures, trialling and then discarding those that are not appropriate signifiers of identity in a process of selection 'based on contemporary perceptions of desirable ethnic associations (or actual contemporary associations that were not encountered historically)'.[8] Because Chamorro dance is a process of decolonization, a self-conscious assertion of culture that is about constructing an identity quite different to that established by colonization, obvious

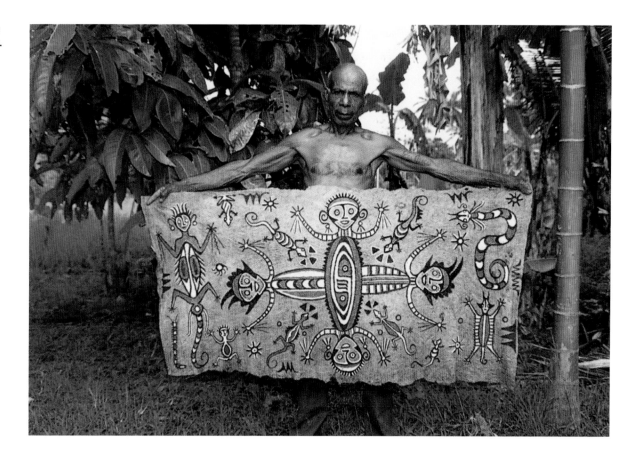

The practice of *maro* painting (painting barkcloth)
in the Lake Sentani region of West Papua almost
disappeared during and after the Second World War,
and few painters were to be found in subsequent
decades. Since the early 1990s *maro* painting has
undergone a renaissance, a process that demonstrates
the importance of outlets outside the community for
the promotion of art production. The revival has
resulted from a number of influences, such as the
state-sponsored arts and crafts festivals, the growth of
the tourist industry and specifically from the staff of
the anthropology museum at West Papua's Universitas
Cenerawasih, located near Sentani. In 1992 the museum
held an exhibition of *maro* paintings, mostly by Seru
Ongge. A second exhibition was held in Jakarta the
following year, including work by Seru Ongge's son,
Agus Ongge, who by the late 1990s had become the
leading *maro* painter. The museum staff continued to
promote the production of barkcloth paintings through
the museum shop and another retail outlet owned by a
museum staff member, both of which facilitated the

sale of paintings to tourists. In addition to hand-
painted works, stencilled *maro* paintings have been
produced since the late 1980s, almost exclusively for the
tourist market. In this climate, *maro* paintings became
a way to earn cash, and were not produced for local use.
The production of customary art for a new audience
outside the context in which the art form developed
inevitably changes it.

Material Matters

One of the notable dimensions of customary art is
the way in which new materials are incorporated into
old practices. This happens for many different reasons,
and it is explained or justified in a variety of ways.
For example, *ngatu* (Tongan barkcloth) is a customary
art produced in both Tonga and New Zealand, where
a substantial number of Tongan people have settled
as a result of political links between the two countries.
The migration of Tongan women to New Zealand has
changed *ngatu*, as with the production of *ngatu pepa*,
made partly or entirely from Reemay or Vilene,

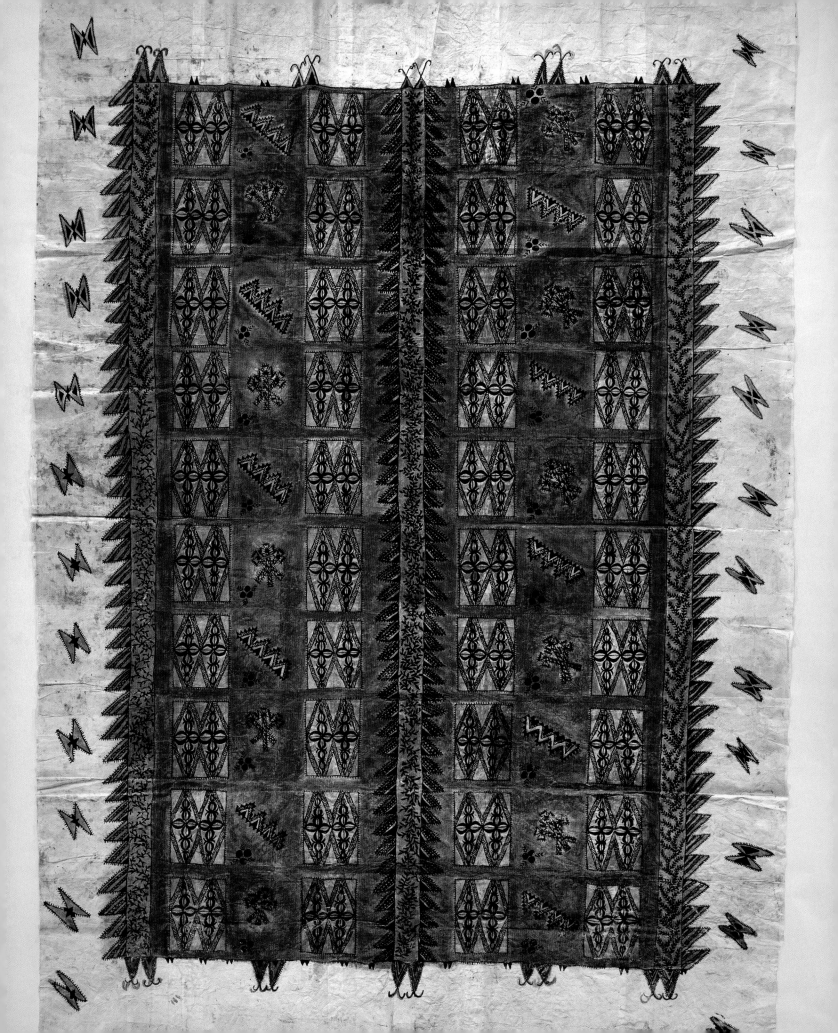

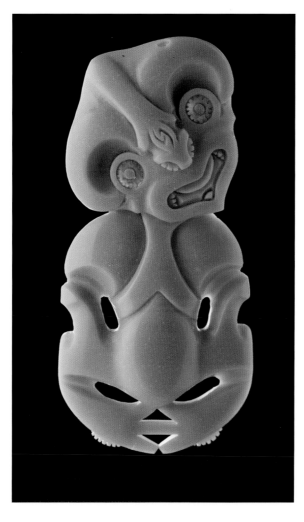

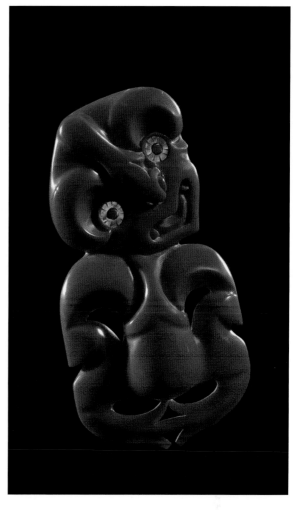

polyester fabrics that are easier to source in New
Zealand, as well as being cheaper and easier to prepare
than *feta'aki*, the felted sheets of paper mulberry bark.
Tongan women in Auckland and Porirua were the first
to make *ngatu pepa* in the mid-1990s, an outcome of
their experiments with new materials such as Reemay,
calico and paper. These new materials are used
according to customary techniques. Hot water and
flour bond the layers together, replacing half-cooked
arrowroot tuber or tapioca, and the designs are
produced with *kupesi* (design templates) and then
over-painted with dark brown or black dyes that have
a very similar appearance to the dark brown or black
dye made from a mixture of koka, candlenut and
mangrove bark. *Ngatu pepa* are even left out in the sun
just like *ngatu* made entirely with *feta'aki*. Yet despite
the adherence to customary processes and aesthetics,
ngatu pepa is still subject to an ambivalent and

conditional acceptance. As Maile Drake suggests,
ngatu pepa is used in most contexts in New Zealand
as part of exchange in formal Tongan events, and while
this material development is welcomed by Tongans
themselves and museums, the *ngatu* made from *feta'aki*
remains more valuable to cultural organizations and
art galleries.[12] A hybrid *tapa* (barkcloth) made of an
upper layer of *feta'aki* and a lower layer of Reemay has
been widely accepted in Tonga and Fiji as well as New
Zealand, unlike *ngatu pepa* made entirely of Reemay,
which is accepted as a lesser alternative in New Zealand
but not elsewhere.[13]

A number of Māori artists have embraced new
materials in their work. Rangi Kipa has successfully
introduced Corian, a composite material commonly
used for counter tops, as a carving material. His *hei
tiki* hand-carved from Corian are *hei tiki* (a stylized
figure worn around the neck) in every way.

Their form and function conform directly to the model of *hei tiki* as it developed within Māori culture (*page 477*). Yet the material declares itself through colour and surface as quite different from the more usual *pounamu* (New Zealand jade) or bone. This contradictory appeal to continuity of process and material change is critical to the meaning of Kipa's work. Supported by a context of cultural expertise evident in the customary carving skills and correct shape and surface pattern, the use of a non-customary material enables Kipa to engage with other issues, such as Māori art's innovative adoption of technologies and materials (steel chisels, manufactured paints, wool and artificial fibres); and the way in which Māori art forms such as *hei tiki* have been misappropriated (for example, the plastic *tiki* that were given to passengers on Air New Zealand, the national airline, in the 1960s and 1970s).

Similar dynamics are at work in the way that Māori artist George Nuku creates his customary Māori art from Perspex. Again, customary carving processes, forms and patterns anchor the new works in terms of the models of Māori art inherited by Māori artists in the present, but the use of a spectacularly different and clearly modern material such as Perspex introduces a new set of issues that become the subject of Nuku's practice. *Outer Space Marae* (2006), for example, was installed at the entrance to the 'Pasifika Styles' exhibition at Cambridge University's Museum of Archaeology and Anthropology. Located in this position, the work functioned as a *waharoa* (entrance way) in accordance with its formal qualities (this is what *waharoa* look like), but it also became a commentary on the issues raised by the exhibition – specifically, ideas about the relationship between *taonga* (heirlooms, treasures) and museums, and

George Nuku, *Outer Space Marae*, 2006.
Installation in exhibition 'Pasifika Styles: Artists inside the Museum', May 2006–February 2008, University of Cambridge Museum of Archaeology and Anthropology.

Nuku's recreations of Māori forms in Perspex work brilliantly with the light and architecture of museum environments. His showing in Cambridge led to residencies and increasingly important commissions for permanent as well as temporary museum displays in London, Edinburgh and Antwerp, exemplifying the considerable impact of Māori art and curatorial practice on the European museum world.

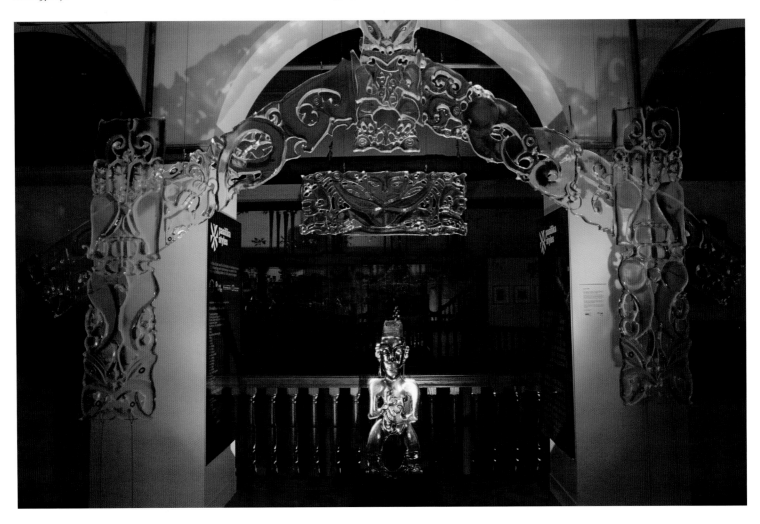

whether *taonga* overseas should be repatriated or remain as ambassadors for the cultures and people they come from. Perspex, with its futuristic and industrial connotations, is a choice of material from which contemporary Pacific cultures such as Māori have nothing to fear in their encounter with modernity. It is also a means of reclaiming modern materials within a Māori cultural system. 'We're living in a plastic world and we cannot continue to have this kind of non-relationship with this material we use constantly,' Nuku was quoted as saying in 2006. 'Where does this material come from? What is its genealogy?'[14] As well as integrating Perspex into a Māori conceptual view of the world, Nuku claims the material as a natural departure for Māori artists because of its light-reflecting qualities, a character that is prized in the best *pounamu*, which glows when held up to the light. In other words, the same impulse that led Māori artists in the past to develop excellence with *pounamu* can lead the customary artist in the present to experiment with new materials that offer similar artistic possibilities.

Sometimes the changes that accompany the introduction of new materials into customary art forms are dramatic. In 1983 Philip Dark wrote about an instance of material change affecting Kiribati dance. A troupe directed by Biteti Tentoa of Abarao, Tarawa, began to wear a new form of headband or headdress, a kind of crown made from glass beads, which copied a Kiribati headdress called *tebuwai ton*. The new headdress was used in a dance that requires a heavy skirt called a *terri ni buki*, weighing around 25 kilograms (55 lbs). The dance costume represents the sea, and the dancer moves in such a way that the skirt knocks the beaded crown off the dancer's head. Because the new headdress was heavier than previous versions, it was harder to knock off. The women who used to perform this dance could no longer do it, and the dance began to be performed by boys, because they are stronger. As Dark concludes, 'The personnel of an activity has been thus completely changed by the introduction of a new material.'[15]

Culture as Place, Culture as Identity

Culture has become a way of defining identity. When this happens, culture is often fixed and policed in ways that were not previously considered necessary. The effects can be significant, and will play out in anxieties about what is authentically and appropriately part of customary art practice. But where identity is tied to place or land, culture can be much more fluid. This has a major impact on the way that customary art is practised and thought about. In Vanuatu, for example, the term *kastom* is used to describe knowledge and practices that are indigenous, or ni-Vanuatu, in contrast to everything that ni-Vanuatu identify as having come from outside their vicinity.[16] Yet *kastom* as a concept is a product of contact with outsiders, such as missionaries who reified Islander ways of living and beliefs and then contrasted them with European lifestyles and Christian beliefs. *Kastom*, then, is best understood as ni-Vanuatu ideas grouped together by Western concepts. It is a term that would not exist without a history of European contact in Vanuatu, yet it articulates ni-Vanuatu ideas and aspirations about their own culture and identity, the past in the present. As *kastom* became a key term within the independence movements of the 1970s, it began to function as a way of describing and identifying the things that made local people different from expatriates, and this in turn affected its meanings. *Kastom* began to signify the practices and characteristics that distinguish ni-Vanuatu and other people, but without codifying the specific kinds of knowledge and practice that fit within the term. Although *kastom* is legitimated by the idea that it represents an identity with historical continuity, the concept does not prejudge whether the best exemplars of that identity lie in the past or the present. Practices that did not occur in the precolonial period can be identified by ni-Vanuatu as *kastom*.

Culture as place, in contrast to culture as identity, allows customary art to shift in obvious and innovative ways without disrupting its value as customary art. In Papua New Guinea this is exemplified by the looped string bag, or *bilum*. Bilums were made throughout almost the whole of mainland Papua New Guinea in traditional contexts, even though the forms of *bilum* and the uses to which they are put vary greatly from place to place within the region. As Maureen MacKenzie pointed out in 1991, in independent Papua New Guinea the *bilum* became a convenient medium to express regional identity. The array of shapes, textures and decorative elaborations in *bilum* form enable each cultural group to distinguish and

differentiate themselves. *Bilums* became an effective marker of tribal identity in urban centres, displaying a migrant's place of origin in an environment where that identity is not otherwise visible. In the 1990s this was particularly evident in the Friday night dances held in many settlements on the edges of Port Moresby, where the *bilum* was an ethnic marker 'among the bricolage of finery constructed from shredded plastic, beer cans, carpet scraps and other remnants of Western consumerism'.[17] At the same time, as the multiple groups in Papua New Guinea combined into a nation, the string bag emerged as a symbol of national unity. Post-independence governments used it extensively as a visual symbol on murals, architectural facades and in street sculpture.

Michael O'Hanlon has traced some of these transformations in the Wahgi Valley in the Papua New Guinea Highlands.[18] Increasingly, *bilums* are looped from non-traditional fibres, including extruded nylon, unravelled and respun rice-bags or unpicked garments, but especially from highly saturated acrylic yarns. Wahgi women purchase these new yarns with income from their coffee plantations, and use them to make decorative net bags. This is particularly true of the type of *bilum* made to carry personal possessions. Designs for these bags are imported and exported from one place to another, sometimes following traditional trade routes. Women also see new designs on a visit to town and then work out how to make them, or they may be taught by immigrants from another area, such as women who have married into the group. These new designs have names like 'Cross' or 'One Ace' or 'Yonki Pawa'. The last is a design based on the pylons from a power-generating station at Yonki in the Eastern Highlands.

New designs are constantly being developed both in rural areas and in town, and these designs no longer index specific regional identities. Rather they are part of a new fashion and identity that stretch across the country. The *komputa* design, new in 2006, depicts the fizzing of information across the internet, and is worn on *bilums* everywhere.

Bilums are also often made for sale to tourists, with, for example, a design of the Papua New Guinea flag. They are also now being informally exported to other Melanesian countries. Since about 2006 it has become very stylish in Port Vila, Vanuatu, to carry a *bilum* made in Papua New Guinea.

Komputa bilum, **Mundika village, Papua New Guinea, 2007.**
Wool, 53 x 35 cm (20⅞ x 13¾ in.).
© The Trustees of the British Museum, London.

In Vanuatu women never made looped string bags, but rather weave baskets, each island or district making their own distinctive type. After independence, women from Pentecost, Futuna and Efate began to make and sell baskets in the Port Vila market, both to other urban ni-Vanuatu and to tourists. The Pentecost basket became a market leader, partly because the form of the baskets was suitable as a carryall for men and women, but also because of their designs.

Unlike the Futuna baskets, which utilized in-weave designs but were otherwise plain, Pentecost baskets incorporated increasingly colourful designs. Using commercial dyes sold for marking copra bags, Pentecost women dyed pandanus in bright colours and used it to weave baskets. In the late 1980s Pentecost baskets incorporated coloured designs produced against a background of undyed pandanus, but by the third decade after independence, baskets were entirely woven from dyed pandanus. The Pentecost style became entrenched as women from other islands began to make baskets in that style. For example, in east Ambae, traditionally, people did not make pandanus baskets, but by the late 1990s east Ambaean women were using their textile plaiting skills to plait Pentecost-style baskets.

From the mid-1990s innovations in basket style had become a constant in Port Vila, so much so that each year it is possible to see a new style of basket, or a new basket design, carried by women on buses and around town, and on sale in the markets in the main street.

Cath Melsisi, contemporary Pentecost basket, Vanuatu, 2001.
Pandanus. Museum of New Zealand Te Papa Tongarewa, Wellington.

The women of Pentecost island are famous for weaving these colourful baskets made of pandanus fibre dyed with natural and synthetic colours. Sold in markets throughout Vanuatu, they offer an important independent source of income for women. Although new patterns are always attributed to particular women, the weavers freely share and copy patterns, resisting the notion of copyright.

Women worked out how to plait words into their basket designs, and a rash of baskets with names and dates appeared. The plaiting technology used to embellish the end of pandanus textiles with openwork designs was incorporated into baskets to produce a new style of basket, entirely worked with holes. In about 2005, women in north Ambae developed yet another new style, using pandanus, but twisting it into plied string and plaiting it in an open fabric like a net. This style, known as 'string baskets', imitates Papua New Guinea *bilums*. Around 2007, Futunese women introduced the 'backpack' basket, woven with two shoulder straps and a drawstring mouth to be worn as a backpack. Meanwhile, in Pentecost, women were developing new designs for their baskets. Sylvia Mabonlala from central Pentecost is credited with

working out how to weave a number of pictorial designs into baskets, such as a butterfly and a canoe with outrigger. At the same time, women from the Shefa Province and especially from Nguna in north Efate began making and selling double-walled baskets woven from wide strips of pandanus. These rigid baskets are stronger for carrying books and papers. All these innovations, while facilitating sales to tourists and other expatriate visitors, have been primarily developed in response to a growing indigenous market within Melanesia.

Customary Art and its Audiences
Customary art in different parts of the Pacific also thrives through its contact with global audiences. This is not necessarily a new phenomenon, even if

Spiderweb and Vine: The Art of Ömie

OCEANIC ART is full of surprises, and one of the greatest of the last decade has been the emergence of a spectacular painting movement. From the perspective of the Ömie, of Oro Province, Papua New Guinea, there is nothing new about *nioge*, painted barkcloths. To the contrary, these fabrics are intimately associated with the beginning of time and the first female ancestor who ventured into the Papuan mountain territory that the Ömie now inhabit. She had her first menstrual period, cut bark from a tree, and decorated it by soaking it in red river mud that symbolized her blood and her capacity to produce children. Ever since, Ömie women have beaten cloth and painted it.

The Ömie had long suffered from sustained conflict with their neighbours, the much larger Orokaiva. And, like many Melanesian peoples, they dealt with the intrusion of Christian missionaries and the local impacts of the Second World War. The 1951 eruption of Mount Lamington was also devastating. By the early 2000s, some among this remote and acutely marginalized population were concerned to take action, to create some positive relationship with the wider world. Consideration was given to encouraging tourism, but the nearest airstrip had closed and access was just too difficult. David Baker, Director of Sydney's New Guinea Gallery, visited in 2002 and 2004 and encouraged Ömie to make *nioge* for sale. Chiefs and elders weighed up the issues and decided to embrace the opportunity. An art that until this time had been produced in and for its own environment would travel to Australia and beyond.

The rapid success of Ömie painting is striking. Shows in Sydney were quickly followed by the inclusion of the work in a major survey of historic and more recent barkcloth, *Paperskin*, at the Queensland Art Gallery and Te Papa, Wellington, in 2009 and 2010; the National Gallery of Victoria in Melbourne simultaneously mounted a dedicated exhibition, *Wisdom of the Mountain*; and currently (2012) exhibitions in the United States and England are being developed. One could speculate that the famous desert painting movements from Papunya, Balgo and elsewhere prepared curators and audiences around the world for this aesthetic and this work – which is not to say that its growing renown is in any sense undeserved.

Historically, Ömie barkcloths were open in structure, their imagery sparse. The prospect of production for sale appears to have empowered the artists. They adapted designs derived from the tattoos that, before the missionaries, they had borne on their bodies. They experimented and created an extraordinarily varied and animated visual language. If all of these works mobilize motifs associated with mountains, vines, pig tusks and other natural forms and creatures, they seem not only different from *tapa* painted elsewhere in the Pacific, but all arrestingly different from each other too.

The designs of Celestine Warina's works are structured by rectangles that incorporate triangles and zigzags formed out of alternate bands of red and yellow. These forms represent both geographic features and parts of the bodies of snakes, insects and grubs. Jean-Mary Warrimou's composition is also organized within rectangles but it images a single organic form, a vine. Dapeni Jonevari's works are dominated by single circular or concentric forms; their titles refer to spiderwebs. And some of Lila Warrimou's works are different again; they are pictorial and depict people atop a mountain and the plants growing on its sides. Yet there is an aesthetic that is exemplified in the work of all of these remarkable artists: every one of these compositions is animated and dynamic. Despite their diversity, none aspires to balance or stillness; instead all seem full of the life of a place, a community, a people.[i] NT

Celestine Warina (Kaaru), *dahoru'e, hi'odeji jä'e, cobburé jö si'o si'o ve'e, sigobu sin'e, udane une ohu'o sabu ahe* (Ömie mountains, backbone of the green snake, pattern of a snake's lip, snake skin, eggs of the giant spiny stick insect and spots of the wood-boring grub). Ömie territory, Oro Province, Papua New Guinea, 2011.
Natural pigments on *nioge* (painted barkcloth). Length 127.5 cm (50 in.). © The artist and Ömie Artists 2011

Jean-Mary Warrimou (Hujama), *vaguré* (fern leaves). Ömie territory, Oro Province, Papua New Guinea, 2010.
Natural pigments on *nioge* (painted barkcloth). Length 118 cm (46½ in.). © The artist and Ömie Artists 2011

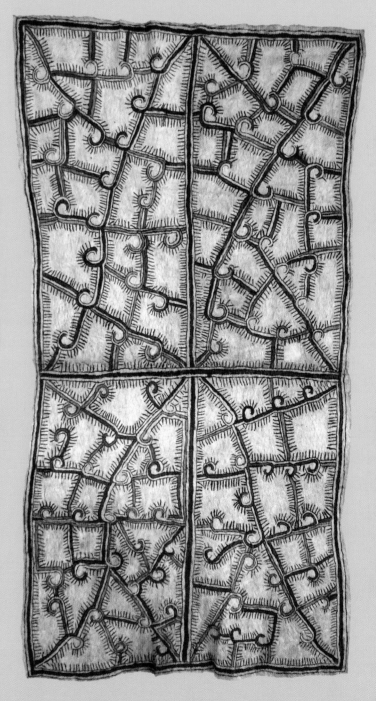

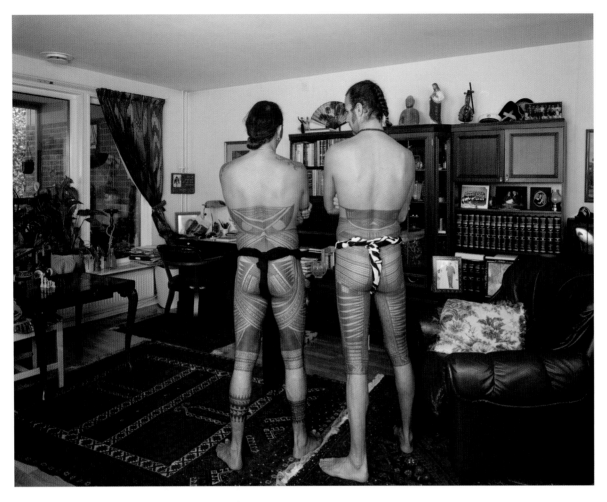

Mark Adams, *3.7.2004.*
Gustav Hollersg, Malmo,
Sweden. John and Marwan
Atme. Tufuga tatatau Su'a
***Sulu'ape Paulo II**, 2004.*
RA colour print.

These two Lebanese brothers,
photographed in the lounge of
their mother's home in Sweden,
were tattooed by Samoan
tattooist Su'a Sulu'ape Paulo II.
Paulo was a radical innovator
among customary tattooists.
He not only tattooed Samoan
migrants in New Zealand but
also invented new forms of
cultural tattoo, forged cross-
cultural alliances with tattoo
artists in Europe and Polynesia,
and, controversially, tattooed
non-Samoans with the
traditional *pe'a*.

the scale of global cultural flows is unparalleled as
an outcome of modernity. Samoan *tufuga tatatau*
(tattooing experts), for example, were tattooing Tongan
nobles in the 1700s, which means that the European and
Samoan cultural exchange of tattoo that has taken place
since the nineteenth century is not a novel or unusual
occurrence, but the latest in a series of cultural exchanges
happening in the Pacific over a long period of time.[19]
Tufuga tatatau now practise their art all over the globe
– in Amsterdam as well as Auckland, Savai'i as well as
San Francisco, and on European as well as Samoan
skins. Two audiences are being served here: the migrant
Samoan communities who have settled outside of
Samoa and demand *tatau* as an important part of
community rituals and identity, and a community of
tattoo aficionados who appreciate Samoan *tatau* as an
elaborate and beautiful form of tattooing. In both cases
it is important that the work is done by an acknowledged
expert and is culturally sanctioned in some way – even
if the reasons for wanting this, and what 'authenticity'
will actually consist of, is different for a Samoan
receiving the *pe'a* (male body tattoo) versus a European
receiving the same design.

Museums also play a key role in bringing
customary art from the Pacific to a global audience.
The Asmat Museum of Culture and Progress in West
Papua opened on 17 August 1973, funded and managed
by the Catholic Church. According to a museum
catalogue published in 1985, the institution 'was
primarily built to preserve the artefacts, to keep
the people from losing their sense of identity, and to
encourage renewal of carving'.[20] Nick Stanley notes
that one of the ways in which the Asmat Museum of
Culture and Progress manifests its difference from
other ethnographic museums and fulfils its role as
an active supporter of artistic change is through its

Mark Adams, *17.9.2005. Avondale Road, Avondale, Auckland. From left: Lui Betham, Pasina Willie Betham, Su'a Tavui Pasina Iosefo Ah Ken, Tafili Fune Betham, unidentified man and Gus Betham. Tufuga tatatau Su'a Tavui Pasina Iosefo Ah Ken*, 2005.
RA colour print.

Samoans have formed large migrant communities in many cities around the world where signs of ethnic identity have become increasingly important. For Samoan men none is more significant than the customary male tattoo, known as the *pe'a*. In this photograph by Mark Adams, members of the Betham family pose beside their *tufuga tatatau* (tattooist) Su'a Tavui Pasina Iosefo Ah Ken, the first tattooist to tattoo migrants in Aotearoa New Zealand.

sponsorship of an annual carving competition. This gives Asmat carvers the opportunity to inspect other carvers' work and to meet and deal with a varied audience of dealers, museum staff, government officials, tourists and international corporations. The museum buys and displays the winners of the six categories in the competition, and the objects that are selected but don't win become part of an auction attended by national and international buyers and dignitaries. In 2009, after years of advocacy and fierce debate, women's textile art was included in the exhibition for the first time.[21]

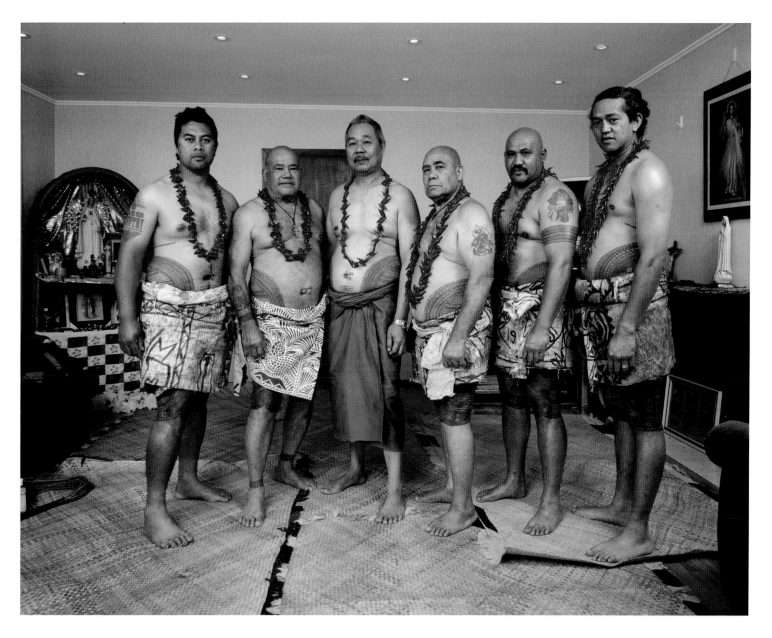

VOICE

'WE STARTED CALLING THEM ISLAND DRESSES'

From 1913 there was a Presbyterian missionary at Craig Cove, Dip Point, Ambrym. Our grandparents went to live with them and the missionary's wife taught the women to sew. She taught them to make a dress called a lydia dress. These days you never see this kind of dress though I have a photo of my grandmother wearing one – I was looking for it to show you but I couldn't find it. From then until World War II our grandmothers and mothers wore lydia dresses and corner dresses. I don't know what a corner dress was like. I was born in 1942. In the past Catholic women on Ambrym wore a dress like the New Caledonia style dress of today, it was called 'French made' or 'French frill': Catholic women used to wear these dresses to church. Around 1950, women from Port Vila came to Ambrym and they taught our mothers to make island dresses, which we call 'Tavila' – Tavila dress. By 1990, island dresses were changing: we could see tavila changing, and after 1990 we started calling them 'island dresses'. These days, since 1990, some of us make tavila without ribbons or lace on them: they make tavila the way people in Vila now do it.

As I explained at the workshop at Tagabe school last year, on our island when we hold a kastom ceremony we decorate our dresses with yellow or red ribbons and red lace (the colours traditionally worn to show achieved rank), to show that our grandmothers have registered us in kastom. Then we got to 1980 and gained Independence and since then we women have gone up in status. Island dresses have become a national dress. We've made our own symbols apply to this national dress: red ribbons show that our grandmothers were high-ranking women. And now we today have founded the National Council of Women and we've founded the Women Fieldworkers Cultural Research Network. When we look at the history of dresses we can see how Vanuatu women have gained in importance. We can stand and know that we are Vanuatu women, and be proud.

Lucy Moses, North Ambrym, Vanuatu, October 2002.
Report to the Women Fieldworkers Island Dress History workshop.[i]

The competition, writes Stanley, represents the museum's agenda to facilitate 'the continuous artistic evolution of Asmat art under the conditions of the world art market'.[22] It also illustrates a number of tensions and conflicts for Asmat carvers. Open competition goes against Asmat cultural codes, and the question of aesthetic judgment is complex. The judging is done by non-Asmat, and it tends to certify types of Asmat art that fit the expectations of collectors. The carvers also face pressures to reconcile the kind of work produced for the competition with the low-cost and high-volume work that is demanded by the mass or tourist market, in which Asmat art is a recognizable and popular form of 'primitive or folk' art. And distinctions between customary and commercial work are undermined by the museum itself, which displays both kind of objects alongside the annual competition winners. Stanley suggests that the global connections effected by the Asmat Museum come with a cost, demanding that the Asmat learn to see 'museologically'

– which involves a kind of self-consciousness and distance from the objects on display and the cultural processes they represent. Yet all these tensions remain productive. 'The dialectic between authenticity and innovation remains constantly alive in Asmat art, serving, as it does, traditional purposes as well as global art worlds.'[23]

A complex set of forces is at work in the artistic connections that have developed between Māori and Northwest Coast artists in Canada, in part because of the work of the Spirit Wrestler Gallery in Vancouver, a dealer gallery specializing in Inuit, Northwest Coast and Māori artists. The gallery focuses on 'contemporary directions in aboriginal art, including cross-cultural communication, the use of new materials (such as glass and metal), and modern interpretations of shamanism, environmental concerns, and other issues pertaining to the changing world.'[24] The Spirit Wrestler Gallery favours a form of customary art that has been reshaped by the demands of the 'ethnic' art world. In practice,

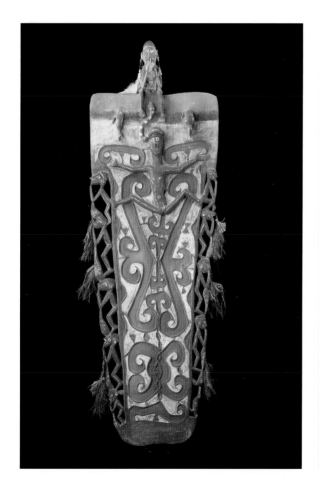

right
Contemporary Asmat shield/sculpture with three-dimensional ornamentation. Late twentieth century.
Wood. Konrad Collection, Völkerkundemuseum, Heidelberg.

far right
Primus Oambi with his sculpture that was selected for the small carving category of the 2009 Asmat Carving Festival and Art Auction.

Jaki-ed: Marshall Islands Textiles

JAKI-ED ARE BEAUTIFUL WOVEN TEXTILES created by Marshallese women. Made from pandanus, with geometric designs of banana, hibiscus and beach-burr fibre, one form of *jaki-ed* are the *neided* (clothing mats), which have an unadorned central panel surrounded by a decorated border. Women would wear two *neided* sewn together as a skirt held in place by a belt, the rear *neided* wrapping over the hips so that the motifs on the border were visible. Men would wear the *neided* as a kind of loincloth, tucked into a belt at the front and back.

The knowledge of *jaki-ed* techniques and designs began to disappear in the mid-nineteenth century, when Western traders introduced cloth and missionaries encouraged women to cover their breasts. According to local accounts, the last *neided* were made during the Second World War. In 2006 a revitalization project was initiated by Maria Kabua Fowler, a Marshallese leader and activist, and Dr Irene Taafaki, Director of the Marshall Islands Campus of the University of the South Pacific. They travelled to Hawai'i to view the collection of *jaki-ed* and other Marshall Islands textiles in the collection of the Bishop Museum. A series of workshops followed, in which a group of weavers re-learned the fine-weaving techniques and patterns of the past and shared their skills and knowledge with a new generation, including high-school students.

This cultural restoration project has been sustained by a series of exhibitions and auctions, the first held in 2007, which provide an audience and an income for the weavers. In 2009 the new *jaki-ed* were displayed alongside two nineteenth-century *jaki-ed* from the Bishop Museum. Facilitator Caroline Yacoe reported two of many positive comments made by the students of Marshallese weaving, 'most of whom were seeing the beautiful work of past weavers for the first time':

'This makes me very proud to be Marshallese' and 'They give me [goose]bumps.'[i] The following year the 2010 prize-winner, Ashken Binat of Arno atoll, employed traditional designs inspired by the nineteenth-century *jaki-ed*.

As a self-conscious revival of the practice of Marshall Islands weaving, the project is supported by a range of resources that make past models available to the contemporary weavers. As well as local exhibitions of *jaki-ed* from museum collections, a video documenting the history of *jaki-ed* and demonstrating weaving techniques was released in 2009, and a book is currently in production. While celebrating the history of Marshall Islands textiles, the purpose is to sustain the contemporary practice and to create a framework for the appreciation and acquisition of new *jaki-ed* by developing an enthusiastic and knowledgeable audience.

Although this is a revival of an art form that was in decline, the emphasis is not primarily on creating contemporary *jaki-ed* that closely follow customary models. Designs such as diamonds with crosses (star of the eye), parallel stripes (man and woman), zigzag lines (the wavy land of islands), lozenges (the underbelly of turtles) play a role in contemporary *jaki-ed*, linking the new textiles directly with the old, but innovations in design and material are both accepted and encouraged. In 2009 first place in the Master Weaver category was won by Airine Jieta of Mejit, with an outstanding *jaki-ed* weaving incorporating both customary and new patterns. Unique creativity is an attribute ascribed to Marshallese women – this means that no two mats will ever be identical – and although a weaver may follow the form of an ancient design, a weaver will always add her own inventions. This dynamic process of creativity is termed *kōrā im an kōl* in Marshallese. DS

Jaki-ed textile, Ashken Binat, Arno atoll, Marshall Islands, 2010. Winner 2010 Jaki-ed Exhibition/Auction, Majuro, Marshall Islands. Woven hibiscus fibre. Length approx. 55 cm (21⅝ in.).

this means objects that conform to fine art or craft types (sculptures, paintings, non-functional ceramics) and are suitable for display as art, and subjects, forms and patterns that relate strongly to customary models.

Māori art has had a long time to adapt to the demands of the art world, and the objects made for the Spirit Wrestler Gallery are the latest in a long line of customary-derived artworks that interpret Māori art for display in art galleries, museums or domestic spaces. Yet one of the most notable aspects of the gallery's exhibitions such as 'Kiwa: Pacific Connections' (2003) and 'Manawa: Pacific Heartbeat' (2006) is that the featured artists belong to a number of different art worlds. There are, for example, customary practitioners like Lyonel Grant alongside artists more commonly found within the Pākehā (European New Zealander) art system such as Brett Graham or Robert Jahnke. Since the Spirit Wrestler Gallery is interested in contemporary directions in Māori art, it can hold a very catholic view of what constitutes Māori art, an attitude very much in sympathy with a Māori point of view that rejects a firm distinction between customary or contemporary art practice, seeing these as the imposition of an anthropological or art-historical framework that reifies Māori art in a way not found within the culture itself.[25]

But the way in which the Spirit Wrestler Gallery has primarily impacted on the production of this form of customary Māori art is in creating a context for a kind of hybrid Māori-Northwest Coast art, which plays up connections between indigenous people in Aotearoa and North America. Todd Couper's *Karanga (The Calling)* (2006) and *Strong* (2003) were both carved for Spirit Wrestler Gallery exhibitions, and in both works Couper combines the aesthetic of Māori and Northwest Coast art to represent the coming together of two peoples and cultural traditions that is the framing device of the shows. This artistic connection is validated in a number of ways, not only through contemporary exchanges, or larger similarities between the two cultures, but through historical links, such as the account told to Northwest Coast artist Tim Paul about three Māori who travelled to North America by *waka* (canoe) and who were presented with wives whom they took back to New Zealand.[26] While it is perhaps unique to find Pacific artists claiming cultural and genealogical links to First Nations people in North

Todd Couper, *Karanga (The Calling)*, 2005.
Wood (kauri). Height 56 cm (22 in.).

America, the use of customary art to establish connections across the Pacific is not at all uncommon. The emergence of indigenous art as a category has had a big impact on Pacific peoples, and formed a number of allegiances across national boundaries.

Spirit Wrestler Gallery represents a category of art production that might be called ethnic art, and most of the objects that it exhibits and sells belong to this category. They tend to show a high level of technical skill, a deep engagement with materials, and references to forms (such as containers, canoe technologies or adornment) that historically involve function. This places them within the domain of craft, which has an awkward relationship with the fine art world. And indeed the idea that customary art is more craft than art is one of the tensions that shapes the way

Sopolemalama Filipe Tohi, *Hautaha (Coming Together)*, 2004. Stainless steel. Height 3 m (10 ft). Onehunga Community Centre, Auckland, New Zealand.

Sopolemalama Filipe Tohi found his voice as an artist after studying the Tongan art of *lalava*, the lashing system used in traditional house construction that generates complex geometric patterns. Tohi's work is based on this system which he sees as a distinctively Tongan mode of knowledge and communication, reinterpreted in contemporary media such as customwood and stainless steel.

left
Manos Nathan, *Pokopoko te Taniiwha, c.* 2005.
Fired clay, oxides, paua shell. Length 25.4 cm (10 in.).

customary art is absorbed into the art world. Without the aura of authenticity that attends to older forms of customary art and gives these objects a place within the art gallery or museum, contemporary examples of customary art tend to find themselves framed as craft and thus placed within the social history or ethnographic museum more readily than the white cube of the art gallery.

The role of customary practices as a kind of art is not just negotiated by customary artists. There are also contemporary artists who make references to customary art in works that are intended to belong less ambiguously in the spaces of fine – or contemporary – art. Filipe Tohi, who was born in Tonga and now lives in New Zealand, produces contemporary sculpture (*previous page*) based on *lalava* (sennit lashing). A critical practice within Tongan culture because of its importance to technologies of shelter, voyaging and food gathering, *lalava* is also a system of knowledge, a way of abstracting the experience of the physical and social environment as geometric designs. As Karen Stevenson writes, 'Tohi believes that these patterns have been modelled into symbols of human interaction. These designs teach us how to: live/interact/be. As these lashings were used on canoes, they often reference navigational knowledge, knowledge transferred in the process of doing.'[27] By developing these lashings into three-dimensional sculptures, Tohi creates compositions that make the complex geometries of *lalava* visible and thus able to be appreciated as a form of communication. By eschewing customary materials and forms (such as canoes or buildings) in favour of constructions in plastic, aluminium, or stainless steel, Tohi creates contemporary art, in which the Pacific references do not distract from the way these sculptures can be positioned within specific tendencies of art production (op art, minimalism, abstraction). Indeed, the reference to Tongan technologies and conceptual systems helps to position Tohi from the point of art history as part of the important history of cross-cultural borrowing in the development of modern art. In the gallery, where Western art-history references come to the fore, writes Simon Rees, 'Tohi's vocabulary, tracing its genealogy to traditional Tongan art, is suspended in an intermediate space: vibrating between histories.'[28]

opposite
Ken Thaiday Snr, *Beizam* (hammerhead shark) articulated dance mask, 2002. Cairns, Australia.
Wood, cane, feathers, paint, plastic. Museum of Archaeology and Anthropology, Cambridge.

Thaiday's ingenious and engaging works are entirely different in composition and mechanics from the historic masks of the Torres Straits, but also completely consistent with their dynamic and transformational aesthetic.

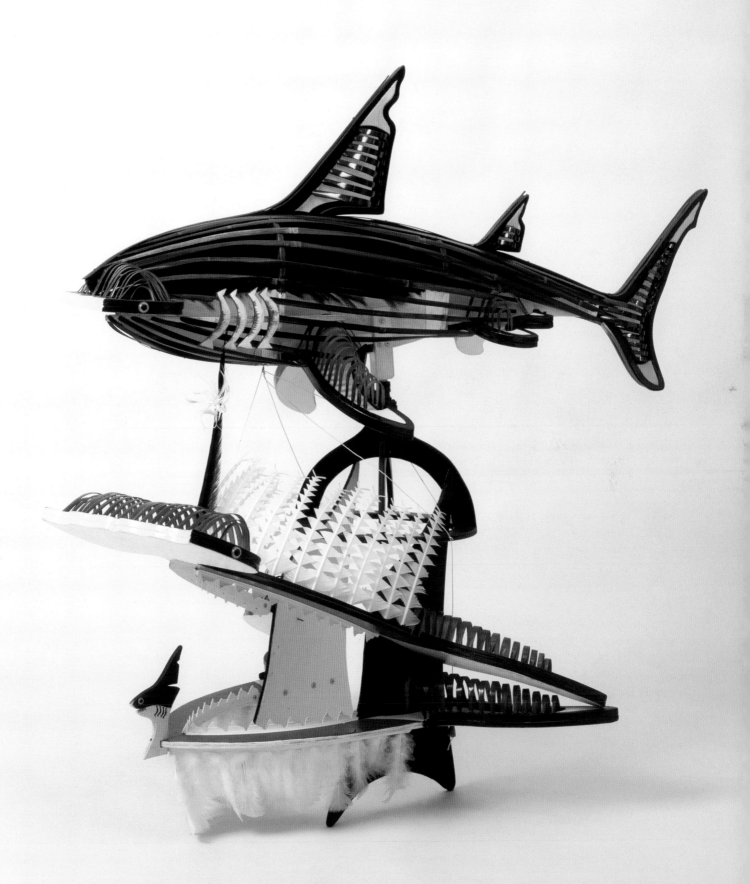

Collaborating with the Contemporary

THE DISTINCTIVE CHARACTER of customary art is typically thought to reside in its relationship to particular communities. Yet customary arts are open to all kinds of entanglements with the wider world today: with museums, art galleries, government agencies, churches, tourist schemes, universities and so on. Customary artists are savvy operators in seizing opportunities to sell, share, promote or otherwise disseminate their art in spaces beyond their communities. Does this signify the inevitable disintegration of strong communities or some vital dynamic at work in the way they are rearticulating their place in the contemporary world?

One arena where this dissemination is taking place is in contemporary art galleries. Consider, for example, a project of 2009 by Leba Toki, Bale Jione and Robin White entitled *Teitei Vou (A New Garden)*, commissioned for the sixth Asia Pacific Triennial and now in the collection of the Queensland Art Gallery, Australia. Toki and Jione come from the island of Moce in the Lau group of the Fijian islands and are makers of traditional *masi* (decorated barkcloth); White is a contemporary artist from New Zealand with a career dating back to the 1970s. From 1981, she lived for eighteen years on the island of Tarawa in Kiribati, often passing through Fiji on trips to New Zealand. In this time she developed a practice of collaborating with Island women in the creation of works that draw on communal traditions and techniques such as embroidery, barkcloth and flax weaving.

These collaborations were enabled by the fact that White shared with many of these women a common faith. They were Baha'i – a religion with adherents in many Pacific islands that advocates an ideal of diversity, affirming many cultural practices as authentic expressions of the faith. In that respect, these collaborations can be understood as forms of religious practice, exploring the intersection between faith and culture.

But they are also collaborations with the institutions of the contemporary art world, for which *Teitei Vou* was made.

The work comprises nine pieces of cloth of varying types, including the decorated *masi* illustrated opposite. The cloth is a form of customary gift given by Fijian families at a wedding – the ceremony that ritually enacts the joining together of complex differences: between individuals obviously; but also between families, villages, ethnic groups, religions, classes, nationalities, as the case may be. And these days, they are often heterogeneous in the extreme. The particular focus of *Teitei Vou* is revealed in the hybrid character of the cloth, which includes two 'rag mats' made from Indian *sari* cloth, and the iconography of the main *masi*, a blend of traditional patterns and unique imagery designed by the three collaborators. The imagery refers in part to Fiji's sugar industry, to its history of indentured Indian labour in the nineteenth century, and the social and political legacy of that history in the present as the two races, 'wedded' to each other by the past, struggle to coexist. On the other hand, the iconography offers a hopeful symbolism for the future. Sugar doubles as a metaphor for the 'sweetness' of 'peaceful human relations' while the artists have placed at the centre of the *masi* the image of the Baha'i World Centre at Haifa, Israel, amid echoes of its terraced gardens on the slopes of Mount Carmel.

Thus a religious vision, drawing on the wells of cultural custom, is addressed to the situation of present-day Fiji via the public space of a contemporary art gallery. There *Teitei Vou* is a precise articulation of big questions facing contemporary art and the 'public sphere' in general today: how is the experience of multiple modernities to be expressed? How can communities speak across their own boundaries? What do venerable traditions – cultural and religious – have to say to global audiences? And how will customary forms and values be translated in that context? PB

Robin White, Leba Toki, Bale Jione, *Teitei Vou (A New Garden)* (detail), 2009. Natural dyes on barkcloth, 390 x 240 cm (153½ x 94½ in.). Collection Queensland Art Gallery.

The cloth illustrated, called a *taumanu*, is one of nine components in the complete work, which includes mats made of woven pandanus with commercial wool, woven barkcloth and sari fabric.

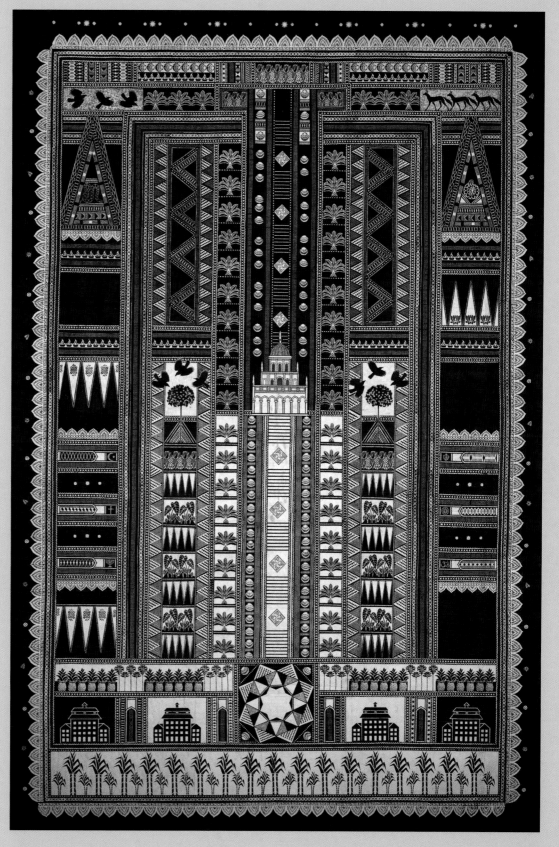

AFTERWORD

Over the years we were working on this volume, a wide-ranging debate was taking place among art historians about the status and future of their discipline. Prompted by the globalization of the art world and the rising challenges of dealing with 'world art', the conversation involved searching reflection on the relevance, limitations and possibilities of the discipline in the throes of transformation.

This book is at once at some remove from, and intimately connected with, this debate. At some remove, because it was written only partly from within the discipline. Of our number, only two of us are formally identified as art historians and of those only one – Peter Brunt – actually teaches the subject in a university art history department. The others have all written on art historical subjects but their backgrounds and professional orientations are in anthropology, history, ethnography, material culture, indigenous studies and architectural history. Four work in museums with ethnographic collections, one as a curator of craft and jewelry. We exemplify what James Elkins has called the 'dispersal' of art history into hybrid, multi-disciplinary or interdisciplinary forms, or into material or visual culture studies. Nonetheless, we have presented this book as a history of art, and placed it on art history's bookshelves. The book represents not only a response to much-debated issues from the vantage point of a particular part of the world, but also an effort to exemplify what a new history could look like.

The questions art historians have tackled ranged from the institutional and pedagogical to the ethical, methodological and historic.[1] What to make of art history's basic surveys and textbooks, such as Ernst Gombrich's classic *The Story of Art*, where Oceanic, African and Native American art feature in the first chapter alongside cave art as 'strange beginnings',

not to appear again? What narrative patterns and preconceptions do these books establish? Where are they produced and who writes them? Another question was where is art history taught and researched and where is it not? A simple question whose statistical answer could only expose the deeply Western bias of its predominant concerns and historic formation. Art history is overwhelmingly taught in Western nations, their former settler colonies and parts of Asia. Among the many places it is not taught or established as a discipline are the Pacific Islands, outside of Australia, New Zealand and Hawai'i. And even there questions can be raised – and have been raised – about the extent to which the discipline taught indigenous art or was considered an important form of knowledge by indigenous researchers, students and communities.[2] To the question 'Is art history a global discipline?', the answer was an unequivocal no.

Yet the discussion would not have taken place if the situation was not profoundly changing. Recognition of this fact led to probing questions about the future of art history: was it *becoming* a global discipline or was it disappearing or transforming into something else? What is art history for and what social purpose does it serve? What is the value of its legacy of concepts, methods and narrative structures? Are they still useful? Can they be adapted to the global range of artistic traditions seeking scholarly illumination within the concept of 'art' today? Must the discipline re-think this humanistic idea to accommodate both the differences and universality of artistic practices and aesthetic experiences in human history, as David Summers attempted to do in his book *Real Spaces*?[3] And what role will non-Western concepts and values play in both informing and transforming the discipline if it is to become genuinely global? At a symposium held

in Wellington in 2011, a young Māori law scholar speaking to an art world audience as an 'outsider' proffered three Māori concepts – *mauri, utu* and *ihi* and *wehi* (briefly, a spiritual essence or power manifested through the physical realm, a concept of reciprocity entailing the social or communal aspect of artworks, and the expression and apprehension of power in a work of art or performance) – as dialogical terms for approaching not only the nature of Māori art but also *any* art of any time.[4]

On another front the sense of crisis in art history was directly related to the advent since 1989 of a genuinely global art world.[5] Art history may still be a European province but contemporary art and the world it inhabits now epitomize the forces of globalization. This 'event', as Hans Belting calls it, has created a 'new situation in the world', which, more than anything else, has stopped art history in its tracks as a master narrative equipped to account for it.[6] The globalization of the art world in which multiple histories, cultural memories and artistic traditions now influence contemporary practices has exposed the Eurocentrism of art history ('a local game that worked only for Western art and only from the Renaissance onward'[7]).

The 'new situation' has also confounded the divisions and exclusions that traditionally characterized the discipline: its relegation of non-Western art to ethnography, anthropology and their associated museums, for example, while retaining Western art (modernism and the white walls of art galleries) for itself, the latter changing and historically progressive, the former static or pre-modern. Today, ethnography is a well-established paradigm in contemporary art practice, while many ethnographic museums have become active institutions in commissioning, exhibiting and collecting contemporary art, opening an avenue of historical significance to the global art world that is only beginning to be explored. Ethnographic museums have also played key roles in re-enlivening the contemporary expression of indigenous art traditions in both local communities and international exhibition circuits. These traditions, still vital in communal contexts, are now also entering contemporary art galleries with the support of innovative curators, or becoming involved in collaborative projects with contemporary artists trained in art schools. Indeed, some are forming art schools of their own. Similarly, art history's traditional concentration on the 'high' and 'fine' as opposed to the 'low' and 'popular' has been scrambled by the popularization of the global art world and the extraordinary currency of cultural difference within it. In addition, artists coming out of postcolonial contexts have complex and creatively productive relationships with the popular, which cannot be explained by the opposition between the critical autonomy of high art and the depredations of mass culture.

But if art history in its traditional formulations is inadequate to this 'new situation in the world', that does not mean history is irrelevant. A generation after Western artists in the 1960s and 1970s broke with the historical idea of art's linear progress, Belting notes, 'the problem of valuing art within the framework of its history increases with the globalization of art'.[8] What forms will this history take and what stories will it tell? For if the global art world mushroomed into existence in the past two decades, that does not mean it came out of nowhere, without deeper roots in the historical past.

Our experiment in this book has been to see what a history of art in Oceania might look like, using the conventional but pedagogically important genre of the art historical survey. It does not pretend to reinvent the epistemological foundations of art history. It is a book that ranges over the *longue durée* and over art forms produced in profoundly different milieux, a book whose multiple authorship reflects the cross-disciplinary collaboration needed to compose the subject as a history of art at all. Like all surveys, it is something of a bricolage: an assemblage of excerpts, fragments and abbreviations. But this heterogeneity, even incommensurability, amounts finally to another kind of coherence, the kind we would have if we curated an exhibition in which all of the artefacts and performances represented in this book, and the interpretations we have brought forward of them, were shown together. The whole coheres, in the sense that all this is art in Oceania – it is what art in Oceania has been, is and will be.

The overall shape of our narrative is, of course, different from Gombrich's 'story of art', and cannot simply be fitted into the conventional formal categories that have traditionally structured Western art history. To acknowledge this is not to suggest that art in Oceania is radically exotic to the art of the West. On the contrary,

our story goes hand-in-hand with Western art history all the way to the present, and future work ought to explore their parallels, intersections, cross-cultural borrowings and conflicts.

The globalized art world, Belting says, 'includes its own contradiction by implying the counter movement of regionalism and tribalization, whether national, cultural or religious'.[9] One could see this book in these terms since it is, obviously, about a region. And the fact that it is, and that it is written by people who do, or have, lived in the region and are committed to it – by 'Oceanians', as Epeli Hau'ofa called us – is an important part of where it is coming from. But its regionalism, we would argue, is not a reactionary counter movement to globalization. On the contrary, it is precisely about globalization in several historical epochs, and it reminds us how different 'the global' looks from various parts of the world.

The Pacific Ocean was the last and largest area of the globe to be discovered and settled by human beings through the epic voyages of 'Austronesians' between three and one thousand years ago, completing the human colonization of the earth. For some three thousand years then, and much longer if we include western Oceania, the Pacific Ocean has constituted a global matrix in which Islanders forged or 'worlded' into being the many cultures, societies and peoples who are rightly called indigenous to it – in large part through the agency of those things we have come to call 'art'. Indigenous here refers to the Oceanic environments in which these cultures developed but it does not mean eternally of a particular place and way of life, because however deep those attachments to place were (and are), Pacific peoples were continually trading, warring, marrying and otherwise connecting with other Pacific people, whether in the next village, down the coast or on another island in a far flung archipelago. Some however were seeking to extend their presence beyond the known world, or to break away from their social entanglements altogether by discovering new, uninhabited places to settle and live in until the Oceanic world was replete. Most of the things we have examined in this book are from, or derive from, those indigenous cultures.

Then, from the sixteenth century, but particularly during the eighteenth century, Pacific Islanders were on the receiving end of European expansion into the Pacific, marking another epoch of globalization, also called modernity. Contact with the West profoundly changed Pacific cultures, but it did not simply erase them or replace them with something in the West's image. In this book we have tried to show something of the complexity of their entanglements and particularly its effects on Oceanic art. Islanders were not crushed by modernity but inhabited it in complex ways. They adopted Christianity, helped to spread it through the region, interpreted it through their own languages transcribed into written texts, visualized it in new ways, as well as resisted and rejected it. They travelled through the imperial world as members of ships' crews and on diplomatic missions to European royalty. Their things and the many ways those things mediated their local lives were sucked into a global economy of knowledge and desire, dispersing them into museum collections around the world, and again profoundly altering what it meant to be an Islander. It is commonplace to think of this dispersal as loss and alienation, which of course it was. Yet it also made palpable what it meant to inhabit the global world, of which Islanders were deeply conscious.

This complex past was recalled in the 1990s by the late Tongan intellectual mentioned earlier, Epeli Hau'ofa, one of the Pacific's wise men. In that decade, Hau'ofa contemplated the implication for the lives of Islanders of yet another epoch of globalization, that which began with the dismantling of empire after World War Two, and which was assuming its most recent configuration after the end of the Cold War, including the formation of a global art world. In a lecture entitled 'The Ocean In Us', given in 1997 to inaugurate the Oceania Centre for Arts and Culture at the University of the South Pacific in Suva, Fiji, a place for artists, Hau'ofa proposed the need for a 'regional identity' based on the concept of the ocean.[10] We began this volume by citing this concept and we might end the book by returning to it. The regional identity Hau'ofa had in mind was not intended to displace ethnic, tribal or national identities: 'our diverse loyalties are much too strong to be erased by a regional identity and our diversity is necessary for the struggle against the homogenizing forces of the global juggernaut. It is even more necessary for those of us who must focus on struggling for their ancestral cultures against seemingly overwhelming forces, to regain their lost sovereignty'.[11]

Rather, it was meant to 'supplement' those identities, to cast them into a different light, refracted through the idea of the ocean.

At a fundamental level, the ocean unites us in our common humanity – and animality – as the very basis of life and survival on the planet. And its care and protection is a moral obligation that should (even if it typically doesn't) transcend all forms of political, economic and personal self-interest. In its ceaseless motion and planetary flow, the ocean is also a metaphor for the past and recent lives of Pacific Islanders. Hau'ofa marvelled at the way migrant Islanders in the post-war era had embraced the opportunities of modern travel, technology and communication to create 'a world of social networks that criss-cross the ocean, all the way from Australia and New Zealand in the southwest to the United States and Canada in the northeast.'[12] But he also recognized that migration could, as it has in the past, separate and alienate individuals and communities from former homes. For them, those homes become distant memories, myths or simply 'history', while they face the challenges of creating new homes in other locations. The idea of 'the Ocean in us' speaks poignantly to these patterns of connection and disconnection that now define an Oceanic identity across a genuinely global space. But the ocean is also history, Hau'ofa said, and he chided Islanders for neglecting it. 'As a region, we are floundering because we have forgotten or spurned the study and contemplation of our pasts, even of our recent histories, as irrelevant for the understanding and conduct of our contemporary affairs.'[13] This book has aimed to redress that neglect by showing how the study and contemplation of our histories, cast through the prism of art, ancient, modern and recent, can broaden our vision, empower critique and inspire respect and creativity.

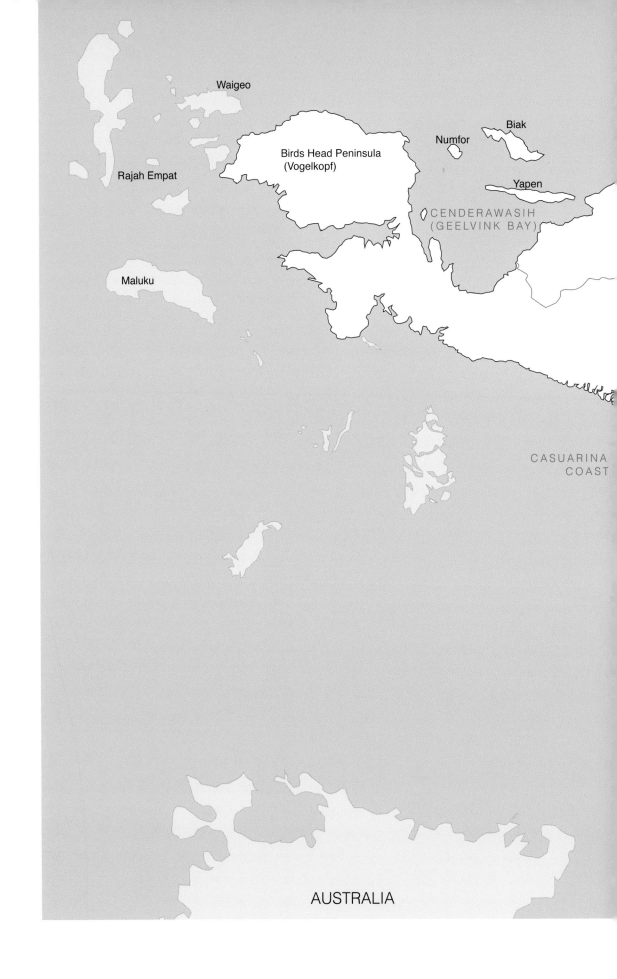

Waigeo

Rajah Empat

Maluku

Birds Head Peninsula
(Vogelkopf)

Numfor

Biak

Yapen

CENDERAWASIH
(GEELVINK BAY)

CASUARINA
COAST

AUSTRALIA

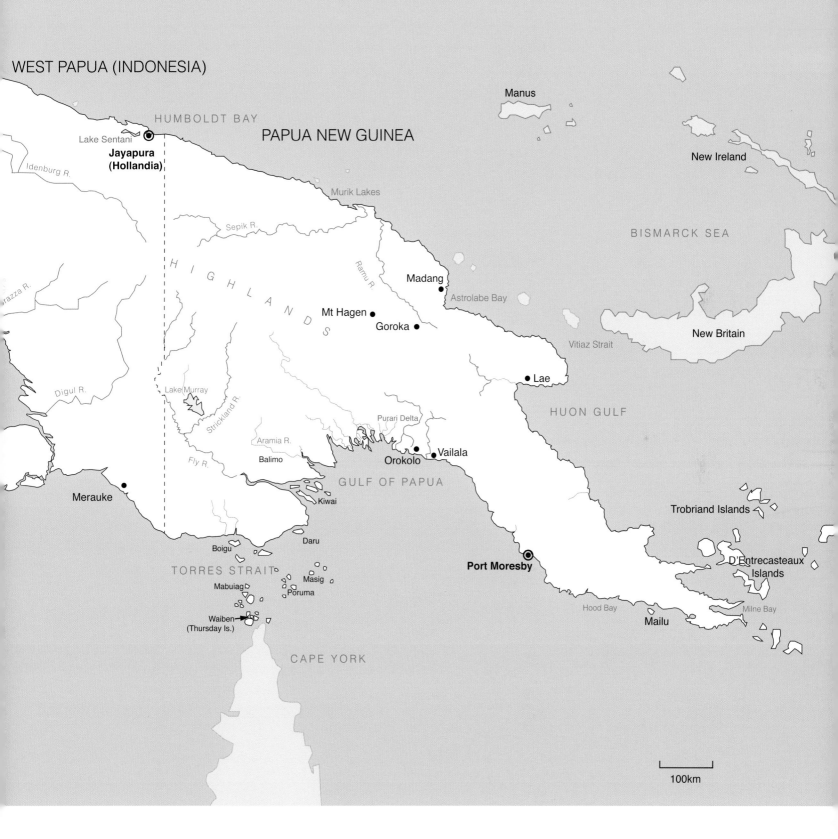

WEST PAPUA (INDONESIA)

PAPUA NEW GUINEA

Manus

New Ireland

BISMARCK SEA

HUMBOLDT BAY

Lake Sentani
**Jayapura
(Hollandia)**

Idenburg R.

Murik Lakes

Sepik R.

H I G H L A N D S

Ramu R.

Madang

Astrolabe Bay

New Britain

Mt Hagen

Goroka

Vitiaz Strait

Arazza R.

Digul R.

Lake Murray

Strickland R.

Lae

HUON GULF

Purari Delta

Aramia R.

Balimo

Orokolo

Vailala

Fly R.

GULF OF PAPUA

Merauke

Kiwai

Trobriand Islands

Boigu

Daru

D'Entrecasteaux
Islands

TORRES STRAIT

Mabuiag

Masig

Poruma

Port Moresby

Waiben →
(Thursday Is.)

Hood Bay

Mailu

Milne Bay

CAPE YORK

100km

NEW GUINEA

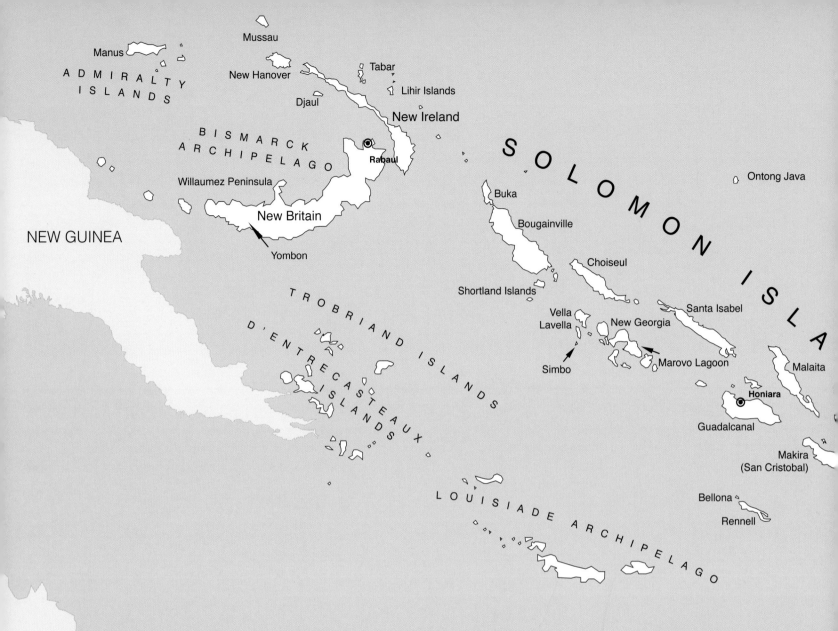

Manus

ADMIRALTY
ISLANDS

Mussau

New Hanover

Djaul

Tabar

Lihir Islands

New Ireland

BISMARCK
ARCHIPELAGO

Rabaul

Willaumez Peninsula

NEW GUINEA

New Britain

Yombon

TROBRIAND ISLANDS

D'ENTRECASTEAUX
ISLANDS

SOLOMON ISLA

Ontong Java

Buka

Bougainville

Choiseul

Shortland Islands

Vella
Lavella

New Georgia

Simbo

Marovo Lagoon

Santa Isabel

Malaita

Honiara

Guadalcanal

Makira
(San Cristobal)

Bellona

Rennell

LOUISIADE ARCHIPELAGO

AUSTRALIA

100km

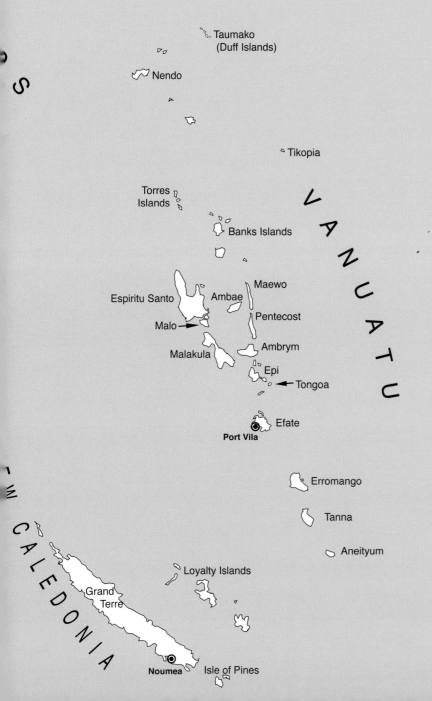

Taumako
(Duff Islands)

Nendo

Tikopia

Torres
Islands

Banks Islands

Maewo

Espiritu Santo Ambae

Malo →

Pentecost

Malakula

Ambrym

Epi

← Tongoa

Efate

Port Vila

Erromango

Tanna

Aneityum

Loyalty Islands

Grand
Terre

V A N U A T U

C A L E D O N I A

Noumea Isle of Pines

ISLAND MELANESIA

NORTHERN

MARIANA

ISLANDS

Saipan

Tinian

Rota

Guam

Ulithi

Fais

Yap

Ngulu

Sorol

Satawal

Chuuk

Babelthuap

PALAU

ISLANDS

CAROLINE

NEW GUINEA

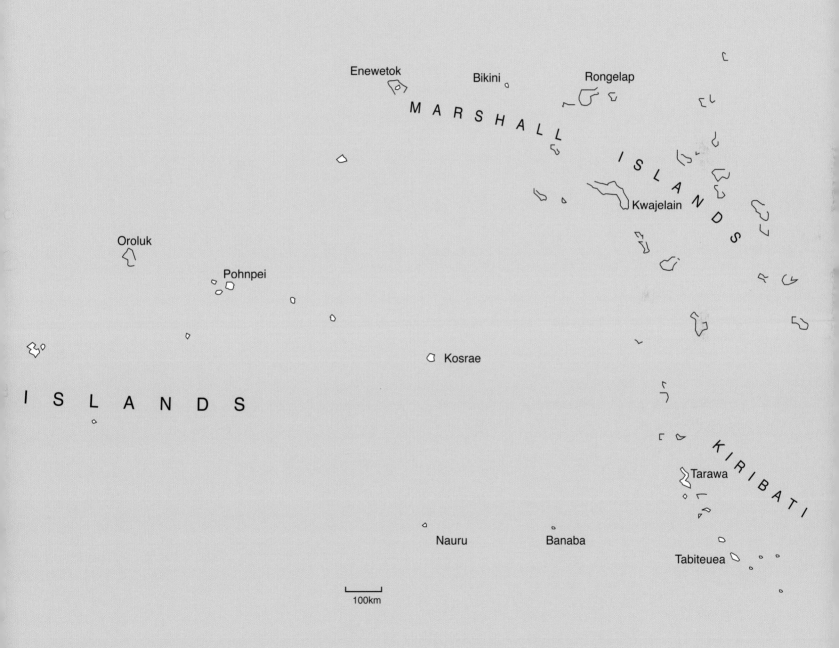

Enewetok Bikini Rongelap

M A R S H A L L I S L A N D S

Kwajelain

Oroluk

Pohnpei

I S L A N D S

Kosrae

K I R I B A T I

Tarawa

Nauru Banaba

Tabiteuea

100km

MICRONESIA

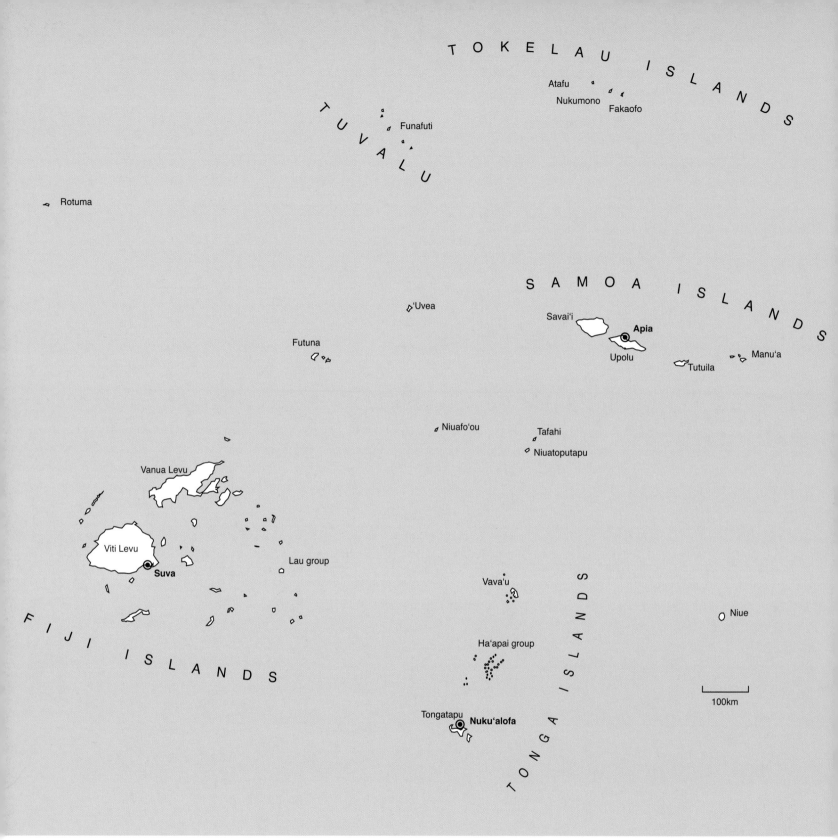

TOKELAU ISLANDS

Atafu
Nukumono
Fakaofo

TUVALU

Funafuti

Rotuma

SAMOA ISLANDS

'Uvea

Savai'i
Apia
Upolu
Manu'a
Tutuila

Futuna

Niuafo'ou
Tafahi
Niuatoputapu

Vanua Levu

Viti Levu
Suva

Lau group

Vava'u

Niue

Ha'apai group

FIJI ISLANDS

TONGA ISLANDS

100km

Tongatapu
Nuku'alofa

FIJI AND WESTERN POLYNESIA

MEXICO

HAWAIIAN ISLANDS

O'ahu Maui

Hawai'i

LINE ISLANDS

Kiritimati

MARQUESAS
ISLANDS

Penrhyn

TUAMOTU ARCHIPELAGO

Nuku Hiva

Hiva Oa

Ra'iatea Huahine

SOCIETY ISLANDS

Palmerston

Aitutaki

Tahiti

COOK ISLANDS

Rarotonga

Mangaia

Rurutu

AUSTRAL

Tubuai

Mururoa

PITCAIRN

Mangareva

ISLANDS

Pitcairn

GAMBIER

ISLANDS

ISLANDS

Rapa Nui

500 km

EASTERN AND NORTHERN POLYNESIA

NOTES

INTRODUCTION

1 For the evolution of these and related debates, see Charlotte Otten, *Anthropology and Art: Readings in Cross-Cultural Aesthetics* (New York: Natural History Press, 1971); Anthony Forge (ed.), *Primitive Art and Society* (London: Oxford University Press, 1973); Jeremy Coote and Anthony Shelton (eds.), *Anthropology, Art and Aesthetics* (Oxford: Oxford University Press, 1992); and Howard Morphy and Morgan Perkins (eds.), *The Anthropology of Art: A Reader* (Oxford: Blackwell Publishing, 2006).

2 Key early statements marking the sea-change in knowledge in Oceania include Epeli Hau'ofa, 'Anthropology and Pacific Islanders', *Oceania* 45 (1975), pp. 283–89, and Albert Wendt, 'Towards a New Oceania', *Mana Review: A South Pacific Journal of Language and Literature* (1976), pp. 49–60. See also Ulli Beier, *Decolonising the Mind* (Canberra: Pandanus Books, 2005). On collaboration, see Laura Peers and Alison K. Brown (eds.), *Museums and Source Communities* (London: Routledge, 2003), and Lissant Bolton, Nicholas Thomas, Elizabeth Bonshek, Julie Adams and Ben Burt (eds.), *Melanesia: Art and Encounter* (London: British Museum Press, 2012).

3 Nelson H. H. Graburn (ed.), *Ethnic and Tourist Arts: Cultural Expressions from the Fourth World* (Berkeley, CA: University of California Press, 1976) was a key early volume dedicated to various forms of 'neo-traditional' art. In the Pacific, Roger Neich's *Painted Histories: Early Maori Figurative Painting* (Auckland: Auckland University Press, 1993), and *Carved Histories: Rotorua Ngati Tarawhai Woodcarving* (Auckland: Auckland University Press, 2001), are landmark historical studies.

4 There are continuities in this respect between, for example, Ralph Linton and Paul S. Wingert, *Arts of the South Seas* (New York: Museum of Modern Art, 1946), and the most recent overviews, including A. L. Kaeppler, C. Kaufmann and D. Newton, *Oceanic Art* (New York: Abrams, 1997).

5 For general background, see the Solomon Islands section in Bolton, Thomas, Bonshek, Adams and Burt 2012; and on the specific genre, Deborah Waite, 'TOTO ISU (*NguzuNguzu*): War Canoe Prow Figureheads from the Western District, Solomon Islands', http://www.tribalarts.com/feature/solomon/index.html/ accessed 28 October 2010.

6 See 'Essays on Head-hunting in the Western Solomon Islands', Special Issue, *Journal of the Polynesian Society* 109 (1) (2000).

7 Edvard Hviding, personal communication; see also Hviding, 'War Canoes of New Georgia', in Ben Burt and Lissant Bolton (eds.), *The Things We Value: Culture and History in Solomon Islands* (Oxford: Sean Kingston Publishing, forthcoming).

8 Discussed in Nicholas Thomas, *Colonialism's Culture: Anthropology, Travel and Government* (Cambridge: Polity Press and Blackwell Publishers, 1994).

9 For Waitere, see Neich 2001, and Mark Adams, Nicholas Thomas, James Schuster and Lyonel Grant, *Rauru: Tene Waitere, Maori Carving, Colonial History* (Dunedin: Otago University Press, 2009).

10 Alfred Gell, *Art and Agency: An Anthropological Theory* (Oxford: Clarendon Press, 1998). Critical discussions include Robin Osborne and Jeremy Tanner (eds.), *Art's Agency and Art History* (Malden, MA: Blackwell Publishers, 2007).

11 For debate about history and historicity in Oceania, see works by Greg Dening, including *Performances* (Chicago, IL: University of Chicago Press, 1996), and Klaus Neumann, *Not the Way it Really Was: Constructing the Tolai Past* (Honolulu: University of Hawai'i Press, 1992).

12 Bernard Smith, *European Vision and the South Pacific*, 2nd ed. (London and New Haven, CT: Yale University Press, 1985). For New Zealand, see Leonard Bell, *Colonial Constructs: European Images of Maori, 1840–1914* (Auckland: Auckland University Press, 1992), and Francis Pound, *The Invention of New Zealand: Art and National Identity 1930–1970* (Auckland: Auckland University Press, 2009). For Hawai'i, see David Forbes, *Encounters with Paradise: Views of Hawai'i and its People, 1778–1941* (Honolulu: University of Hawai'i Press and Honolulu Academy of Arts, 1992). For Australia, see Terry Smith, *Transformations in Australian Art*, vols. 1 and 2 (Sydney: Craftsman House, 2002). It should be added that older books on the art of Oceania took the term to include Australia, but, like most recent scholars, we consider that the very ancient, culturally distinct and essentially 'continental' character of Aboriginal culture makes this inappropriate; in any case, Aboriginal art has deservedly emerged over the last thirty years as a field of study in itself.

13 Epeli Hau'ofa, 'Our Sea of Islands', in *A New Oceania: Rediscovering Our Sea of Islands*, Eric Waddell, Vijay Naidu, Epeli Hau'ofa (eds.) (Suva, Fiji: School of Social and Economic Development, The University of the South Pacific in association with Beake House, 1993), pp. 2–16, 8.

PART ONE: ART IN EARLY OCEANIA
AESTHETIC TRACES:
THE SETTLEMENT OF WESTERN OCEANIA

1 Patrick Kirch, *On The Road of the Winds: An Archaeological History of the Pacific Islands before European Contact* (Berkeley, CA: University of California Press, 2000), p. 67. The opening section of this chapter draws heavily on Kirch's history of Pacific settlement; his work is acknowledged here with appreciation.

2 Cited in Kirch 2000, p. 65.

3 G. Chaloupka and P. Giuliani, 'Strands of Time', in Louise Hamby (ed.), *Twined Together: Kunmadj Njalehnjaleken* (Gunbalanya: Injalak Arts and Crafts, 2005), pp. 2–17, 10.

4 Kirch 2000, p. 74.

5 Jim Allen and Chris Gosden, 'Rocks in the Head: Thinking about Distribution of Obsidian', in J. Davidson, G. Irwin, F. Leach, A. Pawley and D. Brown (eds.), *Oceanic Culture History: Essays in Honour of Roger Green*, in *New Zealand Journal of Archaeology* (1996), p. 185.

6 Matthew Spriggs, *The Island Melanesians* (Oxford: Blackwell Publishers, 1997), p. 29.

7 Kirch 2000, pp. 83–84.

8 ibid., pp. 70, 74.

9 Pamela Swadling, 'Changing Shorelines and Cultural Orientations in the Sepik-Ramu, Papua New Guinea: Implications for Pacific Prehistory', *World Archaeology* 29 (1) (1997), pp. 1–14, 6.

10 Pamela Swadling, 'The Huon Gulf and its Hinterlands: A Long-Term View of Coastal-Highlands Interactions', in *A Polymath Anthropologist: Essays in Honour of Ann Chowning*, Claudia Gross et al. (eds.), Research in Anthropology and Linguistics Monograph no. 6, University of Auckland (2005), pp. 1–14.

11 Swadling 'Changing Shorelines', p. 1.

12 Kirch 2000, p. 88.

13 Stuart Bedford and Christophe Sand, 'Lapita and Western Pacific Settlement: Progress, Prospects and Persistent Problems', in Stuart Bedford, Christophe Sand and Sean P. Connaughton (eds.), *Oceanic Explorations: Lapita and Western Pacific Settlement (Terra Australis 26)* (Canberra: ANU E Press, 2007), pp. 1–15, 2.

14 Kirch 2000, p. 90.

15 Patrick Kirch, *The Lapita Peoples: Ancestors of the Oceanic World* (Oxford: Blackwell Publishers, 1997), p. 133.

16 Bedford et al., 'The Excavation, Conservation and Reconstruction of Lapita Burial Pots from the Teouma Site, Efate, Central Vanuatu', in Bedford, Sand and Connaughton (eds.) 2007, pp. 223–40.

17 ibid.

18 Stuart Bedford and Matthew Spriggs, 'Birds on the Rim: A Unique Lapita Carinated Vessel in its Wider Context', *Archaeology in Oceania* 42 (1) (2007), pp. 12–21.

19 Robin Torrence and J. P. White, 'Tattooed Faces from Boduna Island, Papua New Guinea', in G. R. Clark, A. J. Anderson and T. Vunidilo (eds.), *The Archaeology of Lapita Dispersal in Oceania* (Canberra: Pandanus Books, 2001), pp. 135–40.

20 Christophe Sand, Jacques Bole and André Ouetcho, 'What is Archaeology for in the Pacific? History and Politics in New Caledonia', in Ian Lilley (ed.), *Archaeology of Oceania: Australia and the Pacific Islands* (Malden, MA: Blackwell Publishing, 2006), pp. 321–45.

21 Swadling 1997, p. 8.

22 The following account of New Caledonian archaeological research draws heavily from Sand, Bole and Ouetcho, 'What is Archaeology for in the Pacific?', pp. 321–45.

23 ibid., p. 329.

24 The next section draws on Matthew Spriggs, *The Island Melanesians* (Oxford: Blackwell Publishers, 1997).

25 José Garanger, *Archaéologie des Nouvelles Hébrides*, Publication de la Société des Océanistes, no. 30 (Paris: Société des Océanistes, 1972).

26 Spriggs 1997, p. 212.

27 ibid., pp. 215–17.

28 ibid., p. 231.

AFTER LAPITA: VOYAGING AND
MONUMENTAL ARCHITECTURE
*c.*900 BC – *c.* AD 1700

1 The sequence, direction and dating of discovery and settlement in the Pacific is a subject of continuous scholarly debate and revision in light of new evidence. This chapter takes as its guide three main books that summarize recent scholarship: K. R. Howe (ed.), *Vaka Moana: Voyages of the Ancestors: The Discovery and Settlement of the Pacific* (Auckland: David Bateman and Auckland Museum, 2006); K. R. Howe, *The Quest for Origins* (Auckland: Penguin Books, 2003); and Patrick Kirch, *On the Road of the Winds: An Archaeological History of the Pacific Islands before European Contact* (Berkeley, CA: University of California Press, 2000).

2 David Burley, 'Tongan Archaeology and the Tongan Past', *Journal of World Prehistory* 12 (3) (1998), pp. 353–54. Also see David Burley, Erle Nelson and Richard Shulter, 'A Radiocarbon Chronology for the Eastern Lapita Frontier in Tonga', *Archaeology in Oceania* 34 (1999), p. 66; and Patrick Kirch, *The Lapita Peoples: Ancestors of the Oceanic World* (Cambridge: Blackwell Publishers, 1997).

3 Burley, 'Tongan Archaeology and the Tongan Past', p. 354.

4 Kirch 2000, p. 96.

5 Kirch 1997, pp. 77–78.

6 See Geoffrey Clark and Tim Murray, 'Decay Characteristics of the Eastern Lapita Design System', *Archaeology in Oceania* 41 (2006), p. 115, and Glenn Summerhayes, 'Far Western, Western and Eastern Lapita: A Re-evaluation', *Asian Perspectives* 39 (1–2), p. 130. For a counter-view, see Simon Best, *Lapita: A View from the East* (Auckland: New Zealand Archaeological Association, 2002), p. 94.

7 Burley, 'Tongan Archaeology and the Tongan Past', pp. 359–60.

8 ibid., pp. 360–61; Kirch 2000, p. 258.

9 Janet Davidson, 'Samoa and Tonga', in J. D. Jennings (ed.), *The Prehistory of Polynesia* (Cambridge, MA: Harvard University Press, 1979), pp. 82–109.

10 Patrick Kirch and Roger Green, *Hawaiki, Ancestral Polynesia: An Essay in Historical Anthropology* (Cambridge: Cambridge University Press, 2001).

11 See Kirch 2000, pp. 232–45. On the argument for continuous Polynesian voyaging, see Geoffrey Irwin, *The Prehistoric Exploration and Colonisation of the Pacific* (Cambridge: Cambridge University Press, 1992), pp. 71–74.

12 Dates used in this chapter have been gleaned from Howe (ed.) 2006; Howe 2003; and Kirch 2000, see note 1.

13 Howe 2003, pp. 92–120.

14 David Summers, *Real Spaces: World Art History and the Rise of Western Modernism* (London: Phaidon Press, 2003), p. 201.

15 William Morgan, *Prehistoric Architecture in Micronesia* (Austin, TX: University of Texas Press, 1988), pp. 58–85. This section is indebted to the work of William Morgan.

16 ibid., p. 70.

17 ibid., pp. 86–115.

18 ibid., p. 102.

19 ibid., pp. 116–49.

20 On Polynesian chiefdoms, see Patrick Kirch, *Evolution of the Polynesian Chiefdoms* (Cambridge: Cambridge University Press, 1984).

21 The following section on Lapaha and the Tu'i Tonga is particularly indebted to two articles: Burley 'Tongan Archaeology and the Tongan Past', pp. 368–79; and Geoffrey Clark, David Burley and Tim Murray, 'Monumentality and the Development of the Tongan Maritime Chieftainship', *Antiquity* 82 (2008), pp. 994–1,008. Their work is acknowledged here with appreciation.

22 Clark, Burley and Murray 'Monumentality', p. 1,001.

23 ibid., p. 1,005–7.

24 Jean Guiart, 'Apendice – Un état palatial océanien: l'empire maritime des Tui Tonga', in J. Guiart (ed.), *Structure de la Chefferie en Mélanésie du Sud* (Paris: Institut d'Ethnologie, 1963), pp. 661–97; quoted in Burley 'Tongan Archaeology and the Tongan Past', p. 368.

25 Adrienne Kaeppler, 'Exchange Patterns in Goods and Spouses; Fiji, Tonga and Samoa', *Mankind* 11, 3 (1978), pp. 246–52; Alfred Gell, *Wrapping in Images: Tattooing in Polynesia* (Oxford: Clarendon Press, 1993), pp. 106–20; and Burley 1998, p. 377.

26 Elizabeth Wood-Ellem, 'Conspiracies and Rumours of Conspiracies in Tonga', in Wood-Ellem (ed.), *Tonga and the Tongans: Heritage and Identity* (Sydney: Tonga Research Association, 2007), p. 127.

27 Geoffrey Clark and Helene Martinsson-Wallin, 'Monumental Architecture in West Polynesia: Origins, Chiefs and Archaeological Approaches', *Archaeology in Oceania* 42 (October 2007), pp. 28–40, 30.

28 See David Herdrich, 'Towards an Understanding of Samoan Star Mounds', *Journal of the Polynesian Society* 100 (1991), pp. 405–17; and Patrick Kirch, *On the Road of the Winds: An Archaeological History of the Pacific Islands before European Contact* (Berkeley, CA: University of California Press, 2000), p. 223.

29 Geoffrey Clark, Helene Martinsson-Wallin, Paul Wallin, 'Excavation of the Pulemelei Site 2002–2004', *Archaeology in Oceania* 42 (2007, supplement), pp. 41–59; and Paul Wallin and Helene Martinsson-Wallin, 'Settlement Patterns – Social and Ritual Space in Prehistoric Samoa', ibid., pp. 83–89.

30 Kirch 2000, p. 235.

31 Anne Salmond, *Aphrodite's Island: The European Discovery of Tahiti* (Harmondsworth: Penguin, 2009), pp. 22–32, 28.

32 Kenneth Emory, 'The Societies', in Nancy Pollock and Ron Crocombe (eds.), *French Polynesia: A Book of Selected Readings* (Suva: University of the South Pacific, 1988), pp. 39–40.

33 Alfred Métraux, *Easter Island: A Stone-Age Civilization of the Pacific*, trans. Michael Bullock (London: André Deutsch, 1957), pp. 149–70.

34 Douglas Sutton, Louise Furey and Yvonne Marshall, *Archaeology of Pouerua* (Auckland: Auckland University Press, 2003), p. 232.

35 ibid., p. 237.

36 Howe (ed.) 2006, p. 91. On coastal voyaging, see Roger Neich, 'Pacific Voyaging after the Exploration Period', ibid., pp. 198–245.

PART TWO: NEW GUINEA 1700–1940
ART, TRADE AND EXCHANGE:
NEW GUINEA 1700–1900

1 Clive Moore, *New Guinea: Crossing Boundaries and History* (Honolulu: University of Hawai'i Press, 2003), p. 21. This book provides the most up-to-date historical overview.

2 Melanesian leadership, political systems and gender relations have been extensively debated. Important studies, which include citations to the extensive literature, include M. Godelier and M. Strathern (eds.), *Big Men and Great Men: Personifications of Power in Melanesia* (Cambridge: Cambridge University Press, 1991), and Marilyn Strathern, *The Gender of the Gift* (Berkeley, CA: University of California Press, 1988).

3 The arts of New Guinea are well represented in many compendia ranging from Carl A. Schmitz, *Oceanic Art: Myth, Man and Image in the South Seas* (New York: Abrams, 1969), to Adrienne Kaeppler, Christian Kaufmann and Douglas Newton, *Oceanic Art* (New York: Oxford University Press, 1997). Philippe Peltier and Floriane Morin (eds.), *Shadows of New Guinea: Art from the Great Island of Oceania in the Barbier-Mueller Collections* (Geneva: Somogy, 2006), and John Friede et al., *New Guinea Art: Masterpieces from the Jolika Collection of Marcia and John Friede* (San Francisco, CA: Fine Arts Museums of San Francisco in association with 5 Continents Editions, Milan, 2005), are partial catalogues of two highly significant private collections.

4 Bruce M. Knauft, *South Coast New Guinea Cultures: History, Comparison, Dialectic* (Cambridge: Cambridge University Press, 1993), p. 40.

5 Jack Golson, 'The Ipomoean Revolution Revisited: Society and the Sweet Potato in the Upper Wahgi Valley', in Andrew Strathern (ed.), *Inequality in New Guinea Highlands Societies* (Cambridge: Cambridge Papers in Social Anthropology, 1982), p. 115.

6 Michael O'Hanlon, *Paradise: Portraying the New Guinea Highlands* (London: British Museum Press, 1993), pp. 14–17. Classic studies of Highlands body art include Andrew and Marilyn Strathern, *Self-Decoration in Mount Hagen* (London: Duckworth, 1971); the standard work on *bilums* is Maureen MacKenzie, *Androgynous Objects: String Bags and Gender in Central New Guinea* (London: Routledge, 1991).

7 See e.g. Dirk Smidt (ed.), *Asmat Art: Woodcarvings of Southwest New Guinea* (New York: George Braziller in association with Rijksmuseum voor Volkenkunde, Leiden, 1993), and Dirk Smidt (ed.), *Kamoro Art: Tradition and Innovation in a New Guinea Culture* (Amsterdam: KITLV Press, 2003). Kamoro were formerly known as Mimika.

8 Sidney Littlefield Kasfir, 'One Tribe, One Style? Paradigms in the Historiography of African Art', *History in Africa* 11 (1984), pp. 163–93.

9 Ralph and Susan Bulmer, 'Figurines and Other Stones of Power among the Kyaka', *Journal of the Polynesian Society* 71 (1963), pp. 192–208, dealt with the then-contemporary significance of prehistoric stone pieces among an eastern Enga people. Matthew Spriggs, 'Three Carved Cone Shells from Collingwood Bay', in Lissant Bolton, Nicholas Thomas, Elizabeth Bonshek, Julie Adams and Ben Burt (eds.), *Melanesia: Art and Encounter* (London: British Museum Press, 2012), deals with decorated shells from what is now Oro Province.

10 The argument for a swift and revolutionary transformation was first articulated by J. B. Watson in the mid-1960s, 'From Hunting to Horticulture in the New Guinea Highlands', *Ethnology* 4 (1965), pp. 295–309; the extensive subsequent debate is deftly reviewed by Chris Ballard, 'Still Good to Think With: The Sweet Potato in Oceania', in Chris Ballard, Paula Brown, R. M. Bourke and Tracy Harwood (eds.), *The Sweet Potato in Oceania: A Reappraisal* (Pittsburgh, NJ: University of Pittsburgh Press, 2005).

11 Golson, 'The Ipomoean Revolution Revisited', p. 132. Golson also broaches the possibility that pre-Ipomoean society was more hierarchical: sweet potato opened the way for many more men to enter competitive exchanges.

12 Nancy Lutkehaus et al. (eds.), *Sepik Heritage: Tradition and Change in Papua New Guinea* (Bathurst, New South Wales: Crawford House Publishing, and Durham, NC: University of North Carolina Press, 1990), p. 36.

13 Jürg Wassman, 'The Nyaura Concepts of Space and Time', in Lutkehaus et al. (eds.) 1990, pp. 23–35.

14 Anthony Forge, 'The Power of Culture and the Culture of Power', in Lutkehaus et al. (eds.) 1990, pp. 160–70.

15 ibid., p. 163.

16 Colin Filer, 'Diversity of Cultures or Culture of Diversity', in Lutkehaus et al. (eds.) 1990, pp. 116–28.

17 Bronislaw Malinowski, *Argonauts of the Western Pacific* (London: Routledge, 1922); Marcel Mauss, *Essai sur le don*, in *Sociologie et Anthropologie* (Paris, 1923–24); *The Gift*, trans. Ian Cunnison (London: Cohen and West, 1954).

18 Jaap Timmer, 'Cloths of Civilisation: Kain Timur in the Bird's Head of West Papua', *Asia-Pacific Journal of Anthroplogy* 12 (2011), pp. 383–401.

19 Dirk Smidt, 'The Korwar Area', in Peltier and Morin (eds.) 2006, pp. 30–49, 36.

20 Timmer, 'Cloths of Civilisation', pp. 391–92.

21 Suzanne Greub, *Art of Northwest New Guinea: From Geelvink Bay, Humbolt Bay, and Lake Sentani* (New York: Rizzoli, 1992).

22 The section that follows is quoted with only minor amendment from Lissant Bolton's essay, 'Explorers and Traders of South Papua', in *In the Wake of the Beagle: Science in the Southern Oceans from the Age of Darwin*, ed. Iain McCalman and Nigel Erskine (Sydney: National Maritime Museum, 2009), pp. 115–20.

23 F. R. Barton, 'The Annual Trading Voyage to the Papuan Gulf', in C. G. Seligman, *The Melanesians of British New Guinea* (Cambridge: Cambridge University Press, 1910), p. 96. See also Tom Dutton (ed.), *The Hiri in History* (Canberra: The Australian National University, 1982), and – on this subject more generally – Jim Specht and J. Peter White (eds.), *Trade and Exchange in Oceania and Australia*, special issue, *Mankind* 11 (3) (1978).

24 Barton, 'The Annual Trading Voyage', p. 104.

25 Bronislaw Malinowski, 'The Natives of Mailu', *Transactions of the Royal Society of South Australia* 29 (1915), p. 628.

26 Discussed in David Lipset, *Mangrove Man: Dialogics of Culture in the Sepik Estuary* (Cambridge: Cambridge University Press, 1997), p. 23.

27 Alfred Gell, *Art and Agency: An Anthropological Theory* (Oxford: Oxford University Press, 1998).

28 A. C. Haddon and James Hornell, *Canoes of Oceania* (Honolulu: Bernice P. Bishop Museum, 1936–38), II, p. 231.

ART, WAR AND PACIFICATION:
NEW GUINEA 1840–1940

1 Frank Hurley, *Pearls and Savages: Adventures in the Air, on Land and Sea in New Guinea* (New York and London: Putnam, 1923, 1924), p. 383. For Hurley, a consummate

'showman', and the film, *Pearls and Savages*, see Jim Specht and John Fields, *Frank Hurley in Papua: Photographs of the 1920–1923 Expeditions* (Sydney: Australian Museum Trust, 1984), and Nicholas Thomas, *Entangled Objects: Exchange, Material Culture and Colonialism in the Pacific* (Cambridge, MA: Harvard University Press, 1991), pp. 178–82. The Australian Museum and the National Library of Australia hold major collections of Hurley's Papuan photographs.

2 For a useful summary of Sir Hubert Murray's philosophy and colonial regime, see Hank Nelson, 'Murray, Sir John Hubert Plunkett (1861–1940)', *Australian Dictionary of Biography* (adbonline.anu.edu.au/biogs/A100629b.htm). The discussion of changing perceptions of Melanesian warfare is indebted to Bruce Knauft, 'Melanesian Warfare: A Theoretical History', *Oceania* 60 (1990), pp. 250–311.

3 Knauft, 'Melanesian Warfare', pp. 274–75.

4 War has been intermittently a theme in the anthropology of New Guinea: see Knauft, 'Melanesian Warfare'. A. P. Vayda's *War in Ecological Perspective: Persistence, Change and Adaptive Process* (New York: Plenum Press, 1976), reflected an environmental approach that was influential for a period. Simon Harrison, *The Mask of War: Violence, Ritual and the Self in Melanesia* (Manchester: Manchester University Press, 1993), is among the more ambitious of recent studies. The propensity, discussed by Knauft, of liberal scholars to de-emphasize warfare may be reflected in the topic's near absence in anthologies on Oceanic art, such as the volumes generated by the Pacific Arts Association's symposia (e.g. Sidney M. Mead, ed., *Exploring the Visual Art of Oceania* [Honolulu: University of Hawai'i Press, 1979]). War unavoidably featured, though, in studies of groups among whom the most obvious art objects were associated with war: e.g. Dirk Smidt (ed.), *Asmat Art: Woodcarvings of Southwest New Guinea* (New York: George Braziller in association with Rijksmuseum voor Volkenkunde, Leiden, 1993).

5 For an important recent survey, see Harry Beran and Barry Craig (eds.), *Shields of Melanesia* (Adelaide: Crawford House Publishing, 2005). This section is also informed by a recent British Museum exhibition, 'Dazzling the Enemy: Shields from the Pacific' (May– August 2009).

6 Smidt (ed.) 1993, p. 61.

7 Lissant Bolton, Liz Bonshek, Julie Adams and Ben Burt, 'Dazzling the Enemy', unpublished catalogue, 2009, p. 16.

8 Michael O'Hanlon, 'Modernity and the "Graphicalization" of Meaning: New Guinea Highland Shield Design in Historical Perspective', *Journal of the Royal Anthropological Institute* 1 (1995), pp. 472–74.

9 Bolton et al., 'Dazzling the Enemy', pp. 21, 31–32.

10 E. R. Leach, 'A Trobriand Medusa?', *Man* 54 (1954), pp. 103–05. Several commentaries in succeeding issues disputed Leach's interpretation; for recent local exegesis, see Harry Beran, 'Bronislaw Malinowski and Paramount Chief Pulayasi on Trobriand Shields', in Lissant Bolton, Nicholas Thomas, Elizabeth Bonshek, Julie Adams and Ben Burt (eds.), *Melanesia: Art and Encounter* (London: British Museum Press, 2012).

11 Gender has been a prominent theme in the anthropology of New Guinea cultures, but in relation to the interplay of male and female symbolism in material artefacts, see especially Maureen MacKenzie, *Androgynous Objects: String Bags and Gender in Central New Guinea* (London: Routledge, 1991).

12 Nicholas Thomas, 'Sam Luguna on Trobriand Shields', in Bolton et al. 2012.

13 Anthony Forge was one of the first to pose the problem of meaning in relation to an apparent lack of local exegesis; see especially Forge, 'Style and Meaning in Sepik Art', in Forge (ed.), *Primitive Art and Society* (London: Oxford

University Press, 1973). The theme remained central to debate in the anthropology of art subsequently: see, e.g., Jeremy Coote and Anthony Shelton (eds.), *Anthropology, Art and Aesthetics* (Oxford: Oxford University Press, 1992). Michael O'Hanlon, 'Unstable Images and Second Skins: Artefacts, Exegesis and Assessments in the New Guinea Highlands', *Man* 27 (1992), pp. 587–608, is also illuminating.

14 Michael O'Hanlon, 'Modernity and the "Graphicalization" of Meaning: New Guinea Highland Shield Design in Historical Perspective', *Journal of the Royal Anthropological Institute* 1 (1995), pp. 476–77.

15 Notably Howard Morphy, 'From Dull to Brilliant: The Aesthetics of Spiritual Power among the Yolngu' (1992), reprinted in Morphy and Morgan Perkins (eds.), *The Anthropology of Art: A Reader* (Oxford: Blackwell Publishing, 2006).

16 See Nicholas Thomas, 'Kiss the Baby Goodbye: Kowhaiwhai and Aesthetics in Aotearoa New Zealand', *Critical Inquiry* 22 (1995), esp. pp. 98–103. These arguments are readily extrapolated to presentations of barkcloth, in Fiji and western Polynesia, for example, and the dazzling qualities of shell inlaid decoration in black wooden objects in the Solomon Islands.

17 The distinction between these regimes of value has been much discussed since Marilyn Strathern's essay, 'Kinship and Economy: Constitutive Orders of a Provisional Kind', *American Ethnologist* 12 (1985), pp. 191–209; it subsequently loomed large in comparative analyses such as M. Strathern and M. Godelier (eds.), *Big Men and Great Men: Personifications of Power in Melanesia* (Cambridge: Cambridge University Press, 1991). For a broader discussion of south coast society, etcetera, see Bruce Knauft, *South Coast New Guinea Cultures: History, Comparison, Dialectic* (Cambridge: Cambridge University Press, 1993).

18 Jan van Baal, *Dema: Description and Analysis of Marind-Anim Culture (South New Guinea)* (The Hague: Martinus Nijhoff, 1966), especially chapter 12. See also Paul Wirz's important early work, *Die Marind-anim von Hollandisch-Sud-Neu-Guinea* (Hamburg: Hamburg University, 1922–25); more recent publications include Raymond Corbey, *Headhunters from the Swamps: The Marind Anim of New Guinea as Seen by the Missionaries of The Sacred Heart, 1905–1925* (Leiden: KITLV Press, 2010).

19 Van Baal 1966, p. 713.

20 F. E. Williams, *Papuans of the Trans-Fly* (Oxford: Clarendon Press, 1936), pp. 264ff.

21 Van Baal 1966, pp. 724–33.

22 Williams 1936, p. 267.

23 ibid., pp. 267–68.

24 Van Baal 1966, pp. 714–17; Knauft, 'Melanesian Warfare', pp. 282–83.

25 Williams 1936, p. 282.

26 Marilyn Strathern, 'Prefigured Features: A View from the New Guinea Highlands', *The Australian Journal of Anthropology* 8 (1997), p. 94.

27 A. C. Haddon, 'The Kopiravi Cult of the Namau, Papua', *Man* 19 (1919), pp. 177–79.

28 Clive Moore, *New Guinea: Crossing Boundaries and History* (Honolulu: University of Hawai'i Press, 2003), pp. 181–85.

29 ibid., pp. 125–26.

30 Nicholas Thomas, *Islanders: The Pacific in the Age of Empire* (London and New Haven, CT: Yale University Press, 2010), pp. 251–62.

31 *British New Guinea: Annual Report for 1899–1900*, p. 19.

32 Knauft, 'Melanesian Warfare', p. 287.

33 *British New Guinea: Annual Report for 1895–1896*, p. 30.

34 ibid., p. 31.

35 Corbey 2010.

36 Thanks particularly to Michael O'Hanlon for advice on this topic. See Colin Simpson, *Plumes and Arrows:*

Inside New Guinea (Sydney: Angus & Robertson, 1962), pp. 215ff.

COSMOLOGIES AND COLLECTIONS: NEW GUINEA 1880–1940

1 The best studies for these media are Maureen MacKenzie, *Androgynous Objects: String Bags and Gender in Central New Guinea* (London: Routledge, 1991), and Patricia May and Margaret Tuckson, *The Traditional Pottery of Papua New Guinea* (Sydney: Bay Books, 1982).

2 New Guinea ritual has generated a rich and very extensive ethnographic literature over the last century, and it would be arbitrary to single out a few individual studies for citation here. It may be useful, however, to mention important anthologies that include useful bibliographies: Gilbert H. Herdt (ed.), *Rituals of Manhood: Male Initiation in Papua New Guinea* (Berkeley, CA: University of California Press, 1982); Maurice Godelier and Marilyn Strathern (eds.), *Big Men and Great Men: Personifications of Power in Melanesia* (Cambridge: Cambridge University Press, 1991); and Paul Sillitoe, *An Introduction to the Anthropology of Melanesia* (Cambridge: Cambridge University Press, 1998).

3 Gregory Bateson, *Naven: A Survey of the Problems Suggested by a Composite Picture of the Culture of a New Guinea Tribe Drawn from Three Points of View*, 2nd ed. (Stanford, CA: Stanford University Press, 1958 [orig. 1936]). See also Anita Herle and Andrew Moutu, *Paired Brothers: Concealment and Revelation* (Cambridge: Cambridge University Press, 2004).

4 Bateson 1958, p. 6.

5 Herle and Moutu 2004, p. 37.

6 This section draws particularly on A. L. Crawford, *Aida: Life and Ceremony of the Gogodala* (Bathurst, New South Wales: Robert Brown Associates/National Cultural Council of Papua New Guinea, 1981), and more recent studies by Alison Dundon, 'A Cultural Revival and the Custom of Christianity in Papua New Guinea', in Kathryn Robinson (ed.), *Self and Subject in Motion: Southeast Asian and Pacific Cosmopolitans* (London: Palgrave, 2007); and 'Moving the Centre: Christianity, the Longhouse and the Gogodala Cultural Centre', in Nick Stanley (ed.), *The Future of Indigenous Museums: Perspectives from the Southwest Pacific* (New York: Berghahn Books, 2007).

7 Crawford 1981, pp. 40–41.

8 Bernard Lea, *Papua Calling* (Melbourne: Bacon/UFM, 1940), p. 22; quoted and discussed by Crawford, ibid., pp. 40–45, and also Dundon, 'Moving the Centre', pp. 151–69.

9 Crawford 1981, 42ff.

10 Suzanne Greub, *Art of Northwest New Guinea: From Geelvink Bay, Humboldt Bay, and Lake Sentani* (New York: Rizzoli, 1992), p. 93.

11 Crawford 1981, p. 43.

12 Dundon, 'A Cultural Revival', p. 130.

13 Studies published in 1923 and 1934 were republished in F. E. Williams, *'The Vailala Madness' and Other Essays*, ed. Eric Schwimmer (St Lucia, Queensland: University of Queensland Press, 1976).

14 ibid., p. 360.

15 ibid., p. 361.

16 Williams, 'Trading Voyages from the Gulf of Papua' (1932/33), reprinted in *'The Vailala Madness'*, chapter 1.

17 Again, there is a vast literature on this topic. One of the most influential studies in New Guinea was Peter Lawrence's *Road Belong Cargo: A Study of the Cargo Movement in the Southern Madang District, New Guinea* (Melbourne: Melbourne University Press, 1964). The many movements, apparently of the same kind, prompted comparative studies such as Peter Worsley's

The Trumpet Shall Sound: A Study of 'Cargo' Cults in Melanesia (London: McGibbon and Kee, 1957). Later critical studies included Roger M. Keesing, 'Politico-Religious Movements and Anti-Colonialism on Malaita', *Oceania* 48 (1978), pp. 241–61; 49: pp. 46–73; and Martha Kaplan, *Neither Cargo nor Cult* (Durham, NC: Duke University Press, 1995).

18 See Roger M. Keesing and Robert Tonkinson (eds.), *Reinventing Traditional Culture,* special issue, *Mankind* 13 (1982), and Margaret Jolly and Nicholas Thomas (eds.), *The Politics of Tradition in the Pacific*, special issue, *Oceania* 62 (1992).

19 Both these collections are discussed in Lissant Bolton, Nicholas Thomas, Elizabeth Bonshek, Julie Adams and Ben Burt (eds.), *Melanesia: Art and Encounter* (London: British Museum Press, 2012).

20 Michael O'Hanlon and Robert L. Welsch (eds.), *Hunting the Gatherers: Ethnographic Collectors, Agents and Agency in Melanesia, 1870s–1920s* (New York: Berghahn Books, 2000), is an invaluable set of studies in this area.

21 See Rainer Buschmann, 'Exploring Tensions in Material Culture: Commercialising Ethnography in German New Guinea, 1870–1914', and Robert L. Welsch, 'One Time, One Place, Three Collections: Colonial Process and the Shaping of Some Museum Collections from German New Guinea', both in O'Hanlon and Welsch 2000. For the Cambridge expedition, see Anita Herle and Sandra Rouse (eds.), *Cambridge and the Torres Strait: Centenary Essays on the 1898 Anthropological Expedition* (Cambridge: Cambridge University Press, 1998); Robert. L. Welsch, *An American Anthropologist in Melanesia*, 2 vols. (Honolulu: University of Hawai'i Press, 1998), is a magnificent and full study of A. B. Lewis's expedition and collection.

22 This section is indebted to Michael O'Hanlon, '"Mostly harmless"? Missionaries, Administrators and Material Culture on the Coast of New Guinea', *Journal of the Royal Anthropological Institute* 5 (1999), pp. 377–97.

23 James Chalmers and William Wyatt Gill, *Work and Adventure in New Guinea 1877 to 1885* (London: Religious Tract Society, 1885?), p. 251.

24 O'Hanlon, '"Mostly harmless"?', p. 384.

25 Nicholas Thomas, *Entangled Objects: Exchange, Material Culture and Colonialism in the Pacific* (Cambridge, MA: Harvard University Press, 1991), pp. 165–67.

PART THREE: ISLAND MELANESIA 1700–1940 PLACE, WARFARE AND TRADE 1700–1840

1 Kirk Huffman, 'Trading, Cultural Exchange and Copyright: Important Aspects of Vanuatu Arts', in Joël Bonnemaison, Kirk Huffman, Christian Kaufmann and Darrell Tryon (eds.), *Arts of Vanuatu* (Honolulu: University of Hawai'i Press, 1996), p. 194.

2 See Jean Guiart, *Structure de la chefferie en Mélanésie du Sud*, Travaux et mémoires de l'Institut d'ethnologie (Paris: Institut d'Ethnologie, 1963); David Luders, 'Legend and History: Did the Vanuatu-Tonga Kava Trade Cease in A.D. 1447?', *Journal of the Polynesian Society* 105 (3) (1996), pp. 287–310; David Luders, 'Retoka Revisited and Roimata Revised', *Journal of the Polynesian Society* 110 (3) (2001), pp. 247–87.

3 Luders, 'Retoka Revisited and Roimata Revised', p. 254.

4 Ben Burt, 'Introduction', in Ben Burt and Michael Kwa'ioloa (eds.), *A Solomon Islands Chronicle, as told by Samuel Alasa'a* (London: British Museum Press, 2001), p. 3.

5 ibid.

6 Marie-Joseph Dubois, 'Vanuatu Seen from Maré', in Bonnemaison et al. (eds.) 1996, p. 82.

7 Mary Patterson, 'Moving Histories: An Analysis of the Dynamics of Place in North Ambrym, Vanuatu', *The Australian Journal of Anthropology* 13 (2) (2002), p. 214.

8 Joël Bonnemaison, 'The Tree and the Canoe: Roots and Mobility in Vanuatu Societies', *Pacific Viewpoint* 25 (2) (1984), p. 118; see also J. P. Taylor, *The Other Side: Ways of Being and Place in Vanuatu*, Pacific Islands Monograph Series 22 (Honolulu: University of Hawai'i Press, 2008).

9 Darrell Tryon, 'The Peopling of Oceania: The Linguistic Evidence', in Bonnemaison et al. (eds.) 1996, pp. 54–61.

10 For example, see C. Hyslop, 'The Linguistics of Inhabiting Space: Spatial Reference in the North-east Ambae Language', *Oceania* 70 (1999), p. 39; Edvard Hviding, *Guardians of the Morovo Lagoon: Practice, Place and Politics in Maritime Melanesia*, Pacific Islands Monograph Series 14 (Honolulu: University of Hawai'i Press, 1996), p. 85.

11 N. Bubandt, 'Speaking of Places: Spatial Poesis and Localized Identity in Buli', in J. J. Fox (ed.), *The Poetic Power of Place* (Canberra: Australian National University, 1997), pp. 132–33.

12 R. Richards and K. Roga, *Not Quite Extinct: Melanesian Barkcloth ('tapa') from Western Solomon Islands* (Wellington: Paremata Press, 2005), p. 43.

13 Richard Feinberg, *Polynesian Seafaring and Navigation: Ocean Travel in Anutan Culture and Society* (Kent, OH: Kent State University Press, 1988), p. 112.

14 Martha Alick, pers. comm., 2000.

15 See Hviding 1996, p. 233, for New Georgia; Tim Curtis, 'Talking about Place: Identities, Histories, and Powers among the Na'hai Speakers of Malekula (Vanuatu)', PhD Thesis, Australian National University, Canberra, 2003, for Tomman Island, Malakula.

16 Hviding 1996, p. 192.

17 Sophie Nempan (n.d.), report to the 2002 Women Fieldworkers Workshop, Vanuatu Cultural Centre, Port Vila. Audio recording held in Vanuatu National Film and Sound Archive, manuscript in Nempan's possession.

18 Hviding 1996, p. 15.

19 J. Clifford, *Person and Myth: Maurice Leenhardt in the Melanesian World* (Berkeley, CA: University of California Press, 1982), p. 38.

20 Maurice Leenhardt, *Do kamo: Person and Myth in the Melanesian World* (Chicago, IL: University of Chicago Press, 1979 [1947]), p. 109.

21 ibid.

22 ibid., p. 93.

23 Clifford 1982, p. 173.

24 Leenhardt 1979 [1947], p. 93.

25 A. Bensa and A. Goromido, 'The Political Order and Corporal Coercion in Kanak Societies of the Past (New Caledonia)', *Oceania* 68 (2) (1997), p. 96.

26 A. M. Hocart, 'The Cult of the Dead in Eddystone of the Solomons', *Journal of the Royal Anthropological Institute of Great Britain and Ireland* 52 (1922), pp. 71–117, 259–305.

27 Lissant Bolton, 'Women, Place and Practice in Vanuatu: A View from Ambae', in L. Bolton (ed.), 'Fieldwork, Fieldworkers: Developments in Vanuatu Research', *Oceania*, Special Issue 70 (1) (1999), pp. 47–48.

28 R. Walter, T. Thomas and P. Sheppard, 'Cult Assemblages and Ritual Practice in Roviana Lagoon, Solomon Islands', *World Archaeology* 36 (1) (2004), p. 150.

29 ibid.

30 Bronwen Douglas, *Across the Great Divide: Journeys in History and Anthropology* (Amsterdam: Harwood Academic Publishers, 1998), p. 126.

31 ibid.

32 Bensa and Goromido, 'The Political Order', p. 96.

33 H. A. Robertson, *Erromanga: The Martyr Isle* (London: Hodder and Stoughton, 1902), pp. 392, 22.

34 M. Wilson, 'Bringing the Art Inside: A Preliminary Analysis of Black Linear Rock-Art from Limestone Caves in Erromango, Vanuatu', *Oceania* 70 (1999), pp. 87–97.

35 Richard Walter and Peter Sheppard, 'Nusa Roviana: The Archaeology of a Melanesian Chiefdom', *Journal of Field Archaeology* 27 (3) (2000), pp. 295–318.

36 Robertson 1902, pp. 371–72.

37 Jerry Taki, pers. comm., 2007.

38 ibid.

39 See *Journal of the Polynesian Society* 109 (1) (March 2009), special issue on headhunting in the western Solomons.

40 A. M. Hocart, 'Warfare in Eddystone of the Solomon Islands', *The Journal of the Royal Anthropological Institute of Great Britain and Ireland* 61 (1931), pp. 302–3.

41 Kenneth Roga, pers. comm., 2006.

42 Quoted in Hviding 1996, pp. 176–78.

43 F. Speiser, *Ethnology of Vanuatu: An Early Twentieth-Century Study* (Bathurst, New South Wales: Crawford House Publishing, 1991 [1923]), p. 225.

44 ibid.

45 Feinberg 1988, p. 63.

46 This section is indebted to Huffman, 'Trading, Cultural Exchange and Copyright'.

47 K. R. Howe, *The Loyalty Islands: A History of Culture Contacts, 1840–1900* (Honolulu: University of Hawai'i Press, 1977), p. 8.

48 Huffman, 'Trading, Cultural Exchange and Copyright', p. 187.

49 ibid., p. 189.

50 William Davenport, 'Social Structure of Santa Cruz Island' in W. H. Goodenough (ed.), *Explorations in Cultural Anthropology: Essays in Honor of George Peter Murdock* (New York: McGraw-Hill, 1964), p. 62.

51 H. G. Beasley, 'Notes on Red Feather Money from Santa Cruz Group, New Hebrides', *Journal of the Royal Anthropological Institute of Great Britain and Ireland* 66 (1936), pp. 380–84.

INCURSIONS: LOSS, CONTINUITY AND ADAPTATION 1840–1900

1 I use the term 'Europeans' to index people of European origin, even though they may have come more directly from other places, such as Australia, Canada and the United States.

2 C. E. Fox, *Lord of the Southern Isles: Being the story of the Anglican Mission in Melanesia 1849–1949* (London: A. R. Mowbray & Co., 1958), p. 134.

3 Matthew Spriggs, 'A School in Every District', *Journal of Pacific History* 20 (1) (1985), pp. 23–41, 33.

4 Boyle T. Somerville, 'Ethnographical Notes in New Georgia, Solomon Islands', *The Journal of the Anthropological Institute of Great Britain and Ireland* 26 (1897), pp. 357–412, 364.

5 Charles M. Woodford, 'Exploration of the Solomon Islands'. *Proceedings of the Royal Geographical Society and Monthly Record of Geography*, New Monthly Series 10 (6) (1897), pp. 351–76, 364.

6 Robin Torrence, 'Obsidian-Tipped Spears and Daggers: What Can We Learn from 130 Years of Museum Collecting', in Christian Kaufmann, Christin Kocher-Schmidt and Sylvia Ohnemus (eds.), *Admiralty Islands: Art from the South Seas* (Zurich: Museum Rietberg, 2002), p. 75.

7 Henry N. Moseley, 'On the Inhabitants of the Admiralty Islands', in *Journal of the Royal Anthropological Institute of Great Britain and Ireland* 6 (1887), pp. 379–429, 390. Cited in Torrence, 'Obsidian-Tipped Spears and Daggers', p. 73.

8 Jim R. Specht, *Pieces of Paradise: Australian Natural History*, Supplement no. 1 (Sydney: Australian Museum Trust, 1988), p. 29.

9 Ingrid Heermann (ed.), *Form Colour Inspiration: Oceanic Art from New Britain* (Stuttgart: Arnoldsche, 2001), p. 190.

10 Monique Jeudy-Ballini, 'The Ritual Aesthetics of the Sulka', in Heermann (ed.) 2001, pp. 106–15.

11 ibid., p. 111.

12 ibid. p. 114.

13 Philippe Peltier and Michael Gunn, 'Preface', in Michael Gunn and Philippe Peltier (eds.), *New Ireland: Art of the South Pacific* (Milan: 5 Continents Editions, 2006), pp. 13–17, 14.

14 See Gunn and Peltier (eds.) 2006; and Susanne Küchler, *Malanggan: Art, Memory and Sacrifice* (Oxford: Berg, 2002).

15 Philippe Peltier, '*Malangan* Ceremonies in the North of New Ireland', in Gunn and Peltier (eds.) 2006, pp. 77–81, 80.

16 Küchler 2002, p. 116.

17 Gunn and Peltier (eds.) 2006, p. 222.

18 Antje Denner and Philippe Peltier, 'Wooden Figures', in Gunn and Peltier (eds.) 2006, pp. 114–21, 114.

19 Specht 1988, p. 15.

20 Richard Thurnwald, *Forschungen auf den Salomo-Inseln und dem Bismarck-Archipel : mit Unterstützung der Baessler Stiftung hrsg. im Auftrage der General Verwaltung der Königlichen Museen zu Berlin* (Berlin: D. Reimer [E. Vohsen]), 1912.

21 Kirk W. Huffman, 'Trading, Cultural Exchange and Copyright: Important Aspects of Vanuatu Arts', in Joël Bonnemaison, Kirk Huffman, Christian Kaufmann, Darrell Tryon (eds.), *Arts of Vanuatu* (Bathurst: Crawford House Publishing, 1996), pp. 182–94, 183.

22 Fox 1958, p. 18.

23 Kirk W. Huffman, 'Wooden and Bamboo Food Knives from Northern Vanuatu', in Bonnemaison et al. 1996, pp. 204–7, 206.

24 See Lissant Bolton, *Unfolding the Moon: Enacting Women's Kastom in Vanuatu* (Honolulu: University of Hawai'i Press, 2003).

25 Robert Henry Codrington, *The Melanesians : Studies in their Anthropology and Folklore* (Oxford: Clarendon Press, 1891), p. 110.

26 Huffman, 'Wooden and Bamboo Food Knives from Northern Vanuatu', p. 190.

27 ibid.

TRANSFORMATIONS 1890–1940

1 John Connell, *New Caledonia or Kanaky? The Political History of a French Colony*, Pacific Research Monograph 16 (Canberra: National Centre for Development Studies, Research School of Pacific Studies, Australian National University, 1987), p. 21.

2 ibid., p. 42.

3 ibid., p. 84.

4 Dorothy Shineberg, *The People Trade: Pacific Island Laborers and New Caledonia, 1865–1930* (Honolulu: Center for Pacific Islands Studies/University of Hawai'i Press, 1999), p. 5.

5 ibid., p. 14.

6 Ben Burt and Michael Kwa'ioloa, *A Solomon Islands Chronicle, as told by Samuel Alasa'a* (London: British Museum Press, 2001), pp. 86, 88, 95. As Michael Alasa'a was born around 1890 and was thus a small child at the time of the shelling, his account here was presumably filtered through the accounts of adults who retold the story after the event.

7 ibid., p. 92.

8 ibid., p. 94.

9 ibid. p. 101.

10 *Not in Vain* 7 (April 1928), cited in Ben Burt with David Akin and Michael Kwa'ioloa, *Body Ornaments of Malaita, Solomon Islands* (London and Honolulu: British Museum Press and University of Hawai'i Press, 2009), p. 11.

11 ibid.

12 ibid. p. 7.

13 *Quarterly Jottings from the New Hebrides South Seas Islands* (Woodford, England, 1896), p. 7.

14 Lissant Bolton, 'Gender, Status and Introduced Clothing in Vanuatu', in Chloë Colchester (ed.), *Clothing the Pacific* (London: Berg Publishers, 2003), pp. 119–39.

15 Felix Speiser, *Ethnology of Vanuatu: An Early Twentieth-Century Study*, trans. D. Q. Stephenson (Bathurst, New South Wales: Crawford House Press, 1991 [1923]), p. 178.

16 Cited in Bronwen Douglas, 'Christian Citizens: Women and Negotiations of Modernity in Vanuatu', *The Contemporary Pacific* 14 (1) (2002), pp. 1–38, 5. See also Bolton, 'Gender, Status and Introduced Clothing in Vanuatu'.

17 Helen Leach, 'Translating the 18th-century Pudding', in Geoffrey Clark, Foss Leach and Sue O'Connor (eds.), *Islands of Inquiry: Colonisation, Seafaring and the Archaeology of Maritime Landscapes*. Papers in Honour of Atholl Anderson. *Terra Australis* no. 29 (Canberra: ANU E Press, 2008), pp. 381–96.

18 Douglas Oliver, *Black Islanders: A Personal Perspective of Bougainville 1937–1991* (South Yarra, Victoria: Hyland House, 1991), p. 52.

19 ibid., p. 53.

20 Ton Otto, 'Manus: The Historical and Social Context', in Christian Kaufmann, Christin Kocher Schmid and Sylvia Ohnemus (eds.), *Admiralty Islands: Art from the South Seas* (Zurich: Museum Rietberg, 2002), pp. 29–37, 35.

21 Sylvia Ohnemus, *An Ethnology of the Admiralty Islanders: The Alfred Buhler Collection, Museum der Kulturen, Basel* (Bathurst: Crawford House Publishing, 1996), p. 201.

22 Christin Kocher Schmid, 'Atuna Putty – a Versatile Vegetable Material', in Kaufmann, Schmid and Ohnemus (eds.) 2002, p. 62.

23 Margaret Tuckson, 'Pottery – a Now Lost Art Tradition', ibid., pp. 64–66.

24 Ohnemus 1996, p. 199.

25 Raymond Firth, 'Tikopia Art and Society', in Anthony Forge (ed.), *Primitive Art and Society* (London: Oxford University Press, 1973), pp. 25–48.

26 A version of this story was recorded by Madeline Aru, Loqirutaro Village, Longana, East Ambae, 5 December 1991. The audio recording is in the Vanuatu National Film and Sound Unit archives.

27 Cato Berg and Edvard Hviding (eds.), *The Ethnographic Experiment: Rivers and Hocart in Solomon Islands, 1908* (Oxford: Berghahn Books, forthcoming).

28 Speiser 1991, p. 1.

29 Robert L. Welsch, *An American Anthropologist in Melanesia: A. B. Lewis and the Joseph N. Field Expedition, 1909–1913*, 2 vols. (Honolulu: University of Hawai'i Press, 1998).

30 Patrice Goudon, 'Monnaies de coquillages a Hienghène', in Henri Marchal, Roger Boulay and Emmanuel Kasarhérou (eds.), *De Jade et de nacre: patrimonie artistique kanak* (Paris: Réunion des musées nationaux, 1990), p. 88.

31 Pei-yi Guo, '*Bata*: The Adaptable Shell Money of Langalanga, Malaita', in Ben Burt and Lissant Bolton (eds.), *The Things We Value: Culture and History in Solomon Islands* (London: Sean Kingston Publishing, forthcoming).

32 Speiser 1991, p. 242.

33 Roy Wagner, *Asiwinarong: Ethnos, Image and Social Power among the Usen Barok of New Ireland* (Princeton, NJ: Princeton University Press, 1986), pp. 80–84.

PART FOUR: EASTERN AND NORTHERN OCEANIA 1700–1940
POLITICAL TRANSFORMATIONS: ART AND POWER 1700–1800

1 Adrienne Kaeppler, 'Eighteenth-Century Tonga: New Interpretations of Tongan Society and Material Culture at the Time of Captain Cook', *Man* 6 (2) (1971), pp. 204–20.

2 Meredith Filihia, "'Oro-dedicated *Maro 'ura* in Tahiti: Their Rise and Decline in the Early-European Post-Contact Period', *Journal of Pacific History* 31 (2) (1996), p. 128. See also Anne Salmond, *Trial of the Cannibal Dog* (London: Penguin, 2003), p. 38; Hank Driessien, 'Tupa'ia: The Trials and Tribulations of a Polynesian Priest', in *Vision and Reality in Pacific Religion*, Phyllis Herda et al. (eds.) (Canberra: Pandanus Books, 2005), pp. 68–69.

3 Teuira Henry, *Ancient Tahiti* [Honolulu, 1928], reprinted (Millwood, New York: Kraus Reprint, 1985), p. 130.

4 Karen Stevenson and Steven Hooper, 'Tahitian Fau: Unveiling an Enigma', *Journal of the Polynesian Society* 116 (2007), p. 209.

5 Adrienne Kaeppler, 'Containers of Divinity', *Journal of the Polynesian Society* 116 (2007), pp. 105, 108.

6 Henry 1985, p. 189.

7 Reverend George Bennet *c.* 1820, in Roger Rose, *Symbols of Sovereignty: Feather Girdles of Tahiti and Hawaii* (Honolulu: Bernice P. Bishop Museum, 1978), p. 4.

8 Henry 1985, p. 195.

9 Douglas Oliver, *Ancient Tahitian Society* (Honolulu: University of Hawai'i Press, 1974), pp. 1,236, 1,215.

10 Filihia, "'Oro-dedicated *Maro 'ura*', p. 131.

11 ibid.

12 James Cook in *The Journals of Captain James Cook on his Voyages of Discovery 3 – Voyage of the Resolution and Discovery 1776–80*, John Beaglehole (ed.) (Cambridge: University Press for Hakluyt Society, 1967), vol. 3, pt I, pp. 202–3. See also William Anderson, in Beaglehole (ed.) 1967, vol. 3, pt II, p. 980.

13 Greg Dening, *Mr Bligh's Bad Language* (Cambridge: Cambridge University Press, 1992), p. 205.

14 William Bligh in Ida Lee, *Captain Bligh's Second Voyage to the South Sea* (London: Longmans, Green, 1920), p. 215.

15 Henry 1985, p. 195.

16 James King in *Journals*, Beaglehole (ed.) 1967, vol. 3, pt I, p. 217.

17 James Morrison, *Journal of James Morrison, Boatswain's Mate of the Bounty: describing the mutiny and subsequent misfortunes of the mutineers together with an account of the island of Tahiti* (London: Golden Cockerel Press, 1935), p. 116.

18 See R. Thompson, in Filihia, "'Oro-dedicated *Maro 'ura*', p. 134.

19 P. V. Kirch and R. Green, *Hawaiki, Ancestral Polynesia: An Essay in Historical Anthropology* (Cambridge: Cambridge University Press, 2001), p. 80.

20 Timothy Earle, 'Specialisation and the Production of Wealth: Hawaiian Chiefdoms and the Inka Empire', *Contemporary Archaeology in Theory*, Robert Preucel and Ian Hodder (eds.) (Oxford & Malden, MA: Blackwell Publishers, 1996), p. 177.

21 Steven Hooper, *Pacific Encounters: Art & Divinity in Polynesia 1760–1860* (Honolulu: University of Hawai'i Press, 2006), p. 83.

22 William Ellis, *Narrative of a Tour through Hawaii* (London: Fisher and Jackson, 1826), p. 127.

23 David Malo, *Hawaiian Antiquities* (Honolulu: Bernice P. Bishop Museum, 1951 [1898]), pp. 143, 154.

24 Ellis 1826, pp. 127–28.

25 Adrienne Kaeppler, 'Genealogy and Disrespect: A Study of Symbolism in Hawaiian Images', *Res* 3 (1982), pp. 97, 99.

26 Ralph Kuykendall, *Hawaiian Kingdom: Foundations and Transformation 1778–1854*, I (Honolulu: University of Hawai'i Press, 1938), p. 36.

27 Abraham Fornander, *Account of the Polynesian Race* (London, 1878–85), II, p. 328; Samuel Kamakau, *Ruling Chiefs of Hawaii* (Honolulu: Kamehameha Schools Press, 1961), pp. 154–55.

28 Ellis 1826, pp. 66–67; John Stokes and Tom Dye, *Heiau of Hawaii: A Historic Survey of Native Hawaiian Temple Sites* (Honolulu: Bishop Museum Press, 1991), p. 167.

29 Kaeppler, 'Genealogy and Disrespect', p. 99.

30 Ellis 1826, pp. 58–62, 118.

31 Adrienne Kaeppler, Christian Kaufmann and Douglas Newton, *Oceanic Art* (New York: Harry Abrams, 1997), p. 92.

32 Earle, 'Specialisation and the Production of Wealth', p. 176.

33 Hooper 2006, pp. 84, 85.

34 Gertrude MacKinnon Damon in Hohn D. Holt, *The Art of Featherwork in Old Hawaii* (Honolulu: Bishop Museum Press, 1985), p. 21; Hooper 2006, p. 108.

35 Samuel Manaiakalani Kamakau, *Tales and Traditions of the People of Old* (Honolulu: Bishop Museum Press, 1991), pp. 162–63; Kamakau, *The Works of the People of Old* (Honolulu: Bishop Museum Press, 1976), p. 143.

36 Te Rangi Hiroa (Peter H. Buck), 'The Local Evolution of Hawaiian Feather Capes and Cloaks', *Journal of the Polynesian Society*, 53 (1) (1944), pl. 2.

37 Adrienne Kaeppler, *Pacific Arts of Polynesia and Micronesia* (New York: Oxford University Press, 2008), p. 122.

38 Peter Buck, *Arts and Crafts of Hawai'i* (Honolulu: Bishop Museum Press, 1957), p. 231.

39 Holt 1985, p. 21; Hooper 2006, p. 115.

40 Kaeppler 2008, p. 122.

41 ibid., p. 123.

42 See Stacey Kamehiro, *Arts of Kingship: Hawaiian Art and National Culture of the Kalakaua Era* (Honolulu: University of Hawai'i Press, 2009).

43 M. L. Berg, 'Yapese Politics, Yapese Money and the *Sawei* Tribute Network before World War I', *Journal of Pacific History* 27 (2) (1992), p. 156; William Lessa, 'Ulithi and the Outer Island World,' *American Anthropologist* 52 (1) (1950), p. 42.

44 Berg, 'Yapese Politics', p. 160; Scott M. Fitzpatrick, 'Maritime Interregional Interaction in Micronesia: Deciphering Multi-Group Contacts and Exchange Systems through Time', *Journal of Anthropological Archaeology* 27 (2008), p. 139; Lessa, 'Ulithi', p. 39.

45 Donald Rubinstein, 'Cultural Preservation of Traditional Textiles on Fais Island in Micronesia: Problems and Paradoxes', paper prepared for the Second ASEAN Textile Symposium, Manila, 2–3 February, 2009, p. 5. The following section is indebted to this and other works of Donald Rubinstein: 'Fabric Arts and Traditions', and 'Cultural Fabrications: Woven Symbols of Identity, Power and Wealth', both in *Art of Micronesia*, Jerome Feldman and Donald H. Rubinstein (eds.) (Honolulu: University of Hawai'i Art Gallery, 1986).

46 Michiko Intoh, 'Cultural Contacts between Micronesia and Melanesia,' in Jean-Christophe Galipaud and Ian Lilley (eds.), *The Pacific from 5000 to 2000 BP: Colonisation and Transformations* (Paris: Institut de Recherche pour le Développement, 1999), p. 417.

47 This chant in the Fais language and in English translation is presented in Donald Rubinstein and Sophiano Limol, 2007, 'Reviving the Sacred Machi: A Chiefly Weaving from Fais Island, Micronesia', in *Material Choices: Refashioning Bast and Leaf Fibers in Asia and the Pacific*, Roy W. Hamilton and B. Lynn Milgram (eds.) (Los Angeles, CA: Fowler Museum at UCLA), p. 161.

48 Fitzpatrick, 'Maritime Interregional Interaction', p. 131. The following section is indebted to the work of M. L. Berg, 'Yapese Politics' (see note 43), and S. M. Fitzpatrick (see note 44).

EUROPEAN INCURSIONS 1765–1880

1 For early maritime visits, see e.g. O. H. K. Spate, *The Pacific since Magellan*, 3 vols. (Canberra: Australian National University Press, 1979–88); for the invasion of Guam, Robert F. Rogers, *Destiny's Landfall: A History of Guam* (Honolulu: University of Hawai'i Press, 1995), chapter 3; and Anne Salmond, *Aphrodite's Island: The European Discovery of Tahiti* (Auckland: Auckland University Press, 2009).

2 The best account of contact, commerce and cultural exchange in the Hawaiian archipelago over the relevant period is in Patrick V. Kirch and Marshall Sahlins, *Anahulu: The Anthropology of History in the Kingdom of Hawaii* (Chicago, IL: University of Chicago Press, 1992), esp. vol. 1. For the ramifications of the Sydney settlement on Pacific encounters, see e.g. H. E. Maude, *Of Islands and Men: Studies in Pacific History* (Melbourne: Oxford University Press, 1968).

3 For the Māori case, see Roger Neich, *Carved Histories: Rotorua Ngati Tarawhai Woodcarving* (Auckland: Auckland University Press, 2001), pp. 147–49.

4 See, among recent discussions, Nicholas Thomas, *Discoveries: The Voyages of Captain Cook* (London: Allen Lane, 2003), and Anne Salmond, *The Trial of the Cannibal Dog: Captain Cook in the South Seas* (London: Allen Lane, 2003).

5 The standard catalogue of the first voyage visual archive is Rüdiger Joppien and Bernard Smith, *The Art of Captain Cook's Voyages*, vol. 1 (Melbourne: Oxford University Press, 1985), where it was tentatively suggested that 'The Artist of the Chief Mourner' might have been Joseph Banks. It was Banks's biographer, Harold B. Carter, who found a letter in the massive Banks archive that unambiguously identifies Tupaia as the author of the group of drawings. See Anne Salmond, *Between Worlds: Early Exchanges between Maori and Europeans 1773–1815* (Auckland: Auckland University Press, 1997), p. 16. For further discussion of Tupaia's work, see Thomas 2003, pp. 75–77.

6 For Devis and the interests of Palauans in Devis's practice, see George Keate, *An Account of the Pelew Islands*, Karen L. Nero and Nicholas Thomas (eds.) (London: Leicester University Press, 2002 [1788]), esp. pp. 121–22.

7 'The Journal of Archibald Menzies', 4 March 1792, BL, Add. Mss. 32641. For Tapioi, see Nicholas Thomas, *Islanders: The Pacific in the Age of Empire* (London and New Haven, CT: Yale University Press, 2010), pp. 48–54.

8 Joppien and Smith 1985, vol. 3, p. 649. Here it is stated that after 1792 'the portrait fades from knowledge', but in fact it was shown to members of the first London Missionary Society party on 6 March 1797, soon after their arrival on the island, by 'Pyteah', 'the chief of the district' of Matavai: William Wilson, *A Missionary Voyage to the Southern Pacific Ocean* (London: Chapman, 1799), p. 60. It does, however, appear to have been destroyed, probably as a result of ongoing inter-tribal conflicts, not long afterwards.

9 Lieut. George Mortimer, *Observations and remarks made during a voyage…in the Brig Mercury* (London, 1791), pp. 25–26.

10 The most important of many studies are Greg Dening, *Mr. Bligh's Bad Language: Passion, Power and Theatre on the Bounty* (Cambridge: Cambridge University Press, 1992), and Anne Salmond, *Bligh: William Bligh in the South Seas* (Berkeley, CA: University of California Press, 2011).

11 Mortimer 1791, p. 33.

12 'The Journal of James Morrison', in Vanessa Smith and Nicholas Thomas (eds.), *Mutiny and Aftermath* (Honolulu: University of Hawai'i Press, 2012).

13 ibid.

14 J. C. Beaglehole (ed.), *The Journals of Captain James Cook*, vol. 3 (Cambridge: Cambridge University Press, 1955–67), p. 220; see Joppien and Smith 1985, vol. 3, p. 381.

15 Sean Mallon, *Samoan Art and Artists: O Measina a Samoa* (Nelson: Craig Potton, 2002), pp. 95–96.

16 Anne D'Alleva, 'Change and Continuity in Decorated Tahitian Barkcloth from Bligh's Second Breadfruit Voyage, 1791–1793', *Pacific Arts 11–12* (1995), pp. 29–42.

17 See for example the pieces from Cook's second voyage, now in Göttingen: Brigitta Hauser-Schäublin and Gundolf Krüger (eds.), *James Cook: Gifts and Treasures from the South Seas. The Cook/Forster Collection, Göttingen* (Munich: Prestel, 1998).

18 See Thomas 2010, chapter 4. The key source for Tahiti is C. W. Newbury (ed.), *The History of the Tahitian Mission* (London, Hakluyt Society, 1961).

19 Anne D'Alleva, 'Christian Skins: Tatau and the Evangelization of the Society Islands and Samoa', in Nicholas Thomas, Anna Cole and Bronwen Douglas (eds.), *Tattoo: Bodies, Art and Exchange in the Pacific and the West* (London: Reaktion Press, 2005). The original visual records, as well as the published 'Atlas historique' volumes for voyages such as those of Freycinet (in the *Uranie*, 1817–20), and Duperrey (in the *Coquille*, 1822–25), offer much rich and largely unstudied material for post-contact tattooing, particularly in the Society Islands and Hawai'i.

20 Among important reappraisals of missionaries in general, see Jean and John Comaroff, *Of Revelation and Revolution* (Chicago, IL: University of Chicago Press, 1991–95).

21 Albert J. Schütz (ed.), *The Diaries and Correspondence of David Cargill, 1832–1843* (Canberra: Australian National University Press, 1977), p. 52.

22 Nicholas Thomas, 'The Case of the Misplaced Ponchoes', *Journal of Material Culture* 4 (1999), pp. 5–20; Chloë Colchester (ed.), *Clothing the Pacific* (Oxford: Berg, 2003); Susanne Küchler and Graeme Were (eds.), *The Art of Clothing: A Pacific Experience* (London: UCL Press, 2004).

23 For the hats, see Kenji Yoshida and John Mack (eds.), *Images of Other Cultures* (Osaka: National Museum of Ethnology, 1997), p. 167.

24 John Pule and Nicholas Thomas, *Hiapo: Past and Present in Niuean Barkcloth* (Otago: University of Otago Press, 2005).

25 Peter H. Buck, *Arts and Crafts of the Cook Islands* (Honolulu: Bishop Museum, 1944), pp. 380–81; Steven Hooper, *Pacific Encounters: Art and Divinity in Polynesia 1760–1860* (London: British Museum Press, 2006), p. 229.

26 I draw here on Steven Fischer's monumental study, *Rongorongo: The Easter Island Script: History, Traditions, Texts* (Oxford: Clarendon Press, 1997), which provides an absorbing account of the European recognition, investigation of, and preoccupation with, the art form, as well as documentation of known extant tablets. However, I am not fully in agreement with Fischer's interpretation of *rongorongo* history, nor am I in a position to assess the adequacy of his effort to decipher the script.

COLONIAL STYLES: ARCHITECTURE AND INDIGENOUS MODERNITY

1 James Nason, 'Tourism, Handicrafts and Ethnic Identity in Micronesia', *Annals of Tourism Research* 11 (1984), p. 431.

2 Janet Davidson, *Prehistory of New Zealand* (Auckland: Longman Paul, 1984), p. 146; William Phillipps, *Maori Houses and Foodstores* (Wellington: Dominion Museum, 1952), p. 95.

3 Deidre Brown, 'Te Hau-ki-Turanga', *Journal of the Polynesian Society* 105 (1996), pp. 7–26.

4 Karen Nero, 'Breadfruit Tree Story: Mythological Transformation in Palauan Politics', *Pacific Studies* 15 (4) (1992), p. 244.

5 David Robinson, 'The Decorative Motifs of Palauan Clubhouses', in *Art and Artists of Oceania*, Sidney M. Mead and Bernie Kernot (eds.) (Palmerston North: Dunmore Press, 1983), p. 164.

6 George Keate, *Account of the Pelew Islands*, Karen Nero and Nicholas Thomas (eds.) (London, New York: Leicester University Press, 2002 [1788]), pp. 20–21, p. 388, n. 9. Karen Nero, pers. comm., 27 June 2010.

7 Robinson, 'Decorative Motifs', p. 165.

8 J. P. Hockin, *Supplement to the Account of the Pelew Islands*, in Keate 2002, p. 289.

9 Janet Davidson, 'Settlement Patterns in Samoa before 1840', *Journal of the Polynesian Society* 78 (1969), p. 64. This section is indebted to Janet Davidson's paper and to Shawn Barnes and Roger Green, 'From Tongan Meeting House to Samoan Chapel: A Recent Tongan Origin for the Samoan *fale afolau*', *Journal of Pacific History* 43 (1) (2008), p. 45.

10 John Williams, *Samoan Journals of John Williams 1830–1832*, Richard Moyle (ed.) (Canberra: Australia National University Press, 1984), p. 127.

11 Anne Allen, 'Modernity and Tradition: Western Architecture Styles in Western Samoa', *Pacific Arts* NS6 (2007), pp. 16–17; Anne Allen, 'Space as Social Construct: the Vernacular Architecture of Rural Samoa', PhD thesis, Columbia University, 1993, p. 222; Peter Buck, *Samoan Material Culture* (Honolulu: Bernice P. Bishop Museum, 1930), p. 20.

12 Judith Binney, *Redemption Songs: A Life of Te Kooti Arikirangi Te Turuki* (Auckland: Auckland University Press, 1995), p. 115.

13 Roger Neich, *Painted Histories* (Auckland: Auckland University Press, 1993), pp. 175–94.

14 Sidney (Hirini) Mead, *Te Toi Whakairo: Art of Maori Carving* (Auckland: Raupo Publishing, 1995), p. 104.

15 Roger Mitchell, 'Palauan Story-Board: The Evolution of a Folk-Art Style', in *Folk Groups and Folklore Genres*, Elliot Oring (ed.) (Logan: Utah State University Press, 1989), p. 324.

16 Carl Semper, *Palau Islands in the Pacific Ocean*, Robert Craig (ed.), Mark Berg (trans.) (Mangilao: University of Guam, 1982 [1873]), pp. 123–24, 275.

17 ibid., pp. 292–93.

18 Augustin Krämer, *Palau* II (Hamburg, 1929), pp. 291–98; Jan Kubary, *Sozialen Einrichtungen der Pelauer* (Berlin, 1885), pp. 149–50.

19 Ely Kahn, *Reporter in Micronesia* (New York: Norton, 1966), p. 280; Nason, 'Tourism, Handicrafts', p. 431.

20 See Deidre Brown, *Māori Architecture: From Fale to Wharenui and Beyond* (Auckland: Penguin, 2009), p. 70.

21 Judith Binney, pers. comm., 1993.

22 See Deidre Brown, 'Moorehu Architecture', PhD thesis, University of Auckland, 1997, p. 135.

23 Allen, 'Modernity and Tradition', pp. 17–18.

24 Edward Handy and Willowdean Handy, *Samoan House Building, Cooking, and Tattooing* (Honolulu: Bernice P. Bishop Museum, 1924), p. 13.

25 Roger Neich, *Material Culture of Western Samoa: Persistence and Change* (Wellington: National Museum of New Zealand, 1985), p. 27.

26 Nero, 'Breadfruit Tree Story', p. 246; Mitchell, 'Palauan Story-Board', pp. 325–26.

27 Karen Nero, pers. comm., 6 July 2010.

28 Brown, *Māori Architecture*, p. 117.

29 Laurence Carucci and Lin Poyer, 'Western Central Pacific', in *Oceania: Introduction to the Cultures and Identities of Pacific Islanders*, Andrew Strathern et al. (eds.) (Durham, NC: North Carolina Academic Press, 2002), pp. 226–27.

30 Machiko Aoyagi, 'Gods of the Modekngei Religion in Belau', in *Cultural Uniformity and Diversity in Micronesia*, Iwao Ushijima and Ken-ichi Sudo (eds.) (Osaka: National Museum of Ethnology, 1987), pp. 342ff; Homer Barnett, *Palauan Society* (Eugene, OR: University of Oregon, 1949), pp. 218, 221. This section is indebted to Aoyagi and Barnett's work, including also Homer Barnett's *Being a Palauan* (New York: Holt, Rinehart & Winston, 1960), and Machiko Aoyagi's *Modekngei: A New Religion in Belau, Micronesia* (Tokyo: Shinsensha Press, 2002).

31 Carucci and Poyer, 'Western Central Pacific', p. 227.

32 See Jeffrey Sissons, 'Traditionalisation of the Māori Meeting House', *Oceania* 69 (1998), pp. 36–46.

33 Āpirana Ngata, 'Maori Arts and Crafts', in *Maori People Today*, Ivan Sutherland (ed.) (Wellington: New Zealand Institute of International Affairs and New Zealand Council for Educational Research, 1940), p. 325.

34 Shinji Yamashita, 'Japanese Encounter with the South: Japanese Tourists in Palau', *Contemporary Pacific* 12 (2000), p. 451.

35 Nero, 'Breadfruit Tree Story', pp. 248, 250.

36 Semper 1982, pp. 280–81; Krämer 1929, frontispiece.

PART FIVE: ART, WAR AND THE END OF EMPIRE 1940–89
WAR AND VISUAL CULTURE 1939–45

1 Tarak Barkawi, *Globalization and War* (Oxford: Rowman and Littlefield, 2006), p. 92.

2 David Held and Anthony McGrew, *Globalization/Anti-globalization* (Cambridge: Blackwell Publishers, 2002), p. 1.

3 Geoffrey White and Lamont Lindstrom (eds.), *The Pacific Theater: Island Representations of World War II* (Honolulu: University of Hawai'i Press, 1989); Lamont Lindstrom and Geoffrey White, *Island Encounters: Black and White Memories of the Pacific War* (Washington and London: Smithsonian Institution Press, 1990); L. Poyer, S. Falgout and L. Crucci (eds.), *The Typhoon of War: Micronesian Experiences of the Pacific War* (Honolulu: University of Hawai'i Press, 2000).

4. R. J. May, 'Political and Social Change in the East Sepik: A Research Agenda', in Nancy Lutkehaus et al. (eds.), *Sepik Heritage: Tradition and Change in Papua New Guinea* (Bathurst: Crawford House Press, 1990), pp. 175–84.

5 Margaret Mead, *New Lives for Old, Cultural Transformation – Manus, 1928–1953* (London: Victor Gollancz, 1956), pp. 167–68.

6 Hank Nelson, 1980, cited in David Akin, 'World War II and the Evolution of Pacific Art', *Pacific Arts Newsletter* 27 (1988), p. 6.

7 Leo Scheps, 'Chimbu Participation in the Pacific War', *Journal of Pacific History* 30 (1) (1995), p. 77.

8 G. C. Kenney, 1949, quoted in Scheps, 'Chimbu Participation', p. 80.

9 Scheps, 'Chimbu Participation', p. 80.

10 ANGAU War Diary, 1943, cited in Scheps, 'Chimbu Participation', p. 79.

11 Paul Ruscoe and Richard Scaglion, 'Male Initiation and European Intrusion in the Sepik', in Nancy Lutkehaus et al. (eds.), *Sepik Heritage: Tradition and Change in Papua New Guinea* (Bathurst: Crawford House, 1990), pp. 414–23.

12 ibid., p. 420.

13 C. Dambui, cited in Ruscoe and Scaglion, 'Male Initiation and European Intrusion in the Sepik', p. 420.

14 K. E. Read, 'Effects of the Pacific War in the Markham Valley, New Guinea', *Oceania* 18 (2) (1947), p. 103.

15 ibid., p. 99.

16 C. Dambui, cited in Ruscoe and Scaglion, 'Male Initiation and European Intrusion in the Sepik', p. 420.

17 White and Lindstrom 1989, p. 270.

18 Kirk Huffman, 'The "Decorated Cloth" from the "Island of Good Yams": Barkcloth in Vanuatu, with Special Reference to Erromango' in Joel Bonnemaison, Kirk Huffman, Christian Kauffmann and Darrell Tryon (eds.), *Arts of Vanuatu* (Honolulu: University of Hawai'i Press, 1996), p. 133.

19 Lin Poyer, 'Echoes of Massacre: Recollections of World War II on Sapwuahfik (Ngatik Atoll)', in White and Lindstrom 1989, p. 108.

20 Byrant Allen, 'The Importance of Being Equal: The Colonial and Postcolonial Experience in the Torricelli Foothills', in Lutkehaus et al. (eds.) 1990, p. 190.

21 James Sinclair, an Australian patrol officer in the Highlands immediately following the war, pers. comm. September 2010.

22 White and Lindstrom 1989, p. 27.

23 Jari Kupiainen, 1999, '*Toto isu*s, Charms and Photos: Visual Ethnography on Gatokae, Western Solomon Islands', *SIGHTS – Visual Anthropology Forum*, 1999, http://cc.joensuu.fi/sights/jari.htm.

24 Charles De Burlo, 'Islanders, Soldiers, and Tourists: The War and the Shaping of Tourism in Melanesia' in White and Lindstrom 1989, p. 309.

25 David Akin, 'World War II and the Evolution of Pacific Art', p. 6.

26 Sir Frederick Osifelo, cited in ibid., p. 8.

27 Poyer, Falgout and Crucci (eds.) 2000, p. 272.

28 Wilbert Chapman, quoted in David Akin, 'World War II and the Evolution of Pacific Art: A Note', *Pacific Arts Newsletter* 28 (1989), pp. 11–12.

29 B. Mamara and T. Kaiuea, 'Awakening: The Gods at War in the Atolls', in Sister Alaima Talu et al., *Kiribati: Aspects of History* (Suva: Fiji. Institute of Pacific Studies and Extension Services, University of the South Pacific and the Ministry of Education, Training and Culture, Kiribati Government, 1979), pp. 96–97.

30 Lamont Lindstrom and Geoffrey White, 'Singing History: Island Songs from the Pacific War', in Philip J. C. Dark and Roger G. Rose (eds.), *Artistic Heritage in a Changing Pacific* (Honolulu: University of Hawai'i Press, 1993), pp. 185–96; Tammy Duchesne, 'Micronesian World War II Songs and Chants Serving a Variety of Functions', *Micronesian Journal of Humanities and Social Sciences* 5 (1 & 2) (2006), pp. 285–92.

31 Henry P. Van Dusen, *They Found the Church There: The Armed Forces Discover Christian Missions in the Pacific* (New York: Charles Scribner Sons, 1945), pp. 50–52.

32 Geoffrey White, pers. comm., 2010.

33 A. Kaeppler, 'Airplanes and Saxophones: Postwar Images in the Visual and Performing Arts', in D. Scarr, N. Gunson and J. Terrell (eds.), *Echoes of Pacific War: Papers from the 7th Tongan History Conference* (Canberra: *Journal of Pacific History*, 1997), pp. 38–63, 51–57.

34 J. W. Groves, 'Notes on the Samoan Tattoo (pe'a), a Non-interpretative Account of Samoan Tattooing as Observed and Drawn between 1947 and 1952', British Museum Ethnography Department, cited in Noel L. McGrevy, 'O Le Tatatau, Traditional Samoan Tattooing', unpublished manuscript, 1989, p. 122.

35 Lindstrom and White 1990, p. 34.

36 David McCarthy and H. C. Westermann, *H. C Westermann at War: Art and Manhood in Cold War America* (Newark, NJ: University of Delaware Press, 2004), pp. 31–32.

37 ibid.

38 Scheps, 'Chimbu Participation', p. 79.

39 ibid., p. 80.

40 Susan Crane, *The Performance of Self: Ritual, Clothing, and Identity During the Hundred Years War* (Philadelphia, PA: University of Pennsylvania Press, 2002), p. 11.

41 ibid., p. 20.

42 Tom Kashida and Kenji Mashina, *The Yasukuni Swords: Rare Weapons of Japan, 1933–1945* (Tokyo: Kodansha International [English edition], 2004), pp. 47–49.

43 ibid., p. 46.

44 ibid., p. 47.

45 Jennifer Haworth, *The Art of War: New Zealand War Artists in the Field 1939–1945* (Christchurch: Hazard Press, 2007), pp. 22–23.

46 'We wouldn't paint war art', interview with Maruki Iri and Maruki Toshi in Huruko Cook and Theodore Cook (eds.), *Japan at War: An Oral History* (New York: The New Press, 1992), p. 256.

47 Jacqueline Atkins (ed.), *Wearing Propaganda: Textiles on the Home Front in Japan, Britain, and the United States, 1931–1945* (London and New Haven, CT: Yale University Press, 2005), p. 19.

48 ibid., p. 27.

DECOLONIZATION, INDEPENDENCE AND CULTURAL REVIVAL 1945–89

1 See Lamont Lindstrom, *Cargo Cult: Strange Stories of Desire from Melanesia and Beyond* (Honolulu: University of Hawai'i Press, 1993); G. W. Trompf (ed.), *Cargo Cults and Millenarian Movements: Transoceanic Comparisons of New Religious Movements* (Boston, MA: Walter de Gruyter, 1990); and Geoffrey White and Lamont Lindstrom (eds.), *The Pacific Theater: Island Representations of World War II* (Honolulu: University of Hawai'i Press, 1990).

2 Ralph Linton and Paul S. Wingert, *Arts of the South Seas* (New York: Museum of Modern Art, 1946).

3 Robert Goldwater, *Primitivism in Modern Art* (Cambridge, MA: Harvard University Press, 1986 [1938, 1966]), pp. 3–13.

4 ibid., pp. 11–12. (This passage occurs in the revised 1966 edition.)

5 Georg W. F. Hegel, *Aesthetics: Lectures on Fine Art*, 2 vols., trans. Malcolm Knox (Oxford: Clarendon Press, 1975), vol. I, p. 11.

6 Paul Ricoeur, 'Universal Civilization and National Cultures', *History and Truth* (Evanston, IL: Northwestern University Press, 1965 [1955]), pp. 271–84.

7 Claude Lévi-Strauss, *Tristes Tropiques*, trans. John and Doreen Weightman (New York: Atheneum, 1974), pp. 37–38.

8 'Before It Is Too Late', *Pacific Islands Monthly* (March 1947).

9 *The Asmat of New Guinea: The Journal of Michael Clark Rockefeller*, Adrian Gerbrands (ed.) (New York: The Museum of Primitive Art, 1967).

10 'Erzatz Curios: A Flourishing Trade in Polynesia', *Pacific Islands Monthly* (March 1945).

11 Sven Kirsten, *Tiki Modern and the Wild World of Witco* (Köln: Taschen, 2007).

12 *Velvet Dreams*, dir. Sima Urale, 1998.

13 'When the Eastern Highlands Put on a Show', *Pacific Islands Monthly* (July 1956), pp. 84–86.

14 'Hagen Turns on "The Greatest Show on Earth"', *Pacific Islands Monthly* (June 1963), pp. 39–40.

15 Guy Debord, *The Society of the Spectacle* (New York: Zone Books, 1995 [1967]).

16 Ranginui Walker, *He Tipua: The Life and Times of Sir Āpirana Ngata* (Auckland: Penguin Books, 2001).

17 Hirini Moko Mead, 'Rotorua Arts Institute Under Fire – Tourist Zoo?', *Te Maori* 2:4 (July/August 1971), p. 15.

18 'Future of the Maori Race', *Pacific Islands Monthly* (October 1947), p. 80 (my emphasis).

19 For an analysis of Pacific decolonization, see Stewart Firth, 'Decolonization', in Robert Borofsky (ed.), *Remembrance of Pacific Pasts: An Invitation to Remake History* (Honolulu: University of Hawai'i Press, 2000), pp. 314–32.

20 See Robert Aldrich, *France and the South Pacific since 1940* (Honolulu: University of Hawai'i Press, 1993).

21 Nicolaas Jouwe, 'Conflict at the Meeting Point of Melanesia and Asia', *Pacific Islands Monthly* (April 1978), p. 12.

22 On the political history of West Papuan decolonization, see: Pieter Drooglever, *An Act of Free Choice: Decolonization and the Right to Self-determination in West Papua* (Oxford: Oneworld Publications, 2009);

George Monbiot, *Poisoned Arrow: An Investigative Journey through Indonesia* (London: Joseph, 1989); Otto Ondawame, 'One Soul, One People: West Papuan Nationalism and the Organisasi Papua Merdeka (OPM)/Free West Papua Movement', PhD Thesis, Australian National University, 2000; *Pacific Islands Monthly* documents the unfolding history of West Papua in numerous editorials and articles from September 1949 onwards.

23 See 'Collector in the Tropics: Jac Hoogerbrugge', in Raymond Corbey, *Tribal Art Traffic: A Chronicle of Taste, Trade and Desire in Colonial and Post-Colonial Times* (Amsterdam: Royal Tropical Institute, 2000), pp. 141–54, 151; Monbiot 1989, p. 178.

24 Quoted in *Kanak Sculptors and Painters Today. Ko i Névâ*, Noumea (New Caledonia: ADCK with the support of the North Province, The Loyalty Islands Province, The Cultural Affairs delegation, 1992), p. 28 (translation from English supplement).

25 Jean-Marie Tjibaou, *Kanaky*, trans. Helen Fraser and John Trotter (Canberra: Pandanus Books/Research School of Pacific and Asian Studies, The Australian National University, 2005), p. 8.

26 ibid., pp. 11–12.

27 From a statement by Godwin Ligo, organizer of the festival. Quoted in Lissant Bolton, *Unfolding the Moon: Enacting Women's Kastom in Vanuatu* (Honolulu: University of Hawai'i Press, 2003), pp. 20–21.

28 See Soroi Marepo Eoe and Pamela Swadling, *Museums and Cultural Centres in the Pacific* (Port Moresby: Papua New Guinea National Museum, 1991).

29 Bolton 2003, pp. 11–22.

30 South Pacific Festival of Arts Souvenir Programme, Rotorua, 1976, p. 3.

31 *Pacific Islands Monthly* (October 1975), p. 45.

32 Bernard M. Narokobi, 'Art and Nationalism', *Gigibori: Institute of Papua New Guinea Studies*, vol. 3, no. 1 (1976), pp. 12–15, 13.

33 ibid., p. 14.

34 ibid., p. 15.

35 Ngahiraka Mason, *Tūruki Tūruki! Paneke Paneke! When Māori Art Became Contemporary*, exhibition catalogue, Auckland Art Gallery Toi o Tāmaki, 2008.

36 Ulli Beier, *Decolonising the Mind* (Canberra: Pandanus Books, Research School of Pacific and Asian Studies, The Australian National University, 2005).

37 Carol Henderson, *A Blaze of Colour: Gordon Tovey Artist Educator* (Christchurch: Hazard Press, 1998), p. 55.

38 Francis Pound, *The Invention of New Zealand: Art and National Identity 1930–1970* (Auckland: Auckland University Press, 2009).

39 Buck Nin and Baden Pere, *New Zealand Maori Culture and the Contemporary Scene 1966: An Exhibition of Painting and Sculpture Derived from Maori Culture* (Christchurch: Christchurch Museum, 1966), n.p.

40 Nicolaï Michoutouchkine, *Aloï Pilioko: 50 ans de création en Océanie* (Madrépores, 2008); Marie Claude Teissier-Landgraf, *The Russian from Belfort: 37 Years' Journey by Painter Nicolaï Michoutouchkine in Oceania* (Suva: Institute of Pacific Studies, The University of the South Pacific, 2005).

41 Albert Wendt, 'Towards a New Oceania', *Mana Review* 1 (1976), pp. 49–60, 58.

42 ibid., p. 59.

43 Damian Skinner, 'Another Modernism: Māoritanga and Māori Modernism in the 20th Century,' PhD Thesis, Victoria University of Wellington, 2005, p. 29. See also Damian Skinner, *The Carver and the Artist: Māori Art in the Twentieth Century* (Auckland: Auckland University Press, 2008).

44 Cited in 'Reviving Maori Art and Craft is Dead Loss, says Maori', unsourced newspaper clipping, 1966(?). Arnold

Wilson Artist Files, E. H. McCormack Research Library, Auckland Art Gallery Toi o Tāmaki.

45 George S. Kanahele, 'The Hawaiian Renaissance', May 1979. (http://kapalama.ksbe.edu/archives/pvsa/primary%202/79%20kanahele/kanahele.htm) Accessed 22 October 2009.

46 My thanks to Damian Skinner for help with writing parts of this section.

47 Beier 2005, p. 76.

TOURIST ART AND ITS MARKETS 1945–89

1 See Roger Neich, 'Tongan Figures: From Goddesses to Missionary Trophies to Masterpieces', and Steven Hooper, 'Embodying Divinity: The Life of A'a', in Steven Hooper & Judith Huntsman (eds.), 'Polynesian Art: Histories and Meanings in Cultural Context', *The Journal of the Polynesian Society* 116 (2) (2007).

2 Ngaire Douglas and Norman Douglas, 'Paradise and Other Ports of Call: Cruising in the Pacific Islands', in Ross K. Dowling (ed.), *Cruise Ship Tourism* (Oxfordshire: CABI publishers, 2006), p. 187.

3 Jese Sikivou, 'A Conversation with Two Sword Sellers', in Freda Rajotte and Ron Crocombe (eds.), *Pacific Tourism as Islanders See It* (Suva: University of the South Pacific, 1980), p. 99.

4 Ross Ewing and Ross MacPherson, *The History of New Zealand Aviation* (Auckland: Heinemann, 1986), p. 171.

5 Ann Stephen, 'Introduction' in Ann Stephen (ed.), *Pirating the Pacific: Images of Travel, Trade and Tourism* (Haymarket: Powerhouse Publishing, 1993), pp. 15–17.

6 Malama Meleisea and Penelope S. Meleisea, 'The Best-Kept Secret: Tourism in Western Samoa', in Rajotte and Crocombe (eds.) 1980, pp. 35–46.

7 N. Eustis, *Aggie Grey of Samoa* (Adelaide: Hobby Investments PTY Ltd., 1980), p. 182.

8 *Pacific Islands Monthly* (May 1974), p. 118.

9 Grant McCall, 'Another (Unintended) Legacy of Captain Cook? The Evolution of Rapanui (Easter Island) Tourism', in John Connell and Barbara Rugendyke (eds.), *Tourism at Grassroots: Villagers and Visitors in the Asia-Pacific* (New York: Routledge, 2008), p. 47.

10 Sven A. Kirsten, *The Book of Tiki: The Cult of Polynesian Pop in Fifties America* (Cologne: Taschen, 2003).

11 Jane C. Desmond, *Staging Tourism: Bodies on Display from Waikiki to Sea World* (Chicago, IL: University of Chicago Press, 1999), p. 11.

12 *Encyclopédie de Polynésie* 8, pp. 126–27, cited in Karen Stevenson, 'Heiva: Continuity and Change of a Tahitian Celebration', *The Contemporary Pacific* 2 (2) (1990), pp. 255–78.

13 Carol S. Ivory, 'Art, Tourism and Cultural Revival in the Marquesas Islands', in Ruth B. Phillips and Christopher B. Steiner (eds.), *Unpacking Culture: Art and Commodity in Colonial and Postcolonial Worlds* (Berkeley, CA: University of California Press, 1999), p. 321.

14 Robert B. Nicolson, *The Pitcairners* (Sydney: Angus and Robertson Ltd., 1965), p. 173.

15 'Trust Territory Economic Fair', *Micronesian Reporter* 8 (6) (1960), pp. 1–4.

16 'Palau Fair', *Micronesian Reporter* 8 (4) (1960), pp. 9–11.

17 Manus District Annual Report 1956–57, cited in Ton Otto and Robert J. Verloop, 'The Asaro Mudmen: Local Property Public Culture?', in *The Contemporary Pacific* 8 (2) (1996), pp. 329–86.

18 Otto and Verloop, 'The Asaro Mudmen: Local Property Public Culture?', p. 357.

19 'The First Annual Micronesia Arts Festival Awards', in *Micronesian Reporter* 17 (3) (1969), pp. 21–29, 24.

20 Anthony Forge, 'The Abelam Artist', in M. Freedman (ed.), *Social Organisation: Essays Presented to Raymond Firth* (Chicago, IL: Aldine, 1967), p. 84.

21 Atpatoun Vianney, 'The Vanuatu Cultural Centre', in Soroi Marepo Eoe and Pamela Swadling (eds.), *Museums and Cultural Centres in the Pacific* (Port Moresby: Papua New Guinea National Museum, 1991), p. 155.

22 Palau Museum, *Palauan Craft* (1962), unpaginated.

23 Angus McBean, *Handicrafts of the South Seas* (Noumea: South Pacific Commission, 1964), p. 1.

24 ibid., p. 19.

25 H.R.H. Prince Tu'ipelehake, in *Tongan Handicrafts* (Canberra: Australian Government Publishing Service, 1980), p. iii.

26 Francis Hezel, *Strangers in Their Own Land: A Century of Colonial Rule in the Caroline and Marshall Islands* (Honolulu: University of Hawai'i Press, 1995), p. 312.

27 J. Grimwade, 'Tattoo Tricks Catch on again among Samoans', *Pacific Islands Monthly* (September 1993), p. 42.

28 ibid., pp. 42–43.

29 Albert Wendt, 'Afterword: Tatauing the Post-Colonial Body', in V. Hereniko and R. Wilson (eds.), *Inside Out: Literature, Cultural Politics and Identity in the New Pacific* (Lanham, MD: Rowman and Littlefield, 1999).

30 V. Vale and Andrea Juno, *Modern Primitives: An Investigation of Contemporary Adornment and Ritual* (San Francisco, CA: Re/Search Publications, 1989).

31 McBean 1964, pp. 39–40.

32 Thor Heyerdahl, *Aku-Aku: The Secret of Easter Island.* (London: George Allen and Unwin Ltd., 1958), pp. 39–40.

33 McCall, 'Another Unintended Legacy of Captain Cook', 2008, p. 51.

34 Kevin Clark, *Handcraft Trade in the South Pacific: A Case Study – Trade Aid (NZ) Inc.* (New Zealand Coalition for Trade and Development: Pacific Handcraft Research Project Report no. 2, 1984), p. 31.

35 Enid Schildkrout, 'Gender and Sexuality in Mangbetu Art', in Phillips and Steiner (eds.) 1999, p. 204.

36 Philip J. C. Dark, 'Tomorrow's Heritage Is Today's Art, and Yesteryear's Identity', in Allan Hanson and Louise Hanson (eds.), *Art and Identity in Oceania* (Bathurst: Crawford House Press, 1990), p. 258.

37 *Tongan Handicrafts* (Canberra: Australian Government Publishing Service, 1980), pp. 21–22.

38 Dark, 'Tomorrow's Heritage is Today's Art, and Yesteryear's Identity', p. 262.

39 Jane Freeman Moulin, 'What's Mine Is Yours? Cultural Borrowing in a Pacific Context', in *The Contemporary Pacific* 8 (1) (1996), pp. 128–53.

40 Simon Kooijman, 'Traditional Handicraft in a Changing Society: Manufacture and Function of Stencilled Tapa on Moce Island', in S. M. Mead (ed.), *Exploring the Visual Art of Oceania, Australia, Melanesia, Micronesia and Polynesia* (Honolulu: University of Hawai'i Press, 1979), pp. 374–76.

41 Jane C. Desmond, 'Invoking "The Native" Body Politics in Contemporary Hawaiian Tourist Shows', in *The Drama Review* 41 (4) (1997), p. 83.

42 Sidney M. Mead, 'The Production of Native Art and Craft Objects in Contemporary New Zealand Society', in Nelson H. H. Graburn, *Ethnic and Tourist Arts: Cultural Expressions from the Fourth World* (Berkeley, CA: University of California Press, 1976), p. 298.

43 Nelson H. H. Graburn, 'Ethnic and Tourist Arts Revisited', in Phillips and Steiner (eds.) 1999, p. 352.

44 ibid., p. 351.

45 ibid., p. 352.

46 Roger Neich, 'Samoan Figurative Carvings and Taumualua Canoes – A Further Note', *Journal of the Polynesian Society* 100 (1991), pp. 317–28, 317.

47 Phillip Lewis, 'Tourist Art, Traditional Art, and the Museum in Papua New Guinea', in Hanson and Hanson 1990, pp. 154–59.

48 Cema A. B. Bolabola, 'The Impact of Tourism on Fiji Woodcarving', in Rajotte and Crocombe 1980, pp. 93–97.

49 Sidney M. Mead, cited in Nelson H. H. Graburn, 'New Directions in Contemporary Arts', in Mead 1979, p. 357.

50 Lynn Martin, *An Investigation into Contemporary Micronesian Crafts* (1980), pp. 15–16 (unpublished manuscript held in Richard F. Taitano Micronesia Area Research Center).

51 Haunani-Kay Trask, *From a Native Daughter: Colonialism and Sovereignty in Hawai'i* (Honolulu: University of Hawai'i Press and Kamakakūokalani Centre for Hawaiian Studies, University of Hawai'i, 1999 [1993]), p. 137.

52 Albert Wendt, 'Contemporary Arts in Oceania: Trying to Stay Alive in Paradise as an Artist', in Sidney M. Mead and Bernie Kernot (eds.), *Art and Artists of Oceania* (Palmerston North: Dunmore Press, 1983), p. 200.

54 Trask 1999, p. 145.

55 Ngaire Douglas, *They Came for Savages: 100 Years of Tourism in Melanesia* (Lismore, New South Wales: Southern Cross University Press, 1996); Eric Kline Silverman, 'Cannibalizing, Commodifying or Creating Culture? Power and Art in Sepik River Tourism', in V. Lockwood (ed.), *Globalization and Culture Change in the Pacific Islands* (New York: Prentice-Hall, 2004), pp. 339–57.

56 Silverman, 'Cannibalizing, Commodifying or Creating Culture?', pp. 344–47.

57 Ngaire Douglas, 'Tourism', in Brij V. Lal and Kate Fortune (eds.), *The Pacific Islands: An Encyclopedia* (Honolulu: University of Hawai'i Press, 2000), p. 401.

PART SIX: ART IN OCEANIA NOW 1989–2012 CONTEMPORARY PACIFIC ART AND ITS GLOBALIZATION

1 Mark Cross, 'Tulana Mahu: A Collaborative Art Project by Tahiono Arts Collective of Niue', unpublished manuscript.

2 *Tulana Mahu* exhibition flyer (my emphasis).

3 Pamela Lee, 'Boundary Issues: The Art World under the Sign of Globalism', *Artforum* (November 2004), pp. 164–7, 165.

4 See Sean Mallon, *Samoan Art & Artists O Measina a Samoa* (Honolulu: University of Hawai'i Press, 2002), pp. 129–30.

5 Ralph Regenvanu, 'Transforming Representations: A Sketch of the Contemporary Art Scene in Vanuatu', in Joël Bonnemaison, Kirk Huffman, Christian Kauffmann and Darrell Tryon (eds.), *Arts of Vanuatu* (Honolulu: University of Hawai'i Press, 1996), pp. 309–17, 310.

6 See Alexander Alberro, 'Periodising Contemporary Art', *Australian and New Zealand Journal of Art* 9 (1–2) (2008/9), pp. 67–73.

7 Simon Rees, 'Pacific Trade and Exchange', in *Mladin Bizumic, Fiji Biennale Pavilions*, 6 December 2003–29 February 2004, exhibition catalogue, Govett-Brewster Gallery, 2003, pp. 5–12. My account of *Fiji Biennale Pavilions* is indebted to Simon Rees's essay.

8 See *Mladin Bizumic, Fiji Biennale Pavilions* (2003), pp. 24–32.

9 Epeli Hau'ofa, 'The Ocean in Us', in Anthony Hooper (ed.), *Culture and Sustainable Development in the Pacific* (Canberra: Asia Pacific Press and The Australian National University Press, 2000), pp. 32–43. Originally published in *The Contemporary Pacific* 10 (2) (1998), pp. 392–410.

10 ibid., p. 35.

11 On the Oceania Centre and the Red Wave Collective, see Katherine Higgins, *Red Wave: Space, Process, and Creativity at the Oceania Centre for Arts and Culture* (Suva: IPS Publications, University of the South Pacific, 2008); and Katherine Higgins, 'The Red Wave Collective: The Process of Creating Art at the Oceania Centre for Arts and Culture', *The Contemporary Pacific* 21 (1) (Spring 2009), pp. 35–70.

12 On Mara-i-Wai, see *Pacific Institute of Advanced Studies in Development and Governance Newsletter* (April/May 2007), p. 4; Letila Mitchell, 'Colours of Grief', *MaiLife* (July 2007), pp. 18–19; Jakki Leota-Ete, 'Malaga i Mara-i-Wai: Decomposing the Pacific at Sea', MA Thesis, University of the South Pacific, 2007.

13 For more on this period and the significance of the Tjibaou Cultural Centre, see Kylie Message, 'Contested Sites of Identity and the Cult of the New', *reCollections: Journal of the National Museum of Australia* 1 (1) (March 2006), pp. 7–28. For more on the political history of this era, see David Chappell, 'The Noumea Accord: Decolonization without Independence in New Caledonia?', *Pacific Affairs* 72 (3) (Autumn 1999), pp. 373–91; John Connell, 'New Caledonia: An Infinite Pause in Decolonisation?', *The Round Table* 368 (2003), pp. 125–43; and Robert Aldrich, *France and the South Pacific since 1940* (Honolulu: University of Hawai'i Press, 1993), pp. 240–84.

14 Caroline Graille, 'From "Primitive" to Contemporary: A Story of Kanak Art in New Caledonia', *State, Society and Governance in Melanesia Project*, Discussion Paper 01/2, Research School of Pacific and Asian Studies/The Australian National University, 2001, pp. 1–11 (http://rspas.anu.edu.au/melanesia). My discussion is indebted to Graille's paper.

15 ibid., p. 7.

16 On Māori Modernism, see Damian Skinner, *The Carver and the Artist: Māori Art in the Twentieth Century* (Auckland: Auckland University Press, 2008), pp. 79–126; Ngahiraka Mason, *Tūruki Tūruki! Paneke Paneke! When Māori Art Became Contemporary*, exhibition catalogue, Auckland Art Gallery Toi o Tāmaki, 2008; and Jonathan Mane-Wheoki, 'The Resurgence of Maori Art: Conflicts and Continuities in the Eighties', *The Contemporary Pacific* 7 (1) (Spring 1995), pp. 1–19.

17 On this era in New Zealand art, see Francis Pound, *The Invention of New Zealand: Art & National Identity 1930–1970* (Auckland: Auckland University Press, 2009); and M. Barr (ed.), *Headlands: Thinking through New Zealand Art*, exhibition catalogue (Sydney: Museum of Contemporary Art, 1992).

18 Rangihiroa Panoho, 'Maori: At the Centre, On the Margins', in Barr (ed.) 1992, pp. 123–34.

19 For more on 'Choice!', see Peter Brunt, 'Since "Choice!": Exhibiting the New Maori Art', in Lydia Wevers and Anna Smith (eds.), *On Display: New Essays in Cultural Studies* (Wellington: Victoria University Press, 2004), pp. 215–42.

20 George Hubbard and Robin Craw, 'Beyond Kia-Ora: The Paraesthetics of "Choice!" Exhibition flyer. This essay was subsequently published in *Antic* 8 (December 1990), p. 8.

21 On the art history of Hawai'i, see David Forbes, *Encounters with Paradise: Views of Hawai'i and its People, 1778–1941* (Honolulu: University of Hawai'i Press and Honolulu Academy of Art, 1992).

22 Linda Moriarty, 'Artists' Hawaii', *Art Asia Pacific* 2 (17) (1998), pp. 40–41.

23 See Karen Kosasa, 'Pedagogical Sights/Sites: Producing Colonialism and Practising Art in the Pacific', *Art Journal* (Fall 1998), pp. 47–54, 54.

24 For example, see Robert Hughes, *Culture of Complaint: The Fraying of America* (Oxford: Oxford University Press, 1993), written partly in response to the 1993 Whitney Biennial in New York City.

25 For an overview of Pacific artists in Australia, see Pamela Zeplin, 'Artful Dodger: the "Big Island" in the

Pacific', *Art Monthly Australia* (August 2010), pp. 5–10.

26 See Karen Stevenson, *The Frangipani is Dead: Contemporary Pacific Art in New Zealand, 1985–2000* (Wellington: Huia Publishers, 2008).

27 On this exhibition, see Nicholas Thomas, 'The Dream of Joseph: Practices of Identity in Pacific Art', *The Contemporary Pacific* 8 (2) (Fall 1996), pp. 291–317.

28 On *Bottled Ocean*, see Nicholas Thomas, 'From Exhibit to Exhibitionism: Recent Polynesian Presentations of "Otherness"', *The Contemporary Pacific* 8 (2) (1996), pp. 319–48.

29 Boris Groys, *Art Power* (Cambridge and London: MIT Press, 2008), p. 151.

30 See exhibition catalogues, *Paradise Now? Contemporary Art from the Pacific* (New York: Asia Society, 2004); and *Dateline: Contemporary Art from the Pacific* (Ostfildern: Hatje Cantz Verlag, 2007).

31 See *Pasifika Styles: Artists Inside the Museum*, Rosanna Raymond and Amiria Salmond (eds.) (Cambridge: University of Cambridge Museum of Archaeology and Anthropology/Otago University Press, 2008). On Lisa Reihana, see pp. 51–53.

URBAN ART AND POPULAR CULTURE

1 Greg Dening, *Islands and Beaches: Discourse on a Silent Land: Marquesas 1774–1880* (Honolulu: University of Hawai'i Press, 1980), p. 3.

2 Donovan Storey and Philip McDermott, 'Living in Cities', in Brij V. Lal and Kate Fortune (eds.), *The Pacific Islands: An Encyclopedia* (Honolulu: University of Hawai'i Press, 2000), p. 89.

3 Ron Crocombe, *Pacific Neighbours: New Zealand's Relations with Other Pacific Islands* (Centre for Pacific Studies, University of Canterbury and Institute of Pacific Studies, University of the South Pacific, 1992), p. 13.

4 Etta Gillon, quoted in Melani Anae, Lautofa (Ta) Iuli and Leilani Burgoyne (eds.), *Polynesian Panthers: The Crucible Years 1971–74* (Auckland: Reed Publishing Ltd., 2006), p. 75.

5 Kopytko, 'Breakdance as an Identity Marker in New Zealand', *Yearbook for Traditional Music*, vol. 18, International Council for Traditional Music, 1986, p. 23.

6 Ku'ualoha Ho'omanawanui, 'From Ocean to O-shen: Reggae, Rap and Hip Hop in Hawai'i', in Tiya Miles and Sharon P. Holland (eds.), *Crossing Waters, Crossing Worlds: The African Diaspora in Indian Country* (Durham, NC: Duke University Press, 2006), pp. 277–81.

7 Susan Cochrane, *Bérétara: Contemporary Pacific Art* (Rushcutters Bay, New South Wales: Halstead Press, 2001), p. 139.

8 *TRUE RED: The Dog Rules*, by Tuhoe 'Bruno' Isaac with Bradford Haami, http://www.true-red.com/sample.html (accessed 6 January 2010).

9 Belinda Borell, 'Living in the City Ain't So Bad: Cultural Identity for Young Māori in South Auckland', in James Liu, Tim McCreanor, Tracey McIntosh and Teresia Teaiwa (eds.), *New Zealand Identities: Departures and Destinations* (Wellington: Victoria University Press, 2005), p. 201.

10 Jemma Field, 'Shane Cotton Blackout Movement', *Webbs Auction Catalogue: Important Works of Art 30 March 2009*, http://www.webbs.co.nz/auction-item/blackout-movement (accessed 5 January 2011).

11 Reuben Friend, *Urban Kainga*, Exhibition flyer, City Gallery, Wellington, 2009.

12 Steven Ball, pers. comm., 2010.

13 Ralph Regenvanu, 'Transforming Representations: A Sketch of the Contemporary Art Scene in Vanuatu', in Joël Bonnemaison, Kirk Huffman, Christian Kaufmann and Darrell Tryon (eds.), *Arts of Vanuatu* (Bathurst: Crawford House Publishing, 1996), pp. 312–13.

14 April K. Henderson, 'Dancing Between Islands: Hip Hop and Samoan Diaspora', in Dipannita Basu and Sidney J. Lemelle (eds.), *The Vinyl Ain't Final: Hip Hop and the Globalization of Black Popular Culture (foreword by Robin D. G. Kelley)* (London: Pluto Press, 2006), pp. 180–99. See also Kopytko 1986, p. 21.

15 April K. Henderson, 'Dancing Between Islands', pp. 180–99.

16 Kopytko 1986, p. 25.

17 April K. Henderson, 'Gifted Flows: Making Space for a Brand New Beat', in *Flying Fox Excursions: A Special Issue of The Contemporary Pacific* 22 (2) (2010), pp. 219–15.

18 April K. Henderson, quoted in David Smith, 'The Art of Urban Embroidery', *Salient: The Student Magazine of Victoria University Wellington*, 20 September 2010, http://www.salient.org.nz/features/the-art-of-urban-embroidery (accessed 20 December 2010).

19 Jaime R. Vergara, 'Bike Trails 4: The Graffiti in Kilili', http://www.saipantribune.com/newsstory.aspx?cat=3&newsID=100787 (accessed 5 January 2011).

20 April K. Henderson, quoted in David Smith, 'The Art of Urban Embroidery'.

21 Sweet One Gilliam and Zita Y. Taitano, 'Sinjana Mural Tells Untold Stories', in *Marianas Variety: The Local and Regional Newspaper Guam Edition*, 11 August 2010, http://mvguam.com/index.php?option=com_content&view=article&id=13642:sinjana-mural-tells-untold-stories&Itemid=1 (accessed 20 December 2010).

22 Sean Mallon, Kupa Kupa and Jack Kirifi, 'Toki Niu Hila: Making Tokelauan Adzes and Identity in New Zealand', *Tuhinga: Records of the Museum of New Zealand* 14 (2003), pp. 11–24.

23 Faye Ginsburg, 'Indigenous Media: Faustian Contract or Global Village?', *Cultural Anthropology: Journal for the Society of Cultural Anthropology* 6 (1) (1991), p. 104.

24 Akhil Gupta and James Ferguson, 'Beyond "Culture": Space, Identity and the Politics of Difference', *Cultural Anthropology* 7 (1) (1992), pp. 6–23, 10–11.

25 V. M. Diaz, 'Simply Chamorro: Telling Tales of Demise and Survival in Guam', *The Contemporary Pacific* 6 (1) (1994), pp. 29–58, 51–52.

26 S. Mallon and U. Fecteau, 'Tatau-ed: Polynesian tatau in Aotearoa', in S. Mallon and P. Pereira (eds.), *Pacific Art niu sila: The Pacific Dimension of Contemporary New Zealand Arts* (Wellington: Te Papa Press, 2001), pp. 21–37.

27 Ulf Hannerz, 'Mediations in the Global Ecumene', in G. Palsson (ed.), *Beyond Boundaries: Understanding, Translation and Anthropological Discourse* (Oxford: Berg, 1993), pp. 41–57, 43.

28 Sean Mallon, 'Samoan Tattoo as Global Practice' in Nicholas Thomas, Anna Cole and Bronwen Douglas (eds.), *Tattoo: Bodies, Art and Exchange in the Pacific and Europe* (London: Reaktion Books and Duke University Press, 2005), pp. 145–69.

29 Michael Goddard, 'The Rascal Road: Crime, Prestige and Development in Papua New Guinea', *The Contemporary Pacific* 7 (1) (1995), pp. 55–80, 59.

30 Reuben Friend, unpaginated exhibition flyer, 2009.

31 Ema Tavola, 12/03/2007 Blogpost Colour Me Fiji //Ema Tavola, http://colourmefiji.com/author/theworstartaward/page/20/ (accessed 5 January 2011).

32 Maureen Mahon, 'The Visible Evidence of Cultural Producers', *Annual Review of Anthropology* 29 (2000), pp. 467–68.

33 Gupta and Ferguson, 'Beyond "Culture"', pp. 10–11; Faye Ginsburg, 'Indigenous Media: Faustian Contract or Global Village?', *Cultural Anthropology: Journal for the Society of Cultural Anthropology* 6 (1) (1991), pp. 92–112.

34 Diaz, 'Simply Chamorro', pp. 29–58.

35 Hannerz, 'Mediations in the Global Ecumene', p. 44.

36 Greg Dening, 'History "in" the Pacific', *The Contemporary Pacific* 1 (1–2) (1989), pp. 134–39.

CONTINUITY AND CHANGE IN CUSTOMARY ARTS

1 Michael O'Hanlon, *Paradise: Portraying the New Guinea Highlands* (London: British Museum Press, 1993), p. 61.

2 Michael O'Hanlon, 'Modernity and the "Graphicalization" of Meaning: New Guinea Highland Shield Design in Historical Perspective', *The Journal of the Royal Anthropological Institute* 1 (3) (September 1995), p. 481.

3 ibid., pp. 487–88.

4 See Lyonel Grant and Damian Skinner, *Ihenga: Te Haerenga Hou – The Evolution of Māori Carving in the 20th Century* (Auckland: Reed Publishing, 2007).

5 Philip Dark, 'The Future of Pacific Arts: A Matter of Style?', in Philip Dark and R. G. Rose (eds.), *Artistic Heritage in a Changing Pacific* (Honolulu: University of Hawai'i Press, 1993), p. 216.

6 Judy Flores, 'Art and Identity in the Mariana Islands: The Reconstruction of "Ancient" Chamorro Dance', in Anita Herle et al. (eds.), *Pacific Art: Persistence, Change and Meaning* (Adelaide: Crawford House Publishing, 2002), p. 106.

7 ibid., p. 111.

8 ibid., p. 112.

9 Jean Tekura'i'imoana Mason, 'Tatou – Tattoo: Mortal Art of the Maori', in Ron Crocombe and Marjorie Tua'inekore Crocombe (eds.), *Akono'anga Maori: Cook Islands Culture* (Cook Islands: Institute of Pacific Studies in association with the Cook Islands Extension Centre, University of the South Pacific, Cook Islands Cultural and Historic Places Trust, Ministry of Cultural Development, 2003), pp. 65–66.

10 ibid., p. 65.

11 ibid., p. 62.

12 Maile Drake, 'Ngatu Pepa: Making Tongan Tapa in New Zealand', in Sean Mallon and Pandora Fulimalo Pereira (eds.), *Pacific Art Niu Sila: The Pacific Dimension of Contemporary New Zealand Arts* (Wellington: Te Papa Press, 2002), p. 60.

13 ibid., p. 58.

14 Matt Cooney, 'Carving a New Tradition', *Ideolog* 3, 2006; http://idealog.co.nz/magazine/3/carving-a-new-tradition (accessed 2 July 2010).

15 Philip Dark, 'Tomorrow's Heritage is Today's Art, and Yesteryear's Identity', in Allan Hanson and Louise Hanson (eds.), *Art and Identity in Oceania* (Honolulu: University of Hawai'i Press, 1990), p. 254.

16 Lissant Bolton, *Unfolding the Moon: Enacting Women's Kastom in Vanuatu* (Honolulu: University of Hawai'i Press, 2003), p. xiii.

17 Maureen MacKenzie, *Androgynous Objects: String Bags and Gender in Central New Guinea* (London: Routledge, 1991), p. 14.

18 See O'Hanlon 1993.

19 Sean Mallon, 'Samoan Tatau as Global Practice', in Nicholas Thomas, Anna Cole and Bronwen Douglas (eds.), *Tattoo: Bodies, Art and Exchange in the Pacific and the West* (London: Reaktion Books, 2005), p. 149.

20 Quoted in Nick Stanley, 'Museums and Indigenous Identity: Asmat Carving in a Global Context', in Anita Herle et al. (eds.), *Pacific Art: Persistence, Change and Meaning* (Adelaide: Crawford House Publishing, 2002), p. 154.

21 Julie Risser, 'Asmat Art Festival: Developments and Opportunities', in *In Context* 18 (2) (Spring 2010), University of St Thomas, College of Arts and Sciences.

22 Stanley, 'Museums and Indigenous Identity', p. 157.

23 ibid., p. 163.

24 http://www.spiritwrestler.com/catalog/index.php?cPath=69 (accessed 2 July 2010).

25 Robert Jahnke, 'Contemporary Maori Art: Fact or Fiction', in D. C. Starzecka (ed.), *Maori Art and Culture* (London: British Museum Press, 1996), p. 159.

26 Nigel Reading and Gary Wyatt, *Manawa: Pacific Heartbeat: A Celebration of Contemporary Maori & Northwest Coast Art* (Auckland: Reed Publishing, 2006), pp. 30–31.

27 Karen Stevenson, 'Lalava-ology: A Pacific Aesthetic', in Simon Rees (ed.), *Filipe Tohi: Genealogy of lines – Hohoko ē tohitohi* (New Plymouth: Govett-Brewster Art Gallery, 2002), p. 18.

28 Simon Rees, 'Introduction', ibid., p. 4.

AFTERWORD

1 James Elkins (ed.), *Is Art History Global?* New York: Routledge, 2007.

2 See, for example, Jonathan Mane Wheoki, 'Art's Histories in Aotearoa New Zealand', *Journal of Art Historiography*, no. 4 (June 2011), pp. 1–12.

3 David Summers, *Real Spaces: World Art History and the Rise of Western Modernism*, New York: Phaidon, 2003.

4 Tai Ahu, Paper given at *Re: Locate*, a symposium held at City Gallery Wellington, New Zealand, 29 November 2011.

5 See Hans Belting and Andrea Buddensieg (eds.), *The Global Art World: Audiences, Markets and Museums*, Ostfildern: Hatje Cantz Verlag, 2009.

6 Belting and Buddensieg (eds.) 2009, pp. 38–73; and Hans Belting, *Art History After Modernism*, Chicago: University of Chicago Press, 1992, p. 192.

7 Belting and Buddensieg (eds.) 2009, p. 45.

8 ibid., p. 55.

9 ibid., p. 40.

10 Epeli Hau'ofa, 'The Ocean In Us', in Anthony Hooper (ed.), *Culture and Sustainable Development in the Pacific*, Asia Pacific Press, 2000 (1998), pp. 32–43.

11 ibid., p. 33.

12 ibid., p. 32.

13 ibid., p. 43.

FEATURES AND VOICES (reference by page number)

34 (i) Christopher J. Healey, 'Trade in Bird Plumes in the New Guinea Region', *Occasional Papers in Anthropology* 10 (Brisbane: Anthropology Museum, University of Queensland, 1980). (ii) Ian Saem Majnep and Ralph Bulmer, *Birds of my Kalam Country* (Auckland and Oxford: Auckland University Press, Oxford University Press, 1977), p. 138. (iii) ibid.

42 (i) Fidel Yoringmal, interviewed by Lissant Bolton, 19 and 21 October 2010.

48 (i) This story was told to Edvard Hviding by James Vora of Chubikopi village in 1987, and published in a bilingual version with an illustration of the figure, in Edvard Hviding (ed.), *Vivinei tuari pa ulusaghe/Custom Stories of the Marovo Area* (Norway: Centre for Development Studies University of Bergen, and Gizo, Solomon Islands: Western Province Division of Culture, 1995). (ii) Cited in Rhys Richards, 'Kimbo: Stone Figures from Western Province, Solomon Islands', *Pacific Arts*, 23/24, 2001, pp. 103–12.

55 http://pvs.kcc.hawaii.edu/index/voices_of_voyaging.html

56 (i) Henry Lyons, 'The Sailing Charts of the Marshall Islanders', *The Geographical Journal*, 72:4, 1928, p. 326. (ii) Ben Finney and Sam Low, 'Navigation', in K. R. Howe (ed.), *Vaka Moana: Voyages of the Ancestors; The Discovery and Settlement of the Pacific* (Auckland: David Bateman, 2006), p. 175. (iii) W. H. Davenport, 'Marshall Islands Cartography', *Expedition*, 6:4, 1964, p. 13.

66 (i) Excerpt from Hon. Tui Atua Tupua Tamasese Ta'isi Tupuola Tufuga Efi, 'In Search of Tagaloa: Pulemelei, Samoan Mythology and Science' in *Archaeology in Oceania*, vol. 42 Supplement (October 2007), pp. 5–10, p. 5. Reprinted with permission.

68 (i) Georgia Lee, 'Oceania', in David S. Whitley (ed.), *Handbook of Rock Art Research* (Walnut Creek, CA:

AltaMira Press, 2001), pp. 576–604. (ii) David Burley, 'As a Prescription to Rule: The Royal Tomb of Mala'e Lahi and the 19th-Century Tongan Kingship', *Antiquity* 68, 1994, pp. 504–17. Quoted in Lee, ibid., p. 578. (iii) J. Halley Cox and Edward Stasack, *Hawaiian Petroglyphs* (Honolulu: Bishop Museum Press, 1970), p. 67. (iv) ibid., pp. 23–24.

72 (i) H. D. Skinner, 'The Awanui (Kaitaia) Carving', *Journal of the Polynesian Society* 30, 1921, p. 247; 'The Kaitaia Carving', *Journal of the Polynesian Society* 31, 1922, p. 57.

96 (i) Kathleen Barlow, 'Achieving Womanhood and the Achievements of Women in Murik Society: Cult Initiation, Gender Complementarity and the Prestige of Women', in N. Lutkehaus and P. Roscoe (eds.), *Gender Rituals: Female Initiation in Melanesia* (New York: Routledge, 1995), pp. 85–112, p. 96. (ii) David Lipset, *Mangrove Man: Dialogics of Culture in the Sepik Estuary* (Cambridge: Cambridge University Press, 1997), p. 43. (iii) Barlow, 'Achieving Womanhood and the Achievements of Women in Murik Society', p. 106. (iv) David Lipset, personal communication.

103 (i) Vincent Eri, *The Crocodile* (Milton, Queensland: Jacaranda Press, 1970), p. 25. Reprinted with permission.

104 (i) This section draws extensively upon Anita Herle's essay, 'The Torres Strait: Art and Customs', in Philippe Peltier and Floriane Morin (eds.), *Shadows of New Guinea: Art from the Great Island of Oceania in the Barbier-Mueller Collections* (Paris: Somogy, 2006), pp. 220–33.

108 (i) Reprinted in Nikolai Miklouho-Maclay, *Travels to New Guinea: Diaries, Letters, Documents*, D. Tumarkin (ed.) (Moscow: Progress Publishers, 1982), pp. 451–52.

124 (i) *Sydney Morning Herald*, 6 November 1889.

127 (i) A. C. Haddon, *Head-hunters: Black, White and Brown* (London: Methuen, 1901), pp. 177–78.

141 (i) Anthony Crawford, *Aida: Life and Ceremony of the Gogodala* (Bathurst, New South Wales: National Cultural Council of Papua New Guinea in association with Robert Brown and Associates, c. 1981), p. 33. Reprinted with kind permission from Anthony Crawford.

147 (i) Excerpt from Vincent Eri, *The Crocodile* (Melbourne: Jacaranda Press, 1970) pp. 12–14.

150 (i) Reprinted courtesy of the Field Museum Archives.

152 (i) See Anita Herle and Sandra Rouse (eds.), *Cambridge and the Torres Strait: Centenary Essays on the 1898 Anthropological Expedition* (Cambridge: Cambridge University Press, 1998), p. 53. (ii) See James Urry, *Before Social Anthropology: Essays on the History of British Anthropology* (Harwood Academic Publishers, 1993), pp. 61–82; and Anita Herle and Sandra Rouse (eds.), *Cambridge and the Torres Strait: Centenary Essays on the 1898 Anthropological Expedition* (Cambridge: Cambridge University Press, 1998). (iii) A. C. Haddon, *The Decorative Art of British New Guinea* (Dublin: Academic House, 1894), and *Evolution in Art: As Illustrated by the Life-Histories of Designs* (London: Walter Scott, 1895). (iv) Haddon 1894, p. 4. (v) ibid., p. 199. (vi) Anita Herle, 'The Life-Histories of Objects: Collections of the Cambridge Anthropological Expedition to the Torres Strait', in Herle and Rouse (eds.), op. cit., pp. 77–105, 77.

163 (i) From Raymond Firth, *We, The Tikopia* (Boston: Beacon Press, 1963 [1936]), p. 52.

164 (i) Lloyd Maepeza Gina, *Journeys in a Small Canoe: The Life and Times of a Solomon Islander*, Judith Bennett and Khyla Russell (eds.) (Canberra: Pandanus Books, 2003), p. 17.

182 (i) Tom Harrisson, *Savage Civilisation* (London: Gollancz, 1937), p. 30. (ii) ibid., p. 25.

190 (i) L. Cohn, unpublished field notes, 1912. Bremen, archives of the Übersee Museum; quoted in Dieter Heintze, 'Taim bilong ol Jeman: Dealing with Traders, Officials, Missionaries, Anthropologists', in *Admiralty Islands*, Christian Kaufmann, Christin Kocher Schmid,

Sylvia Ohnemus (eds.) (Zurich: Museum Rietberg, 2002), p. 88. (ii) Robin Torrence, 'Ethnoarchaeology, Museum Collections and Prehistoric Exchange: Obsidian-Tipped Artefacts from the Admiralty Islands', *World Archaeology* 24:3, February 1993, pp. 470–71. (iii) ibid., pp. 474–76; Robin Torrence, 'Just Another Trader? An Archaeological Perspective on European Barter with Admiralty Islanders, Papua New Guinea', in *The Archaeology of Difference: Negotiating Cross-Cultural Engagements in Oceania*, Robin Torrence and Anne Clarke (eds.) (London: Routledge, 2000), pp. 128–31.(iv) Torrence, 'Ethnoarchaeology, Museum Collections and Prehistoric Exchange', p. 477.

193 (i) Maurice Leenhardt, *Gens de la Grande Terre* (Paris, 1937), pp. 166–168. This passage translated by James Clifford and Stella Ramage.

202 (i) Jim Specht, *Pieces of Paradise: Australian Natural History*, Supplement no. 1 (Sydney: Australian Museum Trust, 1988), pp. 18–19. (ii) Maurice Leenhardt, *Do kamo: Person and Myth in the Melanesian World*, Basia Miller Gulati (trans.) (Chicago: University of Chicago Press, 1979 [1947]), p. 153.

205 (i) R. G. Crocombe and Marjorie Crocombe (trans. and eds.), *The Works of Ta'unga: Records of a Polynesian Traveller in the Southern Seas, 1833–1896* (Canberra: Australian National University Press, 1968), pp. 59–62.

206 (i) P. Lambert, *Moeurs et superstitions des Néo-Calédoniens* (Noumea: Société d'Études Historiques de la Nouvelle-Calédonie, 1985 (orig. 1900)), p. 67. The most recent and valuable publication is Roberta Colombo Dougoud, *Bambous kanak* (Geneva: Musée d'Ethnographie de Genève, 2008).

221 (i) Recorded on 7 February 1997, transcribed and translated by Lissant Bolton.

230 (i) The food trough was discussed in several early twentieth-century communications to the anthropological journal *Man*; for details and for an enormously informative discussion that I have drawn upon here, see Deborah Waite and Ben Burt, 'The Davis Collection from Roviana', in Lissant Bolton et al. (eds.), *Melanesia: Art and Encounter* (London: British Museum Press, 2012).

252 (i) This essay draws on three main sources: the archaeological classic by Katherine Routledge, *The Mystery of Easter Island* (London: Sifton, Praed & Co. Ltd., 1919, reprinted by Rapanui Press, 2005), see especially pp. 254–66; Alfred Métraux, *Ethnology of Easter Island* (Honolulu: Bernice P. Bishop Museum, 1971 (1940)), pp. 311–15, 331–41; and Alfred Métraux, *Easter Island: A Stone-Age Civilization of the Pacific*, trans. Michael Bullock (London: André Deutsch Ltd., 1957), pp. 130–39. For two more recent accounts, see Patrick Kirch, *The Evolution of Polynesian Chiefdoms* (Cambridge: Cambridge University Press, 1984), pp. 264–78; and Steven Roger Fischer, *Island at the End of the World: The Turbulent History of Easter Island* (London: Reaktion Books Ltd., 2005), pp. 45–85. (ii) Routledge, 1919, op. cit., p. 208. (iii) ibid., pp. 205–6.

254 (i) Samuel M. Kamakau, *The Works of the People of Old: Na Hana a ka Po'e Kahiko*, Mary Kawena Pukui (trans.), Dorothy B. Barrère (ed.) (Honolulu: Bishop Museum Press, Special Publications no. 61, 1976), pp. 30–31.

262 (i) Paul Gauguin, *The Writings of a Savage*, Daniel Guérin (ed.) (New York: Paragon House, 1990), p. 280. (ii) Eric Kjellgren and Carol S. Ivory, *Adorning the World: Art of the Marquesas Islands* (New York and New Haven: The Metropolitan Museum of Art and Yale University Press, 2005), pp. 85–88. (iii) Alfred Gell, *Wrapping in Images: Tattooing in Polynesia* (Oxford: Clarendon Press, 1993), pp. 163–217. (iv) See Patrick Kirch, *On the Road of the Winds: An Archaeological History of the Pacific Islands before European Contact* (Berkeley, CA: University of

California Press, 2002), pp. 257–65. (v) *The Marquesan Journal of Edward Robarts, 1797–1824*, Greg Dening (ed.) (Canberra: Australian National University Press, 1974), p. 20. See also Greg Dening, *Islands and Beaches: Discourse on a Silent Land: Marquesas 1774–1880* (Chicago, IL: The Dorsey Press, 1980), and Nicholas Thomas, *Marquesan Societies: Inequality and Political Transformation in Eastern Polynesia* (Oxford: Clarendon Press, 1990). (vi) For an attempt to answer the question, see Alfred Gell, *Art and Agency: An Anthropological Theory* (Oxford: Clarendon Press/Oxford University Press, 1998), pp. 155–220.

266 (i) Donald Rubinstein and Sophiano Limol, 'Reviving the Sacred Machi: A Chiefly Weaving from Fais Island, Micronesia', in *Material Choices: Refashioning Bast and Leaf Fibers in Asia and the Pacific*, Roy W. Hamilton and B. Lynn Milgram (eds.) (Los Angeles: Fowler Museum at UCLA, 2007), p. 161. Translation by Donald Rubinstein. Reproduced with the author's kind permission.

280 (i) Steven Hooper, 'Embodying Divinity: The Life of A'a', *Journal of the Polynesian Society* 116 (2007), 131–79. Hooper's is the most important and wide-ranging study of the figure to date. (ii) Alain Babadzan, 'The puta tupuna of Rurutu', in Antony Hooper and Judith Huntsman (eds.), *Transformations of Polynesian Culture* (Auckland: The Polynesian Society, 1985), esp. 184–85. Alfred Gell argued for the 'fractal' character of A'a in *Art and Agency* (Oxford: Clarendon Press/Oxford University Press, 1998), pp. 137ff, though it should be noted that the small figures do not strictly replicate the larger one.

283 (i) LMS South Seas Journals, Box 4, LMS Archives, School of Oriental and African Studies, London.

294 (i) Jane Roth and Steven Hooper (eds.), *The Fiji Journals of Baron Anatole von Hügel 1875–1877, Suva* (Fiji Museum in association with Cambridge University, 1990), pp. 31–32.

296 (i) BM website address: http://www.britishmuseum.org/ research/search_the_collection_database/search_ object_details.aspx?objectid=3151753&partid=1&IdNum =Oc%2cA3.63. Accessed November 2010. (ii) George W. Stocking, *Victorian Anthropology* (New York: Macmillan, 1987), p. 246. See also Elizabeth Edwards (ed.), *Anthropology and Photography 1860–1920* (New Haven, CT, and London: Yale University Press/Royal Anthropological Institute, 1992).

314 (i) Quoted in Bengt Danielsson, *Gauguin in the South Seas*, trans. Reginald Spink (London: George Allen and Unwin Ltd., 1965), p. 259. (ii) For the provenance of the house panels, see Anne Pingeot, 'The House of Pleasure', in George T. M. Shackelford and Claire Frèche-Thory, *Gauguin Tahiti: The Studio in the South Seas* (London: Thames & Hudson, 2004), pp. 263–71.

318 (i) Reprinted from Roger Neich, *Carved Histories* (Auckland: Auckland University Press, 2001), pp. 63–64.

322 (i) Richard Gilson, *The Cook Islands 1820–1950*, ed. Roger Crocombe (Wellington: Victoria University Press in association with the Institute of Pacific Studies of the University of the South Pacific, 1980). (ii) Elizabeth Akana, *Hawaiian Quilting: A Fine Art* (Honolulu: Hawaiian Mission Children's Society, 1981). (iii) Joyce D. Hammond, 'Polynesian Women and Tīfaifai Fabrications of Identity', *The Journal of American Folklore*, vol. 99

(393), July–September 1986, pp. 259–79. Vicki Poggioli, *Patterns from Paradise: The Art of Tahitian Quilting* (Pittstown, NJ: Main Street Press, 1988). Lynnsay Rongokea, *The Art of Tivaevae: Traditional Cook Islands Quilting* (Honolulu: University of Hawai'i Press, 2001). (iv) Susanne Küchler and Andrea Eimke, *Tivaivai: The Social Fabric of the Cook Islands* (London and Wellington: British Museum Press and Te Papa Press, 2009). (v) Alfred Gell, *Wrapping in Images: Tattooing in Polynesia* (Oxford: Clarendon Press, 1993).

332 (i) Unidentified correspondent, *Pacific Islands Monthly*, March 1945, p. 40

335 (i) In Lamont Lindstrom and Geoffrey White, 'Singing History: Island Songs from the Pacific War', in *Artistic Heritage in a Changing Pacific*, Philip J. C. Dark and Roger G. Rose (eds.) (Honolulu: University of Hawai'i Press, 1993, pp. 185–96).

344 (i) Laura Brandon, Peter Stanley, Roger Tolson and Lola Wilkins, *Shared Experience: Art and War – Australia, Britain and Canada in the Second World War* (Canberra: Australian War Museum, 2005), p. 75. (ii) Stewart Firth, 'The War in the Pacific', in *The Cambridge History of the Pacific Islanders*, Donald Denoon et al. (eds.) Cambridge: Cambridge University Press, 1997), pp. 291–323; see especially pp. 304–8. (iii) Donald Denoon, *A Trial Separation: Australia and the Decolonisation of Papua New Guinea* (Canberra: Pandanus Books, 2005), pp. 7–20.

352 (i) Albert Maori Kiki, *Kiki: Ten Thousand Years in a Lifetime: A New Guinea Autobiography* (Melbourne: Cheshire Publishing, 1968), pp. 47–48.

354 (i) Diane Losche, 'The Importance of Birds', *Double Vision : Art Histories and Colonial Histories in the Pacific*, Nicolas Thomas and Diane Losche (eds.) (Cambridge: Cambridge University Press, 1999). (ii) P. M. Kaberry, 'The Abelam Tribe, Sepik District, New Guinea', *Oceania* 11: 3, 4, 1941. (iii) A. Forge, 'Art and Environment in the Sepik', *Proceedings of the Royal Anthropological Institute of Great Britain and Ireland*, 1965, pp. 23–31, p. 29.

365 (i) In Jean-Marie Tjibaou, *Kanaky*, Alban Bensa and Éric Wittersheim (eds.), Helen Fraser and John Trotter (trans.) (Canberra: Pandanus Books, The Australian National University, 2005), pp. 128–29.

373 (i) Albert Wendt, 'Towards a New Oceania', *Mana Review* 1, 1976, pp. 49–60, p. 53.

376 (i) Ralph Hotere interviewed by Garth Hall, 1973. Quoted by Frank Davis in 'Maori Statements in a European Idiom', *Education*, 25:9 (1976), p. 29.

388 (i) Paul Ricoeur, 'Universal Civilization and National Cultures', in *History and Truth*, Charles Kelbley (trans.) (Evanston, IL: Northwestern University Press, 1965 [1955]), pp. 277–78.

390 (i) http://www.millenniumhotels.co.nz/ kingsgaterotorua/index.html. Accessed August 2009. (ii) Ngahuia Te Awekotuku, *The Sociocultural Impact of Tourism on the Te Arawa People of Rotorua*, New Zealand (PhD thesis, University of Waikato, 1981), p. 178.

403 (i) Haunani-Kay Trask, 'Lovely Hula Hands: Corporate Tourism and the Prostitution of Hawaiian Culture' in *From a Native Daughter: Colonialism and Sovereignty in Hawai'i* (Monroe, ME: Common Courage Press, 1993), pp. 194–96.

406 (i) Dean MacCannell, 'Cannibal Tours', in Lucien Taylor (ed.), *Visualizing Theory: Selected Essays from V.A.R. 1990–1994* (New York and London: Routledge, 1994), pp. 99–114, 100.

424 (i) Gordon Walters, in Michael Dunn, *Gordon Walters* (Auckland: Auckland City Art Gallery, 1983), p. 124. (ii) 'Ngahuia Te Awekotuku, in conversation with Elizabeth Eastmond and Priscilla Pitts', *Antic* 1, June 1986, p. 51. (iii) Rangihiroa Panoho, 'Maori: at the Centre, on the Margins', in Mary Barr (ed.), *Headlands: Thinking Through New Zealand Art* (Sydney: Museum of Contemporary Art, 1992), pp. 131–33. (iv) Nicholas Thomas, *Possessions: Indigenous Art/Colonial Culture* (London: Thames & Hudson, 1999), p. 158. (v) Nicholas Thomas, 'Kiss the Baby Goodbye: Kowhaiwhai and Aesthetics in Aotearoa New Zealand', *Critical Inquiry* 22, Autumn 1995, p. 119.

430 (i) Sia Figiel, 'Seabird Tales: The Pacific Paintings of Dan Taulapapa McMullin', in *Art & Australia*, vol. 46 (4), Winter 2009, pp. 635–41. Reprinted with permission.

436 (i) Michael Mel, 'Am I Black or White?' in *News from Islands* (Campbelltown Arts Centre, 2007), pp. 44–45. Reprinted with permission.

446 (i) Serge Tcherkézoff , 'La hiérarchie au quotidien, contre l'inégalité (1980). Une théorie samoane de l'action : tapuai/fai; le voyage en autocar à Samoa', in S. Tcherkézoff, *Faa-samoa, Une Identité Polynésienne (Économie, Politique, Sexualité). L'anthropologie comme dialogue culturel* (Paris: L'Harmattan ('Connaissance des hommes'), 2003), pp. 177–210, and forthcoming English translation: 'A Bus Ride in Samoa: A Microcosm of Hierarchy' in J. Robbins and S. Tcherkézoff (eds.), *Louis Dumont in Oceania*.

449 (i) http://yamasawaenglish.blogspot.com/2009/06/ea-lyrics-from-sudden-rush.html. Accessed October 2011.

460 (i) Marjorie Kelly, 'Projecting an Image and Expressing Identity: T-Shirts in Hawai'i', *Fashion Theory*, vol. 7, issue 2, 2003, p. 192. (ii) ibid., p. 202. (ii) Belinda Borell, 'Living in the City Ain't So Bad: Cultural Identity for Young Māori in South Auckland' in James Liu, Tim McCreanor, Tracey McIntosh and Teresia Teaiwa (eds.), *New Zealand Identities: Departures and Destinations* (Wellington: Victoria University Press, 2005), p. 202.

470 (i) John Hovell, 'Te Aute Notes', unpublished text, 2006, artist's collection. (ii) ibid. (iii) See Damian Skinner, *The Passing World, The Passage of Life: John Hovell and the Art of Kōwhaiwhai* (Auckland: Rim Books, 2010).

484 The fullest publication on Ömie to date is the catalogue of the National Gallery of Victoria show: Sana Balai, Judith Ryan and Drusilla Modjeska, *Wisdom of the Mountain: The Art of Ömie* (Melbourne: National Gallery of Victoria, 2009). See also the online catalogue, *Paperskin: Barkcloth across the Pacific*, www.tepapa.govt.nz/SiteCollectionDocuments/ Exhibitions/Paperskin.Publication.Barkcloth.Across. The.Pacific.11.11.pdf

488 (i) Lucy Moses, Report to the Women Fieldworkers Island Dress History workshop, North Ambrym, Vanuatu, October 2002. Excerpt courtesy of Lissant Bolton.

490 (i) Caroline Yacoe, 'Marshall Islands Jaki-ed Mats', September 2009, exhibition flyer.

INTRODUCTION

Bolton, Lissant, Nicholas Thomas, Elizabeth Bonshek, Julie Adams and Ben Burt (eds.), *Melanesia: Art and Encounter* (London: British Museum Press, 2012).

Bonnemaison, Joël, with Kirk Huffman, Christian Kauffmann and Darrell Tryon (eds.), *Arts of Vanuatu* (Bathurst, New South Wales: Crawford House Publishing, 1996).

Borofsky, Robert (ed.), *Remembrance of Pacific Pasts: An Invitation to Remake History* (Honolulu: University of Hawai'i Press, 2000).

Colchester, Chloë (ed.), *Clothing the Pacific* (London: Berg Publishers, 2003).

Coote, Jeremy and Anthony Shelton (eds.), *Anthropology, Art and Aesthetics* (Oxford: Oxford University Press, 1992).

Craig, Barry, Bernie Kernot and Christopher Anderson (eds.), *Art and Performance in Oceania* (Honolulu: University of Hawai'i Press, 1999).

D'Alleva, Anne, *Arts of the Pacific Islands* (New Haven, CT: Yale University Press, 2010 [1998]).

Dark, Philip and Roger G. Rose (eds.), *Artistic Heritage in a Changing Pacific* (Honolulu: University of Hawai'i Press, 1993).

Denoon, Donald et al. (eds.), *The Cambridge History of the Pacific Islanders* (Cambridge: Cambridge University Press, 1997).

Edwards, Elizabeth (ed.), *Anthropology and Photography 1860–1920* (New Haven, CT and London: Yale University Press/Royal Anthropological Institute, 1992).

Feldman, Jerome and Donald H. Rubinstein (eds.), *Art of Micronesia* (Honolulu: University of Hawaii Art Gallery, 1986).

Forge, Anthony (ed.), *Primitive Art and Society* (London: Oxford University Press, 1973).

Gell, Alfred, *Art and Agency: An Anthropological Theory* (Oxford: Clarendon Press, 1998).

Guiart, Jean, *The Arts of the South Pacific*, Anthony Christie (trans.) (New York: Golden Press, 1963).

Hanson, Allan and Louise Hanson (eds.), *Art and Identity in Oceania* (Honolulu: University of Hawai'i Press, 1990).

Hanson, Louise and F. Allan Hanson, *The Art of Oceania: A Bibliography. Reference Publications in Art History* (Boston, MA: G. K. Hall and Co., 1984).

Hereniko, Vilsoni and Rob Wilson (eds.), *Inside Out: Literature, Cultural Politics and Identity in the New Pacific* (Lanham, MD: Rowman & Littlefield Inc., 1999).

Herle, Anita, with Nick Stanley, Karen Stevenson and Robert L. Welsch (eds.), *Pacific Art: Persistence, Change and Meaning* (Adelaide: Crawford House Publishing, 2002).

Hooper, Steven, *Pacific Encounters: Art & Divinity in Polynesia 1760–1860* (Honolulu: University of Hawai'i Press, 2006).

Howe, K. R. (ed.), *Vaka Moana: Voyages of the Ancestors; The Discovery and Settlement of the Pacific*, (Auckland: David Bateman, 2006).

——, Robert C. Kiste and Brij V. Lal (eds.), *Tides of History: The Pacific Islands in the Twentieth Century* (Honolulu: University of Hawai'i Press, 1994).

Kaeppler, Adrienne, *Pacific Arts of Polynesia and Micronesia* (New York: Oxford University Press, 2008).

——, Christian Kaufmann and Douglas Newton, *Oceanic Art* (New York: Abrams, 1997).

Lal, Brij V. and Kate Fortune (eds.), *The Pacific Islands: An Encyclopedia* (Honolulu: University of Hawai'i Press, 2000).

Lutkehaus, Nancy C. et al. (eds.), *Sepik Heritage: Tradition and Change in Papua New Guinea* (Bathurst, New South Wales: Crawford House Publishing, 1990).

Mead, Sidney Moko (ed.), *Exploring the Visual Art of Oceania, Australia, Melanesia, Micronesia and Polynesia* (Honolulu: University of Hawai'i Press, 1979).

—— and Bernie Kernot (eds.), *Art and Artists of Oceania* (Palmerston North: Dunmore Press/Ethnographic Arts Publications, 1983).

Morphy, Howard and Morgan Perkins (eds.), *The Anthropology of Art: A Reader* (Oxford: Blackwell Publishing, 2006).

Schmitz, Carl A., *Oceanic Art: Myth, Man and Image in the South Seas* (New York: Abrams, 1969).

Strathern, Andrew et al. (eds.), *Oceania: Introduction to the Cultures and Identities of Pacific Islanders* (Durham, NC: Carolina Academic Press, 2002).

Thomas, Nicholas, *Oceanic Art* (London: Thames & Hudson, 1995).

——, *Islanders: The Pacific in the Age of Empire* (London: Yale University Press, 2010).

—— and Diane Losche (eds.), *Double Vision: Art Histories and Colonial Histories in the Pacific Islands* (Cambridge: Cambridge University Press, 1999).

PART ONE: ART IN EARLY OCEANIA

Bedford, Stuart, Christophe Sand and Sean P. Connaughton (eds.), *Oceanic Explorations: Lapita and Western Pacific Settlement* (*Terra Australis* 26) (Canberra: ANU E Press, 2007).

Clark, G. R., A. J. Anderson and T. Vunidilo (eds.), *The Archaeology of Lapita Dispersal in Oceania* (Canberra: Pandanus Books, 2001).

Cox, J. Halley and Edward Stasack, *Hawaiian Petroglyphs* (Honolulu: Bishop Museum Press, 1970).

Davidson, Janet et al. (eds.), *Oceanic Culture History: Essays in Honour of Roger Green*, in *New Zealand Journal of Archaeology*, special publication, 1996.

Garanger, José, *Archéologie des Nouvelles Hébrides*, Publication de la Société des Océanistes, No. 30 (Paris: Société des Océanistes, 1972).

Howe, K. R., *The Quest for Origins* (Auckland: Penguin Books, 2003).

—— (ed.), *Vaka Moana: Voyages of the Ancestors; The Discovery and Settlement of the Pacific* (Auckland: David Bateman, 2006).

Irwin, Geoffrey, *The Prehistoric Exploration and Colonisation of the Pacific* (Cambridge: Cambridge University Press, 1992).

Jennings, J. D. (ed.), *The Prehistory of Polynesia* (Cambridge, MA: Harvard University Press, 1979).

Kirch, Patrick V., *Evolution of the Polynesian Chiefdoms* (Cambridge: Cambridge University Press, 1984).

——, *The Lapita Peoples: Ancestors of the Oceanic World* (Oxford: Blackwell, 1997).

——, *On The Road of the Winds: An Archaeological History of the Pacific Islands before European Contact* (Berkeley, CA: University of California Press, 2000).

—— and Roger C. Green, *Hawaiki, Ancestral Polynesia: An Essay in Historical Anthropology* (Cambridge: Cambridge University Press, 2001).

Lilley, Ian (ed.), *Archaeology of Oceania: Australia and the Pacific Islands* (Malden, MA: Blackwell Publishing, 2006).

Métraux, Alfred, *Easter Island: A Stone-Age Civilization of the Pacific*, Michael Bullock (trans.) (London: André Deutsch, 1957).

Morgan, William, *Prehistoric Architecture in Micronesia* (Austin, TX: University of Texas Press, 1988).

Spriggs, Matthew, *The Island Melanesians* (Oxford: Blackwell Publishers, 1997).

PART TWO: NEW GUINEA 1700–1940

Baal, Jan Van, *Dema: Description and Analysis of Marind-Anim Culture (South New Guinea)* (The Hague: Martinus Nijhoff, 1966).

Bateson, Gregory, *Naven: A Survey of the Problems Suggested by a Composite Picture of the Culture of a New Guinea Tribe Drawn from Three Points of View*, 2nd ed. (Stanford, CA: Stanford University Press, 1958 [1936]).

Beran, Harry and Barry Craig (eds.), *Shields of Melanesia* (Adelaide: Crawford House Publishing, 2005).

Corbey, Raymond, *Headhunters from the Swamps: The Marind Anim of New Guinea as Seen by the Missionaries of The Sacred Heart, 1905–1925* (Leiden: KITLV Press, 2010).

Crawford, Anthony L., *Aida: Life and Ceremony of the Gogodala* (Bathurst, New South Wales: Robert Brown Associates/National Cultural Council of Papua New Guinea, 1981).

Dundon, Alison, 'A Cultural Revival and the Custom of Christianity in Papua New Guinea', in Kathryn Robinson (ed.), *Self and Subject in Motion: Southeast Asian and Pacific Cosmopolitans* (London: Palgrave, 2007).

Dutton, Thomas (ed.), *The Hiri in History* (Canberra: The Australian National University, 1982).

Friede, John et al., *New Guinea Art: Masterpieces from the Jolika Collection of Marcia and John Friede* (San Francisco: Fine Arts Museums of San Francisco in association with 5 Continents Editions, Milan, 2005).

Godelier, Maurice and Marilyn Strathern (eds.), *Big Men and Great Men: Personifications of Power in Melanesia* (Cambridge: Cambridge University Press, 1991).

Greub, Suzanne, *Art of Northwest New Guinea: From Geelvink Bay, Humboldt Bay, and Lake Sentani* (New York: Rizzoli, 1992).

Haddon, A. C., *Decorative Art of British New Guinea* (Dublin: Academic House, 1894).

——, *Head-hunters: Black, White and Brown* (London: Methuen, 1901).

Harrison, Simon, *The Mask of War: Violence, Ritual and the Self in Melanesia* (Manchester: Manchester University Press, 1993).

Herdt, Gilbert H. (ed.), *Rituals of Manhood: Male Initiation in Papua New Guinea* (Berkeley, CA: University of California Press, 1982).

Herle, Anita and Andrew Moutu, *Paired Brothers: Concealment and Revelation* (Cambridge: Museum of Archaeology and Anthropology, 2004).

—— and Sandra Rouse (eds.), *Cambridge and the Torres Strait: Centenary Essays on the 1898 Anthropological Expedition* (Cambridge: Cambridge University Press, 1998).

Hurley, Frank, *Pearls and Savages: Adventures in the Air, on Land and Sea in New Guinea* (New York and London: Putnam, 1924).

Jolly, Margaret and Nicholas Thomas (eds.), *The Politics of Tradition in the Pacific*, special issue, *Oceania* 62, 1992.

Kaplan, Martha, *Neither Cargo nor Cult* (Durham, NC: Duke University Press, 1995).

Knauft, Bruce M., 'Melanesian Warfare: A Theoretical History', *Oceania* 60, 1990, pp. 250–311.

——, *South Coast New Guinea Cultures: History, Comparison, Dialectic* (Cambridge: Cambridge University Press, 1993).

Lawrence, Peter, *Road Belong Cargo: A Study of the Cargo Movement in the Southern Madang District, New Guinea* (Melbourne: Melbourne University Press, 1964).

Lipset, David, *Mangrove Man: Dialogics of Culture in the Sepik Estuary* (Cambridge: Cambridge Studies in Social and Cultural Anthropology, 1997).

Lutkehaus, Nancy and Paul Roscoe (eds.), *Gender Rituals: Female Initiation in Melanesia* (New York: Routledge, 1995).

MacKenzie, Maureen, *Androgynous Objects: String Bags and Gender in Central New Guinea* (Amsterdam: Harwood Academic Publishers, 1991).

Malinowski, Bronislaw, *Argonauts of the Western Pacific* (London: Routledge, 1922).

May, Patricia and Margaret Tuckson, *The Traditional Pottery of Papua New Guinea* (Sydney: Bay Books, 1982).

Moore, Clive, *New Guinea: Crossing Boundaries and History* (Honolulu: University of Hawai'i Press, 2003).

O'Hanlon, Michael, *Paradise: Portraying the New Guinea Highlands* (London: British Museum Press, 1993).

——, 'Modernity and the "Graphicalization" of Meaning: New Guinea Highland Shield Design in Historical Perspective', *Journal of the Royal Anthropological Institute* 1 (1995), pp. 472–74.

—— and Robert L. Welsch (eds.), *Hunting the Gatherers: Ethnographic Collectors, Agents and Agency in Melanesia, 1870s–1920s* (New York: Berghahn Books, 2000).

Peltier, Philippe and Floriane Morin (eds.), *Shadows of New Guinea: Art from the Great Island of Oceania in the Barbier-Mueller Collections* (Geneva: Somogy, 2006).

Seligman, C. G. (ed.), *The Melanesians of British New Guinea* (Cambridge: Cambridge University Press, 1910).

Sillitoe, Paul, *An Introduction to the Anthropology of Melanesia* (Cambridge: Cambridge University Press, 1998).

Simpson, Colin, *Plumes and Arrows: Inside New Guinea* (Sydney: Angus & Robertson, 1962).

Smidt, Dirk (ed.), *Asmat Art: Woodcarvings of Southwest New Guinea* (New York: George Braziller in association with Rijksmuseum voor Volkenkunde, Leiden, 1993).

—— (ed.), *Kamoro Art: Tradition and Innovation in a New Guinea Culture* (Amsterdam: KITLV Press, 2003).

Specht, Jim and John Fields, *Frank Hurley in Papua: Photographs of the 1920–1923 Expeditions* (Sydney: Australian Museum Trust, 1984).

Strathern, Andrew (ed.), *Inequality in New Guinea Highlands Societies* (Cambridge: Cambridge Papers in Social Anthropology, 1982).

—— and Marilyn Strathern, *Self-Decoration in Mount Hagen* (London: Duckworth, 1971).

Strathern, Marilyn, *The Gender of the Gift* (Berkeley, CA: University of California Press, 1988).

Thomas, Nicholas, *Entangled Objects: Exchange, Material Culture and Colonialism in the Pacific* (Cambridge, MA: Harvard University Press, 1991).

Welsch, Robert. L. (ed.), *An American Anthropologist in Melanesia*, 2 vols. (Honolulu: University of Hawai'i Press, 1998).

Williams, F. E., *Papuans of the Trans-Fly* (Oxford: Clarendon Press, 1936).

——, 'The Vailala Madness' and Other Essays, Eric Schwimmer (ed.) (St Lucia: University of Queensland Press, 1976).

Worsley, Peter, *The Trumpet Shall Sound: A Study of 'Cargo' Cults in Melanesia* (London: McGibbon and Kee, 1957).

PART THREE: ISLAND MELANESIA 1700–1940

Berg, Cato and Edvard Hviding (eds.), *The Ethnographic Experiment: Rivers and Hocart in Solomon Islands* [1908] (Oxford: Berghahn Books, *forthcoming*).

Bolton, Lissant, *Unfolding the Moon: Enacting Women's Kastom in Vanuatu* (Honolulu: University of Hawai'i Press, 2003).

——, Nicholas Thomas, Elizabeth Bonshek, Julie Adams and Ben Burt (eds.), *Melanesia: Art and Encounter* (London: British Museum Press, 2012).

Bonnemaison, Joël, Kirk Huffman, Christian Kaufmann, Darrell Tryon (eds.), *Arts of Vanuatu* (Bathurst, New South Wales: Crawford House Publishing, 1996).

Burt, Ben with David Akin and Michael Kwa'ioloa, *Body Ornaments of Malaita, Solomon Islands* (London: British Museum Press and University of Hawai'i Press, 2009).

—— and Lissant Bolton (eds.), *The Things We Value: Culture and History in Solomon Islands* (Oxford: Sean Kingston Publishing, 2011).

—— and Michael Kwa'ioloa (eds.), *A Solomon Islands Chronicle, as Told by Samuel Alasa'a* (London: British Museum Press, 2001).

Clifford, James, *Person and Myth: Maurice Leenhardt in the Melanesian World* (Berkeley, CA: University of California Press, 1982).

Codrington, Robert Henry, *The Melanesians: Studies in their Anthropology and Folklore* (Oxford: Clarendon Press, 1891).

Colchester, Chloë (ed.), *Clothing the Pacific* (London: Berg, 2003).

Connell, John, *New Caledonia or Kanaky? The Political History of a French Colony*, Pacific Research Monograph 16 (Canberra: National Centre for Development Studies, Research School of Pacific Studies, The Australian National University, 1987).

Douglas, Bronwen, *Across the Great Divide: Journeys in History and Anthropology* (Amsterdam: Harwood Academic Publishers, 1998).

Dougoud, Roberta Colombo, *Bambous Kanak* (Geneva: Musée d'Ethnographie de Genève, 2008).

Feinberg, Richard, *Polynesian Seafaring and Navigation: Ocean Travel in Anutan Culture and Society* (Kent, OH: Kent State University Press, 1988).

Firth, Raymond, *We, The Tikopia* (Boston, MA: Beacon Press, 1963 [1936]).

Forge, Anthony (ed.), *Primitive Art and Society* (London: Oxford University Press, 1973).

Geismar, Haidy and Anita Herle, *Moving Images: John Layard, Fieldwork and Photography on Malakula since 1914* (Adelaide: Crawford House Publishing, 2009).

Gina, Lloyd Maepeza, *Journeys in a Small Canoe: The Life and Times of a Solomon Islander*, Judith Bennett and Khyla Russell (eds.) (Canberra: Pandanus Books, 2003).

Gunn, Michael and Philippe Peltier (eds.), *New Ireland: Art of the South Pacific* (Milan: 5 Continents Editions, 2006).

Heermann, Ingrid (ed.), *Form Colour Inspiration: Oceanic Art from New Britain* (Stuttgart: Arnoldsche, 2001).

Howe, Kerry R., *The Loyalty Islands: A History of Culture Contacts, 1840–1900* (Honolulu: University of Hawai'i Press, 1977).

Hviding, Edvard, *Guardians of the Morovo Lagoon: Practice, Place and Politics in Maritime Melanesia*, Pacific Islands Monograph Series 14 (Honolulu: University of Hawai'i Press, 1996).

Journal of the Polynesian Society, 109 (1), March 2009, special issue on headhunting in the western Solomons.

Kaufmann, Christian, Christin Kocher Schmid and Sylvia Ohnemus (eds.), *Admiralty Islands: Art from the South Seas* (Zürich: Museum Rietberg, 2002).

Küchler, Susanne, *Malanggan: Art, Memory and Sacrifice* (Oxford: Berg, 2002).

Leenhardt, Maurice, *Gens de la Grande Terre* (Paris, 1952 [1937]).

——, *Do Kamo: Person and Myth in the Melanesian World*, Basia Miller Gulati (trans.) (Chicago, IL: University of Chicago Press, 1979 [1947]).

Marchal, Henri, Roger Boulay and Emmanuel Kasarhérou (eds.), *De Jade et de Nacre: Patrimonie Artistique Kanak* (Paris: Réunion des musées nationaux, 1990).

Ohnemus, Sylvia, *An Ethnology of the Admiralty Islanders: The Alfred Bühler Collection* (Basel: Museum der Kulturen, and Bathurst, New South Wales: Crawford House Publishing, 1996).

Oliver, Douglas, *Black Islanders: A Personal Perspective of Bougainville 1937–1991* (South Yarra, Victoria: Hyland House, 1991).

Richards, Rhys and Kenneth Roga, *Not Quite Extinct: Melanesian Barkcloth ('tapa') from Western Solomon Islands* (Wellington: Paremata Press, 2005).

Shineberg, Dorothy, *The People Trade: Pacific Island Laborers and New Caledonia, 1865–1930* (Honolulu: Center for Pacific Islands Studies/University of Hawai'i Press, 1999).

Specht, Jim, *Pieces of Paradise*, Australian Natural History Supplement No. 1 (Sydney: Australian Museum Trust, 1988).

Speiser, Felix, *Ethnology of Vanuatu: An Early Twentieth-Century Study*, D. Q. Stephenson (trans.) (Bathurst, New South Wales: Crawford House Publishing, 1991 [1923]).

Taylor, J. P., *The Other Side: Ways of Being and Place in Vanuatu*, Pacific Islands Monograph Series 22 (Honolulu: University of Hawai'i Press, 2008).

Torrence, Robin and Anne Clarke (eds.), *The Archaeology of Difference: Negotiating Cross-Cultural Engagements in Oceania* (London: Routledge, 2000).

Wagner, Roy, *Asiwinarong: Ethnos, Image and Social Power among the Usen Barok of New Ireland* (Princeton, NJ: Princeton University Press, 1986).

Welsch, Robert L. (ed.), *An American Anthropologist in Melanesia: A. B. Lewis and the Joseph N. Field Expedition, 1909–1913*, 2 vols. (Honolulu: University of Hawai'i Press, 1998).

PART FOUR: EASTERN AND NORTHERN OCEANIA 1700–1940

Allen, Anne, 'Space as Social Construct: the Vernacular Architecture of Rural Samoa', PhD thesis, Columbia University, 1993.

——, 'Modernity and Tradition: Western Architecture Styles in Western Samoa', *Pacific Arts* NS, 6, 2007, pp. 14–23.

Aoyagi, Machiko, *Modekngei: A New Religion in Belau, Micronesia* (Tokyo: Shinsensha Press, 2002).

Beaglehole, John (ed.), *The Journals of Captain James Cook on his Voyages of Discovery*, 3 vols. (Cambridge: University Press for Hakluyt Society, 1955).

Berg, Mark L., 'Yapese Politics, Yapese Money and the *Sawei* Tribute Network before World War I', *Journal of Pacific History* 27, 2, 1992, pp. 150–64.

Binney, Judith, *Redemption Songs: A Life of Te Kooti Arikirangi Te Turuki* (Auckland: Auckland University Press, 1995).

Brown, Deidre, 'Te Hau-ki-Turanga', *Journal of the Polynesian Society* 105, 1996, pp. 7–26.

——, *Māori Architecture: From Fale to Wharenui and Beyond* (Auckland: Penguin, 2009).

Buck, Peter H. (Te Rangi Hiroa), *Samoan Material Culture* (Honolulu: Bernice P. Bishop Museum, 1930).

——, *Arts and Crafts of the Cook Islands* (Honolulu: Bishop Museum Press, 1944).

——, *Arts and Crafts of Hawaii* (Honolulu: Bishop Museum Press, 1957).

Colchester, Chloë (ed.), *Clothing the Pacific* (Oxford: Berg, 2003).

Dening, Greg, *Islands and Beaches: Discourse on a Silent Land: Marquesas 1774–1880* (Chicago, IL: Dorsey Press, 1980).

——, *Mr. Bligh's Bad Language: Passion, Power and Theatre on the Bounty* (Cambridge: Cambridge University Press, 1992).

Feldman, Jerome and Donald H. Rubinstein (eds.), *Art of Micronesia* (Honolulu: University of Hawai'i Art Gallery, 1986).

Filihia, Meredith, ''Oro-dedicated *Maro 'ura* in Tahiti: Their Rise and Decline in the Early-European Post-Contact Period', *Journal of Pacific History*, 31(2), 1996, pp. 127–43.

Fischer, Steven, *Rongorongo: The Easter Island Script: History, Traditions, Texts* (Oxford: Clarendon Press, 1997).

——, *Island at the End of the World: The Turbulent History of Easter Island* (London: Reaktion, 2005).

Gell, Alfred, *Art and Agency: An Anthropological Theory* (Oxford: Clarendon Press, 1998).

——, *Wrapping in Images: Tattooing in Polynesia* (Oxford: Clarendon Press, 1993).

Gilson, Richard, *The Cook Islands 1820–1950*, Roger Crocombe (ed.) (Wellington and Suva: Victoria University Press/Institute of Pacific Studies of the University of the South Pacific, 1980).

Hammond, Joyce D., 'Polynesian Women and Tīfaifai Fabrications of Identity', *The Journal of American Folklore*, 99 (393), 1986, pp. 259–79.

Henry, Teuira, *Ancient Tahiti* ([Honolulu, 1928] reprinted Millwood, NY: Kraus Reprint, 1985).

Holt, John D., *The Art of Featherwork in Old Hawaii* (Honolulu: Bishop Museum Press, 1985).

Hooper, Steven, *Pacific Encounters: Art & Divinity in Polynesia 1760–1860* (Honolulu: University of Hawai'i Press, 2006).

——, 'Embodying Divinity: The Life of A'a', *Journal of the Polynesian Society* 116, 2007, pp. 131–79.

Joppien, Rüdiger and Bernard Smith, *The Art of Captain Cook's Voyages*, 4 vols. (Melbourne: Oxford University Press, 1985).

Kaeppler, Adrienne, 'Genealogy and Disrespect: A Study of Symbolism in Hawaiian Images', *Res* 3, 1982, pp. 83–107.

——, 'Containers of Divinity', *Journal of the Polynesian Society*, 116 (2), 2007, pp. 97–130.

Kamakau, Samuel Manaiakalani, *Ruling Chiefs of Hawaii* (Honolulu: Kamehameha Schools Press, 1961).

——, *Tales and Traditions of the People of Old* (Honolulu: Bishop Museum Press, 1991).

Keate, George, *An Account of the Pelew Islands*, Karen L. Nero and Nicholas Thomas (eds.) (London: Leicester University Press, 2002 [1788]).

Kirch, Patrick V., *The Evolution of Polynesian Chiefdoms* (Cambridge: Cambridge University Press, 1984).

—— and Roger Green, *Hawaiki, Ancestral Polynesia: An Essay in Historical Anthropology* (Cambridge: Cambridge University Press, 2001).

Kjellgren, Eric and Carol S. Ivory, *Adorning the World: Art of the Marquesas Islands* (New York and New Haven, CT: The Metropolitan Museum of Art and Yale University Press, 2005).

Küchler, Susanne and Andrea Eimke, *Tivaivai: The Social Fabric of the Cook Islands* (London and Wellington: British Museum Press and Te Papa Press, 2009).

—— and Graeme Were (eds.), *The Art of Clothing: A Pacific Experience* (London: UCL Press, 2004).

Kuykendall, Ralph, *Hawaiian Kingdom: Foundations and Transformation 1778–1854*, vol. 1 (Honolulu: University of Hawai'i Press, 1938).

Malo, David, *Hawaiian Antiquities* (Honolulu: Bernice Bishop Museum, 1951 [1898]).

Maude, Henry E., *Of Islands and Men: Studies in Pacific History* (Melbourne: Oxford University Press, 1968).

Mead, Sidney (Hirini), *Te Toi Whakairo: Art of Maori Carving* (Auckland: Raupo Publishing, 1995).

Neich, Roger, *Material Culture of Western Samoa: Persistence and Change* (Wellington: National Museum of New Zealand, 1985).

——, *Painted Histories* (Auckland: Auckland University Press, 1993).

——, *Carved Histories: Rotorua Ngati Tarawhai Woodcarving* (Auckland: Auckland University Press, 2001).

Newbury, C. W. (ed.), *The History of the Tahitian Mission* (Cambridge: Hakluyt Society, 1961).

Oliver, Douglas, *Ancient Tahitian Society* (Honolulu: University Press of Hawai'i, 1974).

Poggioli, Vicki, *Patterns from Paradise: The Art of Tahitian Quilting* (Pittstown, NJ: Main Street Press, 1988).

Pule, John and Nicholas Thomas, *Hiapo: Past and Present in Niuean Barkcloth* (Otago: University of Otago Press, 2005).

Rogers, Robert F., *Destiny's Landfall: A History of Guam* (Honolulu: University of Hawai'i Press, 1995).

Rongokea, Lynnsay, *The Art of Tivaevae: Traditional Cook Islands Quilting* (Honolulu: University of Hawai'i Press, 2001).

Rose, Roger, *Symbols of Sovereignty: Feather Girdles of Tahiti and Hawaii* (Honolulu: Bernice P. Bishop Museum, 1978).

Rubinstein, Donald and Sophiano Limol, 'Reviving the Sacred Machi: A Chiefly Weaving from Fais Island, Micronesia', in Roy W. Hamilton and B. Lynn Milgram (eds.), *Material Choices: Refashioning Bast and Leaf Fibers in Asia and the Pacific* (Los Angeles, CA: Fowler Museum at UCLA, 2007).

Sahlins, Marshall, *Islands of History* (Chicago, IL: University of Chicago Press, 1985).

Salmond, Anne, *Between Worlds: Early Exchanges between Maori and Europeans 1773–1815* (Auckland: Auckland University Press, 1997).

——, *The Trial of the Cannibal Dog: Captain Cook in the South Seas* (London: Allen Lane, 2003).

——, *Aphrodite's Island: the European Discovery of Tahiti* (Auckland: Auckland University Press, 2009).

Semper, Carl, *Palau Islands in the Pacific Ocean*, Robert Craig (ed.), Mark Berg (trans.) (Mangilao: University of Guam, 1982 [1873]).

Sissons, Jeffrey, 'Traditionalisation of the Māori Meeting House', *Oceania* 69, 1998, pp. 36–46.

Spate, Oskar H. K., *The Pacific since Magellan*, 3 vols. (Canberra: Australian National University Press, 1979–88).

Stokes, John and Tom Dye, *Heiau of Hawaii: A Historic Survey of Native Hawaiian Temple Sites* (Honolulu: Bishop Museum Press, 1991).

Thomas, Nicholas, *Discoveries: The Voyages of Captain Cook* (London: Allen Lane, 2003).

Thomas, Nicholas, Anna Cole and Bronwen Douglas (eds.), *Tattoo: Bodies, Art and Exchange in the Pacific and the West* (London: Reaktion Press, 2005).

Williams, John, *Samoan Journals of John Williams 1830–1832*, Richard Moyle (ed.) (Canberra: Australia National University Press, 1984).

PART FIVE: ART, WAR AND THE END OF EMPIRE 1940–89

Akin, David, 'World War II and the Evolution of Pacific Art', *Pacific Arts Newsletter* 27, 1988, pp. 5–11.

Aldrich, Robert, *France and the South Pacific since 1940* (Honolulu: University of Hawai'i Press, 1993).

Barkawi, Tarak, *Globalization and War* (Oxford: Rowman and Littlefield, 2006).

Basu, Dipannita and Sidney J. Lemelle (eds.), *The Vinyl Ain't Final: Hip Hop and the Globalization of Black Popular Culture* (London: Pluto Press, 2006).

Beier, Ulli, *Decolonising the Mind* (Canberra: Pandanus Books, 2005).

Bladinières, Gilbert (ed.), *Nicolaï Michoutouchkine, Aloï Pilioko: 50 ans de création en Océanie* (Nouméa: Madrépores, 2008).

Bolton, Lissant, *Unfolding the Moon: Enacting Women's Kastom in Vanuatu* (Honolulu: University of Hawai'i Press, 2003).

Bonnemaison, Joël, Kirk Huffman, Christian Kauffmann and Darrell Tryon (eds.), *Arts of Vanuatu* (Bathurst, New South Wales: Crawford House Publishing, 1996).

Borofsky, Robert (ed.), *Remembrance of Pacific Pasts: An Invitation to Remake History* (Honolulu: University of Hawai'i Press, 2000).

Cochrane, Susan and Hugh Stevenson, *Luk Luk Gen! Look Again! Contemporary Art from Papua New Guinea* (Townsville, Queensland: Perc Tucker Regional Gallery, 1990).

Connell, John and Barbara Rugendyke (eds.), *Tourism at Grassroots: Villagers and Visitors in the Asia-Pacific* (New York: Routledge, 2008).

Corbey, Raymond, *Tribal Art Traffic: A Chronicle of Taste, Trade and Desire in Colonial and Post-Colonial Times* (Amsterdam: Royal Tropical Institute, 2000).

Dark, Philip and Roger Rose (eds.), *Artistic Heritage in a Changing Pacific* (Honolulu: University of Hawai'i Press, 1993).

Denoon, Donald, *A Trial Separation: Australia and the Decolonisation of Papua New Guinea* (Canberra: Pandanus Books, 2005).

——, et al. (eds.), *The Cambridge History of the Pacific Islanders* (Cambridge: Cambridge University Press, 1997).

Desmond, Jane C., *Staging Tourism; Bodies on Display from Waikiki to Sea World* (Chicago, IL: University of Chicago Press, 1999).

Douglas, Ngaire, *They Came for Savages : 100 Years of Tourism in Melanesia* (Lismore, New South Wales: Southern Cross University Press, 1996).

Drooglever, Pieter, *An Act of Free Choice: Decolonization and the Right to Self-Determination in West Papua* (Oxford: Oneworld Publications, 2009).

Duchesne, Tammy, 'Micronesian World War II Songs and Chants Serving a Variety of Functions', *Micronesian Journal of Humanities and Social Sciences* 5 (1 & 2), 2006, pp. 285–92.

Eoe, Soroi Marepo and Pamela Swadling, *Museums and Cultural Centres in the Pacific* (Port Moresby: Papua New Guinea National Museum, 1991).

Firth, Stewart, 'Decolonization', in Robert Borofsky (ed.), *Remembrance of Pacific Pasts: An Invitation to Remake History* (Honolulu: University of Hawai'i Press, 2000, pp. 314–32).

Forbes, David, *Encounters with Paradise: Views of Hawai'i and its People, 1778–1941* (Honolulu: University of Hawai'i Press and Honolulu Academy of Arts, 1992).

Gerbrands, Adrian (ed.), *The Asmat of New Guinea: The Journal of Michael Clark Rockefeller* (New York: The Museum of Primitive Art, 1967).

Graburn, Nelson H. H. (ed.), *Ethnic and Tourist Arts: Cultural Expressions from the Fourth World* (Berkeley, CA: University of California Press, 1976).

Hanson, Allan and Louise Hanson (eds.), *Art and Identity in Oceania* (Bathurst, New South Wales: Crawford House Publishing, 1990).

Hereniko, Vilsoni and Rob Wilson (eds.), *Inside Out: Literature, Cultural Politics and Identity in the New Pacific* (Lanham, MD: Rowman & Littlefield, 1999).

Hezel, Francis, *Strangers in Their Own Land: A Century of Colonial Rule in the Caroline and Marshall Islands* (Honolulu: University of Hawai'i Press, 1995).

Kiki, Albert Maori, *Kiki: Ten Thousand Years in a Lifetime: A New Guinea Autobiography* (Melbourne: Cheshire Publishing, 1968).

Kirsten, Sven A., *The Book of Tiki : The Cult of Polynesian Pop in Fifties America* (Köln: Taschen, 2003).

——, *Tiki Modern and the Wild World of Witco* (Köln: Taschen, 2007).

Lal, Brij V. and Kate Fortune (eds.), *The Pacific Islands: An Encyclopedia* (Honolulu: University of Hawai'i Press, 2000).

Lévi-Strauss, Claude, *Tristes Tropiques*, John and Doreen Weightman (trans.) (New York: Atheneum, 1974).

Lindstrom, Lamont, *Cargo Cult: Strange Stories of Desire from Melanesia and Beyond* (Honolulu: University of Hawai'i Press, 1993).

—— and Geoffrey White, *Island Encounters: Black and White Memories of the Pacific War* (Washington and London: Smithsonian Institution Press, 1990).

Lockwood, Victoria (ed.), *Globalization and Culture Change in the Pacific Islands* (New York: Prentice-Hall, 2004).

Lutkehaus, Nancy, et al. (eds.), *Sepik Heritage: Tradition and Change in Papua New Guinea* (Bathurst, New South Wales: Crawford House Publishing, 1990).

MacCannell, Dean, 'Cannibal Tours', in Lucien Taylor (ed.), *Visualizing Theory: Selected Essays from V.A.R. 1990–1994* (New York and London: Routledge, 1994).

Mane-Wheoki, Jonathan, 'The Resurgence of Māori Art: Conflicts and Continuities in the Eighties', *The Contemporary Pacific* 7.1 (Spring 1995), pp. 1–19.

Mason, Ngahiraka, *Tūruki Tūruki! Paneke Paneke! When Māori Art Became Contemporary*, exhibition catalogue (Auckland Art Gallery: Toi o Tāmaki, 2008).

Mead, Sidney Moko (ed.), *Exploring the Visual Art of Oceania, Australia, Melanesia, Micronesia and Polynesia* (Honolulu: University of Hawai'i Press, 1979).

—— and Bernie Kernot (eds.), *Art and Artists of Oceania* (Palmerston North: Dunmore Press/Ethnographic Arts Publications, 1983).

O'Hanlon, Michael, *Reading the Skin: Adornment, Display and Society among the Wahgi* (London: British Museum Press, 1989).

Otto, Ton and Nicholas Thomas (eds.), *Narratives of Nation in the South Pacific* (Amsterdam: Harwood Academic, 1997).

Pacific Islands Monthly (Sydney: Pacific Publications, 1931–2000).

Phillips, Ruth B. and Christopher B. Steiner (eds.), *Unpacking Culture: Art and Commodity in Colonial and Postcolonial Worlds* (Berkeley, CA: University of California Press, 1999).

Poyer, Lin, Suzanne Falgout and Laurence M. Crucci (eds.), *The Typhoon of War: Micronesian Experiences of the Pacific War* (Honolulu: University of Hawai'i Press, 2000).

Rajotte, Freda and Ron Crocombe (eds.), *Pacific Tourism as Islanders See It* (Suva: University of the South Pacific, 1980).

Scarr, Deryck, Niel Gunson and Jennifer Terrell (eds.), *Echoes of Pacific War: Papers from the 7th Tongan History Conference held in Canberra in January 1997* (Canberra: Target Oceania, 1998).

Skinner, Damian, *The Carver and the Artist: Māori Art in the Twentieth Century* (Auckland: Auckland University Press, 2008).

Tausie, Vilsoni, *Art in the New Pacific* (Suva: Institute of Pacific Studies, 1980).

Te Awekotuku, Ngahuia, 'The Sociocultural Impact of Tourism on the Te Arawa People of Rotorua, New Zealand', PhD thesis (University of Waikato, 1981).

Teissier-Landgraf, Marie Claude, *The Russian from Belfort: 37 Years Journey by Painter Nicolaï Michoutouchkine in Oceania* (Suva: Institute of Pacific Studies, University of the South Pacific, 1995).

Thomas, Nicholas, *Possessions: Indigenous Art/Colonial Culture* (London: Thames & Hudson, 1999).

—— and Diane Losche (eds.), *Double Vision: Art Histories and Colonial Histories in the Pacific* (Cambridge: Cambridge University Press, 1999).

Tjibaou, Jean-Marie, *Kanaky*, Alban Bensa and Éric Wittersheim (eds.), Helen Fraser and John Trotter (trans.) (Canberra: Pandanus Books, 2005).

Trask, Haunani-Kay, *From a Native Daughter: Colonialism and Sovereignty in Hawai'i* (Monroe, ME: Common Courage Press, 1993).

Trompf, G. W. (ed.), *Cargo Cults and Millenarian Movements: Transoceanic Comparisons of New*

Religious Movements (Boston, MA: Walter de Gruyter, 1990).

Walker, Ranginui, *He Tipua: The Life and Times of Sir Āpirana Ngata* (Auckland: Penguin Books, 2001).

Wendt, Albert, 'Towards a New Oceania', *Mana Review* 1, 1976, pp. 49–60.

White, Geoffrey and Lamont Lindstrom (eds.), *The Pacific Theater: Island Representations of World War II* (Honolulu: University of Hawai'i Press, 1989).

PART SIX: ART IN OCEANIA NOW 1989–2012

Anae, Melani, Lautofa (Ta) Iuli and Leilani Burgoyne (eds.), *Polynesian Panthers: The Crucible Years 1971–74* (Auckland: Reed Publishing, 2006).

Asia-Pacific Triennial of Contemporary Art (Brisbane: Queensland Art Gallery, 1993 (ongoing)).

Biennale de Nouméa: d'Art Contemporain (Agency for the Development of Kanak Culture, 2000).

Bolton, Lissant, *Unfolding the Moon: Enacting Women's Kastom in Vanuatu* (Honolulu: University of Hawai'i Press, 2003).

Bonnemaison, Joël, Kirk Huffman, Christian Kauffmann and Darrell Tryon (eds.), *Arts of Vanuatu* (Bathurst, New South Wales: Crawford House Publishing, 1996).

Brunt, Peter, 'Since "Choice!": Exhibiting the New Maori Art', in Lydia Wevers and Anna Smith (eds.), *On Display: New Essays in Cultural Studies* (Wellington: Victoria University Press, 2004, pp. 215–42).

Cochrane, Susan, *Contemporary Art in Papua New Guinea* (Sydney: Craftsman House, 1997).

——, *Bérétara: Contemporary Pacific Art* (Rushcutters Bay, New South Wales: Halstead Press, 2001).

—— and Hugh Stevenson, *Luk Luk Gen! Look Again! Contemporary Art from Papua New Guinea* (Townsville, Queensland: Perc Tucker Regional Gallery, 1990).

Craig, Barry, Bernie Kernot and Christopher Anderson (eds.), *Art and Performance in Oceania* (Honolulu: University of Hawai'i Press, 1999).

Dark, Philip and Roger G. Rose (eds.), *Artistic Heritage in a Changing Pacific* (Honolulu: University of Hawai'i Press, 1993).

Dateline: Contemporary Art from the Pacific (Ostfildern, Germany: Hatje Cantz Verlag, 2007).

Graille, Caroline, 'From "Primitive" to Contemporary: A Story of Kanak Art in New Caledonia', *State, Society and Governance in Melanesia Project*, Discussion Paper 01/2, Research School of Pacific and Asian Studies/The Australian National University, 2001, pp. 1–11.

Hanson, Allan and Louise Hanson (eds.), *Art and Identity in Oceania* (Honolulu: University of Hawai'i Press, 1990).

Hau'ofa, Epeli, *We Are the Ocean: Selected Works* (Honolulu: University of Hawai'i Press, 2008).

Henderson, April K., 'Dancing Between Islands: Hip Hop and Samoan Diaspora' in Dipannita Basu and Sidney J. Lemelle (eds.), *The Vinyl Ain't Final: Hip Hop and the Globalization of Black Popular Culture* (London: Pluto Press, 2006).

——, 'Gifted Flows: Making Space for a Brand New Beat' in *Flying Fox Excursions, a special issue of The Contemporary Pacific*, 22 (2), 2010, pp. 219–315.

Herle, Anita, Nick Stanley, Karen Stevenson and Robert L. Welsch (eds.), *Pacific Art: Persistence, Change and Meaning* (Adelaide: Crawford House Publishing/University of Hawai'i Press, 2002).

Higgins, Katherine, *Red Wave: Space, Process, and Creativity at the Oceania Centre for Arts and Culture* (Suva: IPS Publications, University of the South Pacific, 2008).

Hooper, Anthony (ed.), *Culture and Sustainable Development in the Pacific* (Canberra: Asia Pacific Press and The Australian National University Press, 2000).

Jahnke, Robert, 'Contemporary Māori Art: Fact or Fiction', in Dorota Starzecka (ed.), *Maori Art and Culture* (London: British Museum Press, 1998).

——, 'Voices beyond the Pae', in Nicholas Thomas and Diane Losche (eds.), *Double Vision: Art Histories and Colonial Histories in the Pacific*, pp. 193–209 (Cambridge: Cambridge University Press, 1999).

Jolly, Margaret, 'On the Edge? Deserts, Oceans, Islands', *The Contemporary Pacific*, 13.2 (Fall 2001), pp. 417–66.

Kanak Sculptors and Painters Today. Ko i Neva (Noumea, New Caledonia: ADCK with the support of the North Province, The Loyalty Islands Province, The Cultural Affairs delegation, 1992).

Kosasa, Karen, 'Pedagogical Sights/Sites: Producing Colonialism and Practicing Art in the Pacific', *Art Journal* (Fall 1998), pp. 47–54.

Küchler, Susanne and Graeme Were, *Pacific Pattern* (London: Thames & Hudson, 2005).

Lal, Brij V. and Kate Fortune (eds.), *The Pacific Islands: An Encyclopedia* (Honolulu: University of Hawai'i Press, 2000).

Lutkehaus, Nancy C., *Sepik Heritage: Tradition and Change in Papua New Guinea* (Bathurst, New South Wales: Crawford House Publishing, 1990).

MacKenzie, Maureen, *Androgynous Objects: String Bags and Gender in Central New Guinea* (London: Routledge, 1991).

Mallon, Sean, *Samoan Art and Artists: O Measina a Samoa* (Honolulu: University of Hawai'i Press, 2002).

—— and Pandora Fulimalo Pereira (eds.), *Speaking in Colour: Conversations with Artists of Pacific Island Heritage* (Wellington: Te Papa Press, 1997).

—— and Pandora Fulimalo Pereira (eds.), *Pacific Art Niu Sila: The Pacific Dimension of Contemporary New Zealand Arts* (Wellington: Te Papa Press, 2002).

Message, Kylie, 'Contested Sites of Identity and the Cult of the New', re*Collections: Journal of the National Museum of Australia* 1(1), March 2006, pp. 7–28.

Nā Maka Hou: New Visions. Contemporary Native Hawaiian Art (Honolulu: Honolulu Academy of Arts, 2001).

Nena, Tauhiti and Chantal Selva, *L'Art en Mouvement: Émergence d'un art contemporain à Tahiti* (Ministère de la Jeunesse de la Culture et du Patrimoine chargé de la sensibilisation à l'art contemporain, 2005).

Nero, Karen (ed.), *Pacific Studies: Special Issue, the Arts and Politics*, vol. 15, no. 4 (December 1992).

News from Islands (Campbelltown, New South Wales: Campbelltown Arts Centre, 2007).

O'Hanlon, Michael, *Paradise: Portraying the New Guinea Highlands* (London: British Museum Press, 1993).

Panoho, Rangihiroa, *Te Moemoea no Iotefa; The Dream of Joseph: A Celebration of Pacific Art and Taonga*, exhibition catalogue (Sarjeant Gallery, Wanganui, 15 December 1990–3 March 1991).

——, 'Maori: At the Centre, On the Margins', in Mary Barr (ed.), *Headlands: Thinking Through New Zealand Art*, exhibition catalogue (Sydney: Museum of Contemporary Art, 1992).

Paradise Now? Contemporary Art from the Pacific (New York: Asia Society, 2004).

Phillips, Ruth and Christopher Steiner (eds.), *Unpacking Culture: Art and Commodity in Colonial and Postcolonial Worlds* (Berkeley, CA: University of California Press, 1999).

Raymond, Rosanna and Amiria Salmond (eds.), *Pasifika Styles: Artists Inside the Museum* (Cambridge: University of Cambridge Museum of Archaeology and Anthropology/Otago University Press, 2008).

Skinner, Damian, *The Passing World, The Passage of Life: John Hovell and the Art of Kowhaiwhai* (Auckland: Rim Books, 2010).

—— and Lyonel Grant, *Ihenga: Te Haerenga Hou – The Evolution of Māori Carving in the 20th Century* (Auckland: Reed Publishing, 2007).

Starzecka, Dorota C. (ed.), *Maori Art and Culture* (London: British Museum Press, 1998).

Stevenson, Karen, *The Frangipani is Dead: Contemporary Pacific Art in New Zealand, 1985–2000* (Wellington: Huia Publishers, 2008).

Te Awekotuku, Ngahuia and Linda Waimarie Nikora, *Mau Moko: The World of Māori Tattoo* (London: Penguin, 2007).

Thomas, Nicholas, 'From Exhibit to Exhibitionism: Recent Polynesian Presentations of "Otherness"', *The Contemporary Pacific* 8.2, 1996, pp. 319–48.

Thomas, Nicholas, Anna Cole and Bronwen Douglas (eds.), *Tattoo: Bodies, Art and Exchange in the Pacific and the West* (London: Reaktion Books and Duke University Press, 2005).

Turner, Caroline (ed.), *Art and Social Change: Contemporary Art in Asia and the Pacific* (Canberra: Pandanus Books, 2005).

This book had its origins in conversations between two of its authors, Peter Brunt and Sean Mallon, about the challenges of teaching Oceanic art and the state of its literature. Much new and exciting scholarship was being published, museums were waking up to new ways of making their collections relevant, Contemporary Pacific art was burgeoning across the region, galvanizing new audiences and generating its own literature in magazines and exhibition catalogues. Most important, Pacific people, ourselves included, were more involved and interested than ever before. However, the one genre that did not reflect the wider sea change was the classic regional survey, so crucial for teaching the subject and shaping broad public perceptions of art in Oceania. For us, the existing books in that genre felt outdated for the reasons Nicholas Thomas outlines in our introduction. At the time, the early 2000s, a couple of short surveys by Thomas and Anne D'Alleva had broken the mould, but the need for a more substantive volume was apparent. We bandied ideas back and forth about what such a book might look like.

The opportunity actually to create one came through a serendipitous meeting with Timothy Evans, a director at Thames and Hudson, who visited Victoria University of Wellington in 2005, promoting a recently published book, the brilliant but controversial text, *Art Since 1900*. That book's glaring omission of almost half the planet from its narrative was alarming, yet it mirrored the absence in books on Oceanic art of any real account of the region's artistic engagement with the modern world 'since 1900', if not since 1700. Somehow they were like two sides of the same coin. The conventional identification of art in Oceania, as in Africa, with canons of tribal masterpieces, and in North America and Europe with modernism and the avant-garde was still in place, totally skewing how we think about the relationship between art and modernity. Peter Brunt was arguing in this way about how the whole genre of art historical surveys needed to be reconfigured when Timothy Evans said, 'well, propose something'. That invitation was the catalyst for the mammoth undertaking which ultimately produced this book.

So we thank Timothy Evans and his colleagues at Thames and Hudson, especially Ian Jacobs, Rebecca Pearson and Robert Davies for their roles in shepherding this book to completion. Thanks also to Richard Mason for his editorial services and Maggi Smith for her excellent design work.

At its core has been a team of seven authors, four based in New Zealand and three in the United Kingdom. Six, however, originate from the southern hemisphere and we like to think of the book as a collaboration between North and South. As authors we have learnt and benefitted enormously from each other through stimulating conversations at team meetings and in countless exchanges over email as chapter drafts were shared, discussed and revised.

The project would not have been possible without a generous grant from the (competitive) Marsden Fund of the Royal Society of New Zealand and we thank them for their support. Other organizations have also been significant financial contributors. We thank Victoria University of Wellington and the University of Auckland for the donation of funds towards image research and book production, as well as the British Museum, the Museum of New Zealand Te Papa Tongarewa, and the Museum of Archaeology and Anthropology at Cambridge University for their generosity in waiving reproduction fees for objects illustrated from their collections. 'Melanesian Art', a project funded by the Arts and Humanities Research Council at the British Museum and the University of Cambridge, helped support Lissant Bolton and Nicholas Thomas's research for this book. Sean Mallon's research was generously supported by Te Papa.

The Art in Oceania project formally began in 2006 and had its 'headquarters' in the midst of the Art History programme at Victoria University of Wellington. At Victoria, we thank John Davidson and Chris Marshall, Heads of the School of Art History, Classics and Religious Studies, and especially Annie Mercer, School Manager, for her extensive and unstinting support, both practical and moral, on the project over five years. We thank the staff at Art History – David Maskill, Roger Blackley, Raymond Spiteri, Geoffrey Batchen, Christina Barton, Phyllis Mossman, Pippa Wisheart, Sarah Caylor and Rebecca Rice – and its students for the many ways in which they have accommodated and assisted work on this book since its inception. We also thank Chris Dean and Jeannette Vine of Victoria Research Trust; members of the University's Senior Management who have lent their support in various ways, in particular Professors Neil Quigley, Charles Daugherty, Piri Sciascia, Deborah Willis and Luamanuvao Winnie Laban; and Robert Cross and Kerie McCombe of Image Services for invaluable technical assistance.

A group of outstanding students at Victoria have also assisted us with research, image acquisition and the organization of team meetings: thank you to Jessica Adams, Safua Akeli, Mena Antonio, Vivian Morrell and above all Stella Ramage. Special thanks must go to Stella who undertook the enormous task of acquiring images and permissions, liaising with scores of museums, libraries, art galleries, artists, academics and other individuals around the world. She also assisted Peter Brunt with all aspects of editing and project management.

Our work draws on the research and scholarship of hundreds of fellow academics in the field, whose work we acknowledge in our notes. But each of us has also accumulated more personal debts. Nicholas Thomas would like to thank Elizabeth Bonshek, Tony Crawford, Bruce Knauft, Michael O'Hanlon, Nick Stanley and Jaap Timmer for information and suggestions regarding the New Guinea chapters. Thanks especially to Alison Dundon for her help with Gogodala material, and to Chris Ballard for detailed and generous comments on draft chapters. He is tremendously grateful also to colleagues at the Museum of Archaeology and Anthropology in Cambridge for their support and shared interests in the Pacific, and especially to Anita Herle, whose research is drawn on in the 'Crocodile into Man' feature. The late Jim Vivieaere, John Pule, Sofia Tekela-Smith and Lisa Reihana among other Auckland friends have challenged and enlarged his sense of Oceania and art in many ways over many years. As always, he is indebted to Annie Coombes for conversation and encouragement, for reactions and ideas that have done much to improve his chapters in this book.

Sean Mallon would like to thank the many people who have assisted him in the course of his research. They include Steven Ball, Susan Cochrane, April Henderson, 808 urban, Reuben Friend, Jack Kirifi, Kupa Kupa, Fuli Fati, Fulimalo Pereira, Siliga David Setoga, Ema Tavola, Nicole Lim, Grant McCall, Lamont Lindstrom, Geoffrey White, Jim Sinclair, Barry Craig, Bruce M Knauft, Bill Gammage, Michel Theme, Mark Adams and Dionne Fonoti. In Japan, he is grateful for the advice and assistance of Hiroshi Nakajima, Makiko Kuwahara, Matori Yamamoto, Michiko Intoh and Niko Besnier. In Guam, he thanks Don Rubinstein, Judy S. Flores, the staff at the Micronesia Area Research Center, Filamore Palomo Alcon, Phoebe Kelm and Emelihter Kihleng. Thank you also to his colleagues at Te Papa, especially Dame Claudia Orange, Safua Akeli, Grace Hutton, Kolokesa Mahina-Tuai, Stephanie Gibson and the staff at Te Aka Matua Library. To his family, Teresia Teaiwa, thank you for reading, listening and good advice, and to Manoa and Vaitoa, thank you for allowing time for this project to happen.

Deidre Brown gives sincere thanks to Professor Karen Nero for her advice on Micronesian research, and also to Dr Michael Gunn and the late Professor Roger Neich for earlier collaborative work that has informed discussions of *atua* figures. She also thanks Professor Jenny Dixon, Dean of the Auckland National Institute of Creative Arts and Industries, and the School of Architecture and Planning at the University of Auckland for release time for her work on this project.

Lissant Bolton would like to thank Ben Burt, Liz Bonshek, Edvard Hviding, David Luders, Jim Specht, Robin Torrence, Darrell Tryon and Vivienne Morell for advice and assistance in finding relevant material. Especial thanks to Stuart Bedford for much assistance in relation to the prehistory of island Melanesia and to Lucy Moses, Jif Willie Bongmatur Maldo, Madeline Aru, Sophie Nempan and the late Fidel Yoringmal for their contributions to this book. Her enduring thanks to the Vanuatu Cultural Centre Fieldworkers, especially the Women Fieldworkers Network, and notably Jean Tarisesei, for two decades of learning and insights about life and art in island Melanesia.

Damian Skinner would like to thank Robin Torrence, the staff of the H.B. Williams Memorial Library in Gisborne, John Hovell, Lyonel Grant and Studio La Gonda.

Peter Brunt would like to thank all the people from Victoria University mentioned earlier, especially Jessica Adams and Stella Ramage with whom he has worked particularly closely on this project. He also thanks Lydia Wevers for good advice at the beginning; Jenny Rouse, Maud Page, Mark Adams, Jonathan Mane-Wheoki, Momoe von Reiche, Marilyn Kohlhase, Rebekah Clements, Suela and Richard Cook (and their family) for hospitality and insight in Samoa, his students of 'Art in the Pacific' over the years, and Gerar Edizel of Alfred

University and Shirley Samuels of Cornell University for the opportunity to deliver a version of one of his chapters in this book at their universities. Thanks finally to his family, Leonie Brunt for reading, listening and love, and Johanna, Nathaniel, Michael, Mariah, Charlie, Theo, Peppa and Sadie for patience and sweetness.

We thank Mark Adams for photographic work and Mat Hunkin for maps.

We thank the many artists, photographers, writers and copyright holders who have kindly given us permission to reproduce works they have created or own, all of whom are named in the captions or picture credits. We apologize if we've left anybody out.

Finally, we thank the multitude of people at museums, galleries and libraries around the world who have helped us with the provision of images and photography, particularly those institutions with whom we developed an ongoing relationship over an extended period: Agata Rutkowska and Beatriz Waters at the British Museum, London; Fuli Pereira, Diane Gordon, Simona Traser, Anna Cable and Finn McCahon-Jones at Auckland Museum Tamaki Paenga Hira; Melanie van Olffen and Carl Bento at the Australian Museum, Sydney; Alexandra Wessel, Doris Kähli, Derek Li Wan Po and Flavia Abele of Museum der Kulturen, Basel; and Becky Masters, Rebecca Loud and Anita Hogan at the Museum of New Zealand Te Papa Tongarewa, Wellington. We also thank Geoffrey Heath at the Auckland Art Gallery Toi o Tamaki; Peter Attwell at the Alexander Turnbull Library, Wellington; Fiona Gray, National Library of New Zealand; Ema Tavola, Fresh Gallery Otara, Bev Eng, Dowse Art Museum, Lower Hutt; Genevieve Webb, Dunedin Public Art Gallery; Nicola Frean and staff of the J.C. Beaglehole Room, Victoria University of Wellington Library; Rebecca Rice, Adam Art Gallery, Victoria University of Wellington; Jean Mason, Cook Islands Library and Museum; June Bela Norman, National Library of Vanuatu, Port Vila; Carol Romanillos-Varas, Micronesian Seminar, Pohnpei; Jennifer Duparc, Musée de Nouvelle-Calédonie, Nouméa; Drusilla Modjeska, Brennan King and Ōmie Artists; Leo Tanoi, Casula Powerhouse Art Centre, NSW; Nic Brown, Flinders University Art Museum, Adelaide; Rebecca Conway, Macleay Museum, Sydney; Heather Gaunt, Museum Victoria, Melbourne; Nick Nicholson, National Gallery of Australia, Canberra; Vicki Jovanovski, National Library of Australia, Canberra; Almaz Berhe, National Museum of Australia, Canberra; Kathleen Hackett, Powerhouse Museum, Sydney; Judy Gunning, Queensland Art Gallery, Brisbane; Di Jackson, State Library of New South Wales, Sydney. In the northern hemisphere we thank Charles Myers, Bishop Museum, Honolulu, Hawai'i; Wanda Anae-Onishi, State Foundation on Culture and the Arts, Honolulu, Hawai'i; Stu Dawrs, Hamilton Library, University of Hawai'i-Manoa; Jocelyne Dudding at the Museum of Archaeology and Anthropology, University of Cambridge; Markus Schindlbeck, Staatliche Museen zu Berlin; Norbert Ludwig, Museum of Ethnology, Berlin; Jeanette Kokott and Paul Schimweg, Museum für Völkerkunde Hamburg; Judit Csorba, Néprajzi Museum of Ethnography, Budapest; Christopher J. Philipp and John Weinstein, Field Museum, Chicago; Harry Haase, Göttingen University; Ingeborg Eggink, KITLV / Tropenmuseum, Amsterdam; Margit Zara Krpata, Rautenstrauch-Joest-Museum – Kulturen der Welt, Köln; Julia A. Kupina, Peter the Great Museum of Anthropology and Ethnography, St. Petersburg; Monique Green-Koek, National Museum of Ethnology, Leiden; Christiane Klaucke, Museum für Völkerkunde zu Leipzig; Ingrid Heermann and Elfie Hoefling of Linden-Museum Stuttgart; Chris Bertoni, Peabody Essex Museum, Salem, Massachusetts; Jeremy Coote, Pitt Rivers Museum, Oxford; Eline Kevenaar, Wereldmuseum, Rotterdam; Nigel Reading, Spirit Wrestler Gallery, Vancouver; and Silke Seybold, Übersee-museum, Bremen.

PICTURE CREDITS

Information regarding sources, artists, collectors, media and dimensions is detailed in the captions. Museum numbers and additional photo credits not otherwise included in the caption are listed by **page number** below.

Abbreviations:

AAG	Auckland Art Gallery Toi o Tāmaki
AklMus	Auckland Museum
ANZ	Archives New Zealand, Wellington
ATL	Alexander Turnbull Library, Wellington
AustMus	Australian Museum, Sydney
AWM	Australian War Memorial, Canberra
Basel	Museum der Kulturen, Basel
Berlin	Museum für Ethnologie, Berlin
Bishop	Bernice P. Bishop Museum, Honolulu
BL	British Library, London
BM	British Museum, London
Field	Field Museum, Chicago
JCB VUW	JC Beaglehole Room, Victoria University of Wellington Library
Leiden	Rijksmuseum voor Volkenkunde, Leiden
Leipzig	Museum fur Völkerkunde, Leipzig
LMS	Linden-museum Stuttgart
MAA	Museum of Archaeology and Anthropology, Cambridge
MOMA	Museum of Modern Art, New York
NAA	National Archives of Australia, Canberra
NGA	National Gallery of Australia, Canberra
NLA	National Library of Australia, Canberra
PRM	Pitt Rivers Museum, Oxford
QAG	Queensland Art Gallery
Rotterdam	Wereldmuseum, Rotterdam
SLNSW	State Library of New South Wales, Sydney
Te Papa	Museum of New Zealand Te Papa Tongarewa, Wellington
Tropen	Tropenmuseum, Amsterdam
UG	University of Göttingen
USNA	US National Archives, Washington, DC

a=above, b=below, c=centre, l=left, r=right

10 Photograph Derek Li Wan Po. Basel, Vb7525. 11 Photograph Ange Bizet. 13 BM, Oc,B75.1. 14 Photograph Edward A. Salisbury. Library of Congress, Washington, DC. 15 Te Papa, FE003876. 16 W. H. Rivers Papers, Cambridge University Library, Cambridge. 18 Te Papa, ME004211. 19 BM, Oc1896,-.1216. 20l Photograph James Austin. University Of East Anglia, UEA188. 20r Basel, Vb2906. 21 AklMus, Eth.5587. 23 BM, Oc,lge.7. 26 BM, Oc1908,0423.1. 27 Photograph courtesy Professor Glenn Summerhayes, Otago University. 30l AustMus, E.43963. 30r AustMus, E.49701. 31l AustMus, E.62594. 31r AustMus, E.65762. 32 NLA, 3314350. 33 Photograph Robin Torrence. 36, 37, 38b Photographs courtesy Professor Patrick V. Kirch. 40al Photograph Caroline Brunet, courtesy Stuart Bedford. 40r Photograph Stuart Bedford. 41l Photograph courtesy Robin Torrence. 44 Photograph Emil and Liliana Schmid. 45 Photograph © Christophe Sand, IANCP. 46, 47 Photographs José Garanger. 50, 51 Photographs Peter Brunt, 2006. 52a Interpretive drawing by R. Schultz. Reprinted with permission of David Burley. 52b Photograph courtesy David Burley. 53 Fiji Museum; Te Papa, AR000632/1. 56–57 BM, Oc1941,01.4. 58 Photograph © Monte Costa, 1980. 59a, 60 Photographs Newton Morgan, 1988. 59b, 61b, 62a Drawings William Morgan, reprinted with permission. 61a NLA. 62b Bishop. 63a, 64 JCB VUW. 65a Photograph Helene Martinsson-Wallin, 2003. 65b AklMus, 52079. 70a, 71 Photographs Peter Brunt, 2006. 70c BL, Add.Ms.23921,f.28. 73a AklMus, 6341. 73b MAA, D1914.34. 78 AustMus, E.23151A. 79 NLA 20650880-28. 80a AustMus, A.15767. 80b NLA 3598914. 81 AustMus,V.4768. 82 MAA. 83l, 83r Leiden, RMV 1416-12; RMV 1889-255. 84 AustMus, E.15597. 86 NGA 77.637. 88 NLA 14325672-5. 89l Photograph Ingrid Hänse. Leipzig, ME17248. 89r Basel, Vb22106. 90 BM, Oc,+.3422. 91, 92 Photographs © Erik Hesmerg. Rotterdam 50149; 44980. 93l, 93r Rotterdam, 11653; 17264. 94a BM, Oc,A12.110. 94b BM, Oc,B119.151. 95 Powerhouse Museum, NSW, 72D/30. 97 AustMus, E.52227. 98 NLA 3334433. 99 AustMus, E.18271. 101 Mitchell Library, SLNSW, PXC 281,f.106. 102 BM, Oc1851,0103.2. 105l MAA, E1890.182. 105r BM, Oc2006,Drg.406. 106 BM, Oc,+.6317. 109 NLA 3314295. 110 Bayerische Staatsbibliothek, Munich. 111a Leiden, RMV 3070-212. 111b NLA 10668912. 112 Leiden, RMV 1971-985. 113 BM, Oc,B23.5. 114l, 114r BM, Oc1964,03.81. Photograph B. Cranstone. 115 BM, Oc1990,09.22. 116 Konrad Collection, Völkerkundemuseum, Heidelberg, KCS040. 117l Leiden, RMV 1447-73. 117r Tropen, 10008155. 119l, 119r Leiden, RMV 1392- 63; RMV 2385-36. 120 NAA, A6003,2. 122a MAA, P.1630.ACH. 122b Basel, Vb8070. 123 Mitchell Library, SLNSW, MOM 248. 125 BM, Oc,B101.11. 128l Photograph Louis J. Luzbetak. 128r AustMus, E.22945; E.22946. 129 Basel, Vb7784; Vb7785. 130, 131l MAA 131r Tropen, 1302-9. 132 MAA, 1935.29. 133a Basel, Vb 8068. 133b National Museum of Australia, Canberra, 1985.0358.0001. 134 AustMus, E.72960. 135 Reproduced courtesy Anthony Crawford. 136 NGA, 74.214. 137 Basel, (F)Vb35456. 138, 139b AustMus, E.46315; E.31769. 145 BM, Oc1951,07.9. 148 NLA, 4854415. 149 PRM, 1998.267.262.6. 151 Basel, (F)Vb12760.02. 153, 157 NLA. 160 NLA, 24229801. 161 PRM, 1886.1.1466. 162 Photograph José Garanger, 1972. 165 MAA, Z.264A. 166 BM, Oc1944,02.1335. 167 BM, Oc1940,03.5. 168 BM, Oc1978,Q.543. 169l, 169r AustMus, E.73301; E.27357. 170 BM, Oc1904,0621.14. 171 AustMus, E.087327. 172 AklMus, Eth.27310. 173a, 173b UG, Oz 705; Oz 693-698. 174 NLA, 729453. 175l BM, Oc1941,06.1. 176 BM, Oc1904,0621.4. 177 BM, Oc,C42.42. 178 BM, Oc1881,0519.1.a-j. 179 Map drawn by Kirk Huffman and reprinted with permission. 181 BL, Ms.15743,f.3. 182, Basel, Vb4702. 184–185 BM, Oc1976,11.236. 186 Basel, Vb 5676. 188 AustMus, B472. 189l AustMus, E.74062. 189r Musée du quai Branly, Paris, QB.71.1938.42.8. 190 Te Papa, FE003549. 191 Übersee-Museum, Bremen, P18966. 194 Rautenstrauch-Joest-Museum, Inv.5021. 195 BM, Oc1986,03.1. 196al, 196ar Berlin, VI 30.850; 37.647. 196b Photograph Monique Jeudy-Ballini. 197 LMS, 65344. 198 AustMus, E.24808. 199 LMS, 30158. 200 BM, Oc1884,0728.25. 201 BM, Oc1884,0728.2. 202 BM, Oc1904,0621.13. 203 AustMus, E.18184. 204 Néprajzi Museum of Ethnography, Budapest, 14332. 206 Berlin, VI 12819. 207 BM, Oc1913,1115.369. 208 AustMus, E.7646. 209 Te Papa, FE000694. 210 BM, Oc1909,-.87. 211 BM, Oc1900,-.65. 212 NLA. 213 BM, Oc1944,02.1066. 214 BM, Oc,RHC.25. 215 BM, Oc,B34.28. 216 BM, Oc1944,02.1091. 217 AustMus, E.74349. 218 BM, Oc,B35.15. 219 MAA, N.98453. 220 NLA 11279871. 222–223 BM, Oc,+.5541. 223 BM. 224a BM, Oc1944,02.1782; Oc1991,08.77. 225l AklMus, 32349. 225c AklMus, 15242. 225r BM, Oc1944,02.1804. 227l BM, Oc,C46.20. 229 Photograph © Peter Horner. Basel, Vb10520. 230, 231 BM, Oc1903,1007.1. 232 Photograph © Anatol Dreyer. LMS, 57308. 233 Photograph Stuart Humphreys. AustMus, E.84637; E.84639. 234l AklMus, 14391. 234r BM, Oc,C46.18. 235a, 235b BM, Oc,B112.99; Oc1944,02.1136. 236 BM, Oc2006,Drg.311. 237a MAA, N.98572. 237b AustMus, E.73924.

238 LMS, 20725. 239 BM, Oc,Ca43.11. 240 AklMus, 47649. 241 Te Papa, OL000679. 244 Photograph Peter Brunt, 2006. 246l BM, Oc,TAH.67. 246r Bishop, B.10548a. 248 JCB VUW. 249l SLNSW, PXA 565/f.19. 249r Dixson Library, SLNSW. 250 BM, Oc1839,0426.8. 251 BM, Oc,VAN.231; Oc,HAW.78; Oc,LMS.221. 253 BM, Oc1869,1005.1. 255 BL, Add.Ms 15513,f.27. 256–257 Bishop, 1922.129. 258 Photograph Peter Brunt, 2006. 259 Te Papa, FE000327. 261a BM, Oc,HAW.133. 261b Bishop, 06829. 262 BM, Oc1920,0317.1. 265 Kunstkamera, St Petersburg, 711/16. 267 BM, Oc,B31.6. 268 BM, Oc,B31.3. 270 Australian National Maritime Museum, 00006125. 272al, 272ar, 272b, 273, 274 BL, Add. Ms.15508,f.9; f.12; f.14; f.11(a); f.10(a). 276l, 276r BL, Add. Ms.15513,f.26; Shelfmark: 454.f.22.(2). 277l JCB VUW. 277r Peabody Essex Museum, Massachusetts, E4802. 278, 279 UG, Inv. Oz 577; Inv. Oz 141. 280, 281 BM, Oc,LMS.19. 282a, b NLA. 284 Service Historique de la Marine, Vincennes, Ms. SHM 356. 286 Photograph © Michael Myers. 287 Te Papa, FE001055/2. 288 BM, Oc.4252. 289 Minpaku, Osaka, H137822. 290 BM, Oc1953,+.3. 291 BM, Oc.7272. 292–293 BM, Oc1903,-.150. 296–297 BM, Oc,B31.26; Oc,B96.35; Oc,B96.25; Oc,A3.63. 298, 300 Te Papa, F2204/11. 299 NLA. 301 NLA. 302a, b NLA NK887; NK6471. 303 Te Papa, C.001446. 304 ATL, PA1-0-795-47. 306 ATL, B-080-021. 310 NLA, Q 572.9966 K96. 311l, r ATL, PAColl-1892-78; 1/1-012106-G. 312 ATL, 1/2-002915-F. 312l, r Te Papa, B.013035; B.013004. 319a ATL, MNZ-2746-1/2-F. 319b Te Papa, B.013096. 320, 321 Bishop, 1981.074.026; 1981.074.027. 323 Te Papa, FE011982. 326 Photograph Peter Brunt, 2008. 328 AWM, 017083. 329 USNA, 111-SC-364409. 330l, r AWM, 071702; 125786. 333 USNA, 80-G-37519. 334l AWM, REL32937. 336a Photograph Ian Forrester, courtesy Jenny Scott. 336b AWM, 093644. 337 Te Papa, FE008723. 338 BM, Oc,2006.Drg.148. 339 US Navy Archives, Woodstock, Georgia. 340 AWM, PO1672.004. 342 Photograph courtesy Phillip James. 343 Photograph © The Bunting Family. 345 AWM, ART22885. 346a, b AWM, REL33874; REL38042; REL/02982.004; REL33407; REL23942. 353al Photograph Samuel Putnam, courtesy Rockefeller Foundation. 357 SLNSW PXA 907 Box 109 #23. 362 Photograph © Martin Jenkins. 364a, b Photographs Michel Folco/Claude Rives. 367 NLA, MS 437, Box 19, Folder 12/4. 368 NGA, 2006.654.47. 369 ANZ, AAQT 6401,A81942. 371 Photograph courtesy James Birrell. 374b AAG, 1992/33/2. 379 MAA, 2009.43. 380 MAA, 2009.29. 384 Te Papa, GH009293. 386 Te Papa, ME017062. 389 Photograph © Adrian Turner. 393l University of Hawai'i at Mānoa, Honolulu, Hamilton Pacific TT Archives Photo 1769.27. 393r Photograph © Ross Johnson, Papua New Guinea Association of Australia. 394b Photograph Charles and Josette Lenars, © Corbis Images. 396l Photograph Richard Yourzic. 396r Te Papa, FE008660. 397 Te Papa, FE010655. 398a Photograph Peter Brunt, c. 2006. 398b Photograph Philip Dark, c. 1990. 399 Leiden, 4518-47. 400 Field, LCN / CJP 7/ 2004. 402l ANZ, AAQT 6401,A88472. 402r Burke Museum, 2001-58/9. 411 Photograph Mark Cross. 412 Photograph © Jennifer French. 413l Photograph Fata von Reiche. 413r Photograph Peter Brunt, 2001. 415 Photograph © Bryan James. 419 Photograph Judith Ragg. 421 Photograph Richard Stringer. 423a Photograph courtesy ArtSpace archives held at the E.H. McCormick Research Library, AAG. 423b Photograph © Bryan James. 427 Photograph © Macario. 429 AAG, C1998/1/16. 431a Image courtesy the artist and Okaioceanikart Gallery, Auckland. 431b Photograph courtesy AAG. 432 Courtesy David Bateman Ltd. 434–435 AAG, 1999/30. 437 Photograph Tom Hogarty. 438, 439 Photographs Kerry Brown. 440 Photograph Sean Mallon, 2010. 443 Photograph Susan Cochrane, c. 2000. 444l Image courtesy Cam Stokes. 444r, 445bl & 445br Images courtesy Luanne Bond. 448 Photograph © Christophe Iaïchouchen, 2011. 451 Photograph Stella Ramage, 2011. 452a Photograph J. R. Manuel, 2010. 452b Photograph courtesy 808 Urban. 453 Image courtesy Aranud of kreativconcept. 454l Te Papa, FE010246. 454r Photograph Jan Nauta, courtesy Te Papa. 456l Photograph © Cameron Spencer/Getty Images Sport. 456r Image courtesy Greg Semu/Casula Powerhouse Art Centre. 457 Te Papa, FE011298. 460–461 Te Papa, FE011942; FE011940; FE011998. 462, 463 Photographs courtesy City Gallery, Wellington. 464 Photograph Vinesh Kumaran, courtesy Fresh Gallery Otara. 467 PRM, 2002.22.1. 473 Photograph Bryson Kim, courtesy Heidi Quenga. 474 Photograph Jean Mason, 2011. 475 Photograph courtesy Michael Howard. 476 Te Papa, FE011603. 477 Te Papa, ME023268; ME023266. 478–479 Te Papa, FE012441. 480 Photograph Kerry Brown. 482 BM, 2008,2004.28. 483 Te Papa, FE009703. 485 Photographer Brennan King. 489l Photograph Ursula Konrad. 489r Photograph Julie Risser, 2009. 492 Photograph courtesy Kenji Nagai/Spirit Wrestler Gallery. 493 Photograph courtesy Tohi Foundation. 494 Photograph courtesy Kenji Nagai/Spirit Wrestler Gallery. 495 MAA, 2002.71. 497 QAG, 2009.196.001-009.

Peter Brunt was born in Auckland to migrant parents from Samoa (both with Samoan and English ancestry). He received his PhD from Cornell University and is currently Senior Lecturer in Art History at Victoria University of Wellington. He has published articles on contemporary Māori and Pacific art and was part of the Getty-funded research project *Tatau/Tattoo*, for which he co-edited the book *Tatau: Samoan Tattoo, New Zealand Art, Global Culture* (2010) and curated the exhibition *Tatau: Photographs by Mark Adams*. He is currently involved in the collaborative research project *Multiple Modernities: Twentieth Century Modernisms in Global Perspective*, for which he is writing on aspects of modernism in the Pacific.

Nicholas Thomas was born in Sydney in 1960. His parents too were born in Sydney, of northern and eastern European as well as English descent. He first visited the Pacific Islands in 1984 to research his PhD thesis on the Marquesas Islands and has since written widely on art, voyages, colonial encounters and contemporary culture in the Pacific. His books include *Entangled Objects* (1991), *Oceanic Art* (1995), *Discoveries: The Voyages of Captain Cook* (2003) and *Islanders: The Pacific in the Age of Empire* (2010), which was awarded the Wolfson History Prize. Since 2006 he has been Director of the Museum of Archaeology and Anthropology in Cambridge.

Sean Mallon is of Samoan and Irish descent and is Senior Curator Pacific Cultures at the Museum of New Zealand Te Papa Tongarewa. He is the author of *Samoan Art and Artists* (2002) and co-edited *Pacific Art Niu Sila: The Pacific Dimension of Contemporary New Zealand Arts* (2002), *Tatau: Samoan Tattoo, New Zealand Art, Global Culture* (2010) and *Tangata o le Moana: The story of New Zealand and the People of the Pacific* (2012). His exhibitions include *Paperskin: The Art of Tapa Cloth* (with Maud Page) (2009), *Tangata o le Moana* (2007), *Voyagers: Discovering the Pacific* (2002) and *Tatau/Tattoo* (2002). He has been a council member of The Polynesian Society since 2008.

Lissant Bolton is Keeper (Head) of the Department of Africa, Oceania and the Americas at the British Museum and previously worked for the Australian Museum in Sydney and the Australian National University, Canberra. Australian-born, she is an anthropologist with wide research interests in the Pacific and a special focus on Vanuatu, where for many years she has worked collaboratively with the Vanuatu Cultural Centre on programmes to document and revive women's knowledge and practice. Her publications include the monograph *Unfolding the Moon: Enacting Women's Kastom in Vanuatu* (2003) and the co-edited book *Melanesian Art: Objects, Narratives and Indigenous Owners* (2012). Her curated exhibitions include *Baskets and Belonging: Australian Indigenous Histories* (2011) and *Power and Taboo: Sacred Objects from the Pacific* (2006), both at the British Museum.

Deidre Brown is Senior Lecturer in Architecture at the University of Auckland. She is a member of the Ngāpuhi and Ngāti Kahu tribes of Northland. Her teaching and research is in the areas of Māori and Pacific art and architectural history, cultural property, indigenous knowledges, and culturally responsive design. She has written a number of books on Māori art and architecture, including *Māori Architecture* (2009), *Te Puna: Māori art from Te Tai Tokerau Northland* (2007, co-edited with Ngarino Ellis), *Introducing Māori Art* and *Māori Art of the Gods* (both 2005) and *Tai Tokerau Whakairo Rākau: Northland Māori Wood Carving* (2003).

Damian Skinner, a Pākehā art historian, is currently a British Academy Newton International Fellow at the Museum of Archaeology and Anthropology, Cambridge, and Curator of Applied Arts and Design at the Auckland Museum. His books include *Ihenga: Te Haerenga Hou – The Evolution of Māori Carving in the 20th Century* (2007), *The Carver and the Artist: Māori Art in the Twentieth Century* (2008) and *The Passing World, The Passage of Life: John Hovell and the Art of Kōwhaiwhai* (2010). He is currently working on a project about art and decolonization in settler societies.

Susanne Küchler was born in Germany and educated in both Germany and the UK. She is Professor of Anthropology and Material Culture at University College London. She has conducted ethnographic fieldwork in Papua New Guinea and eastern Polynesia, studying art, innovation and futurity in political economies of knowledge from a comparative perspective. Her more recent work on the history of the take-up in the Pacific of cloth and clothing as 'new' material has focused on social memory and material translation and its role in long-term social change. Her publications include *Malanggan: Art, Memory and Sacrifice* (2002), *Pacific Pattern* (2005, with Graeme Were) and *Tivaivai: The Social Fabric of the Cook Islands* (2009, with Andrea Eimke).